YORUBA
NINE CENTURIES OF AFRICAN ART AND THOUGHT

YORUBA
NINE CENTURIES OF AFRICAN ART AND THOUGHT

Henry John Drewal and John Pemberton III
with Rowland Abiodun
Edited by Allen Wardwell

The Center for African Art
in association with
Harry N. Abrams Inc., Publishers, New York

Foluso Longe Sùn Re O
1940 – 1987

Yoruba: Nine Centuries of African Art and Thought is published
in conjunction with an exhibition of the same title organized and
presented by The Center for African Art, New York. At the time
of publication additional presentations of the exhibition are
scheduled at: The Art Institute of Chicago; The National Museum
of African Art, Smithsonian Institution, Washington, DC; The
Cleveland Museum of Art; The New Orleans Museum of Art; and
the High Museum of Art, Atlanta.

The exhibition is supported by grants from the National Endow-
ment for the Humanities; The National Endowment for the Arts;
New York State Council on the Arts; and the Anne S. Richardson
Fund.

Design: Linda Florio
Production: Red Ink.

Trade edition is distributed by Harry N. Abrams Inc., 100 Fifth
Avenue, New York City 10011.

Library of Congress catalogue card no. 89-22182
Clothbound ISBN 0-8109-1794-7
Paperbound 0-945802-04-8

Printed in Japan

Contents

Foreword 10
Susan Vogel

Preface 11
Wande Abimbola

1/The Yoruba World 13
*Henry John Drewal, John Pemberton III,
and Rowland Abiodun*

2/Ife: Origins of Art and Civilization 45
Henry John Drewal

3/The Stone Images of Esie 77
John Pemberton III

4/The Kingdom of Owo 91
Rowland Abiodun

5/Art and Ethos of the Ijebu 117
Henry John Drewal

6/The Oyo Empire 147
John Pemberton III

7/The Carvers of the Northeast 189
John Pemberton III

8/The Artists of the Western Kingdoms 213
Henry John Drewal

9/The River that Never Rests 233
*Henry John Drewal, John Pemberton III,
and Rowland Abiodun*

Notes 235

Glossary of Yoruba Words 248

Bibliography 250

Photograph Credits 255

Index 256

Current Donors

Charles B. Benenson
Bernice and Sidney Clyman
Denyse and Marc Ginzberg
Lawrence Gussman
Drs. Marian and Daniel Malcolm
Adrian and Robert Mnuchin
Carlo Monzino
Don H. Nelson
Mr. and Mrs. James J. Ross
Lynne and Robert Rubin
Cecilia and Irwin Smiley
Sheldon H. Solow
Robert Aaron Young

Armand Arman
Mr. Gaston T. deHavenon
Alain de Monbrison
Sulaiman Diané
Gail and George Feher
John Friede
Mr. and Mrs. Irwin Ginsburg
Dr. and Mrs. Gilbert Graham
Clayre and Jay Haft
Mr. and Mrs. Murray Gruson
Mrs. Melville W. Hall
Jacques Hautelet
Dave Johnson
Jill and Barry Kitnick
Helen and Robert Kuhn
Helene and Philippe Leloup
Mr. and Mrs. Brian Leyden
Junis and Burton Marcus
Nancy and Robert Nooter
Freddy Rolin
Alfred L. Scheinberg
Mr. and Mrs. Edwin Silver
Marsha and Saul Stanoff
Mr. and Mrs. Paul Tishman
Faith-Dorian and Martin Wright

Mr. and Mrs. S. Thomas Alexander
Ernst Anspach
Dr. & Mrs. Pickward J. Bash, Jr.
Dr. and Mrs. Richard Baum
Mr. Stephen Benjamin
William Bolton
Mr. and Mrs. William W. Brill
Pamela and Oliver Cobb
Drs. Nicole and John Dintenfass
Drs. Noble and Jean Endicott
Mr. and Mrs. Richard Faletti
Monica Wengraf-Hewitt
Lorraine and Victor Honig
Mr. George H. Hutzler Jr.
Jerome L. Joss
Mrs. Helen L. Kimmel
Gabrielle and Samuel Lurie
Donald Morris Gallery
Mr. and Mrs. Timothy Nordin
Ms. Susan Potterat
Dorothy Brill Robbins
Eric Robertson
Mrs. Harry Rubin
Maurice W. Shapiro

Hope and Roy C. Turney
Dr. and Mrs. Leon Wallace
Kate Wendleton
James Willis Gallery
Dr. and Mrs. Thomas L. Young

Susan Allen
Joan Barist
Saretta and Howard Barnet
William W. Bell
Dr. Michael Berger
Alan Brandt
Eileen Cohen
Mr. Frederick Cohen and Diane Feldman
Lila and Gerald Dannenberg
Davis Gallery
Davis De Roche
Mr. Marc Felix
Mr. James Freeman
Mr. John Giltsoff
Mr. and Mrs. Joseph Goldenberg
Mr. and Mrs. Stuart Hollander
Udo Horstman
Mr. Stanley Lederman
Josephine and Sol Levitt
Mr. and Mrs. Morton Lipkin
Lee Lorenz
Mr. William Machado
Mrs. Robin Mix
Dr. Werner Muensterberger
Mr. and Mrs. Mickelson
Mr. and Mrs. Klaus Perls
Mr. and Mrs. Fred Richman
Mr. and Mrs. Milton Rosenthal
Jerome Ross
Mrs. Franyo Schindler
Dr. and Mrs. Jerome H. Siegel
Mr. and Mrs. Anthony Slayter-Ralph
Vincent M. Smith
Mr. and Mrs. Morton Sosland
Mr. Dwight V. Strong
Tambaran Arts, Inc.
Spencer Throckmontoon
Ruth E. Wilner
Mr. and Mrs. William S. Woodside
Arnold Alderman
Barbara and Daniel Altman
Ms. Leonore Anholt
Neal Ball
Mr. Walter Bareiss
Leonard S. Barton
Armand Bartos, Jr.
Elizabeth and Michel Beaujour
Dr. F. Beineke
Dr. and Mrs. S. Berkowitz
Gae and Sid Berman
Ms. Judith P. Bernard
Ms. Virginia A. Buxton
Katherine and Carroll Cline
Glenda D. Cohen
Mr. and Mrs. Allan D. Cohn
Mr. and Mrs. Herman Copen
Daniel and Joyce Cowin
Mr. and Mrs. Duval Cravens

Katherine D. Crone
Mme. Marie D'Udekem D'Acoz
Roland de Montaigu
Mr. and Mrs. Kurt B. Delbanco
Morton Dimonstein
Ms. Shelley and Dr. Norman Dinhoffer
Mr. John B. Elliot
Dr. and Mrs. Thomas Feary
Vianna Finch
Mr. and Mrs. Donald Flax
Mr. Gordon Foster
Ruth and Marc Franklin
Dr. Joseph French
Dr. Murray Frum
Clara K. Gebauer
Ms. Nelsa Gidney
Larry Mark Goldblatt
Hubert Goldet
Mr. and Mrs. Neal Gordon
Donald S. Gray
Edwin Greenblatt and Ursula Von Rydingvard
Dr. Irwin E. Gross
Ronald S. Hansford
Mr. and Mrs. John Heller
Herbert Waide Hemphill Jr.
Arnold Herstand
Elizabeth Hird
Mr. Donald C. Hofstadter
Dr. Norman Hurst
Mr. Steve Hyman
Judith and Harmer Johnson
Mr. and Mrs. Charles Jones
Leonard Kahan
Mr. Isadore Kahane
Mr. Kewulay Kamara
Carol and Jerome Kenney
Margaret and Joseph Knopfelmacher
John W. Kunstadter
Mr. Alvin S. Lane
John D. Lang
Roxanne and Guy Lanquetot
Amy and Elliot Lawrence
Mr. Jay C. Leff
Mimi and Richard Livingston
Mr. George Lois
Mrs. J. Hart Lyon
Mr. and Mrs. Lester Mantell
Mr. and Mrs. Thomas Marill
Barry D. Maurer
Anne and Jacques Maus
Nancy G. Mayer
Balene McCormick
Dr. Margaret McEvoy
Mr. and Mrs. John McGree
John McKesson
Ms. Genevieve McMillan
Mrs. Robin McMillin
Ms. Jane B. Meyerhoff
Edwin Michalove
Sam Scot Miller
Mrs. Franklin Moon
Mrs. John R. Muma
Mrs. Judith Nash

Mr. and Mrs. Roy R. Neuberger
Mr. Hank Noguchi
Mr. and Mrs. Richard Ohrstrom
David Owsley
Pearl Oxorn
Ms. Margaret Pancoast
Ellen Pearlstein
Mr. and Mrs. Pulitzer
Mr. and Mrs. Cecil A. Ray
Warren M. Robbins
Ms. Flavia Robinson
Dr. and Mrs. Jose H. Rodriguez
John B. Rosenthal
Mr. and Mrs. Daniel G. Ross
Mr. and Mrs. David B. Ross
Mr. and Mrs. Philip Rothblum
Mr. and Mrs. Stephen Rubin
Mr. William Rubin
Mr. Robert H. Schaffer
Richard H. Scheller
Mr. Mark Seidenfeld
Sydney L. Shaper
Ms. Mary Jo Shepard
Paul Simon
Mr. and Mrs. Dixton Stanton
Carolyn and John Stremlau
Mr. and Mrs. Arnold Syrop
Mr. and Mrs. William E. Teel
Mr. Paul Lebaron Thiebaud
Mrs. Edward Townsend
Margo and Anthony Viscusi
Mrs. Dorothy G. Voss
Dr. and Mrs. Bernard M. Wagner
Lucille and Frederic Wallace
Dr. and Mrs. Leon Wallace
Stewart J. Warnow
Mr. Frank Weissman
Mr. Thomas G. Wheelock
Mr. and Mrs. O. S. Williams
Xanadu Gallery
Susan Yecies
Bernard Young
Sylvia and Arthur Zucker

Institutional Donors

Department of Cultural Affairs, City of New York
National Endowment for the Arts
National Endowment for the Humanities
New York State Council on the Arts
Pace Primitive and Ancient Art
Philip Morris Companies Inc.
Puget Sound Fund of the Tides Foundation
Readers Digest Foundation
Anne S. Richardson Fund
Sotheby's

Current as of July 15, 1989.

Lenders to the Exhibition

Afrika Museum, Berg en Dal
America West Primitive Art, Tucson
The Art Institute of Chicago
Ian Auld
Neal Ball
Mr. and Mrs. William W. Brill
Marie-Catherine Daffos and Jean-Luc Estournel
Mr. and Mrs. Charles Davis
Gaston T. deHavenon
Balint B. Denes
Department of Archaeology, Obafemi Awolowo University,
 Ile-Ife, Nigeria
The Detroit Institute of Arts
Drs. John and Nicole Dintenfass
Dufour Collection
Drs. Jean and Noble Endicott
Barbara and Richard Faletti
The Fine Arts Museums of San Francisco
Valerie Franklin
Lawrence Gussman
Clayre and Jay Haft
Dr. and Mrs. Jeffrey Hammer
Toby and Barry Hecht
Ben Heller

The High Museum of Art, Atlanta
Hood Museum of Art, Dartmouth College
Ida and Hugh Kohlmeyer
Dr. and Mrs. Robert Kuhn
Mr. and Mrs. Sol Levitt
Drs. Marian and Daniel Malcolm
Barry D. Maurer
William McCarty-Cooper
The Metropolitan Museum of Art
The Minneapolis Institute of Arts
Mr. and Mrs. Robert E. Mnuchin
Museum Rietberg, Zurich
Michael Myers, New Orleans
National Commission for Museums and Monuments, Nigeria
National Museum of African Art, Smithsonian Institution
New Orleans Museum of Art
George Ortiz, Geneva
Jane and John Pemberton
Port of History and Civic Center Museums, Philadelphia
The Milton D. Ratner Family Collection
Cynthia and Cecil A. Ray Jr.
Rita and Fred Richman
Eric D. Robertson
Seattle Art Museum
Staatliches Museum für Völkerkunde, Munich
Christopher Taylor
Arthur R. Thomson
The Toledo Museum of Art
University Art Museum, Obafemi Awolowo University,
 Ile-Ife, Nigeria
The University of Iowa Museum of Art, Iowa City
Dr. and Mrs. Bernard M. Wagner
The Walt Disney Company
Arnold and Phyllis Weinstein
Whipple Collection
James Willis Gallery, San Francisco
and anonymous lenders

Authors' Acknowledgments

The creative process is always a collective endeavor. Many persons have assisted us in our research, the organization of the exhibition and the writing of this book. We cannot name them all. There are, however, individuals and institutions to whom we owe a public word of appreciation.

We are grateful to Professor Ade M. Obayemi, Director General, National Commission for Museums and Monuments for permitting the loan of antiquities from the National Museum in Lagos, Nigeria; Mrs. Helen O. Kerri, Chief Curator and Head of Museums, and Mr. Abu Edet, Chief Conservator, for arranging for the packing and shipping of objects from the National Museum in Lagos, Nigeria; Professor Wande Abimbola, Vice Chancellor, Professor Omotoso Eluyemi of the Department of Archaeology and Professor J. R. O. Ojo of the Department of Fine Arts for permitting the loan of antiquities from the collections of Obafemi Awolowo University, Ile-Ife, Nigeria; Mr. Princeton Lyman, Ambassador of the United States of America to Nigeria, and Mr. Robert R. LaGamma, Counselor of the Embassy of the United States of America for Public Affairs, Lagos, for assistance in arranging the loan of Nigeria's antiquities.

We relied upon the technical skills of Stan Sherer who prepared the black and white prints of John Pemberton's field photographs and Nate Eatman who prepared black and white prints for Henry Drewal. The Royal Anthropological Institute, London, granted us permission to publish photographs from the William Fagg Collection and the Foreign and Commonwealth office, Library and Records Department kindly permitted John Pemberton to photograph portions of their photographic archives.

Ms. Diane Beck spent hours converting software programs, recovering lost texts, keyboarding, editing and express mailing manuscripts. Professor J. F. Ade Ajayi and Mr. Sanmi Adu-Fatoba assisted Pemberton in translating the *oriki* for Olowe of Ise.

We wish to express our gratitude to Susan Vogel, Director of The Center for African Art, who offered us the opportunity to organize the exhibition and who set standards of connoisseurship and scholarship that served us well as curators and authors. Without the wise counsel, patience, careful attention to detail and unfailing grace of Allen Wardwell, Ima Ebong, and Jeanne Mullin of The Center for African Art this volume would not have gone to press.

Grants were provided by The National Endowment for the Humanities in support of collaborative field research by Henry J. Drewal and John Pemberton III in 1982 and 1986 (with Margaret T. Drewal) through the award of a Basic Research Grant (RO-20072-81-2184); the Amherst College Research Award Program for a grant to John Pemberton III for research in Nigeria and Europe in 1988; the Cleveland State University Faculty Research and Creative Activity Program for a grant to Henry John Drewal to survey American and Canadian collections of Yoruba art; and the New York State Council on the Arts for a planning grant.

Finally, we owe an immeasurable debt of thanks to all our Yoruba colleagues, friends, and associates who took the time to share their insights gained from lives of action and reflection. We hope we have captured in some small measure the richness of their wisdom and the aesthetic power of their art.

H. D.
J. P.
R. A.

Acknowledgments

We are grateful for generous funding received from both public and private sources. The National Endowment for the Humanities and the National Endowment for the Arts both provided implementation grants, and the New York State Council on the Arts awarded crucial funds for planning. In addition, the symposium held at the opening, "The Sustaining Power of Yoruba Art and Thought: Nigeria and the Americas," was underwritten by the Anne S. Richardson Fund. We also deeply appreciate the generosity of the many lenders in Nigeria, Europe and The United States of America for sharing their objects and the information that accompanied them with us.

Thanks are due to the three authors for their patience in dealing with numerous queries, and especially to Henry Drewal and John Pemberton III for their encyclopedic texts and fine photographs. Rowland Abiodun's excellent contributions have provided a Nigerian scholar's viewpoint to the book as well.

Copy editing was skillfully and efficiently handled by Martina D'Alton, who organized and polished the quantity of materials sent her. As he has in the past, Jerry Thompson set aside days and weekends to produce his exemplary photographs, and we have once again benefited from the taste of Jeffrey Strean for the New York installation. Linda Florio has designed her sixth fine book for The Center, again under considerable time pressure.

In one way or another, the entire staff was involved with this project. Those particularly responsible were Thomas G. B. Wheelock, who worked on the installation; Amy McEwen, who scheduled the tour; and Melanie Forman, who secured the necessary funding. Essential support was provided by Carol Thompson, Pam Bash, Albert Hutchinson, Joan Sternthal and Pat Gloster. Assistance with all aspects of the exhibition installation was provided by Linus Eze, Tajudeen Raji and Terrance Noel. The ultimate responsibility for the coordination of all the text information, illustrations, and loans fell to Ima Ebong, who worked many extra hours and weekends with the authors, the photographers and the designer to bring this book and exhibition to their completion. Her constant attentions are reflected throughout.

A. W.
S. V.

Foreword

"No one says 'did you see something?' when an elephant passes."

Yoruba saying

I suspect that more superlatives can be applied to the Yoruba than to any other African people, including this superlative. Over fifteen million strong, they are known as one of the largest and most prolific art-producing groups of Africa. Their art and institutions are among the oldest continuous traditions in Subsaharan Africa; their art and culture have been more extensively studied, published, and admired than almost any other. The bibliography on the Yoruba seems endless; it contains at least 4,000 references, including a growing number by Yoruba scholars. The Yoruba are probably unique in Africa in having four universities located in their homeland; these create intellectual centers that have attracted scholars from all of Nigeria and beyond. In Europe, Yoruba art has been collected, studied, exhibited and published since the beginning of this century. At a time when the art of Africa was generally held in low regard, the genius of ancient Yoruba sculptors was so undeniably evident their works were paid the ironic and misguided compliment of being attributed to the artists of Atlantis.

The Yoruba are exceptional among the peoples of Subsaharan Africa in having formed large towns and cities in the nineteenth and twentieth centuries. By the 1950s nearly a quarter of the Yoruba population lived in towns of over 100,000 inhabitants and the archaeological record indicates that Yoruba kings ruled substantial cities by the eleventh century.

The king or Oni reigning today at Ife belongs to a dynasty that is probably one of the oldest in the world. It has ruled in unbroken succession since the ninth century. Many of the remarkable naturalistic heads dating from the eleventh to the fifteenth centuries still belong to the Oni and are kept in a museum at the palace. Undisturbed by revolution or invasion, one of the most remarkable of these works, the Obalufon mask (Figure 76), is said to have always been kept on a shrine in the palace. There is nothing to disprove this evidence of a continuity found in few places in the world. Along with the institution of kingship itself, this naturalistic copper mask has remained right where it was made, kept by descendants of the original owner for nine centuries.

The art of Ife is by far the most naturalistic of all Sub-saharan art styles. As early as the eleventh century Ife shows a superb mastery of bronze casting technique at a time when no craftsman in Europe or the Near East knew how to cast a life-size bronze. It is also remarkable for its invention and great beauty. The selection of Yoruba antiquities exhibited here extends our comprehension of Ife art by showing the broad and rarely repeated range of subjects and styles treated by the artists of ancient Ife.

Today traditional Yoruba artists continue to flourish, slightly modifying their materials and subject matter to express the realities of contemporary culture. They create works in wood and bronze for use in traditional rituals, and as decoration for homes in Nigeria, Europe and the Americas. Yoruba artists working in Oshogbo from the early 1960s on have created one of the best-known contemporary art styles in Africa and often draw on traditional Yoruba mythology for their subject matter. The Yoruba have given Subsaharan Africa her first Nobel prize winner in the writer Wole Soyinka. The creative vitality and enduring culture of the Yoruba have provided a foundation for the lives of millions of people not only in Africa, but in Brazil, the Caribbean, and the United States. Through their beliefs and the ritual and artistic expressions of them, they have enriched the heritage of the world.

Susan Vogel
Executive Director
The Center for African Art

Preface

It is my honor and privilege to write these few words as a preface to *Yoruba: Nine Centuries of African Art and Thought*. Henry J. Drewal, John Pemberton III, and Rowland Abiodun spent many years of research on Yoruba art and culture, consulting numerous oral and written sources in preparing this book. I am particularly delighted, however, that they have made extensive use of the Ifa literary corpus, which is the most authoritative of the numerous genres of Yoruba oral literature.

To gain an in-depth understanding of Yoruba culture, the serious researcher must take into consideration the poetry of Ifa, which sheds wonderful light on Yoruba life and thought. Through the study of Ifa one discovers the philosophical concepts that are the basis for understanding Yoruba aesthetics. The poetry of Ifa, for example, enables us to comprehend the place of the individual in the Yoruba universe, whether this individual be king, commoner, artist, or art historian. In Ifa it is said: *Emi, omo Olodumare* (Spirit [or breath] is the offspring of Olodumare). It is *emi* that dwells in every person and raises him to the level of the divine. Another Yoruba concept is that of *ori inu*, which refers to a person's "inner head" or personal destiny. In Ifa, *ori* is thought of as an *orisa*, a deity, one of the most important gods in the crowded pantheon of the Yoruba. The concepts of *emi* and *ori inu*, explored in the chapters that follow, are essential for understanding the creative capacities of the individual.

Through the literature of Ifa we are able to learn that the divine forces governing the universe are of two different types: the *orisa* and the *ajogun*. There are 401 *orisa*, while the *ajogun* are said to be only 200. The *orisa* are by nature thought to be benevolent to man, while the *ajogun* are perceived as malevolent. There is an eternal and relentless struggle between these divine forces that affects the lives of all who dwell on earth. Hence, one of the most important themes running throughout the Ifa literary corpus is that of conflict, between *orisa* and *ajogun* and between *ajogun* and human beings. A temporary resolution of the struggle is achieved only through *ebo* (sacrifice). By acknowledging the powers that impinge on their lives and by relying on those forces that are for the moment favorable to their cause, individuals can be at peace with their world.

It is this story of conflict and resolution which the Yoruba artist expresses in his work. The artist is himself a product of this conflict and resolution process, and it is through his chosen medium that he articulates his experience. What he produces is a work that tells a whole story in his own way and in the context of the Yoruba mythical world view. The artist is, therefore, historian, critic, messenger, and even at times, prophet. The artist seeks to understand and record the world in which we live. Hence, the artist is indispensable in our own efforts to know ourselves and our culture. He enables us to sense and respond to the multiple rhythms that shape our lives. As we struggle to understand his artistry, let us hope that together we shall understand the intricate forces, both human and supernatural, that govern the complicated and fascinating world of the Yoruba.

Wande Abimbola
Vice-Chancellor
Professor of African Languages and Literatures
Obafemi Awolowo University
Ile-Ife, Nigeria

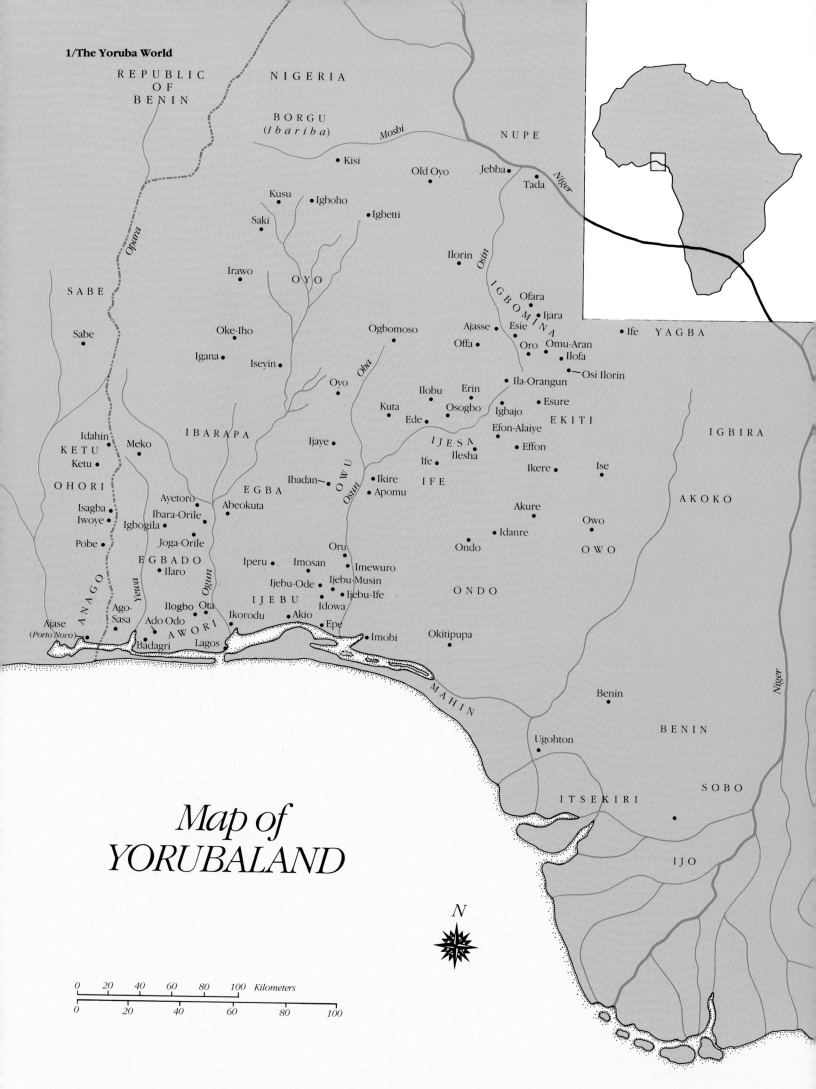

REPUBLIC
OF
BENIN

NIGERIA

BORGU
(*Ibariba*)

Moshi

NUPE

Kisi

Old Oyo

Jebba

Tada

Niger

Kusu

Igboho

Saki

Igbetti

SABE

Irawo

OYO

Ilorin

Osin

Ofara

Ijara

IGBOMINA

Sabe

Oke-Iho

Ogbomoso

Ajasse

Esie

Ife

YAGBA

Igana

Oba

Offa

Oro

Omu-Aran

Ilofa

Iseyin

Oyo

Ila-Orangun

Osi Ilorin

Ilobu

Erin

IBARAPA

Kuta

Osogbo

Igbajo

Esure

EKITI

IGBIRA

KETU

Meko

Idahin

Ijaye

Ede

IJESA

Efon-Alaiye

Ketu

Ife

Ilesha

Effon

OHORI

EGBA

Ibadan

Ikire

IFE

Ikere

Ise

AKOKO

Isagba

Ayetoro

Abeokuta

Apomu

Akure

Owo

Iwoye

Ibara-Orile

Idanre

OWO

Igbogila

Joga-Orile

Pobe

Oru

Ondo

EGBADO

Iperu

Imosan

Imewuro

ONDO

Ilaro

Ijebu-Ode

Ijebu-Musin

ANAGO

Ago-Sasa

Ilogbo

Ota

IJEBU

Idowa

Ijebu-Ife

Yewa

Ado Odo

Ikorodu

Akio

Okitipupa

Ajase
(*Porto Novo*)

AWORI

Epe

Badagri

Ogun

Lagos

Imobi

Benin

MAHIN

Ugohton

BENIN

Map of
YORUBALAND

SOBO

ITSEKIRI

IJO

Niger

N

0 20 40 60 80 100 Kilometers

0 20 40 60 80 100

The Yoruba World

Henry John Drewal
John Pemberton III
Rowland Abiodun

The Yoruba-speaking peoples of Nigeria and the Popular Republic of Benin, together with their count-less descendants in other parts of Africa and the Americas, have made remarkable contributions to world civilization.[1] Their urbanism is ancient and legendary, probably dating to A.D. 800–1000, according to the results of archeological excavations at two ancient city sites, Oyo and Ife.[2] These were only two of numerous complex city-states headed by sacred rulers (both women and men) and councils of elders and chiefs. Many have flourished up to our own time. The dynasty of kings at Ife, for example, regarded by the Yoruba as the place of origin of life itself and of human civiliza-tion, remains unbroken to the present day.

In the arts, the Yoruba are heirs to one of the oldest and finest artistic traditions in Africa, a tradition that remains vital and influential today. By A.D. 1100 the artists at Ife had already developed an exquisitely refined and highly naturalistic sculptural tradition in terracotta and stone that was soon followed by works in copper, brass and bronze (Figure 10). Large figures portraying an array of social roles have been found in the region of Esie.

Of the series of remarkable Yoruba kingdoms over the last nine centuries, one of the earliest was Oyo, sited near the Niger River, the "Nile" of West Africa. Straddling this important trading corridor Oyo and its feared cavalry flourished between 1600 and 1830 and came to dominate a vast territory that extended northward to Borgu country, eastward to the Edo, westward to the Fon, and southward to the coast at Whydah, Ajase, and Allada. In Allada the presence of the Yoruba divination system known as Ifa was docu-mented in an early divining tray (Figure 11).

Another Yoruba kingdom in the southeast, Owo, main-tained close ties to Ife and also experienced the power-ful artistic and cultural influences of Benin between the fifteenth and nineteenth centuries. Both were changed in the process—Owo artists supplying fine ivory work to the court at Benin, and Owo royalty adapting and trans-forming many Benin titles, institutions, and the regalia of leadership in the process(Figure 4).

The Ijebu Yoruba kingdoms (1400–1900) of the coas-tal plain were shaped by many of these same factors. These Yoruba became masters of trade along the lagoons, creeks, and rivers as well as masters of bronze casting and cloth weaving (Figure 5). They were the first Yoruba to establish trading ties with Europeans in the late fifteenth century. Over the next four centuries, the Yoruba kingdoms prospered and then declined as the devastating effects of the slave trade and inter-necine warfare of the nineteenth century took their toll. The stage was set for the ascendancy of the British and the advent of colonial rule at the end of the nineteenth century.

One of the effects of eighteenth- and nineteenth-cen-tury disruptions was the dispersal of millions of Yoruba peoples over the globe, primarily to the Americas—Haiti, Cuba, Trinidad, and Brazil—where their late arrival and enormous numbers ensured a strong Yoruba character in the artistic, religious, and social lives of Africans in the New World. That imprint persists today in many arts and in a variety of African-American faiths that have arisen not only in the Caribbean and South America, but also in urban centers across the United

States.[3] Yoruba philosophical, religious, and artistic tenets, ideas, and icons have transformed and continue to transform religious beliefs and practices and the arts of persons far beyond Africa's shores.

There are several fundamental concepts that are distinctive to a Yoruba world view. They provide a foundation for comprehending the dynamics of Yoruba art and culture through time and space. Furthermore, these concepts are expressed in words, images, and actions. All three modes of expression contribute to the shaping of Yoruba culture and our understanding of it. Here, we concentrate on concepts conveyed in words and images that seem to permeate a wide variety of forms, media, and contexts. In the Yoruba view, all the arts are closely related and are often meant to be understood and seen as images in the mind's eye. Such mental images (*iran*) are related to *oju inu* (literally "inner eye" or "insight").[4] Thus, both the words and the forms considered in this chapter embody concepts that are pervasive and enduring markers of Yoruba civilization.[5]

The Yoruba Cosmos

The Yoruba conceive of the cosmos as consisting of two distinct yet inseparable realms—*aye* (the visible, tangible world of the living) and *orun* (the invisible, spiritual realm of the ancestors, gods, and spirits) (Figures 2 and 3). Such a cosmic conception is often visualized as either a spherical gourd, whose upper and lower hemispheres fit tightly together, or as a divination tray with a raised figurated border enclosing a flat central surface (Figure 14). The images clustered around the perimeter of the tray refer to mythic events and persons as well as everyday concerns. They depict a universe populated by countless competing forces. The intersecting lines inscribed on the surface by a diviner at the outset of divination symbolize metaphoric crossroads, *orita meta* (the point of intersection between the cosmic realms).[6] The manner in which they are drawn (vertical from bottom to top, center to right, center to left) shows them to be three paths—a symbolically significant number. These lines are always drawn by Yoruba priests at the outset of divination to "open" channels of communication before beginning to reveal the forces at work and to interpret their significance for a particular individual, family, group, or community. Thus the Yoruba world view is a circle with intersecting lines.

Such an image also has temporal implications since the Yoruba conceive of the past as accessible and essential as a model for the present.[7] They believe that persons live, depart, and are reborn and that every individual comes from either the gods or one's ancestors on the mother's or the father's side. In addition,

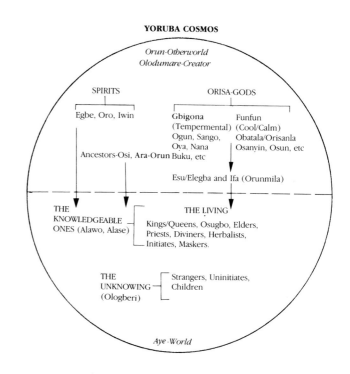

2. A diagram of some of the key elements of the Yoruba cosmos. It consists of two distinct yet interactive realms—*aye*, the tangible world of the living and *orun*, the invisible realm of spiritual forces such as the gods, ancestors, and spirits. All beings, whether living or spiritual, possess life force, *ase*. Those wise individuals such as priests, initiates, diviners, rulers and elders who learn to use it for the benefit of themselves and those around them are known as *alase* or *alawo*. Drawing by H. J. Drewal.

rituals are efficacious only when they are performed regularly according to tenets from the past and creatively re-presented to suit the present.[8]

Orun: The Otherworld

Olodumare (also known as Odumare, Olorun, Eleda, Eleemi) is conceived as the creator of existence, without sexual identity and generally distant, removed from the affairs of both divine and worldly beings. Olodumare is the source of *ase*, the life force possessed by everything that exists. *Orun* (the otherworld), the abode of the sacred, is populated by countless forces such as *orisa* (gods), *ara orun* (ancestors) and *oro, iwin, ajogun,* and *egbe* (various spirits), who are close to the living and frequently involved in human affairs.

The *orisa* are deified ancestors and/or personified natural forces. They are grouped broadly into two categories depending upon their personalities and modes of action—the "cool, temperate, symbolically white gods," (*orisa funfun*), and the "hot, temperamental gods" (*orisa gbigbona*). The former tend to be gentle, soothing, calm, and reflective and include: Obatala/Orisanla, the divine sculptor; Osoosi/Eyinle, hunter and water lord; Osanyin, lord of leaves and medicines; Oduduwa, first monarch at Ile-Ife; Yemoja,

Osun, Yewa, and Oba, queens of their respective rivers; Olosa, ruler of the lagoon; and Olokun, goddess of the sea. Many of the "hot gods" are male, although some are female. They include: Ogun, god of Iron; Sango, former king of Oyo and lord of thunder; Obaluaye, lord of pestilence; and Oya, Sango's wife and queen of the whirlwind. The latter tend to be harsh, demanding, aggressive and quick-tempered.

This characterization of the *orisa* has nothing to do with issues of good and evil. All gods, like humans, possess both positive and negative values—strengths as well as foibles. Only their modes of action differ, which is the actualization of their distinctive *ase* (life force), as expressed by their natures or personalities (*iwa*). Furthermore, the gods are not ranked in any hierarchy. Their relative importance in any given part of the Yoruba world reflects their relative local popularity, reputation, and influence, and the order in which they are invoked in ceremonies has to do with their roles in the ritual and their relationships to each other.[9]

The gods regularly enter the world through their mediums—worshippers who have been trained and prepared to receive the spirit of their divinities during possession trances in the course of religious ceremonies (Figure 6). When the gods are made manifest in this way, they speak through their devotees, praying and giving guidance.

While all the gods periodically journey to the world, two sacred powers, Ifa and Esu/Elegba, stand at the threshold between the realms of *orun* and *aye*, assisting in communication between the divine and human realms. Ifa, actually a Yoruba system of divination, is presided over by Orunmila, its deified mythic founder, who is also sometimes called Ifa. Esu/Elegba is the divine messenger and activator.[10]

Ifa offers humans the possibility of knowing the forces at work in specific situations in their lives and of influencing the course of events through prayer and sacrifice. The diviner, or *babalawo* ("father of ancient wisdom") uses the rituals and poetry of Ifa to identify cosmic forces: the gods, ancestors, and spirits, and the machinations of the enemies of humankind personified as Death, Disease, Infirmity, and Loss; certain troublesome entities such as *egbe abiku* (spirit children), who may cause newborn children to die and be reborn frequently thus plaguing their parents until rituals and offerings can set matters right; and the sometimes evil-intentioned persons known collectively as *araye* ("people-of-the-world") who include *aje* (witches), *oso* (wizards), and others.

While Ifa symbolizes the revealable, Esu/Elegba is the agent of effective action, who also reminds one of the unpredictable nature of human experience. Esu's

constant and often unsettling activity reminds humans of the need for guidance in lives of engaged action. Esu, who bears the sacrifices of humans to the *orisa* and other spirits, is the guardian of the ritual process. A verse from Ifa warns that if Esu is not acknowledged, "life is the bailing of waters with a sieve."[11]

The ancestors (*oku orun, osi, babanla, iyanla*), constitute another major category of beings in *orun*. They are departed but not deceased. They can be contacted by their descendants for support and guidance and can return to the world either for short stays in the form of maskers called *egungun* (Figure 17), or as part of new persons in their lineages who are partially their reincarnation. A young female child revealed to be the incarnation of her grandmother, for example, will be named Yetunde ("Mother-has-returned"). The grandmother continues to exist in *orun*, but part of her spirit, or breath, *emi*, is a constituent element of the new child.

Aye: The World of the Living

Aye, the world, is the visible, tangible realm of the living, including those invisible otherworldly forces that visit frequently and strongly influence human affairs. The importance and omnipresence of the otherworld in this world is expressed in a Yoruba saying: "The world is a marketplace [we visit], the otherworld is home" (*Aye l'oja, orun n'ile*). A variant of this phrase, *Aye*

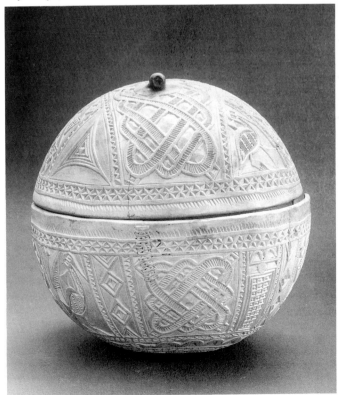

3. Calabash. Oyo, 19th century. The Yoruba conceive of the cosmos as consisting of two distinct yet inseparable realms, *aye* and *orun*. Such a cosmic view is often visualized as a spherical gourd, whose upper and lower hemispheres fit tightly together. Carved gourd, Diam. 9 ¾ in. Staatliches Museum für Völkerkunde, Munich.

l'ajo, orun n'ile ("The world [life] is a journey, the other-world [afterlife] is home"), contrasts the movement and unpredictability of life with the haven of the afterworld that promises spiritual existence for eternity.[12] Individual goals and aspirations in the world include long life, peace, prosperity, progeny, and good reputation. Ideally, these can be achieved through the constant search for *ogbon* (wisdom), *imo* (knowledge), and *oye* (understanding).

Yoruba society is traditionally open, but with a long history of monarchial and hierarchical organization. Nevertheless, decision making is shared widely—consensual rather than autocratic or dictatorial—and an elaborate series of checks and balances ensures an essentially egalitarian system.[13] Just as all the gods are equal in relation to Olodumare, so too all lineages are structurally equal in their relation to the sacred king. At the same time, the possibility of mobility is fundamental, depending on how one marshals the forces in the environment. The situation is remarkably fluid and dynamic. Within this context, there is some recognition of rank, yet distribution of responsibilities and authority are given more importance than hierarchy. Seniority is based on the age of the person, the antiquity of the title, and the person's tenure in office. Such an ideal for social interaction is rooted in the concept of *ase*, the life force possessed by all individuals and unique to each one. Thus *ase* must be acknowledge and used in all social matters and in dealings with divine forces as well.

Ase: Life Force

Ase is given by Olodumare to everything—gods, ancestors, spirits, humans, animals, plants, rocks, rivers, and voiced words such as songs, prayers, praises, curses, or even everyday conversation. Existence, according to Yoruba thought, is dependent upon it; it is the power to make things happen and change.[14] In addition to its sacred characteristics, *ase* also has important social ramifications, reflected in its translation as "power, authority, command." A person who, through training, experience, and initiation, learns how to use the essential life force of things is called an *alaase*. Theoretically, every individual possesses a unique blend of performative power and knowledge—the potential for certain achievements. Yet because no one can know with certainty the potential of others, *eso* (caution), *ifarabale* (composure), *owo* (respect), and *suuru* (patience) are highly valued in Yoruba society and shape all social interactions and organization.

Social processes encourage the participation of all and the contribution of the *ase* of every person. For example, members of the council of elder men and

women, known as Osugbo among the Ijebu Yoruba and Ogboni in the Oyo area, have hereditary titles that rotate among many lineages, and there are other positions that are open to all in the society, as well as honorary titles bestowed on those who have made special contributions to the community (Figure 19). Members stress the equality of such positions in emphasizing their distinctive rights and responsibilities. All are seen as crucial to the successful functioning of the society as evident in Osugbo rituals. The members share kola nut, the drummers play the praises of titles, individuals take turns hosting a series of celebrations, each person has the opportunity to state opinions during debates, and all decisions are consensual. Osugbo members stress the autonomy of their individual roles while at the same time asserting their equality in decision making. At various times some will dominate while others acquiesce, which is entirely in keeping with Yoruba notions of the distinctive *ase* of individuals and the fluid social reality of competing powers that continually shape society.[15]

Rituals to invoke divine forces reflect this same concern for the autonomous *ase* of particular entities. Those invoked first are not more important or higher in rank, rather they are called first in order to perform specific tasks—such as the divine mediator Esu/Elegba who "opens the way" for communication between humans and gods. The recognition of the uniqueness and autonomy of the *ase* of persons and gods is what structures society and its relationship with the otherworld.

Ase and Composition in Art for Ifa and Esu

The concept of *ase* seems also to influence how many of the verbal and visual arts are composed. In the visual arts, for example, a design may be segmented or seriate—a discontinuous aggregate in which the units of the whole are discrete and share equal value with the other units.[16] The units often have no prescribed order and are interchangeable. Attention to the discrete units of the whole produces a form which is multifocal, with shifts in perspective and proportion. Such elements can be seen in Ifa trays and lidded bowls (Figure 8), veranda posts (Figure 9), carved doors (Figure 20), and ancestral maskers (Figure 18).[17] Such compositions (whether representational or not) mirror a world order of structurally equal yet autonomous elements. It is a formal means of organizing diverse powers, not only to acknowledge their autonomy but, more importantly, to evoke, invoke, and activate diverse forces, to marshal and bring them into the phenomenal world. The significance of segmented composition in Yoruba art can be appreciated if one understands that art and ritual are integral to each other.

The design of Ifa sacred art forms both expresses the presence of a host of cosmic forces and recalls valuable precedents from the mythic past.[18] Ifa divination trays, *opon*, by their composition, articulate a cosmos of competing, autonomous forces. The etymology of the term *opon* means "to flatter,"[19] and the tray, through the artistry of its embellishments, is meant to praise the momentous work of diviners as they seek to disclose the forces active in a situation. The tray's iconography is often documented in myth, which preserves the lessons of the past. More importantly, the arrangement of motifs in an object, together with efficacious invocations and actions enacted in its presence, not only acknowledge supernatural forces and events, but bring them into the present world from the otherworld and the past for the benefit of devout Yoruba (Figures 12, 13).

One *opon* from the Ulm Museum, West Germany, collected at Allada during the first half of the seventeenth

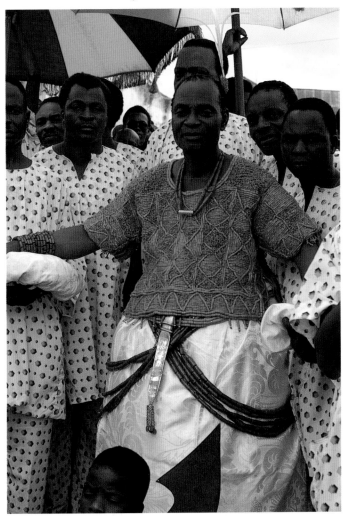

4. The Oba Ogunoye II, Olowo of Owo, wearing his ceremonial costume during the Igogo festival. Stuck in his plaited hair are two white egret tail feathers. He wears a short-sleeve blouse made up of red tubular coral beads. On either side of his white skirt (Ibolukun) are suspended several rows of stringed red coral beads and a small ceremonial knife hanging down the center from beneath the beaded blouse. Igogo, Owo, Nigeria, 1975. Photograph by H. J. Drewal.

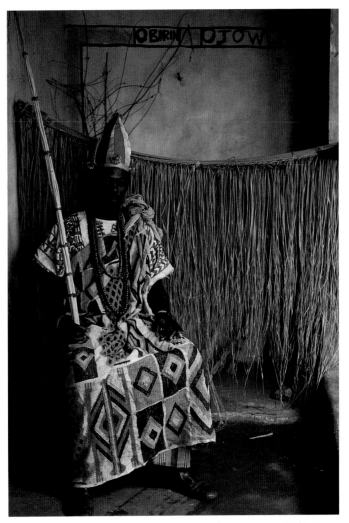

5. The Olowa, an Ijebu priest, wears an *aso olona*, "the artful cloth," named for the richness and complexity of its woven designs. These and other woven cloths from Ijebu were traded widely in the Niger Delta. After the Portuguese established trading links with Ijebu in the late 15th century, Ijebu cloth was also traded to Brazil where it became known as *pano da costa*, "cloth from the [West African] coast." Ijebu-Ode, Nigeria, 1982. Photograph by H. J. Drewal.

century, documents the antiquity of segmented composition (see Figure 11).[20] A large frontal face centered at the top has been identified by some as Esu/Elegba, the divine mediator, although others identify this face with other forces. Three calabash medicine gourds crown the brow, and two profile figures, one with a gourd at the end of a tailed coiffure, may be Esu/Elegba references. Arranged around the border are a myriad of images: quadrupeds, cowrie shells, birds, reptiles, women, men, and cultural items such as pipes, tools, swords, sheaths, axes, cups, brooms, shackles(?), drums, gourds, guns, market goods, and divination tappers. Things present in the world crowd the space and express a wide variety of themes: leadership, warfare, survival, fertility, protection, and sacrifice, among others. There is no unifying narrative; instead these diverse depictions convey the autonomous forces in the Yoruba cosmos that affect and concern the diviner and his clients. Each is given approximately equal visual impor-

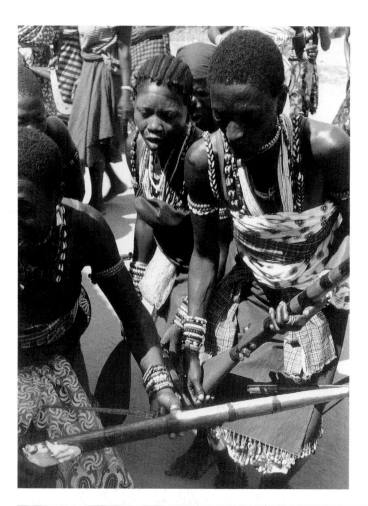

6. Initiates of the god Omolu in possesion dance during a ceremony. They wear the beads of their divinity as well as ritual fringed garments and carved wooden imitations of guns, symbolic of the generally aggressive nature of the god. During such spirit possessions, the gods assert their omnipresence and, speaking through their devotees, bless and guide the living. Egua, Egbado area, Nigeria, 1977. Photograph by M. T. Drewal.

7. Two animal maskers or "miracles" (*idan*) performing during an annual Egungun festival. Imasai, Egbado, 1978. Photograph by H. J. Drewal.

tance, thus evoking a dynamic and fluid cosmos of the same forces that "speak" through the verses (*ese*), recited by the diviner. The composition is segmented and egalitarian, with the marked shifts in perspective and proportion throughout the figurated border.[21] In keeping with seriate design and the autonomy of motifs, any visual element may be enlarged or reduced at the discretion of the artist.

A segmented composition and multiple proportions and perspectives are not the only features of composition in Ifa divination trays. There is also an explicit orientation and emphasis on four directions, the four quadrants between these, and the center of the tray. The four directions refer to the cardinal points. The orientation of a diviner's shrine should be eastward, so that morning light enters the room. Frobenius, citing information received early in this century from diviners in

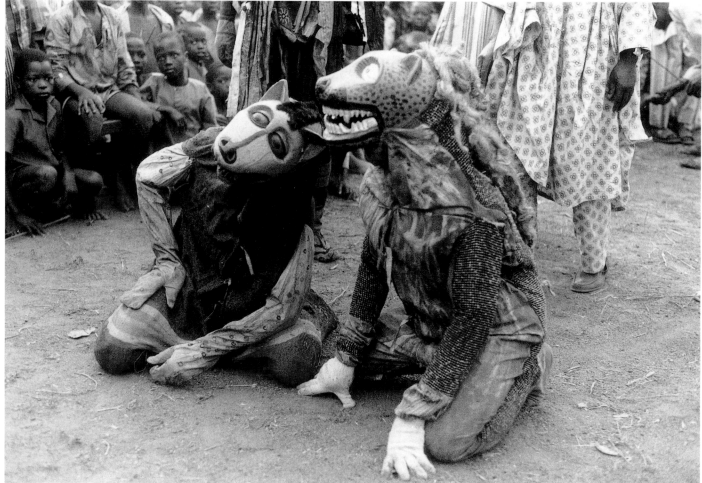

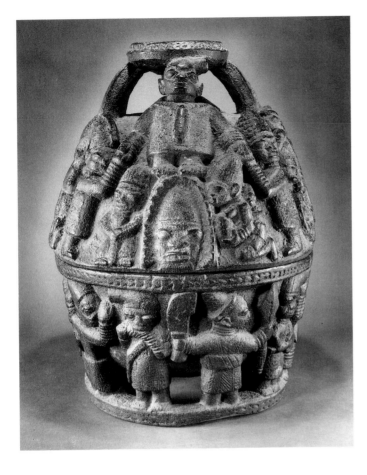

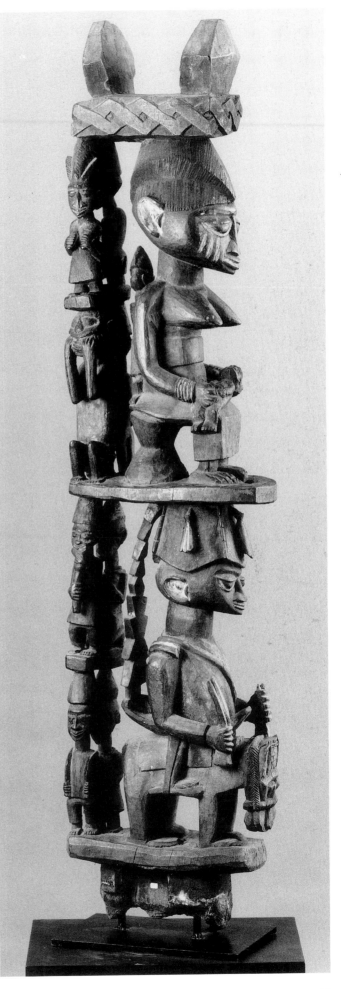

8. Ifa bowl, Osi-Ilorin, 19th–20th century. This splendid figurated bowl was carved by Areogun (c. 1880–1954) of Osi-Ilorin to hold the materials of divination used by a priest of Ifa. A master of composition, Areogun arranged the figures in the low–relief carving to symbolize the Yoruba experience of the universe as one of continuous change and transformation, and interdependence and interaction. The sacrificial way of life is shown as the appropriate response for making one's way propitiously through this world. Wood. H. 23½ in. Holly and David Ross collection.

9. Veranda Post, Ekiti, 19th–20th century. Agunna (died c. 1930) of Oke-Igbira, near Ikole-Ekiti, was a carver of great originality. He saw the human figure in terms of fundamental geometric shapes. The veranda posts that he carved for the palace of the Owa of Ilesa and another at Ijero, which depict the same subjects, are conceptually more severe than this veranda post. In this carving, and in a similar one in the collection of the Staatliches Museum für Völkerkunde, Munich, Agunna clusters figures behind each of the principal figures, conveying a sense of the larger social world in which every individual exists. Wood, pigment. H. 58 in. Cynthia and Cecil A. Ray Jr.

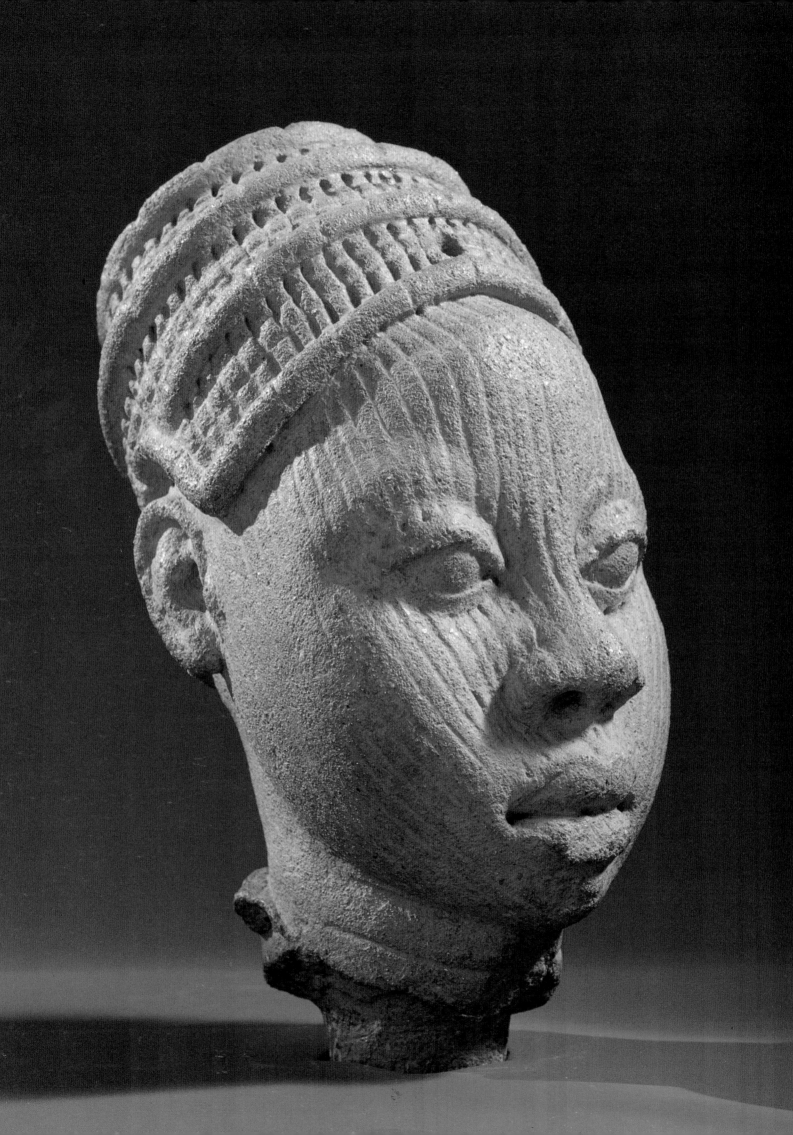

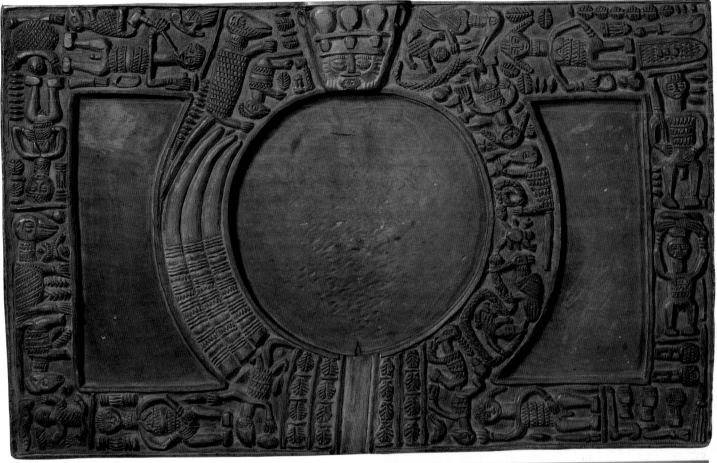

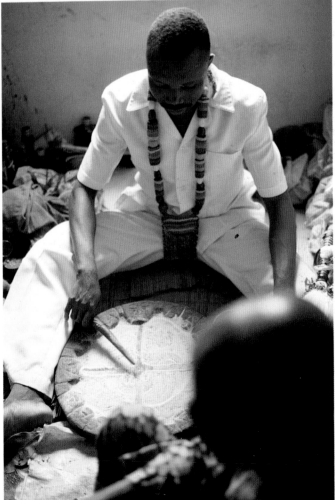

10. Head of a Figure, Ife, 11th–12th century. One of the best preserved Ife terracotta heads. Its refined, idealized naturalism and sensitive modeling suggest its origins in The Early Pavement Era. Terracotta. H. 6¼ in. National Commission for Museums and Monuments, Nigeria.

11. Ifa Divination Tray, Aja Fon, 16th/17th century. Collected at Allada in the early 17th century. Its style and elements of its iconography suggest it was probably carved by an Aja or Fon artist who was familiar with Yoruba sacred art. L. 11 in. Ulmer Museum, Ulm.

12. Babalawo Kolawole Ositola beginning the rite of divination. He marks the crossroads pattern in the *irosun* powder on the surface of the *opon* Ifa and rhythmically taps the tray with an *iroke* Ifa while invoking the presence of ancient Ifa priests. Porogun Quarter, Ijebu-Ode, Nigeria, 1982. Photograph by J. Pemberton III.

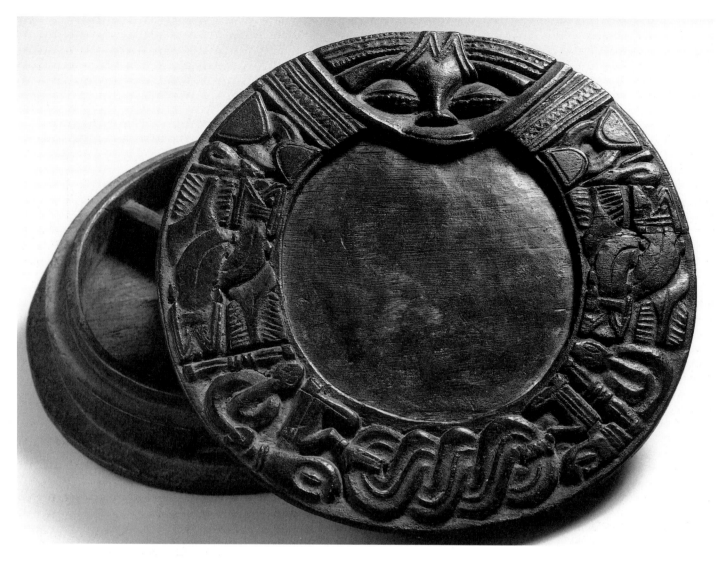

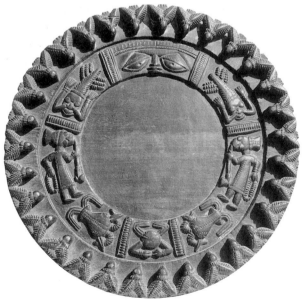

13. Ifa Tray, Ijebu, 19th–20th century. The bold composition of this divination tray is noteworthy. The face of Esu, guardian of the ritual process, appears at the top. It is unusually large, the lower portion is framed by a curve that sweeps into the central section of the tray where the priest would trace the marks of the Odu that would be revealed during the divination rite. Opposite the face of Esu, two kneeling figures grasp either end of the intertwined pattern. On either side of the tray are coiled snakes. Above them are pairs of intertwined fish. A simple design of juxtaposed triangles and circles completes the imagery. The total effect is a remarkable interplay of formal and geometric patterns and images of harmony and tension. The carving is a succinct expression of the dynamic at the heart of the Yoruba universe. Wood. Diam. 14 in. Barry D. Maurer.

14. Ifa Tray, Oyo, 19th–20th century. Thirty-one birds gather around the edge of this beautifully carved divination tray to witness the consultation with Orunmila, the *orisa* of wisdom. In the poetry of Ifa, birds are often associated with female power. (Some priests of Ifa assert that it was Odu, Orunmila's wife, who disclosed the secret of Ifa to him.) The iconography of the inner circle depicts two figures smoking pipes and the face of Esu, the *orisa* who transforms the sacrifices of men into food for the gods. At the bottom of the inner circle the carver depicts a crab and two mudfish, creatures which are like Esu in their ability to move in marginal realms. On either side of the face of Esu there is a motif often found in southern Yoruba carvings. It is a visual pun. On the one hand, it shows a face from which arms extend from the nostrils to frame the face, and three parallel lines which radiate from a conical crown. It also has the structural appearance of a mudfish. On the other, it is an image of kingship, for kings are marginal beings in whose sacred persons are combined the powers of men and gods. They thus become mediators between the realms of the human and the divine. Wood. Diam. 17¾ in. Peter Schnell.

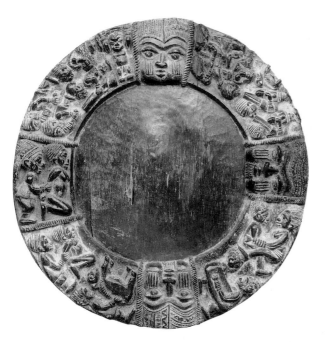

15. Ifa Tray, Ekiti, 20th century. The three faces on this beautifully carved tray are similar to those found on carvings by Olowe of Ise (see Chapter 7), although it is doubtful that Olowe was the carver. On divination trays there may be from one to four faces representing the ever-observant Esu. In addition to the three faces, the carver has depicted Esu in action. The figure with the phallic hairstyle, an iconographic reference to Esu, forces a supplicant to her knees. Wood. Diam. 19 in. Drs. Daniel and Marian Malcolm.

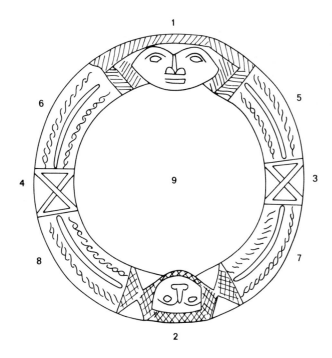

16. Divination tray inherited by *babalawo* Kolawole Ositola with numbers indicating the order and position of invocations, Ijebu, Nigeria. Drawing after a photograph by H. J. Drewal.

Ibadan, Ife, and Lokoja (Lokoya) recorded a myth explaining the origins of this practice: "Long, long ago, when everything was in confusion and young and old died, Olodu-mare (God) summoned Edshu-ogbe and said: 'Create order in the region of the sunrise.' To Oyako-Medyi: 'Create order in the region of he sunset.'

Next morning Edshu-ogbe created order in the east and in the evening Oyako-Medyi created order in the west."[22] In divination trays, then, the compositional interplay of a circle and lines reflects the unity of the Yoruba cosmos populated by diverse, autonomous forces. It represents the intersection of cosmic realms at the metaphoric crossroads, and the cardinal directions and mythic personages associated with them.

The divination tray also speaks of legendary diviners and their exploits, which provide precedents for actions and remedies in the present. One old tray, discussed by its owner, the diviner Kolawole Ositola, has eight sections plus one said to represent ancient diviners (Figure 16). The diviner invokes each section as he "opens" the tray by inscribing lines on it at the beginning of a consultation. The main, often the largest, section is called Oju Opon ("Face of the Tray"; no. 1)[23] oriented opposite the diviner. The part nearest the diviner is the Ese Opon ("Foot of the Tray"; no. 2). At the right-hand side is Ona Oganran ("Straight Path"; no. 3), while the left is Ona Munu, ("Direct Path"; no. 4). As Ositola explained: "These are ancient forefathers. When you work, work, work, your name will remain in history. That Ona Munu is one of the hard-working, ancient diviners, and he became so famous that we shall remember his name forever."[24] Ona Oganran ("Straight Path") was also famous. His way was straight, meaning he was "a straightforward person. . . a good man." Straightness is a metaphor for openness, honesty, and trustworthiness. The upper right quadrant of the tray is Alabalotun ("One-who-proposes-with-the-right"; no. 5); the upper left is Alaselosi ("One-who-implements-with-the-left"; no. 6). On the lower right is Aliletepowo ("Early-riser-who-sits-down-and-prospers"; no. 7), and on the lower left is Afurukeresayo ("One-who-has-a-diviner's-flywhisk-and-is-happy"; no. 8). The center, designated the "leader," of the tray, where the verses of Ifa are marked, is the Erilade Opon ("Center-of-the-tray-has-the-crown"; no. 9). This point of intersection of paths and realms is thus seen and explained as a "crown," *ade*, a conical form with profound symbolic significance in Yoruba thought as we shall see.

After the diviner "greets" these nine ancients, he may then pay homage to his forefathers, the deities, and certain birds. These birds symbolize the diviner's ability to chant and also, according to Ifa lore, represent ancient diviners. As Ositola explained, "all the birds and animals have the knowledge of Ifa in the ancient times." Many stories in the Ifa corpus recount the trials and tribulations of these bird diviners. Their victories presage the success of the diviner who invokes their memory. In praising all the sections of the tray, the diviner alerts its spiritual powers, readies it for action,

17. An Egungun masker or "miracles," *idan,* performing during an annual Egungun festival. The success of their performance is judged by the fun and excitement they generate as they cavort about the area. They chase and grab the children in the audience who sometimes taunt them with abusive songs and challenges. Imosan, Nigeria, 1986. Photograph by M. T. Drewal.

18. Two ancestral maskers of the type known as *alabala.* The distinctive feature of their costume is a brightly colored patchwork facing said by Yoruba to "make the cloth shine." Its segmented composition reflects the belief in diverse and autonomous powers in the cosmos that must be evoked and marshalled for the survival and benefit of society. Ilaro, Nigeria, 1975. Photograph by M. T. Drewal.

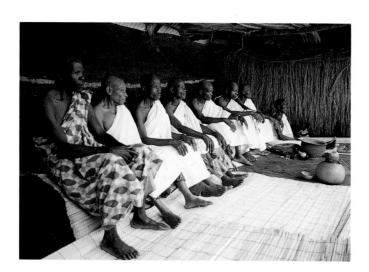

19. Titled male elders in the council of female and male elders known as Osugbo among the Ijebu Yoruba Ogboni, the Oyo and others. They are Osugbo/Ogboni members seated in their lodge, *iledi.* Ibese, Nigeria, 1977. Photograph by H. J. Drewal.

and, at the same time, focuses the attention of all those present on the divining process. It is also a means by which the diviner establishes his own powers of concentration.

Even more important, the diviner, by invoking famous past diviners, brings them to the consultation in the world from the otherworld. The divination session is similar to all Yoruba spectacles in that the invocation temporarily makes manifest an otherworldly reality.[25] Each section of the tray is a path and simultaneously a personified entity. All ways are recognized and invoked separately, some with attributes that distinguish their roles. For example, the diviners whose praise names are "The-one-who-proposes-with-the-right" and "The-one-who-implements-with-the-left" refer to the Yoruba belief about the use of the right hand in social/secular matters and of the left in sacred/mystical affairs. The diviner orients himself facing toward an open doorway or path. This direction must be kept clear during invocations to give free access to the forces called upon. The invocation and the presence of these forces assure success, their neglect courts disaster.

Just as guidance from Ifa mediates the interactions of spiritual forces and humans, so too does Esu/Elegba, a divine messenger, facilitator, transformer, and provocateur. Esu/Elegba, the embodiment of the principles of life force, action, and individuality, epitomizes much of the dynamism and vitality in the Yoruba world. He intercedes on behalf of humans in their appeals to spiritual beings, if appropriately treated and honored, but garbles messages and wreaks havoc if angered. Since Esu is crucial to persons' positive relations with their divine origins and interactions, every individual has a personal Esu who assists in interpretations and actions in specific situations. Esu is also essential to the gods. His ritual objects often have faces pointing in opposite directions and/or figures playing flutes (Figure 24), references to his mediating and messenger roles. He plays the praises of the gods, encouraging them to enter the heads of worshippers during possession trance dances, as is done at Igbogila among the Egbado and Ohori Yoruba (Figure 22).

Probably the most dramatic icon in Esu arts depicts projections bursting from heads (Figure 23). Such projections, in the form of long-tailed coiffures or peaked caps, blades, or phalluses surprise and amaze the viewer. At the same time, they evoke the union and passage between this world and the realm of divine forces, this life and the next. Both visibly and metaphorically they *command*, for they refer to potent medicines (*oogun ase*) that are embedded in the head and allow things to happen, life to be lived. The image of a projecting form is a fundamental motif in many Yoruba

art forms and in many spheres of Yoruba life.[26] It is particularly prevalent in Esu imagery because it announces the themes of existence and individuality. In the broadest sense, Esu/Elegba personifies action, generative power, and command—the *ase* that animates the Yoruba world[27] (Figures 25 and 26).

Because interpretations in matters involving supernatural forces can be personal, and because there are regional variations of practice, generalizations about Yoruba religious beliefs and practices are risky. The practice of Yoruba religion is dynamic, not rigidly proscribed. At its center is the use of *ase*, upon which one's strength and effectiveness are dependent. Because it is essentially performative power, *ase* diminishes with inaction and strengthens with activity

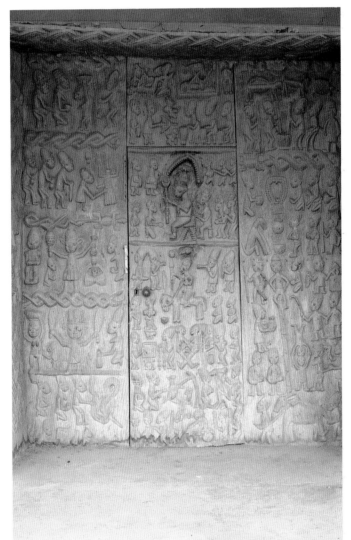

20. The door and panels on the palace veranda in Ila-Orangun were carved in 1927 under the supervision of Ogundeji (c. 1870–1962), the elder and head of Ila's carvers. Akobiogun Fakeye of Inurin's compound carved the door leading to the room where the King's crowns are kept on ritual occasions. His son, Adeosun, carved the panel above the door. The panel on the left was carved by Oje and other carvers from Aga's compound and that on the right by carvers from Ore's and Obajisun's compounds. The frame for the panels was carved by Ogunwuyi of Ore's compound. Ila Orangun, Nigeria, 1984. Photograph by John Pemberton 3rd.

As the diviner Ositola explained: "If a person neglects his or her shrine [by not offering prayers or gifts] the spirits will leave....All you are seeing are the images... The person has relegated the deities to mere *idols*, ordinary images." Or as another priest declared, "If you don't feed it, it will die."[28] Art is important, therefore, in worshipping the *orisa*. The creation of artifacts for shrines and their placement is an act of devotion that equals the ritual significance of prayer or sacrifice. The Yoruba say that a shrine is the "face" (*oju*) of the divinity or the "face of worship" (*ojubo*).[29] The shrine is the place of meeting, of facing the gods and locating oneself relative to the gods. The objects on a shrine, in particular carved figures, are not images of the deity but of the worshippers of the gods. They provide images of devotion and represent the empowerment by the god of those who kneel and present sacrifices and offerings. Hence, ritual art both shapes and is shaped by the imagination of the artist who seeks to reveal the interrelatedness of the divine and the human through sculpted image, song and dance.

Within this dynamic ethos of constant flux, creation, re-creation, renewal, and action in a cosmos of *ase*, certain core principles can still be identified. These define and distinguish Yoruba religious thought and the arts that both shape and express it.

Ori Inu: Inner Head and the Concept of Individuality

The head, *ori*, is of immense importance in Yoruba art and thought. In sculpture its size is often enlarged in relation to the body (1:4 or 1:5) in order to convey its position as the site of a person's essential nature (*iwa*), and her or his *ase* (see Figure 24). More precisely, this spiritual essence is sited in the inner head, (*ori inu*), a reflection of the Yoruba conception of self as having exterior (*ode*) and interior (*inu*) aspects. Inner qualities should rule outer ones, especially such qualities of mind as inner calm, self-control, and patience. A prayer: "May my inner head not spoil my outer one" (*ori inu mi ko ma ba ti ode je*), expresses this concern. *Ode* denotes the visible, physical appearance of a person. It may mask one's inner essence, but it also reveal it. Ideally it should express a confident nobility of mind and dignity (*iyi*), as exemplified in the unruffled facial expressions of sculptures (see Figure 9) especially exquisite Ife terracottas (see Figure 10). This eleventh/twelfth-century terracotta documents not only the antiquity of Yoruba civilization, but also a refined, idealized naturalism suggestive of a tradition of portraiture which celebrates individuals by means of likenesses.

Almost from birth, the Yoruba perform elaborate rituals that reveal both the uniqueness of individuals and their inherent relationship to others. Newborns are given special names, known as *oruko amutorunwa* ("names brought from the otherworld") that reflect their spiritual nature as revealed by the ways in which they arrived, their origins and their special qualities and potential. For example, children born with their head inside the caul are called *amusan* if male, or *ato* if female. They are thought to have a special affinity with their ancestors and are destined to become active members in the *egungun* or ancestral masking society (see Figure 17). Those born with a head of thick, curly hair are called *Dada*, while those with soft, slightly curled hair that looks like sea shells are called *ekine* or *omolokun* and are associated with water spirits (Figure 21).

Names known as *oruko abiso* are given after birth and provide other clues to the nature of the person. *Oruko abiku*, for example, are names given to those who are reincarnations of themselves, that is, they are "children-born-to-die," meaning to be reborn frequently. *Oruko eya* names are those given to partial reincarnations of an ancestor, such as a grandmother or grandfather. The reincarnation is partial because the *emi* (spirit/breath) of the ancestors continues to exist in *orun*, but part of it dwells in the newborn and may even appear in several children in the same lineage at the same time. These names indicate the spiritual qualities and propensities of the person, stressing their uniqueness and their connection to the past, the ancestors, and the spiritual forces in the universe.

Names such as *oruko abiso* or *oruko eyo* become the central focus in the verbal arts of *oriki* (praise poems) and *orin* (songs). These arts embellish the imagery associated with names. They serve to integrate their owner into an unbroken chain of relations from departed ancestors to living relatives, to celebrate the distinctive qualities and uniqueness of the individual, to invoke the spiritual essence of the person, and to elevate the person by encouraging perfection and "faultless performance."[30] When such praises are voiced, the head becomes *wu* ("inspired" or "energized") with the spirit of one's noble ancestry, which is calculated to encourage high achievement. Naming is important because the Yoruba say, *oruko nro ni* ("a person's name directs actions and behavior").[31] It also encapsulates the person's and the family's history, for names are used to reconstruct historical circumstances. The enlarged head in Yoruba sculpture, therefore, plays several roles. It is the site of one's spiritual essence, the place through which divine forces enter during possession trance, and a kind of visible *oriki* conveying a person's dignity and pride in positive achievement.

Much of this personal information is often kept private, to be shared only among family members or very close, life-long friends. It is believed that enemies might use such knowledge to one's detriment. In some

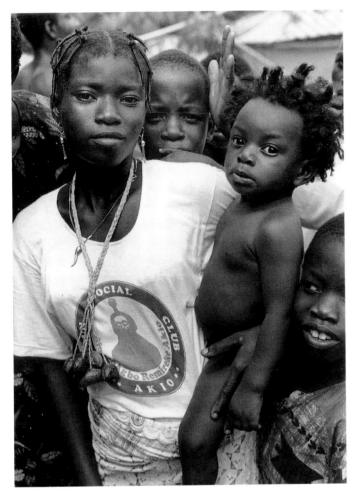

21. Children born with soft, curly hair are called *momolokun*, "children of the sea," because of their spiritual affinity with water spirits. Their curly hair is allowed to grow long and is likened to sea shells. This *omolukun* is being carried by a woman who wears a T-shirt commemorating the annual water spirit festival. It pictures one of the maskers that appears during the occasion. Akio, Ijebu, Nigeria, 1982. Photograph by H. J. Drewal.

bols of individuality. These visual contrasts demonstrate how Yoruba artists convey ideas about the inner or spiritual life of persons through abstract forms while depicting the physical exterior of persons in realistic or figurative ways.

At the top of the *ibori* is a stem. It visually and actually commands the cone; it refers to the spiritual head's link with *orun* and contains power substances that are intended to actualize this relationship. The cone, with or without stem, is a symbol of the *ori inu* (inner head), as are: the *osu* and *sonso ori* (projections) on the heads of *orisa* initiates; the headdresses of ancestral maskers; the crowns of priests, chiefs, and kings; and the sculptures in honor of Esu/Elegba.[32] The cone is also an ancient Yoruba symbol of persons and their place in the universe. This is evident in the headgear of prominent persons represented in bronze and terracotta, and in the cone-shaped terracotta heads unearthed at Ife.

The cone-shaped *ibori* is a fundamental image that resonates throughout Yoruba culture. The form of an *ibori* and its *oke iponri* (summit), are made of the

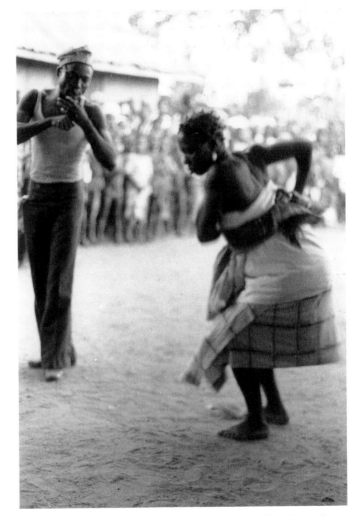

22. Man playing a flute, assisting the drummers in calling down the *orisa* to enter the spiritual heads of their devotees during a ritual. Egbado, Nigeria, 1978. Photograph by M. T. Drewal.

areas, for example, it is forbidden to call out a person's name at night in order to avoid attacks by evil-intentioned persons or spirits. Protecting the privacy of the inner being ensures its well-being, wholeness, and vitality.

The privacy and uniqueness of a person are the theme of the *ile ori* ("house of the head") in Figure 30, and the object it holds is the symbol, called the *ibori*, of a person's inner, spiritual essence or individuality known as *iponri* (Figure 32). This potent symbol contains elements of *egun iponri* (ancestors), *orisa*, and *ewo* (potentials, restrictions)—everything that plays a significant role in the life of the person. The *ile ori* is a cloth and leather cylinder elaborately cloaked in cowrie shells, a primary sign of prosperity and good fortune. It is surmounted by a projecting stem, sometimes figurated as, for example, an equestrian figure in leather on top of a conical, open-work crown.

In striking contrast to the stylized humanism of most Yoruba sculpture, the *ile ori*, with its *ibori*, is an abstract conical form, even though the objects are sym-

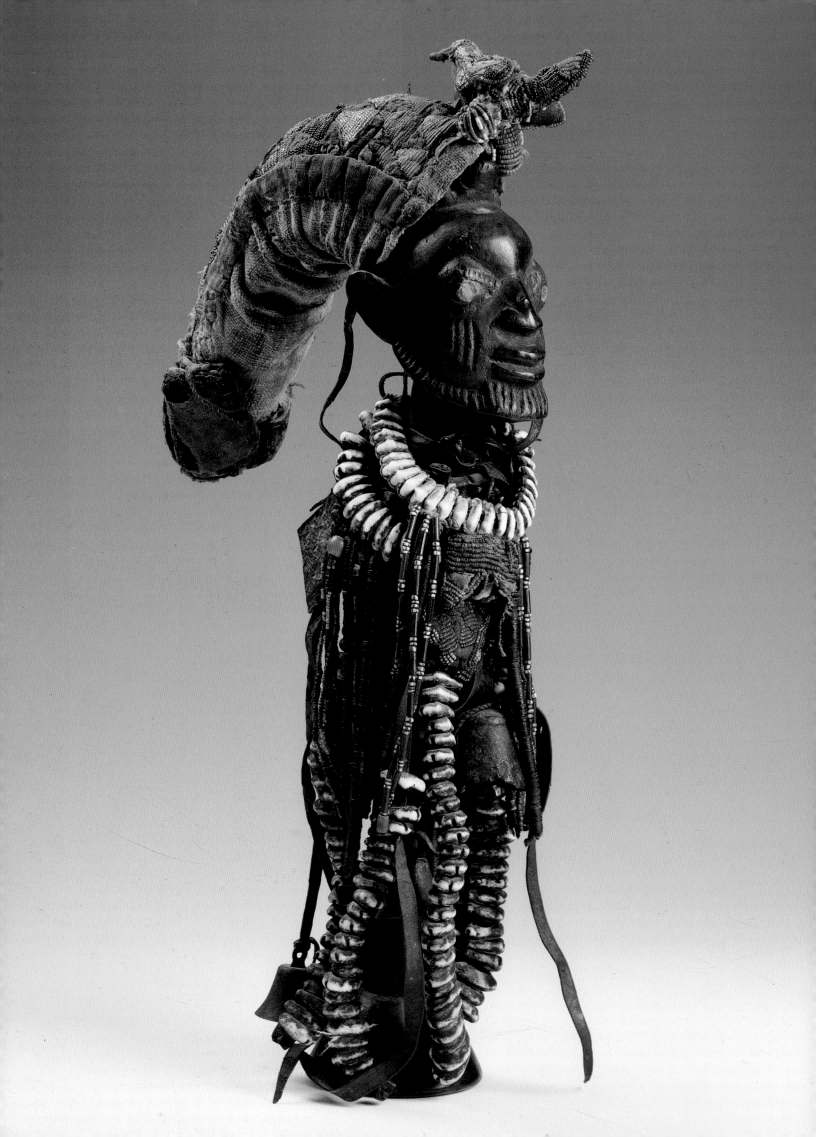

23. Esu Dance Staff, Osogbo, 19th century. Esu, the guardian of the ritual way, bestows riches upon those who follow the sacrificial way of life and steals from those who do not acknowledge his authority, *ase*. Hence, Esu figures are often laden with beads and cowries, signs of wealth and power. The sexual symbolism in the myths and iconography associated with Esu is emphasized in this figure. Its owner encased the long phallic hair shape, a hallmark of Esu, in an elaborately decorated beaded sheath. Wood, beads, cowries. H. 18¼ in. Dr. and Mrs. Robert Kuhn.

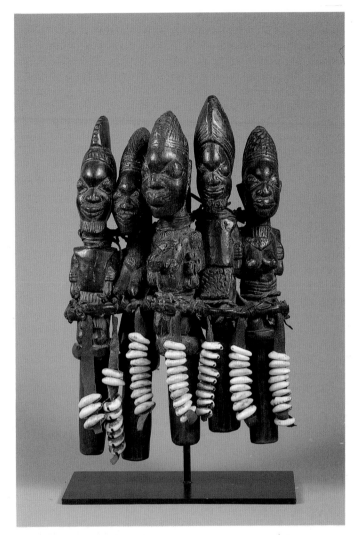

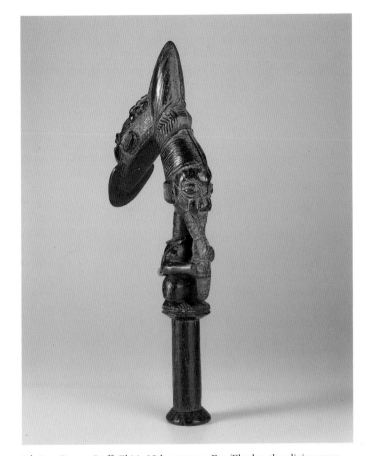

24. Esu Dance Staff, Ekiti, 19th century. Esu/Elegba, the divine messenger, facilitator, transformer and provocateur mediates between the interactions of spiritual forces and humans. He intercedes on behalf of humans in their appeals to spiritual beings, if appropriately treated and honored, but garbles messages and wreaks havoc if angered. Since Esu is crucial to peoples' positive relationship with their divine origins and interactions, each individual has a personal Esu who assists in interpretations and actions in specific situations. His ritual objects often have faces pointing in opposite directions and/or figures playing flutes, references to roles as mediator and messenger. Wood, indigo dye, beads, H. 16⅞ in. The University of Iowa Museum of Art; The Stanley Collection.

25. Esu Figures, Igbomina, 19th–20th century. The Igbomina Yoruba employ a distinctive ritual object for Esu, the messenger of the gods. It consists of a group of carvings, usually two pairs of male and female figures, to which long strands of cowrie shells, symbols of wealth, are attached. A third female figure, probably once part of a similar grouping which has been damaged, has been added. It is Esu who possesses the power to bring opposites together in fruitful relationships. Wood, cowrie shells. H. 13½ in Sol and Josephine Levitt.

26. At the time of the annual festival for Esu in the Igbomina town of Ila-Orangun, an Esu devotee from Obajoko's compound carries her Esu shrine to the market to dance in honor of her lord. The grouping consists of paired male and female figures. Beneath the cowrie shells, black seed pods cascade from the figures, suggestive of the wealth and fecundity that Esu can shower upon those who acknowledge his power. Ila-Orangun, Nigeria, 1977. Photograph by John Pemberton 3rd.

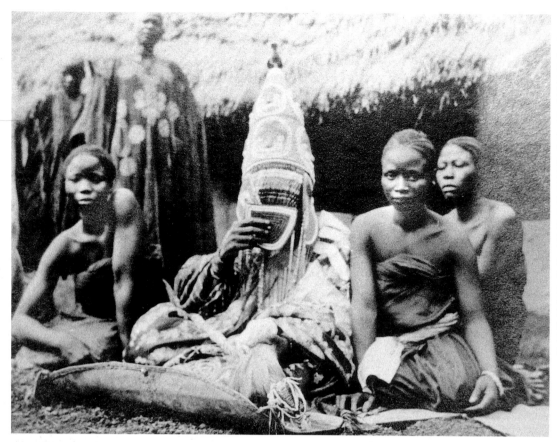

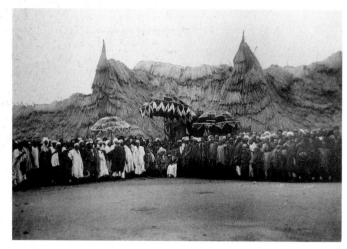

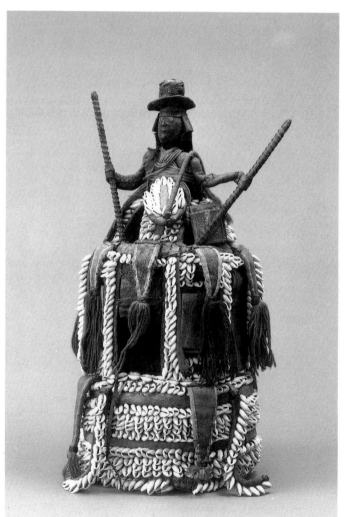

27. The Ataoja, Oba of Osogbo, wearing the great crown at the concluding rite of the Osun festival. Osogbo, Nigeria, 1965. Archives of the Institute of African Studies, University of Ibadan. Photograph by D. Simmonds.

28. The Ore of Otun with his wives. The King's face is not only covered by a veil of beads but is concealed by a beaded shield held over his mouth. In the past the faces of kings were not to be seen, for it is in the crown, not the face that royal power resides. The photograph was taken in the first decade of the twentieth century by an unknown photographer whose caption reads: "'Ore of Awton.' Tribal Photographs", Vol. 9, Foreign and Commonwealth Office, Library and Records Department, London, England.

29. The palace at Oyo with the Aremo, the son of the Alafin, and palace officials taken in the early twentieth century. "Photographs of Nigeria c. 1907-1912." Vol. 16. Foreign and Commonwealth Office, Library and Records Department, London, England.

30. House of the Head Shrine, Oyo, 19th–20th century. The "house of the head," *ile ori*, made of cloth and leather and covered with cowrie shells, holds the symbol of a person's spiritual essence and individuality, *ibori*. The shells are signs of wealth and well-being. The equestrian serves as an image of prestige. Together they proclaim the prosperity and good fortune resulting from a life well-lived. Cloth, cowries, fiber. H. 21½ in. The Seattle Art Museum; Katherine White Collection.

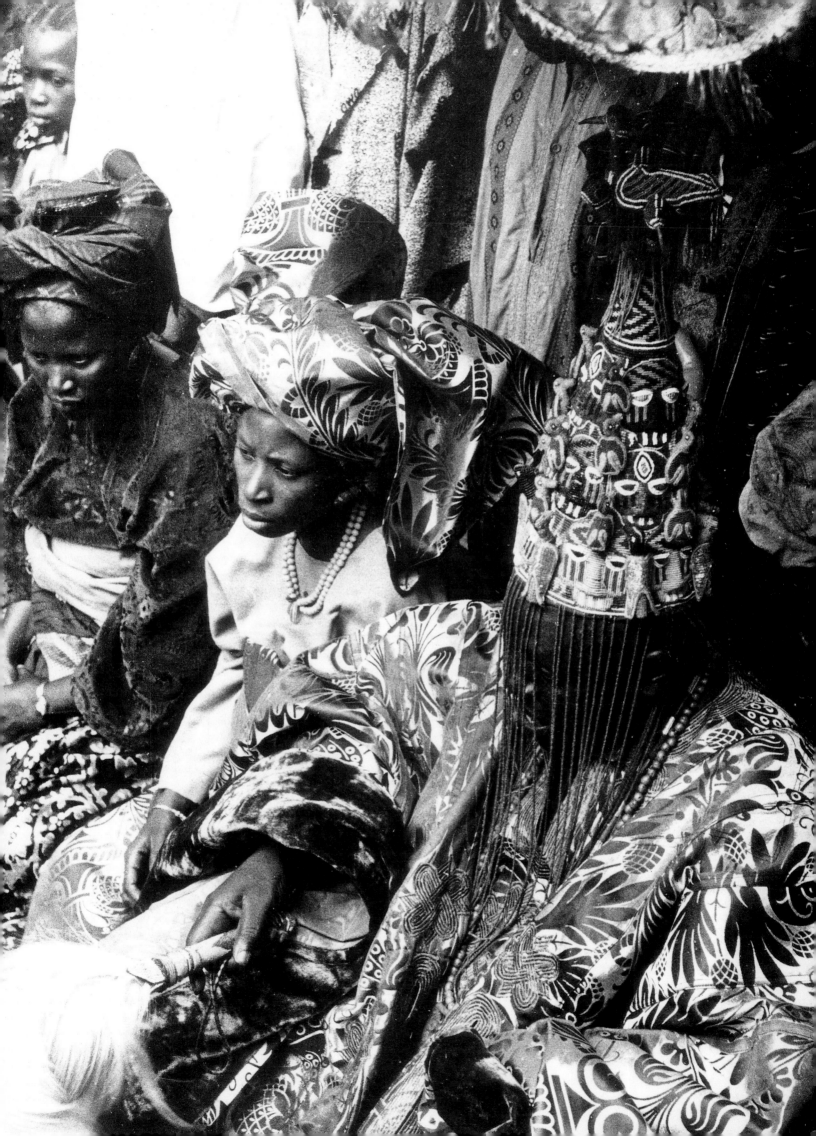

person's placenta and materials that represent deities or others, for example water (if river deities are present), stone (for Ogun), palm nut (for Ifa), mud (for Ogboni, mothers, ancestors), and wind (for Oya, Sango, Oranfe). Other conical forms also refer to the *igbori*: various types of Esu/Elegba forms; *sigidi* (clay sculptures) for various purposes; face bells of the Ijebu; the *orun oba* of Ekiti; the concept of *okiti* ("mounds of agreement") establishing boundaries and marking momentous pacts; the *ebe* or conical earthen mounds holding the symbols of each of the sixteen major verses of Ifa in addition to one for Esu for certain Ifa ceremonies. In addition, umbrellas and peaked roofs seem to be part of this complex of *ibori* symbols.[33] The cloth cone of umbrellas, primary symbols of kings and their sacred heads, and the conical form of roofs can be seen in an early photograph of the Aremo, son of the Alafin, and other palace officials in front of the palace at Oyo (Figure 29). The pointed spires mark the location of the *kobi* (verandas) where the king sits for important meetings and during public rituals, making them the architectural equivalent to the conical crowns that cover and protect the king's sacred head during once-rare public appearances. The cone is also part of every version of the Yoruba creation myth: a creature descends and spreads earth on the surface of water to create a cone of land—the origin of the name Ile-Ife (Home-Spread). This cone is a primal image for *ase* in the world.[34] Rendered two-dimensionally, the cone is a triangle. It can be found in the triangles of cowries and leather panels on *ibori*, in the red, serrated border enclosing the ancestral spirit in *egungun* maskers (see Figure 17), and in amulets containing power substances (Figure 33). Furthermore, Yoruba artists often render the pubic area of both women and men as triangles, representing centers of great generative power, and given praise names such as "path to the otherworld," "power concealed," *egun*, or *oba ninu aye* ("the ruler of the world").[35] Pointed downward, the triangle becomes the symbol of the heart, an organ that figures prominently in certain rites as in the enthronement of kings.

It is the head that also links the person with the otherworld. When a child comes into the world, one of the first rites to be performed is *imori* ("Knowing-the-Head") ceremony during which a diviner determines from where the child comes—from the father's or mother's lineages, or from a particular *orisa*.[37] If the child comes from an *orisa*, it means the person should become a follower of that god. At the time of *orisa* initiation (which usually occurs during adulthood), the person undergoes elaborate instruction and preparations in order to be able to receive, that is, become a

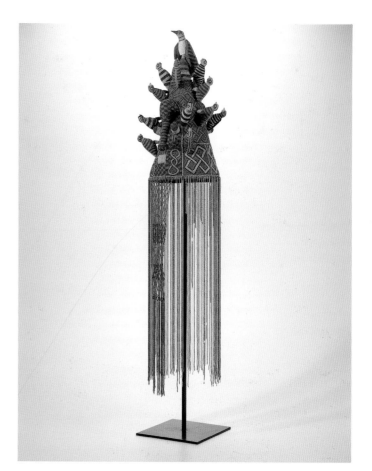

31. Crown, Ekiti, 19th–20th century. The conical beaded crown with veil symbolizes the inner spiritual head of the king and links him with all his royal ancestors who have joined the pantheon of gods. Cloth, Venetian glass beads, fiber. H. 30 in. The Milton D. Ratner Family Collection.

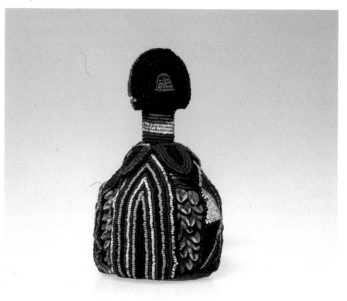

32. Ori Container, western Yoruba, 19th–20th century. The *ibori* is made of various ingredients associated with one's ancestors, gods, and the restrictions or taboos (*ewo*) one must abide by. It thus contains everything essential to a person's life. All of these substances are tightly packed and covered in beads in an abstracted human form with a stylized head or conical form to convey something of the inner or spiritual life of individuals. Glass beads, cowrie shells, leather. H. 6½ in. Lent from the Alexandra Collection by Balint B. Denes.

vessel for, the spiritual presence or *ase* of her/his divinity during the trances that are an essential part of Yoruba worship. In preparation for such occasions, because it is the *ori inu* that receives the spirit (Figure 34), a person's head is shaved, bathed, anointed, inoculated, and painted with spiritually potent substances and symbolic colors possessing the *ase* to attract and direct spiritual forces in particular ways. When possession occurs, the Yoruba say that the gods have *gun* ("mounted") their worshippers. They are known as *elegun orisa* ("gods' mounts") or *esin orisa* ("horses of the gods").

Such a metaphor is remarkably similar to another used in relation to art. The Yoruba say that "proverbs are the horses of speech" (*owe, l'esin oro*). In other words, proverbs are succinct verbal evocations and embellishments of conversation that support, carry, and elevate speech, and intensify the expressiveness of ideas. Proverbs are verbal art, not simply verbal communication.[38] Thus we may understand Yoruba arts as embellishments that literally uplift and move their viewers by the beauty and power of their expressiveness.

The Oba's Crown: Symbol of Authority

Among all Yoruba peoples, the *ade* (crown) is the principal symbol of a king's authority. According to the Orangun-Ila, the crown is an *orisa* (Figure 31).[39] When the *ade* is placed upon the king's head, his *ori inu* (inner head) becomes one with all those who have reigned before him, who are now *orisa*.

There is an ancient story that says that before he died, Oduduwa, the founder and first king of the Yoruba people, gave a beaded *ade* to each of his sons and sent them forth to establish their own kingdoms. Another version, with many variations, states that when Oduduwa was old and almost blind, his sons stole their father's *ades* and with the authority of the *ade* established their own kingdoms. Taken together, as they should be, the stories acknowledge the primacy of Ile-Ife as the earliest "crowned town" from which all Yoruba kings must trace their descent, and they reflect the tension that has existed over the centuries between Ile-Ife and other Yoruba kingdoms.

Certain local oral histories of some Yoruba sub-groups (for example, towns and villages among the southern Ekiti, Igbomina, Ondo and Ijebu peoples) frequently suggest an origin other than Ile-Ife, a claim often supported by evidence derived from a people's material culture and religious practices. Nevertheless, since the mid-nineteenth century there has been a widespread concern to establish the authority of the *oba* (king) through an identification with Oduduwa and Ile-Ife. Over the centuries, and ever since the civil wars

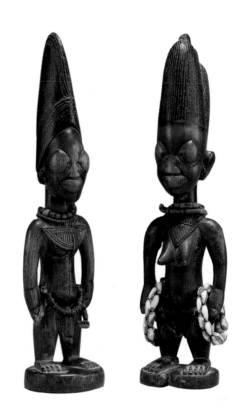

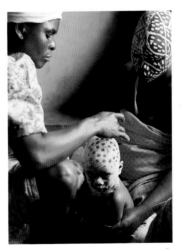

33. Pair of Ibeji figures, Igbomina, 19th century. Pair of *ere ibeji* with carved Islamic amulets (*tira*) suspended from their necks. The carvings are in the style of Bogunjoko, master carver from Inurin's compound, Ila-Orangun, who died about 1870. Wood, beads, cowries. Courtesy of Sotheby's.

34. Those who receive the spirit of their divinity during possession trance are required to undergo extensive training. In preparing for such occasions, the heads of initiates are shaved, bathed, anointed, and painted with substances, colors, and patterns to attract and direct the spirits that will be important in the life of the person. Iparinla, Ijebu, 1986. Photograph by M. T. Drewal.

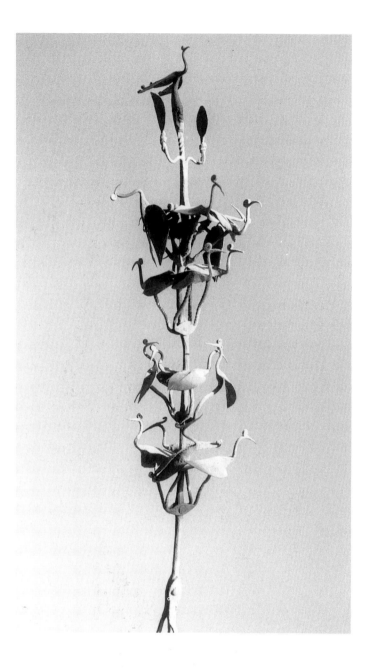

35. Staff with Birds, western Yoruba?, 19th–20th century. Many of the iron staffs for Osanyin, the deity of herbal medicines, consist of a ring on which sixteen birds are perched facing inward toward a large bird at the top of the central shaft. On staffs among the southwestern Yoruba, especially among those living in the Republic of Benin, the birds are arranged in several clusters along the upper portion of the shaft, with a single bird at the top, whose position is enhanced by two branches with large oval leaves. Iron. H. 44 in. Dufour Collection, France.

36. Staff with Birds, Southern Yoruba, 19th–20th century. The simple, graceful lines and energetic interplay of curves by which a blacksmith depicted the birds on this staff disclose an admirable artistic sensitivity. In the poetry of Ifa it is told that *eye kan*, ("the lone bird"), also known as *eye oko*, ("the bird of the bush"), was bisexual and could not give birth. After consulting Ifa and making the appropriate sacrifices, *eye kan* gave birth to male and female birds. In gratitude to Ifa, *eye kan* took up residence in the house of the diviner, and was henceforth known as *eye ile*, ("the bird of the house"). Iron..H. 45 in. Drs. Daniel and Marian Malcolm.

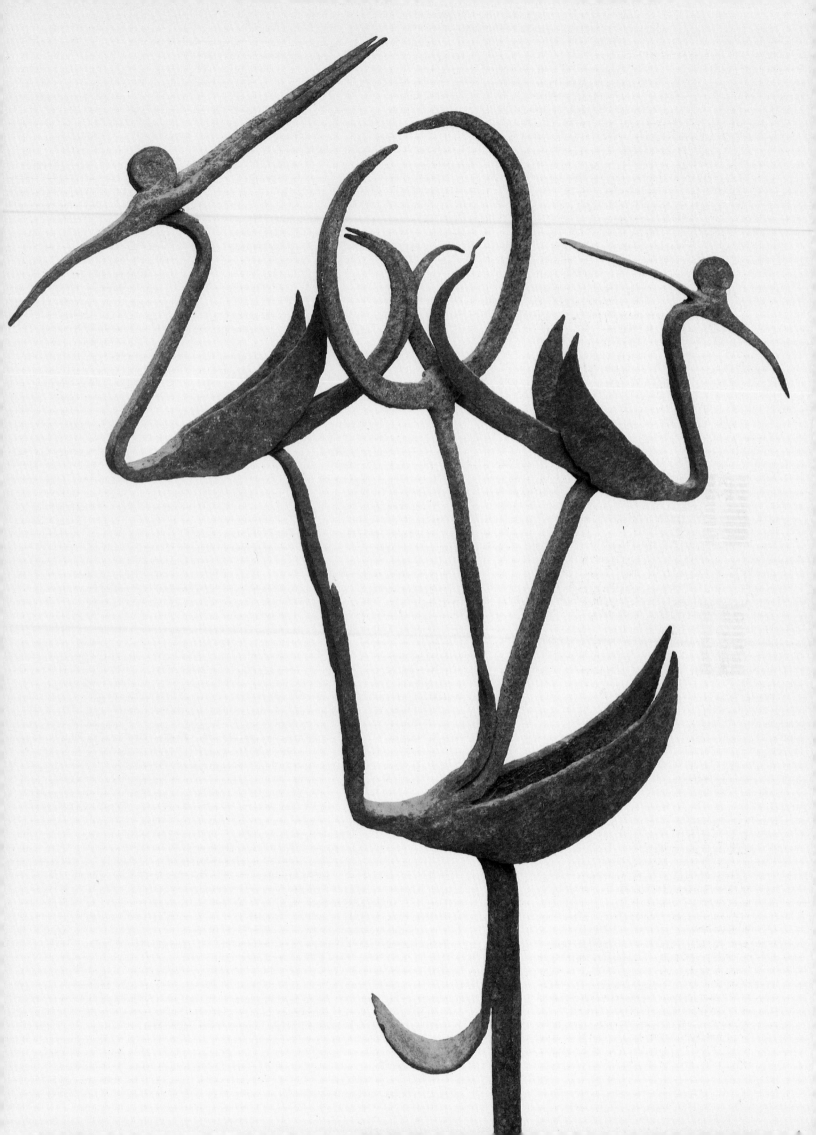

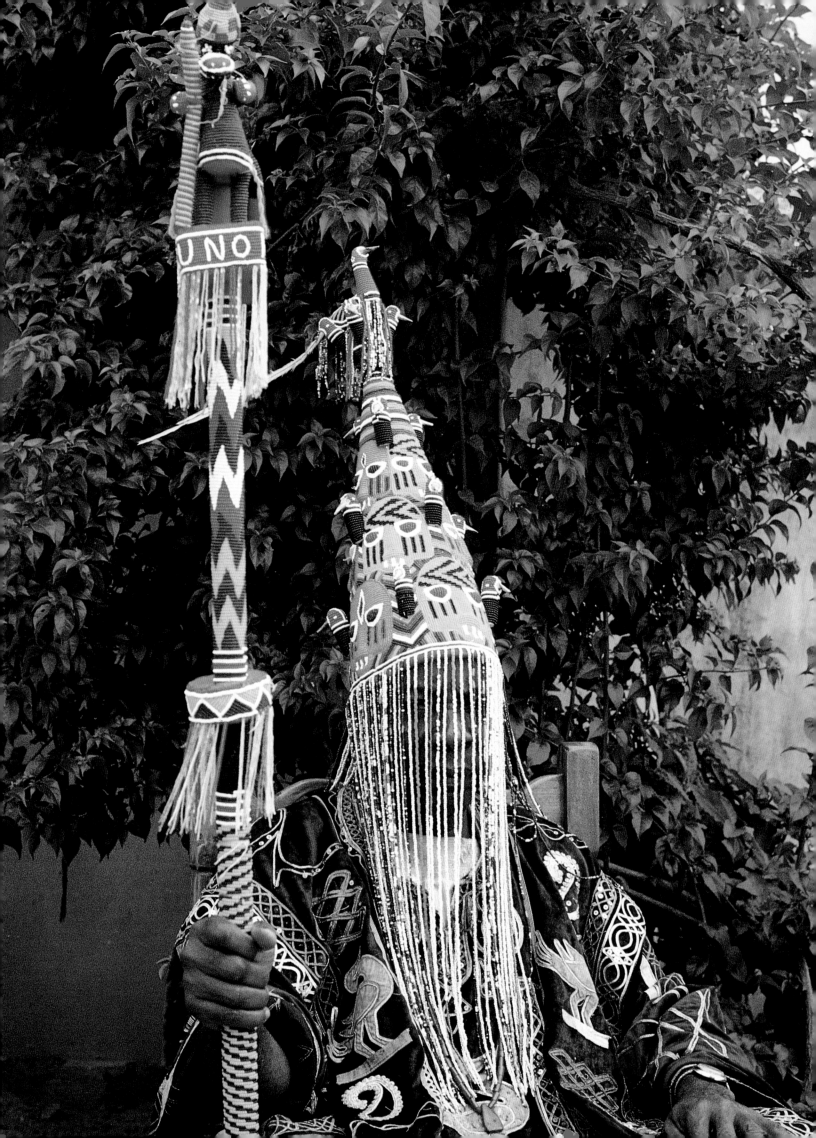

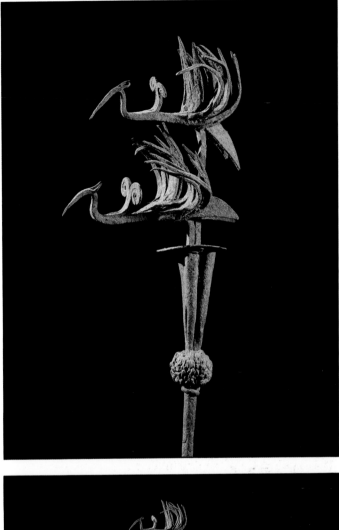

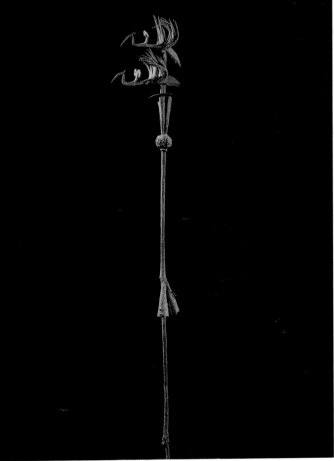

37. The bird on the top of the great beaded crown of the Orangun-Ila has the long white tail feathers of the Okin, which is often referred to as "the royal bird." Ila-Orangun, Nigeria, 1977. Photograph by J. Pemberton 3rd.

38. Staff with Birds, Southern Yoruba, 19th–20th century. Near the entrance door at the foot of a tree in the center of a compound one often finds a metal staff with a single bird or a pair of birds at the top, beneath which is an inverted cone piercing a sphere containing protective medicines. Many blacksmiths reveal a high order of artistic imagination as well as technical skill in their stylized depiction of birds. Iron. H. 39¾ in. Drs. John and Nicole Dintenfass.

that followed in the wake of the fall of the Oyo Empire, there has been among the Yoruba an increasing need to affirm a cultural center or hegemony, while also affirming their individual histories and distinctive modes of cultural expression. Hence, the importance of the Oduduwa tradition and the authority of the crown.

There is little information on the nature of the crowns and other regalia worn by the Yoruba *obas* from the sixteenth to eighteenth centuries, although

> the strings of re-painted beads on the Oni's robes in the classical period may provide a hint of continuity, if, as is likely, the beads were of carnelian or other red stone of the types now often known as "Ilorin beads" in Nigeria, although, in fact, they came from farther west, passing through and often being processed in Ilorin. Certainly they have continued to reach Benin (whose kingship was under Ife influence) from at least 1550 to the present, and they have played an essential part in the regalia, along with the smaller beads of red coral whose origin is in the Balearic Islands.[40]

One ancient crown of the Owa of Idanre, which was dated to the eighteenth century and in rather poor condition, was made of leather overlaid with a mixture of red stone and coral beads, strands of which cascaded over the face of the wearer.[41] Another eighteenth-century crown from the Ijebu area was made of cowrie shells, which were in use in West Africa before coral.[42] It is interesting because of the presence of three bird images.

In the nineteenth century European "seed beads"— tiny beads, about two millimeters in diameter and in a glorious array of colors—arrived in West Africa. Yoruba crown makers, such as the Adesina family in Efon Alaiye, soon put them to use with extraordinary artistry. The great crowns with veils of beads (*adenla*) are always conical in shape (Figure 27). In every instance the *adenla* is surmounted by the image of a bird. In a splendid study of the sacred regalia of the Olokuku of Okuku, the image of the bird has been identified with Okin, the "royal bird."[43] It is a tiny whitish bird with a very long tail feather; and it is this tail feather that is affixed to the image of the bird at the top of the *adenla* (Figure 37). The other constant image on an *adenla* is a frontal face. On some crowns there are faces on the front and back, and on others there will be as many as sixteen faces organized in a pattern over the entire crown. There is almost no agreement on the significance of the face. The Orangun-Ila and others have said that it is the face of Oduduwa.[44] Other persons claim that it is the "face" of the king, that is, the face of the *ori inu* of the one who wears the crown. The bead workers in Efon Alaiye have said that it was the face of *orisa* Olokun, god of the sea and "the owner of beads," but the Olokuku, king of Okuku, said that the double lines

under each eye "represent Ejiogbe," an *odu* of Ifa that is associated with the Olokukus.[45] In the face on the crown in Figure 31 there is a visual pun (and metaphor). At one moment the viewer may see the head of an elephant; at another moment, a human face.

The creation and consecration of a crown are attended by elaborate precautions and rituals. The crown makers move to the palace where they must work in secret while preparing the crown.[46] They first construct a cone of palm ribs, and then build it up with four layers of white cloth, fixed to the framework by applying damp corn starch. Whiteness has many subtle meanings and may refer in this instance to birth. As one diviner said, "We all come into the world in white [the caul]."[47] When the *oba* dons the crown for the first time, he is transformed into one whose head is empowered by an *orisa*.

The beadworker first offers prayers to Ogun, the god of iron and patron of those who use iron instruments, such as needles. Gifts of snail fluid to gain the composure for creating a momentous work and a tortoise to ensure the wisdom to complete the project successfully are then presented, after which the beadworker begins to sew the beads to the surface of the crown.[48] The multicolored beaded pattern refers to the gods in *orun* and their devotees in *aye*. The pattern and colors proclaim the power and authority of the sacred king.

Before a new crown can be worn, it must be prepared by herbalist priests. A packet of herbal medicines is secreted in the top of the crown. Hence, in Oyo, when the crown is placed on the Alafin's head at the time of his enthronement by the Iya Kere (one of the royal wives), she stands behind the king.[49] The one who wears the crown must never look within. To do so is to risk blindness. The power of woman is depicted not only in this ritual act of the Iya Kere, but also in the cluster of birds that appear on many of the great crowns.

There is a gathering of birds on staffs for *orisa* Osanyin, god of herbal medicines, (Figures 35, 36, 38) as well as on those carried by Ifa divination priests (Figure 41), suggesting an iconographic link with the birds on kings' crowns.[50] In almost all instances of Yoruba ritual art, birds are references to the mystical power of women, known affectionately as *awon iya wa* ("our mothers"), or abusively as *aje* ("witches"). As there are positive and negative valences to the mystical powers of women (and gods, spirits and ancestors), so too the substances guarded by the bird-mothers can either protect or destroy the person who wears the crown. Given the central role played by women in controlling, placing, protecting, and sacrificing to the crown, the birds signify that the king himself rules only with the support and cooperation of *awon iya wa*.

According to the Orangun-Ila: "Without the mothers I could not rule. I could not have power over witchcraft in the town."[51]

The beaded veil masks the identity of the *oba*. His awesome performative powers are intensified when he wears the crown. It is taboo for people to look directly at the head of the king because of the powers it embodies. In the past, judging from descriptions of the first audiences European visitors had with Yoruba kings, they were not to be seen at all but were hidden behind screens and sequestered within their palaces, as were the most powerful sacred objects used throughout Yorubaland. When the *oba* appeared in public wearing the veiled crown, he was surrounded by palace servants, wives, and drummers, with the great royal umbrella whirling above his head (Figures 28, 29). It would have been difficult to catch a glimpse of the crown and impossible to see the face of the one who wore it.

Concealment constitutes heightened spirituality. It is a way of conveying the ineffable qualities and boundless powers of the divine person of the *oba*. The veil, therefore, is a mask, hiding the face of the *oba* so that the power of the crown may be seen. It also moderates the penetrating, piercing gaze of one whose power is like that of a god. More importantly, as a person's *ibori* is guarded within its cloth, cowrie, and leather house, so too the king's inner, spiritual person is protected, enclosed within the enveloping form of the cone and beaded fringe of the crown.

For the Yoruba the *ase* of the crown is awesome. When the chiefs kneel before their crowned ruler, they greet the crown and the one who wears it with the salutation: *Kabiyesi! Oba alaase ekeji orisa!* ("Your Highness! The king's power is next to that of the gods!").

The Staffs of Osugbo

The Osugbo (Ogboni) is a society of male and female elders who are responsible for the selection, installation, and burial of kings, and who render judgment and stipulate punishment in cases of serious crimes in the society, including the removal of errant rulers.[53] The powers and pacts between women and men proclaimed by the birds on the beaded crown are seen again in paired images among this society. The primary symbols of Osugbo are the paired male and female brass figures called *edan*, castings on iron spikes that are joined at the top by a chain (Figure 42). The term is used in the singular, since each pair is viewed as one object. Likewise, a single *edan* always implies the existence of its mate of the opposite sex—concepts ancient in Yoruba art and thought, and in the symbolism of Osugbo.[54]

Paired Osugbo brasses, especially those joined by a chain, evoke the importance of the bond between males and females, both within Osugbo and in the larger society. As diviner Kolawole Ositola, whose father was a titled elder in an ancient Osugbo lodge, elaborates, the chains

> have joined [male and female] together to make one couple...because the two together have only one power...It's for oneness. It's for [the] oneness of Osugbo. You see, men and women, they all come to the world at the same time. There has never been a time when we have men and we don't have women. And there has never been a time when we have women and we don't have men. So everybody comes to play his role successfully....If you leave woman, then the role of the men cannot be played successfully. That's how they have been mixing every issue, and everyone has his own secrets, too. Men have the secret and women have the secret, just to trouble each other, just to add more salt to the world.[55]

The casting process itself suggests a joining of female and male elements. Iron is put inside Osugbo brass castings, even when it has no structural function.[56] Iron is most often associated with men and male divinities such as Ogun, and brass with women and female deities such as Osun. In the *edan* castings, the two have been fused into one.

The theme of the couple also helps to explain the apparent visual emphasis placed on sexual identity in *edan* iconography. When *edan* depict heads without torsos, female and male genitals still appear—a visual reminder of the importance of the couple. Castings, portraying Osugbo members, usually depict nude figures with sex organs displayed. In initiation rites, the novice, who must be nude, is washed by the Oluwo, a titled elder, in the presence of other Osugbo members who are themselves nude. Similar procedures continue today where all Osugbo members and guests must remove footwear and bare their chests or shoulders before entering the courtyard of the lodge. Such acts connote honesty, openness, humility, and reverence—no secrets will be kept among the membership and, at the same time, no secrets will be revealed to outsiders.

Iwa l'ewa: The Beauty of Truth

Many authors have contributed to our understanding of Yoruba aesthetics,[57] the foundation of which is contained in the phrase *iwa l'ewa*, most often translated as "character is beauty."

The heart of the matter emerges in a detailed exploration of the meanings of *iwa* and its relation to *ewa* (beauty).[58] *Iwa* derives from the word for "existence" and by extension from the concept that "immortality is perfect existence."[59] *Iwa* has no moral connotations;

39

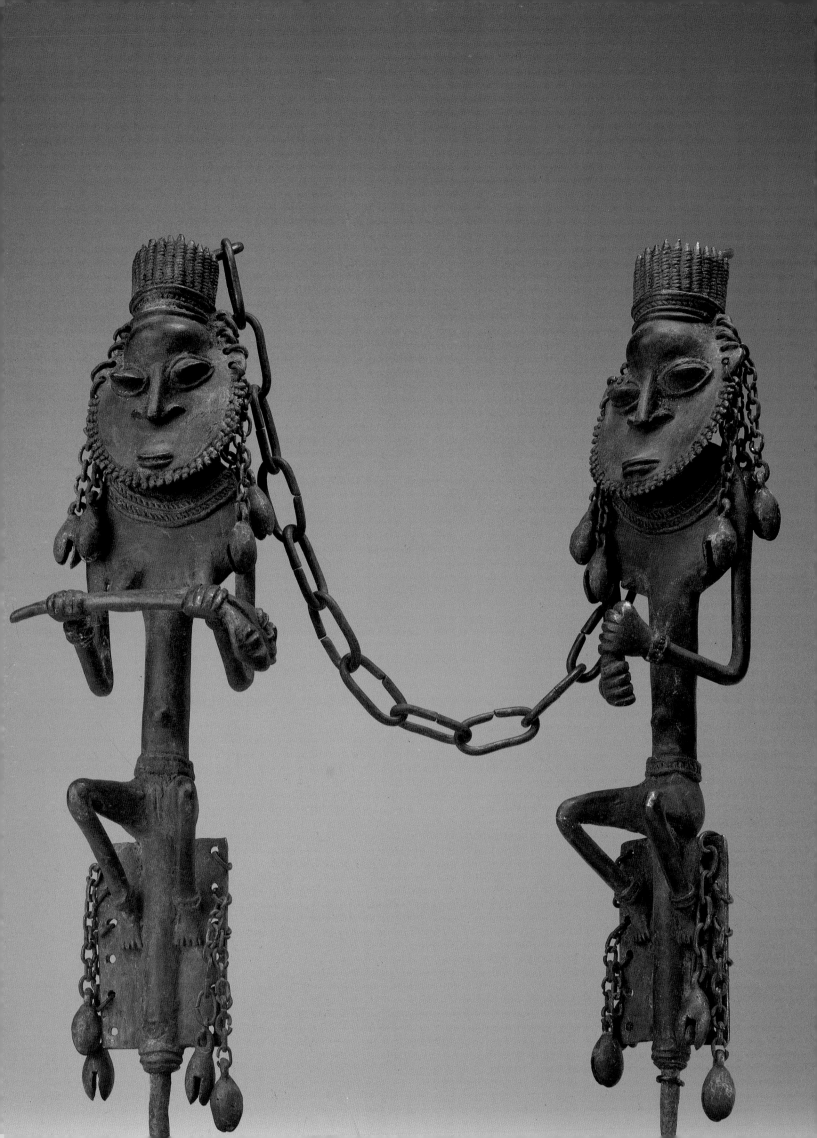

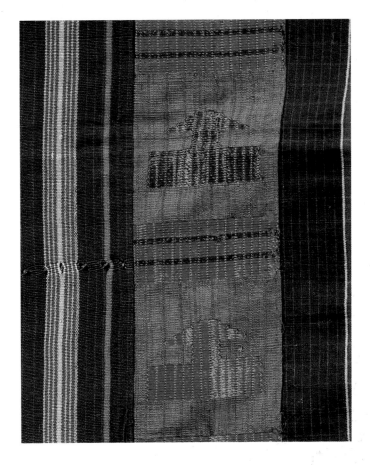

39. Textile, Ijebu, 20th century. This beautiful cloth consists of five basic juxtaposed patterns. The predominantly red strips with the green design are in the shape of an Islamic writing board. They alternate with the more traditional darker strips. The latter, however, are not uniformly arranged, but vary as single or paired placements. The weaver has enhanced the visual impact such weaving and dying techniques as an overlay pattern on the predominantly red strips, an occasional open-work pattern on the red, white and black strips, and the use of ikat dyed hand-spun cotton in the red and white stripe that moves through the gray area of the gray and red strip. Cotton, rayon. L. 91 in. Barbara and Richard Faletti Collection.

40. The head and shoulder scarves of this singer at a festival for Ogun, deity of iron and war, is made in part of ikat–dyed cotton. The warp yarn for the thread that varies from a dark to a lighter shade of blue has been tie-dyed before it was mounted on the loom. The process is known as "ikat" and entails tying lengths of hand-spun thread at various intervals before dipping the thread in vats of indigo dye. The thread "resists" the dye where it is tied, creating variations in the shades of blue. Egunsen Ipeja, Nigeria, 1982. Photograph by J. Pemberton 3rd.

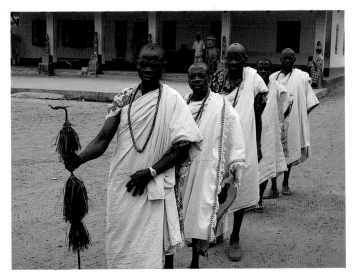

41. Ifa priests leaving the palace in Ila-Orangun after divining for the King in preparation for the King's Festival. They are led by the priest whose turn it was to cast Ifa. He carries an *opa* Ifa as he leads the priests to the house of the Chief Priest, the Oloriawo Ifa. Ila Orangun, Nigeria, 1982. Photograph by J. Pemberton 3rd.

42. Pair of Edan Osogbo, Ijebu, 19th–20th century. Linked male and female figures in bronze are the symbols of Osugbo, the society of the elders whose moral and political authority equals that of kings and chiefs. Their heads, not their ascetic bodies, radiate with power, for their authority is the wisdom of those who have followed the ritual way of life. Nonetheless, their sexual identity is clear, as it is in the coming together of opposites, that the meaning of life is to be found. The left fist over right is the sign of Osugbo membership. Bronze, H. 11 in. The University of Iowa Museum of Art; The Stanley Collection.

rather it refers to the eternal constancy, the essential nature, of a thing or person—it is a specific expression of *ase*. Thus when art captures the essential nature of something, the work will be considered "beautiful." That is the significance of the saying *iwa l'ewa*—"essential nature is beauty." This can of course include subjects that are humorous (Figure 7), or terrifying (Figure 43), as well as those that are pleasing and admirable (see Figure 10). Beauty encompasses all, as long as the representation is appropriate to the subject.

In Yoruba thought, everything in existence possesses *iwa* and, when fulfilling its essential nature, is thought beautiful, *ewa*. Hence, the Yoruba are taught to "concede to each person [or thing] his or her own particular character [essential nature]."60 In other words, the Yoruba ideally acknowledge and respect difference, which they recognize as an expression of *iwa*; they counsel *suuru* (patience) as a mark of respect for difference. Yoruba *onisona* (artists), no matter what medium they employ, must possess and manifest the attributes of good character in order to create beautiful forms. These include: *ifarabale* (calmness); *iluti* (teachability); *imoju-mora* (sensitivity, good perception, appropriate innovation); *tito* (lastingness, endurance genuineness); *oju-inu* (insight); and *oju-ona* (design-consciousness, originality).61 In addition, there is admiration for the visual (photographic) memory, which is expressed in the judgment that the artist is "one who sees well and remembers," and the ability to concentrate that requires the attribute of patience. As the master sculptor Ebo Segbe explains, "A good artist must be a good person, of good character, friendly and interested in others, *fa enia mura*. He must not be ill-tempered, *ko gbodo kanra*." And the body artist Ogunole added that artists must have a "cool and patient character," *iwa tutu ati suuru*.62 When taken together, these attributes indicate that the Yoruba value reasoned openness and creativity—a mental outlook that carefully evaluates creative production in the past and the present in order to lead to new, appropriate, and efficacious creations in the future. Such a dynamic is one reason for the longevity, strength, and continuing vitality of Yoruba art.

43. Janus Plaque, Ijebu, 18th–19th century. This powerful bronze casting was probably once part of an Ijebu Janus image associated with the worship of water spirits. The metal loops by which the teeth are rendered are found on a number of Ijebu Agbo Janus headdresses. The inverted crescents on the forehead, however, are found on many Ijebu Osugbo bronzes. Bronze. H. 15½ in. Private collection.

2 Ife: Origins of Art and Civilization

Henry John Drewal

According to Yoruba myth, everything begins at Ile-Ife, the literal translation of which is "Home-Spread," the place where life and civilization began.[1] Embodied in the name and the stories surrounding it are key images and ideas that may help to explain the primacy and distinctiveness of the art of Ife which flowered from about A.D. 800 to 1600.

There are countless versions of the myth of the creation of the world and of human civilization at Ile-Ife.[2] Almost all of these myths describe fights for the authority to perform certain roles. The richness of this lore attests to its importance as an anchor that ultimately unites all Yoruba-speaking peoples, despite the diversity among their many kingdoms and long periods of warfare and fierce rivalry among their city-states.[3] All versions describe how the creator, Olodumare, instructed one of the deities to go from *orun* to *aye* in order to establish life and civilization. At this point the accounts diverge. Some identify the deity as Obatala/Orisanla, the artist-god who molds humans in clay. Others name Oduduwa, who usurped Obatala's role when he drank palm wine, started to create misshapen humans such as hunchbacks and dwarfs, and finally fell asleep on the job. The story goes on to describe how the world was covered with water so the divinity descended on an iron chain, taking along a snail shell (or gourd) filled with earth, a cockerel (or five-toed chicken/bird), and a chameleon. Upon arrival, the deity poured the earth from the shell onto the water, and the bird spread it to create land. Then, after the chameleon walked warily and gently on it to test its firmness, the other deities arrived to establish society, and eventually spread out to found many kingdoms, all of whose rulers trace their origins to Ife.

The descendants of these rulers cite Oduduwa as the founder of the institution of sacred kingship and as first *oba* (king) at Ile-Ife. Others stress that Obatala/Orisanla, as the original creator, has ultimate divine authority, while Oduduwa has political authority. These two perspectives are elaborated in myths. Those who support Obatala identify Oduduwa as female—a goddess, while Oduduwa supporters hold him as a powerful warrior king and god who came from elsewhere,[4] conquered, and then assimilated with the indigenous peoples at Ife who originally worshipped Obatala at Ile-Ife. These opposing versions are still recalled and reenacted in ritualized conflicts during the annual Edi festival at Ile-Ife today.

Both versions and their many variants are shaped by various sociopolitical and religious agendas. They express the essence of flexibility, action, and openness in Yoruba society, as well as the ways in which the fabric of society can stretch and adapt, rather than rupture—by assimilation through intermarriage, incorporation, and/or division of rights and responsibilities. Whereas Obatala has taken on the more sacred dimensions as Ife's original divinity and molder of humans, Oduduwa has become the symbol of political rule as the first king to wear the sacred crown and pass on that right to his descendants.[5]

44. Ceremonial Vessel with Figure. Ife, 11th–12th century. This small metal sculpture shows the figure with a tiered headdress wrapped around a vessel positioned on the circular platform of a stool. The figure holds the looped handle of the stool with its left hand and a scepter in its right. Zinc brass. H. 4⅞ in. National Commission for Museums and Monuments, Nigeria.

Another recurrent theme has to do with the sex and gender roles of both gods and humans. The sexual identity of some divinities, such as Oduduwa, is uncertain or disputed. Some have suggested that originally Yoruba society may have been matrilineal, or at least cognatic in its descent systems. Today there appears to be a difference between northern (patrilineal) and southern (matrilineal/cognatic) Yoruba realms, although many Yoruba city-states both north and south, such as Ife, Ijero, Oyo, Owo, Ijebu, Ondo, and others, have frequently in the past been ruled by queens.[6]

A third theme that may have some historical significance is the mention of specific materials such as stone, iron, clay, and bronze. All possess distinctive *ase* and are associated with named mythic entities: Obatala/Orisanla molds humans in clay, for example; Oduduwa, the invading warrior god descends on an iron chain, associated with Ogun, god of iron; and Oramfe the Ife thundergod is a stone-throwing deity. Because materials symbolize and embody divine forces, their presence in ancient myths probably expresses the remembrance of certain ages, technologies, and specific historical personalities who were later deified.

A fourth feature is the recurrence of icons such as the gourd, snail, chameleon, and cockerel/chicken/bird. They appear in almost all versions of the creation myth and in many genres of Yoruba oral lore and art. The persistence of such themes and icons thus allows us to speak of *Yoruba* history and art history, as we detail the distinctive traditions of the city-states of Yoruba-speaking peoples.

Despite large gaps in our knowledge of early Ife, there are several distinct eras. These can be identified by certain key features as follows:

Archaic Era, before A.D. 800—minimalist style stone monoliths combined with iron

Pre-Pavement Era, 800-1000—stylized stone and terracotta pieces

Early Pavement Era, 1000-1200—elaborately decorated pavements in shards and stones; refined, idealized naturalism in terracotta and metal work

Late Pavement Era, 1200-1400—increasingly expressive naturalism, a freer style, many of the same motifs and feel as Owo

Post-Pavement Era, 1400-1600?—increasing stylization

Stylized Humanism Era, 1600?-Present—style of Yoruba art in recent centuries

The prehistoric era at Ife is still unknown, but data from a Late Stone Age site at Iwo Eleru about 47 miles from Ife contributes some collateral data. There human remains identified as Negroid, dating to 8000 B.C., were found.[7] Some artifacts from the site may support the possibility that these inhabitants were Yoruba-speaking

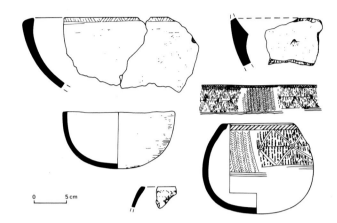

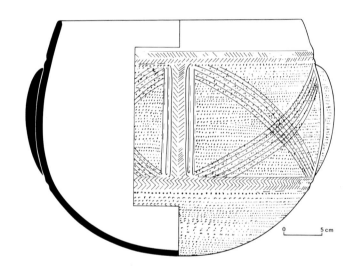

45. A drawing of decorated pottery from Iwo Eleru that dates to about 1000 B.C.. The shapes and rouletted and combed designs show some similarities with Ife pottery dated to the 13th and 14th centuries. After Shaw 1984.

peoples. Hoe and sicklelike stone tools appear to indicate the beginnings of agriculture in the forest region.[8] Many ground and chipped stone implements, grinding stones, and granite and chalcedony axe or hoe heads were also found. Since at least around A.D. 1200, these objects have been venerated and placed on altars at Ife and elsewhere in Yorubaland. More significantly, about 1000 B.C. decorated pottery appears in abundance with combed or rouletted patterns similar to the interlace and zigzag patterns found widely at Ife (Figure 45) and to thirteenth/fourteenth-century Ife ware (Figure 46) that has strong affinities with recent Ife Yoruba ceramics.[9] A systematic study of this early decorative pottery and the earliest Ife ware may reveal cultural connections between Iwo Eleru and the Yoruba at Ife.

The site of Ile-Ife was occupied as early as 350 B.C.

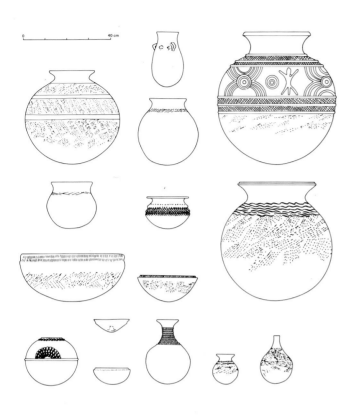

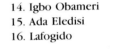

46. A drawing of 13th–14th century Ife ware which shows a variety of combed, stamped, and rouletted designs. It seems related to both early pottery at Iwo Eleru and recent Yoruba ware. After Garlake 1977.

KEY:
1. Ita Yemoo
2. Odo Ogbe
3. Wunmonije
4. Aroye Compound
5. Opa Oranmiyan
6. Ogun Oké-Mògún
7. Ore Grove
8. Obatala Shrine
9. Oduduwa Shrine
10. Olokun Grove (Igbo Olokun)
11. Obalara's Land
12. Woye Asiri
13. Orun Oba Ado
14. Igbo Obameri
15. Ada Eledisi
16. Lafogido

and consisted of a cluster of hamlets, thirteen by some accounts. Pottery fragments, tools, and quartz flakes were found at one of the original hamlets that made up Ile-Ife.[10] The next confirmed date is A.D. 500, according to radiocarbon dates from the Ife site of Orun Oba Ado.[11] Little is known about these early occupations, but a city wall may have surrounded the original settlement termed Enuwa, possibly connoting an agreement to join together as in *enuwa ko* ("we see eye to eye").[12] A second outer wall was built soon after. Such an event suggests the arrival of a sizable influx of people perhaps associated with the stories of conflict and competition in Ife's creation myths.

The first millenium A.D., the period in which major state formation took place throughout Africa, is only now beginning to yield its secrets to archeological research.[13] Two sites at Ife now confirm the presence of iron-working agriculturalists between around A.D. 500 and 900, by which time Ife may have become a major urban center to judge from its walls, network of shrines, sometimes monumental stone sculptures, planned complexes of buildings, streets, courtyards, and domestic and communal altars covered with shard mosaics and elaborately patterned potsherd and stone pavements dating to as early as the eleventh century. These domes-

48. A map of sites in the Ife region mentioned in the text showing the distribution of Ife-related works.

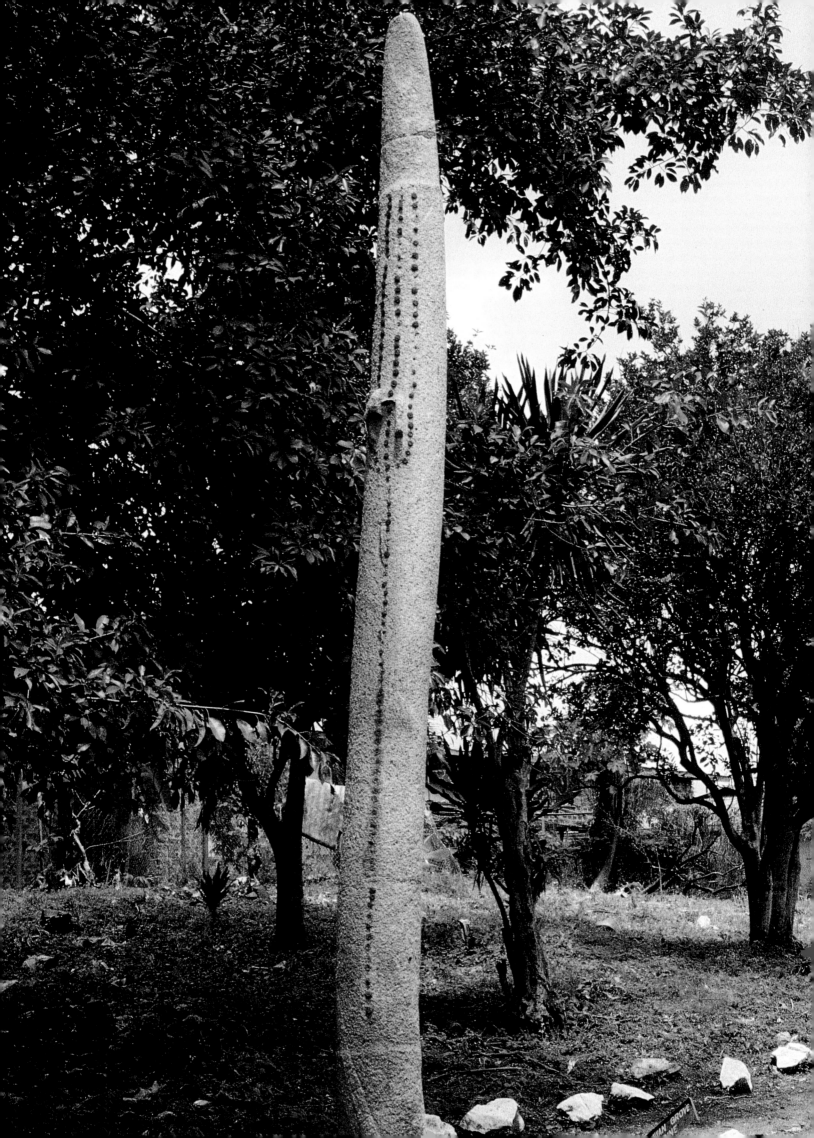

tic ritual contexts persist in household altars and family compound burials today. Within the early sites have been found exquisite terracotta sculptures and vessels depicting a wide variety of human, animal, and otherworldly subjects. Their number and remarkable refinement, diversity in style, subject matter, and scale suggest that they were the outgrowth of a widespread and highly specialized sculpting tradition in clay that may have begun about A.D. 800. This terracotta tradition led to an artistic flowering in other media as well, namely naturalistic stone sculptures and lost-wax castings in copper and brass.

Works in stone, terracotta, and metal were located at sites both near and far from the center of the city where the palace was sited (Figures 47 and 48). Often they were associated with ancient town walls, gateways leading in various directions, and forest groves (*igbo*) devoted to important sacred entities. The distribution suggests that these works were not the prerogative of royalty, but served a wide variety of persons and purposes.

The proposed chronological sequence is intended only to serve as a general overview for the reader. It is based on the hypothesis that the stone monoliths and minimalist terracottas are probably early. The more naturalistic stonework and terracottas can now be firmly linked with the Pavement Era and dated. The early ones are refined and composed; later ones show a general trend toward increasingly expressive and then stylized humanism characteristic of Yoruba art from about the sixteenth to the twentieth centuries. Such a schema tends to emphasize differences at the expense of continuities, simplicity over complexity. There are major gaps in our knowledge of Ife and its art, which can be filled only through systematic and sustained archeological, art historical, and ethnographic research. In addition, few works have been found in primary sites due to the continuous use of objects over the centuries. A remarkable example is an Egungun mask headdress near Ife that has incorporated a Pavement Era terracotta head (Figure 61).

Archaic Stonework

Stones with a variety of forms and identities mark an ancient presence in Ife. Because the stonework at Ife, although undated, is often associated or combined with ironwork, it can be linked with Ife's confirmed early iron-working culture in the first millenium A.D. One of the most dramatic pieces of early stonework is the Opa Oranmiyan, the "staff of Oranmiyan" (Figure 50). Oranmiyan was the mythic son of Ogun and Oduduwa, and founder of dynasties at Benin and Oyo. Carved of granite gneiss, Opa Oranmiyan stands over 18 feet (plus 1 foot

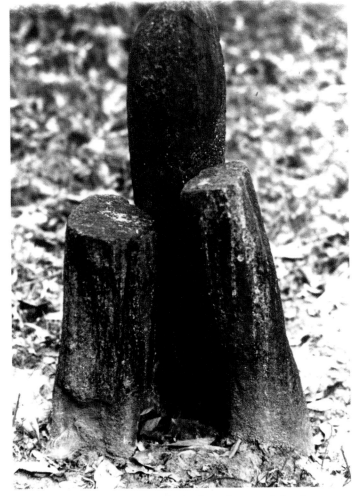

49. Liths at Ogun Oke Mogun, Ife, the focus for annual rites for Ogun. These and other stone phallic forms evoke Ogun's aggressive masculinity. Ife, Nigeria, 1970. Photograph by H. J. Drewal.

50. The "staff of Oranmiyan," (Opa Oranmiyan), a granite shaft more than eighteen feet in height, is studded with spiral-headed iron nails along its length. A hole and engraved lines at the top confirm its phallic identity. Ife, Nigeria, 1970. Photograph by J. Pemberton 3rd.

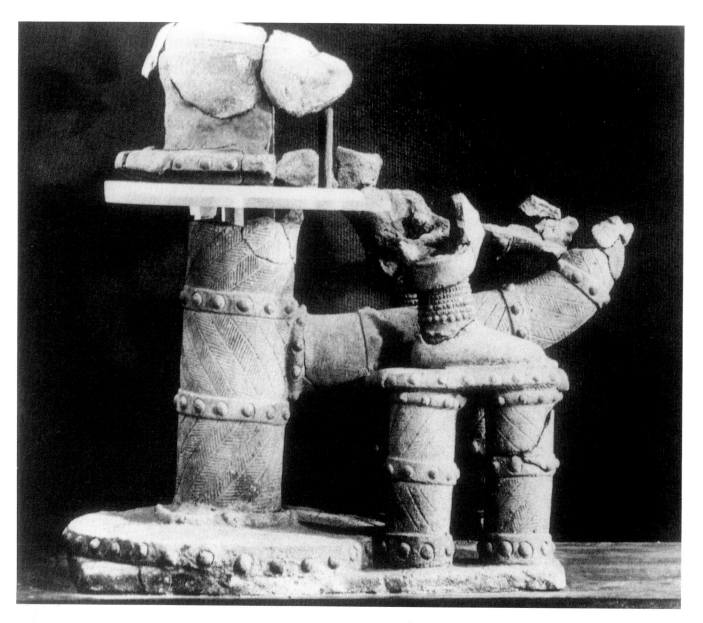

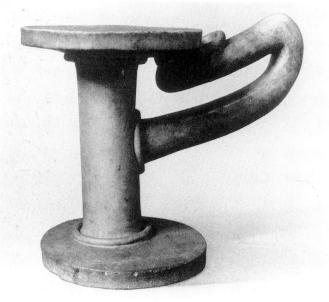

51. A fragmented terracotta shows a figure seated on the stool, the legs straddling the looped handle and feet placed on a smaller rectangular foot stool. It was found in Iwinrin Grove and appears to be a representation of a stool made of wood and decorated with brass bands and glass bosses. Source: Willett 1967.

52. Stool, Ife, 11th–15th century. A finely worked quartz stool with a looped handle. Its form relates to stool containers known as *apere*. The handle may represent an elephant's trunk. One of the first Ife works seen outside of Africa, it was given as a gift to a colonial official by the Oni of Ife in 1895 and entered the British Museum the following year. While its date remains uncertain, its style and iconography seem related to Pavement Era pieces. Source: Allison 1968, photograph courtesy of the British Museum, London.

53. Idena, the "gate keeper," is a relatively naturalistic stone sculpture with iron nails in its coiffure and an elaborately tied sash at its left hip. The figure is bare-chested, wears a beaded necklace and clasps its hands in front. Source: Allison 1968, photograph by Frank Willett.

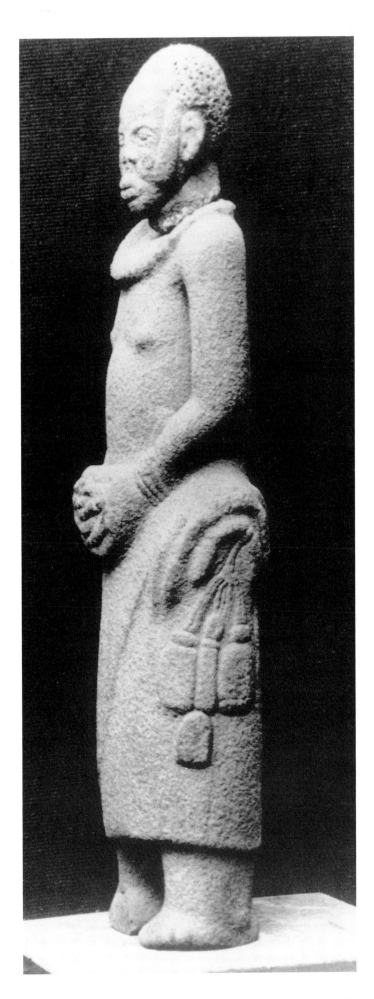

54. A terracotta elephant-head potlid dating to c. 1300 A.D. which was found at Lafogido, Ife. Its head is bedecked in an elaborate head-dress of beads, its neck is surrounded by a globular bead necklace, and its trunk is turned upward. Source: Eyo and Willett 1980.

55. Head fragment, Ife, 11th–13th century. A marvelous terracotta fragment of a face showing the conventionalized naturalism of the Early Pavement period at Ife. Notice the distinctive eye treatment and carefully rendered striations over the sensitively modelled facial features. Terracotta. H. 6 in. The Brooklyn Museum; lent by The Guennol Collection.

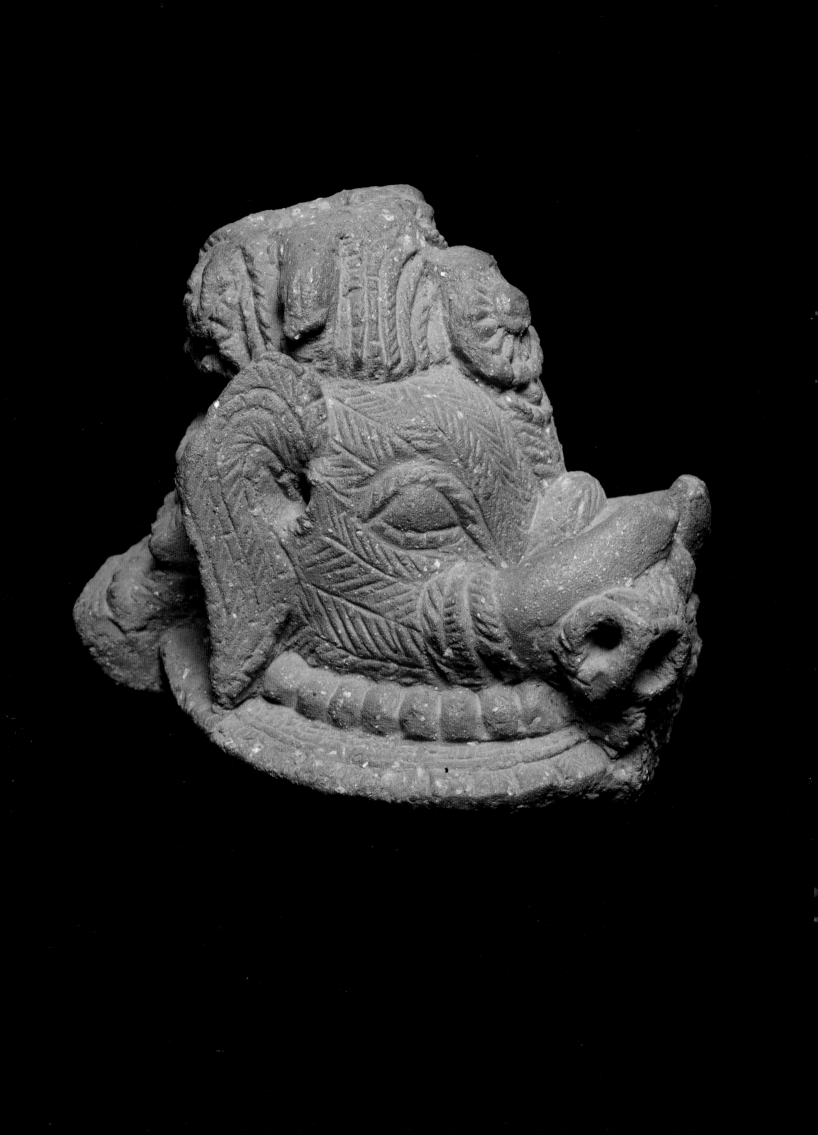

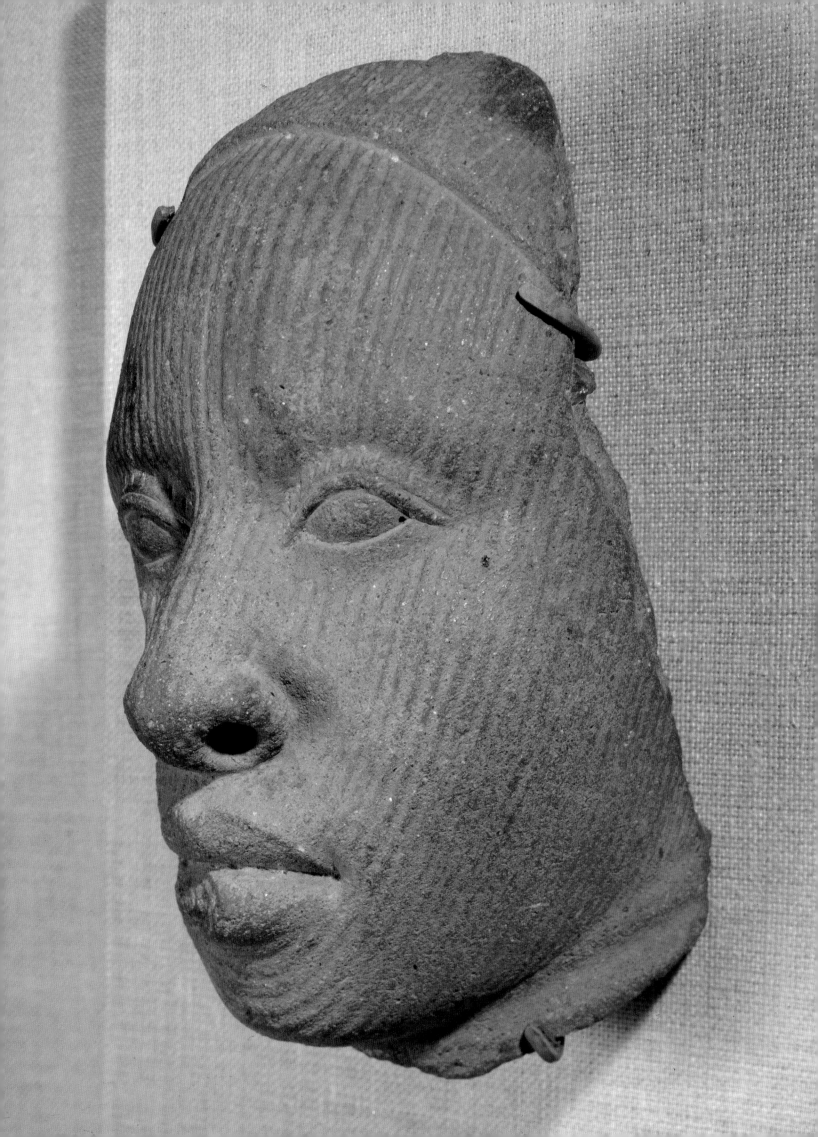

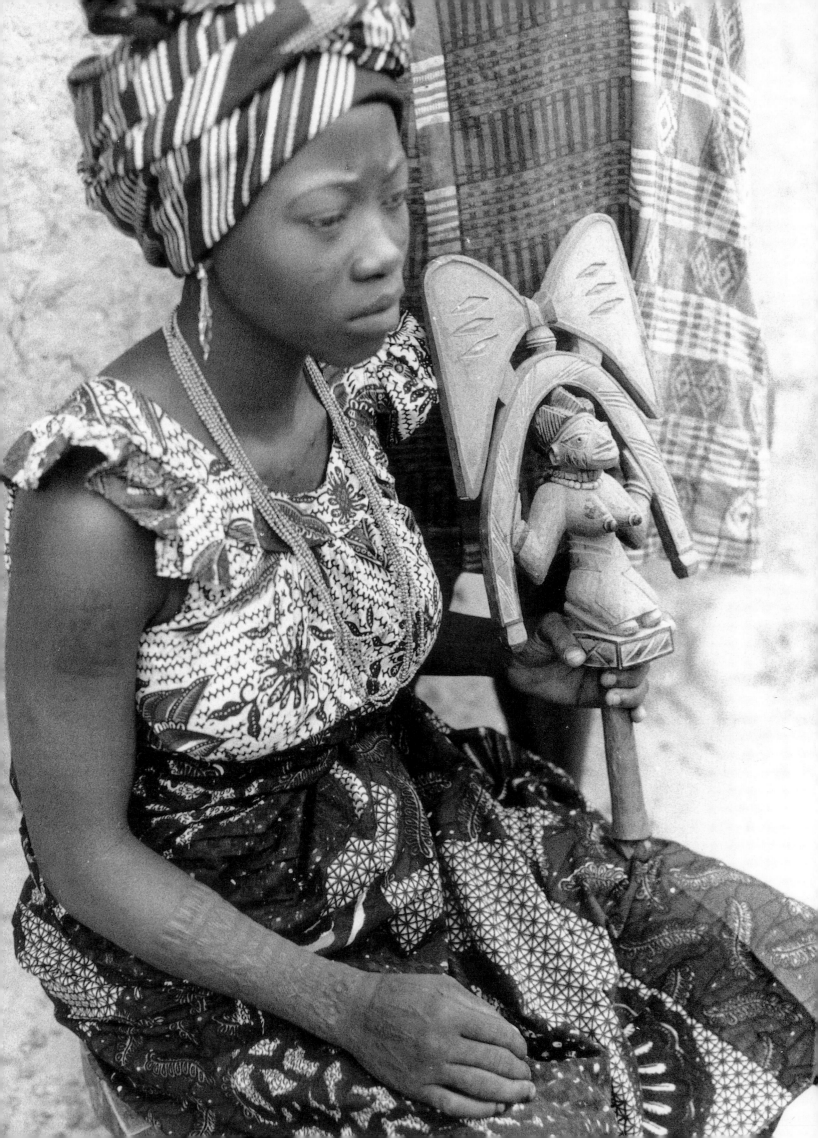

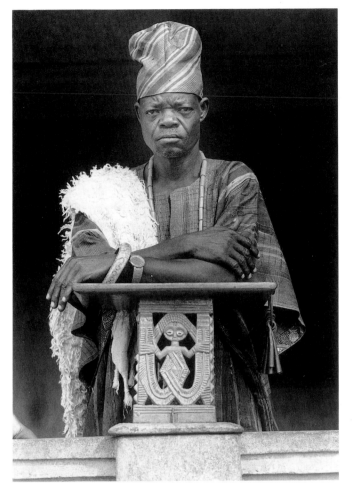

Another sculpted stone, Ada Eledisi ("Sword of Eledisi") is a monolith whose end curves at right angles to its length—an ancient sword form shared by the Yoruba, their close neighbors the Edo, and others. Swords and iron generally are linked to Ogun, the ancient Yoruba god of iron. Ogun's primary symbol is the fresh palm frond known as *mariwo*. It must be collected from the topmost new growth of the palm tree (*Elaeis guineensis*), which stands straight up and then bends at the tip of each frond. Ogun worshippers have explained to me that the palm frond is Ogun's sword—its form is the form of blades and of Eledisi's stone sword.

Stone and iron in combination in early Ife works may indicate the transition from a Neolithic to an Iron Age technology. They also suggest a time of warfare when such technology determined winners and losers. This appears to be the case with other Ogun shrine objects at the palace at Ile-Ife—a large stone mudfish and an enormous tear-shaped lump of wrought and fused iron.[15] Other sites contain a variety of stone and iron objects or themes.[16] Their massiveness and figurative minimalism suggest a date in the Archaic Era.

57. Posa, an Agemo chief, leans on his stool when making pronouncements. Note the fish-legged figure that forms the base of the stool, the beaded necklace, and the thick ivory bracelet on the chief's left wrist. Ijebu, Nigeria, 1982. Photograph by H. J. Drewal.

underground) and is studded over much of its length with spiral-headed iron nails arranged in a three-pronged forklike configuration. Where they branch into three lines, a low-relief, open, rectangular form rises from the surface of the stone. This arrangement of nails is probably not merely decorative, but has a symbolic significance that has been lost over the centuries. Each nail would have been laboriously inserted into the granite before the stela was raised.

The stela, like several others associated with Ogun at Ife (Figure 49), which vary in height from 1 to 4 feet at various sites in the town, is phallic in form. A hole and engraved lines at the tip of the Oranmiyan "staff" confirm its phallic identity.[14] This general conical shape may relate all these stelae to the cone-shaped icons (see Chapter 1), and to conical forms associated with heads in terracotta (see Figure 66).

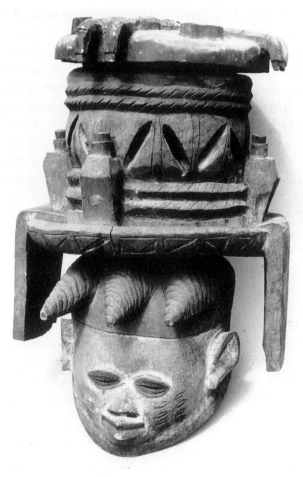

56. An initiate of the gods sits on a carved wooden stool when preparing to go into possession trance. In her left hand she holds a Sango dance wand that was carved in the Anago town of Pobe. Egbado, Nigeria, 1977. Photograph by M. T. Drewal.

58. An *apere* or *odu* Ifa container, represented in the superstructure of a Gelede mask from Idofa, Ketu Yoruba, said to have been carved by Moses Iji. National Museum, Lagos, 1971. Photograph by H. J. Drewal.

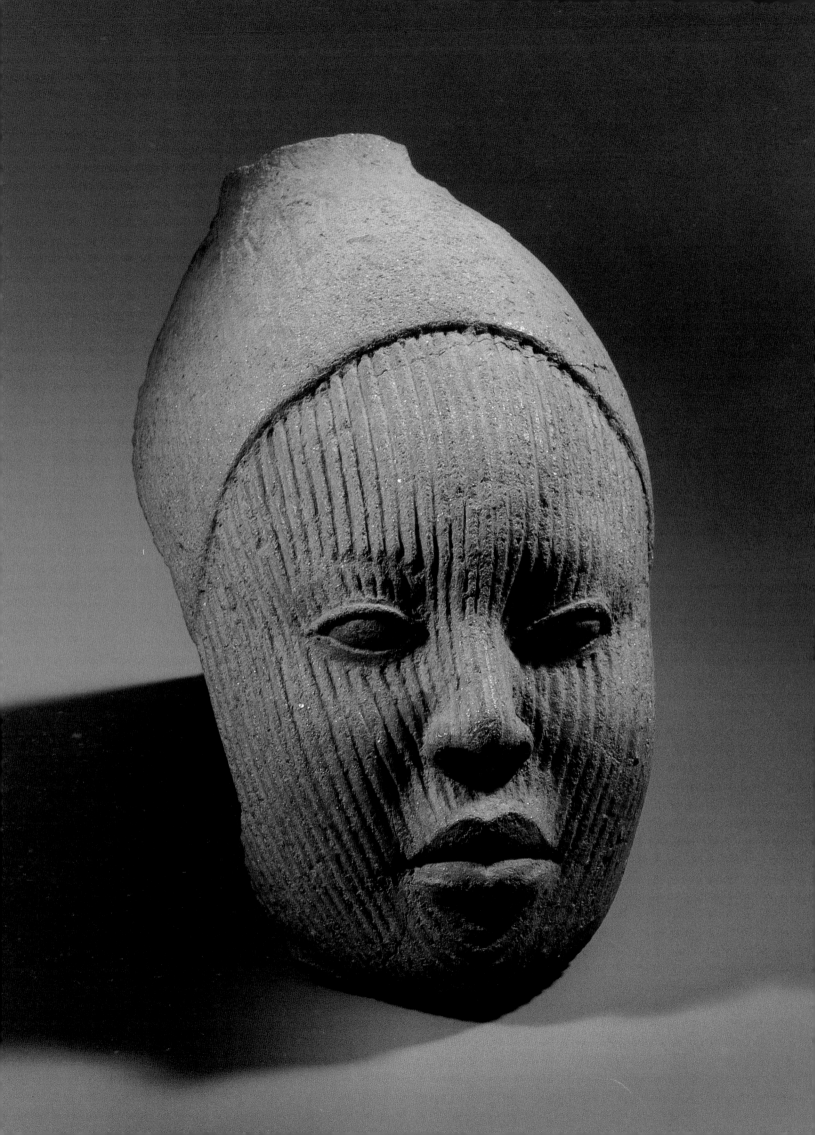

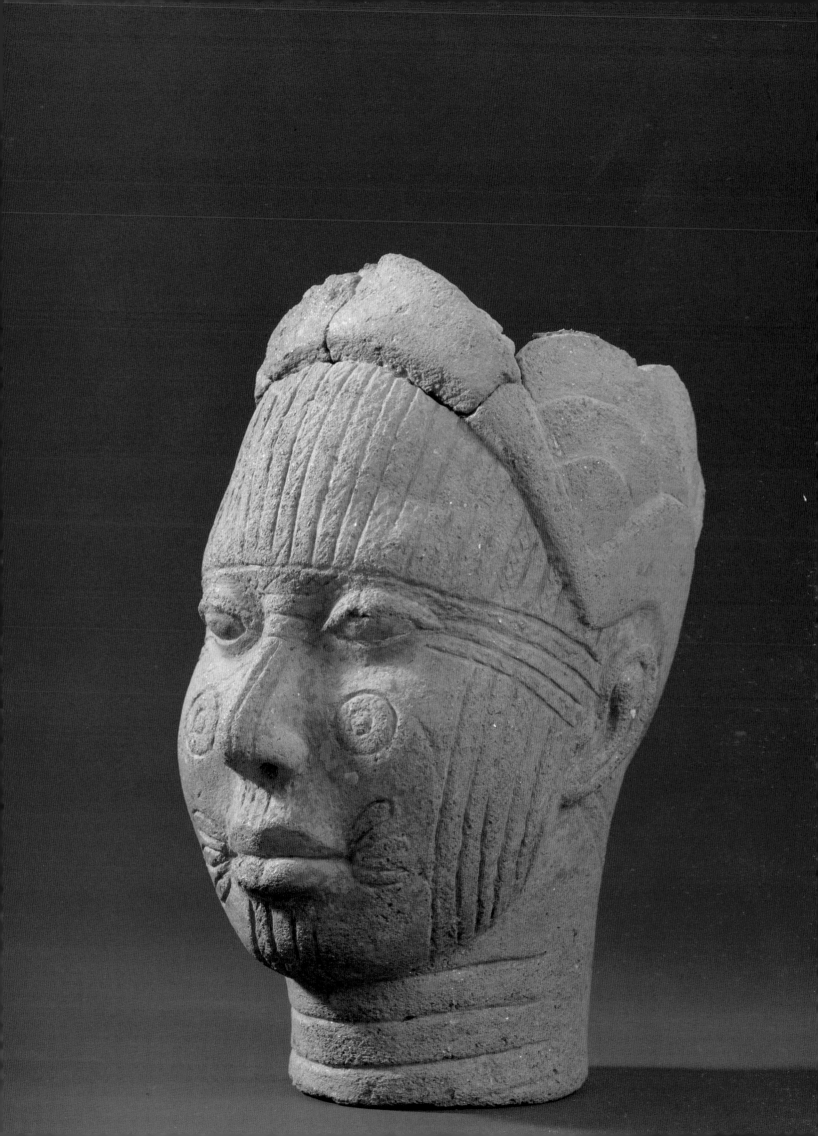

Pre-Pavement Stone Sculpture

Two finely carved stone figures at the Ore Grove seem to fall closer in time to Pre-Pavement urban developments than Archaic ones. *Idena*, ("gate keeper"; Figure 53) is relatively naturalistic in style with a head/body proportion of about one to six. It has spiral-headed nails in its coiffure, a modeled torso, and an elaborately tied sash on its left hip. The legs are very broad, presumably to give the figure stability. The second sculpture, called Ore, is much shorter, with a head proportionately larger (1:4), thickened neck, and distended abdomen. These features suggest the depiction of a dwarf or deformed person who, according to Yoruba belief, would have been a devotee of Obatala/Orisanla and have performed a ritual role as guardian of shrines. Both statues are bare-chested, wear heavy necklaces with globular beads, bracelets, and wrappers, and clasp their hands in front at the waist.

Two other statues, one close in style to Idena, the other with a globular head and spiral-headed nails embedded in the back of the head and right side of the body, are found near Esure, a town about 60 miles east/northeast of Ife, where remnants of a potsherd pavement can still be seen. Other pieces at this site include a head with a conical cap and surface decorations of a snake, an elephant's head, sword, male genitals, a tear-shaped stone, a drum-shaped object, two cylindrical stones covered with nail holes, and a long, pointed stone object with low-relief decorations looking like tusks.[17] Some of these objects, which are arranged in a line about a mile long in the forest, are vaguely associated with the early Ife king known as Obalufon.[18]

The wide range of styles in the Pre-Pavement stone sculptures probably represents a relatively long time-frame and varying connections with Ife. If, however, these minimalist works are taken as early expressions of Yoruba art, then they may fall in that unknown era, the first millenium A.D. The most cryptic (lumps of iron and stone, staffs, swords, phalli) are the earliest, while figurative and descriptive pieces (Idena, Ore, and some Esure works) could be dated to sometime between 800 and 1000 when Ile-Ife began to flower.

59. Head Fragment, Ife, 11th–12th century. The refined idealized naturalism of this terracotta head fragment suggests its origins in the Early Pavement Era. It has delicate vertical striations over its entire face. Terracotta. H. 7 in. University Art Museum; Obafemi Awolowo University.

60. Head Fragment, Ife, 14th–15th century. This terracotta head with a variety of scarification patterns of striations, circles, and loops is somewhat more stylized in its treatment of eyes, facial form and neck rings than the more naturalized idealism found in figure 59. It comes from Obalara's Land and may therefore date from the Late Pavement Era. It is very similar in style and iconography to terracottas found at Obaluru near Ife. Terracotta. H. 6¾ in. Department of Archaeology, Obafemi Awolowo University.

Pavement-Era Stools—Seats of Power

The stool is an ancient, significant ritual form in Yoruba art and history. Some of the first works from Ife seen in Europe were three stone stools (made of quartz, granite gneiss, and soapstone) given as gifts to a colonial official by the Oni of Ife in 1895 (Figure 52). The stool's basic form consists of two circular discs supported by a central cylindrical column encircled at the top and bottom by rings. From the middle of the column emerges an upwardly curving, looped "handle" that attaches to the top platform.

Works in other media depicting this and another stool (Figures 51 and 44) provide crucial data about the stool's ritual uses. The fragmented terracotta in Figure 51 shows a person seated on the stool, his/her legs straddling the looped handle with the feet on a smaller rectangular footstool. In the small metal sculpture in Figure 44, the figure wearing a tiered headdress becomes the body of a vessel placed on the platform, the left hand holding the looped handle and the right, a scepter.[19]

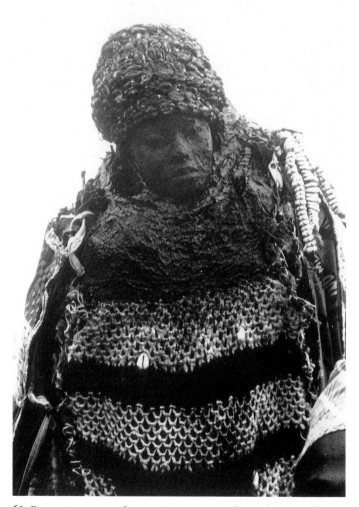

61. Egungun masquerader wearing a costume that includes an Ife head made in the Pavement Era. Few Ife works have been found in primary sites due to the continuous use of objects over the centuries. Antiquities found accidentally may be incorporated into later ensembles as here. Near Ife, Nigeria, 1970. Photograph by H. J. Drewal.

62. The pavement at Obalara's land, Ife covers a rectangular area and consists of a series of rows of shards set on edge, often in a herringbone pattern, alternating with rows of stones. A vessel for libations is set into the center of the pavement and marked by several concentric circles of shards and stones. A semicircular intrusion at one end of the rectangular pavement indicates the position of a raised earthen altar. Drawing after Garlake 1974.

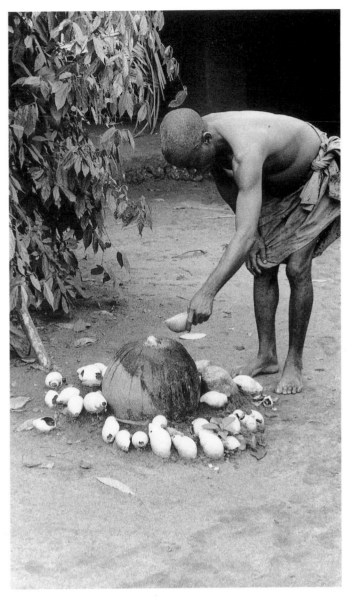

63. An Osugbo member pours a libation with his left hand at a spot near the middle of a rectangular courtyard where a pot covers a "face of worship." The remnants of offering appear on the vessel itself and among the snail shells which encircle it. Egbado, Nigeria, 1977. Photograph by H. J. Drewal.

64. The reconstructed Idena gate at Ketu shows the extensive roof protecting the entrance structure that has several guard rooms within. On either side, roofs cover earthen walls with ditches running along their exterior. Ketu, Republic of Benin, 1971. Photograph by H. J. Drewal.

These intriguing, enigmatic images relate to the import of *ijoko* (seats), in Yoruba thought. Seats are literally, as well as metaphorically, understood as seats of power. Initiates and priests to the gods sit on them when preparing to go into possession trance (Figure 56). Chiefs use them when making important decisions and pronouncements (Figure 57). Kings use them when engaged in momentous matters—rituals, court occasions, judgments, and so forth.[20] Altars for the divine are referred to as the *ijoko orisa* (seats of the gods), endowed with substances containing *ase* and sanctified to serve their various purposes. Often, like crowns, mask ensembles, or protective amulets, they are also containers. The seat's physical proximity with the owners' genital zones, areas possessing concentrations of *ase*, makes the presence of power substances within the seat even more effective.[21] They strengthen those who sit on them by preparing them spiritually and elevating them to ensure ritual's efficacy.

The Ife stool depicted in Figure 52 may relate in form to an ancient ritual container, a cylindrical box called *apere* with a leather handle. This box is used at Ife to hold ritual paraphernalia and other materials much like

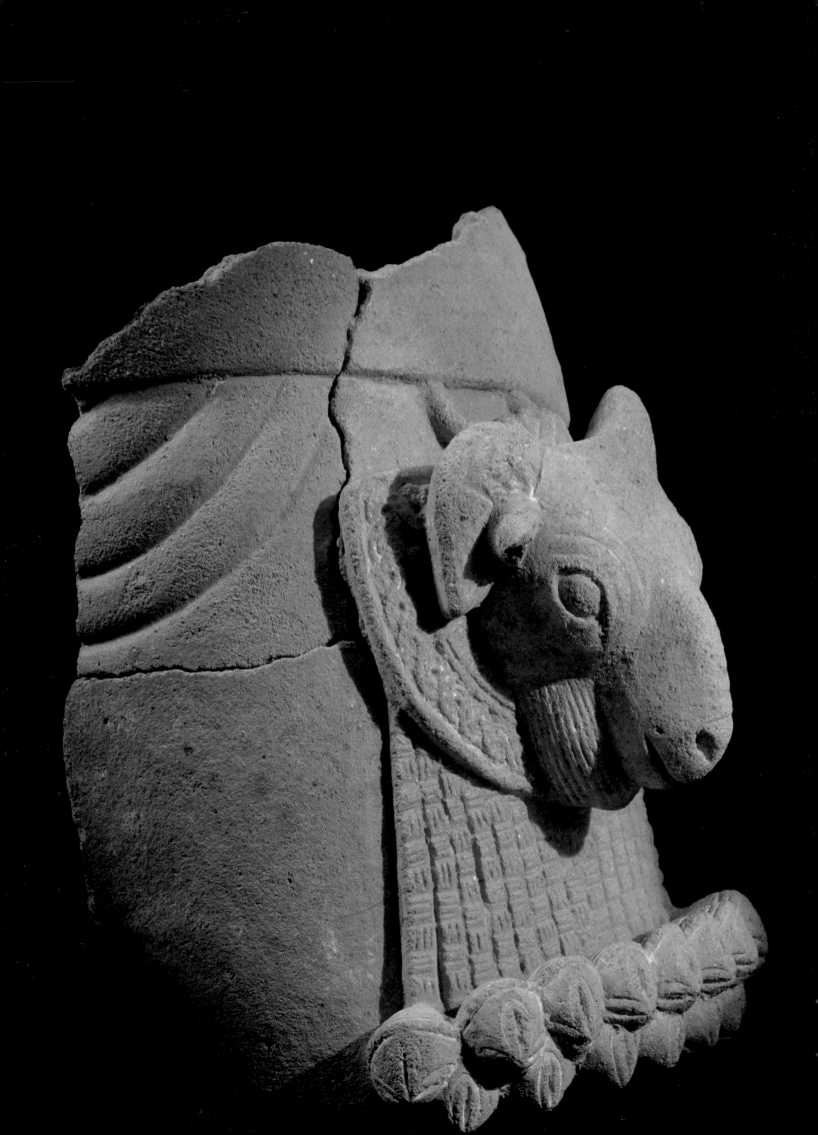

containers and thrones at Benin and Igala.[22] Such stool-containers are also among the most important items of Ifa priests of the highest rank. Like the cylindrical box, they are known as *apere*, or *odu*, represented here in the superstructure of a Gelede mask (Figure 58). What may be even more significant is that the highest level of diviners, those who divine for the king at Ife, possess an *apere/odu* (stool-container), usually one that is elaborately decorated.[23]

The quartz stool with looped "handle" from Ife (see Figure 52) must have been the center of momentous rites. It has a hole in the center of its top platform, no doubt the site for powerful materials—medicines to intensify the one who sat upon them, libations to alert and soothe forces, or other powerful substances. The looped "handle" may be more than that—it appears to be modeled after the trunk of an elephant, an ancient Yoruba symbol of mighty leadership, a presence that cannot be ignored. As the Yoruba say, "No one ever says 'did you see something?' when an elephant passes."[24] An elephant-head potlid in clay was found at Lafogido dated about 1300 (Figure 54), its head bedecked in an elaborate headdress of beads, its neck surrounded by a globular bead necklace, and its trunk turned upward like the looping trunk-handle of the stool.[25]

Their representation in art and their ritual use by humans suggest the importance of these seating forms. Certainly those who sat upon them must have been powerful in Ife society, made even more so by the substances embedded in the stools themselves. Their feet were elevated on a smaller rectangular stool, a procedure used by Yoruba rulers today to convey their elevated status as "deputy to the gods."[26] When they sat straddling the elephant trunk-handle, their genitals would have been in close proximity to its nostril-end, suggesting the transfer of power from one to the other and reinforcing the analogy between sovereigns of the forest and of the city-state.

A miniature brass casting of the stools reveals other uses and meanings (see Figure 44). The bead-covered person actually is the vessel or container. Such a person would be an *alaase*, possessing performative power and command, as is evident by the scepter in the right hand used for social matters. The left hand, used for sacred matters, holds the trunk-handle, while the head is positioned directly over its opening. Since stools are essential furniture for sacred rites, especially when

powerful and potentially dangerous forces are invoked, they must have participated in annual ceremonies of renewal and purification, as well as rites of transition between reigns. The transfer of power from one of the gods' deputies to the next was attended by complex propitiatory and preparatory rites. Numerous examples of such stools are found in the sacred groves dedicated to various *orisa*, the divine lords of the realm, whose support would have been essential.

The Pavement and Post-Pavement Eras

Pavements of potsherds and stones are an extremely important anchor for dating Ife art. Thanks to radiocarbon dating, we can define the Early and Late Pavement Eras from about 1000 to 1400 A.D. Like the distinctive combination of stone and iron seen earlier, the pavements are a synthesis of rows of shards set on edge, usually in a herringbone pattern, alternating with rows of stones (Figure 62). This style of pavement appears to be unique to the Yoruba, appearing throughout their land.[27]

In addition to providing firm dates, the pavements

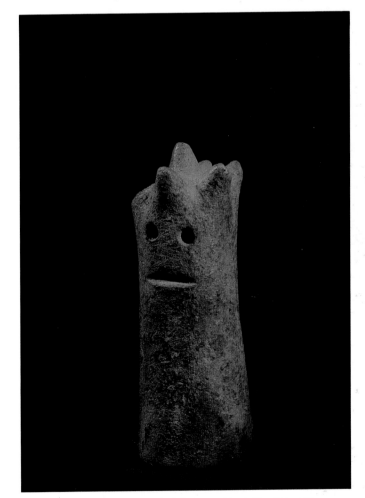

65. Ram's Head Fragment, Ife, 11th–12th century. A terracotta representing a ram's head with a fringe attached to a garment. Ram images appear to be ancient and widespread symbols of power and leadership among various Yoruba peoples and their neighbors in southern Nigeria. Terracotta. H. 8 in. Department of Archaeology, Obafemi Awolowo University.

66. Cylindrical Representation of a Human Head, Ife, 13th–14th century. An abstract terracotta head with several lobes on its top is very similar to one shown beside the naturalistic head with conical headdress on the vessel in Figures 70 and 71. It probably refers to the inner or spiritual head of an individual. Terracotta. H. 6⅜ in. National Commission for Museums and Monuments, Nigeria.

reveal a glimpse of Ife concepts of space, especially sacred spaces. The sites with pavements show a deeply engrained rectilinearity of ground plan. At one end of this rectangular plan a semicircular intrusion undoubtedly indicates the location of an altar, probably a raised earthen platform for sacred objects serving as a focal point for devotions. Embedded in the center of the pavement, and often highlighted by the shard/stone pattern, was a vessel, such as the elaborately figurated one shown in Figure 70. It was meant to receive offerings during rites. This central site would have been the *ojubu* (face of worship)[28]. The raised platform would have been the *ijoko orisa* (god's seat). In some cases the *ijoko orisa* may have been walled in and covered by a leafy canopy, probably a palm-frond fringe, as shown in Figures 5 and 7. In other instances, they may have been out in the open and arrayed about a courtyard.

The precise orientation of these altars seems to have been an important concern. Five pavements at the Obalara site dated to the early fourteenth century are aligned slightly south of a clear east-west axis, and others at Woye Asiri are on a north-south axis. The semicircular altars at both sites either face east or south, recalling the importance of the cardinal directions associated with Ifa ritual procedures.[29] All of these spatial arrangements and their implied ritual actions persist in Yorubaland today, most notably in the design of Osugbo *iledi* (lodges) where a pot in the center of the courtyard receives libations (Figure 63; also see Chapter 5).

In addition to pavements, earthen walls also define a distinctive Yoruba historical and cultural ethos. Almost all the major Yoruba city-states over the last nine centuries were enclosed by a series of walls. Most consisted of ditches and banks, although the earliest ones seem to have been free-standing walls about 15 feet high and 6 feet thick.[30] They appear to have been primarily for defensive purposes. Portions of the later wall system at Ife overlies a pavement that dates to sometime in the eleventh/twelfth centuries. This and other evidence suggest that the expansion phase of Ife lasted until about the sixteenth or seventeenth century.[31]

The tradition of walled cities must have been widespread in Yorubaland by at least the late fifteenth century.[32] Beginning before the thirteenth century, Yoruba city-states and their neighbors southwest of the Niger River experienced a period of rivalry, conflict, and competition that required the construction of defensive enclosures. This lasted through much of the nineteenth century and probably fostered the development of high-density urban settlements surrounded by agricultural lands that are characteristic of Yoruba civilization.

An important feature of urban walls is the system of entrances or gates. They were distinguished by often large architectural structures and passageways with intervening enclosures for security and customs purposes, as seen in a restored one at Ketu (Figure 64).[33] The measurements of those at Ife, especially the most massive ones facing east and south toward Benin, are based on multiples of four and sixteen, and there "is strong evidence that early entrances were standard 256-feet squares."[34] These numbers are symbolically important in Yoruba ritual and divination. In addition, the uniformity of the gates leading to the north and east/south-east in comparison with those facing south, suggests Ife's stronger relations with cities in those directions—Oyo-Ile to the north and Akure, Owo and Benin to the east.[35]

Gates are thresholds, liminal locations like crossroads. They are places where forces (whether worldly or otherworldly) are believed to meet, where friends and foes alike pass. People within a wall's boundaries assure their own safety by guarding such passageways with both physical and spiritual defenses.[36] Thus city gates, or the roads leading to them, were often important ritual sites, not only for Esu/Elegba, the divine messenger and guardian of crossroads, but also other forces involved in the protection and prosperity of the town. When gates were established, the most elaborate sacrifices, including human sacrifice, for example, criminals, foreigners, the diseased, or the extraordinary, are performed.[37] Such sacrifices were necessary to the survival and fortune of the entire realm that depended on the effectiveness of the gate's vigilance and protective powers. Sacred art was also probably clustered at such places. In fact, the site of Ita Yemoo—the name itself refers to the meeting of roads, *ita/orita*—is where many terracottas, castings, and pavements were found. It is located near the northeastern gate to Ilesa.

Beadworking was another distinctive technique of Ife. Sites have been found all over Ife city, especially the Olokun Grove where masses of crucibles and bluish waste materials were first reported in 1912.[38] It is not yet certain whether glass beads were produced locally or imported from elsewhere and then melted down and reshaped at Ife. The bluish glass wastes may be derived from the famous Segi beads or may be those known as *akori*.[39] These are thought to have come from the west, perhaps down the Niger River, although the location of the grove in which the industry was concentrated—Olokun, the name of the goddess of the sea—is near the Great Eastern Gate at Ife on the southeastern road to Benin and the coast.

The presence of pavements, city walls/gates, and beadworking sets the context for Ife terracottas and metalwork, expressions of the prosperity and impor-

tance of Ife in the Pavement Era. Ife terracotta, a large and diverse corpus of material, some of it datable to the Pavement Era, is at present our best source for an art historical picture of Ife life. It consists of almost life-size figures to very small figurines, freestanding heads, animals, figurated vessels, disks for wall mosaics, and a vast array of other subjects and styles. This enormous diversity testifies to a long-standing tradition involving many artists and aesthetic sensibilities.

The metalwork, exquisite lost-wax casts in brass and copper, is of less help in dating Ife art. It is a much smaller corpus (less than thirty pieces) with a very cohesive style which suggests that they were done over a relatively short period of time, perhaps by only a few artists in a single workshop. The two or three that have been found in a datable context relate closely to certain datable terracottas and will be discussed with them.

The twenty-five published radiocarbon dates available for Ife place the style of refined, idealized naturalism with the Early Pavement Era. The marvelous facial fragments in Figures 55 and 59 fall into this era, while others seem to be more expressive and therefore later (Figures 60, 67).

In the Early Pavement Era, the careful modeling of flesh and cartilage over bone creates a very convincing realism in contrast to the stylized treatment of the eyes, hairline, lips, and neck creases. The sources of this combined style remain conjectural. There is, however, an abiding humanism in Yoruba art throughout its long history. Culture has always been a primary concern of Yoruba artists. The aesthetic of *jijora* (resemblance) has characterized at least the last five hundred years, if we use the Owo terracottas dated to the fifteenth century and ivories from the sixteenth and seventeenth centuries as diagnostic.[40] The conventionalized realism of Ife art during the Pavement Era is not radically different. This style may also reflect the general flow of Yoruba style toward increased stylization and generalization and away from portraiture. The trend toward role depictions, a kind of visual shorthand, may be likened to the verbal shorthand of proverbs. The Yoruba saying that "half a speech to the wise is sufficient," reminds us that allusions alone convey meaning to knowledgeable persons. Furthermore, we know that at Ife abstract works were used side by side with realistic ones (see Figures 70 and 71). The juxtaposition of both artistic styles may indicate a tradition of using abstraction to express inner, invisible spirituality, and realism to convey outer, visible physicality of persons and things.

A ram's-head with fringe (Figure 65) probably comes from the Early Pavement Era. Such attachments have a long and important history in the art of this region, where variants in bronze and wood are especially associated with the southern Yoruba states of Ijebu and Owo, and the Benin kingdom. At Ife, the ram appears

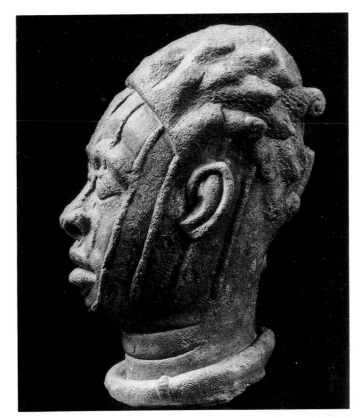

67. Head with Scarifications, Ife, 13th–14th century. A terracotta head with vertical keloid scarifications over its face and rows of curled braids of hair on the head. The expressive style and presence of the neck ring relate it to works found at Obalara's Land and Obaluru that may date to the Late Pavement Era. Terracotta. H. 7½ in. Staatliche Museen Preussicher Kulturbesitz, Museum für Völkerkunde, Berlin (west).

68. Human/Owl Janus Figure, Ife, 13th–14th century. A terracotta Janus image depicts a bird, perhaps an owl, holding what may be a cloth in its beak. On the other side, a human figure with a mouth covering holding a club in the right hand and perhaps a cloth in the left. A distinctive overall pattern of incised lines covers the face and upper torso. Terracotta, H. 4¼ in. Staatliche Museen Preussicher Kulturbesitz, Museum für Völkerkunde, Berlin (west).

69. Grotesque Face Fragment, Ife, 13th–14th century. A terracotta sculpture of a diseased individual wearing a small simian skull pendant around its neck. The large stone bead crowning its head may indicate rank or authority in rituals that must have been concerned with sacrifice, death and life. Terracotta. H. 6 in. University Art Museum, Obafemi Awolowo University.

to be linked with leadership judging from the head-dress, crest, and globular necklace that surrounds its head at Lafogido, where it is one of several animal-headed potlids (see Figure 54). The same regalia appears in sculptures of humans.[41] At Lafogido, animal-head, lidded pots were arranged in a rectangular pattern around a pavement with a hole, probably for a buried vessel as found at Obalara. These animal potlids most likely derive from the Yoruba practice of putting the actual heads of major sacrifices on the tops of vessels that constitute altars. Thus they were rendered in terracotta to commemorate, in a more permanent way, rituals properly performed, and they were then displayed as attachments on persons responsible for such rituals.[42]

One of the most remarkable works of art uncovered at Ife is a statue depicting the head and shoulders of a diseased person wearing a small simian skull around the neck (Figure 69).[43] It was found above a group of eight human skulls and bones. Another statue of a similarly diseased person, with misshapen head and swollen features, emaciated arm, distended belly and runny nose was found nearby, along with similar fragments—a swollen hand holding a cockerel and an anacephalous head with what appear to be snakes issuing from its nostrils. Radiocarbon dates place the site be-

tween 1230 and 1410, which makes it somewhat later than Ita Yemoo and perhaps Lafogido.[44]

Also stunning is a cylindrical necked vessel with an elaborate arrangement of images in relief around its circumference (Figures 70 and 71). It was found embedded in the ground at the center of a pavement with only the top of its neck showing.[45] Like all the vessels at Obalara, it had been broken at the bottom before being positioned. Moving around the vessel counter-clockwise are the following motifs: 1) an open rectangle with two conical heads with minimal facial features flanking a realistic head with a conical head-dress in the middle, a fringed canopy suspended overhead, and a serpent facing downward just over the central head; 2) a pair of human legs and feet projecting upside down out of a cylindrical woven container; 3) a pair of elongated, slightly curved blade forms joined by a cord looped once around a knob; 4) a tall rounded cylindrical drum with a slightly flared pedestal base and decorative band around its middle; 5) a knife with a broad, curved blade with a pointed end; 6) a long sinuous form with an incision at the end; 7) two horns, possibly a bush cow, joined by a cord looped once around a knob; and 8) a circular rod with slightly splayed and overlapping ends. These images are spaced irregularly around the vessel, with radical shifts in perspective. They thus present a clearly segmented composition—a very old approach to composition by Yoruba artists (see Chapter 1).

These two very striking works, and the others found with them, tell us much about Ife art and culture in the thirteenth and fourteenth centuries. Clearly the themes of sacrifice, disease, death, and life are central at Obalara. The skull pendant, gaping mouth and tongue, and grimacing face in Figure 69 dramatically evoke such themes which must be interpreted according to Yoruba aesthetic and philosophical concepts. Given the primary canon of appropriateness in the depiction of a subject and the principle of conceding "to each his/her own essence or *iwa*," these works may be representing the beauty of differentness. A large head is *special*—the visible handiwork of Obatala/Orisanla, patron of dwarfs, hunchbacks, and others whose physical form marks them as extraordinary. The large cylindrical bead on its head is a sign of this specialness. Furthermore, it defines someone destined to serve at sacred sites—and prepared to be offered there as well.

On the vessel, the portrayal of a knife (motif 5) and wrapped human sacrifice (motif 2) support this theme. The looped blades on cords (motif 3) look very much like the bullroarers on a carved door from Ijebu. Used by the Oro society, these blade-like forms attached to a cord were whirled over the head to make a humming

noise. They were used at night to signal executions, burials, and other momentous ritual events. Plain, pointed staffs joined by a cord on an Obalara leopard-headed vessel are identical to the unfigurated *edan* staffs of the Osugbo (see Chapters 1 and 5), the society that works with the Oro executioners.

The linked horns (motif 7) are worn around the neck as shown in a terracotta figure of a shackled person suffering from elephantiasis.[46] This suggests their role in relation to the diseased persons and sacrifices that are represented at Obalara. The drum (motif 4) looks like an Osugbo type known as an *agba*, and the sinuous form (motif 6) resembles a whip. Arrayed before us then are ritual implements and offerings to be made in the presence of the *ojubo* (face of worship) represented by three terracotta heads (two conical, one realistic) on an enclosed altar with what may be a palm frond canopy draped over it (motif 1). The slithering snake draws our eyes to this altar.

Some of these motifs are found on two other fragments at Obalara: the linked staves and horns, ring, and drums. A human sacrifice is shown on one fragment as a gagged head and on the other as a bound, gagged, and decapitated human victim. A leopard and snake join the series.[47]

One of several terracotta heads (Figure 60) was also recovered from Obalara.[48] It has a distinctive set of fa-

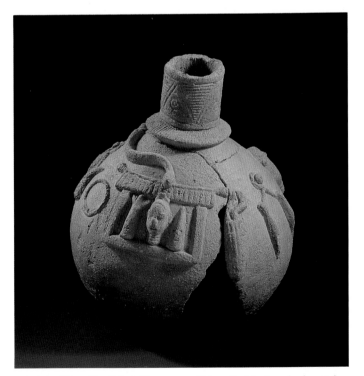

70. Ritual Pot, Ife, 13th–14th century. This cylindrical necked vessel with an elaborate program of images in relief around its circumference was buried in a potsherd pavement with only its neck showing. Its bottom had been broken before being placed in the pavement, which suggests that the libations poured into it were meant to penetrate the earth. Terracotta, H. 9¹³⁄₁₆ in. University Art Museum, Obafemi Awolowo University.

cial scarification patterns including vertical striations on the forehead, nose, upper lip, chin, and outer cheeks as well as radiating marks at the corner of the mouth, and circles on the cheeks. Traces of red pigment can be seen on the face and neck, and white on the eyeballs and within scarifications. The head appears to have been cut from a larger piece, probably a globular vessel like two that were found at the Olokun shrine of Obaluru, Ife.[49] The Obaluru heads, and another in the same style at Obalara, are shown with thick rings or beaded necklaces around their necks.

The style of the Obalara pieces is different from similar pieces at Ita Yemoo. The Obalara works were probably made somewhat later. They seem to suggest a movement toward a less precise, stylized realism. This freer, more expressive style would place them in the Late Pavement Era.

In 1978, an elaborately decorated vessel (Figure 72) was uncovered by archaeologist Omotoso Eluyemi at the Aroye Compound not far from the Wunmonije Compound and the palace at Ife. It includes a medium-relief image of a horned head with tongue protruding from gaping mouth. Encircling the vessel originally were sixteen rosettes with mica mirror insets at their centers, a distinctive mixing of media as we have already seen in stone/iron, shards/stones, and clay/iron sculpture.[50]

The expressive face is somewhat similar to that at Obalara (see Figure 69) and the textured overall cubic pattern on the vessel recalls headgear (probably beaded) on other Ife terracottas. According to reported oral traditions of the people of Aroye Compound, their ancestor was a famous warrior and herbalist and the pot may have been used to hold power materials. Perhaps at one time it was part of an altar ensemble or buried in a pavement to serve as the "face" for worship. On the basis of style, the piece might be contemporaneous with Obalara, around the fourteenth century, and part of a long, continuous Yoruba tradition of figurated ritual pottery that continues today.[51]

Ife Metalwork

The style of Ife's metalwork shows a remarkable uniformity close to datable terracottas from the Early Pavement Era.[52]

While the dates of Ife castings are becoming more certain, the purposes of life-size heads, such as Figure 75, remain uncertain. They may have served as the *dignitas* of the ruler during royal second-burial ceremonies to symbolize the continuity of the office despite the death of the office holder. Naturalistic wooden figures, *ako*, at Owo, for example, may derive from a similar *ako* ceremony at Benin, as well as hunters' funeral effigies at Ife.[53] The *ako* at Owo, however, were originally

71. Drawing of the series of eight motifs on vessel shown in figure 70. Fragments of two other vessels with similar motifs were also found at Obalara's Land, as well as another at Koiwo Layout, Ife, Source: Garlake 1974.

molded in clay over straw, to be used for chiefs, or mothers of chiefs, but not for royalty.[54]

There are several other reasons to dismiss the possibility of these perplexing metal heads being *dignitas*. As Yoruba have explained, no image of a departed king ever appears as part of second burials because kings, being "deputies of the gods," do not die. They disappear or descend "into the earth" like the gods. The only tradition of funeral effigies at Ife is reserved for hunters for whom an image is sometimes made. There are no ancestral maskers such as Egungun among Ife peoples, just as there were none in either Ijebu or Owo. Egungun is an Oyo tradition, not an Ife or southern Yoruba one.[55]

As for the funeral effigies at Benin and Owo, these were either buried, destroyed, or allowed to disintegrate. Preservation would have been counterproductive to their purpose. Therefore it is unlikely that effigies would be created in a durable material such as brass. Rather, this metal medium suggests long-term and repeated use.

Neither brass nor terracotta heads could be associated with royal burials or graves because these do not exist: As Yoruba have pointedly explained, "No one has ever seen the tomb of an *oba*." The thrust of this somewhat cryptic remark goes deep, for it reveals that the departure of a "deputy to the gods" is no ordinary matter. Kings become *orisa* when they leave this world, and their physical remains, which contain an enormous amount of *ase*, are redirected and scattered to important sites and for important ritual purposes so they can serve useful, supportive, and protective functions for those they leave behind.[56] The creation of a funeral effigy or *dignitas*, therefore, seems totally incompatible with Yoruba beliefs and practices surrounding sacred kings.

If the *dignitas* theory is untenable, what purpose might the heads have served? Many heads, whether in

brass, copper, or terracotta, were made to be freestanding, probably for display on an altar as we now know from the figurated vessel at Obalara (see Figure 70) where a realistic head with a conical headdress is flanked by two conical heads.

All the life-size heads have holes for attachments (see Figure 75), while the smaller ones do not. There is evidence of such attachments in the presence of thread, nail, and beads in the holes. It seems logical that the heads were created to display actual regalia in a shrine context, or in performance as in the case of a copper mask (Figure 76).[57] Rather than being *dignitas* in supposed royal second-burial contexts, the heads may be part of annual rites of purification and renewal for the ruler and his people and, more precisely for his spiritual head and beaded regalia.

This hypothesis is supported by a description of annual crown rituals at Okuku.[58] The crowns are concealed in a box until the time of the ritual, much as the terracottas were kept at the Iwinrin Grove or the brass heads were buried at Wunmonije Compound. The annual rites coincide with the new yam festival and include a ritualized battle between the chief priest (*aworo*) and the king like that of the Edi festival at Ife. Afterward the victorious king is carried on the shoulders of his supporters and returned to his palace. On the fifth day, all beaded royal regalia is displayed in an inner courtyard of the palace. Then the royal wives (*olori*) and children carry the regalia to the king's mother to be blessed. If she is deceased, the regalia is carried to her grave site where prayers are offered. On the seventh day the king brings a sacrificial offering to the shrine of his predecessors. Then he makes sacrifices to his own spiritual head, his *ori inu*, in a special room within the palace where all the crowns are displayed. As the king sits with the crowns, sacrifices of snail, chameleon, pigeon, and goats are made.[59] The king must sit on the threshold of this room as each crown is

placed on his head, starting with the earliest one, the *iya ade* (mother crown) as *oriki* (praise poems) are sung for each.

It seems certain that annual royal rituals of renewal and purification involving crowns must have been momentous, elaborate occasions in the past, given the power embodied in the crowns themselves. The continuing importance of rituals at Okuku and other kingdoms is testament to this. As the monarch sits on the threshold of the crown room, a place where medicines are buried, his head is covered with the containers of his predecessors as his own *ori inu* is built up. The freestanding life-size brass heads, and perhaps some of the terracotta ones as well, may have been commissioned by a wealthy, aesthetically minded Oni of Ife to serve as mounts for the display of the royal regalia during these annual rites. They may have also served during periods of transition between rulers such as installations, but not at second burials.[60] The two conical heads symbolic of the *ori inu*, and a realistic one with headdress representing the *ori ode* (outer physical head), are shown on the Obalara vessel (see Figure 70). They may thus be understood as representing an altar to a person's head and being, or perhaps more specifically the altar for a ruler's *ori inu* and beaded regalia.

Two other features on the brass heads require some explanation. Several have two lines of holes in the face running along the jawline and upper lip (see Figures 75 and 76). Recent evidence indicates that instead of being used for the insertion of hair to create a beard and mustache, these holes served to attach a beaded veil for the lower face.[61] A black bead was found lodged in a cheek hole of one of the brass heads, and traces of black pigment on the upper lip of some heads were also found. A very fine terracotta mask, almost identical to the so-called Obalufon copper mask, confirms the use of a lower face veil (Figure 77).[62] The area is defined by cross-hatching within a clearly defined raised border—a face covering, not a beard. An impressive bronze head that may have originated among the Ijebu Yoruba (see Chapter 5) also shows this veil with a series of cross-hatched lines over the exact same area as in the terracotta mask.[63] Yoruba traditions concerning kings support this interpretation. The Oni holds a fan over his mouth when eating, and kings often cover their mouths when speaking because of the potentially dangerous *ase* of their spoken words (see Figure 28).[64] The beaded veil is a more recent form of such facial coverings.[65]

Around the neck of the life-size heads are four holes which may have been used to attach it to an armature in order to create a full effigy.[66] A nail found in one of these seems to support this interpretation. Yet if the

heads were not used as part of second-burial effigies, but were used on their own in other rituals, what were the holes on the neck used for? It seems plausible that they, like the holes in the face, were intended to hold other royal accoutrements, specifically neck rings. Several heads show such a ring positioned exactly where the holes are on the brass heads: the terracotta head in Figure 67; one of the heads from Obalara; and the two heads on globular pots from Obaluru, Ife, discussed earlier. Furthermore, these unfigured rings may be the prototype for later, more elaborate rings (see Chapter 5).[67] Such rings, found both among the Yoruba and Benin, may have served to display heads, whether actual or of metal, of rulers or of those sacrificed during important rites—a hypothesis strengthened by the presence of a ring in the Obalara pot reliefs (see Figure 70).[68] Further evidence comes from a site at Ayetoro, Ife, where a terracotta head of a sacrificed animal was found with a "massive bronze neck-ring."[69] The recurrent images of decapitated human sacrifices on these bronze rings certainly support such a theory. In eighteenth- and nineteenth-century Benin bronze heads, the rings may have become figurated flanges.[70]

Not all Ife metalwork has been found at Ile-Ife. A few pieces have turned up far from their place of creation, for example, a standing figure in elaborate beaded regalia found at Benin.[71] Another, a copper casting of a seated person (Figure 73), was found at Tada, a Nupe village on the right bank of the Niger River not far from Oyo-Ile. It is undoubtedly of Ife manufacture as evident in its style. The striated patterns on its torso are identical to those on a half figure from Wunmonije Compound and several other Ife works in terracotta. The knotting of the garment on the left hip also marks it as of Ife origin. Thermoluminescent dating places it about 1300, well within the Pavement Era.

How did this statue get to Tada? Stone, terracotta, and metal objects were scattered at various shrines, many at the perimeters of the city itself, or near city gates—like the distribution of the body parts of former rulers to various sacred sites around the realm. In both instances they were used for apotropaic purposes. Therefore, it seems possible that representations of rulers, court officials, or regalia serving as symbols of authority would have been sent to important sites to mark political boundaries or agreements. Many migration myths in Ijebu speak of founders carrying metal objects as symbols of their authority to found new communities. According to Benin traditions, the Ogane (interpreted by most as the Oni of Ife) sent regalia to the new Benin monarch as part of installation rites.[72] It is likely that Ife sent objects in other directions as well,

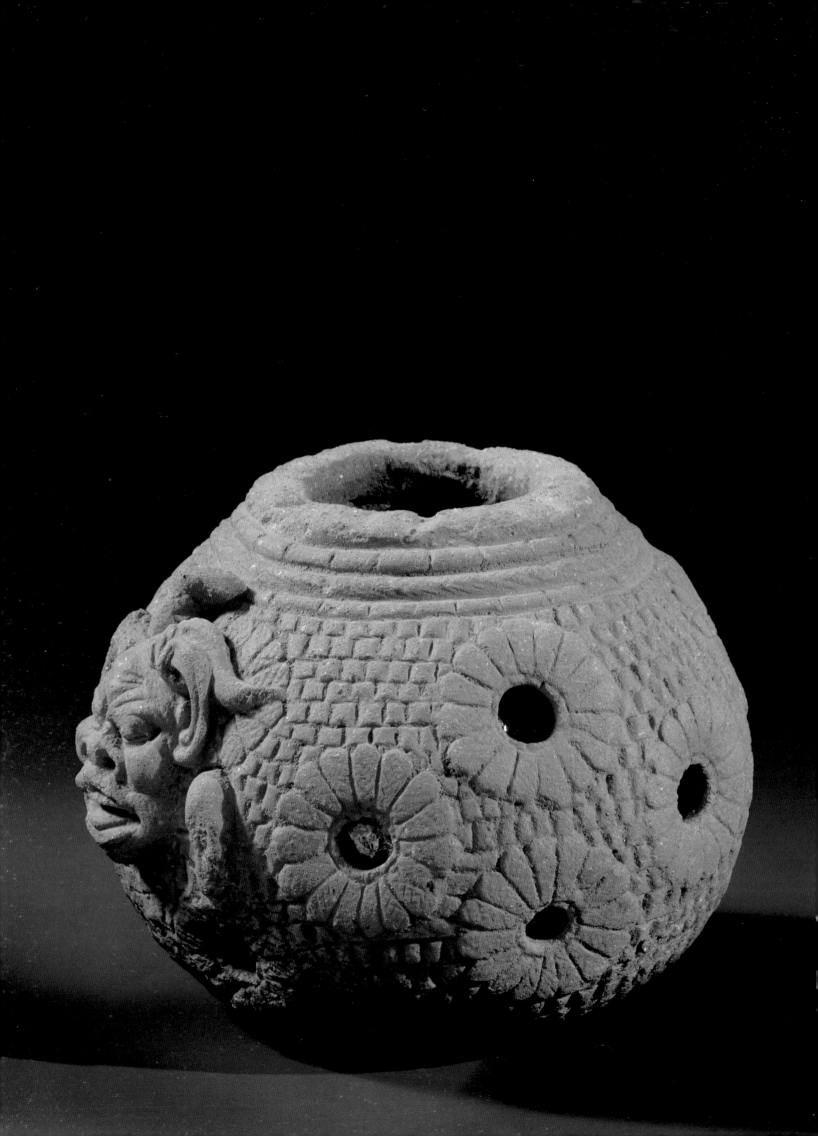

especially to the growing Yoruba city-state at Oyo-Ile situated near the Niger River. The Nupe kingdom was just across the river, which for a time probably served as a natural boundary demarcating "spheres of influence." In the early sixteenth century, Nupe began to expand its territory. The impressive seated figure, a marker of Oyo's authority, was probably "appropriated" by the Nupe when they forced the Oyo to abandon their city and set up a government in exile at Igboho.[73]

Later Works

Stone sculpture in the vicinity of Ife continued over several centuries as evidenced by an eighteenth/nineteenth-century work from Igbajo, 35 miles north of Ife (Figure 78).[74] This sculpture most likely served as an image in honor of Esu/Elegba, based on the remnants of sacrificial offerings and icons of a horn, club, and triple-crested and tufted coiffure. The massing of the head, shoulders, and pectoral muscles as well as the shape and size of the eyes recall the style of wood sculpture in this region that dates to the nineteenth century (see Chapter 7). The creation of three such images at Igbajo at approximately the same time indicates a particular set of historical circumstances. Esu/Elegba, as the guardian of markets and roads, would have been especially crucial in times of political or economic unrest. Images and rites in his honor might have been prescribed as a means of preventing disaster. Such an era occurred when the Oyo Yoruba expanded from

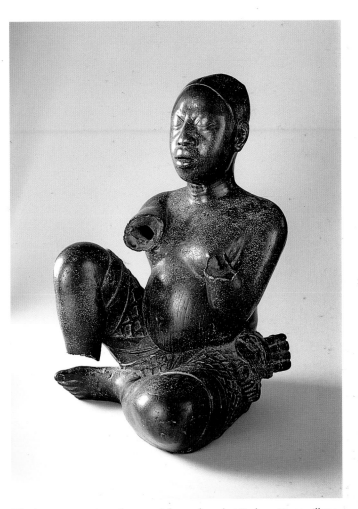

73. A copper casting of a seated figure found at Tada, a Nupe village on the right bank of the Niger river not far from Oyo-Ile. Its style and iconography clearly indicate its origin at Ife during the Pavement Era. Its location near Oyo-Ile may indicate its role as a marker of authority and/or territory. Source: Willett 1976.

Ibadan into Ijesa/Ekiti territories (between about 1860 and 1886), during which a deep gash was said to have been inflicted in one of the stone figures at Igbajo. This might suggest a mid-nineteenth-century date for this Igbajo figure. Alternatively, it may be associated with the boundary established between the Oyo and Benin kingdoms at Otun sometime in the sixteenth or seventeenth century.[75] Igbajo, which is near Otun, may have been the site of sacred shrines that marked the boundary, to be guarded by substances and forms evocative of (and invoking) the *ase* of the patron of paths, Esu/Elegba, and his warrior companion, Ogun.[76]

Artistic achievements at Ife mark an era of excellence. While these artistic traditions may have diminished over the centuries, they are still in evidence today, although the full record of them remains incomplete. Terracotta figured vessels, figures, beadwork in stone and glass, altarpieces, brass/copper casts, and stonework continue to be created. Styles have altered, as one might expect, but the religious concepts at their foundation have survived.

Ife flourished because of its local stature and its trad-

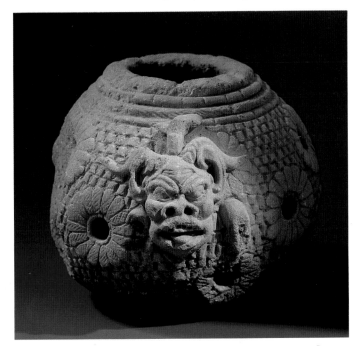

72. Aroye Pot, Ife, 14th–15th century. Two views of an elaborately decorated vessel from the Aroye Compound near the Ife palace. It displays a medium relief image of a horned head with tongue protruding from a gaping mouth. Encircling the vessel were sixteen rosettes with mica mirrors inset into their centers. Similar rosettes decorate a terracotta head from Akarabata, Ife. Terracotta. H. 6.3 in. Department of Archaeology, Obafemi Awolowo University.

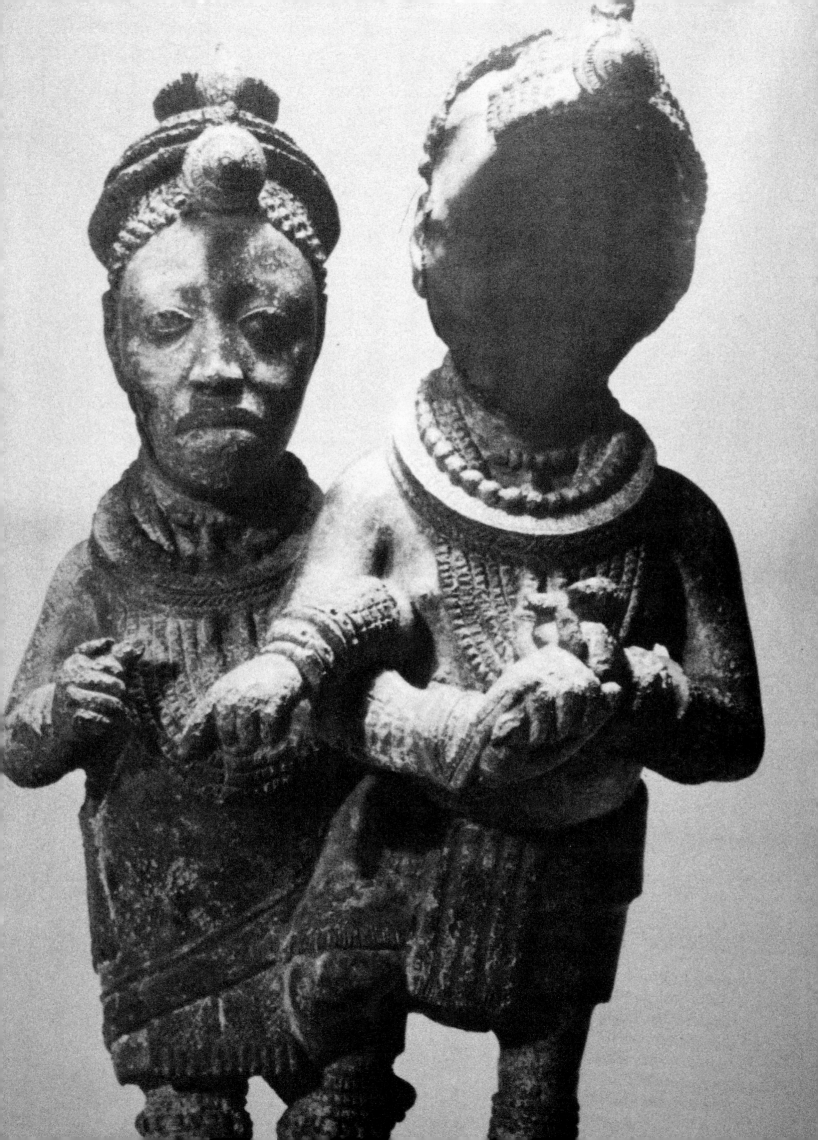

ing links with peoples far distant. The flowering of art at Ife seems to coincide with the early expansion of Oyo.[77] This city-state probably served as an trading center for goods coming down the Niger River from the Songai Empire which at its apex around 1400-1500 A.D., reached quite close to Oyo-Ile. Goods, especially shea butter, copper, salt, and luxury items such as beads would have been exchanged for kola, cloth, ivory, slaves, and forest products. The north was an important direction for Ife because of the Oyo-Niger River-Songai-Saharan trading routes, but not because of any direct North African or Mediterranean presence. Such an unsupportable hypothesis has been based partly on the erroneous interpretation of the "whiteness" of Obatala as somehow associated with his skin color![78] White is a color of deep symbolic and ritual significance for Obatala/Orisanla, having nothing to do with supposed "racial" origins.

Kingdoms to the southeast were also important to Ife. The art at the Yoruba city-state of Owo, while it may have exhibited strong Benin influences, has now been shown to have much closer and earlier links with Ife. All the motifs formerly linking Owo art with Benin—such as the leopard, a snake above the altar canopy, expressive facial qualities, open mouths, keloid forehead marks, and snakes issuing from nostrils—are present together at Ife and at dates earlier than those at Owo.[79] These clearly indicate a closer relationship between Ife and Owo than previously suspected, suggesting perhaps closer early ties between Ife and Benin as well, although we are still uncertain about the nature and direction of these artistic interactions.

Ile-Ife was a thriving metropolis. Its layout suggests an orderly city plan with multiple courtyard buildings in alignment. Hinged doors set in stone sockets opened onto these courtyards, many of them embellished with decorative pavements, pottery mosaic walls, and semicircular raised altars arrayed with a great variety of pottery and figurative sculpture, much of it painted in strong colors—red, black, and white. This artistic wealth was not restricted to leaders or royalty, but was commonplace in a variety of both sacred and domestic contexts.

Persons of high rank, whether priests, chiefs, or rulers, are depicted in a naturalistic style that is strongly conventionalized. Heads and faces are emphasized, open to full view. Postures and gestures are both formal and more relaxed as seen in the seated Tada figure (Figure 73). The sense of composed openness and directness in these works suggests that during the florescence of Ife, rulers may not have been as removed or restricted as they came to be in later centuries, when they became virtual prisoners in their own palaces, hidden from view except on certain ritual occasions, and then only seen dimly through beaded veils.

In contrast to the composed elegance of such subjects are images of the extraordinary or startling—the deformed and diseased, the stranger, the otherworldly, and the doomed.[80] But though the subject matter may differ, its style does not. All are rendered in naturalistic ways, yet idealized in the sense of expressing "perfectly" and appropriately their true essence or iwa. That is their great beauty and evocative power.

Not all Ife works are rendered in naturalistic ways. Cones with realistic or minimal facial features were used together with naturalistic heads. Such juxtapositions demonstrate an openness toward radically different approaches to conveying ideas visually. They appear to co-exist in order to present the inner and outer dimensions of existence. The inner sphere is spiritual and invisible—only to be visualized by artists using their fertile imaginations. The outer aspect is the physical, tangible aspect of the human presence—to be proclaimed by artists in their representation of visible form as perceived through their senses. We are witnesses to expressions of ori inu and ori ode in Ife art, and Yoruba art generally.

Were the creators of these exquisite works women or men? An analysis of sculpting technique used in the terracottas suggested that the artists were male.[81] This hypothesis is based on a comparison with the smoothing of exterior and interior of pottery done by women. This surface treatment is not evident in the sculptures which have rough interiors. However, at least one naturalistic head at Obalara has such a smoothed interior.[82] In any case, it seems unlikely that this difference can determine the sex of the artist, only that pots and sculpture serve different functions. The Yoruba tradition that women, not men, work clay for both sacred and secular purposes is deeply rooted, which suggests that women created the Ife terracottas. It does seem likely that men did the stone and iron work as well as the castings in copper and brass, based on equally strong traditions of men as sculptors of stone, metal, and also wood. If these sug-

74. Pair of Figures, Ita Yemoo, 11th–12th century. In 1957 this extraordinary bronze sculpture was found by workmen beside the road to Ilesa. The face of the male figure was destroyed. The casting, scarcely 1/16 inch thick in some places, appears to portray an Oni and his queen. They wear and hold the symbols of their authority, (ase). The crown and hair of the queen were painted black. The large beads on the king's crown, the beads around their necks, and their wrappers were painted red. The forefingers of his hands are hooked together in what appears to be a ritual gesture. Her arm is linked through his, and his leg encircles her leg. The linking of male and female in Yoruba art is expressive of the cultural theme of the dependence of the sexes upon one another for the actualization of their essential natures (iwa). Bronze and pigment. H. 7½ in. Ife Museum of Antiquities, Ita Yemoo. Willett 1976.

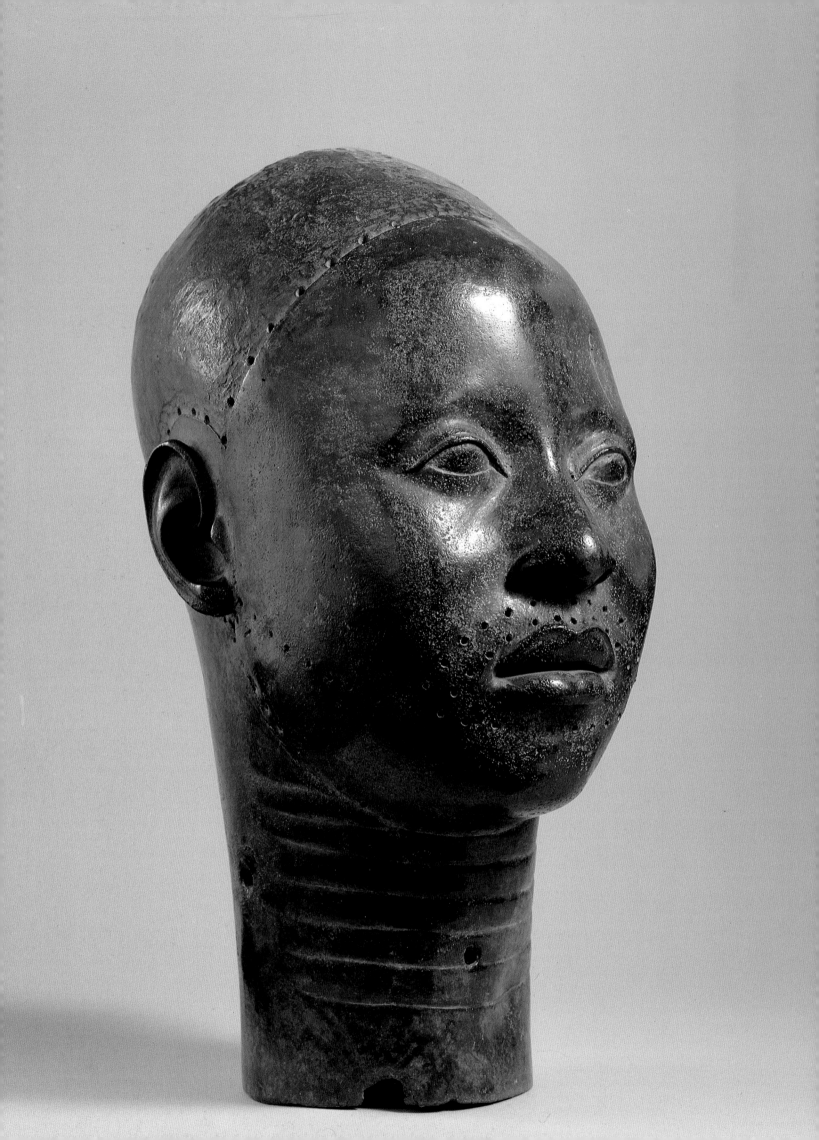

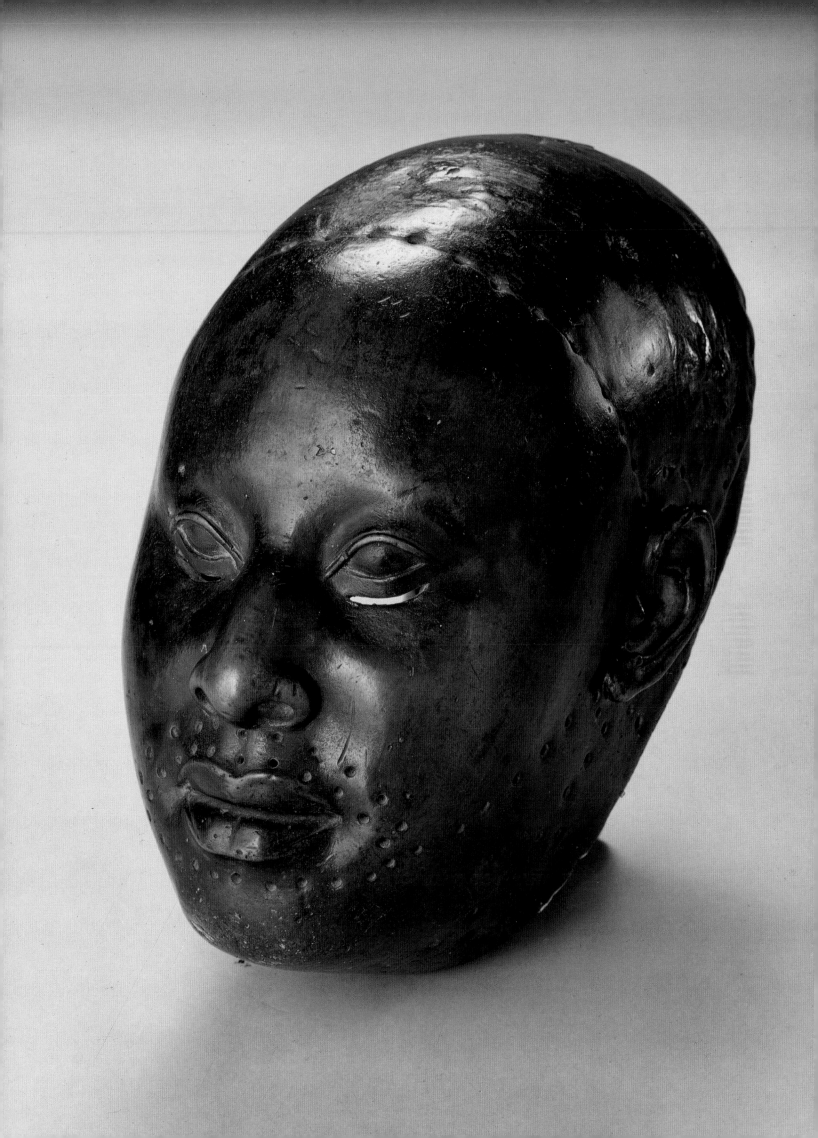

gestions are correct, then who made the clay cores over which wax would have been modeled to create the casting? It is possible that women did these and then the final modeling in wax was performed by men before being invested and cast in metal. The instances in Yoruba art production where women and men combine their efforts to produce the final work—for example, Gelede and Egungun masking ensembles and mat-weaving—support this hypothesis. The theme of cooperation between the sexes, so vividly portrayed by the interlocking couple in brass from Ita Yemoo (Figure 74) and the *edan* pairs of the Osugbo (see Figure 42), is further explored in Chapter 5. Artistic efforts done jointly by both men and women cannot be ruled out in the case of Ife art.

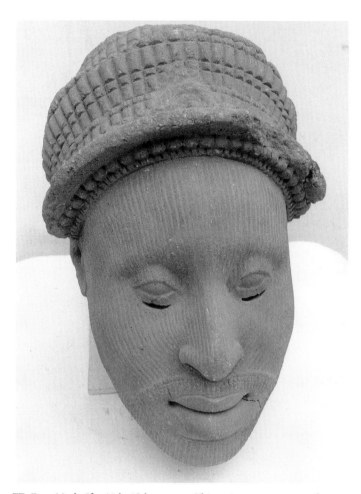

77. Face Mask, Ife, 11th–12th century. This unique terracotta sculpture was excavated at Obalufon's Compound in 1983. The slits below the eyes indicate that it was designed to be used as a face mask. In this respect it is similar to the famous copper face mask, which is said to represent the Oni Obalufon. The crest on the front of the crown is missing. The cross-hatching within a clearly defined raised border and the grayish color of the lower portion of the face strongly suggest a face veil, since the face of a king was not to be seen on ritual occasions. Terracotta. H. 8¾ in. Department of Archaeology, Obafemi Awolowo University.

75. Head of an Oni, Ife, 11th–12th century. One of a remarkable group of life-sized free-standing heads found at Wunmonije's Compound in Ile-Ife in 1938 and 1939. These superbly crafted sculptures may have served as mounts for the display of royal regalia during annual rites for the Oni, the king of Ile-Ife. The holes across the forehead, jawline, and upper lip were used to attach a crown to the head and a beaded veil to the lower portion of the face. Zinc brass. H. 12³⁄₁₆ in. National Commission for Museums and Monuments, Nigeria.

76. Obalufon Mask, Ife, 11th–12th century. This famous copper mask, known as "Obalufon," has holes for the attachment of regalia and slits under the eyes to allow the wearer to see. Copper. H. 11⅝ in. Museum of Antiquities, Ife.

78. Stone Figure in Honor of Esu, Igbajo, 18th–19th century. This stone figure is probably one of three from the town of Igbajo, about 35 miles north and east of Ife. The remnants of sacrificial offerings and such iconographic features as a crested coiffure, club, and horn suggest its association with Esu/Elegba, divine mediator and guardian of crossroads and markets. In addition, it may have served as a boundary marker. Stone. H. 25 in. The Fine Arts Museums of San Francisco, Museum Purchase, Salinger Fund.

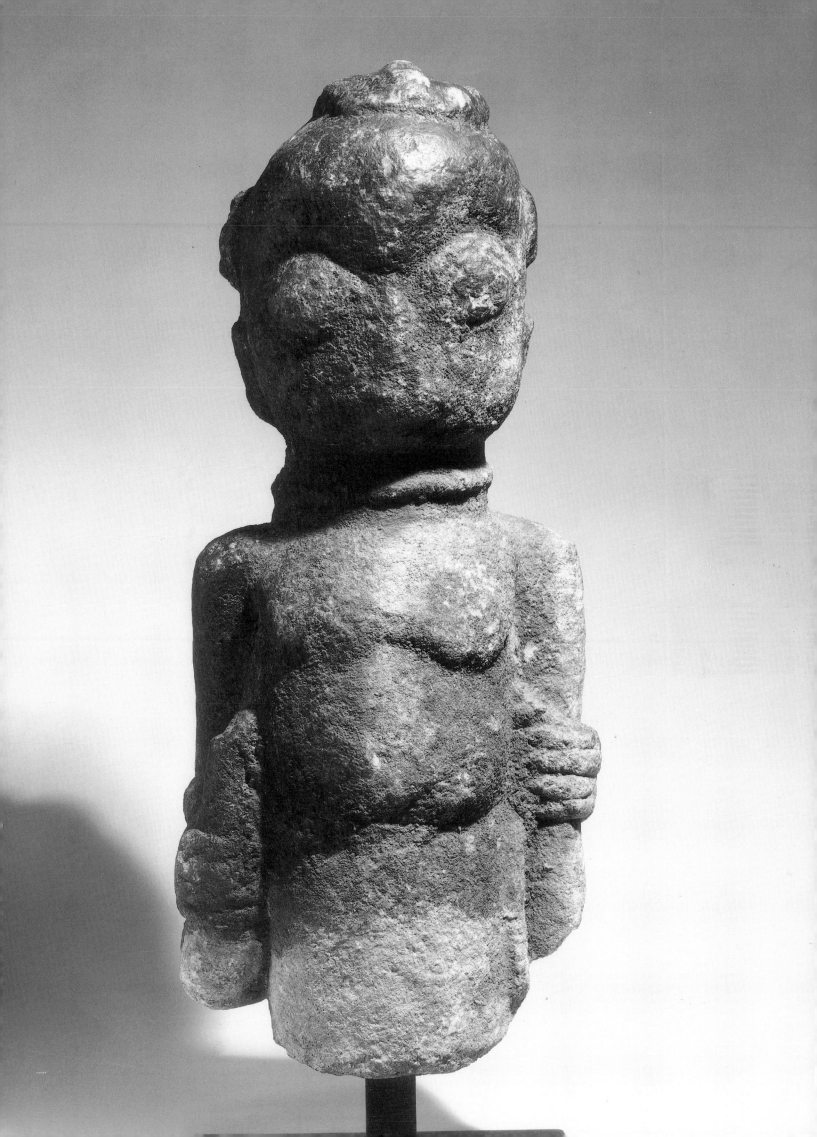

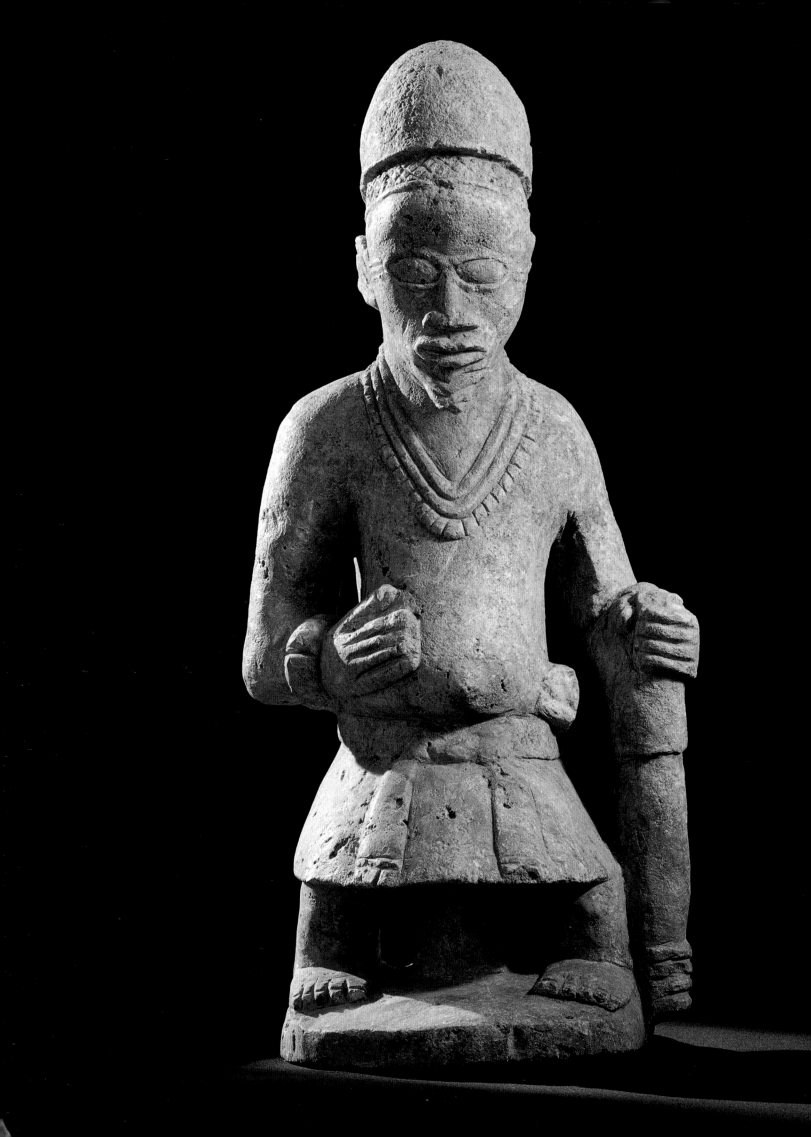

John Pemberton III

The thousand or more soapstone images and fragments lying for centuries in a grove in the Igbomina Yoruba town of Esie pose a fascinating problem for the historian of Yoruba art (Figure 80). While reflecting the work of a number of carvers, they share a distinctive stylistic affinity with one another that sets them apart from the corpus of artifacts associated with antiquities from Nok, Ife, Benin, or later Yoruba artistry. All are damaged in a manner that suggests an act of deliberate destruction or possibly desecration, but there is no evidence that the Esie townspeople had anything to do with their creation or destruction.

The German ethnographer, Leo Frobenius, was the first European to take note of the stone images. In 1912 he collected three heads carved in the Esie style in the neighboring town of Offa (Figure 81). Overwhelmed by the artistic qualities of the Ife terracottas, Frobenius was less enthusiastic about the Esie heads. In *The Voice of Africa* he wrote:

> Excavations I undertook in the district of Offa allow me to state that there, too, in recent times, that is about the Dutch period, stone images were manufactured larger in size than those in Ili-Ife.... [T]hey show the greatest partiality for dressing the hair and ornamenting it as fantastically as might be, exactly as happens with the Benin bronzes of the same period. They are, however, so poor and degenerate in form as to possess no importance as works of art, but may well serve as documentary evidence of decadence in steatite shape.[1]

Frobenius might have modified his dismissive assessment, had he seen the entire collection of images at Esie, and not just three isolated pieces. The images remained relatively undisturbed until 1933, when H. G. Ramshaw, Schools Inspector for the Church Missionary Society in Nigeria, learned of them and told others about them. Over the next few years three publications on the Esie stone carvings appeared.[2] Kenneth C. Murray, Surveyor of Antiquities beginning in the late 1930s, wrote an article in 1951. He had long been concerned about the preservation of the images and had faced stiff opposition by the people of Esie when he and others urged that steps be taken for their preservation and exhibition in Esie. It was not until 1965, however, that any serious study of the Esie carvings began. Phillips Stevens, Jr., then a young Peace Corps volunteer affiliated with Nigeria's Department of Antiquities, spent seventeen months in Esie cataloguing and photographing the images, a project he completed in 1973 and 1974. His book, *The Stone Images of Esie, Nigeria* (1978), presents a careful analysis of the ethnographic and archaeological data and an extensive photographic catalogue. It is the principal work to date on Esie and makes a major contribution to the study of Nigeria's antiquities. The present essay is dependent upon Stevens' data and indebted to his analysis.

The Artistry of the Esie Images
Those who have written about the Esie stone carvings have been more concerned with the question of their origin and establishing links with Ife or Old-Oyo than

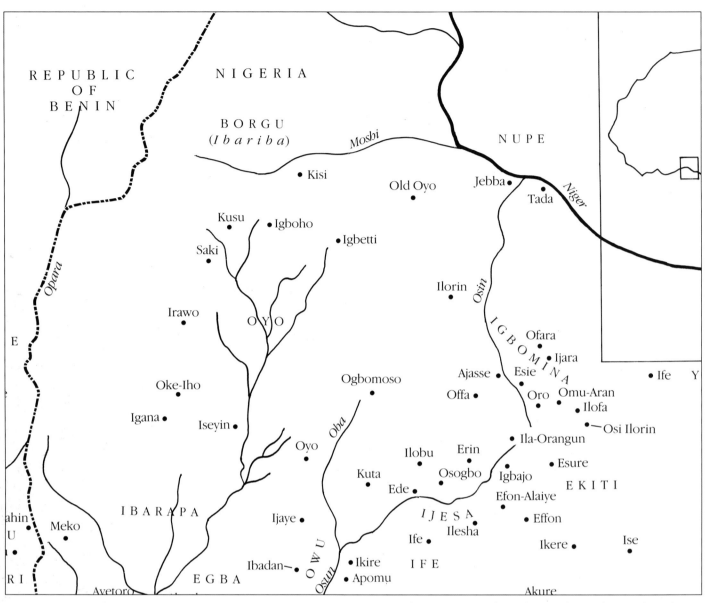

80. Map locating Esie in relationship to other north central Yoruba towns.

81. Head, Esie, 12th–15th century. An Esie stone head collected by the German ethnographer and explorer, Leo Frobenius, in 1912 in the town of Offa near Esie. Stone. H. 11¾ in. The Metropolitan Museum of Art, The Michael C. Rockefeller Memorial Collection, Bequest of Nelson A. Rockefeller, 1979.

79. Seated Male Figure, Esie, 12th–15th century. This carving is one of the few that survived relatively unscathed the days of willful destruction and the ravages of time. The artist conveys the authority of his subject in the composure of the face and the directness of the gaze, as well as in the seated position and gestures of the left hand on staff and right hand on the side of the abdomen. The placing of the hands in this manner is found in many of the carvings, suggesting not only a stylistic convention in Esie carving but gestures employed by those holding particular offices in the ancient culture. The expressive power of this carving is that the artist not only depicts a social role, but also makes one aware of a person who held the role. The face of the elder is carefully modeled, ending in a small beard, the shape of which is repeated in the necklaces of office that lie on his chest. There is a fleshy quality in the once-powerful shoulders and arm. One feels the weight of the man in the abdomen as it protrudes above the sash and in the spread of the hips as he sits on the stool. Balance, composure, and authority achieved through office and age are his. Stone. H. 25 in. National Commission for Museums and Monuments, Nigeria.

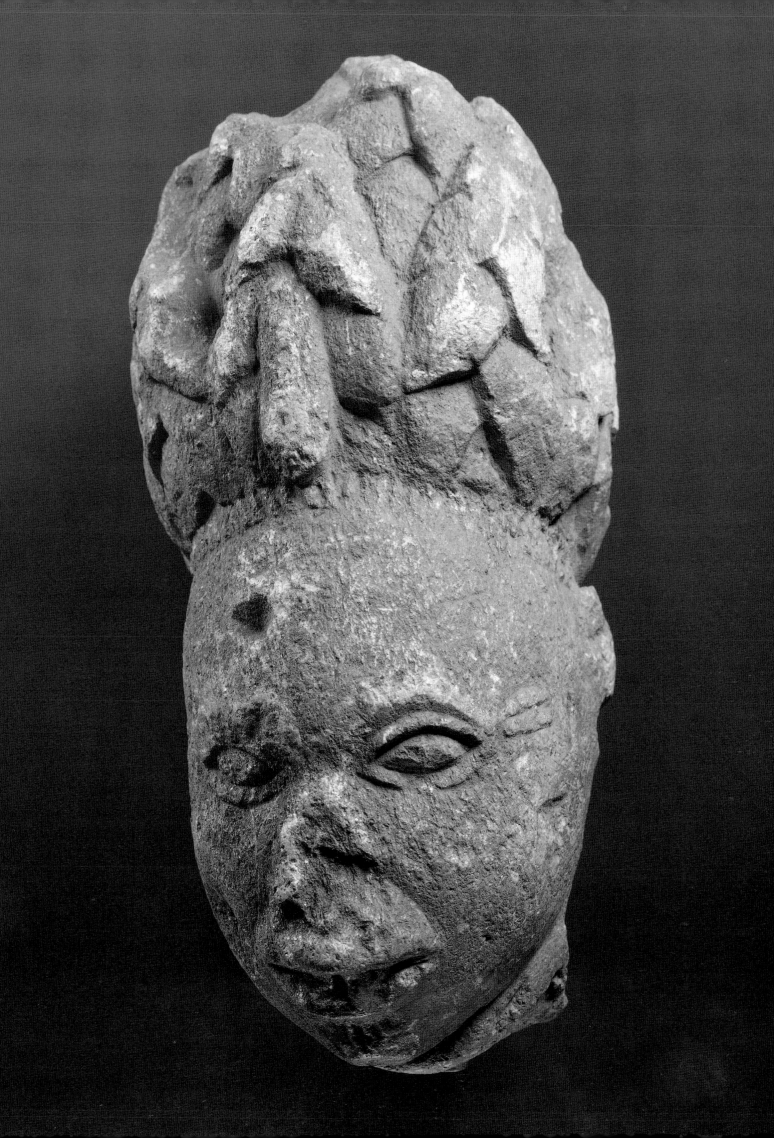

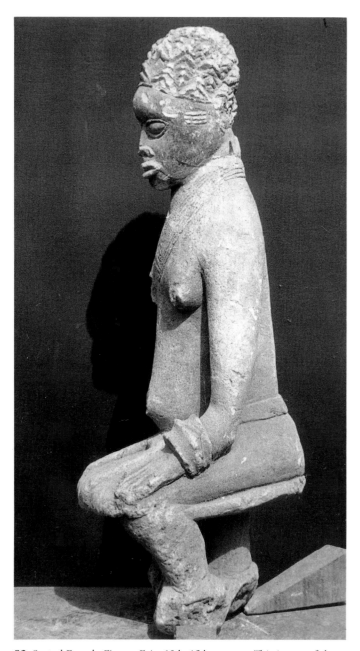

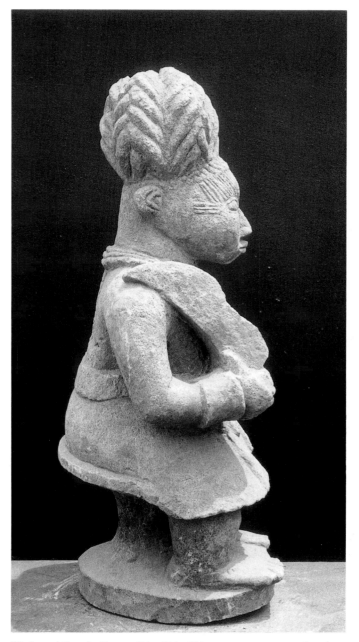

82. Seated Female Figure, Esie, 12th–15th century. This is one of the largest of the Esie stone carvings. The cutlass that she once held in her right hand and which rested against her shoulder is missing. The strong vertical line of her back and head and the ease with which she sits on her stool, with her feet tucked back on its base, form the pose of one with authority. Stone. H. 28¾ in. From Stevens H394-T238 no. 617.

83. Seated Female Figure, Esie, 12th–15th century. Esie stone female figure holding a cutlass that rests on her right shoulder. The elaborate hairstyle consisting of a cluster of triangular or conical tufts is typical of female sculptures. The horizontal row of three delicately incised marks on the head are found on male and female Esie sculptures (see also Figures 84 and 87). Stone. H. 26 in. From Stevens HT 190 no. 383.

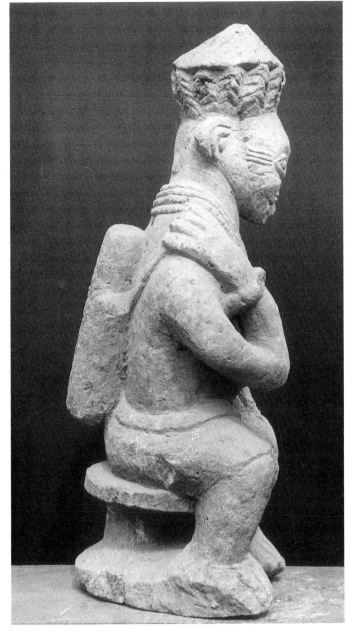

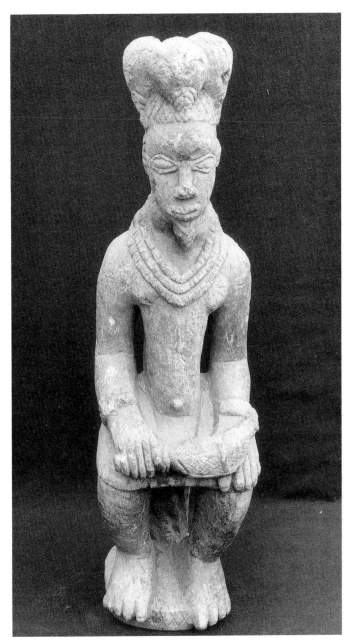

84. Seated Male Figure, Esie, 12th–15th century. An Esie stone seated male figure shown reaching for his quiver. Below the conical hat, the hair is styled in the fashion of the woman depicted in Figure 83. The three horizontal marks appear on the temple. Stone. H. 29⅛ in. From Stevens HT33 no. 67.

85. Seated Male Figure, Esie, 12th–15th century. This Esie stone seated male figure holds a dagger in his lap. He wears an elaborate headdress consisting of shapes resembling four snail shells affixed to a striated conical cap. Stone. H. 26⅓ in. From Stevens H348-T95 no. 610.

with seeing them as an artistic achievement in their own right. On the basis of the relatively few figures that were found intact, as well as those that have been repaired, the technical skill and artistic imagination of the carvers of the Esie images is impressive. The scale of the project, around a thousand images of men, women, children and animals carved from soapstone (talc schist) with stone and iron tools, is in itself extraordinary.[3] The majority of the figures, including the fragments, attest to a highly refined craftsmanship and an awareness of the possibilities and limits of the medium with which the artist was working. The softness of the stone permitted an indulgence in surface ornamentation, but the sculptures show an impressive restraint. The artists were far more interested in addressing the problems of modeling the human figure and creating images of persons that conveyed the dignity and authority of a social role than in creating a highly ornamental surface. Most of the figures range from 11⅗ to 25⅖ inches (30-65 cm.), but some artists pressed the limits of height and weight, creating sculptures of 28½, 32, and 43 inches (73, 82 and 110 cm.), weighing about 143 to 243 pounds (65-110 kg., *e.g.*, Figures 82 and 89).

The proportions by which the carvers of the Esie images defined the human figure are similar to those in Ife and later Yoruba figure sculpture. The head is given prominence, constituting at least a quarter of the full sculpture and enhanced by the addition of hats of various shapes and/or elaborate hairstyles (Figures 79, 83). Almost all of the figures have three horizontal marks immediately behind the eye on either side of the face. Many have delicately inscribed scarification patterns on the forehead and/or cheeks and chin, and several of the female figures are elaborately scarified down the center of the back. In all of the figures, the torso and arms are about twice the height and width of the head. The vast majority of the figures are seated and a few are kneeling, thereby minimizing the legs and feet without overly distorting the figure. Figural representation, however, is subordinate to portraying social position and authority as the subject of the artist.

The figures present a variety of social roles, although the number of figures holding cutlasses and daggers, as well as having medicinal gourds tied to the upper arm, gives the impression of a warrior group. That almost all of them are seated indicates that they represent persons of authority. Many of the male figures hold a staff in one hand, with the other hand placed on the knee or lifted to the chest. Others carry quivers on their backs. One is depicted reaching over his shoulder to adjust or call attention to the quiver, a sign of his authority (Figure 84). Some hold a dagger (Figure 85), others a shield, and one the tools of a blacksmith. Many of the

female figures are raising a cutlass in their right hand, the blade resting against the shoulder, left hand positioned on the knee (Figure 86). A few hold a cutlass in their laps, while others sit with both hands on their knees. All of the seated figures wear skirts or aprons with the cloth tied in the front. The kneeling figures are usually naked; kneeling male figures have shaved heads except for a small circular patch toward the back, as was the tradition among court slaves in many Yoruba palaces.

All of the figures convey a quiet dignity and composure. They share with Ife and Yoruba figure sculptures a strong frontal emphasis, but moving around the sculptures makes it clear that the carvers were sensitive to seeing the image from various angles. In the frontal view, balance is achieved by the legs being spread apart. The side view reveals a slight forward tilt of the body, which is balanced in some instances by the lower legs being pulled back, with the feet resting on the edge of a disk that forms the base of the stool (Figures 82 and 85). Viewed from the back, there is a feeling of weight to the body, its hips spread on the circular top of the stool (Figure 87). Not all carvers were equally skilled, but the carvings as a group reflect a high degree of technical accomplishment, visual sensitivity, and individual imagination by those who created them. (Compare, for example, Figures 82, 85, 88, and 89.)

In Figure 82, the head and face of the young woman are exquisitely modeled. She has an elaborate hairstyle, powerful forehead above deeply recessed eyes, and a fullness of lips. The strings of beads around her neck, her youthful breasts, and the fullness of her abdomen are evidence of her beauty and power as woman. She sits upright, but not rigid. The weight of her body on the stool is felt in the slight spread of her thighs and hips. Her left hand rests lightly on her leg; her right hand once held a raised cutlass. Her feet are pulled back beneath the stool at an angle that creates a slight counterpoint to the verticality of the figure.

Like the woman in Figure 82, the carving of a man in Figure 85 is remarkable for its size—measuring 30⅖ inches (78 cm.)—as compared with many other smaller Esie carvings. This man has a "Northern type of face with swelling forehead, straight nose and pointed beard."[4] There are other reasons, however, to be impressed by this sculpture. He wears an elaborate headpiece. Several head fragments and a few other full but damaged figures also depict such a hat—a striated conical form embossed with four or five inverted, softly molded conical shapes resembling snails' shells—but the size and form of the headdress in Figure 85 almost threaten to overwhelm the sculpture. The artist

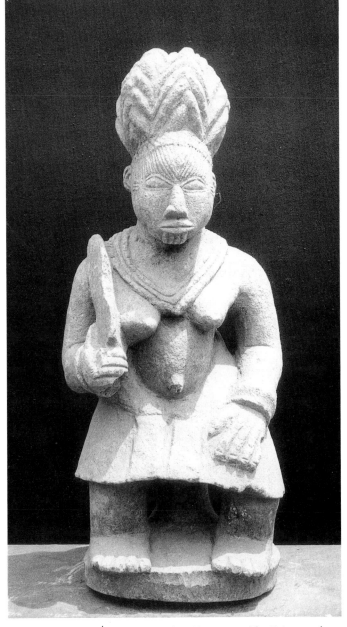

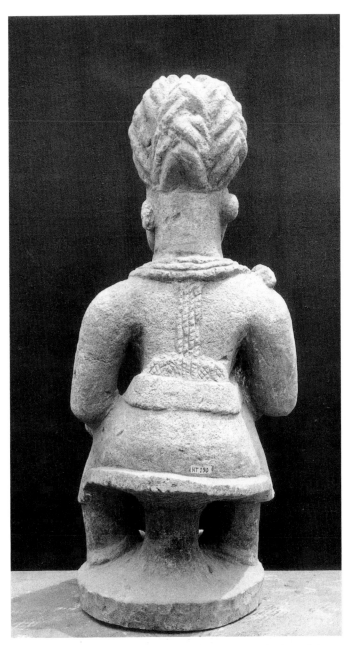

86. Seated Female Figure, Esie, 12th–15th century. The Esie seated female figure holds a cutlass, which rests against her right shoulder as the symbol of her office (see also Figures 83 and 87). Note the delicate scarification marks on her forehead and the heavier marks incised on her chin. The height of her elaborate coiffure is equal to that of her face, emphasizing the importance of the head, typical of so many Esie and later Yoruba figure sculptures. Stone. H. 26 in. From Stevens HT190 no. 385.

87. Seated Female Figure, Esie, 12th–15th century. Back view of the Esie seated female figure shown in Figures 83 and 86. Note the four vertical rows of body scarification along the spine, which then splay out in a pattern above the waistband of her skirt. The stool, consisting of two circular disks connected by a cylinder, is typical of most Esie carvings. Stone. H. 26 in. From Stevens HT190 no. 385.

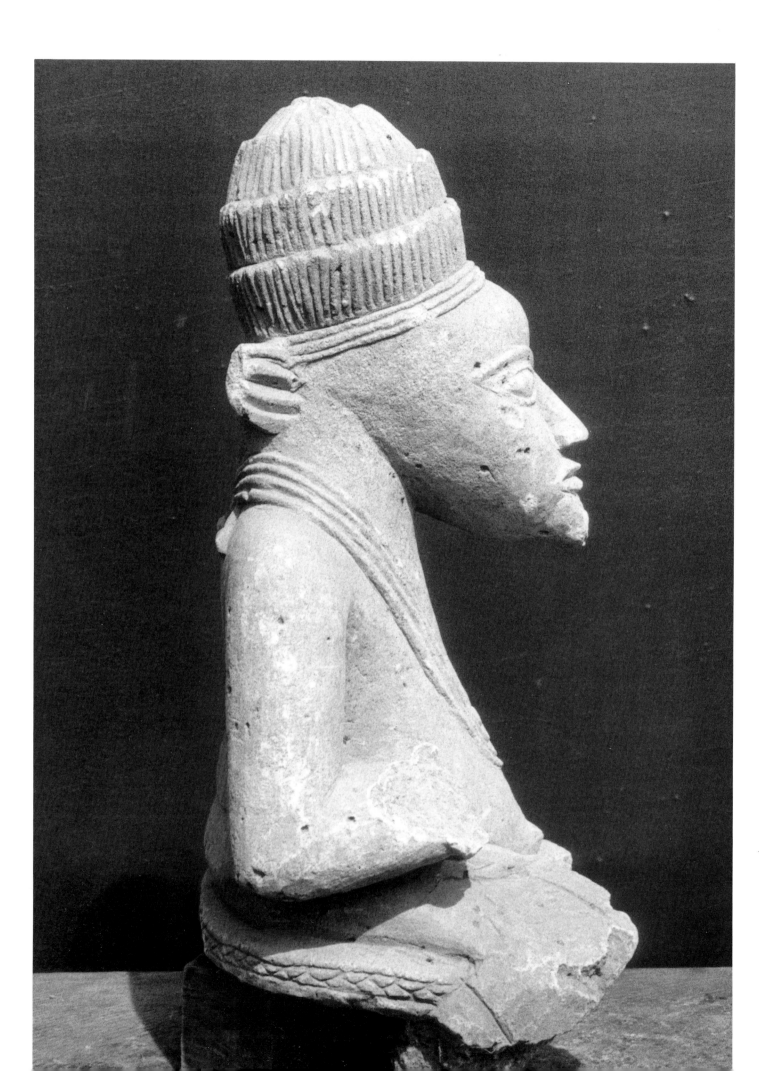

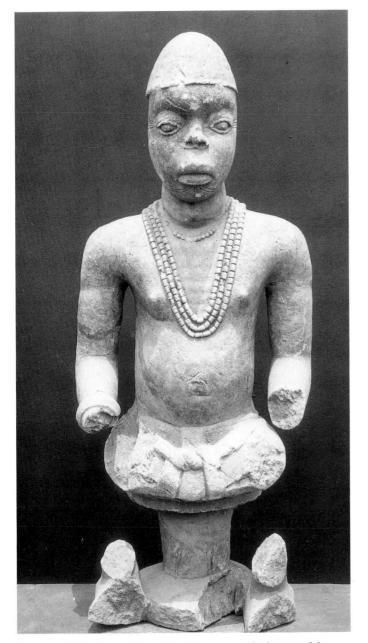

89. Seated Male Figure, Esie, 12th–15th century. The largest of the Esie stone carvings, this sculpture of a seated male figure contrasts with other Esie sculptures. It conveys a sense of physical strength, and there is an absence of any bodily adornment apart from the necklace of beads and the bow tying the skirt. Stone H. 39¾ in. From Stevens HT58 no. 117.

88. Seated Male Figure, Esie, 12th–15th century. The sculpture, although a fragment, is remarkable among Esie carvings for the rendering of the head, the elongation of the jaw line, and the thrust of the chin, which is enhanced by the projection of the beard. Stone. H. 17⅜ in. From Stevens HT92 no. 186.

manages to achieve a sense of balance and to convey the authority of one who can wear such a headpiece by carefully modeling the face, enhancing the gaze by outlining the almond-shaped eyes and elongating the oval shape of the face with the addition of a small beard. The length of hat and head equal the length of the body from shoulder to seat. The strength of this vertical line is both enhanced and offset by the parallel lines of the arms, the lower portions of which are brought together in the fullness of the hips of the seated figure, and the powerful legs and feet which reach back to rest on the lower portion of the stool. The figure alone possesses such authority that the dagger resting in his lap, emblematic of his role, is almost unnoticed and unnecessary.

Even though Figure 88 is a fragment of a larger work, its originality is impressive. As in most Esie carvings, the ear is placed well back on the head, actually on the neck in this instance. Its placement contributes to the attention-getting line and angle of the jaw. The power of the face and directness of its gaze are created not only by the oversized head in proportion to the body, but by the thrust of this jawline as well. It is the mark of a bold hand among the many carvers of the Esie images.

Phillips Stevens' informants called the sculpture in Figure 89 "Tapa" (Nupe), and Stevens notes that "the marks on the chin are used by some modern Nupe; but there is no record of parallel lines back of the eye [which appear on this and so many other Esie carvings], among Nupe."[5] The sculpture is the largest in the collection, measuring 43 inches (110 cm.) and weighing 229³⁄₁₀ pounds (104 kg.). In spite of the severe damage to the lower portion, the sculpture strongly conveys the physical power of the figure. Apart from the necklace of beads, there are no other insignia of office (although one may have been lost), no gourds of medicine or knives tied to the upper arms, no elaborate scarification of the face, as on other sculptures, and no adornment of the head. Indeed, the absence of ornamentation reinforces the massiveness and power of head and body. The almond-shaped eyes, which are more fully defined than on many other Esie pieces, and the fullness of the mouth add to the sense that here is a powerful physical presence, rather than the representation of a social role, as are many of the other Esie sculptures.

The Question of Origins

Given the artistic skill and imagination that produced these remarkable sculptures and the sad fate that befell them, it is little wonder that scholars have been intrigued with the question of their origins.

Oral histories, *itan,* of Esie provide varying accounts of the origin of the stone images. Several histories (with numerous variations) refer to strangers who came in

search of a place to settle. Believing that they had been offended by the Elesie, the king of Esie, they placed a curse on him. Other *itan* state that the strangers harassed the townspeople, and Olorun, the High God, offended by their action, turned them to stone. This theme—of condemnation and judgment—occurs in several of the histories.

The one point of agreement in the various accounts is that the town existed before the images appeared. Recent archaeological evidence confirms that the site of Esie was occupied as early as "the last three centuries of the first millenium A.D.," but it is not certain that these occupants were the forefathers of the people of modern Esie. Some of the current residents of Esie claim that their ancestors came from Oyo some time in the fifteenth century[7] and "met" the carvings when they arrived.

The age of the stone images is less easily determined. Because the objects may have been deposited in their present location by those who sought to destroy them (although this is far from certain) and because the location shows evidence of having been subsequently disturbed, the usual procedures for archaeological investigation have been seriously compromised. Thermoluminescent tests of terracotta fragments of sculptured figures found at the same location as the stone images suggest "a date of around A.D. 1100."[8] More recent archaeological excavations at another site in Esie, known as the Iwoto Grove, disclosed a soapstone fragment about 11 7/10 inches (30 cm.) in length showing signs of chipping all over it in preparation for carving. In addition, terracotta fragments were found for which radio carbon analysis provided dates ranging from the tenth to the eighteenth centuries.[9] It is not clear, however, whether the terracotta and stone artifacts were made at the same time, and therefore their exact age may never be known.[10]

In many cases, rituals can provide historical information about a person or occasion that gave rise to the celebratory rite being studied. Rituals, and the myths associated with them, also articulate deeply felt concerns in the memories of a people, concerns that find expression (and may have their origin) in "ancient happenings." In the case of the Esie stone carvings, however, the historian of religion has little to contribute to the question of origins.

The earliest field studies of the Esie images refer to a cult led by an *aworo* (a chief priest), whose rituals focus upon the images. A description of the site in 1936 and photographs taken in 1937 indicate the creation of a shrine (Figure 90).[11] The images were assembled in a U-shaped pattern around a large palm tree. As in all Yoruba sacred spaces, a curtain of *mariwo* (palm

fronds) hung across the open end at the west. The perimeter of the oval-shaped cleared area was marked by a planting of peregun trees beyond which was the dense growth of high grass and forest.

Stevens gives us the only detailed account of Odun Ere, a three-day annual festival of the images, which he witnessed in 1965.[12] The fact that the festival takes place in late March or early April, six days after Odun Egungun, an annual festival for the ancestors, suggests that the festival for the images may be linked in the minds of the devotees with rites for the ancestors, those to whom one is related by kinship ties. On the first day of the festival, as the devotees approach the shrine, they sing, "We are the children who bring together the images, *ere*, and the *egungun*."[13] In Odun Ere the focus of the rites is a statue called *Oba Ere* (king of the images) (Figure 91). (Whether the sculpture was originally thought of as the focus is doubtful, because he resembles many other seated male figures in the Esie corpus.) Ritual offerings of food are placed before Oba Ere, and the blood of the sacrificial animal is poured on the image. A kola nut is cast before him to determine whether he is pleased with the offerings and how he will respond to the petitions of his devotees, which in 1965 were exclusively petitions by women to have children. When it is determined that Oba Ere has accepted the offerings and sacrifices, word is sent that the surrounding fields of dry grass, which are believed to belong to the Oba Ere, may be burned. It is important to note that the Elesie, the *oba* (king) of Esie, is forbidden to see the images and thus does not attend the festival, although his representatives bring gifts from the palace and witness the proceedings.

The Odun Ere rituals described by Stevens are similar to those performed for the ancestors, *Ara Orun* ("the dwellers in heaven") and for the *orisa*, or gods of the pantheon. As Stevens notes, for various reasons the rites have been modified over the years.[14]

When taken together, the oral histories, rituals, and myths appear to refer to a time when the authority of the traditional ruler, the Elesie, was seriously challenged. It is not unusual for Yoruba towns to have traditions of dual leadership, reflecting the differing backgrounds of the principal lineage groups, the conquest of the original inhabitants by later arrivals, or a combination of such factors.[15] The Esie myths suggest that the stone images are associated with a challenge to the authority of the Elesie by outsiders, and for this reason, the Elesie may not look upon them or participate in rituals for them. He sends his representatives, however, because

90. The Aworo presenting his salutation to the King of images. Esie, Nigeria, 1933. Photograph by E. H. Duckworth. Courtesy of Phillips Stevens Jr.

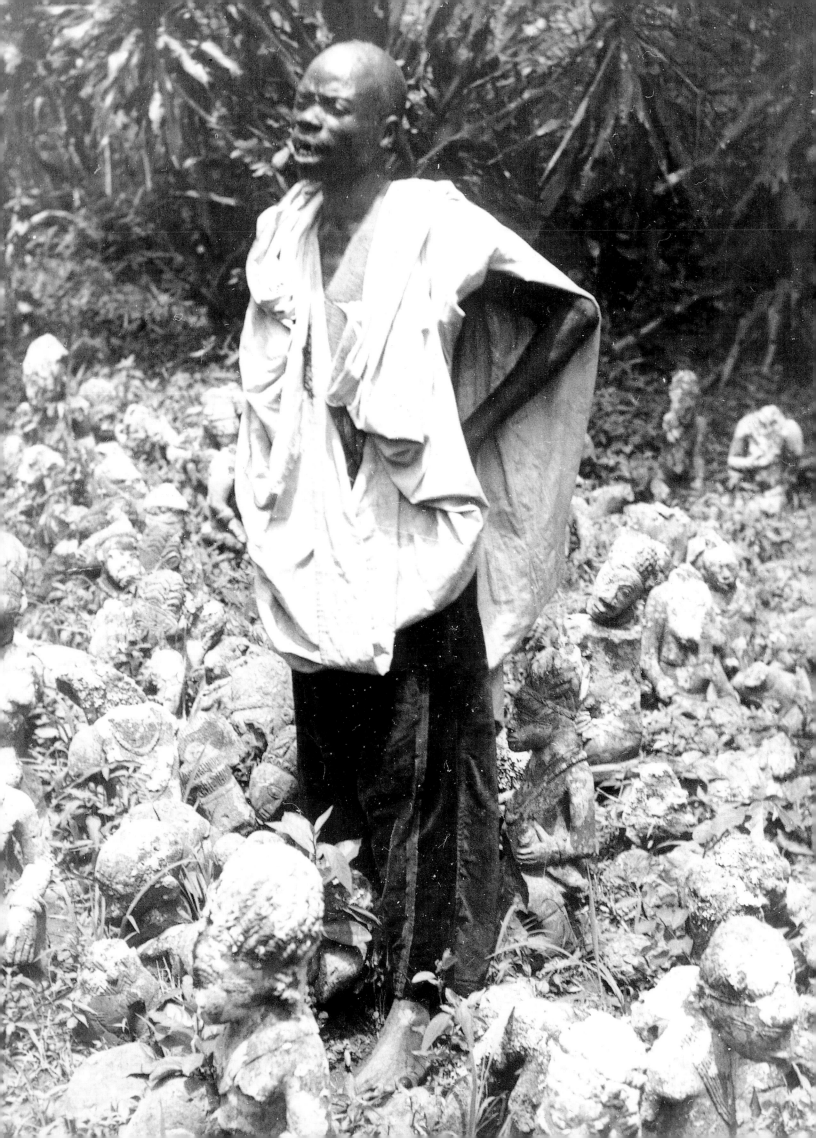

the spirits of the deceased, even those who once threatened the Elesie's authority, remain powerful presences in the world of the living.

There is another possible explanation, based on an opposing viewpoint. Oral histories are constantly being rewritten in order to legitimatize the claims of those holding power, and it is altogether possible that the stone images represent a culture that preceded that of the people of the Elesie. These earlier people may have been conquered and forced to leave their home, but their lingering presence remains in the stone images and the ritual memory of the people of Esie. The images are greeted both as *ere* (carvings), and as *egungun* (masquerades, or "powers concealed"), terms that are used not only for the ancestral masquerades of lineages, but also for Elefon and Epa, which are masquerades in festivals unique to Igbomina and Ekiti towns. Although the images are not associated with lineage groups in Esie, as is the case for Egungun, Elefon, and Epa, they are addressed in the ritual language appropriate to the deceased upon whom the present community is founded. If this is the case, however, and they do represent a conquered people, then why is there no celebration of victory in the oral histories or rituals of Esie? Were the people of the culture of the stone images forced to abandon their town long before the settlers of Esie arrived? Those of Oyo descent, who date their arrival in Esie to the seventeenth century, claim to have "met the images" in Esie. On the basis of various Esie traditions Stevens concludes that "the images were there before the Igbomina settlers, under Baragbon, migrated into the area in the late 18th century" and, furthermore, that the "willful destruction" of the images was "before the arrival of the [current] inhabitants of Esie."[16]

Stevens develops a complex and fascinating argument for an Oyo origin for the images, which would have them carried to Esie by Oyo families fleeing from the attacks of the Nupe in the fifteenth century.[17] There is also an argument for an Ife connection, based largely on stylistic similarities between the Esie stone images and Ife terracottas. According to this argument, the stone images are "representations of people" who participated in the "migration of the Yoruba from their original home...[at the time of] the collapse of the early Kanuri Empire" (east of Lake Chad, in the late thirteenth century) and who subsequently moved to the Igbomina area when various groups left Ife to establish other Yoruba towns.[18] Both arguments are imaginative and inconclusive.

The question of the assembling and destruction of the images in the grove, which is known locally as Igbo Aworoko ("Forest of the Crooked or Deformed"), poses

an equally difficult problem. When did this catastrophe occur and at whose hands?[19] Given the data now available, one may venture a few tentative observations.

There is a growing consensus among Yoruba historians and archaeologists that the question of the origins of the Esie stone carvings should be discussed in the context of historical and archaeological investigations of the Igbomina area and not in terms of speculations about their importation from Oyo-Ile or Ile-Ife.[20] Studies of the oral histories (*orile*) in the neighboring towns of Oba-Isin and at Oba,[21] near Akure, as well as recent research on the history of other Igbomina towns,[22] provide evidence that there was an early civilization similar in some respects to that of Ile-Ife and remembered in Igbomina traditions as "Oba," a civilization that may be dated to the eleventh or twelfth centuries. "[Alt]hough nearly all the towns and settlements controlled by Oba are now extinct, its early paramountcy and dominance [are] generally acknowledged in extant traditions in different parts of the region. These traditions record the existence of an ancient Oba state which was broken up and its inhabitants massacred by immigrants whose leaders probably established new states in various parts of the region."[23]

Traditions preserved among the Isedo people of Ila-Orangun, as well as among the people of Oba-Isin and Oba, near Akure, point to Oba-Isin as the original center of the Oba kingdom, which is about 18⅔ miles, as the crow flies, from Esie. The presence in the region of ancient iron-smelting furnaces, extensive deposits of iron slag, terracotta blow-pipes used in connection with iron-smelting and a potsherd pavement about 2 miles southwest of Oba, which may be dated to c. A.D. 900–1100, provide material evidence in support of the oral traditions regarding the antiquity of the Oba kingdom. The oral histories also suggest that the destruction of Oba was at the hands of the Olowu immigrants at some time during the twelfth and thirteenth centuries.[24]

While the Esie figures reflect a monarchial tradition in the regalia and social roles depicted, including slavery, to which frequent reference is made in *orile*, one cannot directly link the Esie carvings with the Oba culture of the eleventh and twelfth centuries. Rather, the most that one may say at this stage of the inquiry is "that the civilization of Oba [is] the earliest remembered cultural complex in the area, followed...by the 'extinct' group represented by the Esie, Ijara and Ofaro stone figures," whose culture we may reasonably assume had some connection with that of Oba.[25]

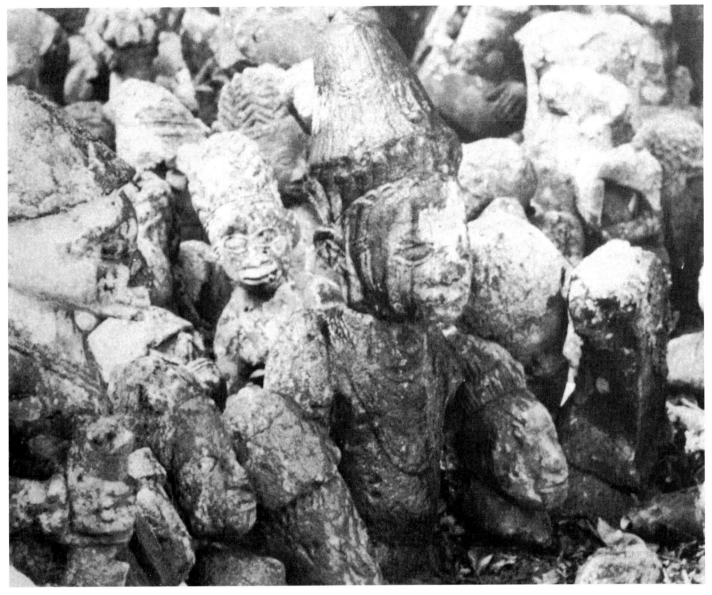

91. The "King" of the images in 1937, streaked by the blood of sacrifices. It is sunk in the earth to a depth of approximately 11¾ in. Esie, Nigeria, 1937. Photograph by E. H. Duckworth. Courtesy of Phillips Stevens Jr.

4 The Kingdom of Owo

Rowland Abiodun

The ancient Yoruba city of Owo is located approximately midway between Ile-Ife and Benin City, the headquarters of the powerful Benin kingdom to the south (Figure 93). Although this was a highly vulnerable position, Owo not only survived but managed to carve out and sustain a sizable kingdom of her own in precolonial days.[1] Owo's sphere of influence included many settlements, and her territory has been defined by "southern boundaries at the confluence of rivers Ogbese and Osse, its western boundaries at the southern border of Ekitiland, its northern boundaries at the southern border of Kabba province, and its eastern boundaries at the western border of the Benin kingdom, an area of well over 2,000 square miles."[2]

By reason of its large size and political power, the kingdom of Owo accommodated many strangers and immigrants whose social, religious, and artistic traditions were influential in various ways and at different times in its history. The *egungun* cult, for example, which now blends into the cultural landscape and is part of the ritual calendar of Owo, was not indigenous but was introduced by immigrant communities that settled permanently at Owo.[3]

Despite a plethora of such cultural influences, recent field research and archaeological work are now making it possible to identify art forms and styles that are native

to Owo[4] and may fill in crucial missing links in Nigerian art history. It can no longer be assumed that almost anything significant in Owo culture must have been derived from Benin.

Owo's precolonial social, political, military, and religious institutions provided the natural contexts within which the arts functioned, and new knowledge about these institutions supports the notion of an independent Owo arts tradition. It is, for example, noteworthy that even though the militarily powerful Benin kingdom did place considerable armed pressure on Owo around the fifteenth and sixteenth centuries,[5] there is no evidence that a Benin native or chief actually ruled or participated in the political administration of Owo. Instead, Owo was relatively secure, expanding her domain and enjoying considerable affluence. The Owo royal palace, extending over more than 108½ acres, was "by far the largest palace in Yorubaland," more than twice the size of the next largest palace at Ilesa which covered about 51 acres.[6]

The extent of Benin influence in Owo has been a fundamental issue in the study of Owo culture. To understand it requires comprehending the nature of the Owo-Benin relationship and studying traditional Yoruba patterns of diplomacy and military defense strategy. The myths involving the origin of Owo also provide insight into certain practices and customs which would otherwise appear to be merely Benin influences in Owo.

There are at least two stories that describe the origin of Owo. In the first, Olowo Ojugbelu, also called Arere, who was the youngest of the sixteen sons of Oduduwa (founder of the Yoruba people), was hunting in the

92. Young woman decked with beads during the Igogo festival. Her beaded hip decorations are characteristic of the manner in which teenage girls exhibit their wealth and family status on such occasions as the Igogo festival and funeral celebrations. Owo, Nigeria, 1972. Photograph by R. Abiodun.

93. Map of Yoruba Kingdoms.

woods while his brothers divided their father's property and dispersed to different parts of Yorubaland to found kingdoms. Angry Ojugbelu gathered the little bits and pieces that were left over by his brothers, took some of his father's chiefs with him, and headed eastward. After several stops, Ojugbelu's party arrived at Owo and settled at Okitiasegbo under Ojugbelu's son.[7]

The second story begins in the city of Ife, where Orunmila (the Yoruba Ifa divination deity), childless for a long time, lived.[8] His enemies boasted that he would remain that way forever, but to the amazement of all he had eight children who eventually became kings of ancient and historically important Yoruba towns. Alara, the eldest son, became king of Ara, while Olowo, the youngest, became king of Owo. According to the divination literature, Orunmila named all his children after the prevailing circumstances at the time of their birth. Olowo is described as "It-was-after-I-delivered-children-that-people-started-to-respect-me-because-of-my-children" who was given the title of Olowo in the city of Ife.[9]

As was the custom in those days, Orunmila celebrated an important annual ritual during which his eight children were expected to pay homage to their father, saying: "May the rituals be blessed and the sacrifices accepted," (Aboruboye bo sise). Only the Olowo refused to comply, explaining:

> You, Orunmila, wrap yourself with odun cloth
> I, Olowo also wrap myself with odun cloth
> You, Orunmila, carry osun walking stick made of brass
> I, Olowo, also carry osun walking stick made of brass
> You, Orunmila, wear a pair of brass sandals
> I, Olowo, also wear a pair of brass sandals.
> You, Orunmila, wear a crown
> I, Olowo, also wear a crown.
> And it is usually said that
> Nobody uses a crowned head to bow down for another person.[10]

The Olowo's attitude angered Orunmila who is said to have departed for orun soon afterward, thus precipitating a major crisis on earth. It was only after much appeasement and propitiation that Orunmila decided to give his children ikin (sixteen sacred palm-kernel nuts), which would thereafter represent him and provide the answer to all their questions and problems.

This second story is certainly important because of the personality sketch of the Olowo out of which the actual historical events of the founding of Owo can be deduced. The Olowo is presented as an arrogant son who not only dressed himself exactly like Orunmila, but refused to accept Orunmila's authority. The Olowo replicates Orunmila's social, cultural, and artistic institutions and invokes a traditional Yoruba axiom to defend himself and his position. This strategy suggests the protective strategy and authority, or ase, of the alagemo

(chameleon), one of the most revered animals in Yoruba creation mythology. Many incantations requiring this ase will say "It is the wish of the chameleon that the Deity above acts upon" (Aba ti Alagemo ba ti da ni Orisa oke ngba). For this reason the chameleon is able to take on any color in its immediate environment and protect itself.

Following the power struggle between Orunmila and his son the Olowo, Orunmila was forced to rise higher in status, to become more ancestral in nature. Henceforth, he is given awe-inspiring praise-names such as Erinmi l'ode Owo (Erinmi in the city of Owo). Erinmi is the deity of Death in Owo, who inspires suspicion but is a necessity. Through the Olowo's numerous oriki, the significance of Owo as a city founded by Orunmila's youngest but special child named "It-was-after-I-delivered-children-that-people-started-to-respect-me-because-of-my-children" will become clearer. Related, although tangentially, to the meaning of Olowo[11] is the ase suggested in the following lines from Ogede oru, an incantation used to beget respect and escape danger:

> I have today become a person to be respected, grant me free passage.
> Even if there is death on the way, let it move away.
> Let all evil things on my way clear off.
> It is with a single stick that one scatters a thousand birds.
> Let the path before me be safe.[12]

Myths such as these usually contain facts disguised as allegories. The Ifa story, which tells us of Olowo's encounter with Orunmila, hints at a cultural and historical relationship between Owo and Ile-Ife. This relationship, although undatable through the myth, must be of great antiquity since the encounter is linked with the introduction of ikin, the sixteen sacred palm-kernel nuts, into the ancient Ifa divination system, and the departure of Orunmila from the earth.

In the Ifa account, the Olowo skillfully uses Yoruba court art and traditions, with which he must have been familiar, in his encounter with Orunmila. Recent archaeological excavations at Owo support the mythological connection between the Owo and Ife kingdoms. Culturally and artistically, they shared a great deal. In a pair of bronze figures found at Ita Yemoo, in Ile-Ife,[13] for example, there is evidence of chiefs' regalia in ancient Ife which, while not observed in modern Ife, still features prominently in ritual and other ceremonial contexts in Owo today. The slightly shorter of the two figures appears to be female. She ties an iro (wrapper cloth) just high enough on the torso to partially cover her breasts as Yoruba women traditionally wear their wrapper. Her iborun (shoulder cloth), which is probably beaded, hangs diagonally across the chest with the tied end resting on the left hip. This iborun is probably indicative of both the woman's status and probably her

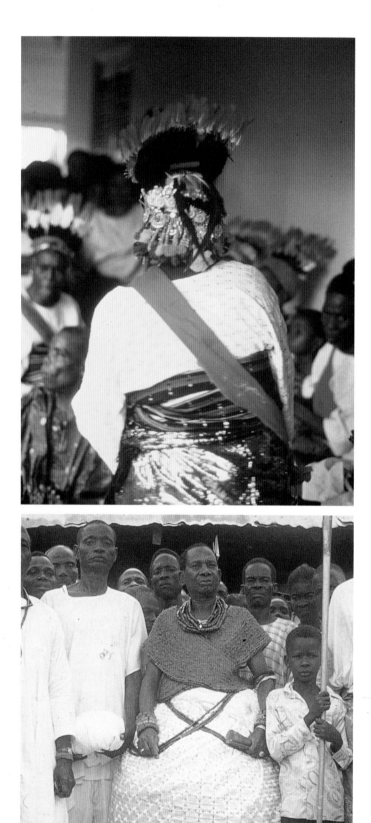

94. A priestess (*yeye olorisa*) dancing during the Igogo festival. She wears a bright red shoulder cloth which hangs diagonally across the chest. A pair of bronze figures from Ita Yemoo, Ile-Ife, are depicted wearing similar diagonal shoulder bands. Owo, Nigeria, 1974. Photograph by R. Abiodun.

95. The Ojomo of Ijebu-Owo wearing a pair of beaded bands, *pakato iholukun,* during the Igogo festival. Only the Olowo and his "brother" the Ojomo may wear *pakato* in criss-crossed pairs. Owo, Nigeria, 1974. Photograph by R. Abiodun.

96. Bearded Head From a Figure, Owo, 15th century. This head has a deeply furrowed brow and unusually pronounced eyeballs. The facial expression is one of consternation. The individual may have been a peasant who came from elsewhere to work in Owo, but there are no scarification marks on his face to identify his origin. Terracotta. H. 4⁵⁄₁₆ in. National Commission for Museums and Monuments, Nigeria.

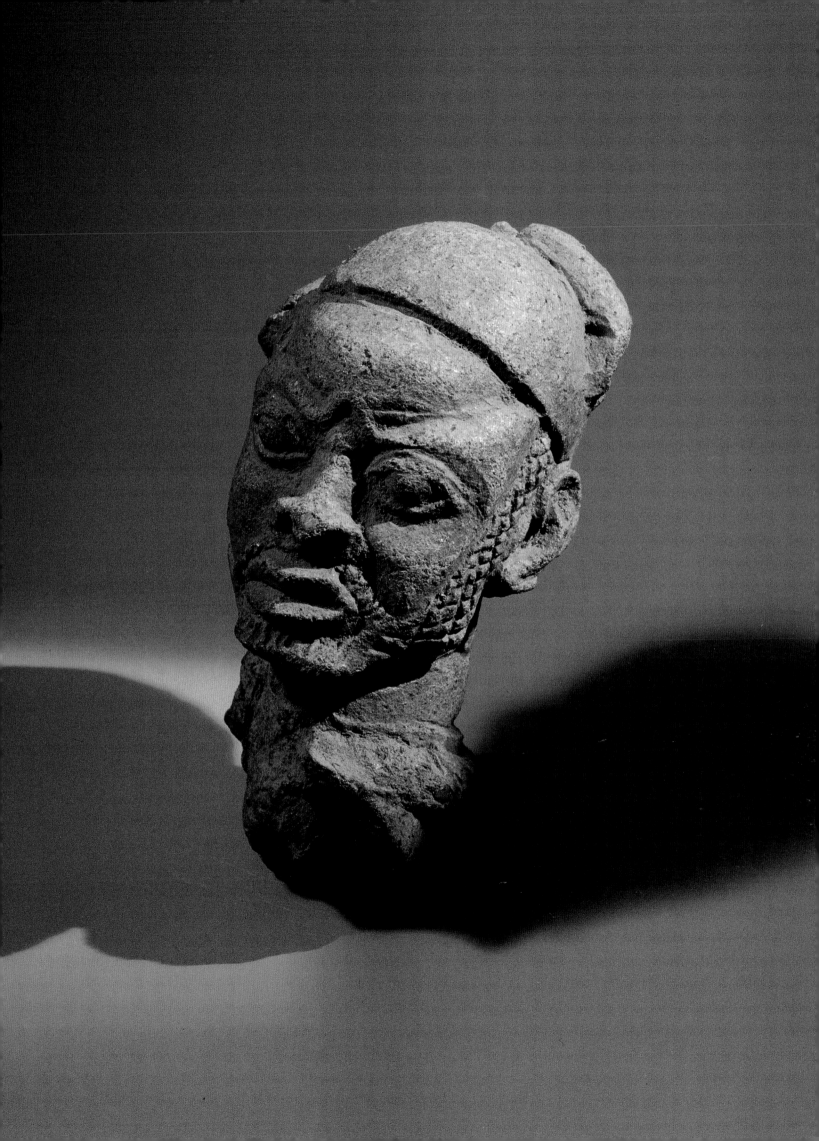

cult affiliation. Members of a modern female cult group called Yeye Olorisa in Owo (Figure 94) wear similar attire, particularly a bright red *iborun* worn diagonally. The male figure in the bronze pair also wears a shoulder piece, possibly beaded, across the chest. Modern Owo chiefs wear similar beaded bands during the town's annual Igogo festival. Called *pakato*, this beaded band is made up of several strands. Only Olowo and his "brother," the Ojomo of Ijebu quarter, may wear *pakato* in crisscrossed pairs (Figure 95).

Despite such evidence of strong, ancient Owo-Ife connections, especially in court arts and customs, there is a Benin claim that the Yoruba at Owo learned of Yoruba arts and customs at the Benin court. According to this claim, the sixteenth Olowo, Osogboye, was sent to Benin as a crown prince by his father to learn court arts and customs and bring them back to Owo.[14] This claim, among others, has been cited often as evidence that Owo was "for periods of time under the suzerainty of the Obas of Benin."[15]

The primary reason for Osogboye's trip to Benin, however, may not have been to learn court arts and customs, although he would certainly have been exposed to them, but to study Benin's military organization. Several theories refute the first claim and support the second. It seems unlikely that the Owo would have waited until the sixteenth Olowo to learn court arts and customs whether from Ife or the Oba of Benin. There is no mention of any crown prince before or after Osogboye involved in a similar training program. In any event, by the sixteenth Olowo, Owo had already had a fairly long history of association with Ife and presumably therefore with Yoruba court practices. Furthermore, the Ifa myth, by stating that the cause of Orunmila's quarrel with the founding Olowo was over his use of the highest-ranking kingly paraphernalia in the land, suggests knowledge of this paraphernalia and the arts and customs that went along with it.

In support of the second theory, when Osogboye, the only crown prince ever to go through this training, left the court of Benin and returned to Owo, he directed the digging of a moat around Owo and led an attack against the Benin forces. He may have learned both defensive and aggressive strategies at Benin. He has certainly become the Olowo who is still remembered as having put an end to the constant war threats of the Benin empire.

While there may have been hostility between Benin and Owo sometime in the sixteenth century, this was not always the case. Both cities, in their oral traditions, acknowledge and confirm the same origin and ancestral home, Ile-Ife. Being on good terms with Owo was vital to Benin's economy and trade with the hinterland, be-

cause Owo was the gateway to western and northern Yorubaland.

It would not have been in the interest of Benin to alienate Owo. Possibly, however, as Benin trade and political ambition increased, Owo may have become intimidated, fearful for its economic independence and political security.

A well-known Owo proverb—he "who kills the leopard sends himself on a trip to Benin"[16]—hints at the dread of the Benin kingdom. While this proverb might indicate that Benin was indeed powerful and probably exerted some authority in matters such as the protection of animals sacred to the Oba of Benin, it does not prove that Owo was under Benin rule. The Owo had their own leopard in the Olowo, who is called *ekon* (leopard) when being praised. Very likely, an Owo terracotta sculpture showing a leopard gnawing on a human leg represents the awesomeness of the Olowo, not Benin, leopard (Figure 97). This terracotta sculpture was found near one that represents a basket of severed heads. Because only the highest and most expensive sacrifice was considered good enough to renew Olowo's strength and revitalize his magical powers,[17] such proximity suggests that the Owo revered their king and treated him as an *orisa*. He is not only a divine king but the personification of *uku* (death) itself. Olowo's well-being meant that the kingdom over which he ruled would also prosper, or, as expressed in a Yoruba incantation, "Daybreak does not dawn such that the leopard does not touch blood with his hands."[18]

Considering the mission of Osogboye in Benin in this light strengthens the suggestion that he might have exploited the Owo-Benin family relationship as established in Ife myths of origin to gain access to the secrets of Benin power and defense. This would have been a perfectly reasonable choice of action in view of Owo's will to survive as an independent neighbor of Benin, the most powerful forest state in the sixteenth century.

The defense strategy of Owo must have included the active use of *oogun* (traditional medical preparations) and other psychological weapons. It is even conceivable that such ancient skills as those employed by the first Olowo in his encounter with Orunmila were used. According to the late Ojomo of Ijebu-Owo, the Olowo borrowed a tactic of the *alagemo* (chameleon), who not only protects itself but enriches its wardrobe by appropriating the "dresses" of other creatures in its environment. The Olowo appropriated certain Benin titles, chiefly paraphernalia, and other objects, which served magically as neutralizers, strengthening him and

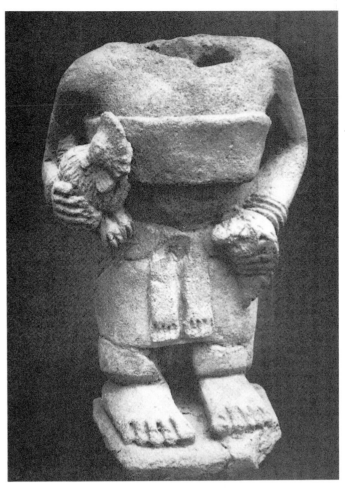

97. A leopard gnawing on a human leg. The Olowo is often praised as *ekon* (leopard). This terracotta may well represent his awesome nature. Ugbo' Laja, Owo, Nigeria. Photograph from Eyo and Willet, 1980: Figure 36.

98. Woman holding a cock. She wears a traditional wrapper, (*iro*) and ties a wide cloth sash (*oja*) around her waist, perhaps in readiness to carry out some sacrifice. Ugbo' Laja, Owo, Nigeria. Photograph from Eyo and Willet, 1980: Plate 66.

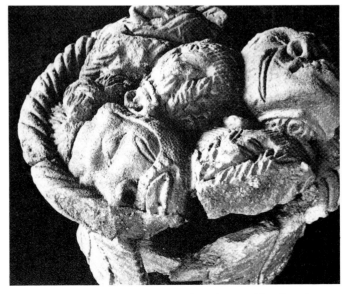

99. Terracotta sculpture showing a basket of severed heads with slashed faces. Human sacrifice was required under certain circumstances in precolonial times. As in most Yoruba towns, however, it was taboo in Owo to sacrifice an Owo native on a local shrine. Ugbo' Laja, Owo, Nigeria. Photograph from Eyo and Willett, 1980: Figure 33.

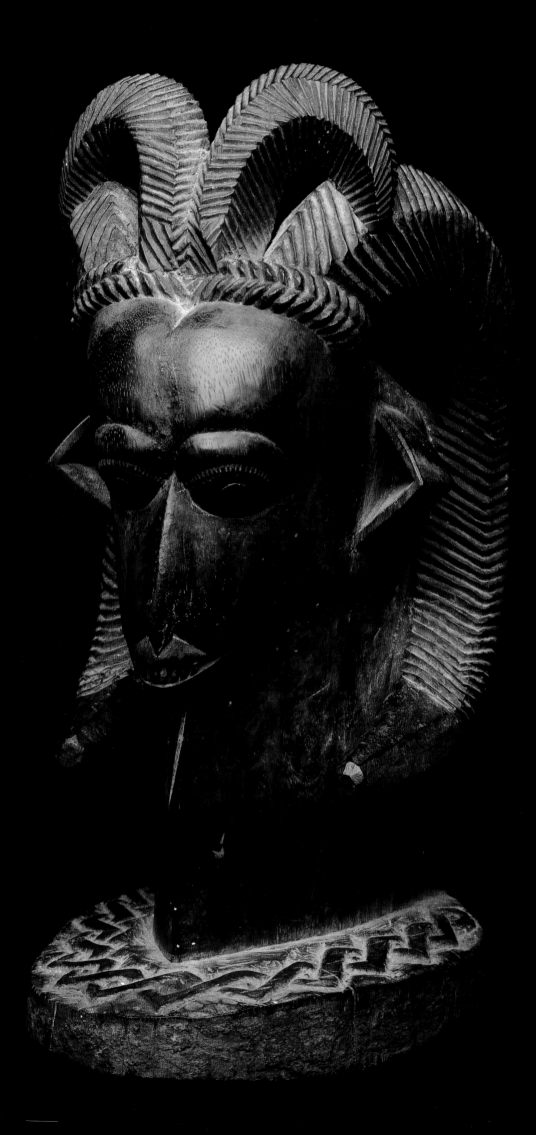

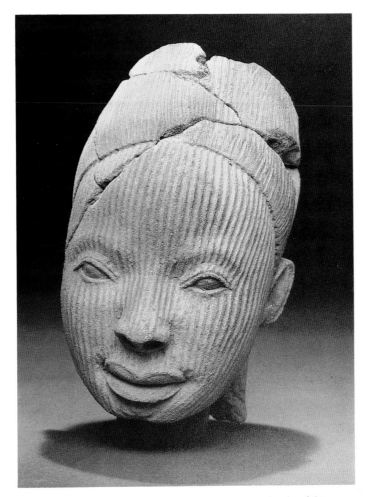

100. Head from a figure. The technical execution and style of this head falls within the general Ife naturalistic tradition. Though stylized, it is an attempted portrait of a woman, regal in pose and disposition. The facial expression is that of Oronsen, the legendary wife of Olowo Renrengenjen. She is described as a beautiful and pleasant woman in the Owo tradition. Ugbo' Laja, Owo, Nigeria. Photograph from Eyo and Willett, 1980: Plate 60.

protecting the city against the menace of the Benin kingdom.[19]

The origins of many of the cultural institutions, titles, and practices which we call Benin in Owo will remain problematic until more is known of the cultural history of Ife and Owo. For now, it is only clear that "title correspondences are more complicated than a simple one-way borrowing. A number of Benin titles are derived from Yoruba. It is possible that some of these came from Owo, and that some Owo titles came from Benin, and that both Owo and Benin derived titles from other sources."[20]

Owo Terracottas

The first major archaeological excavation in Owo at Ugbo' Laja was begun in 1969. The site is historically and culturally significant. Not only is it in close proximity to important places such as the palace and Okitiasegbo, one of the earliest Owo settlements, but it also roughly coincides with the area in which Oronsen, wife of Olowo Renrengenjen, is said to have disappeared

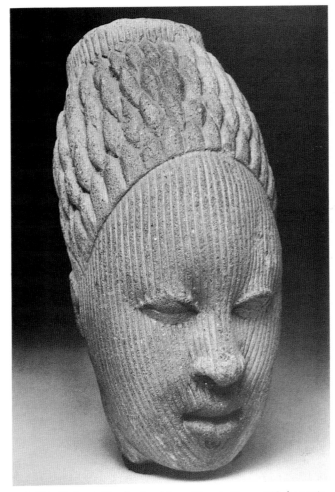

101. Ram's Head Altarpiece, Owo, 18th–19th century. This carved wooden sculpture of the ram (*osanmasinmi*), is usually placed on the ancestral altar. Through the powerful visual and verbal elements of the art of *osanmasinmi*, communication with the ancestors is made possible on a firm and regular basis. Wood. H. 19½ in. Richard and Barbara Faletti Collection.

102. This Ife head, like the head from Owo in Figure 100, has striations which accentuate its form and soften the look of the face. The Owo head, however, does not possess the same degree of refinement and delicacy as its Ife counterpart. Otutu compound, Ile-Ife, Nigeria. Photograph from Eyo and Willett, 1980: Plate 52.

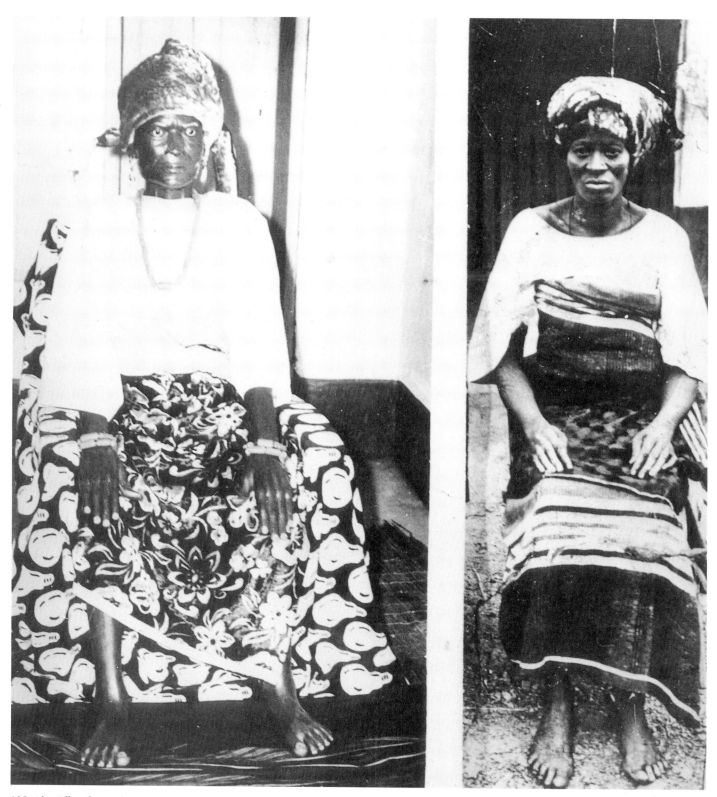

103. Ako Effigy for Madam Alade. Wood, the material used for this effigy, is concealed under paint. Before the application of paint, however, the wood was smoothed and finished to the extent that the technical elements of the carving could no longer be perceived. The open eyes are a response to the plea by the survivors asking her not to sleep in *orun* (heaven). It was hoped that she would open her eyes wide and always look after her children, taking good care of them, providing for their needs, and aiding them in difficulties. Ipele-Owo, Nigeria, 1972. Photographer unknown.

104. Photograph of my grandmother, Madam Olakoli Abiodun, in 1947, (from a family album). This picture demonstrates the high degree of naturalism of the lifelike *ako* effigy of Madam Alade shown in Figure 103. It also demonstrates how the *ako* tradition may have influenced the way elderly people posed for photographs in the first half of this century in Owo. Owo, Nigeria, 1947. Photographer unknown.

following an angry confrontation with her co-wives. Oronsen, an unusually beautiful, influential, and affluent woman, brought great riches and respect to the Olowo and the entire kingdom. In Owo oral tradition, before Oronsen finally disappeared, the Olowo's search party caught up with her at Ugbo' Laja. They tried to persuade her to return to the palace, but she refused, and as they tried to forcibly bring her back, she disappeared into the earth. They were left holding the *oja* (a length of cloth) that she tied around her head. Hence, to this day, the area has been called Ugbo' Laja, the grove of *oja*.[21]

It was Oronsen's last demand that many sacrifices, including rats, fish, rams, birds, cowries, snails (a thousand each in number), be offered in this grove annually during the Igogo festival. These offerings would appease her and appeal for her assistance, particularly in times of war, famine, epidemic, and the like. During the Igogo festival, no woman or man may wear a headtie or cap.

The Ugbo' Laja excavation uncovered two main concentrations of artifacts and remains. One concentration may have represented

> a mudhouse in which precious things were kept, probably with a thatched roof over it. If there was a hut housing the terracotta sculptures in the first concentration, then the second concentration was probably outside. In the second concentration, mainly broken fragments of pottery, some sacrificial pots, iron implements, and polished stone axes were found. It looks as if this represents a place where unimportant objects that could be left out in the open, like pots, were heaped year after year. The whole shrine might have been vandalized during a conflict between the Benin and Owo people, possibly when Benin was trying to subdue Owo in the fifteenth century.[22]

So many of the terracotta sculptures found at Ugbo' Laja exhibit such strong stylistic affinities with objects in Ife and, to some extent, Benin, that it is tempting to conclude that they had been bought or were made in these other places. This possibility exists, but it is also possible that the founding Olowo brought with him to Owo artists and artisans from Ife to continue the production of vital traditional arts.[23]

Most of the terracotta sculptures found at Ugbo' Laja relate to the theme of sacrifice. Animals that are depicted, such as the cock, rat, and ram, were presumably offered as sacrifice. The bearers of these offerings were female, as is quite evident in the sculpture of a woman holding a cock (Figure 98). She wears a traditional *iro*, wrapped just high enough to cover her breasts, and around her waist she has tied an *oja*, traditionally worn around the head. Since she is not carrying any baby on her back, it is presumed that she probably represents a priestess carrying out some sacrifice during the Igogo festival. Her beaded wrist decoration is also characteristic of the way women exhibited their wealth and not infrequently their status, on this occasion. Young ladies and girls are sometimes so heavily decked with beads that little or no clothing is worn except to cover the genitals (Figure 92).

Like a traditional Yoruba shrine complex, Ugbo' Laja served as a place of contact with powerful beings and spirits. It probably accommodated other deities such as Ogun and Esu, with altars on which to place offerings meant for them. It is also conceivable that some of the shrine objects, such as ritual pots and possibly sculptures perceived as vessels of power, might have originated from outside Owo. This would make good sense in a traditional system which believes in increasing its own power base by accumulating the power objects of others. It is conceivable that here too, at Ugbo' Laja, sacrifices must have been offered to the "Leopard," the Olowo, to renew his energy and prepare him to meet any enemy.

That Owo or indeed any Yoruba city might be secure, peaceful, and prosperous, no sacrifice was considered too expensive in precolonial days. If the situation called for human sacrifice, it was made. Like most Yoruba towns, however, it was taboo in Owo to sacrifice an Owo native on a local shrine. Human sacrificial victims in Owo therefore must have been "strangers," meaning those who came from other towns to work, farm or settle in Owo. The terracotta sculpture showing a basket of severed heads with slashed faces seems to bear this out (Figure 99). In the basket there is a head of a bearded man which resembles the head of another sculpture (Figure 96). The facial expression on the sculpture's head is one of consternation. He does not appear to be relaxed, calm, and dignified as are some of the other people represented in Owo terracotta sculptures.[24] He has a deeply furrowed brow and unusually pronounced eyeballs. With flared nostrils, broad mouth, roughly modeled beard, moustache, sideburns, and an awkward cap, it is as though this powerfully expressionistic head is intended as a portrait. This man may in fact be the same one whose head appears in the basket of severed heads. He seems to be a peasant type and may have come from elsewhere to work in Owo, but there are no clues and no tribal marks on the face to identify him.

Other impressive finds from Ugbo' Laja include a terracotta head from a figure whose technical execution and style is very much within the Ife tradition (Figure 100), and might have been inspired by the naturalistic heads of Ife. Unlike the bearded peasant figure, this head, which probably belongs to a woman, has a serene, pleasant, and attractive face. It could represent

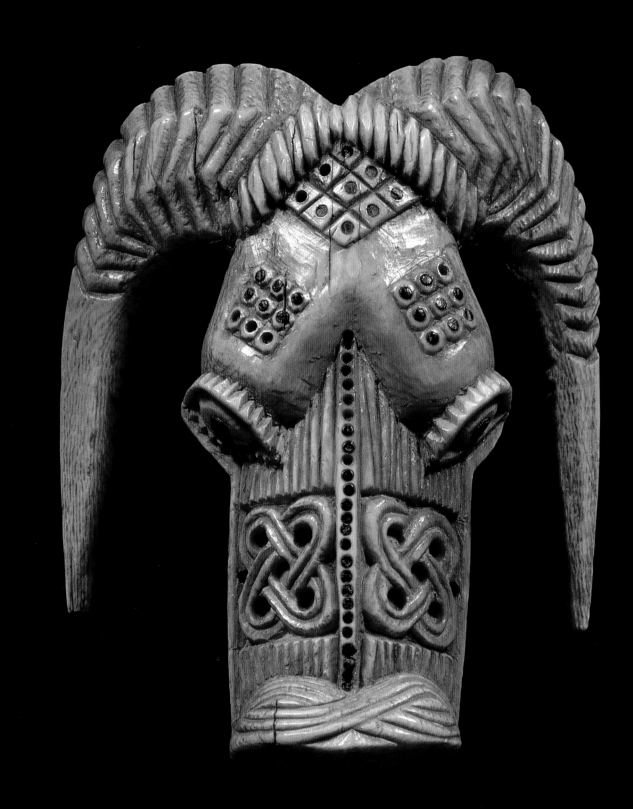

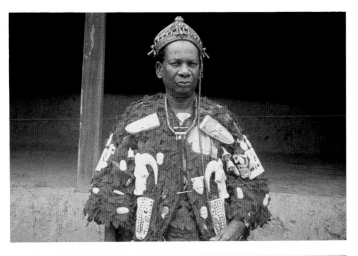

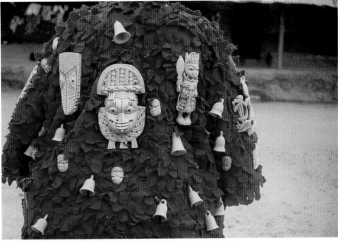

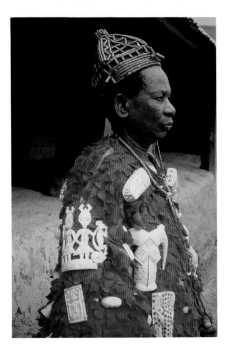

105. The Ojomo of Ijebu-Owo in his Orufanran costume, showing the side and back views. The ivory attachments, *omama*, which include a ram head piece, are not pendants as they have often been described in the literature. Photograph by R. Abiodun.

106. Attachment, Owo, 17th–18th century. This attachment (*omama*) is one of the many potent attachments sewn to the Orufanran costume. Subjects or animals depicted are usually related to the themes of war, protection, and success. Ivory. H. 6 in. Private collection.

Oronsen herself. Though stylized, it is an attempted portraiture of a lady, regal in pose and disposition. She does not wear a head-tie, which suggests Oronsen just before she disappeared in the grove.

Whether inspired by Ife antecedents or not, this head appears to be the product of an Owo artist. It is possible to discern the subtle but significant differences between Owo and Ife styles. Compared with an Ife head also in terracotta depicting a female (Figure 102), the overall treatment of the Owo head is less delicate. The eyes are far apart, making them appear smaller in proportion to the nose and mouth. The nose is flatter and wider in the Owo example than in the Ife head. The nostrils in the Owo head are also less acutely angled, and the upper lip more bow-shaped with greater stylization. Perhaps because the forehead of the Owo face is somewhat wider and the chin shorter than the Ife example, the Owo head ends up looking round and the Ife one, oval. Even though the Owo and Ife heads have striations, which help to accentuate their form and soften the look of the face, the Owo head does not demonstrate the same degree of refinement and delicacy as its Ife counterpart.

The naturalistic works unearthed at Ugbo' Laja have helped to define Owo's place in the art history of Ife, Benin, and southern Nigeria in general. Not only do Ugbo' Laja terracotta sculptures overlap those of Ife in period and style, their themes strongly indicate that they shared the same functions with comparable Ife examples. Indeed the evidence is now much stronger than before the Ugbo' Laja excavations that the source and inspiration for the Owo naturalistic phase must have been Ife. While the making of naturalistic terracotta sculptures has since ceased in Owo, its spirit survived in the *ako*, a second burial effigy whose institution may be as old as five hundred years.

Ako: Second-Burial Effigy in Owo

Ako is a naturalistic, life-size effigy used in and named after the second-burial ceremony in Owo (Figure 103). The ceremony is

> performed some months, or sometimes one or two years, after the death of an important man or woman, at which a life-size image, *ako*, of the deceased is dressed in his or her clothes, given a funeral, and buried or kept in a kind of shrine in the house. It is essential that the face at least be a portrait as realistic as possible of the deceased. The naturalism that the carvers achieve is certainly equal to that found in the Ife bronzes and terracottas. . . . [In the case of a] figure carved for the mother of chief Sashere by the sculptor Ogunleye. . . apart from a slight stylization of the ear, the face is extremely naturalistic. The limbs are hinged and less realistic because they are covered by the clothing. This naturalism is not. . . a recent development, but of great antiquity. Indeed, its essential purpose seems to be to deceive the eye.[25]

I believe that the naturalism of these figures is firmly rooted in the very concept of *ako*. They are the focal point of the *ako* ceremony and must be as ancient as the institution itself which could be well over five hundred years old.

In preparation for *ehin-iwa* (the afterlife), the *ako* ceremony is of great importance. After all, those who pass from this world to the next look forward to "an afterlife which is superior to temporal existence."[26] *Ako* provides for the symbolic elevation of the social and material status. A total reconstruction of the physical, social, and psychological identity of the deceased takes place through the *ako* effigy. These sculptures employ a controlled *ako* naturalism sanctioned by a tradition, that already provides a "vocabulary" for this style. The *ako* device makes it possible for the distinguished dead to enter *orun* and start the afterlife with assured success. Thus in the following *Owonrin Meji* (the name of a specific verse) in Ifa divination, the concept and meaning of *ako* emerges:

> *Koo ngo koo [Take charge, I refuse to take charge]*
> *They all divined for Ako Alaworonpapa [Ako the Restless]*
> *They lamented his lack of children*
> *[He] Was advised to appease the god's anger*
> *And be blessed.*
> *Ritual sacrifice was the remedy.*
> *After the offering of the ritual sacrifice*
> *He started to bear children*
> *He danced in appreciation*
> *He rejoiced and made merry*
> *He gave honor to his priests*
> *Who in turn glorify Ifa*
> *When he opened his mouth*
> *It was a divination song that came forth*
> *As he stretched forth his feet*
> *Dance claimed them*
> *It was exactly in this manner*
> *That his priests joyfully called on Ifa*
> *Koo ngo koo*
> *They all divined for Ako Alaworonpapa*
> *Who mourned his lack of children*
> *The bitch does not remain for long outdoor*
> *Without delay*
> *I shall go home to have children quickly.*[27]

The effigy with its *ako* naturalism should not be judged for its photographic realism, but for its efficacy within the context of the *ako* ceremony which is intended to make the end of this life, and the beginning of the next one, honorable and dignifying for one's parents, whose good will is needed by those still on earth.

Owo Ivories

Owo has always had an insatiable appetite for the most elaborate and expensive traditional cultural and social institutions. The *ako*, for example, disappeared in virtually all Yoruba towns but survived in Owo until the first half of the twentieth century. Inextricably linked with this appetite is Owo's strong support for artists and the artistic industry. For example, the weaver of an *asigbo* cloth (a small sash which may be commissioned from members of the Sasere family by anyone who is entitled to use it) received two hundred of each of the following items: yam tubers, plantains, sugar cane, bean cake, *akara*, kola nuts and *awusa* (a nut, *Tretacarpidium conoforum*). Added to this list were seven antelopes, one goat, and seven mats.[28]

Ivory carvers were greatly esteemed. Owo's location was conducive to the development of the finest skills in traditional carving in ivory. The more affluent Benin kingdom, also a major ivory-working center, must have competed for the services of Owo artists. This would help to explain, at least in part, the presence of many objects by Owo artists in Benin as well as other places in southern Nigeria. It is in fact possible that Owo ivory carvers were more actively involved in the Afro-Portuguese ivory art commissions than has been hitherto acknowledged. Certainly of art-historical significance is the gradually increasing number of lidded ivory vessels produced before 1800 which are now being attributed to Owo on the basis of style.[29] Owo ivories, long misattributed, actually provide "a striking example of how it is possible for such a place to escape notice. Some hundreds of ivories since known to be of Owo origin were, in 1950, in the Western world (some probably having been there for two or three centuries), but none, or virtually none, was identified as from Owo, most (since 1897) being treated as Benin work, the rest generally as Yoruba work."[30] Elephants once inhabited the thickly forested areas around the city. As late as 1960, farmers in surrounding villages such as Imoru, Ute, Igbatoro, Arimogija, and Igbo-Ofosu complained of the menace of elephants on their farms. Not all hunters, however, were permitted to kill them in Owo. One had to be experienced and graduate to the class of elephant hunters (*ode-aperin*), in the guild of hunters.

Killing an elephant was never a secret affair. The animal's size could not be hidden, which is why the Yoruba say, "An elephant is not a creature one can say he sees faintly. When one sees an elephant, he must say so."[31] Any time an elephant was killed, invariably all the villagers in the area knew of it and were by custom entitled to a portion of it. This practice inspired another proverb: "One encounters all shapes and sizes of knife during the sharing of elephant meat. It is there that you see farmers' children with their (strange-looking) kitchen knives."[32]

As for the tusks, however, one always went to the Olowo, while the other was kept by the hunter. Traditionally, therefore, the elephant tusk has always

because it was not an item to be imported from outside, and in Yoruba myths, Orunmila used ivory objects.

In his dual role of political and religious leader, Orunmila is represented not only as having received elephant tusks, but also as having this as a significant part of his *oriki*: "The Wealthy-One, offspring of the two tusks that make the elephant trumpet."[33] On Orunmila's departure from the earth, his children, including the Olowo, and his priests (the **babalawo**) would be entitled to use tusks in their different capacities. Thus, while the Olowo has continued to use the tusk to promote his own political image and that of his high chiefs, especially those with military offices, the Ifa priests seem to have used it mainly to promote Orunmila in his role as the supreme provider of Ifa system in Yoruba religious thought.

The trumpet used to herald the Olowo's arrival at and departure from the palace is usually made from an elephant tusk. On other important occasions and festivals in the town, the trumpeter and the flutist take turns in showering *oriki* on the Olowo with their instruments. In addition, the Olowo is the only one who can

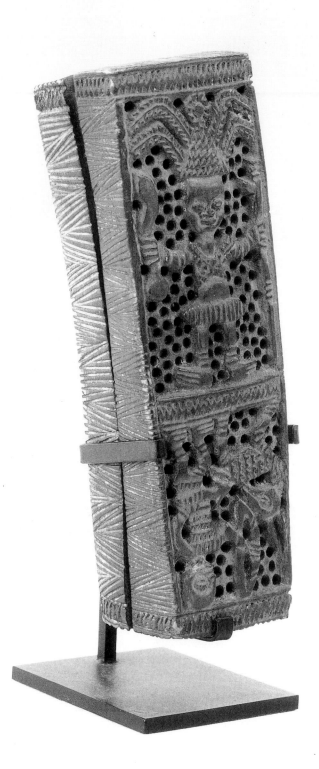

107. Lidded Box, Owo, 18th century. This ivory box is used to store and convey special ritual gifts to designated deities and shrines during major festivals in Owo. Because the box is never opened in public, its contents are unknown to most. Ivory. H. 7 in. Fred and Rita Richman.

remained a prestige item, indicating the power and status of the owner. This is a primary reason for its inclusion in the costumes and paraphernalia of kings, chiefs, warriors, and diviners. Its use in Owo, as in any important Yoruba city, must be of great antiquity

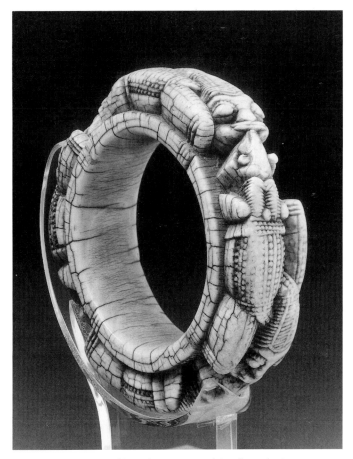

108. Bracelet, Owo, 16th–18th century. Judging from the iconography of this bracelet, it was probably carved for the Olowo and worn by him. The fish-legged figure and a head with protrusions from the nostrils are important to the Owo concept of divine kingship. Ivory. Diam. 4²¹⁄₆₄. Founders Society, Detroit Institute of Art.

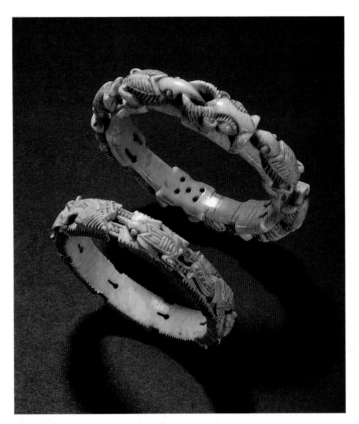

109. Pair of Bracelets, Owo, 16th–18th century. Carved on this pair of ivory bracelets are a variety of aquatic creatures resembling crabs, lobsters, frogs and fish. The carving is generally stylized. The larger one is executed in high relief and is three-dimensional in feeling, while the smaller one is in low relief and has nearly all its surfaces covered with decorative motifs. Ivory. Diam. 3½ in. Diam. 2¾ in. Ulmer Museum, Ulm.

wear any number or size of ivory ornaments on his person at any time. Ivory armlets (Figure 108), must have been worn by the Olowo during Ore, a very ancient and important festival said to have been brought from Ife.[34] The armlets bear "mystical emblems," consisting of "a fish-legged figure and a head with protrusions from the nostrils. . . along with at least three other motifs, symbols of divine sanction and kingship."[35]

The head with protrusions from the nostrils has appeared in Owo and Ife archaeological finds, the tin bronze figure of a warrior from Tada, and several other works in the Yoruba-speaking areas. Possibly this motif and the stylized representation of the Olowo as a fish-legged figure on these armlets allude to his mystical power and authority during the now defunct Ore. Unlike the Igogo festival in which the Olowo uses an abundance of red beads, the Ore festival may have called for and relied more on carved ivories than beads in the Olowo's regalia. Perhaps, with the cessation of the performance of the Ore festival, many of the ivory carvings worn by the royalty were no longer in great demand and subsequently disappeared. It is, therefore, possible that Owo ivories such as these ivory armlets may be three hundred or more years old.

Also falling roughly within the period are some Yoruba lidded vessels in ivory made after the Portuguese had landed on the coast of West Africa. Owo, being much farther inland than Benin, did not receive any Portuguese or European visitor until the tail end of the nineteenth century. The subject, iconography, and style of the lidded vessel illustrated here indicate that it is from Owo and might have been used in the palace of the Olowo (Figure 110). The theme on this vessel revolves around a fish-legged figure who is flanked by two chiefs. This fish-legged figure is wearing a conical crown into which two feathers are stuck, two beaded *pakato,* one crossing the other, and a big *ibolukun* (ceremonial skirt). The dress of the two supporting chiefs is less elaborate. They do not wear the *pakato* and have no feathers in their conical crowns. The fish-legged, central figure appears to be representing an *oba,* presumably the Olowo whose many *oriki* include "the mighty and expansive ocean whose bottom [*i.e.,* secrets] can never be known" (*Okun aragbarigbi, o o rudin okun, o o rudin osa*). This *oriki* also alludes to Olowo's high status as the *orisa* to whom all must pay homage as suggested in the incantatory line, "All rivers and streams must pay their respect to the ocean" (*Gede omi e mo ri i ghun olokun*).

On the other side of the same ivory vessel, there is another standing figure which we also presume represents on *oba.* In each hand he grasps a crocodile biting a round-eyed fish. This appears to be a continuation of the visual metaphor for the Olowo as *okun aragbarigbi.* It reinforces the powerful image of a king who not only is revered but also effectively controls all the creatures in his domain, a point made in a proverb, "even the very dangerous crocodile is the child of [*i.e.,* is controlled by] the river."[36] Similarly, a coiled snake encircling the top of the lid, its head turned down to devour the lower half of a man, may refer to the *oba*'s venomous potential to deal ruthlessly with his adversaries.

In the lower part of the ivory vessel, there is a skull-like face from whose jaws leafy branches proceed. This skull alludes to "the house of death," as the following Yoruba proverb suggests: "Heads are never wanting in the tomb [literally, the house of death]; if you don't find recent ones, you will find skulls."[37] The leafy branch issuing from the jaws of the skull has been called *akoko,* a plant used in traditional Yoruba installation rites of kings and chiefs.[38] *Akoko* is believed to bring long life and ensure a successful reign. The way the skull-like

110. Lidded Vessel, Owo, 18th century. The theme of the carving on this vessel revolves around a fish-legged figure who is flanked by two chiefs. The fish-legged figure is wearing a conical crown into which two feathers are stuck, the beaded *pakato* (one crossing the other) and a big *ibolukun* (ceremonial skirt). Ivory. H. 19¼ in. Private Collection.

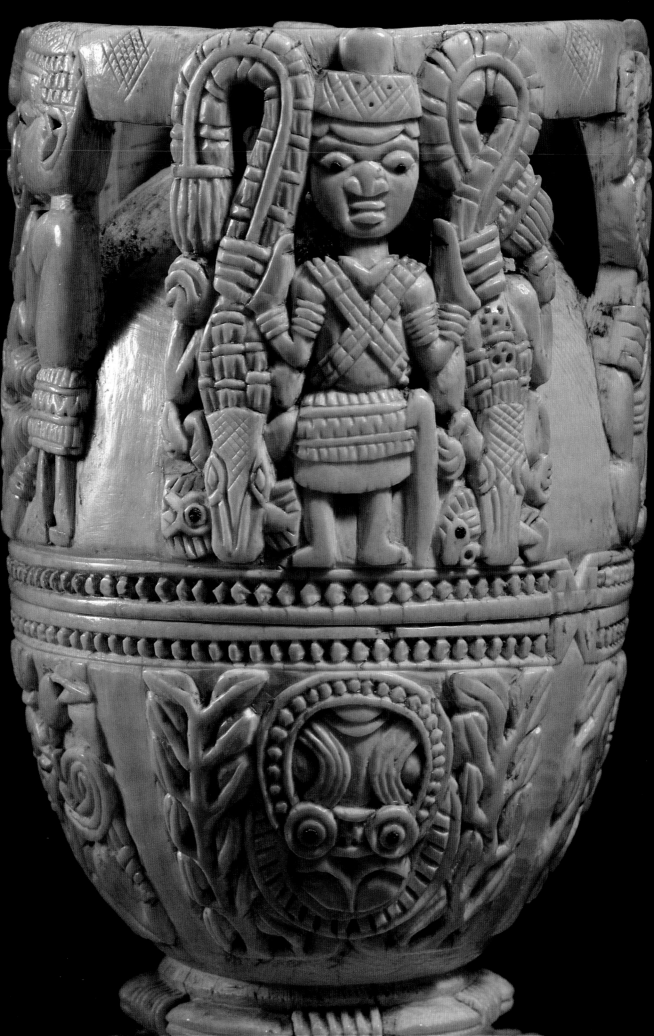

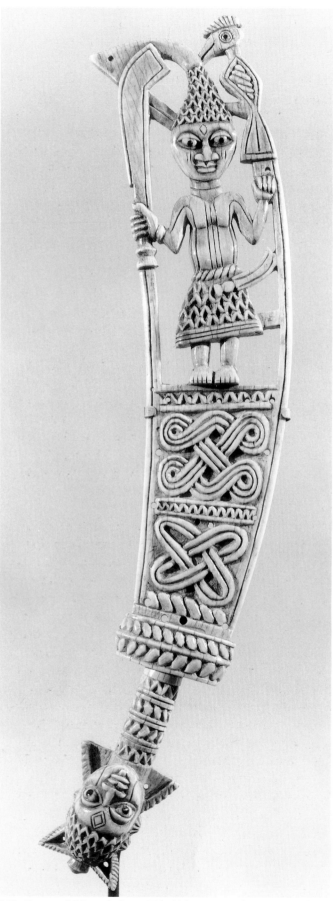

111. Ceremonial Sword, Owo, 17th–18th century. This ceremonial sword (*udamalore*) is worn by the Olowo and many high-ranking chiefs during the Igogo and other major festivals. It indicates that the wearer descends from a respected and famous family. He is looked upon as mature, powerful and influential; someone in a position to meet the challenges of life. Ivory. H. 19¼ in. Private Collection

face and *akoko* leaves are brought together here may be indicative of a desire to overcome sudden or premature death and have a long and harmonious reign on the throne.

Frequently, the Olowo used other finely carved ivory containers to store small items (usually gifts) in the reception area of the palace (Figure 110). He probably had more carved ivory objects than he could use and occasionally gave some as presents to deserving citizens and distinguished visitors.[39]

Orufanran

An *orufanran* is a ceremonial costume which the Olowo uses to honor his high chiefs, particularly those with traditional military offices or distinguished military records. The *orufanran* consists of three pieces: jacket, skirt, and hat. The jacket has wide three-quarter sleeves (Figure 105). They are made of an inexpensive cotton material on which has been sewn scale-shaped pieces of red wool flannel. The hat (not the one in these illustrations) is a tall miterlike headdress with two long ivory pieces on the sides, each carved to look like a feather.[40] The overall impression of the surface of the garment is like that of a scaled pangolin skin. This notion of the pangolin is certainly relevant to the magical function and significance of *orufanran*. The pangolin is an animal that rolls into a ball when there is danger and is protected by its hard scaly skin. It is therefore reasonable to suggest that "this costume alludes. . . to the power and invincibility of its wearer through its form, its material and its iconography."[41]

The *orufanran* was worn during the Ore festival, but these days, it is worn mostly on occasions such as the *ajo-Olowo* (seventeen-day meeting of chiefs) at the palace; the burial ceremonies, *oposi* and *ako*; and also after *ero* (age-grade ceremony) to pay a thank-you visit to the Olowo in his palace. In these circumstances, a special music called *oluserepe* is played for the *orufanran* wearer. *Oluserepe* has a distinctively regal, heavy rhythm produced by beating several tall, huge drums. It is never accompanied by singing; dance-steps to it are complex, requiring rehearsal before being performed in the Olowo's palace. Part of the skill required of the *oluserepe* dancer is the ability to twirl and toss the *ape* (ceremonial dance sword) and catch it with grace before it lands on the ground. The origin as well as the concept of the *orufanran* deserve further study. All we can say for now is that, possibly through Osogboye's sojourn in Benin, the use of the *orufanran* came to the fore in Owo's social and religious ceremonies around the seventeenth century.

The images on the *orufanran* ivories and their combination include clearly identifiable Benin masklike

faces and figures alluding to the appropriation of Benin power on this dress. Some carvings represent heads of animals such as the leopard, crocodile, and ram (Figure 105), all of which are used in medicines and charms for *awure* (to bring good luck and riches). There is also a pair of standing, chiefly figures with a squatting monkey (a sacred animal in Owo), which is probably a prayer/incantation for courage and strength to be steadfast in defending one's home or property.[42] Bells, usually used to announce the presence and movement of a high-ranking warrior chief in Owo, are depicted as well. Thus, even though the *orufanran* may appear to be all Benin, on closer investigation a strong layer of Owo character and Yoruba-derived values shows in the iconography and combination of the ivories used.

It is conceivable that in times of war most warchiefs prepared *awure* charms in which the following would be standard ingredients: heads of leopard, crocodile, and brown monkey, and a human skull. Such an assemblage would be accompanied by the following incantation:

> Brown monkey, child within the forest
> Crocodile, child of the river
> Human being, child of the town
> Human being, bring the money of today for me
> Leopard does not eat stale food
> The money of yesterday has become stale
> It is the new money of today that you should bring me
> Daybreak does not dawn such that the leopard does not
> touch blood with his hand
> I awake on my own today
> Let me be spreading my hands to get money.[43]

Udamalore

The *udamalore* is a ceremonial sword often made of ivory, normally worn by the Olowo and his high-ranking chiefs during the Igogo festival in Owo (Figure 111).[44] It hangs fairly loosely on the left hip resting on the *ibolukun* (skirt). Apart from being the main focus of aesthetic interest in a festival, it gives the audience important information about the wearer. It indicates that he is "well-born," meaning not an illegitimate child, but one who hails from a respected and famous family. The wearer is looked upon as mature, powerful, and influential, and as someone who is in a position to meet the challenges of life.[45] The *udamalore* can be made from other materials than just ivory, namely, brass, iron, wood covered with glass beads, or a combination of these (Figures 113, 114).

The iconography of the *udamalore* would seem to support traditional notions of its significance. The topmost part of every known example of *udamalore* represents a chiefly figure wearing only a skirt identifiable as *ibolukun* in Owo, on top of which, on his left hip, hangs an *udamalore*. He is bare-chested. He holds with the right hand an *uda*, not an *ada* (a ceremonial sword carried by the Olowo's page, who is known as an *omada*).[46] The bird perching on the cap alludes to the powerful, indispensable presence and assistance of "our mothers," while the confident grip of the *uda* (sword) at the hilt represents the courage and strength that follow the feeling of being independent and capable of defending oneself. The *uda* here has a practical function even though the context in which it features is ceremonial. For related reasons, the Yoruba say, "One dares not investigate the cause of his father's death without having a firm grasp on the sword," (*Ti owo eni ko ba te kuku ida a kii bere iku to pa baba eni*).

Ifa Divination Objects

Ifa priests, (*babalawo*) who have inherited the spiritual duties of Orunmila constitute the next most important users of ivory carvings after the Olowo. Divination implements are among the items usually done in ivory, including an *iroke-Ifa* (divining tapper with clapper), an *agere-Ifa* (a container for holding and/or storing the sacred Ifa divination palm-kernel nuts), and *olumeye* (a simple but decoratively carved bowl for holding gifts generally of kola nuts). The Ifa priest is entitled to wear as many ivory ornaments as he desires, although it is unlikely that he would own as many as the Olowo. He may also possess as many ivory objects as he can afford for his divination practice.

The *iroke Ifa* (Figure 112) is an important divination implement used to invoke Orunmila during divination. The pointed end is gently tapped against the divination tray, *opon*. This long, slim rod is usually carved in ivory but sometimes also found in brass or wood covered with small colorful glass beads. *Iroke* range from about 8 to 12 inches in length and can be seen as a combination of three major parts. The topmost or pointed-end section is usually without any design or decoration and may be ready to use without any carving on the lower portion. The middle section is either a human head or a kneeling nude female figure holding her breasts. The third, bottom section does not have a specified subject matter. The images often emphasize material and worldly success, the most common being an equestrian figure. This portion requires the two upper sections to make it iconographically complete and ritually usable. The kneeling women and mounted figures represented in the second and third sections are usually rendered frontally and bisymmetrically. There is little or no suggestion of movement. Other than being reflective of intense concentration and perhaps energy, the faces do not usually express any emotion.

In the precolonial past, an *iroke* cost about 1,400 cowries. This was an extremely high price in the cowrie-

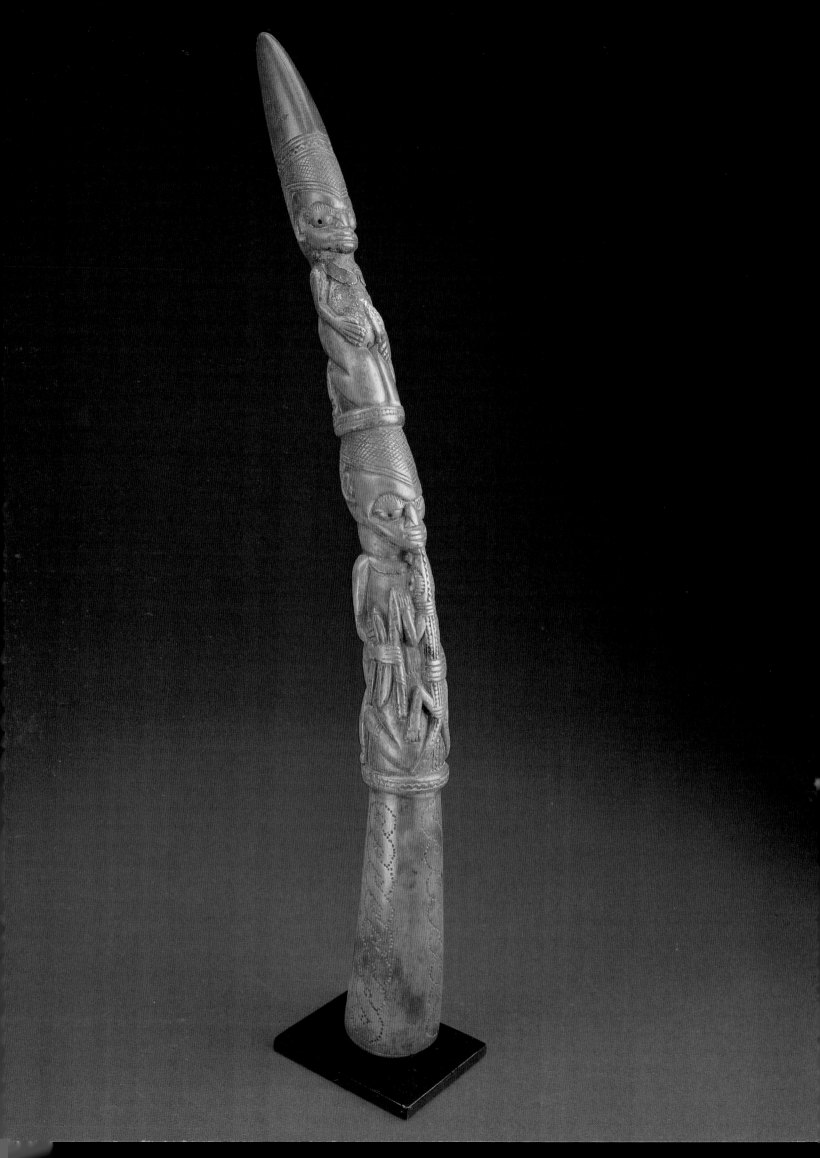

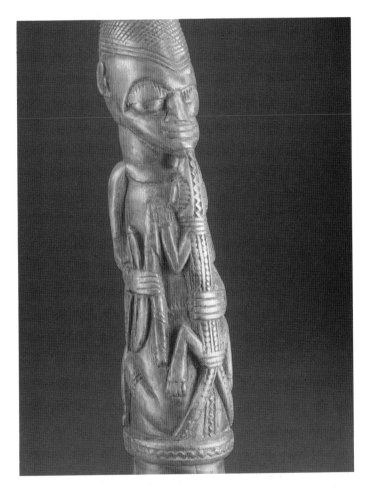

112. Divination Tapper, Owo, 17th–18th century. The divination tapper (*iroke Ifa*) is an important implement used to invoke the deity Orunmila during divination. At the beginning of an Ifa session, the priest taps the divination tray (*opon*) with the tapper and greets Orunmila. This gesture can be interpreted as an invocation during which Orunmila reveals future events in the life of a supplicant and prescribes sacrifices. Ivory. H. 18½ in. Richard and Barbara Faletti collection.

currency period, caused by the fact that elephant tusk was reserved for the *oba* and a few important high-ranking chiefs and warrior-leaders. *Iroke* is no doubt an indicator of the honor and prestige enjoyed by the Ifa priest who appears to have gained professional success and, with it, enhanced economic status. Thus, Orunmila's *oriki, Gbolajokoo, omo okinkin tii merin nfon*[47] ("The Wealthy-One, the offspring of the two delicately-white tusks that make the elephant trumpet") could also be applied to *babalawo*. When, at the beginning of an Ifa divination session, the priest taps the *opon* with the *iroke* and greets Orunmila, that action might be seen as an invocation during which Orunmila reveals future events in the life of a supplicant and prescribes sacrifices.

Ori (generally translated as "destiny" but closer to a metaphysical concept embodying man's past, present, and future) is here symbolized by the topmost segment of the *iroke*. This plain, conical part sits on top of a naturalistic and recognizable physical head in such a way that the head's owner cannot see it. Thus, a visual

and psychological distinction is created between *ori ode* (the visible head) and *ori inu* (the inner head), an invisible counterpart which is the symbol for one's destiny and is conveyed by the simple abstract, conical form. The placement of the *ori inu* directly on the *ori ode* is in agreement with the manner in which the *ori inu* in Yoruba myth is supposed to become wholly part of man, once chosen in *orun*. This arrangement, whereby the *ori inu* sits on the *ori ode* is called *ayanmo* ("that-which-is-affixed-to-one"). This section of the *iroke*, therefore, is regarded as the most important section. Its form is not only constant but self-sufficient and suitable for use in divination rituals.[48]

When the two upper segments are viewed together, they recall a traditional Yoruba myth dealing with the Ajala, the great molder of *ori* in heaven. The choosing of *ori* is the most important event in the life and the creation of man before birth. Humanity is here represented by a female figure because of her effectiveness in the act of honoring, soothing, and cooling the gods, influencing their decisions to favor man. Her position, *ikunle abiyamo* ("the kneeling posture of a woman experiencing the pains of childbirth") is the most appropriate way to salute the *orisa*, who are called Akunlebo ("the-ones-who-must-be-worshipped-kneeling-down"). To choose a good *ori*, the most sacred virtue of womanhood needs to be put to work. Moreover, *ori* is *akunleyan* ("that-which-is-received-kneeling-down"). Nudity among adult Yoruba is not considered normal except on very rare occasions as, for example, when a person is communicating with his

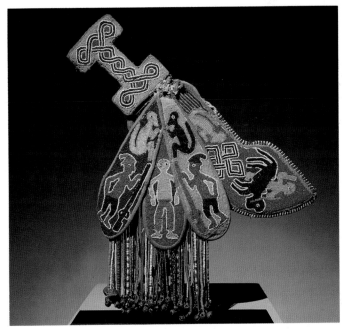

113. Ceremonial Sword and Sheath, Owo, 19th–20th century. The elaborate patterns and rich beadwork decorating ceremonial swords often provide the focus of aesthetic interest. Such swords are worn during the Igogo festival. They hang fairly loosely on the left hip, resting on the *ibolukun* (skirt). Cloth, glass beads, brass, iron, leather. H. 20¾ in. New Orleans Museum of Art, Gift of Mr. and Mrs. Charles Davis in memory of Robert P. Gordy.

creator or taking an oath on a most important issue. Similarly, a woman holding her breasts is considered to be performing a sacred act.[49]

The third segment of the *iroke* appears to be presenting the desires of the supplicant in concrete terms. Thus, a horseman, for example, may be interpreted as a prayer to be socially and economically successful, while a repetition of the theme of a kneeling woman could be an expression of gratitude for one's *ori*.

Agere-Ifa, another divination implement, is a carved container with a lid that normally holds the sixteen sacred palm-kernel nuts of divination called *ikin*. *Agere-Ifa* are available in ivory but they are not as numerous as those in wood (Figure 115). *Agere* vary in size, but those in ivory are from about 4 to 14 inches in height including the carved figures which hold up the bowl in a caryatidlike fashion.

The subject matter of *agere* are based on the desires of clients who come to the Ifa priest for divination. The majority wish to be blessed with "riches, children, and long life" (*ire owo, ire omo, ire aiku pari iwa*). They pray to be able

> . . . to dance carrying a baby on the right arm,
> sling another on the back with the left one,
> . . . and ride on horseback. . .[50]

The *agere* may depict equestrian figures to show prosperity and/or victory over one's enemies and difficult situations. There are frequently carved figures of men and women dancing, rejoicing, offering sacrifices, and expressing gratitude in the traditional manner.[51] Those represented are not godlike and do not often possess that solemn look that characterizes devotees. They appear to be ordinary people who are not rigidly posed or grouped in any regimented fashion, but move about freely. They exude life, as though they have just had successful divination. With these carved figures supporting the bowl of the *agere*, the *ikin* within, the most important symbol for Orunmila on earth, are symbolically elevated. The *agere* is transformed to a miniature earthly temple of Orunmila. The richness of design and high quality of workmanship and creativity involved in the execution of *agere* is reflected in its monetary value, which in Ifa literature was sometimes as high as 3,200 cowries.[52]

Both the Ifa priests and their clients contribute to the iconographic and aesthetic features of *agere* sculpture. The priest may commission the container; the clients may present him with one in gratitude for a successful divination. The dancers, musicians, equestrian figures, kneeling women, and relaxed mood of celebrants are reminiscent of the happy endings of many Ifa divination sessions. Ifa literature captures this aura very vividly in the following poem:

> *He [the successful client] was dancing*
> *He was happy,*
> *He gave honor to the priests,*
> *Who in turn praised Ifa.*
> *As he opened his mouth,*
> *It was the divination song that he sang.*
> *As he stretched forth his feet,*
> *Dance claimed them.*[53]

The figures in the sculpture of *agere* are ordinary men responding humanly and naturally to the success of their supplication. In the conventional way they drum, sing, and dance with horse-tail fly-whisk in hand, ride on horseback with or without a weapon, and make ritual sacrifice to express their gratitude to Orunmila.

Altar Carvings

Among the wide range of materials, techniques, and styles of the artist, there is the area of ancestral altar arts. Such powerful sculptures as the *osanmasinmi* (wooden ram heads) and their elaborately carved wooden panels (Figure 101) are part of these arts.[54] The motif in *osanmasinmi*, the ram head, may also take the form of a combination of the human head with ram's horns, or simply a human head (as is the case in the Ojomo's palace). The Olowo, Ojomo, and high-ranking chiefs who head important families in Owo usually own and maintain *ojupo* (ancestral shrines) which serve as places where those living can communicate with their deceased ancestors on a proper and regular basis, in elaborate ancestral rites during the new yam harvest.

The appearance of the new yam marks a high point in the ritual calendar of the Owo people. It is the end of an agricultural cycle, and the time when all major *orisa* and deceased ancestors must be honored and "fed" (that is, have sacrifices offered to them). This is the appropriate occasion to ask for blessings and protection. Old pledges are fulfilled and new ones are made. All of which make the Owo people greet the arrival of the new yam with the words: "New yams, I am thrilled, I have lived to see you appear; May I survive another yam harvest season!" (*Bobolo, pokee, mo re midiku!*). Out of respect for the ancestors, most families will not eat new yams until they have taken care of the ancestral shrines.

From the way ancestral rites are performed and the kind of prayers said before the altar, it is possible to gain some insight into the meaning and function of *osanmasinmi*. The head of the family, the *olori-ebi*, takes the items to be used for sacrifice, holds each one in turn, and prays for the family. When, for example, he offers the kola nut to the ancestor, he says: "Just as fresh kola nuts never fail to appear on the market stall each year, so may we all be back here hail and hearty

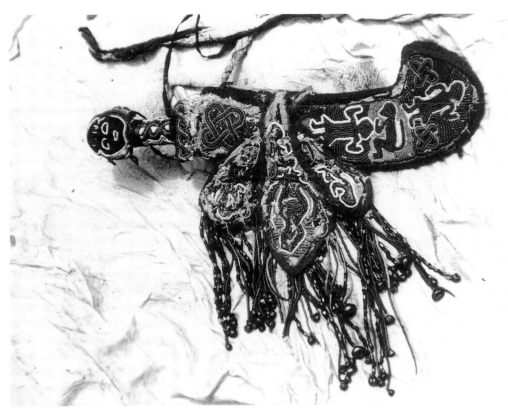

114. Beaded ceremonial sword belonging to Chief Elewere. Owo, Nigeria, 1975. Photograph by H. J. Drewal.

next year; may we never decrease in number"
(*Odoodon o romabi ori ate, we da sumodon, ma da peden*). The *olori-ebi* then splits the kola nut, leaves part of it on the ground in front of the *osanmasinmi*, and recites a long prayer which usually includes lines such as these:

> *The children [fingers] of the hand cannot die while the hand is watching.*
> *The children [toes] of the foot never die when the foot is alert.*
> *It is only a dead ram that cannot fight*
> *Please, stay awake, be vigilant.*
> *Let no evil thing come near your children.*[55]

The ram, because of its qualities of alertness and strength, and its ability to fight and defend itself, has become a most effective visual metaphor for the deceased ancestor. Human and animal virtues mingle, featuring in the verbal and visual arts of *osanmasinmi*. There are "similar shrines in Ishan, also placed on ancestral altars," and it has been suggested that they "have a common source—Benin, where chiefs once placed such carvings on ancestral altars."[56]

The source of the ram-head motif, however, may be more ancient than Benin. Ishan, Owo, and Benin may all have derived their versions from such a source. Owo would seem to be a more logical place to reconstruct many ancient Yoruba and Benin practices.

Archaeologically, Owo has yielded much valuable data which could prove crucial in the interpretation of the naturalistic terracottas and bronzes of Ife. Owo preserved elaborate social and artistic institutions, such as *ako*, into the first half of the twentieth century. Certainly, Owo's oral traditions, the bulk of which are still to be recorded and have been largely ignored by scholars, must also contain an indispensable body of research material. They may reveal obscure meanings that are usually hard or impossible to obtain from even the most cooperative informant.

The survival of Owo's autonomy since the seventeenth century, and her freedom from "the general panic and insecurity that gripped the whole of Eastern Yorubaland as a result of the wars of the 19th century,"[57] suggest a kingdom that enjoyed relative stability. In such an environment, cultural and social institutions and the art not only survived, but thrived.

115. Ifa Divination Cup, Owo, 17th–18th century. Called *agere-Ifa*, this divination implement is a carved container that holds the sixteen sacred palmnuts. The *agere Ifa* may therefore be regarded as a miniature earthly temple of Orunmila. Ivory. H. 8¾ in. Mr. and Mrs. Robert E. Mnuchin.

116. Upper Half of a Figure, Owo, 12th–15th century. This is the upper half of what appears to have been a male figure. It is bare-chested with a collarlike necklace and bracelets covering the forearms. There is a strand of large beads around the waist. The face has a high forehead, a short chin, and wide-set, almond-shaped eyes. Terracotta. H. 9¹³⁄₁₆ in. National Commission for Museums and Monuments, Nigeria.

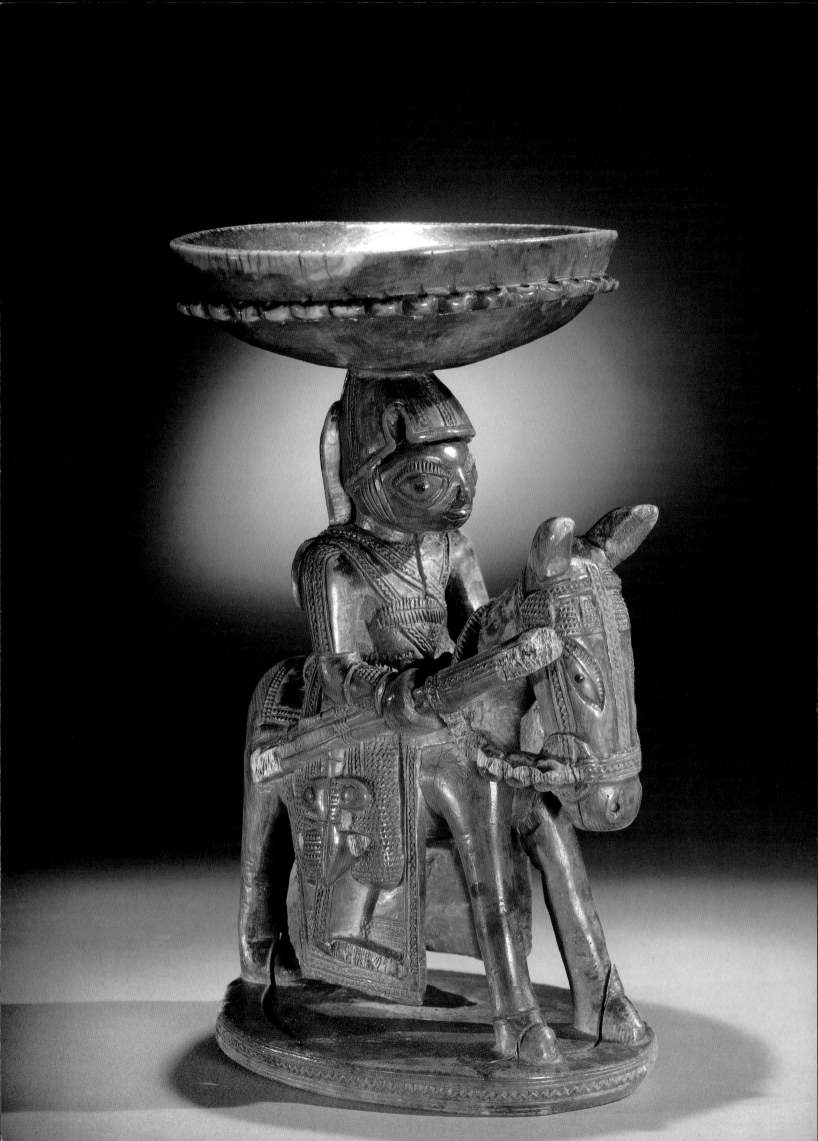

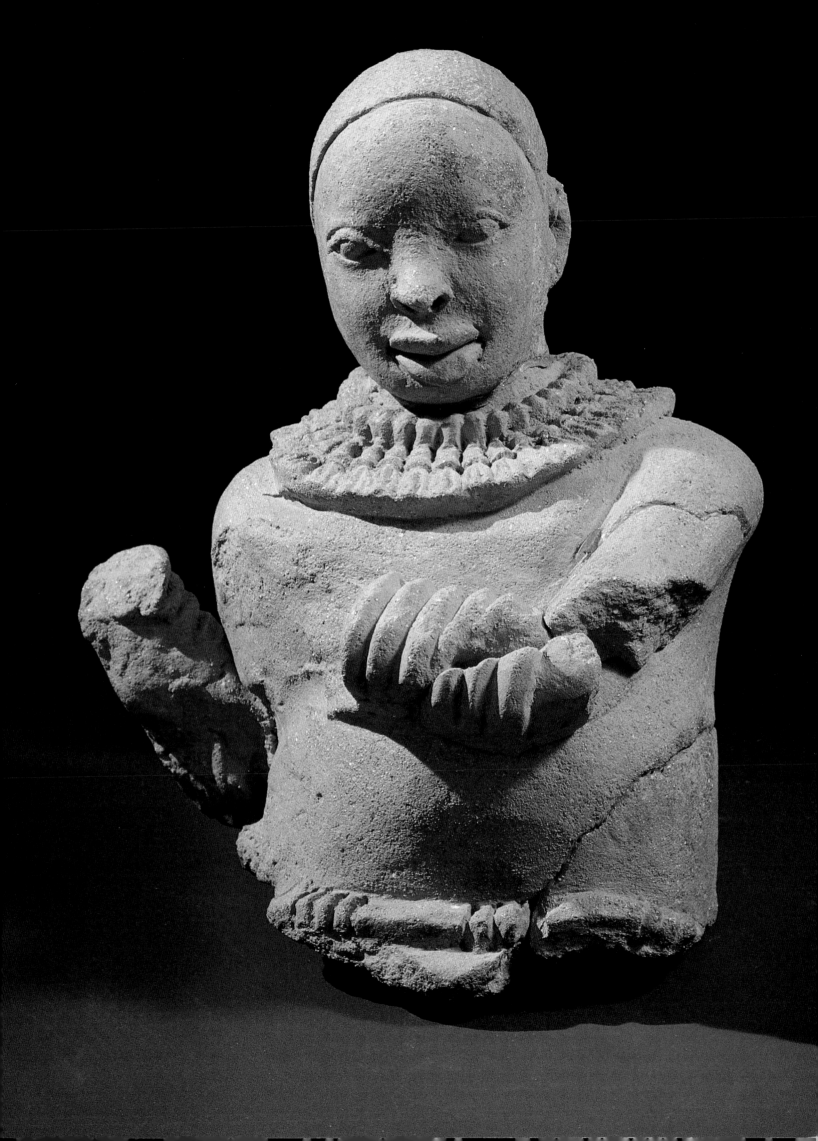

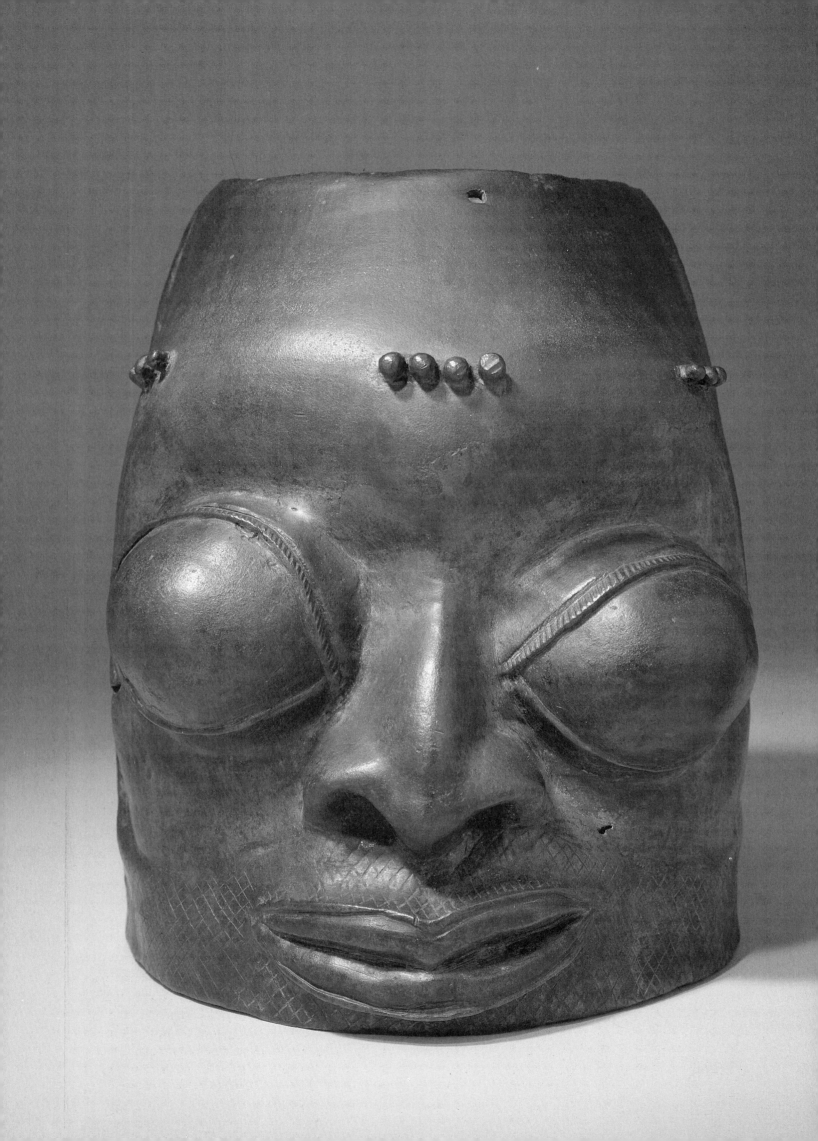

Art and Ethos of the Ijebu

Henry John Drewal

The Ijebu were the first Yoruba-speaking peoples to be mentioned in European texts. Portuguese explorer Duarte Pacheco Pereira wrote in the early sixteenth century: "Twelve or thirteen leagues upstream from Lagos there is a large town called Geebu [Jebu], surrounded by a very large ditch."[1] This "very large ditch" refers to the famous *eredo* (ramparts), that ran 80 miles and enclosed an area of about 400 square miles, encompassing the capital and many other Ijebu towns. By the fifteenth century, Ijebu was a highly organized and powerful nation that clearly perceived the need to defend itself against enemies.[2] Pacheco Periera's further reference to Ijebu as a prime brass-importing kingdom highlights the early importance of metalworking in Ijebuland.

The extensive Ijebu realm, probably second only to Oyo in size, seems to have been created by several waves of conquerors.[3] One account credits Olu-Iwa and his companions Ajebu and Olode as the founders of Ijebu-Ode, the city regarded as the center of Ijebu.

117. Head, Ijebu, 16th century. A bronze head collected at Benin, though possibly cast in Ijebu, which was probably intended for display on a royal ancestral altar. Like many Ife and Benin cast heads, this one has a large hole at the top. Around the back are what appear to be beaded braids with crotals (bells). Ife features are the cross-hatched lines covering the lower portion of the face and upper lip identical to the face veil on the terracotta mask (see Figure 77), and the area defined by holes on the "Obalufon" copper mask (see Figure 76). Bronze. H. 10¼ in. George Ortiz Collection, Geneva.

The term *Ode* is also used to mean "town," not only among the Ijebu, but also the Itsekiri and Ondo,[4] suggesting possible historical and cultural ties with these areas near the western Niger Delta. The best-known story of Ijebu's origin cites Obanta as the first monarch, known as the Awujale, of a pan-Ijebu realm. The present Awujale claims to be the fifty-third, which suggests origins in the early fourteenth century. These histories and others emphasize land disputes, *ija ile*, a theme reflected in the titles of several Ijebu rulers such as Awujale, Ajalorun, Amujaile and Agbejaile, these last two associated with Obanta.[5] The theme of indigenes versus usurpers seen in accounts at Ife are equally prevalent in Ijebu.

The legend of Obanta relates that he was a son of Oduduwa, first monarch of Ile-Ife. Obanta left Ile-Ife and traveled east and south to the coastal area first at Ibu near Benin and then westward to Ijebu-Ode, where he was enthroned.[6] The mythic route of the conquering Obanta, symbolically reenacted during installation rites of all Awujales, points strongly to connections with the kingdom of Benin, which appears to have exercised control over Ijebu, or at least the coastal areas, in the sixteenth or seventeenth century.[7]

Obanta is said to have brought a metal "idol" (known as Irin) with him from Ile-Ife, which served as his symbol of authority—a tradition very similar to accounts at Benin and Oyo-Ile that may explain the dispersion of Ife art to those kingdoms. Obanta, like all rulers in Ijebu, was known as Olurin, or "Owner-of-the-Metal."[8] Ijebu rulers have this title in Osugbo,

118. Embroidered Textile, Ijebu, 19th–20th century. An elaborate velvet cloth used by the Olisa on ritual occasions. The images on its rich, black velvet surface refer to the rites of succession and renewal and the objects used to carry them out. These include leaves, figurated bells, birds, feathers, and containers. Velvet. L. 51½ in. America West Primitive Art, Tucson.

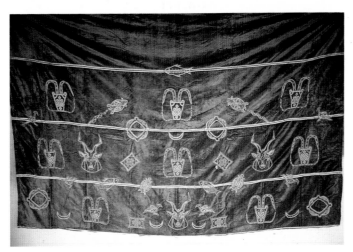

119. A cloth owned by the Olisa at Ijebu-Ode. It has an embroidered array of aquatic creatures, including fish, tortoises, and serpents, reminiscent of some of the images on the bronze stool (Figure 120). Other motifs are devoted to ritual objects. These are brass anklets and face bells of two types, one an antelope-headed bell with a broad base and long horns, and the other an abstracted, horned head with ears and a snout that narrows at the bottom. Ijebu, Nigeria, 1986. Photograph by H. J. Drewal.

120. Bronze stool, Ijebu, 18th–19th century. Said by its owners to have been cast in Ijebu and been in their possession for several generations: a) base, detail of snake, antelope, and interlace; b) faces and shrimp on the base; c) under seat, simian with leaves; d) splayed-leg creature; e) bat. (See Figure 123). Bronze. H. 17 in. University Art Museum, Obafemi Awolowo University.

the council of female and male elders established at the founding of a community and possessing a wide range of powers and responsibilities including that of king-making.

Of all the traditionally metropolitan towns of the Yoruba peoples, the capital of the Ijebu, Ijebu-Ode, is the most urbanized, though it is not the largest.[9] Its relatively small size may be explained by the large number of independent kingdoms scattered throughout the area. In contrast, most northern Yoruba kingdoms are based on centralized living patterns. Ijebu's settlement pattern accords more with kingdoms to the east, including the Ondo Yoruba and Edo-speaking peoples,[10] particularly at Benin. Ijebu-Ode's roughly rectilinear grid, for example, closely resembles Benin practice rather than the radial and more amorphous format of Yoruba capitals.[11] All of these elements seem to be the result of historical and political factors.

The Ijebu cultivated a reputation for the use of medicines, poisons, and curses and adopted the tactics of their national symbol—the chameleon (Figure 122). A well-known story in Ifa tells how a chameleon was challenged by his enemies in a contest. Each time his foes tried a new approach, the chameleon imitated, neutralized, and then made the strategy his own. His powers of transformation defeated them all.

Chameleons are also noted for the frightening hiss they make when threatened. The Ijebu interpret this as a powerful curse. The chameleon's eyes, which are large and work independently, are evidence of its ability to see and know all. In addition, the chameleon is vital to the most potent medicines. The Yoruba saying, "No matter how hungry one is, one never eats the meat of a chameleon," reflects its importance.[12] The Ijebu did not have a strong military as did Oyo and Benin. Like their symbol the chameleon, they transformed the powers of others, turning them to benefit the Ijebu, in order to survive and prosper.

Despite Ijebu's attempts at independence, Oyo under Alafin Ajagbo may have conquered Ijebu Ode for a time in the seventeenth century, and Benin histories make similar claims.[13] There is much evidence, social as well as artistic, to suggest that Ijebu did have a close, on-going relationship with Benin. For example, the Oliha is the head of Benin's Uzama, a council of seven king-makers. The Edo word *Oliha* seems to have become *Olisa* in the Ijebu dialect. The Oliha/Olisa are descendants of families that controlled the capital before the days of the *oba*. The Uzama at Benin, like the Olisa and Osugbo at Ijebu-Ode, are regarded as the original landowners. As part of installation rites in both Benin and Ijebu, Oliha/Olisa and the councils symbolically surrender their control of the land and its wealth to the

new king.[14] In Benin, the crown prince must make sacrifices to the Uzama's ancestors at the Iyanto shrine, the oldest and most important shrine in any Edo community. In Ijebuland the king must pay his respects at the shrines of original founders of communities as part of annual royal rites.

The histories of Ijebu and Edoland are remarkably similar. Edoland was ruled by a federation of chieftaincies until about 1504, when they refused to perform the rights necessary for the accession of the new king.[15] The Uzama were eventually defeated by the Ewedo who developed an increasingly powerful dynasty of divine kings. As warrior rulers in the sixteenth century, these kings greatly expanded Benin's realms.[16] In Ijebuland the process of state-formation that is linked with Obanta follows roughly the same pattern. In the climactic rites of installation in both places, the Oliha/Olisa participate in the crowning of the new monarch. There are many references to Ife in both Ijebu and Benin rites of kingship, which suggests that the similarities in Benin and Ijebu royal rites may be the result of a much earlier incorporation of Ife cultural elements in both societies which were later strengthened by Benin-Ijebu interaction. Whatever the case may have been, and we do not yet have sufficient evidence to detail such interactions, a number of Ijebu objects provide graphic evidence of some very strong Ijebu-Benin artistic ties.

The Bronze Stool

In 1965, an exquisite, enigmatic bronze stool was found at Ijebu-Ode. It was said by its owners to have been cast in Ijebu and to have been in their possession for several generations (Figures 120, 123),[17] but since its discovery, it has also been attributed to Owo and to Benin.[18]

Elements of Ife style are seen in the stool as well. Its circular seat and base with intervening cylindrical column comprise the fundamental form of ancient stools at Ife. At Ife, looped "handles" such as that emerging from the central column may have been inspired by an elephant's trunk. In the same stool form at Benin, the column becomes entwined snakes, and the loops, their necks and heads which are shown devouring various creatures—men, frogs, cows, or antelopes.[19] This ancient stool form, called *apere* at Ife and *erhe* in Benin, is also linked with the *pere* title among the western Ijo of the Niger Delta whose symbol is a miniature bronze stool almost identical to the Benin form. The *pere* title among the western Ijo is associated with Benin.[20] It seems that this title-taking symbol also spread to Ijebu, perhaps during the era of strong Benin influence. In the stool found at Ijebu-Ode,

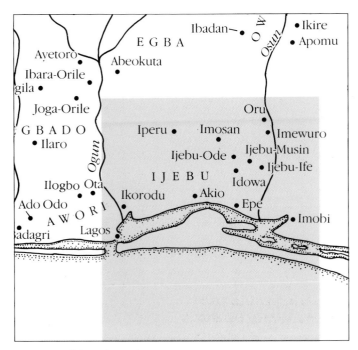

121. Map of the Ijebu realm.

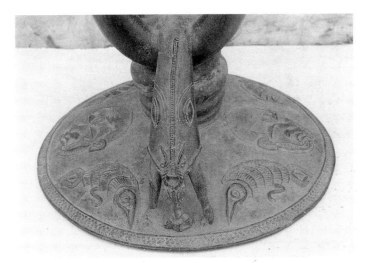

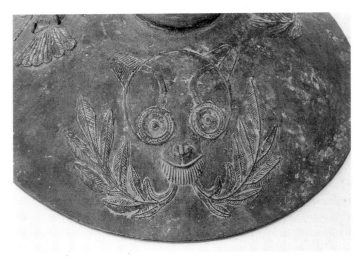

123. Detail studies of Ijebu bronze stool. See Figure 120.

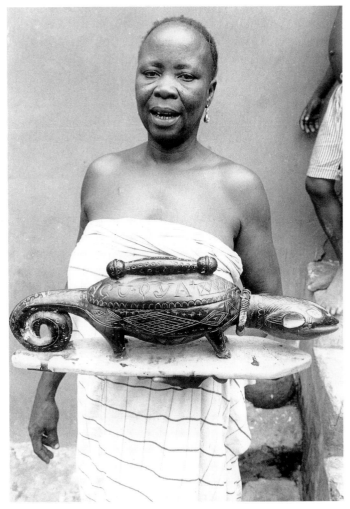

122. A woman holds a ritual container in the form of a chameleon, a creature that has come to symbolize the Ijebu reputation for powerful curses and medicines. The chameleon's ability to change its outer appearance in order to camouflage itself is seen as a transformative strategy likened to the Ijebu ability to neutralize or defeat its powerful enemies. Ijebu, Nigeria, 1982. Photograph by M. T. Drewal.

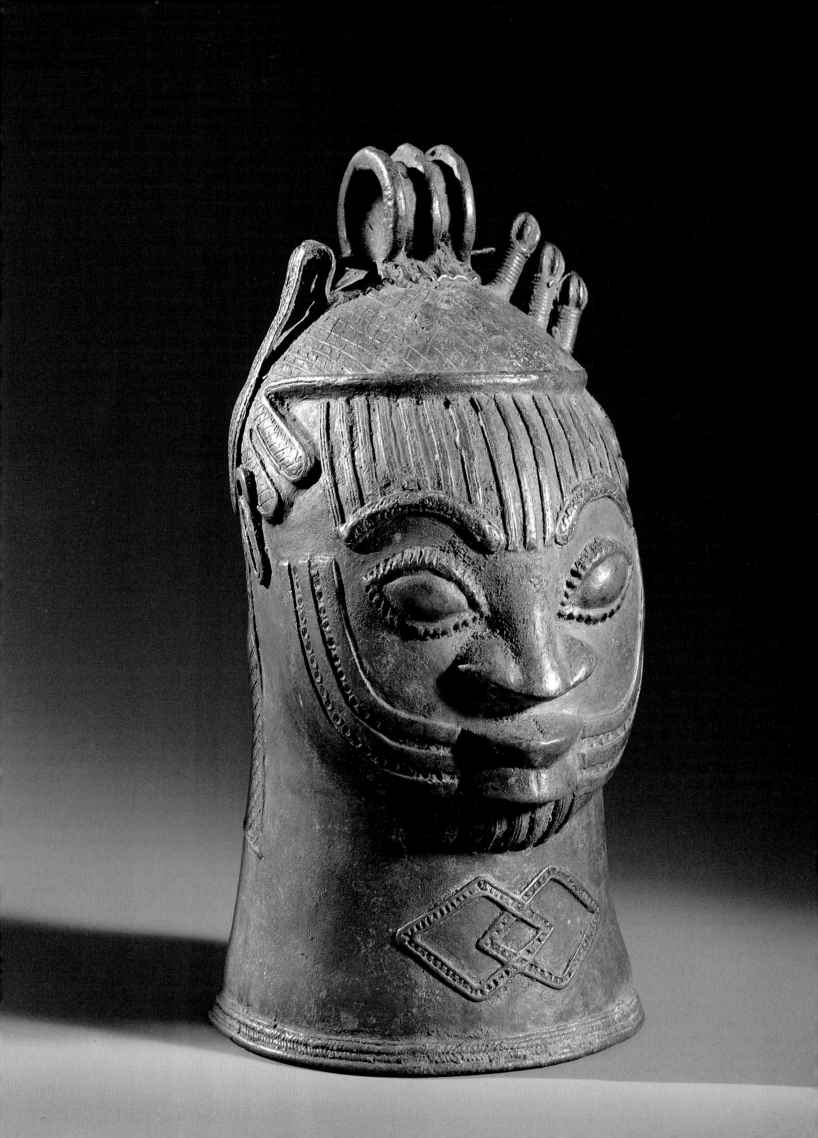

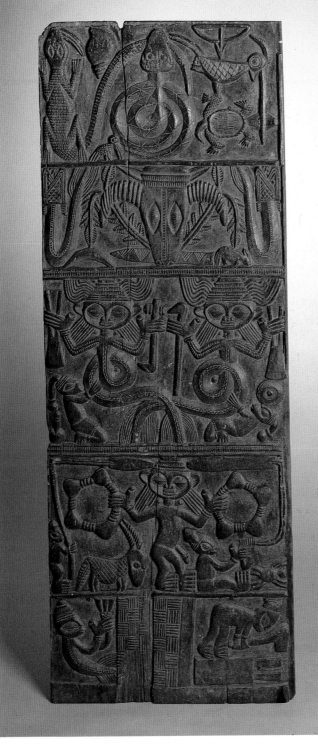

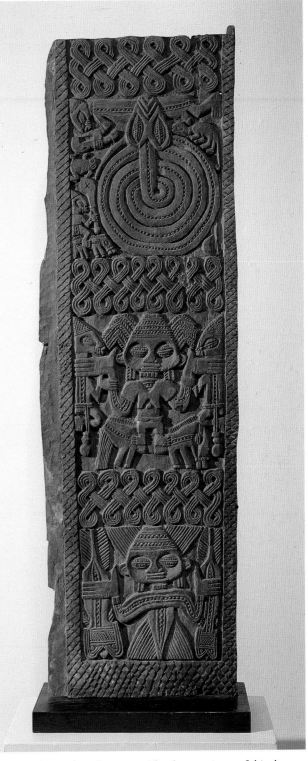

124. Door, Ijebu, 19th–20th century. A door that probably adorned an Osugbo lodge entrance depicts in the second register a horned animal with leaves and the Oro Society bullroarer in its mouth. In the middle panel, fish-tailed figures hold ritual implements in their hands. Below, a figure grasps two ankle rattles while others whirl Oro bullroarers. At the bottom, a fish-tailed figure shakes a triple gong and another wields a hammer. Wood. H. 53⅛ in. Afrika Museum, Berg En Dal, Netherlands.

126. Face Bell, Ijebu, 18th–19th century. Brass face bell used by the Olisa and other important chiefs in Ijebu, whose titles (the Egbo, Apebi, and perhaps the king, Awujale, himself) seem to have a close association with ones at Benin. These bells are worn on a sash over the right shoulder so that they hung down at the left hip. Bronze. H. 9½ in. Eric D. Robertson.

125. Door, Ijebu, 19th–20th century. The three registers of this door evoke the themes of victims, captives, and sacrifice, all important concerns of leaders, the Osugbo and Oro societies. In the top register, a coiled snake grasps its victim while a chameleon and equestrian look on. In the middle, a central figure holds two captives by the throat. Below, a fish-tailed figure displays mudfish sacrifices. Wood. H. 59¾ in. Michael Myers, New Orleans.

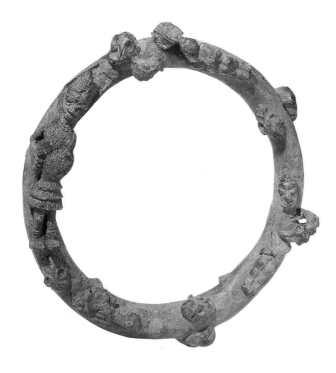

127. Bronze ring with a figure with facial scarifications in full regalia—chest baldrics, necklace, bracelets, anklets, wrapper knotted on the hip, and a staff in the right hand. Other motifs include decapitated and bound victims, vultures devouring corpses, gagged heads, turtles, and skulls. Below the full figure an attendant carries a stool similar to the one in Figure 120. Courtesy of Merton Simpson.

serpents devour antelopes who in turn devour plants (Figures 120, 123). As at Benin, the loops of the central column are snakes' heads.

While there is little doubt of Benin artistic influence, certain icons associated with Owo also appear. These include leaves, animals eating plants or fruit, a leaf-wreathed head, a simian head with large round eyes, and a woven pattern that occurs on certain Owo ivory bowls.[21] In the Ijebu-Ode stool, however, they are rendered in a style that seems distinct from both Benin and Owo—a style much closer to Ijebu bronzes.

Beside the distinctive style, there are other factors that suggest Ijebu. According to the earliest Portuguese accounts, Ijebu was importing a large amount of brass and may have had direct trading contacts with the Portuguese in the late fifteenth and early sixteenth centuries.[22] This implies that Ijebu was a major casting center, while Owo seems to have specialized in ivory carving. In fact, very few castings have come to light at Owo. Ijebu's lagoon ports and well-established trade routes to the Delta, as well as overland routes via the Ondo and Owo Yoruba, were apparently within the Benin sphere of influence in the sixteenth or seventeenth century. Ijebu could have easily been a major source of bronze castings for an expanding Benin kingdom, especially for its western and southern coastal

provinces in the Delta, just as Owo was certainly the source for many ivories found within the Benin realm. The presence of Owo-related motifs in this stool may therefore have come from their presence in Benin art, or a Yoruba repertoire shared with Ijebu, which was then translated into a distinctive Ijebu style.

Entwined snakes devouring other creatures are ubiquitous in Yoruba and Benin art generally. Such a composition seems related to the interlace, an ancient motif especially prevalent in objects associated with leaders—rulers and priests. Here, it also occurs as a pattern around the outer edge of the base. Some have suggested that the interlace may be Islamic in origin, spreading to the Yoruba through the arts in the Sokoto Caliphate such as indigo-dyed and embroidered prestige garments (*etu*), and leatherwork of the Hausa and others. For the motif to be so readily accepted and dispersed, it must have evoked a deep, indigenous mental icon, especially since it appears on the most sacred forms. In Yoruba art where it appears as entwined snakes, it connotes competing powers in the world and the otherworld. An image from a Yoruba verbal art is suggestive. When the Yoruba describe an *alo* tale, an imaginative narrative in which protagonists are in constant conflict, they say it "twists and turns." At the end of the narrative when the conflict is resolved, the storyteller is said to "tie it up or unite it."[23] Such verbal imagery accords with the visual motif of the interlace—it epitomizes both the tensions and resolutions of conflicts in the realms of *aye/orun*. Thus, whatever its ancient, probably unknowable origins, its persistence and importance for the Yoruba seem likely to stem from its encapsulation of fundamental Yoruba philosophical concepts about competing forces in the cosmos.

The image of serpents holding antelopes (Figure 123) is also relevant to Ijebu. Several species of antelopes live in forests near Ijebu and the Delta. They often live close to water and one species, the water chevrotain, can swim long distances underwater.[24] A standard image on masks for water spirits is the antelope, known as *agira* among the Ijebu who adapted this masking tradition from their Western Delta neighbors, the Ijo.[25] The antelopes on the stool are shown eating a plant, as they in turn are eaten by serpents. Like similar motifs in Yoruba art and Gelede masks in particular, this is the theme of competition.[26] The identity of the curious creatures alternating between the eating antelope and the human heads is uncertain, but may be shrimp or prawns.[27] This seems possible, but other composite creatures elsewhere on the stool suggest that they may be bird-crustaceans. Whatever the case, the themes of water and liminal creatures that operate in both aquatic and terrestrial realms (swimming antelopes,

snakes, and shrimp) persist in similar Benin stools where frogs and mudfish appear frequently.

The three faces on the base have certain Ijebu elements (Figure 123). The raised forehead marks are not those of Benin which vary from three to four spread over the eyes, nor are they the two long vertical marks between the eyes usually shown as two iron insets in Benin bronzes and ivory pendants. Rather they seem to approximate the double forehead marks (either straight or opposed crescents) that are characteristic of bronzes used by the Osugbo in Ijebu and elsewhere (see Figures 133, 134). In addition, the three lines with textured patterns between them that rise from the lower corners of the mouth and extend up the sides past the ears, are very reminiscent of marks shown on various Ijebu bronzes, like a face bell from Ijebu-Ode (see Figure 126). The flared nostrils, full eyes, and ear shape have the distinct feel of an Ijebu artist's hand.

The three most enigmatic images are those displayed on the shadowed underside of the seat itself (Figure 123). They express the themes of liminality and transformation. The identity of the head holding leaves in its mouth is uncertain, but its large eyes, ears, and nostrils suggest a simian creature. The two crescent marks on the forehead recall the Osugbo forehead mark. The leaves are almost certainly ones called *iyeye* from the *ekika* tree. Infusions from *ekika* bark are used as medicine for coughs and stomach disorders, and as a soothing dressing after circumcision.[28] More broadly, *iyeye* leaves connote survival and longevity. The leaf is used in installation rites where, at Lagos for example, it is put on the head of the prince who has been chosen to become the ruler.[29] Its use is especially relevant since Lagos had strong ties to Ijebu and was ruled by Benin, probably in the sixteenth century. In addition, a Benin wooden stool of the same type placed on the ancestral altar of Chief Ogiamwen shows an elephant's trunk holding similar leaves.[30]

Another puzzling motif depicts a splay-legged creature that seems to have a hippopotamus snout, antelope horns, frog legs, and tail feathers (Figure 123). In its hands and feet it clutches the same *iyeye* leaves as the simian head. The meaning of this highly inventive composite animal is obscure, however the presence of title-taking leaves and the synthesis of qualities of several beings may suggest a gathering of diverse powers and blessings.

The final image is a bat holding a double-looped form, most probably a cloth, in its mouth (Figure 123). The bat motif occurs very early in Ife art as evidenced by a pot fragment from Orun Oba Ado.[31] Several associations with this strange creature may explain their presence on the stool. According to one Yoruba tradition,

adan (the bat), was originally a blacksmith, who made men's mouths into the present shape and so was condemned to use the same orifice as mouth and anus. Bats hang upside down, and they continually vomit what they eat which has become a Yoruba metaphor for one who takes a purgative to remove poison from one's food. Bats are used as sacrifices and are associated with *aje* (witches) because of their nocturnal habits, and because they suckle their young like humans but can fly like birds, the primary symbol of witches. There is a saying, "A bat hanging upside down still sees everything [that the birds/witches are up to]."[32]

Another Yoruba saying, "bats are neither birds, nor animals," is a clear expression of their liminality and uniqueness.[33] For all these reasons, it is no wonder that bats are important ingredients in powerful protective medicines.[34] The bat is clearly associated with the birds of mystically powerful women, the same birds that appear on the beaded crowns of kings. They possess the powers of transformation, alterations that occur at night. That is perhaps why the bat is shown on the underside of the seat, hanging in the shadowy area, yet seeing everything. The other images on the bottom of the seat convey similar ideas. They are all transformed entities, supernaturals whose presence and powers are essential to the one who sits above them on the stool.[35]

All the devouring motifs suggest the purpose of the Ijebu-Ode stool. If we acknowledge the influence of Benin art and social institutions on Ijebu, then new data

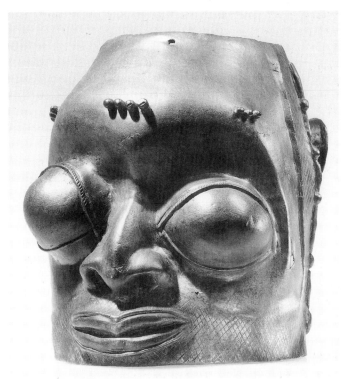

128. Alternative view of Ijebu bronze head. See Figure 117.

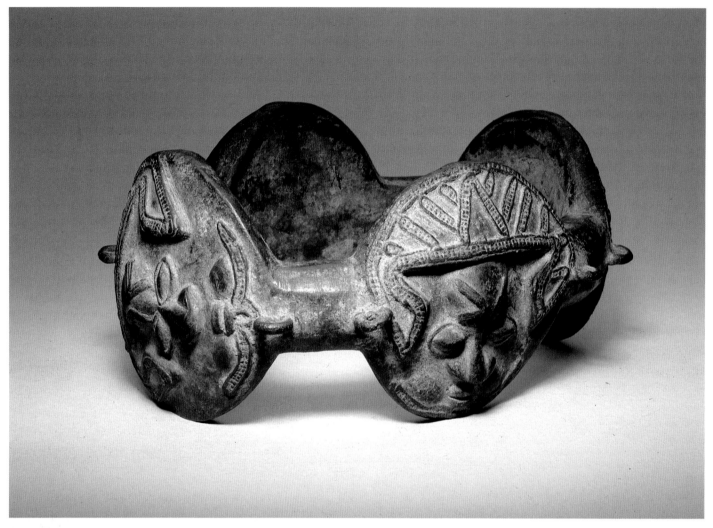

129. Bracelet, Ijebu, probably 18th century. Bracelets much
like this one were probably in widespread use and not necessarily
restricted to royalty, priests, or Osugbo members. Its solidly-crafted
forms and well–executed design reveal the high level of bronze cast-
ing developed by the people of Ijebu. Bronze. Diam. 3½ in. Drs.
John and Nicole Dintenfass.

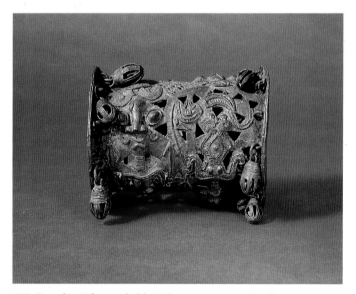

130. Bracelet, Ijebu, probably 18th century. An armlet that
demonstrates the refined and intricate metalwork that must have
adorned the bodies of powerful Ijebu persons in life or death.
Bronze. H. 5¼ in. Lent from the Alexandra Collection by Balint
B. Denes.

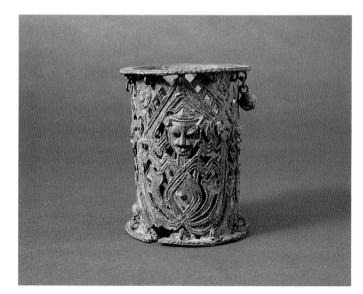

131. Bracelet, Ijebu, probably 18th century. An armlet of the type
worn by royalty and persons of high rank in Ijebu. Woven into the in-
tricate openwork is the widespread motif of the fish-legged figure.
Bronze. H. 5 in. Lent from the Alexandra Collection by Balint B.
Denes.

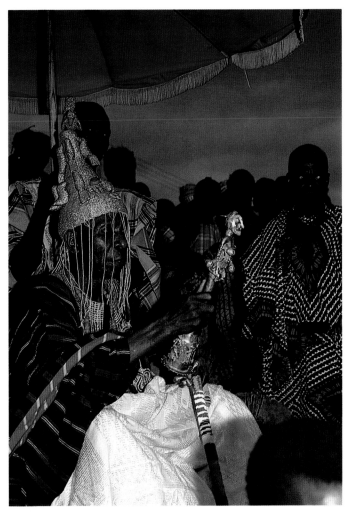

132. The King of Ijebu-Ife wielding his staff, or *ipawo ase*, in blessing one of his people during annual kingship rites. Ijebu, Nigeria, 1982. Photograph by M. T. Drewal.

on the installation rites of Benin kings may be significant. There, in an important preliminary rite, the Oliha as head of the king-makers, must give the crown prince a wooden tray used in food preparation. This object and act symbolize the source of all wealth in the world, and thus imply the source of a successful reign.[36] The theme of eating on this stool may relate to such a rite, and the stool may have been in the possession of the Olisa at Ijebu-Ode who plays a central role in the installation of the Awujale. Wooden versions of this stool, in fact, are owned by the founders of Edo villages and by Chief Ogiamwen, one of the Uzama king-makers involved in the royal installations.[37]

All three creatures on the seat hold objects: the simian figure and the composite animal hold *iyeye* leaves known to serve in installation rites; the bat holds a looped cloth in its mouth, also used in the same context. The cloth may be a stylized rendering of an *itagbe* (the elaborately woven sash of a titled person), that is worn on the shoulder or wrapped and folded on the head. Such a cloth conveys the presence of a person of authority,

with strong *ase*. Its presence in this seat of power, like those at Ife, is eminently appropriate.[38]

King-Maker's Cloth

As ruler of the town, *oba ilu*, the Olisa has an elaborate array of regalia rivaling that of the Ijebu king. It includes crowns, beaded items of clothing, state sword, staffs, and an elaborately embroidered cloth (Figure 118). The abstracted images on its rich, black velvet surface refer to rites of succession and renewal and the objects used to carry out such performances.

At Ijebu-Ode, the court official responsible for such regalia and ritual procedures explained the images on a very similar cloth (Figure 119).[39] On it float an array of aquatic creatures, including fish, tortoises, and serpents, reminiscent of some of the images on the bronze stool. Other motifs are devoted to ritual objects—brass anklets and face bells of two types, one an antelope-headed bell with a broad base and long horns, and the other an abstracted horned head with ears and a snout that narrows at the bottom. From the mouth come two linear forms that curve out and up to join the downward curving horns. In composition and conception, this abstracted motif is related to both the simian head with leaves and the composite creature clutching

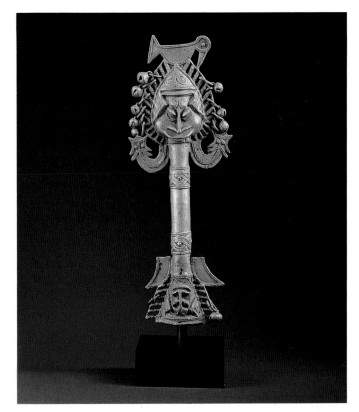

133. Osugbo Staff, Ijebu, 17th–18th century. An *ipawo ase*, or literally "hand-held staff of authority/life force." It was used by all *alaase*, those individuals who possess and utilize *ase* on behalf of their followers which included chiefs, priests, Osogbo elders, and kings. Bronze. H. 13¼ in. Dr. and Mrs. Bernard Wagner.

127

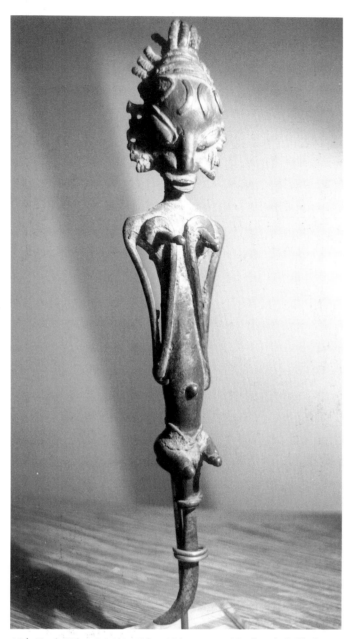

134. Single Edan Osugbo, Ijebu, 19th century. The female half of an *edan* pair cast on a curved iron spike that may refer to a miniature spoon and the female title of the *erelu* who is also known as "Owner-of-the-Spoon." Both this title and the figure's gesture of holding her breasts emphasize the nurturing role of women. Bronze. H. 5¼ in Private collection.

leaves, both found on the underside of the Ijebu-Ode stool seat.

These are representations of *omo* (brass face bells) owned by the Olisa and other prominent chiefs whose titles seem to be associated with Benin—the Egbo, Apebi, and perhaps the Awujale himself (Figure 126).[40] These are worn on a sash over the right shoulder so that the face bell hangs down at the left hip. They are associated with successions to the title, each occupant casting one for his successor.[41]

On almost all examples of these face bells, three long striations with textured patterns between them rise from the corners of the mouth up the sides of the face to the ears or beyond. This same pattern occurs on the stool faces (see Figures 120, 123), which suggests that they may refer to *omo* to be used in the transfer of power from one title-holder to the next, probably one of the purposes of the stool.

Many of the motifs on the cloth discussed by the palace official occur on the cloth shown in Figure 118. The abstracted heads with ears and curving horns on the cloth hold branches with paired leaves that are identical to the *iyeye* leaves on the stool. In a more realistic rendering, a horned animal holds these same leaves in its mouth on an Osugbo door (Figure 124). Figurated bells were used in rites acknowledging one's predecessors. The person places a foot on the sacred spot associated with that ancestor, a ritual act known as *aito*. The repetition of three bells, three birds, and three containerlike forms at the bottom of the cloth is not accidental, for the number three is significant in all sacred matters. Threes also occur on the bronze stool. Here it is most probably a specific reference to the *aito*, when this garment is worn, which involves stepping three times at the sacred site.[42]

In addition, the birds are *okin*, a species known as the "king of birds" whose gorgeous tail feather is often inserted into the pinnacle of king's crowns (see Figure 37). Both the cloth and the stool are related to chiefs and rulers. They express something of the nature of a

leader's *ase* and prerogatives in terms of the ritual objects he owns and uses. The two objects also allude to moments of transition in devouring images, when authority is transferred and blessings proclaimed as *iyeye* leaves are placed on the anointed head of a successor.

Ring of Momentous Ritual

Many of the same motifs on the stool and on an Obalara vessel (see Figure 70) also occur on a large bronze ring (Figure 127).[43] It portrays a figure with facial striations in full regalia (chest baldrics, necklace, bracelets, anklets, wrapper knotted on the hip, a staff held in the right hand). On some similar rings, this bedecked figure has double crescent Osugbo forehead marks and paired Osugbo staffs near the head. Other motifs include decapitated and bound victims, vultures devouring corpses, gagged heads, turtles, monkey skulls, and shells. Like other images of human sacrifice in Yoruba art, the events evoked on this ring were momentous ones for entire communities or realms.

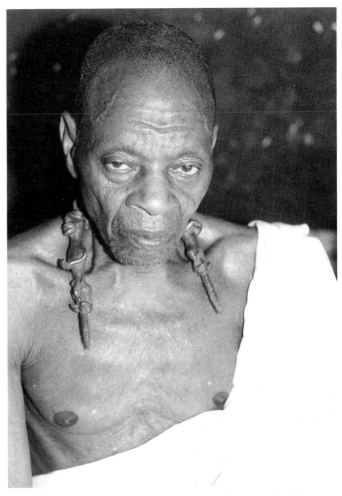

136. *Edan* pair being worn around the neck of an Osugbo elder. They serve as insignias of titled position in the society. Egbado, Nigeria, 1977. Photograph by H. J. Drewal.

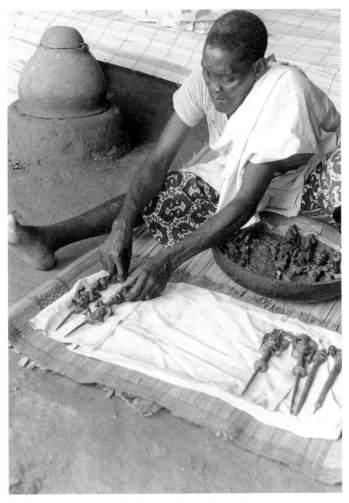

135. The Apena with *edan* laid out before him. The Apena is responsible for carrying out the commands of the Osugbo society, summoning people to the *iledi*, discussing various issues, and offering sacrifices to and protecting the sanctity of the ritual objects in the lodge. Here he is shown displaying *edan* in preparation for a ceremony as part of the annual Osugbo festival. Egbado, Nigeria, 1977. Photograph by H. J. Drewal.

Vultures are essential to any sacrificial offering. They must be present during such rites. At the appropriate moment they should swoop down to devour the remnants, a clear sign that otherworldly forces, especially mystically powerful women known as *eleye* ("owners of birds"), have been placated.

Monkey skulls appear repeatedly. It is significant that such skulls are shown being worn at the back on the belt of the male figure in the interlocking brass pair found at Ita Yemoo at Ife and dated to the Early Pavement Era (see Figure 74). Monkey skulls on belts also occur on a male Osugbo casting and as the simian head with leaves on the stool. Leaves, emerging from a scored ball, are held in a hand on the ring. They are identical to those depicted on a mask belonging to the Oro Society, a group that carries out the orders of Osugbo, including executions and human sacrifices (see Figure 151).

Even more significant is the depiction of the bronze Ijebu-Ode stool on this ring. It is carried by a small figure who is beneath the feet of the figure in full regalia. The marks on the face of the main figure are identical to those on the faces on the stool (Figures 120, 123), as

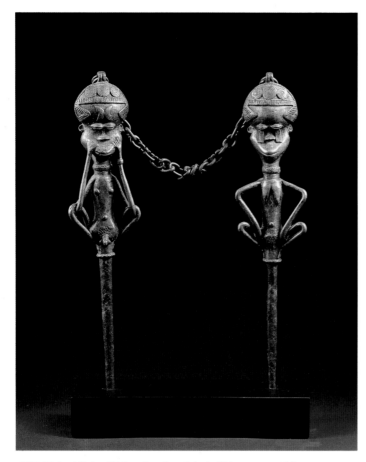

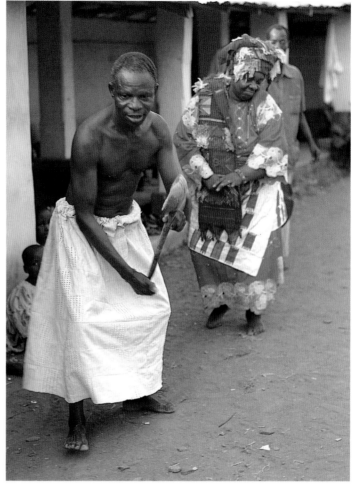

137. Linked Pair of Edan Osugbo, Ijebu?, 19th century. *Edan* are paired and linked Osugbo brass castings on iron shafts, usually figurated as a male and a female. The dramatically displayed posture of the figures, their limbs entwined, emphasizes sexual identities and reinforces the central theme of Osugbo which is the essential need for cooperation between women and men in sustaining society. Bronze. H. 12 in. Eric D. Robertson.

138. The Erelu Olupon accompanied by dancers. The *erelu*, also known as the "Holder-of-the-Spoon," dances in the *iledi* accompanied by the Apena who holds the ritual spoon that is the symbol of her office. Ijebu, Nigeria, 1986. Photograph by M. T. Drewal.

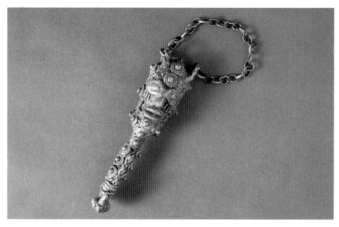

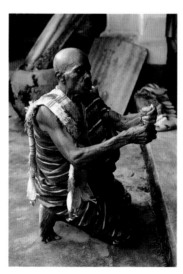

139. Single Edan Osugbo, Obo, Ekiti, 19th–20th century. One from an *edan* pair showing a head and torso with a scorpion near the base. The expressive qualities and embossed surface are distinctive of the Obo style. Bronze. H. 6¼ in. Lent from the Alexandra Collection by Balint B. Denes.

140. The Apena giving a sacred sign. The kneeling position and Osugbo sign is a greeting that communicates respect, obedience, deference, and devotion, as well as blessing. Imosan, Ijebu, Nigeria, 1986. Photograph by M T. Drewal.

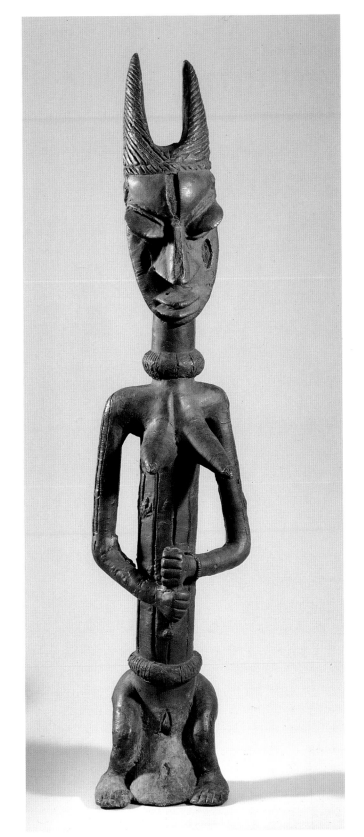

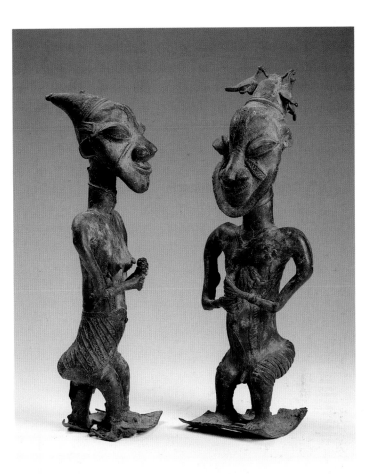

142. Onile Pair of Seated Figures, Ijebu, 18th–19th century. *Onile,* "Owner-of-the-House," a pair of generally large free-standing brass figures of a female and a male, serves an entire Osugbo lodge. Cast at the founding of a settlement and the establishment of an Osugbo Lodge, *onile* symbolizes the original progenitors, the male and female members of Osugbo, and by extension the entire community. They give the Osugbo greeting sign while seated on stools quite similar to that illustrated in Figure 120. Bronze. H. male: 13¼ in.; female: 12¼ in. Dr. and Mrs. Robert Kuhn.

141. Figure of Onile, Owu, 18th century. The female of an *onile* pair gives the Osugbo sign of greeting. Her displayed position straddling a conical mound suggests actions associated with oath-taking. The casting comes from an Osugbo lodge in the kingdom of Owu, just north of Ijebu, and was taken to Iperu about 1840. When Owu was destroyed and its people fled before 1840, several of these sacred objects were saved and carried to other towns. Brass, H. 41¼ in National Commission for Museums and Monuments, Nigeria.

well as those on the face bell (Figure 126). The recurring representations of persons, creatures, objects, and rites in these objects—ring, stool, Olisa's cloth, and the face bell—suggest that all were used in royal rites linked with the Osugbo. In addition, such rings probably served to display the offerings made at these rites— severed heads of departed rulers or those sacrificed to ensure the well-being of the living.[44]

Eyes of Bronze

Another remarkable piece, which was found at Benin yet has a style very different from most Benin casts, may have come from Ijebu. This bronze head was probably intended for display on a royal ancestral altar (Figures 117, 128). Like many Ife and Benin cast heads, this one has a large hole at the top. Around the back are what appear to be beaded braids with crotals (small bells) attached to their ends. The most extraordinary features are the enormous, bulging eyes. Their intensity is transfixing, very reminiscent of the emphasis given to the eyes in Yoruba art generally. An Ife feature is the cross-hatched lines covering the lower portion of the face and upper lip, an area which immediately recalls the face veil on the terracotta mask (see Figure 77) and the area defined by holes on the "Obalufon" copper mask (see Figure 76). Perhaps an actual headdress once surmounted the head—one with a facial fringe to diminish the intense stare of the eyes and to complement the woven covering about the mouth. Holes near the top on both sides suggest that something was inserted or attached.

144. Okooro, the masker that announces and opens the annual water spirit festival, parades through the town surrounded by its supporters. Distinctive *okooro* icons include a delicately braided coiffure and a costume made of a finely woven mat of lagoon reeds. Epe, Ijebu, Nigeria, 1982. Photograph by H. J. Drewal.

Brasses of Rank

Recent archeological work in Ijebu indicates that brass regalia, especially bracelets, armlets, anklets and brass and glass beaded necklaces such as those in Figures 129 to 131 were probably widespread and not necessarily restricted to royalty, priests, or Osugbo members. An excavation near Ijebu-Ode uncovered what was probably the tomb of an early warrior chief or Balogun who came from a royal family at Imupa, Ijebu-Ode. The date of the burial was estimated about 1835. However, the brass regalia seems to have been much older since some of the bells on an armlet had been reattached with string before being placed on the deceased. Perhaps the regalia was inherited from his predecessor, which means that they probably date to the eighteenth century.[45] The bracelet (Figure 129) and two armlets (Figures 130, 131) may date to the same era. They demonstrate the refined and intricate metalwork that must have adorned the bodies of powerful Ijebu persons, whether in life or in death.

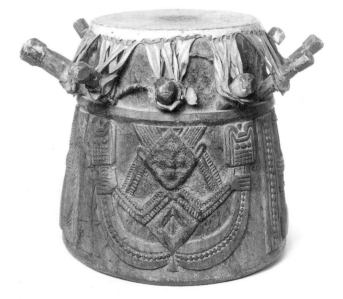

143. Drum, Ijebu, 19th–20th century. The Gbedu drums played for the king. The lead drum, *iya ilu*, has elaborate designs carved around its perimeter, the central motif being a fish-legged figure often identified as Olokun, goddess of the sea. The image shown here is of a figure holding two idiophonic musical instruments. Wood, skin. H. 14½ in. William McCarty-Cooper Collection.

145. An *okenekene* masker has a long headdress representing a fishing eagle in front and *woro* leaves and tendrils at the back. Ijebu, Nigeria, 1982. Photograph by H. J. Drewal.

Staff of Authority

The *ipawo ase* (literally "hand-held staff of authority/life force") in Figure 133 is used by all *alaase*, those individuals who possess and use *ase* on behalf of their followers—chiefs, priests, Osugbo elders, and kings.[46] Some have clappers, others are idiophones whose sound comes from the smaller crotals as they strike each other and the staff. No matter what its source, the sound communicates goodwill and blessing in expressing "so be it, may it come to pass, *ase, ase, ase*!" The owners of such staffs use them only on important ritual occasions, when their actual voices should not be heard (Figure 132). During such times, position is emphasized over person. Those who hold such offices are divinely sanctioned to do so. Thus during rituals proclaiming their rights, the title-holder's individuality diminishes as his/her title dominates. The king's crown with veil masks the ruler's face. So too the *ipawo ase* masks its owner's voice as it creates a sound that is meant to reach far beyond the immediate surroundings to *orun*, the otherworldly realm of gods and ancestors.

The staff of authority here was probably cast for an Osugbo titled elder, the king's representative the

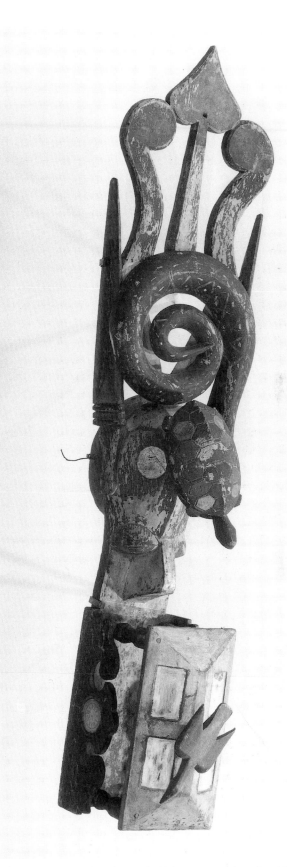

146. Water Spirit Mask, Ijebu, early 20th century. A long headdress worn horizontally is covered in an array of images referring to the world of humans as well as that of the "water people." These are a house, swords, *woro* water leaves, a fishing eagle or *ogolo* who communicates messages from the water people to humans, and a python who is regarded as the progenitor of the other water spirits. This headdress probably comes from the area of Epe or Iwopin on the lagoon. Wood, paint, mirrors, and metal. H. 48½ in. The Fine Arts Museums of San Francisco, Museum Exchange.

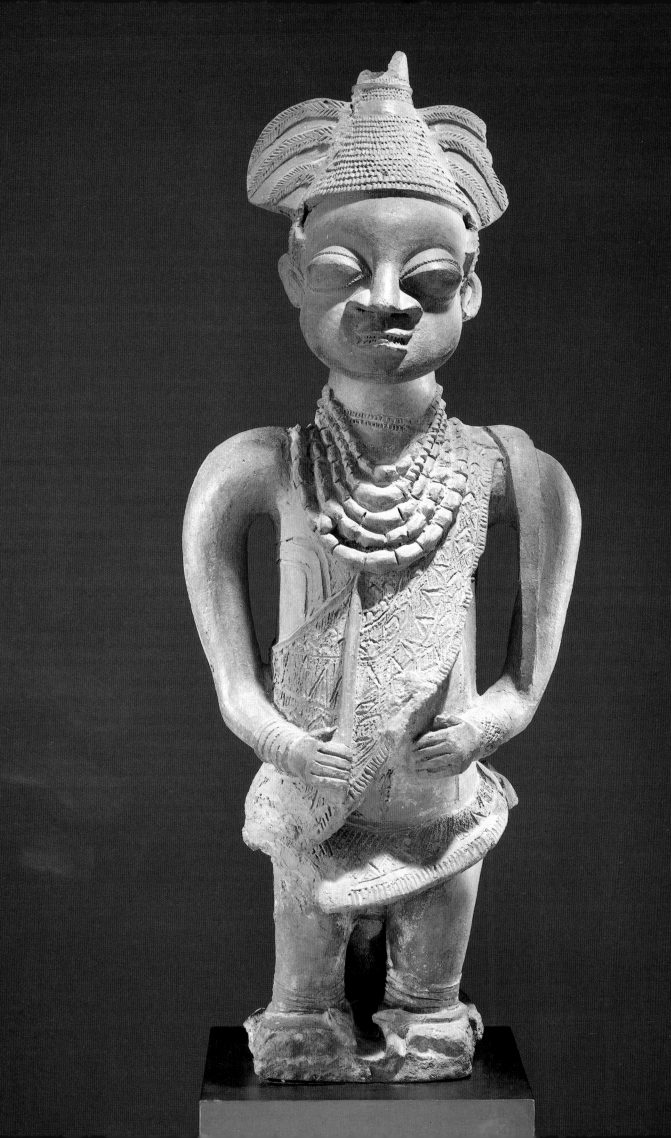

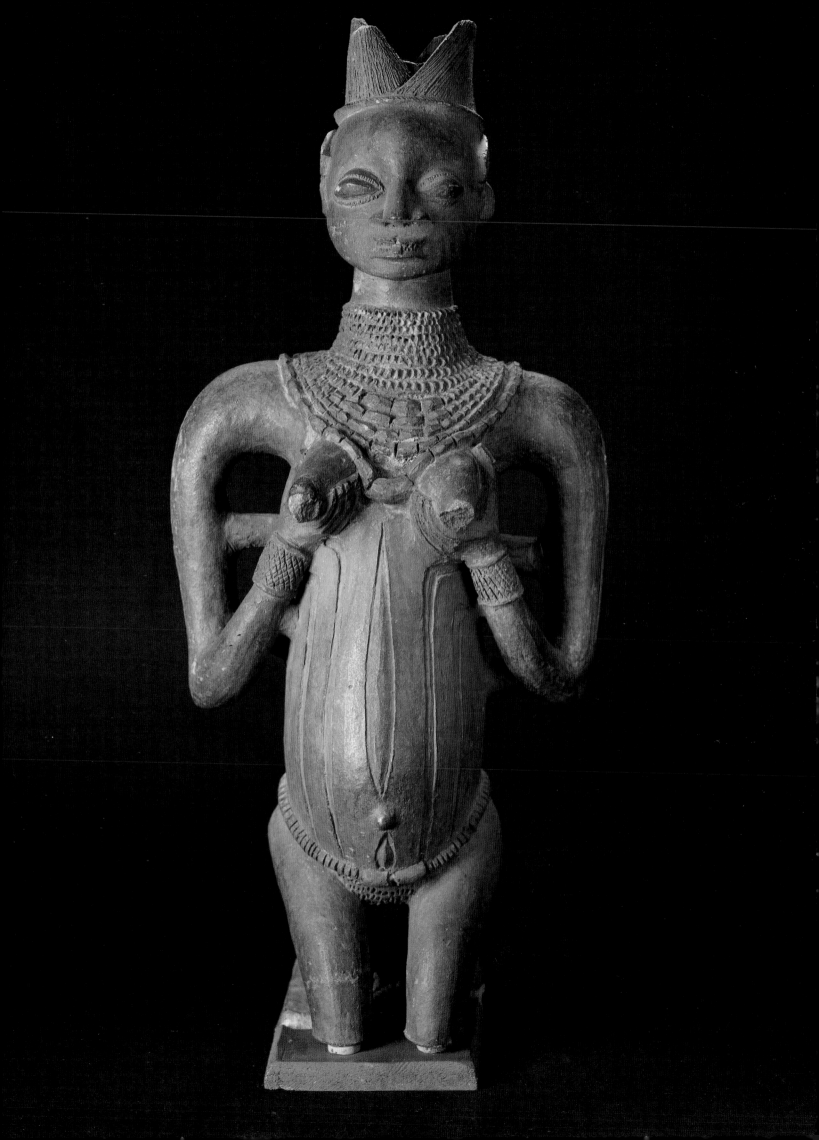

Olurin, "Owner-of-the-Metal." Osugbo double crescent marks are on the forehead, and two mudfish emerge from below the head. In Ijebu, fish-legged figures are ubiquitous on Osugbo *agba* drums, royal *gbedu* drums, and Ifa drums. They are identified as the image of Olokun, goddess of the sea.[47] They also occur on crowns. The bird that crowns the head occurs frequently on the brass objects that are the primary symbols of Osugbo. They may be references to the mystical powers of "our mothers" in transformed state as they are on beaded crowns. They simultaneously acknowledge Osugbo's female and male membership and their role as king-makers.

The imagery as well as the sounds of *gbedu* drums are impressive (Figure 143). The set usually consists of several with an *iya ilu* ("mother" drum), leading the others in musical praises. This set is most often used by kings, but diviners can use them as well. The *iya ilu* usually receives the most elaborately carved decorations. The face in the design is the "face of worship" for those divine forces associated with drums. It is where a token of the sacrifices is placed, and with time this action has obscured some of the facial features. The most important and widespread motif on Ijebu drums for kings, diviners, and the Osugbo is the fish-legged figure. Its prevalence in the arts of leadership among the Ijebu seems to point to Benin, where such figures and Olokun are key royal symbols.[48]

The Osugbo Society

The Osugbo is one of the most important institutions of the Yoruba.[49] Consisting ideally of the eldest and wisest male and female elders in a community, Osugbo decides judicial cases at the capital, serves as an appeals court for village cases, and metes out punishment for all criminals condemned to death.[50] It also controls the selection, installation, abdication, and funeral of kings. The Osugbo thus serves a wide variety of crucial political, judicial, and religious functions. Despite this it remains an enigma. One reason has been the perpetuation of the idea that Osugbo worships an Earth Goddess most often called Onile, which has been translated as "Owner-of-

the-Earth." Recently new data has emerged about the essential nature of the institution and the meanings of its ritual objects—brass castings known as *onile* and *edan* (Figures 134–137, 139, 141–142).[51]

In Ijebu, for example, there is no concept of an earth deity, Earth Mother or "Owner-of-the-Earth." Rather, Ijebu Yoruba conceive of earth as the abode of a host of spirits, such as *imole*, *irunmole*, *oro ile*, including the spirits of ancestors (*osi*). The generic term for all these spiritual presences is *oro*, which may be the origin of the name for another group closely aligned with the Osugbo, the Oro Society. The realm of earth unites all humankind and witnesses everything done by humans. As one priest explains, "Yoruba believe that whoever is in the world is walking on the land . . . and the earth (*ile*) we are walking on combines all of us. And when anyone dies they will be buried in the land. We believe that *ile* is the most senior of all [ancient, pre-existing] . . . so if we ever do bad or anything, we are doing it in the presence of *ile*."[52] Earth spirits, regarded neither as male nor female, dwell in a realm that binds together all the living in the world.[53] These philosophical concepts, together with Ijebu history and social and political organization, provide the context in which to understand Osugbo and its artistic forms.

According to Ijebu, the term *onile* means "owner-of-the-house." It refers specifically to the couple as the original founders of the community, the female and male Osugbo society members, and the Osugbo lodge or "house." Neither the word nor the brass castings have anything to do with an "Earth Goddess," or "Owner of the Earth." Nowhere in the oral literature, Ifa divinatory verses, or lore about the *orisa* in Yorubaland is there a corpus of praises, prayers, stories, myths, rituals, or images devoted to an "Earth Goddess." The concept of an earth divinity has probably never been a central part of Yoruba belief.

Language played a crucial role in obscuring the meaning of the word and therefore the identity of these sculptures, especially for non-Yoruba-speaking scholars. While appearing to be identical, both tone and spelling are different in the Yoruba words for "house" and "earth," a distinction readily understood by a Yoruba speaker, but not so obvious to others. Once the earlier mistranslation of the term *onile* has been recognized, we can begin to understand the large free-standing paired male and female images, known as *onile*, as representations of the co-owners of an Osugbo house, just as the smaller *edan* are seen as representations of female and male Osugbo members. A descendant of an Osugbo Oluwo in Ijebu, and presently the custodian of an *onile*, stated emphatically with reference to his ritual metal object, "You see every *urin* (metal sculpture) in

147. Figure of an Ogboni or Osugbo Chief, Ijebu, date unknown. This terracotta male figure depicts a titled Osugbo elder. He wears the ritual sash, *itagbe*, over his left shoulder, and the beads of office around his neck. His bare upper torso reveals marks associated with Osugbo. Terracotta, H. 30½in. The Paul and Ruth Tishman Collection of African Art, Walt Disney Co., Los Angeles.

148. Terracotta Figure of a Female Osugbo member, Ijebu, date unknown. An elegant kneeling female Osugbo member lifting her breasts in a gesture of generosity and greeting. This work may come from the same workshop or hand as the male terracotta chief in Figure 147 and would have been paired with it. Images of Osugbo elders, formerly in clay and more recently in cement, decorate some lodge courtyards in Ijebu. Terracotta. H. 28 in. The Afrika Museum, Berg En Dal, Netherlands.

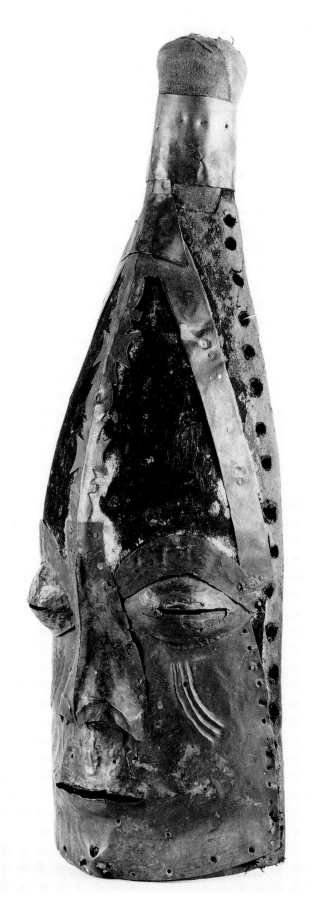

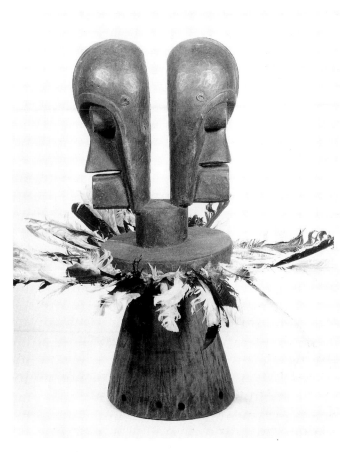

150. Janus Headdress, Ijo, 19th century. A western Ijo headdress with a Janus image in the form of two narrow heads. Feathers, perhaps a reference to the fishing eagle or title-taking, surround a flat, circular platform. Wood, feathers. H. 21¼ in. Peabody Museum of Salem.

twos, one will be male, one will be female. You will never see only one, always two, always màle and female."[54]

The presence of paired images, female and male, is a tangible expression of Ijebu social organization. Ijebu society is based on cognatic descent, or the tracing of inheritance in both male and female family lines. Cognatic descent patterns clearly distinguish the southern Yoruba kingdoms of Ijebu, Ondo, and Owu—and, to some degree, Ife—from northern Yoruba areas. In Ijebu, when candidates for the throne are being identified, preference is given to a child born of a royal woman rather than to one claiming to be the child of a male in the royal household. As the Ijebu explain, one always knows a child's mother but can never be absolutely certain of the father. Cognatic descent often segments lineages into units known as *ojumu*. As evidenced in the migration accounts at Ijebu-Imusin and Ijebu-Ife,[55] paired images brought by the founders are placed in different towns where segments of a lineage settled en route. The theme of female/male duality runs through much of Ijebu history and social thought.

Both *edan* and *onile* sculptures are considered symbols of the Osugbo society. The term *edan* most often

149. Water Spirit Mask, Okitipupa, 20th century. A water spirit mask from Okitipupa with sheet brass on its surface. The tall conical shape may derive from a tradition of water spirit maskers made of cones of cloth and reeds, or perhaps fish traps in the same shape. Wood, brass. H. 22 in. Dr. and Mrs. Robert Kuhn.

137

refers to a pair of relatively small castings on iron spikes that are joined at the top by a chain (Figures 134, 137, 139; see also Figure 42). *Onile*, on the other hand, refers specifically to a pair of generally larger free-standing brass figures (Figures 141, 142). Both terms are used in the singular, since each pair (a female and a male) is viewed as one object—a concept that is central to Osugbo.[56]

The Ijebu sometimes use the term *edan* and *onile* interchangeably, saying that an *onile* is simply a large *edan*. Usually, however, they make a clear distinction between them based on relative spiritual power. Although it is considered an *edan*, *onile* theoretically should be large because it is shared by an entire Osugbo lodge: "the *onile* is to the *edan* as a wall clock is to a wristwatch." The size of an *onile*, it is explained, depends on "how the Osugbo can afford the expense." The *edan* is more personal, serving specific roles for individuals and having specific meanings depending upon its intended use. An *edan* is made for an Osugbo member usually at the time of initiation into the society. Both *edan* and *onile* are considered *irin* or *urin*, a generic term in Ijebu dialect for something made of metal, whether iron, brass, or both.

The Osugbo meeting house, *iledi* (*ile-odi*, which means literally "house with inner sanctum,") is a secured earthen building with a large courtyard, sometimes an enclosed smaller yard in which grow trees and shrubs, and an inner sanctum (*odi*) that holds the primary ritual objects of the society.[57] As a symbol of the entire community, the *iledi* is, according to Ijebu land law, a public building on public land. Such public property was traditionally limited either to shrines for community gods or to meeting spaces.[58] In the *iledi*, members sit on shrines (*osi*), each named after one of the *iledi* titles and the original founders of the town and its governing institution (see Figure 19).[59]

Directing the affairs of the society are four other titled elders: the Oliwo, Apena, Erelu, and Olurin. The Oliwo ("Leader/Head-of-the-Secret-Pact"), serving as a convener, presides over meetings. The Apena (literally "Caller-of-People") is responsible for carrying out the commands of the society, summoning people to the *iledi*, discussing various issues, offering sacrifices to, and protecting the sanctity of the ritual objects in the lodge (Figure 135). The female title-holder is known as Erelu, while other women members of Osugbo may have titles such as Otun Erelu, meaning literally "Right Hand Erelu," and represent the women of the community. The Erelu is also known as Olupon, ("Holder-of-the-Spoon"), because the use of the Osugbo ritual spoon is her prerogative (Figure 138).[60] Finally, the Olurin is the head of the town, whether chief or king. Traditionally the ruler did not attend Osugbo meetings.

Instead an individual, elected by the Osugbo, represented the ruler. Olurin means "Owner-of-the-Metal," a specific reference to the metal ritual objects, *edan* and *onile*, that symbolize the founding of the settlement and the Osugbo lodge.

Both *edan* and *onile* are the responsibility of the Apena and Olurin, or others who have been designated to guard them. At the time of the founding, the elders commissioned an *onile* to be made and conducted elaborate rites to infuse spiritual power into the forms. Then all Osugbo members gathered before the *onile* to swear an oath (*ibura*) of truthfulness and secrecy in all their deliberations.[61] As the custodian of one *onile* explains, "it has the most *ase* because it is the thing that combines all of the members together. . . It is a symbol of unity." Both the *edan* and the *onile* are prepared with "medicine," but *edan* "have only a small amount of *ase* for the usefulness of the Apena and to pray for the other Osugbo members," whereas the *onile*, either cast at the founding of a town and an Osugbo lodge, or carried to a site by immigrants to "unite" all members past, present, and future, possesses enormous, accumulated power.[62] It is kept in the sealed and guarded inner sanctum in the *iledi* and is only seen by those responsible for its care, and even then, only after certain ritual precautions have been taken.[63]

Two fine *onile* demonstrate the power of Ijebu casting. In Figure 142, the couple, seated on stools of authority, arch their strong backs as they salute with the Osugbo sign. Birds crown the head of the male, a horned coiffure the head of the female. In Figure 141 is the female of an *onile* pair with an impressive history. It comes from an Osugbo lodge in the kingdom of Owu, just north of Ijebu. When Owu was destroyed and its people fled before 1840, several of these sacred objects were saved and carried to other towns. This one had been taken to Iperu and another to Apomu. In one account at the Ogboni lodge at Ede, the female figure of another *onile* pair is said to have been brought there about 1830 by the king's wife from her hometown of Owu.[64] Other female figures and one male are now in the Nigerian Museum (LG. 65.4.53; LG. 50.11.32; and LG. 61.5.10). These various accounts document the importance of carrying images to new settlements and

151. Magbo Headdress, Ijebu, 20th century. A mask known as Magbo is used during annual Oro festivals. The profusion of images evokes the momentous communal responsibilities performed by Oro. All walks of life are portrayed, including a prisoner, a nursing mother, a preacher, a man playing a concertina, a colonial soldier, and a palmwine tapper. Floral and scroll motifs recall Brazilian baroque imagery introduced into Lagos and Ijebu by repatriated Yorubas in the late nineteenth century. This mask was carved at Ikorodu, possibly by the master Onabanjo, nicknamed Konkorudugu, from Itu Meko quarter. Wood, pigment. H. 28⁵⁄₁₆ in. Indianapolis Museum of Art, Gift of Harrison Eiteljorg.

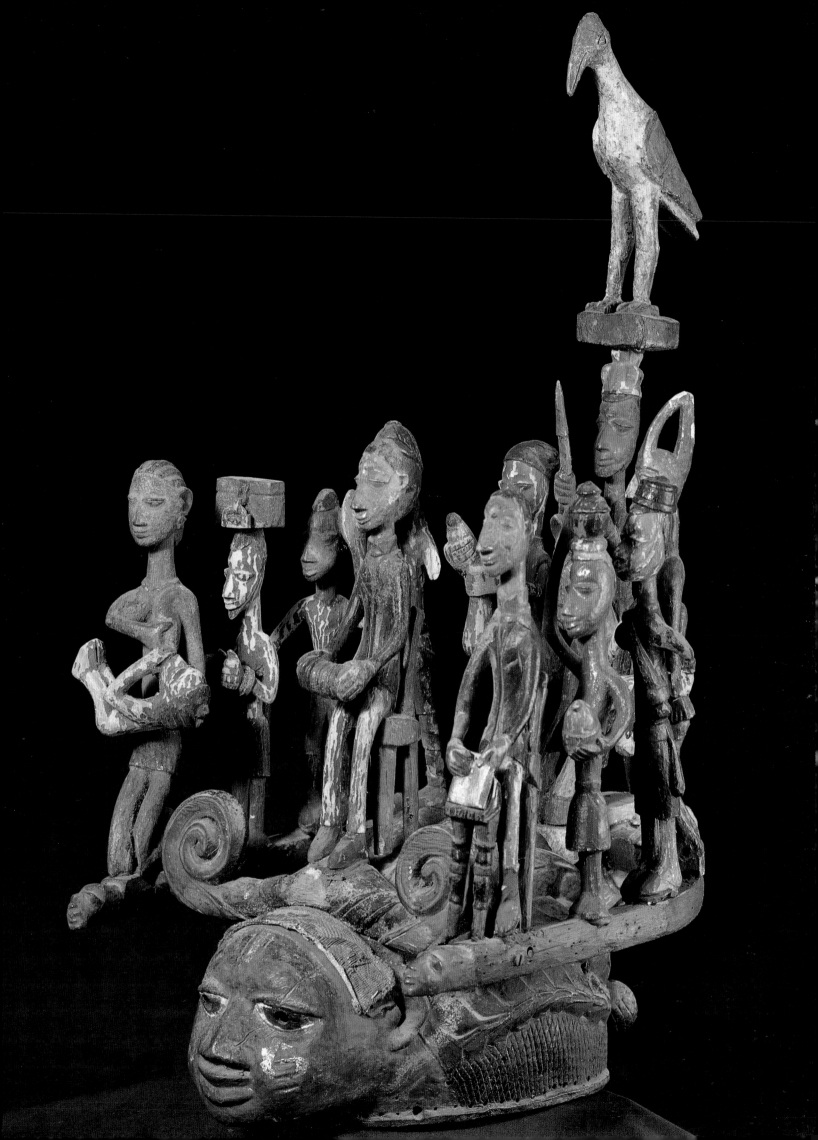

point to their significance as symbols of community and the establishment of Osugbo lodges.

Edan, like *onile*, serve a variety of important purposes but, unlike *onile*, can be seen openly and serve as public emblems of the omnipotence and omnipresence of Osugbo. Being portable, they are carried in public by Osugbo members, both as insignia of office, as messages, and as protective amulets. When worn by Osugbo members, they are draped around the neck and suspended downward on the chest (Figure136). When carried in festivals or other ceremonies, they are kept in a special woven mat bag called an *apo akurodun* by those responsible for Osugbo metal objects.

Edan constitute the commands of the Osugbo members. Thus an appointed messenger holds the *edan* in his two hands and strikes it on his forehead and chest before the summoned individual. The recipient of an Osugbo order in turn holds the *edan*, strikes it on his forehead and chest in acknowledgement of the society's authority.[65] In some instances, the Apena or his surrogate places the *edan* across the path or at the entrance of a farm to prevent disputants in land cases from entering while the issue is under discussion. A violation of this sanction could bring a stiff fine or supernatural retribution.[66] In other civil or criminal matters, the Osugbo can impose a form of "house arrest" or injunction by placing the *edan* across the compound entrance of the accused—the person within cannot leave, nor supporters enter, without permission from the Osugbo.

The *edan* announces other functions, for it can curse and destroy as well as bless and protect. As one Osugbo member explains, "they can pray with it and the prayer will come true, and it is the same with a curse because they have made it strong. *Edan* have the power to kill someone." If Osugbo determines that someone must die, the *edan* is thrust into the ground. The society performs sacrifices, announces the name of the individual to be killed, and pushes the *edan* over, "which means the downfall of the person. . . the person will fall over and die."[67] The ritual objects of Osugbo symbolize momentous decisions, powerful invocations, and efficacious acts. It is also significant that *edan* are joined at their heads—the site of the spiritual essence of a person—connoting a sacred bond evocative of the oath or pact shared by all male and female Osugbo members.

The emphasis on sexual attributes in many *edan* and *onile* and the theme of the couple convey the mystical powers of procreation. Males display themselves, females dramatically present their clitorises (see Figures 137 and 141). If, as the data suggest, these figures witness the most momentous of oaths, such imagery is

most appropriate. According to the Yoruba, the most powerful curse or invocation a woman can utter is done in kneeling position while nude, her clitoris exposed—just as depicted in many female *onile* and *edan* figures.[68] Even when *edan* depict heads on stems, female and male genitals still appear—a visual reminder of the importance of the couple. In initiation rites, the unclothed novice is washed by the Oliwo in the presence of other Osugbo members who are themselves nude. Similar procedures continue today where all Osugbo members and guests must remove footwear and bare their chests or shoulders before entering the lodge. Such acts connote honesty, openness, humility, and reverence. They communicate that no secrets will be kept among the membership and, at the same time, that no secrets will be revealed to outsiders.

Posture and gesture convey the solemnity of Osugbo ritual (Figure 140). The kneeling position captures a traditional Osugbo (and Yoruba) form of greeting. It communicates respect, obedience, deference, and devotion as it brings one in closer contact with the earth.

A uniquely Osugbo gesture is placing the left fist over right fist, thumbs concealed, in front of the abdomen.[69] The complex meanings of this sign are, at present, only partly understood. Some explain it as a greeting that stresses the restricted and hidden information—the concealed thumbs—shared by Osugbo elders. The gesture also represents the blessing and prayer, "may you live long and prosper," (*agbo, ato*). It can also be a supplication. A Yoruba, who feared he had offended a powerful priestly elder at Ipara, Ijebu, quickly fell to his knees and made the Osugbo gesture before the elder, striking his fists together three times. The elder's anger soon dissipated. The supplicant's show of respect and humility had averted a dangerous situation.

The placement of left fist over right signals the dominance of spiritual, sacred matters. The prominence of the left is of great symbolic importance in Osugbo and Yoruba ritual. Greetings among members are with the left hand; members must step three times with their bare left foot before entering the lodge, dance to the left during ceremonial performances, wear bracelets on the left wrist, have pigmented scarifications on their left wrists, position ceremonial sashes (*itagbe*) on their right shoulders during rituals to free their left hand for action, and pass to the left of displayed *edan* in the lodge, bowing or kneeling three times before proceeding to sit down. In non-Osugbo sacred contexts, the left hand is

152. Janus Headdress, Ijebu, 19th–20th century. The two hornlike projections are braids similar to those on other water spirit masks. They recall the coiffures of priests, queens, and elders in Ijebu. Wood. H. 24 in. The Metropolitan Museum of Art, Fletcher and Rogers Funds, 1976.

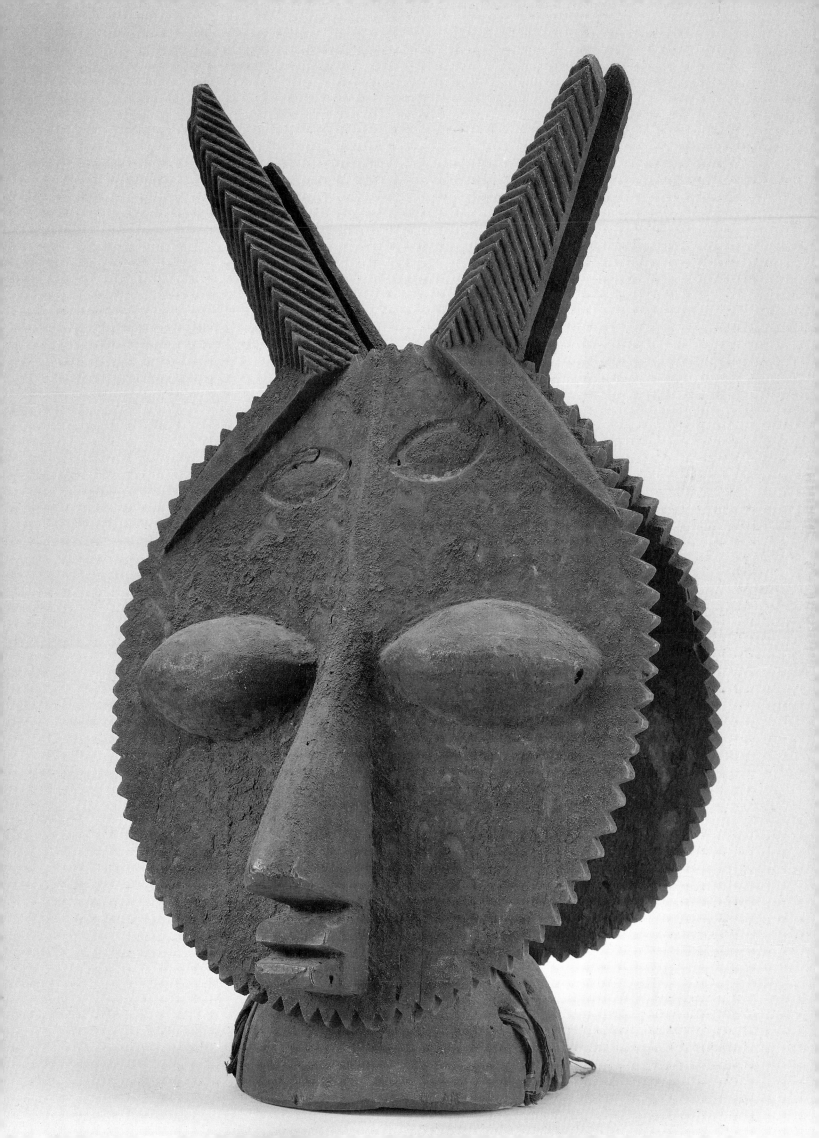

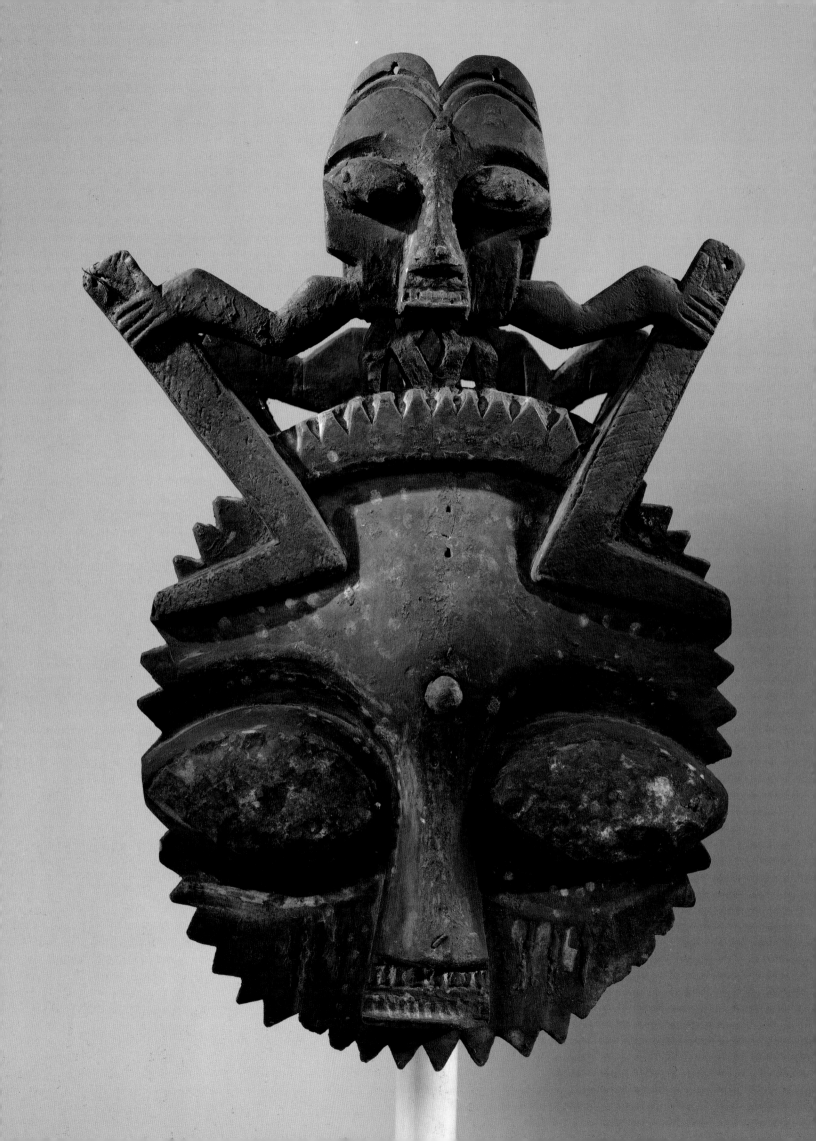

used in greetings between possessed devotees and congregations during trance episodes in honor of Yoruba gods. As one elder explains, "the right is used by humans; the left is for the gods." The left has no connotation of weakness, uncleanliness, femininity, or evil. Rather it emphasizes what is sacred, and therefore potentially dangerous.[70]

The Terracotta Couple

The theme of a female and male couple persists throughout Osugbo iconography.[71] Among the most impressive are remarkable terracottas such as the pair shown in Figures 147 and 148.[72] The male depicts a titled elder, his *itagbe* over his left shoulder, his beads of office around his neck, his upper torso bare, revealing the marks associated with Osugbo. His feathered and beaded headdress may signify the king's representative in Osugbo, the Olurin. His seated position on a stool, similar to the Ife stone stools and the Ijebu bronze one, further suggests the Olurin. In many Osugbo lodges, only the king's representative sits on a stool, all others sit upon traditional mats.

His mate (Figure 148) is an elegant figure of a kneeling woman lifting her breasts in a gesture of generosity and greeting. The image may relate specifically to the cognomen for Osugbo members as *omo iya* ("children of the same mother"), evoking the sacred bond or pact that unites them. Her neck is bedecked in multiple strands of beads while only a single strand of body beads encircles her hips. Her bare body with Osugbo scarifications expresses openness, honesty, and respect in the presence of ancestral and divine forces. The horned coiffure signals a head endowed with power. This motif frequently appears in *onile* castings as well (see Figure 141), and is associated in Ijebu with priests of the gods such as Oduduwa, Eyinle, Osossi, and Osun, and high-ranking women. It also appears on masquerade headdresses, and it is depicted on the royal ancestral staff (*okute*) representing Soko, a queen of Idowa.[73]

The Oro Society

The Oro society is closely related to Osugbo; it is responsible for enforcing the penalties assessed by the Osugbo in their judgments, meting out fines, confiscating forfeited goods, punishments, and carrying out sentences of death in the most serious cases such as those involving capital crimes. The Oro are also at the center of all burial procedures in the community, whether for

153. Janus Headdress, Ijebu, 19th–20th century. Janus headdress with metal covering its enormous eyes. Truncated and abstracted figures at the top grasp crooked staffs. The angularity of volumes and depiction of teeth in square, projecting mouths reveal the influence of the Ijo sculptural style. Wood, pigment, metal. H. 20 in. John Giltsoff.

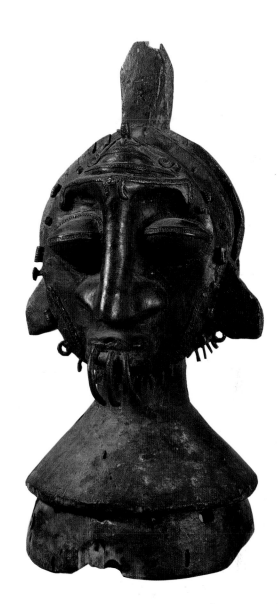

154. Janus Headdress, Ijebu, 19th–20th century. Ijebu Janus headdress with bronze faces mounted on a wooden support. The teeth, rarely shown in Yoruba art but a prominent feature in Ijo art, are rendered by metal loops. Another water spirit headdress photographed in Ijebu also has metal-covered faces and teeth identical to these. The metal may be used in part because of its overseas source and its relation to Europeans, who are viewed as water beings associated with water spirits. Bronze. H. 13½ in. Ben Heller.

rulers, chiefs, priests, or commoners. In all these important matters and like the Osugbo, Oro's work must be carried out in secret to protect its members from sociopolitical pressures and the potential retributions of its opponents.

Because of the restricted visibility of Oro, artwork associated with it is rare and little understood. One of Oro's key symbols, the bullroarer called *aja Oro* ("dog of Oro"), can be seen on a marvelous Osugbo lodge door from Ijebu (see Figure 124). In the second register from the top, the *aja Oro* is held in the mouth of an antelope who also grasps *iyeye* leaves like those held by the creatures on the bronze stool from Ijebu-Ode. Below, two *aja Oro* appear attached to cords and

whirled in the air by two figures. The sound of the bullroarer, like the deep and resonant sound of the Osugbo drums, is both awe-inspiring and ominous. It signals that Oro is about to begin its work and requires that all strangers, women, children, and uninitiates leave the town or lock themselves inside and close all shutters so that the Oro and Osugbo members can carry out their assignments undisturbed.

Another Oro form, in sharp contrast to the cryptic bullroarer, is a mask headdress known as Magbo (Figure 151).[74] The profusion of images that crown its superstructure speak of the communal responsibilities performed by Oro. All walks of life are portrayed. They include a prisoner carrying a load, mother nursing, preacher with his scriptures, man playing an accordion, colonial soldier, elder with his cane, palmwine tapper, and equestrian warrior whose headgear is surmounted by an enormous crested bird with long, curving beak. They stand on a U-shaped platform whose ends are human heads. Below them, the elongated head of the mask is crowned with what appears to be a garland of leaves over plaited hair. Another floral motif projects backward under the equestrian figure. These and a double scroll that crowns the main face of the mask recall Afro-Brazilian baroque imagery introduced by repatriated Yorubas in the second half of the nineteenth century.[75] Such motifs came to dominate architecture and other arts in Lagos, Ijebu, and especially Ikorodu town. This mask may have been carved by the master Onabanjo, nicknamed Konkorudugu, from the Itu Meko quarter of Ikorodu.

The clustering of a myriad of separately carved figures is typical of Ijebu Oro headdresses as can be seen in a fantastic ensemble kept in an Osugbo lodge in central Ijebu. It depicts strange and wonderful sights—masquerades of all types, bird-bodied women, copulating figures, soldiers and prisoners—all rising in a three-tiered cone, topped by the image of a king in his beaded regalia and shielded under his umbrella with a bird finial. The all-encompassing nature of this repertoire proclaims Oro's involvement in all social, political, judicial and spiritual matters. The imagery may be entertaining, but its underlying message is that "what goes around, comes around"—or all things will eventually come to light. Positive actions and contributions will be recognized and praised, antisocial ones will be exposed and punished. Nothing escapes the notice of Osugbo and Oro as the judges and law-enforcers in most parts of Yorubaland. While both male and female Osugbo elders make such judgments jointly and although there are also female members of Oro such as Iya Oro ("Mother of Oro"), women who are not members must not see the masquerades when they swarm through the town during annual Oro festivals. Men, not women, are responsible for executing the decrees of Osugbo.[76]

Water Spirit Images

Among the Ijebu, children born through the intercession of water spirits are known as *omolokun* ("children of the sea," see Figure 21) or *elekine* ("children of the water spirits"), and are praised in verse: "Children of the sea with shells on their heads/Rulers today, rulers tomorrow, rulers forever/Fire on the head that water quenches."[77] Their thick, tightly curled hair is likened to seashells. An elaborate program of masquerades celebrates the role of water spirits who give birth to such children and affect the welfare of Ijebu coastal communities.[78]

Benin influence in Ijebu arts has not been the only influence from Ijebu's eastern neighbors. Ijebu's ports on the lagoons along the coast served as entries for the exchange of goods, ideas, and arts. The lagoons connected them with the vast Niger Delta and its peoples, especially the Ijo, who are renowned for their Ekine masquerades in honor of the "water people" (*owu*)—spirits that "own" portions of lagoons and creeks, controlling their water level, currents, waves, and the depth of their fish shoals.[79] It was from the Ijo that the Ijebu adopted and adapted masks which they call Agbo or Ekine.

The mask that announces the start of the Agbo festival is called *okooro*. *Okooro* masquerades come in the form of elegant, elaborately coiffured women draped in finely woven mats, often with a single, long braid of hair, or sometimes two ascending to look like horns. The finely woven mat is associated with coastal reeds, fishing traps, and therefore water spirits.

To the accompaniment of songs and the rhythms sounded on an instrument called *ike*, made from a hollow tortoise shell, *okooro* parades through the town, greeting the king or chief, elders, and other important persons in the community (Figure 144). She prays and makes offerings at certain shrines before moving to the waterside to call to the water spirits to come and visit their human hosts who are about to honor and entertain them with songs, dances, and a wide variety of masks.

A long water spirit headdress worn horizontally is covered in an array of images referring to the world of humans as well as that of the "water people" (Figure 146). On the projecting snout is a house, its sides decorated with inset clock faces, its roof with mirrors and a bird. The bird is probably a reference to the fishing eagle, or *ogolo*, who, according to the Ijo, communicates messages from the water people to humans. The

mirrors evoke the reflective surface of the water, the threshold of the watery realm of the spirits. According to Ijebu and Ijo accounts, these spirits live in fabulous houses beneath the seas, like those of prosperous humans.[80] The coiled serpent is a python who is regarded as the progenitor of the other water spirits. The two swords flanking the python are used at the outset of the festival to sacrifice a tortoise in preparation for the arrival of the maskers.

At the back of the headdress, two scroll-form tendrils surround the representation of a *woro* leaf. These leaves appear in profusion near the waterside just before the time of the festival, a propitious sign of blessing from the spirits. Actual *woro* leaves are often attached to the headdress before the performance. The scrolls, while evocative of water plants, seem to have been influenced by Afro-Brazilian baroque decorative motifs. Elements of this architectural style can also be seen in the posts and panels of the mask house. Additionally, they may also evoke the curly locks of hair on the "seashell" coiffures of "water children." This headdress, which probably comes from the area of Epe and Iwopin on the lagoon, is very similar to ones called *araromi* and *okenekene* (Figure 145).

Janus Images

While some Agbo masks are horizontally oriented to evoke the image of spirits as they float on the surface of the water, others are vertical in composition. They may derive from western Ijo headdresses that influenced Bini water-spirit masks (known as *igbile*)[81] at Ughoton and another from the Yoruba lagoon town of Okitipupa with metal covering its surface (Figure 149).[82]

A number of western Ijo headdresses include a Janus image (Figure 150). Such forms may have inspired a group of Ijebu Janus headdresses (Figures 152–154). The use of metal in images for water spirits seems to be widespread. Many Ijo pieces have eyes covered in metal along with other metal attachments. This treatment also appears in this Ijebu Agbo Janus headdress whose entire face is metal and whose teeth are rendered by metal loops.[83]

The presence of metal in some of these water-spirit images may be partly because the metal is European, imported from across the seas beneath which the spirits live. Europeans themselves, being from overseas, are regarded in much African and specifically Ijo lore, as water beings associated with water spirits.[84] Imported items, such as cloth and metal, are thought to be preferred by water spirits among the central Ijo. A rumor in one town was that the true emblem of the water spirit Eleke was "a brass mask kept secretly inside the cult house." Two other brasses, one a beautiful face and one ugly, are displayed at annual festivals at Lobia.[85]

Perhaps these are related to a bronze mask thought to be Ijo.[86] Brasses at the western Ijo town of Oproza are considered to be water spirit masks.[87] They were reportedly seized from the Water People who had used them as masquerade headpieces. The bell-shaped form of some of them recalls the *igbile* headdresses of the Edo at Ughoton and the Okitipupa mask covered with metal.

These water spirit masks attest to Ijebu's intimate relationship with the spiritual entities inhabiting the coastal waterways that were essential to Ijebu's commercial success. In moving artistic displays they gave temporary form to eternal forces, beings from the deep.

The rich diversity of Ijebu forms demonstrates the willingness of the Ijebu to incorporate and transform arts from others to serve their own social and cultural objectives. In this they emulate the strategy of their key symbol—the chameleon—and are able to forge a distinctly Ijebu identity and ethos.

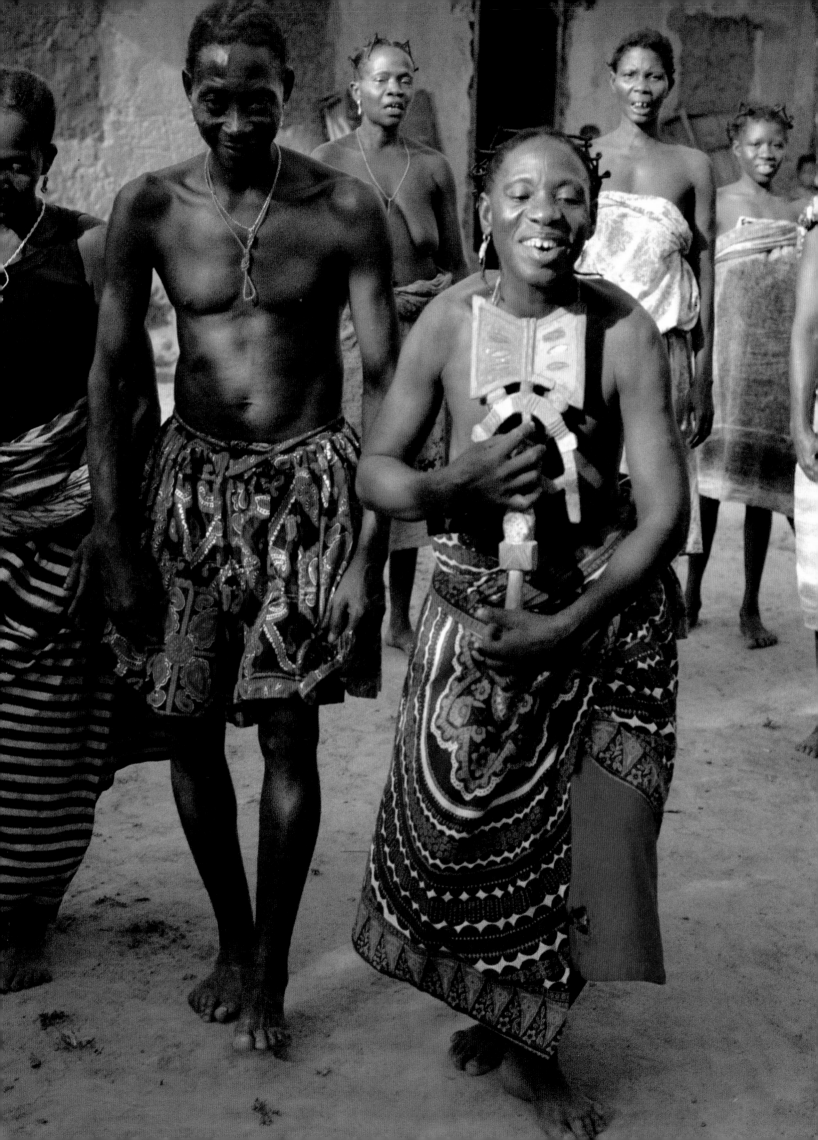

The Oyo Empire

John Pemberton III

One of the most remarkable periods in Yoruba history was that of the Oyo Empire. From about 1680 to 1830 the capital city of Oyo-Ile (Old-Oyo), and its king the Alafin were a powerful presence shaping the course of events for almost all of the Yoruba subgroups and their foreign neighbors (Figure 156).

From at least the thirteenth century Ife had been looked upon by the Yoruba as the *ile* (home) of the Yoruba people and the Oni (the king of Ife) as "the father" of all Yoruba *obas*. But with the conclusion of the wars with the Bariba and the Nupe and the resettlement of Old-Oyo early in the seventeenth century, the Oni's claim to paternal authority began to be challenged by the Alafin of Oyo-Ile. The invasions of the Bariba and Nupe entailed the movements of people into the region of Oyo-Ile and the establishment of outlying towns that would form the nucleus of Oyo's new political power.[1]

The capital city appears to have been a confederacy of *idile* (lineages), organized into wards, which were led by *oloye* (chiefs) and *baale* (titled elders).[2] The chiefs of seven of the nonroyal lineages had inherited titled membership in the Oyo Mesi, a council of chiefs whose power rested in their right to confirm or deny candidates for the throne and, in extreme situations, to require a king to renounce the throne and commit suicide. They shaped policy that affected the internal life of the city and voiced their approval or disapproval on matters of state. Each of the chiefs was also the patron of one of several religious cults, whose devotees from various lineages gathered regularly at the principal shrine of their *orisa* in the compound of the chief. The Oyo Mesi, therefore, represented a definition of Oyo as a confederation of lineages both in matters of governance and of worship. While acknowledging the role of the Alafin, they adhered to the principle of decentralized authority.

In contrast, the Alafin was alternately chosen from Oyo-Ile's three royal wards composed of those lineages that traced their descent from Oduduwa or Oduduwa's son, Oranyan. The Alafin represented another principle of political organization, namely, the centralization of authority in the *ade* (crown) of the *oba* and in the royal court. It was the Alafin who possessed supreme judicial authority, who controlled the succession of chiefly titles and who, when he wore the veiled crown, was acknowledged to be *ekeji orisa*, meaning "next to" or "like unto the gods" of the Yoruba pantheon. Under his authority was an elaborate court organization that included palace slaves or eunuchs, whose leaders were in charge of judicial, religious, and administrative matters; slaves who served as bodyguards, messengers, and collectors of taxes; and "titled officers" who fulfilled various administrative and ritual functions.[3]

According to oral traditions, once the Bariba and Nupe threat from the north was ended, the struggle for power between the Alafin and the Oyo Mesi shaped the political life of Oyo-Ile.[4] Indeed, one of the principal factors in the development of the empire was the royal court's need to establish authority over towns outside of Oyo from which to receive revenues and man-

155. A Sango possession priestess dancing with her *ose* Sango dancewand, the emblem of her lord, whose power is evidenced in thunder and lightning. Ohori, Nigeria, 1975. Photograph by H. J. Drewal.

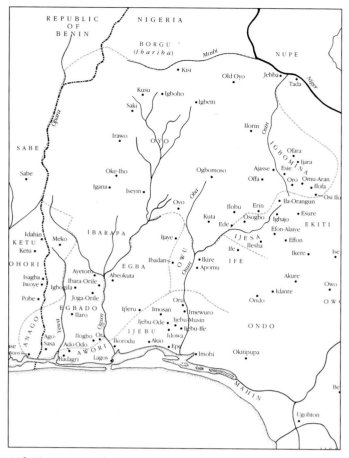

156. The Oyo Kingdom at its greatest extent, around 1780, according to R. Law 1977.

power, resources over which the Oyo Mesi had little or no control. This was achieved by the employment of cavalry, which the Oyo adopted from the Bariba and Nupe, against which many Yoruba towns were defenseless. Once the northern area around the capital had been consolidated early in the seventeenth century, successive Alafin met the potential threat from Benin by establishing their authority, or at least a presence, among Ijesa, Igbomina, and some Ekiti towns to the east.[5] However, the extension of the Alafin's suzerainty to Ondo and Idanre was unsuccessful, in part due to inhospitable terrain for cavalry maneuvers.

The next move on the part of the Alafin was to the south, carefully bypassing Ile-Ife. The kingdoms of Owu and Ijebu were well-established powers in their own right, and even though the nineteenth-century Yoruba historian Samuel Johnson claims that "from the days of Sango [son of Oranyan] they have been very loyal to the Alafin of Oyo,"[6] court traditions suggest that Owu was as an ally or friend closer to Oyo than Ijebu and that Oyo may have on one occasion asserted an influence on, without fully dominating, the internal politics of Ijebu-Ode, the capital city of the Ijebu Yoruba.[7] Indeed, it was the kingdom of Benin that exerted the greatest influence among the Ijebu in the sixteenth century, while Oyo's greatest influence was

among the Egba in the south. Egba was called "an off-shoot of the Yorubas proper" (*i.e.*, Oyo), having been settled by *Eso* (war-chiefs) of Oyo during the campaigns of Oranyan, the founder of Oyo.[8] There is no doubt that some northern Egba towns were founded by Oyo settlers in the early seventeenth century, but Egba traditions claim that the Alafin was the youngest child of Oduduwa and was still a minor when Oduduwa died. His brothers, who were kings of other Yoruba towns, gave the child gifts to enable him to support himself, a tradition that continued. Later Alafin, however, chose to look upon the gifts as tribute and required them "as a matter of right."[9]

In the second half of the seventeenth century the royal court at Oyo-Ile extended its authority into areas of the Egbado and Anago in the southwest, and to a somewhat lesser extent among the western peoples of Ketu and Sabe. By the beginning of the eighteenth century formal rule was established among Yoruba peoples, and Oyo and its Alafin could claim an empire encompassing 18,000 square miles and perhaps a million people.[10] The stage was set for Oyo's conquest of Dahomey (1726-30).

For the next fifty years the Oyo Empire dominated the lives of northeastern, central and southwestern Yoruba peoples and made its presence known in other parts as well. The organization of the slaves of the royal court, whose positions at times were of greater importance than those of many lineage chiefs in Oyo-Ile, enabled the Alafin to supervise closely the administration of the empire. Some areas were colonized, especially among the Egbado. Where long established local kingdoms existed, the capital received annual tribute or recognition through the exchange of gifts and assistance in times of war. For the most part the empire was a confederacy of *ilu-alade* ("crowned towns") and trade centers that acknowledged the primacy of the Alafin of Oyo-Ile. As in the relationship between the Alafin and the Oyo Mesi in the capital city, the same conflicting principles of political organization characterized the relationship between the royal court and the provinces: centralization of authority versus allegiance to local communities. So long as there was a strong figure at the center, such as Alafin Abiodun (reigned 1774–1789), the empire was held intact. But once the struggle for power between the Oyo Mesi and the Alafin in Oyo-Ile reasserted itself, the ephemeral greatness of the Oyo Empire was revealed. With lesser figures on the throne the center collapsed; and within forty-five years of Alafin Abiodun's death the capital city would no longer exist. The empire as a political phenomenon was over, but a powerful cultural legacy continued for another century or longer.

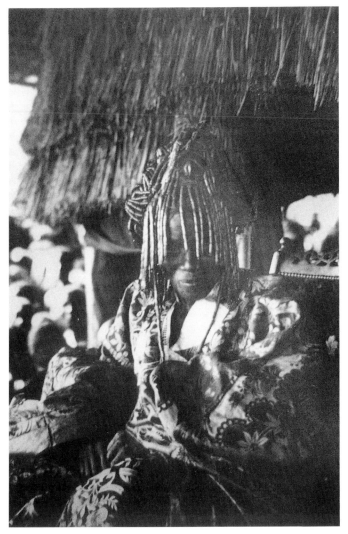

157. Alafin Lawani (1905–1911), King of Oyo. "Photographs of Nigeria 1907-1912." Foreign and Commonwealth Office, Library and Records Department, London. Photograph by C. T. Lawrence.

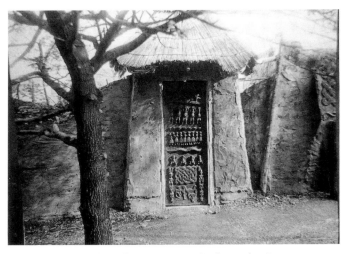

158. A door from the palace at Oyo on display at the Commonwealth Exhibition, Wembley, England in 1924. Foreign and Commonwealth Office, Library and Records Department, London.

The Capital City

We are fortunate to have an eyewitness description of some aspects of Oyo culture shortly before the destruction of the capital city. In 1826 British explorers Captain Hugh Clapperton and Richard Lander visited Oyo-Ile and were cordially received by Alafin Majotu. Clapperton was far more interested in establishing a route from the coastal city of Badagry to Soccatoo than in the cultural life of the people whom he met on his journey. Nonetheless, his journals provide a good deal of information about the political life of the western and northern "Yarriba" as he called them, in the years 1825 to 1827, including references to Oyo towns plundered by the "Fellatahs" (*i.e.*, Fulani) armies. There are occasional glimpses into other aspects of Yoruba culture, including a few that are of importance to the art historian. In one entry, for example, Clapperton writes that:

> The people of Katunga [the Hausa term for Oyo-Ile] are fond of ornamenting their doors, and the posts which support their verandahs, with carvings; and they have also statues or figures of men and women standing in their court yards. The figures carved on their posts and doors are various, but principally of the boa snake, with a hog or antelope in his mouth; frequently men taking slaves, and sometimes a man on horseback leading slaves. [February 13, 1826].[11]

In other passages, Clapperton refers to the king's female attendant who held "a handsome carved gourd, having a small hole covered with a clean white cloth, to hold his majesty's spittle, when he is inclined to throw it away," and he describes the king's gift to him of a "black ebony [gooro nut] box, carved in the shape of a tortoise."[12] He often refers to the high value placed on coral imported from the coast for use by the king and chiefs for beads and perhaps for the king's crown (which Clapperton did not see) and mentions strands of "blue [stone] beads" worn by the king, which came "from a country between this and Benin" (Figure 157).[13]

Before departing from Oyo-Ile, Clapperton made the following observation in his journal:

> The king's houses, and those of his women occupy about a square mile, and are on the south side of the hills, having two large parks, one in the front, and another facing the north. They are built of clay, and have thatched roofs, similar to those nearer the coast. The posts supporting the verandahs and the doors of the king's and caboceers' [chiefs'] houses are generally carved in bas relief, with figures representing the boa killing an antelope or a hog, or with processions of warriors attended by drummers. The latter are by no means meanly executed, conveying the expression and attitude of the principal man in the group with a lofty air, and the drummer well pleased with his own music, or rather deafening noise.[14]

Carved motifs such as these were widely employed by carvers throughout Yorubaland in the nineteenth

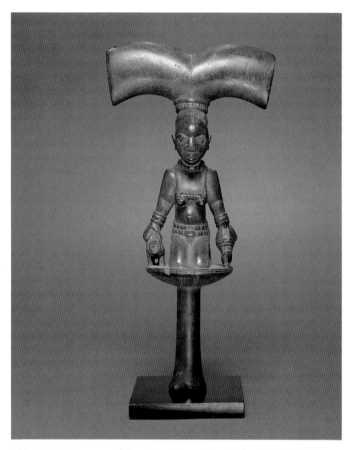

159. Sango Dancewand (*ose* Sango), southern Egbado, 19th–20th century. The simplicity and elegance of this carving convey the remarkable inner composure of the devotee of Sango, whose lord often behaves in a most capricious fashion. She carries Sango's thunderbolts on her head with extraordinary ease and grace. Wood. H. 15¼ in. Richard and Barbara Faletti collection.

160. The Sango shrine at the compound of Baale Koso in Oyo. Hanging on the rear wall is a row of *laba* Sango, bags carried by Sango priests when searching for the stones or celts of the thunder god at a house struck by lightning. The front panels of the red leather bags are divided into four squares of a lighter color, each containing a black and white image of a dancing stick-figure which some devotees identify with Esu/Legba, the energetic bearer of sacrifices to the gods and the troubler of humans who do not observe the ritual way. Oyo, Nigeria, 1971. Photograph by J. Pemberton 3rd.

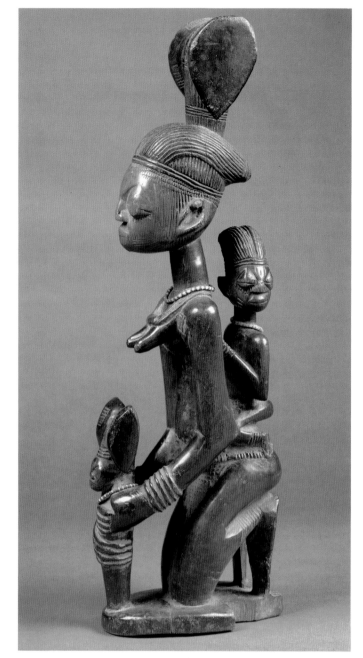

161. Sango Shrine Sculpture, Ede, 19th century. By Abogunde of Ede. The works of this master achieved recognition in the last quarter of the nineteenth century. The faces of his figures are always intense, suggesting the extreme concentration of the Sango devotee. As the child holds on to the mother, so the devotee grasps her *ose* while she kneels before her lord. Wood, beads. H. 21½ in. Ian Auld.

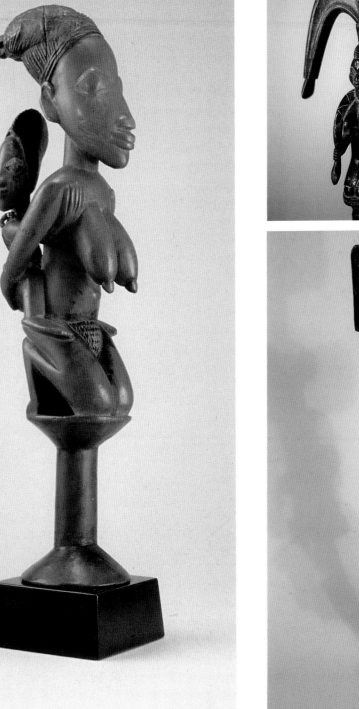

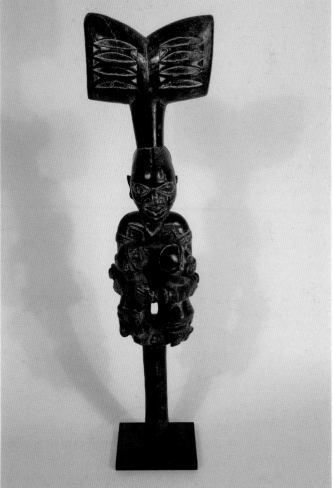

163. Sango Dancewand, Ketu, 20th century. Beauty of line and delicacy of carving are hallmarks of the finest Ketu works. The graceful curves of the double axe symbol, depicted as breasts from which large celts emerge at the top, echo the line of the snake which lies about the neck of the kneeling devotee. The work evokes the power of woman, of Sango, and of the python at one and the same time. Wood. H. 18½ in. Jean and Noble Endicott collection.

162. Sango Dancewand, Ogbomoso, 19th–20th century. This *ose Sango* was collected by Leon Underwood at the Sango shrine in Ogbomoso in 1945. It is unusual in that it lacks the double-axe symbol, which is almost always found on Sango dancewands, although the parted hairstyle of the devotee suggests the motif. The artist's sculptural skill is evident in the repetition of the volume of the head in the voluminous breasts and thighs. Wood. H. 16½ in. National Museum of African Art, Eliot Elisofon Archives, Smithsonian Institution.

164. Sango Dancewand, Southern Egbado area, 19th–20th century. Yoruba ritual sculpture provides images of the devotees of the gods, not images of the gods. *Orisa* Sango gives the blessing of children and is known as the protector of twins. Hence, devotees who are *iyabeji* ("mother of twins") celebrate the gift of their lord with the dancewands that they place on their shrines and carry at the annual festival. Wood. H. 19⅝ in. Musee Royal de l'Afrique Centrale, Tervuren.

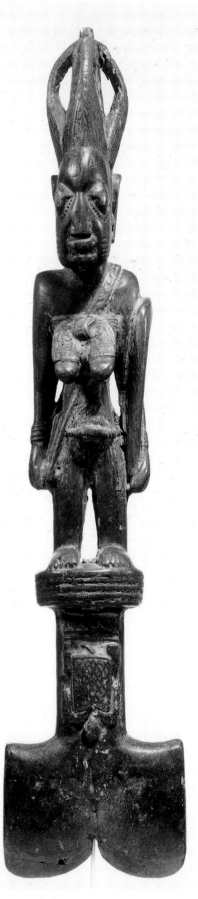

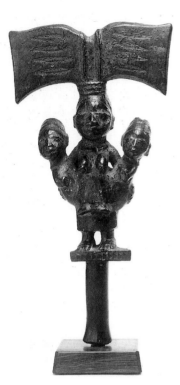

166. Sango Dancewand, Egbado, 20th century. The sensitivity of the carver is evident not only in the way in which he permits the twins, although firmly within their mother's grasp, to lean away from her body, but also depicts the *ibeji* as holding on to each other behind their mother's back. Twins are often referred to as "children of thunder" since they are not only the gift of Sango to his devotee, but are said to accompany Sango after death when he makes known his presence in thunder storms. Wood. H. 15 in. Deborah and Jeffrey Hammer, Los Angeles.

century (Figure 158). Even more elaborate carvings adorned the "Fetish houses" of the Sango cult. Unfortunately Clapperton merely refers to seeing them at the gates of the city and opposite the king's palace,[15] but does not describe them or mention entering one. The Sango cult, which was closely associated with the royal court, had been an important part of Oyo-Ile's ritual life, since the reoccupation of the old capital at Oyo-Ile early in the seventeenth century.[16] If the extraordinary carvings for Sango shrines in other and lesser Oyo towns in the mid-nineteenth century provide a clue, the shrines of Oyo-Ile at the time of Clapperton's visit must have been resplendent with carvings for the *orisa*. Clapperton's silence is all the more disappointing, since within a decade of his visit they would vanish.

With the failure of authority at the center, the rebellion in Dahomey and the loss of control over many of the trade routes to the coast, the weakened capital city was vulnerable to changes taking place to the north: the increasing power of the Fulani; the missionary zeal of Muslim emissaries; and the political ambition of petty chiefs in Ilorin and neighboring towns. Around 1830 Oyo-Ile was under siege by Ilorin forces, and eventually "Oyo was plundered of nearly everything. . . Jimbo

165. Sango Dancewand, Ila-Orangun, 18th–19th century. This *ose* Sango is in the style of carvers from Ila-Orangun, active in the second quarter of the nineteenth century. According to documents in Swiss archives, it reached Switzerland prior to 1820. Wood. H. 18⅞ in. Museum Rietberg Zurich, Collection von der Heydt.

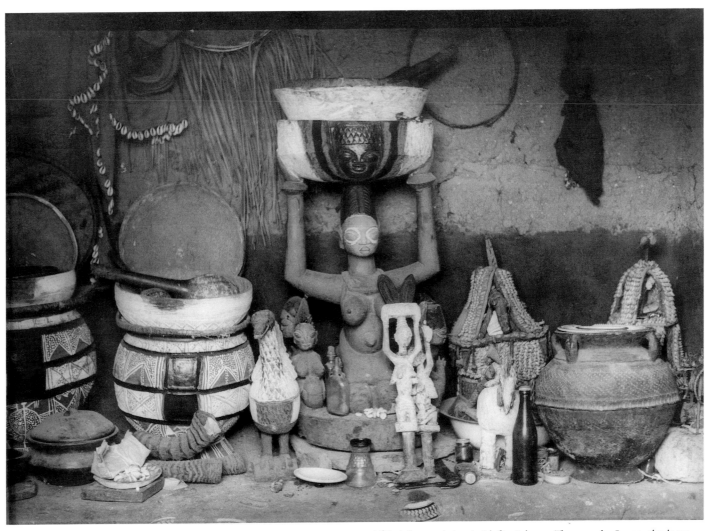

167. A Sango shrine in Idofin, Igbana. The *arugba* Sango, the large figure with bowl, is the principal sculpture found on Sango shrines in Igbomina and Ekiti towns. This carving is in the style of the workshops in Osi Ilorin in northern Ekiti. (See Figure 169.) Nigerian National Museum Archives, Lagos. Idofin, Igbana, Nigeria 1961. Photograph by P. Allison.

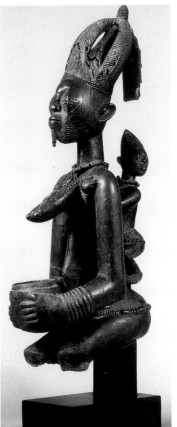

168. Sango Shrine Sculpture, Ede, 19th century. From the workshop of Abogunde of Ede, this extraordinarily powerful figure does not provide evidence that it was made for a Sango shrine. The necklaces of red and white beads placed by a devotee of Sango on the mother and child reveal its function. Ulli Beier photographed similar sculptures by Abogunde and his workshop on shrines for Oya, wife of Sango, in Ilobu. Wood, beads. H. 24½ in. The Art Institute of Chicago. Through prior gifts of the Alsdorf Foundation, Mr. and Mrs. James W. Alsdorf, Mr. and Mrs. Joseph P. Antonow, Herbert Baker and Gwendolyn Miller, Britt Family Collection, Gaston T. de Havenon, Mr. and Mrs. Edwin H. Hoker, Robert Stolper, Mr. and Mrs. Edward H. Weiss, Mr. and Mrs. Raymond J. Wielgus; through prior acquisition of the Samuel P. Avery and Ada Turnbull Hertle Endowments.

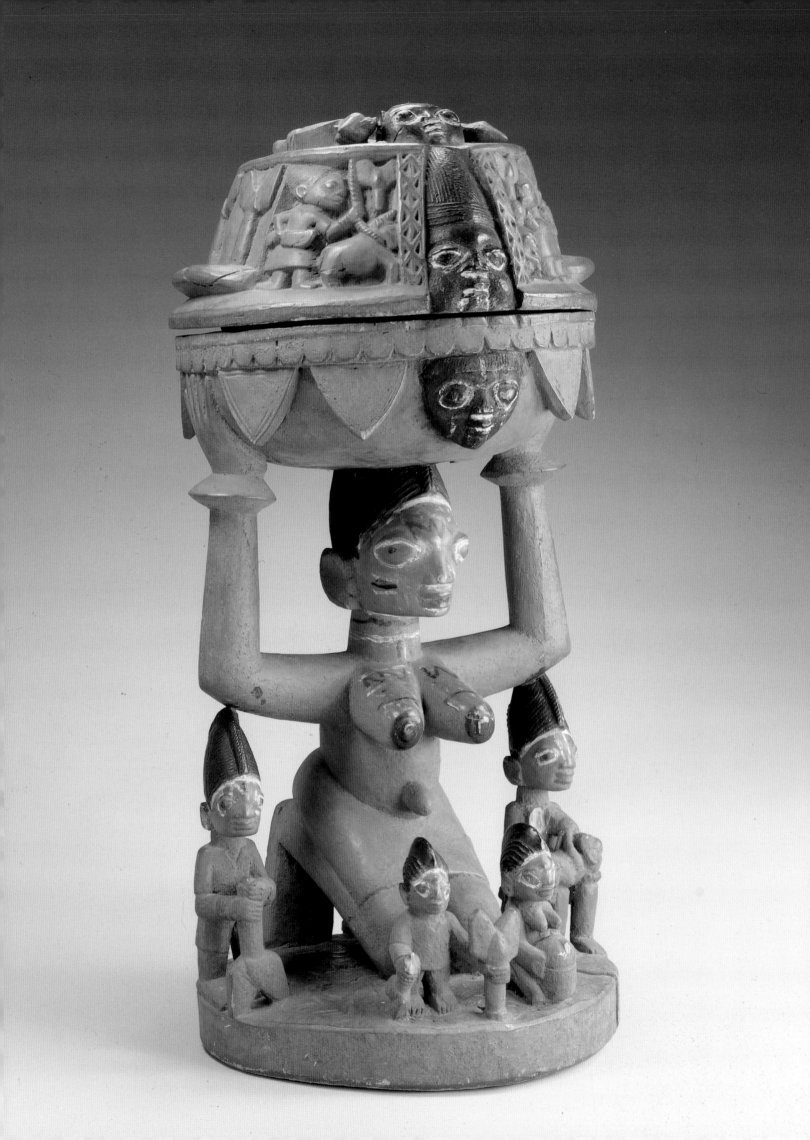

[the leader of the Ilorin forces] took away all the Egungun dress [ancestral masquerades], and forced the citizens to accept the Koran."[17] A few years later, around 1835–36, Oyo troops attempted to reassert their authority over once-submissive northern Yoruba towns but were defeated. After this defeat and with the imminent threat of the Ilorin forces led by Lanloke, Oyo

> the great metropolis was deserted, some fled to Kihisi, some to Igboho, and some even to Ilorin. As it was not a flight from an enemy in pursuit many who reached Kihisi and Igboho safely with their family returned again and again for their household goods and chattels till one Agandangban went and told Lanloke that Oyo had been deserted, and the latter proceeded immediately to plunder, and carry away what was left by the citizens;. . . such was the fall of the great Metropolis "Eyeo or Katunga," the ancient Oyo, still [lies] in ruins.[18]

Archaeological Records

With the passage of time, layers of dust were deposited by the Saharan winds known as the harmattans, torrential rains wore away the clay brick houses, incised the

170. Arugba Sango lid, detail of Figure 169. The devotee lies prostrate before her lord, dancewands suspended from each shoulder, and her hands hold cocks for sacrifice to her god. The painting of the head with indigo dye is not unusual and conveys the notion of the inner head, (*ori inu*), her personal destiny which is inextricably linked to the essential nature, (*iwa*), of Sango.

169. Sango Shrine Sculpture (Arugba Sango), Osi Ilorin, Ekiti, 20th century. This *arugba* Sango is a splendid example of the skill of Areogun of Osi Ilorin. *Arugba* means "bowl carrier." In the bowl the devotees keep neolithic celts, thought to be the thunderbolts which Sango hurls in judgment upon those who do not acknowledge his authority in their lives. Wood. H. 42⅛. Marie-Catherine Daffos/Jean-Luc Estournel.

surface of the land, and buried in mud much of what was left standing. Brush fires, started by hunters, aided in the destruction. In 1938 seven or eight veranda posts were discovered in the area

> near the main entrance to the 'palace.'. . . On these can be seen the original carving and on three which are still upright most of the original design is clear. They differ in style considerably from those generally seen to-day. The Old Oyo posts are ten or eleven inches thick, somewhat tapered, smoothly finished and carved in relief....The Old Oyo posts are divided into horizontal panels, each panel decorated with a continuous 'picture' of men, birds, horses or snakes.[19]

This brief description suggests that the carving style was a simple bas-relief, not the deeply cut designs or three-dimensional figures that Clapperton's observations suggest and which characterized late Oyo Yoruba carving style (Figure 158).

Apart from portions of a few houses, the foundations of the palace and evidence of the town's walls, garden plots, grinding holes, and a foundry where brass or bronze may have been cast, archaeologists have unearthed a few terracotta rain pots and numerous shards. Only one small, weathered terracotta head composed of two fragments has been found. Since it was a surface find, the head cannot be closely dated and remains problematic: "Until we have more examples of terra-cottas from the site we cannot trace its connections [with the Nok or Ife terracottas], though it does appear likely that there was a distinctive style of terra-cotta at Old Oyo."[20]

The Legitimization of Authority

The imperial ambitions of Oyo-Ile were fostered by internal power struggles between the Alafin and the Oyo Mesi and by the need to control resources. The Alafin built his base of power upon the support of kings and chiefs in the surrounding communities, as well as upon the peace and revenues that their allegiance brought to the capital city. Eager to expand his sphere of influence, the Alafin recognized that political power also depended upon the control of resources that attracts or requires allegiance. Hence, the flourishing trade in slaves in exchange for European goods, which in turn funded the purchase of horses from the Hausa for the Alafin's cavalry, required the extension of the empire to the Dahomean court and the control of the trade routes.

The claim of empire, however, requires more than an effective army and the control of resources, especially when the political structure is essentially a loose confederacy of groups with an acute awareness of their own historical identities. The claim to empire requires legitimacy, the perception on the part of ruler and ruled that political power is based upon a recognized claim

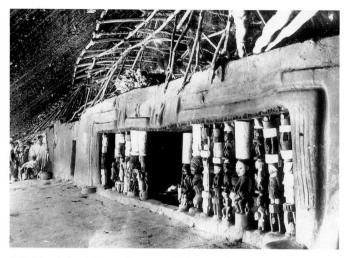

171. The Agbeni Sango shrine in Ibadan. A photograph by Leo Frobenius taken in 1910 of the veranda posts that formed a screen in front of the altar. This and the following photograph are probably the earliest visual documents that exist of Yoruba Sango shrines. Ibadan, 1910. Photograph courtesy of the Frobenius Institute, Frankfurt.

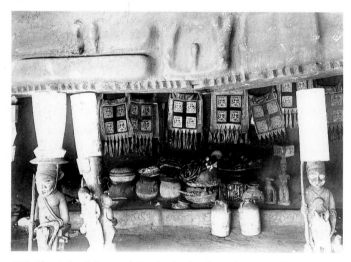

172. The Agbeni Sango shrine in Ibadan from the center front. A photograph by Leo Frobenius. Ibadan, 1910. Photograph courtesy of the Frobenius Institute, Frankfurt.

to moral authority. Hence, successive Alafin of Oyo-Ile sought to establish their legitimacy. They claimed that they were descended from Oduduwa, the founder and first king of the Yoruba at Ile-Ife and that the Alafin was heir to the paternal authority of Oduduwa. This claim was also made by the Oni of Ife. One account relates that the Alafin was the youngest son of Oduduwa, but others assert that he was the "first son" of Oduduwa. These differing claims appear to mark a shift from a time of acknowledging the primacy of Ife to a time when Oyo sought to claim for itself such primacy. Other accounts argue that Oranyan was Oduduwa's son and heir to the throne and that it was Oranyan who founded Oyo and was the first Alafin.[21]

There was also a local tradition upon which Oyo-Ile based its claim to rule. Sango, the son of Oranyan and of Elempe, daughter of the king of Nupe, moved the seat of government from Oko to Oyo,[22] an account

which may "[represent] the original tradition."[23] The extent of Oyo's power in the seventeenth century was dubious and its effective power in the eighteenth century was limited in various ways. In contradiction, Oyo's court histories attempted to create a fictive heritage. Oyo's claim to an Oduduwa heritage was perceived as justifying Oyo's aggression against other kingdoms, including those that also claimed descent from Oduduwa.[24]

The Sango Legend: *Oba* and *orisa*

The appeal to the Oduduwa heritage was not by itself adequate as a claim to legitimacy and empire. The presence of the Oni in Ile-Ife was ample testimony to its limitations. A further source was of historical and divine legitimacy found in the person of Sango, the deified fourth king of Oyo-Ile. For the art historian, the variety of sculptural forms and the richness of iconography as well as the oral poetry associated with the worship of Sango may be Oyo-Ile's greatest legacy to the history of Yoruba art.

Sango has been described by Samuel Johnson in 1893 as "the fourth king of the Yorubas, who. . . was deified by his friends after his death. Sango ruled over all the Yorubas including Benin, the Popos and Dahomey, for the worship of him has continued in all these countries to this day."[25] While there is no historical evidence to support this description of the extent of Sango's rule, some incidents associated with him and other early Alafin may be factual. The remembrance of Sango, however, serves later political purposes. The myths, rituals, and iconography associated with him serve to legitimatize the Alafin's political authority, while also disclosing an acute sense of ambiguity about the power of Yoruba kings.

Many of the Sango myths focus upon the cause and occasion of his death. Some accounts describe him as a ruthless tyrant. Although he was a masterful leader of his troops in war, he ruled by appealing to the envy and vanity of his chiefs, pitting one against the other. Weary of the political discord in the capital, his people turned against him. He was dethroned and sent into exile by the chiefs of Oyo-Ile. Alone, and by some accounts deserted even by his favorite wife Oya, Sango

173. Equestrian Figure, Erin, 19th–20th century. This is by Maku of Erin who was one of the great carvers for *orisa* shrines in the area of Osogbo, Ilobu and Ede at the turn of the century. He died about 1927 and his son, Toibo, an equally gifted artist, died about a decade later. This is one of Maku's finest works. The elongated body of the warrior picks up the slender line of the spear. The warrior's head is equivalent in size to the horse that he rides, an association of power further suggested by the indgo dye that has colored both areas. Maku defines the eyes as circles from which lines radiate, giving the face a boldness of expression that is enhanced by the thrust of the jaw. Wood. H. 38½ in. Private collection.

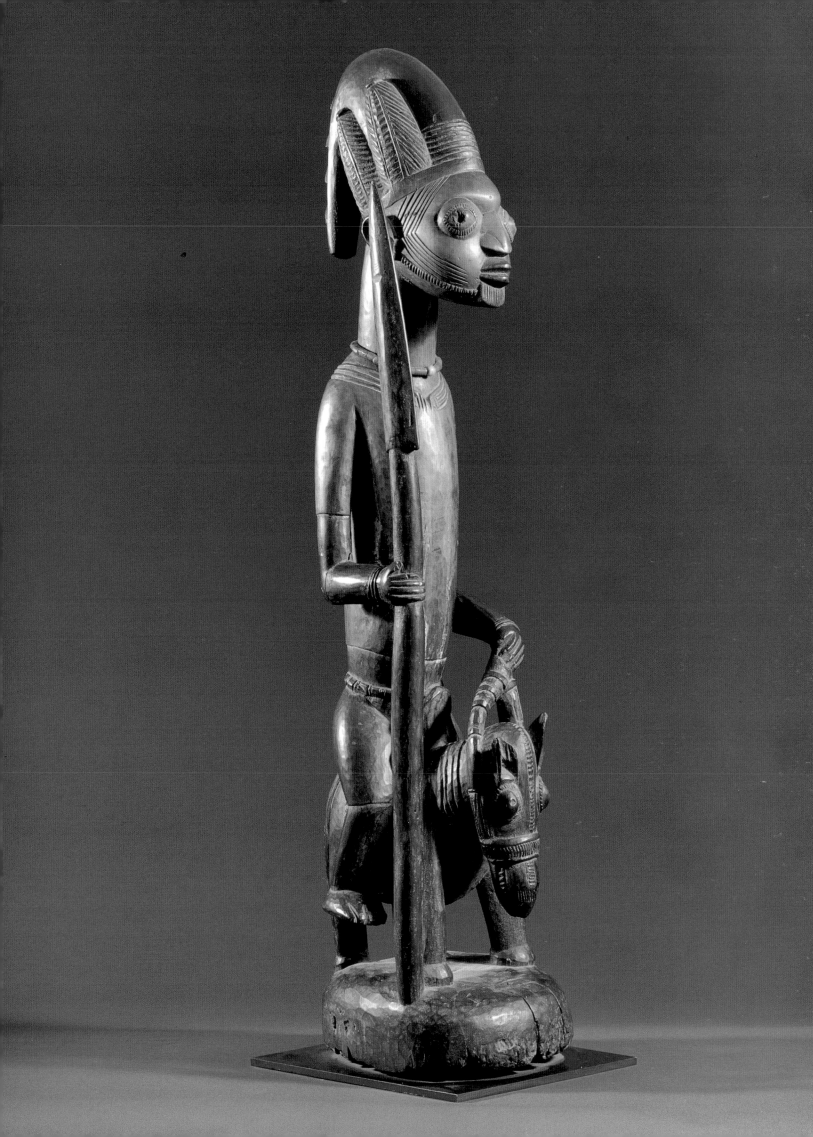

hung himself at a place called Koso. Ashamed and angered by the taunts cast upon Sango's name, his friends visited the neighboring people of Bariba, famed for their ability to make charms. Upon learning the art, they returned to Oyo-Ile and caused violent thunderstorms and lightning to strike the houses of Sango's enemies, setting fire to the thatched rooftops. As the storms increased in number and intensity, Sango's friends declared them to be a display of Sango's vengeance upon his enemies. They proclaimed Sango an *orisa* who required sacrifices. Thus, priests were initiated as intercessors, shrines were established in the palace grounds and at Koso, and Sango's followers chanted "*Oba koso!*" ("The King did not hang!"). (The chant entails a verbal play on the town name Koso by a change in tonality of pronunciation.)

Another myth relates that Sango was fascinated with magical powers. On one occasion he climbed a hill on the edge of the city, and, while preparing a mixture of *oogun ase* (materials containing powerful properties), he inadvertently caused a great storm to occur. Bolts of lightning struck the palace as well as the homes of townspeople, killing all of Sango's wives and children with the exception of Oya. In disgrace Sango left the capital with Oya. When he reached Koso, he hung himself. As in the other myth, when subsequent violent storms rained havoc on the city, Sango's followers declared that the *oba* had become an *orisa* and was avenging the indignities to his name. Thus, a shrine was created in the palace and a priesthood established for performing the appropriate rites of praise and sacrifice to the divine king.

One other myth, important to our understanding of the image of Sango in Yoruba cultural history, appears to have had its origins in Ile-Ife. Obatala, the *orisa* who creates all human bodies, was walking along a dusty road on his way to Oyo-Ile. As he passed a field, he saw a great white horse. Weary from his long trek, he mounted the animal and rode the remaining distance to the capital. The horse belonged to Sango, who, when he heard that someone had ridden it, ordered Obatala to be imprisoned, even though the elderly *orisa* had sent his apologies to the king. As the days and months passed, the rains failed and drought spread through the land. The townspeople appealed to their king to release Obatala, but Sango refused. The earth became parched. Women ceased to give birth to children. Even Sango's wives were barren. Aware of the outrage of his chiefs, Sango released Obatala, who again apologized for his offense to the *oba* and left the capital to continue his journey home to Ile-Ife. Soon the rains returned, the yams grew in the fields, and women again gave birth.

For the historian of religion all myths are true insofar as they are true for someone. The questions are: by whom and for whom are they told? And in what ways do they inform and shape the perceptions of self and world of persons within the community in which they are preserved?

The myths associated with Sango do not present the ancient king as a noble, heroic, or even a tragic figure. As a leader, Sango is portrayed as a tyrant who is ruthless and arrogant. He is also depicted as one whose desire for power exceeds the limits appropriate to political authority: he is fascinated by magical powers that he cannot control, and he imprisons Obatala, the god whose creative work is to give shape to the human body before it enters the world. Obatala is also closely identified with the indigenous peoples of Ife. Sango is rejected by his people, dethroned by Oyo's chiefs, and dies the disgraceful death of suicide.

But Sango lives. The *oba* becomes an *orisa*, and as an *orisa* the fallen king controls the powers of nature, creating terrible thunderstorms and hurling bolts of lightning upon those who do not honor him.

At one level of interpretation, the myths are politically significant, conveying to the conquered kings and subjected peoples an image of the awesome authority of the Alafin. Among Yoruba religious groups, the Sango cult was perhaps unique in being so closely identified with a particular political system. The Mogba, senior priests of Sango at the royal shrine in Koso, initiated the Alafin's *ilari* (bodyguards and messengers) into the Sango cult, and those who were not initiated traveled with Sango priests in their entourage.[26] Furthermore, the cult was centrally organized, the occupancy of some of its high priestly offices limited to members of certain Oyo lineages, and the training and initiation of all Sango priests, *elegun*, confined to the Mogba at Koso.[27] Where compounds were struck by lightning the *elegun*, carrying large, elaborately decorated leather bags, called *laba* Sango, entered the premises to retrieve the thunderbolts represented as celts, (*edan ara*), hurled by Sango, evidence of his displeasure with the household (Figure 160). While the occupants were banned from their homes and relegated to blacksmiths' shops and similar dwellings for several days, the *elegun* performed rites for *orisa* Sango and received food and payments of considerable sums from the occupants.

The imprisonment of Obatala is a metaphor for the limits of the Alafin's authority over Ile-Ife, the place of creation, and the throne of the Oni, Odudwa's successor. At another level, the myth of the imprisonment of Obatala asserts that political power has its limits with respect to the powers of nature—the biological powers operative in the creation of plant, animal, and human life. Kings may, for politically legitimate reasons, be granted the authority to have persons put to death, but

they cannot presume to control the sources of life any more than they can employ magical practices to enhance their authority.

In spite of the close association of the Sango cult with the political power of the royal court of Oyo, as the authority of the latter declined, the cult flourished throughout the areas once part of the empire. Within a year or two following the fall of Oyo-Ile in about 1836, the royal court of Alafin Atiba and those lineages that had not settled in other northern Yoruba towns established a new capital city 75 miles to the south (see Figure 29). The political authority of the Alafin was significantly diminished. *Oba* Atiba sought with some success to check the rising power of the Oyo Mesi in the new capital by introducing the secret society, or cult, of Ogboni as an established organ of government.[28] The towns of Ibadan and Ijaye, however, which had once been the southern military outposts of the Oyo Empire, were now led by politically ambitious warrior chiefs; and other communities claimed their independence from the direct control of the new Alafin.[29] The conflicts among Yoruba towns and subgroups that had begun as early as 1793 now burst into a full-scale civil war.

For over a half century the terrible powers of Ogun, the *orisa* of iron and war, were felt throughout the land. The myths of Sango continued to be told, however, and rituals for the deified king continued to be performed. The Sango mythology and rituals articulated a deeply felt ambivalence about power, not only political power, but the power or powers that play within the human psyche. Sango was a god who disclosed a truth about the human condition that was not easily acknowledged, but that could not be denied by the Yoruba. It was a truth that Yoruba artistry expressed in song and carving.

Verbal and Visual Imagery in Sango Worship

The imagery in the Sango myths is echoed in the *oriki* chanted by Sango's devotees. *Oriki* celebrate in rhythm, rhyme, and word-play the *iwa* (status, essential character, fundamental nature) of the person or god whose praise is heralded. As in every performative utterance, the singer of an *oriki* not only acknowledges the presence and power of the subject of praise, but through verbal imagery evokes the reality that she or he praises.

On the occasion of the annual festival for Sango, female devotees sing lengthy *oriki* known as Sango-pipe.[30] The singing entails a special modulation of the voice, producing a rattling, but sonorous, quality. The tonalities of the Yoruba language permit word-play and rhythmic patterns that echo the sharp staccato sounds

of the *bata* drum. The poetic form consists of a rapid outpouring of similes and metaphors that present a strange juxtaposition of images: the refrains punctuate and bond the total performance together. As she chants, the devotee will grasp a dancewand, called an *ose* Sango, and, in response to the verses she chants, she will cradle it in her hands, thrust it in the direction of bystanders, or shake it violently above her head (Figure 155).

> *Sango-Pipe*
> *Oba Koso. I hope you awakened happily. Ooooo.*
> *My lord, save me from trouble. Ooooo*
> *Did you awaken happily?*
> *You have fire in your mouth, fire in your eyes, and scorch*
> *the metal roof tops.*
> *I awakened happily.*
> *I greet Olu, your messenger, but he did not answer.*
> *Olu is lord in Egbere.*
> *When I awakened, I knelt and greeted Awo, your*
> *messenger.*
> *Awo is a lord in Likii-land.*
> *When I awakened, I greeted Sango, but he did not answer.*
> *I greeted Sere Aboogunde.*
> *I greeted Ose Ogbodoro, who slept without concern.*
> *I greeted Laba, one with a robe of honor.*
> *I greeted the lord of three stars.*
> *I greeted the male.*
> *I greeted the female.*
> *It was they who gave birth to Sango*
> *Sango enters Oyo lowly.*
> *He opened a calabash and withdrew something oily.*
> *Sango, I hope you awakened happily. Ooooo*
> *Sango is as tough as a dried yam.*
> *When he enters the forest, he strikes with his thunderbolts.*
> *Sango, I hope you awakened happily*
> *Leader of devotees. Ooooo.*
> *He strikes a tree and shatters it.*
> *He plunges a hot iron into his eyes.*
> *The husband of Iyamonja.*
> *Orilaku, who overturns the tables of traders.*
> *One who adds stones to the light load of a person. Eeeee.*
> *One who is as light as an asa board.*
> *Do not add more stones to my load.*
> *One whose teeth are like large bones.*
> *The talkative create trouble in the house.*
> *Sango is always willing to talk.*
> *I hope you awakened happily,*
> *Balogun at Ado. Ooooo*
> *I hope you awakened happily*
> *Igbabagobi-iro. Ooooo.*
> *When he is angry, he hurls a person into a stream as*
> *though brushing away a fly.*
> *One who casts stubborn people into boiling water.*
> *Sango, who hurls the stubborn into boiling water,*
> *Do not put my head into hot water.*
> *One whose teeth are like large bones.*
> *The talkative create trouble in the house.*
> *Sango is always willing to talk.*
> *One who knows what you want from him.*
> *One who knows what you are thinking.*
> *Balogun at Ado. Ooooo*

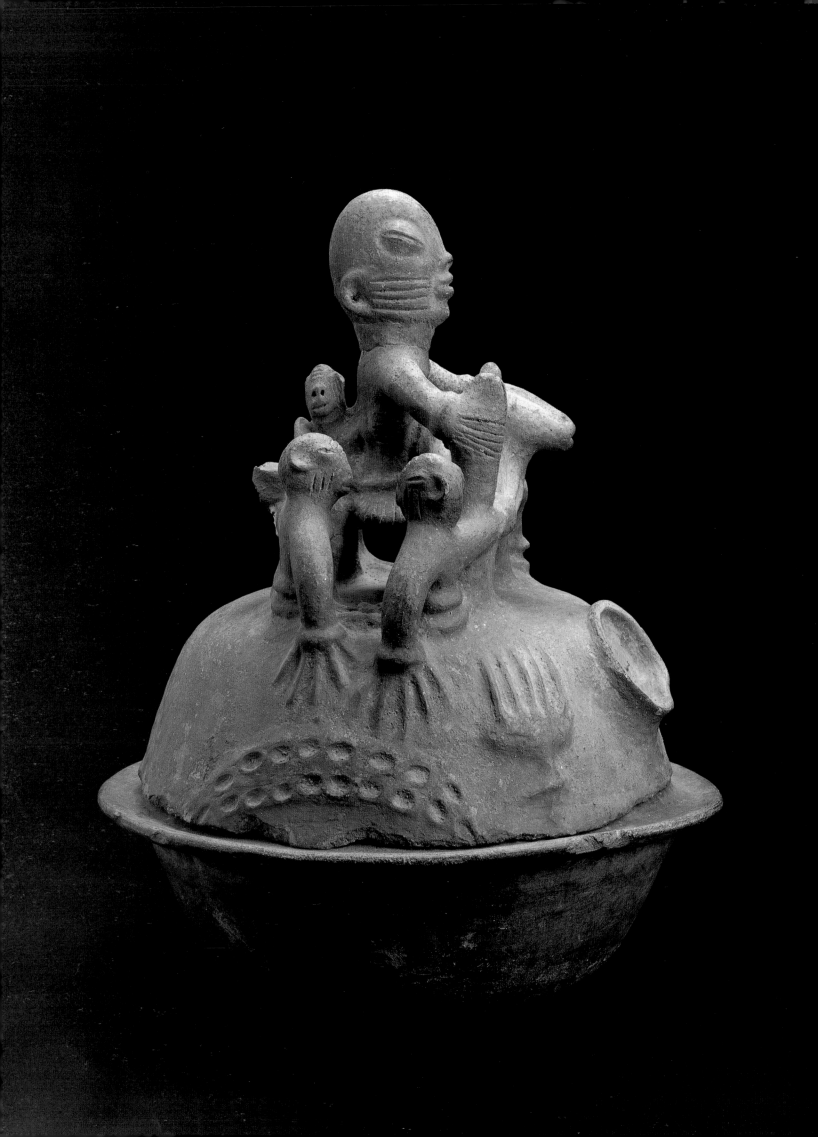

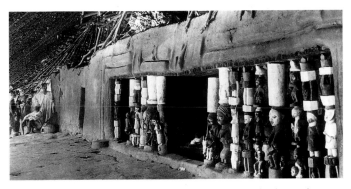

174. The Agbeni Sango shrine in Ibadan. A water color by Karl Arriens, who accompanied Leo Frobenius on his visit to Ibadan in 1910. The accuracy of the drawing is confirmed by Frobenius' photograph. Frobenius remarked that he was "struck dumb" by "the originality of the building" and "the row of brightly painted columns." Photograph from Arriens, 1928.

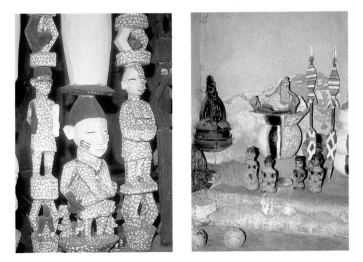

175. A portion of the screen of veranda posts at the Agbeni Sango shrine in Ibadan. 1971. Photograph by J. Pemberton 3rd.

176. A portion of an *orisa* shrine in the Ijebu town of Oke Orundun. The black terracotta pot at the left is for *orisa* Erinle, deity of hunters whose cool waters from hidden forest streams and pools bless his followers with children. *Orisa* Sango's presence is identified by the large pot painted with red and white patterns. It holds ram's horns containing the power (*ase*) of the god and the crown of Banyani, the "sister" of Sango. *Ibeji* figures are placed in front of Sango, who is the protector of twins. Oke Orundun, Nigeria, 1982. Photograph by J. Pemberton 3rd.

177. Ritual Pot, Oyo area, 20th century. The equestrian figure on this ritual pot suggests that it was created for use on a shrine for *orisa* Sango. Pots of this shape, however, are more often found on shrines for *orisa* Erinle, a hunter deity associated with forest glades and streams. In the Oyo and surrounding areas Erinle pots have two intersecting arches that constitute the iconographic motif on the lid, and the pots are usually blackened. Hence, this pot presents a fascinating puzzle and suggests an innovative artistic creation in Sango shrine artifacts. The comb motif embossed on the lower portion of the lid may be associated with *orisa* Osun, which only raises more questions about its origin and use. Whatever the answers may be, the equestrian figure and his attendants are rendered with simple forms, yet possess considerable power. Terracotta. H. 24 in. James Willis Gallery, San Francisco.

One who is angered as one who is asked for a contribution.
When he enters the forest, he strikes with his thunderbolts.
One who uproots an iroko tree.
His fiery eyes are like those of Ogun.
When he enters the forest, he strikes with his thunderbolts.
Balogun at Ado. Ooooo
One who throws away the tray of the sellers of palm
* kernel oil.*
One whose eyes are terrifying to behold.
One who smashes the calabash into pieces.
Ibiyemi, who has medicine for abiku.
Erigitola, who publicly accuses the police and the chief
* clerk.*
One who chases the king and the householder.
Sango is the almighty power who blesses a sensible person
* and maddens the fool*
The orisa who have followed you to today's festival are
* countless.*
All of them have assembled.[31]

The entire poem consists of nine parts and several hundred verses. It begins with a salutation to the god, followed by a series of descriptive images which refer to Sango's *iwa*. He is the one who has fire in his mouth and his eyes and scorches the metal rooftops; who does not answer when he is greeted; who is as tough as a dried yam; who strikes indiscriminately with his thunderbolts; who shatters trees and uproots the great *iroko* tree; who plunges a hot iron into his own eyes; who overturns the tables of traders; who adds stones to the light load of a person; who tosses the stubborn into boiling water; who pursues kings and commoners.

In Part II of the *oriki* reference is made to Sango as an *oba* at Oyo and a *balogun* (warrior chief) at Ado. The allusions presume to locate Sango in Yoruba history, but it is not the historicity of the figure that is important. Instead it is the reality of what Sango represents for Yoruba political experience generally. The *ase* of a Yoruba king, said to be "like that of the *orisa*," includes the power over the life and death of his subjects. Kings, however, are prone to the abuse of their authority, and the awe and adulation which Yoruba kings receive is tempered by a deep suspicion toward their use of power.

Parts III through VI of the poem herald the praises of *orisa*: Osun, deity of medicinal waters and in some myths a wife to Sango; Esu, the guardian of the sacrificial way; and Ogun, god of iron and war. Sango himself is thus proclaimed an *orisa* among the great gods of the Yoruba pantheon.

In Parts VII through IX the singer again praises Sango and refers to various places, families, and persons that are devotees of Sango, including the singer herself, who chants:

Here is my head before you,
The head that is eating eba,
The head that is eating fish,

The head that is eating snails,
The head that is eating ram.
Sango, to you I return.
Olodumare mi! (My Almighty One!)

To hear Sango-*pipe* and to see an *ose* Sango (dancewand) in the context of a festival for Sango is to be confronted with a conflict of imagery. While the singer focuses upon the god's hot temper, capricious behavior, and destructive power, the carver of an *ose* provides us with the figure of a woman who kneels in quiet supplication before her lord, effortlessly balancing upon her head the twin thunderbolts of Sango (Figure 159). The *ose* is a visual representation of the one who holds it, as Abogunde, the great carver from Ede, knew so well (Figure 161). The *ose* depicts the *iwa* and the *ori inu*, of the worshipper of Sango. To be a follower of Sango is to suffer the power of an unpredictable deity. It is to bear the burden of the ancient celts of the god, who hurls them with crackling lightning in the midst of thunder- storms. As lightning is said to be drawn to an object, yet strikes with apparent caprice, so Sango descends upon the world of humankind. His followers "praise" him with the song:

The dog stays in the house of its master
But does not know his intentions.
The sheep does not know the intentions
Of the man who feeds it.
We ourselves follow Sango,
Although we do not know his intentions.
It is not easy to live in Sango's company.
Rain beats the Egungun mask, because he cannot
find shelter.
He cries: "Help me, dead people in heaven! Help me!"
But the rain cannot beat Sango.
They say that fire kills water.
He rides fire like a horse.
Lightning—with what kind of cloth do you cover
your body?
With the cloth of death.
Sango is the death that drips to, to, to,
Like indigo dye dripping from a cloth.[32]

The unpredictable, capricious, self-serving *orisa* is also the one who imparts his beauty to the woman with whom he sleeps. He is the giver of children, (Figure 162) and protector of *ibeji* (twins) (Figures 164, 166). Thus, he is praised again by women in song:

Where shall I find Jebooda, my husband?
He dances, as he sings with us.
He-who-destroys-the-wicked-with-his-truth....
He-who-spends-a-long-time-in-Oya's-grove;
The mighty one that shakes a town like rain.
For, when we wake up,
You who serve the whole world, father of Adeoti,
I will pay homage to you, my father.
Acting without paying due homage ruins one's efforts;
Acting after paying due homage brings one success.
We see marks on our palms but we do not know who
made them there.[33]

Another sculptural form found on Sango shrines in the Igbomina and Ekiti areas is the *arugba* Sango (Figure 167). *Arugba* means bowl carrier, and these large sculptures (often 3 to 3½ feet high) depict a female figure, either kneeling or seated, holding a large bowl above her head. The bowl contains the thunder celts of Sango and portions of kola nuts and other offerings made weekly to the deity. As in the *ose* Sango, where the celts protrude from the devotee's head, the bowl carrier bears the evidence of her lord's power, recalling the *oriki* in which Sango is referred to as the one who "adds stones to the light load of a person."

Figure 169 illustrates a superb example of an *arugba* Sango carved by Areogun (about 1880–1954) of Osi Ilorin in northern Ekiti.[34] In this sculpture Areogun has captured the graceful posture of a woman as she kneels to lift the heavy load that she has carried to the market. As a woman raises her arms in order to lift her load and place it on the ground, those around her will say: *Isokale anfani!* ("We wish you a good delivery!", meaning success in unloading). It is a phrase that is also used to address a pregnant woman who is approaching the time of giving birth.[35] Hence, Areogun has taken a well-known scene and transformed it into a revelation of a devotee of Sango. As a line from a Sango-*pipe* puts it: "The gentle son, who observes the actions of his wife. / The wife, who looks like an *arugba* Sango."[36] In the strength of her composed face, beautifully framed by her upraised arms, and in the apparent ease with which she balances the large bowl above her head, Areogun conveys the *ase* of the devotee.

The iconography of the great bowl is of considerable interest. Faces are embossed on the front of the bowl and its lid. When making offerings to Sango, the devotee will touch his or her own forehead and then one or both of the faces on the bowl with the kola nut offering or the head and blood of the sacrificial victim. The faces are painted with dark indigo coloring, as is the face of the figure who lies prostrate on the lid (Figure 170). In an Ifa verse the suppliant is instructed to desire to be colored "black," (*dudu*), which means to be possessed of the deep knowledge, (the *awo*), of Ifa. For the wisdom of Ifa is like looking into an indigo dye pot; its hidden depths cannot be seen.[37] The figure clutches in each hand a cock for sacrifice to the deity, and *ose* Sango hang from the outstretched worshipper's shoulders. On either side of the face on the lid are scenes carved in bas-relief of persons offering rams to Sango. In the scene to the right, Areogun has added the flute-playing figure of Esu. The remainder of the lid is decorated with a series of embossed *ose* Sango, and celts protrude on either side just above the hands of the

central figure, enabling one to lift the lid with ease. Along the edge of the bowl is a series of triangular shapes reminiscent of the trailing edge of a *laba* Sango, the large leather bag carried by Sango priests.

Areogun's *arugba* Sango represents the burden and power of the devotee of Sango. It tells the celebrant about herself. The great central figure and those surrounding her are figures of composure and graceful power, even when kneeling as supplicants. She carries on her head the burden and power of Sango. It is not her physical ability to carry great weights, but her *ase* that is the very life and defines the *iwa* of the Sango worshipper. The darkly colored faces on the bowl and lid refer to the *ori inu* (the inner head or the personal destiny) of the one with the beautifully composed face below. The bowl is also a metaphor for the devotee's womb. It contains the evidence of Sango's power, a power which strikes unexpectedly, transforming and sometimes destroying, but also giving life. The god, whose *ase* is shown as thunder and lightning gives to his devotees the *ase* to bear his burden.

Just as the visual imagery of the bowl carrier captures aspects of the verbal imagery evoked in Sango-*pipe*, so in the context of a ritual, the interplay of the verbal and visual artistry in Sango worship reflects patterns of experience and conveys a perception of life in Yoruba culture. Art and ritual coalesce, creating a universe of experience and a distinctive sensibility. In the public realm of politics and the private world of the psyche destructive possibilities are present in every act of human creativity. It is this that the Sango worshipper acknowledges.

As in all sculptural art, the aesthetic qualities of the Sango pieces are related to, but not finally dependent upon, iconographic appropriateness to the context of use. With the expansion of the Oyo Empire and the Sango cult, carvers from the northeast to the southwest responded with extraordinary artistic imagination to the basic form of the *ose* Sango—a shaft with a double axehead.

The *ose* Sango in Figure 165 is reported to have "reached Switzerland . . . before 1820, through the activities of the Basel Mission."[38] The date seems remarkably early, but there is little doubt that from a stylistic analysis it was carved by a skilled craftsman from the Igbomina town of Ila-Orangun, and perhaps by a carver from the workshop of Inurin's compound.[39] The carver reverses the conventional form, showing the devotee with celts protruding from her head, and positions her on a base supported by the double axehead. Her elaborate openwork hairstyle composed of four braids brought together in a conical shape is similar to the form and pattern of "the crown of Banyani," the

elder sister of Sango, whose emblem is often found on Sango's shrines. Suspended from her left shoulder a *laba* bag or dance panel rests on her right hip. A sash of office is tied across her breasts. In her left hand she grasps a long cudgel, the baton of office. Hers is an image of solidity and balance, of composure and power: her oblong face, squareness of shoulders, full breasts descending to a narrow waist; long arms, hands grasping the *laba* and cudgel and pressing them firmly against her thighs.

A Ketu carver takes the same basic form of the Sango dancewand, but with sweeping, graceful curves extends the form into the surrounding space (Figure 163). The devotee firmly grasps a python, which lies quietly draped around her neck and extends the length of her body. Where Sango's thunder bolts would ordinarily jut forth from the head, long, pendulous breasts form graceful arches framing the devotee's head and from which the celts of Sango protrude. In the parallel curves of the breasts and the python the artist has created a visual metaphor of the power of the female devotee of the *orisa*. She is possessed by a divine power that gives her the authority, *ase*, by which to control the dangerous power of the python. But her nurturing power as woman, as "mother," is itself a dangerous power, as the celts issuing from the breasts suggest. As with her lord, she too can give life or deny it. It is a motif that echoes the theme of the Efe/Gelede festival, which is held annually in Ketu to celebrate the power of *awon iya wa* ("the mothers"), those elderly women, female ancestors, and female deities whose power affects the generative life of field and family, and who can respond, as Sango, with capricious and volatile behavior when not properly acknowledged.

Sango in the Pantheon of the *orisa*

In 1910 Leo Frobenius, the German ethnographer, photographed a Sango shrine, *ojubo* Sango, in the Agbeni area of Ibadan. These are probably the earliest photographs of the interior of a Yoruba shrine (Figures 171, 172). His colleague, Karl Arriens, made a beautiful watercolor drawing of the veranda posts at the front of the shrine (Figure 174). Recalling his first impressions upon entering the shrine, Frobenius wrote:

> We slipped beneath a curtain-cloth, and I am bound to say that for a moment's space the originality of the building in front of me, whose straggling black facade was broken up with many colours, struck me dumb. A lofty, long and very deep recess made a gap in the row of fantastically carved and brightly painted columns. These were sculptured with horsemen, men climbing trees, monkeys, women, gods and all sorts of mythological carved work. The dark chamber behind revealed a gorgeous red ceiling, pedestals with stone axes on them, wooden figures, cowrie-shell hangings. . . .The whole

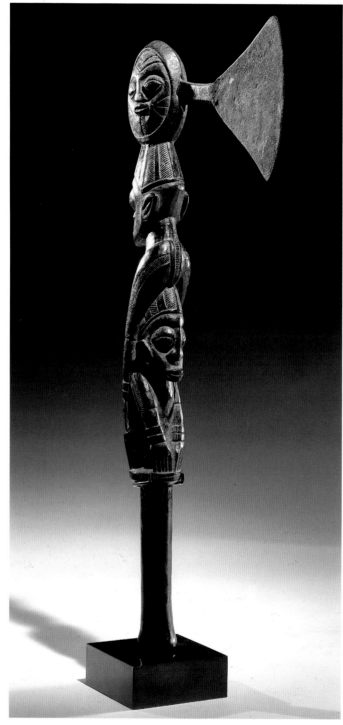

178. Ogun Axe, Ekiti/Kwara area, 19th–20th century. This very fine ceremonial war axe probably came from northeast Yorubaland. The worship of Sango is widespread among the Ekiti peoples, but is not found in the Kwara area, where Ogun is an important deity. The treatment of the eyes and the curved line of the jaw ending in a slightly protruding mouth is similar to figures surmounting chiefs' staffs found in the Kwara area. The integration of the two figures by the long, slender curve of the arm of the upper figure down the back of the lower one is beautifully rendered. Wood, iron. H. 22⅝ in. Christopher Taylor.

179. Chief's Staff, Iffe, Kwara, 19th–20th century. Kwara district men who have achieved distinction in their community are expected to take chieftaincy titles. As a sign of their office, they have staffs made by carvers and blacksmiths. The titles and staffs are not inherited; hence, when a chief dies, his staff is placed with others in a corner of the entrance hall or the room where he slept. Many staffs, especially nineteenth century ones, have an unornamented, slightly narrow phallus or helmet shape on the top. Later ones have abstract facial features on this top portion similar to those of the *ere ibeji* in Figure 198. Recent staffs are surmounted by images of kneeling or seated female figures, the heads of which have retained the shape of the earlier staff tops. The figural carving is markedly different from other Yoruba areas, far more stylized. The eyes are deeply recessed, the mouth is thrust forward, the ears defined by a simple curve. The body and upper arms of the figure may be severely elongated, the breasts prominent. The shaft consists of alternating linked-chain and disk patterns. The base is a short iron shaft. Wood, iron. H. 49 in. National Commission for Museums and Monuments, Nigeria.

180. The "face" of *orisa* Oko is indicated by the cross-pattern, with eyes and facial marks near the center of the staff. A devotee will touch the "face" of her lord with her offering and then touch her own head thereby acknowledging that her *ori*, ("head" and "personal destiny"), are inextricably bound to that of the god. She gives prominence to the "face" of *orisa* Oko by securing cowrie shells and beads to the staff and placing on them an offering of a kola nut. Ila-Orangun, Nigeria, 1974. Photograph by J. Pemberton 3rd.

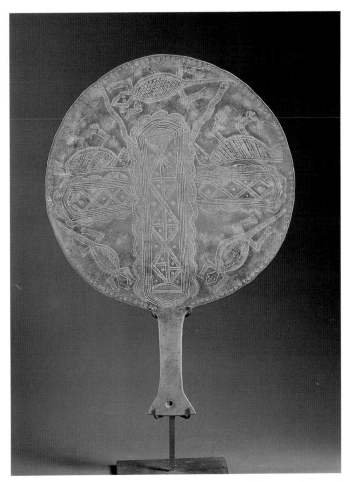

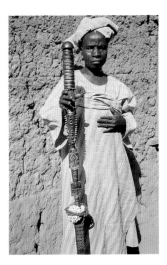

182. Iyawo *orisa* Oko, priestess of *orisa* Oko, holding the shining metal staff of her lord and deity. Women are designated from childhood by Ifa divination to be a priestess and "wife," (*iyawo*), of *orisa* Oko. The red and white marks of her priesthood appear on her forehead. Ila-Orangun, Nigeria, 1974. Photograph by J. Pemberton 3rd.

181. Fan of a Priestess of Osun, Osogbo. Brass bowls are used to carry the waters of *orisa* Osun from the river to the shrine. Devotees wear brass bracelets and priestesses carry brass fans as a sign of office. The surface elaboration here combines abstract geometric patterns with stylized lizards and birds. The cross-within-a-circle motif indicates a place of meeting, in this instance the meeting of the powers of the gods and of nature. Further, the fan is held by a priestess, who is also a mediator between these divine and natural forces and the world of humankind. Brass. Diam. 12 in. Arthur R. Thomson.

scene, the richly carved columns in front of the gaily-coloured altar, . . . and the upward-tending scaffolding towards the front, sustaining the mighty, soaring frame of thatch, was superbly impressive. . . .[40]

Two screens of fifteen veranda posts (nine on the right and six on the left) stood on either side of the entrance to the altar. When I visited the Agbeni Sango shrine in 1971 and again in 1976, it was in a much transformed state. A fire had damaged it about fifteen years earlier, and the devotees had sought to restore it as best they could to its original design. While there were fewer veranda posts in the screen of the restored shrine, many of the same images appeared, for example, the seated female figure with child among the figures on the right (Figure 175). The red and white marks on her forehead indicate that she is a devotee of orisa Oko, deity of the farm. I was told that many of the other figures were followers of various orisa or, as in the case of the monkey, were associated with the cult of the ancestors. Of particular interest is the veranda post on the far right in Frobenius' photograph (see Figure 171). It depicts a Muslim, dressed in white, holding his prayer beads. A similar carving was part of the restored screen as well. For the worshippers of Sango it is perfectly appropriate that the follower of Allah be included along with the devotees of the orisa who assemble to honor the deified king of Oyo-Ile.

It is clear from Frobenius's photographs that the original veranda posts were the work of several carvers. It was not unusual in large sculptural programs for carvers to be commissioned to do one or more pieces, and to come from neighboring and distant towns. Well-known artists, such as Maku of Erin (died about 1915) and Taiwo of Ila-Orangun (about 1855–1935), traveled considerable distances and spent months in residence when a project was important and the compensation attractive.[41] Frobenius's photograph of the interior of the shrine (Figure 172) provides an excellent view of two veranda posts depicting equestrian figures. The carvings are by different hands, although possibly from the same town—perhaps the little town of Erin, lying about 60 miles to the northeast of Ibadan and famed for its carvers, especially the workshop of Maku and his sons (see Figure 173).[42]

The central portion of the shrine is the irubo (place of sacrifice). It contains a beautifully carved, inverted mortar known as odo Sango. There is also a large wooden bowl filled with edan ara (the celts of the thunder god). To the right there are carvings of a kneeling female Sango devotee and another of Sango's dog. There is also a small, figurated terracotta pot. To the left of the odo Sango is a calabash containing rams' horns, usually associated with orisa Oya, and a pair of carv-

ings for ibeji (deceased twins). In a large calabash, which rests on top of this accumulation, there are prayer rattles known as sere Sango, and a striped cloth. Farther to the right there are three terracotta pots, each with distinctive embossed designs or incised patterns. One has been painted with efun, a chalky substance, and may contain the cool, medicinal waters of orisa Osun or orisa Obatala. Each of the pots supports a calabash. The open calabashes contain what appear to be celts, cloths, and other unidentifiable objects. Another figured terracotta pot rests in a depression on the raised portion of the shrine. Two earthen jars, probably for orisa Esu, the guardian of the ritual process, are situated on the floor in front of the odo Sango, focusing the viewer's attention on the place of power and sacrifice. Seven laba Sango hang at the back of the shrine, providing in their sharply contrasting colors and bold, energetic designs expressions of the god's power. For it is in the laba Sango that the celts hurled by the god upon defenseless mortals are retrieved by Sango priests and brought to the shrine.

In the towns and villages that came under the sway of the Oyo Empire, shrines for Sango held a prominent place both in the palace grounds and in association with one of the lineage compounds, some of which became known as Ile Olorionisango ("The-house-of-the-Chief-Priest-of-Sango"). The Sango festival was prominent in the town's festival calendar, but in many towns and villages earlier traditions held fast. In the Igbomina town of Ila-Orangun, for example, which was on the eastern outskirts of the Oyo Empire, the worship of Sango may be important, but Ogun, orisa of iron and war, is still the principal deity. His festival, Odun Ogun, is of the same order of importance as the festival for the ancestors, Odun Egungun, and rites for Ogun, not for Sango, are performed in the annual festival for the king, Odun Oro.[43] Indeed, Ogun, the god of warriors and of the blacksmiths and carvers who forge the instruments of culture, is the orisa most widely worshipped throughout Yorubaland (Figure 178).

In Osogbo, about 45 miles from Ila, the festival for orisa Osun dominates the liturgical calendar. The king and townspeople gather in the sacred forest to watch as priestesses offer libations at the Osun River and return with brass pots filled with the medicinal waters of the goddess. These are placed in the central shrine and other shrines in the palace and town.

As in Osogbo, at the annual festival for Osun in many northern Yoruba towns, the priestesses are dressed in white and carry a pair of yata (beaded panels) resting on their hips (Figure 183). Each panel hangs from a strap which crosses the priestess's body from the opposite shoulder. The straps often have bits of mirror sewn into

the cloth which reflect the light, as ripplets on flowing water. The panels are about 14 inches square. The beads are threaded together and sewn on a cloth which is affixed to a stiff leather backing. As in Figure 184, the colors are usually shades of blue and yellow that are associated with Osun; they are combined with other colors used for aesthetic effect or to refer to other *orisa* associated with the house and shrine of the devotee. The patterns of the *yata* vary greatly, consisting essentially of a combination of geometric patterns, the juxtaposition or overlay of which, combined with the interplay of subtle colors, conveys a controlled energy. In the mid-portion of the design there is usually the image of a human face. The significance of this iconographic detail is variously interpreted by devotees. It recalls similar facial patterns on the crowns of kings (Figure 186) and on the large beaded bags that surround and hold together the numerous strands of cowrie shells, which are the emblem for the worshippers of Alarere, a version of the cult of *orisa* Oko, deity of the farm (Figure 188). Although the facial motif on king's crowns is often associated with Oduduwa, the first king of the Yoruba people, similar motifs on other *orisa* emblems need not be so specific. As in the prominence of the head and face in the sculptural arts, the facial motif on crowns and beaded panels refers to the destiny, or *ori inu*, of the one who wears, carries, or looks upon the emblem; this destiny is inextricably linked to an *orisa*. In the case of the Osun devotee, it is to know that one's destiny is bound up with a power upon which even the sixteen male *orisa* were dependent when they were commissioned to organize the world for human habitation. For it was not until Ogun, Sango, and the other *orisa* honored Osun and included her in their councils that their work on earth and their sacrifices offered to Olodumare, the High God, were effective.

In the neighboring town of Ilobu, *orisa* Erinle, a great hunter who became an *orisa*, is the most important of the gods although there are shrines for Sango, Oya, and other deities. Erinle is said to have conducted the first Olobu, the paramount chief of Ilobu, to the present site of the town, and over the years Erinle protected the people of Ilobu from the invasion of the Fulani. According to local tradition, when Erinle had "stayed long enough in Ilobu 'he returned to the river' from which he had originally come."[44] Thus, in the clay pots which are found on Erinle shrines, the devotee covers a cluster of smooth, round stones found in the nearby Erinle River with water from the river.

The Erinle cult probably existed in Oyo-Ile, for it is found throughout the towns of the Oyo Empire. The emblem of the god has a basic form—an earthenware vessel with ornamented lid. In northern Oyo towns, such as Ilobu, the Erinle cult object is usually conceived entirely of abstract shapes. The surface of the pot and lid are sometimes lightly patterned. The lid is ornamented with two intersecting arches with a cone projecting at the top. As in the iconography of "the crown of Banyani" on Sango shrines, the basic form of the lid for the Erinle pot includes the abstract conical image of the *oba's* crown and that of the shrine for the *ori*.

An earthenware pot with intersecting arches is also found on shrines in the Ijebu area for *orisa* Osoosi, who is also a hunter and, as with Erinle, is associated with forest streams. As hunter gods, they express a relationship to the forest and hunt that contrasts with Ogun's thirst for blood. Their water-filled vessels, as those for *orisa* Osun, often appear on Sango shrines or near his emblems on household shrines, providing a cooling presence to the ill-tempered divine king (Figure 176).

In Saki, a town to the west of Oyo-Ile, to which many of Oyo-Ile's residents fled when the capital city fell, it is *orisa* Oko, deity of the farm, who defines the religious life of the community. *Orisa* Oko was once a hunter and friend of Ogun but abandoned the hunt to become a farmer. In the pantheon of the *orisa* he is associated with the *orisa funfun*, the deities of whiteness: Obatala the fashioner of human bodies, Osanyin the provider of medicinal herbs, Osun the mother of life-giving waters, as well as Yemoja and Osoosi.

It is in Irawo that the blacksmiths forge the *opa orisa Oko*, the "staff" and principal symbol of the *orisa* (Figure 187). The staff of Oko is made by smelting the bundles of hoes brought by devotees from throughout Yorubaland. Since the metal has twice undergone the smelting process, it has almost the quality and appearance of steel. Every staff is a commissioned work and therefore reflects the technical skill and artistry of the blacksmith who creates it. While the size of the staff may vary depending upon the number of hoes brought to the smithy and by the wealth of those who commission it, the form of the staff is constant. The top has a phallus shape, which is readily acknowledged by priestesses, for they are the *iyawo orisa Oko* ("wives of *orisa* Oko"). But the cone-on-stem form is also a reference to the head of the *orisa*. A third of the way down the staff there is a small square on which a cross pattern is inscribed on each side. On the front of the staff, two eyes are etched in the upper quadrants created by the cross. The area is known as the "face" of the *orisa*, and it is here that the priestess touches the offerings after having touched them to her head. Often a priestess will bind clusters of cowrie shells and large translucent beads to emphasize the ritual significance of the "face" (Figure 180). On the

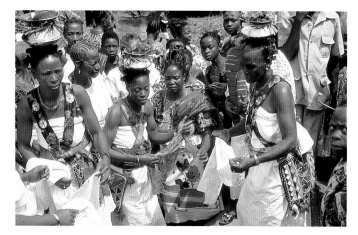

183. Priestesses dancing at the festival for *orisa* Osun in Ila-Orangun. Each wears beaded dance panels (*yata*) and carries on her head a brass bowl filled with the medicinal waters and herbs of the goddess who cures the sick and blesses her followers with children. Ila-Orangun, Nigeria, 1982. Photograph by J. Pemberton 3rd.

184. Beaded Dance Panel, Oyo/Osogbo area, 20th century. The beaded dance panels, (*yata*), worn by priestesses at the annual festival for *orisa* Osun, often combine subtle colors with geometric patterns that convey great energy. The vast majority depict a face. This iconographic motif is given various interpretations, but is at one and the same time associated with a divine presence and also the personal destiny of the devotee. Beads, cloth, leather. H. 11½ in. Collection Dufour, France.

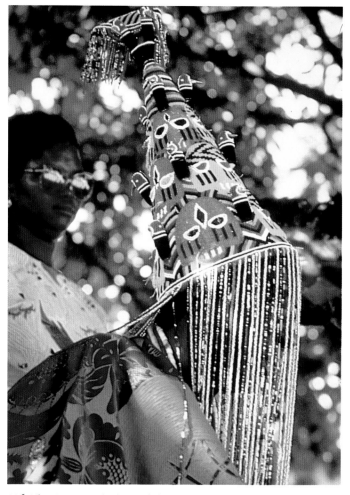

186. The Orangun-Ila, king of Ila, wearing his great crown (*adenla*) called "Ologun," (Crown of the Warrior) during the concluding rite of Odun Oba, the festival for the king. The crown was made by a bead-worker from the Adesina family in Efon-Alaiye. Ila-Orangun, Nigeria, 1984. Photograph by J. Pemberton 3rd.

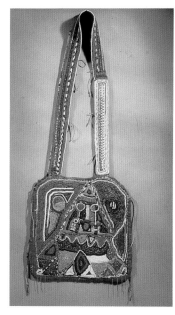

185. Beaded Bag, Oyo/Osogbo area, 20th century. The beaded panel of this bag is a riot of shapes and colors. It expresses an uncontrollable energy like that which possesses *orisa* Sango. The face at the center is depicted in the conical form of a crown, appropriate for the deified king of Oyo-Ile. The series of triangular patterns at the bottom of the crown and along the lower edge of the panel are reminiscent of the seven triangular pieces suspended from the bottom of a *laba* Sango (see Figure 160). Ulli Beier photographed a Sango shrine in Ilobu in the mid-fifties on which beaded dance panels and bags hung on the wall of the shrine along with the traditional leather *laba* Sango. Beads, cloth, leather. H. 39½ in. Valerie Franklin.

187. Staff with Beaded Sheath and Crown, Central Yoruba, 19th–20th century. An *opa orisa* Oko is referred to as the "staff" or "walking stick" of the deity of the farm. It is enclosed within a beaded bag and crown, when it is not displayed on ritual occasions. The staff is forged from hoes which devotees bring to the blacksmiths of Irawo, who alone have the secret knowledge necessary for making these sacred emblems. Although *orisa* Oko was never a king, he is honored by his followers with a beaded garment and crown. Iron, wood, beads, cloth, hide. Staff: H. 56½ in. Sheath: H. 52 in. Crown: H. 7 in. Gift of Evelyn A. Jaffe Hall, Hood Museum of Art, Dartmouth College.

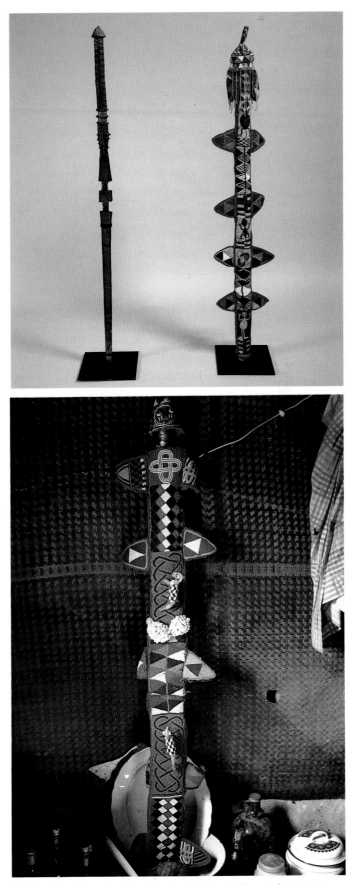

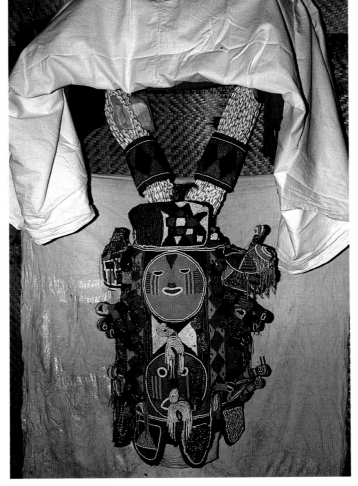

188. An Alarere shrine for *orisa* Oko, deity of the farm. Alarere is a variation of the cult for *orisa* Oko. Its emblem consists of thirty to fifty strands of cowrie shells, a sign of wealth, which are bound together by an elaborately decorated beaded panel. Ila-Orangun, Nigeria, 1972. Photograph by J. Pemberton 3rd.

189. A shrine for *orisa* Oko showing the beaded bag and crown in which the staff of the god is kept when not ritually used. Ila-Orangun, Nigeria, 1974. Photograph by J. Pemberton 3rd.

169

long bladelike lower portion, the ornamentation consists of a series of geometric patterns, although on the larger staffs there will be the image of a bird. Many devotees refer to the bird as "decorative." Others, however, speak of it in a guarded way, suggesting that, as with bird imagery on other ritual artifacts, the bird refers to the power of "the mothers," in other words the *ase* of women.

Often a priestess will have a beaded or cowrie shell-covered case and a crown in which the staff is placed when not being used on ritual occasions (Figure 189). The covering is to honor and enhance the beauty of her lord. (The use of a beaded crown is especially noteworthy, since, unlike Sango and Obatala, Oko was not a king before becoming an *orisa*.) As with the beaded dance panels for Osun, the patterns and diversity of colors reflect the artistic imagination of the beadworker, and, if the patron requests, beaded animal and human figures will be attached along the length of the case. Often the image of a face will be included on the upper portion of the case, the red and white marks appearing on the forehead just as they are worn by priestesses of the *orisa* on ritual occasions (Figure 182).

A surprising variety of gods compose the Yoruba pantheon. There is variation both in names and, to some extent, in the attributes of a particular god. Even within the region of the Oyo Empire, where the power of Sango held sway, other *orisa* remained part of the lives of communities and individuals. From place to place, whether region, town, or compound, there are constantly changing configurations of the gods. Through them, individuals and groups have articulated their deepest concerns, and in them are found perceptions of self and the world. The High God, Olodumare, who has neither shrine nor priesthood, stands surety for the ultimate coherence of the universe; but it is through the many *orisa* that the Yoruba express the dynamics and diversity of the forces that constitute the universe and the individuality of one's experience within it. This situation and rich religious imagination have provided the ground for artistic creativity.[45.]

The Cult of Twins

On many Sango shrines one finds carved images for deceased twins, *ere ibeji*, tucked in among the celts in the great offering bowl or leaning against the base of the *odo* Sango (Figure 160). Sango is known as the protector of *ibeji*, who are identified so closely with him that they have been called the "children of thunder."[46]

The Yoruba have one of the highest rates of twinning in the world, approximately forty-five twin births out of

every thousand births.[47] The reasons for this extraordinary phenomenon are unknown, although recent studies suggest a possible link between dietary and genetic patterns.[48] The response to twin births has its own social history.

Throughout that portion of Yorubaland once under the influence of the Oyo Empire, twins, both living and dead, are referred to as *emi alagbara* ("powerful spirits"), who are capable of bringing riches to their parents and misfortune to those who do not honor them. As with kings, twins are thought to have the powers of an *orisa* and to become *orisa* when they die, but in many of the *oriki* sung for twins an ambivalence about "twin spirits" betrays itself.

> *Taiwo and Kebinde are rich children.*
> *They give me pleasure, as does a crown,*
> *As does one with a long, graceful neck,*
> *As one whom it is good to see in the morning,*
> *As one who attracts attention,*
> *As one with beautiful eyes,*
> *As one with small eyes and a long tail.*
> *In the morning the householder sweeps the ground.*
> *Colobus born of Colobus!*
> *Colobus born of Colobus!*
> *Colobus born of Colobus!*
> *Touraco bird on the tree!*
> *Do not touch my tail or my eyes!*
> *You, who are honored in the morning with drum and carving,*
> *Who sleep with the Oni, but do not roll up your mats in the morning.*
> *You, who are taller than your comrades,*
> *Who enter without greeting the Orangun.*
> *Everyone is a king in his own house.*
> *Tiny children in the eyes of the jealous co-wife,*
> *Who are treated with care by their mother.*
> *You shout, "Abuse me, and I shall follow you home.*
> *Praise me, and I shall leave you alone!"*
> *You, who do not despise the poor,*
> *Who are relatives of the cloth seller.*
> *You enter without greeting the Orangun.*
> *Everyone is a king in his own house.*
> *The Orangun refused to recognize them because they were tiny.*
> *The envious co-wife says: "One with a narrow head and deep set eyes."*
> *Twin, you belong to the people of Isokun.*
> *A tiny person who lives in trees.*
> *Twin who cannot walk alone, who needs another with whom to walk.*[49]

An *oriki* is often a highly original creation of the singer at the time of the performance. She may combine well-known verses from songs for *ibeji* with phrases borrowed from other oral genres, such as the hunter's greeting to the Colobus monkey. She may refer to local persons, including the king of the singer's hometown, the Orangun-Ila, as well as the Oni of Ife. *Oriki* for *ibeji* are sung to celebrate and placate the

orisa-like power of twins. They entertain those listening by clever word play and by the subtlety with which the singer expresses the oddness of twin births, the unique status of twins in Yoruba society, the social tensions that the birth of twins creates between co-wives, and the feelings of ambiguity about the propriety of multiple births for humans.

In the *oriki* cited, the twins, Taiwo (the first born, the "one who tastes the world") and Kehinde (the second born and considered the eldest), are praised for bringing riches to their parents. The co-wife may mock their tiny size, but they are beautiful in the eyes of their mother. Nonetheless, they are thought to be strange even by their parents. They violate social protocol, by not observing the courtesies due kings. The first twins are said to have come from Isokun, a place apparently without specific location.[50] The singer refers to the twin as "a tiny person who lives in trees," and associates *ibeji* with the *edun*, the Colobus monkey, who lives in the marginal world where forest and field border on human habitation. The singer also observes that "The Orangun refused to recognize them because they were tiny." This echoes the historical fact that the "custom of killing twins prevailed all over the country in early times."[51] It is not clear when twin infanticide ended, but the practice may have ceased by decree of the Alafin of Oyo, when one of his wives gave birth to twins. The "King was loth to destroy them. . . [and] thereupon gave orders that they should be removed—with the mother—to a remote part of the kingdom and there to remain and be regarded as dead."[52] One analysis of myths relating to the origins of the cult of twins in southwestern Yoruba communities concludes that there was a remarkable reversal in attitudes toward twin births among the southwestern Yoruba that occurred during the latter part of the eighteenth and early in the nineteenth century, and coincident with the change was the appearance of the cult of twins.[53] In the poetry of Ifa, there is abundant evidence for a radical change in attitudes toward twin births from a time when twins were viewed as "monsters" to a later period when they were received as "kings" and "*orisa*."[54]

Cumulative evidence, therefore, clearly indicates that twin births were once unacceptable among the Yoruba, as well as among neighboring peoples to the southeast, and that such births are still unwelcome among many southeastern Yoruba communities.[55] (For example, the cult of twins is not found among the Ondo Yoruba, and hence there are no carvings for twins from Owo and other Ondo towns.) It also appears to be the case that the reversal of attitudes and practices relating to twin births seems to have been occasioned by Oyo-Ile's contacts with Porto Novo in Dahomey, where, according to

one account, "it was not the custom in those parts to kill twins as in Oyo."[56] The cult then spread to other Yoruba towns within the Oyo Empire. Although Christian and Islamic missions may have played a role in supporting the change, it appears that the emergence of the cult of twins was a development within Oyo Yoruba culture, which was subsequently legitimatized by the identification of Sango as the protector of twins.

The earliest recorded reference to carvings for deceased twins is in an entry in the journal of Richard Lander, who accompanied Clapperton on his explorations in 1826 and returned to West Africa in 1830. In the town of Egga north of the coastal city of Badagry, Lander observed "many women with little wooden figures of children on their heads [who] passed us in the course of the morning—mothers who, having lost a child, carry such rude imitations of them about their persons for an indefinite time as a symbol of mourning. None of them could be induced to part with one of these little affectionate memorials."[57]

Two days later, Lander noted that "the mortality of children must be immense indeed here, for almost every woman we met with on the road, had one or more of those little wooden images, we have spoken of before. Whenever the mothers stopped to take refreshment, a small part of their food was invariably presented to the lips of these inanimate memorials."[58]

Lander's reference to the carvings as "affectionate memorials" is apt. Studies of the care and nurturing of twins in several Yoruba towns document the special attention given to them by their parents, especially the mothers.[59] It is expected that they will carry the twins to the markets to dance in their honor, sing their praises, and receive gifts of money from those who pass by (Figure 190). Special foods must be prepared for twins once a week; beans or cowpeas cooked with palm-oil, for example, are thought to "cool" their spirited temperaments. Privileged attention continues even when one or both of the twins die.

On the occasion of the death of a twin, the parents will consult an Ifa divination priest in order to learn which carver should be asked to carve an *ere ibeji*.[60] Following negotiations with the carver over the fee, sacrificial materials, and food that will be required for the preparation of the carving, the parents wait until they are notified. The carver will place a small sacrifice at the base of an *ire ona* tree, a tree of relatively soft wood used for carving *ibeji* figures. Apart from the parents' decision regarding the lineage markings on the face of the figure, stylistic considerations in the carving of an *ibeji* are solely those of the carver. Before presenting the *ere ibeji* to the parents, the carver will invoke the *emi* (spirit) of the deceased child by submerging

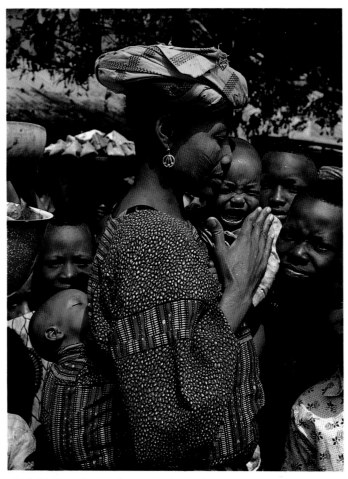

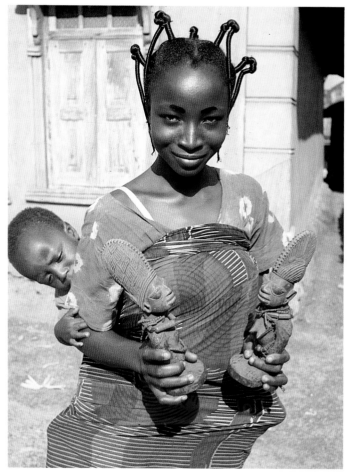

190. Mother of twins dancing in the market. Twins are said to bring wealth to their parents. Hence, *iyabeji*, "mother of twins," will go to the market to dance and to sing songs called *orin ibeji* which celebrate the power of twins, and include general social commentary. Often the songs are improvised on the spot and are highly imaginative creations of the singer, who will be rewarded with gifts of money by the market women and passers-by. Ogbaga, Oyo, Nigeria, 1971. Photograph by M. H. Houlberg

191. A young woman who has inherited the care of *ere ibeji* from her father's mother. The figures were carved by Oje of Aga's compound, Ila-Orangun, about 1925. Isedo Quarter, Ila-Orangun, Nigeria, 1974. Photograph by J. Pemberton 3rd.

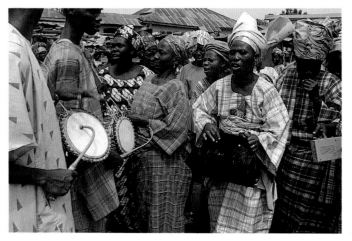

192. Accompanied by drummers and her friends, the mother of twins dances in the market with the living twin on her back and the commemorative carving for the deceased twin tucked into her wrapper. Ogbaga, Oyo, Nigeria, 1971. Photograph by M. H. Houlberg.

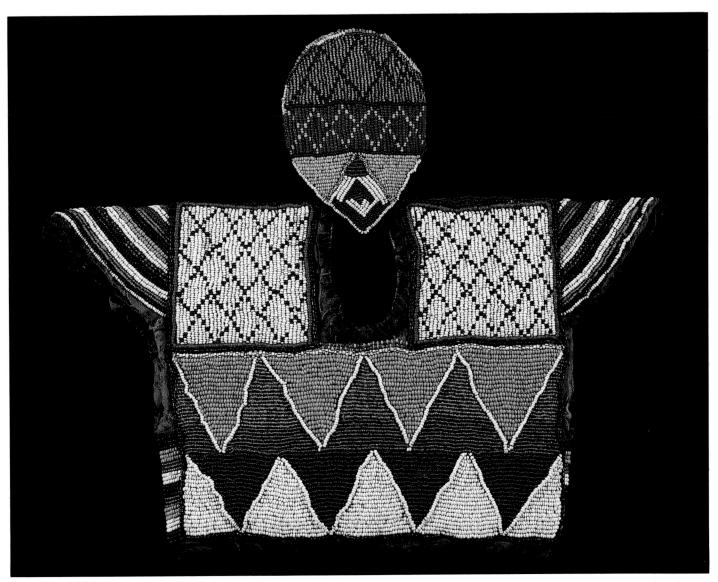

193. Beaded Tunic and Hat for a Twin Figure, Central Yoruba, 19th–20th century. The clothing of a twin figure with a beaded garment honors and placates the spirit of the deceased twin, whose power affects the well-being of the living. Beads, leather, cloth. Tunic: 9½ in. Hat: 5¼ in. Joan and Thomas Mohr collection.

the figure for several days in a concoction of leaves crushed in water. Later, when the wood is dry, he will rub the carving with a mixture called *ero*, consisting of palm oil and shea butter.

On the day that the parents are to receive the *ere ibeji*, they will carry food to the carver's compound to feast the carver and his family. The carver will place the *ere ibeji* on a small mat in front of the shrine to Ogun and offer a sacrifice to the god of iron. The mother will then stretch forward her arms towards the little figure, offer a prayer to her *ibeji* and receive the *ere ibeji* from the carver. Tucking the figure in her wrapper as she would a living child, the mother will dance and sing songs appropriate for twins (Figure 192). As she leaves, she will be instructed by the carver to talk to no one and not to look back as she makes her way home.

The transformation of the carved image into something more than a memorial figure and the shaping of the mother's perception of the child that is once again with her continues with the ritual care of the *ere ibeji* over the days and weeks that follow. The figure will be washed with a coarse, black, medicinal soap and

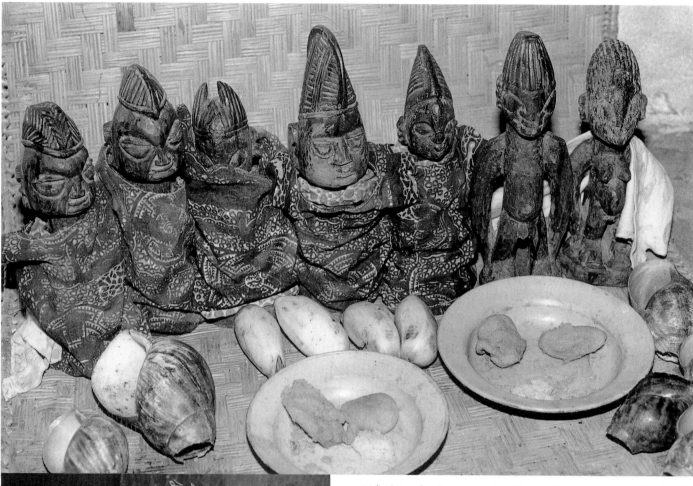

194. Shrine for deceased twins. The carvings represent the deaths of twins over several generations in a family. Each generation takes on the responsibility to sacrifice and care for the spirits of the deceased represented in the twin figures. Imosan, Ijebu, Nigeria, 1982. Photograph by J. Pemberton 3rd.

195. An elderly woman with the memorial figures of her deceased twins. The *ere ibeji* were carved by Ogunwuyi (c. 1890–1965) of Ore's compound, Ila-Orangun. Isedo Quarter, Ila-Orangun, 1984. Photograph by J. Pemberton 3rd.

scrubbed with the soft, white chaff of sugar cane. (Sugar cane is a sacrificial food appropriate for *ibeji*.) A cloth soaked in indigo dye will be used to rub the head, for it is within the *ori* that the deep mystery of one's personal destiny resides. The body will be anointed with ground camwood, both to beautify and protect the *ibeji* from harm. Finally, she will add waist and/or neck beads, the colors of which will refer to the *orisa* she worships, perhaps to more than one (Figure 191). She may add cowrie shells for wristlettes, or brass rings on the ankles for Aro, the *orisa* who protects children from the appeals of *abiku* (spirit-children born to die) (Figures 196, 197). She may dress the figure in cloth or an expensive beaded or cowrie-shell bag (Figure 193). At weekly rites and on the occasion of annual festivals, the mother will prepare food for her *ibeji*, placing it in dishes before the carvings (Figure 194).

Through the process of ritual transformation, the carvings are no longer viewed by the mother, or others in the family, as wooden memorial figures. As the loci of ritual activity, *ere ibeji* come to embody the living dead. The deceased child, whether having died at six weeks or after sixty years, is present to the living in, with, and through the *ibeji* figure. Indeed, the carvings themselves convey the *ase* of the twin child even in death (Figure 195).

One of the striking characteristics of *ibeji* figures is their depiction of the human form in the fullness of life. They often portray physically powerful bodies, the breasts of female figures and the genitals of males prominently displayed. Their bodies are erect, hands usually positioned on hips or legs, emphasizing poise and balance. Their heads constitute a third of the carving and are adorned with an elaborate coiffure or hat, usually of the *abatiaja* type, having triangular projections on each side. The faces convey composure and an inner strength. *Ere ibeji* are an affirmation of life.

For all the pathos that lies behind the creation of *ibeji* carvings, their extraordinary numbers have been a boon to the study of Yoruba art. They provide a single type of art form with which to make comparative studies of regional styles. The emphasis on volume and careful delineation of the figure in the *ibeji* carvings from northern Ekiti (Figure 196), for example, contrasts with those from the western Oyo town of Shaki which are often slender, at times elongated figures, with highly refined features (Figure 197), while carvings from the southern Ijebu area also tend to emphasize volume but in rather squat and crudely defined figures (see Figure 194).

Ere ibeji also provide a means for identifying the distinctive characteristics of various workshops of carvers in a particular town. Studies have identified four major

workshops in the town of Ila-Orangun, and have traced the history of carving styles in Inurin's Compound through four generations of carvers.[62] Two important workshops or "schools" of carvers in the Itoko quarter of the southwestern Yoruba town of Abeokuta have been identified: the Adugbologe school, established in the 1850s by Egbado immigrants from Aibo, and the Esubiyi school, established a decade later by Egbado immigrants from Ibara Orile.[62] The extraordinary number of carvings from these workshops over the years has enabled students of Yoruba art to identify the hands of individual carvers and study changes in craftsmanship and artistry over time.

Ancestral Ensembles

The social world of the Yoruba consists of the living, the not-yet-born, and the deceased. Deceased twins, especially those who died as children, are thought of as not yet born, for they have not experienced the fullness of life and may return to the household. But those who have accomplished their days on earth and made a position for themselves in society become ancestors.

"Ancestor" is the term commonly used to translate the Yoruba phrase Ara Orun, which means literally, "Dwellers in Heaven" or, as more loosely translated by some, "Beings from Beyond." For the Yoruba, "existence" is not defined solely in terms of physical life on earth. The dead also "exist" in the sense that they make their presence known to the living, whose well-being depends upon their relationship to the living dead. Hence, throughout the Oyo Yoruba area annual and/or biennial festivals for the ancestors, called Odun Egungun, are held in every community.[63] They consist of a series of rituals performed over several weeks within the compounds of the lineages that compose a town, as well as public rites at the *igbale* (the forest of the *engungun*), in the marketplace, and at the front of the palace. It is during Odun Egungun and on the occasion of commemorative funeral rites for the deceased that the living dead appear and are honored through the mediation of masquerades, or *egungun*, meaning "powers concealed."[64]

While there are several masking traditions among various Yoruba subgroups, Egungun has its origins among the Oyo Yoruba (Figure 199). The oral histories of the palace and lineages of Oyo, and the myths preserved in Ifa divination poetry, strongly suggest that the peoples of Oyo-Ile adapted a masking tradition found among the Nupe, richly embellishing it for their own purposes of honoring the ancestors.[65] The cult of Egungun, although closely associated with the myths and rituals for Sango and Oya, was probably a later development inspired by palace historians and fol-

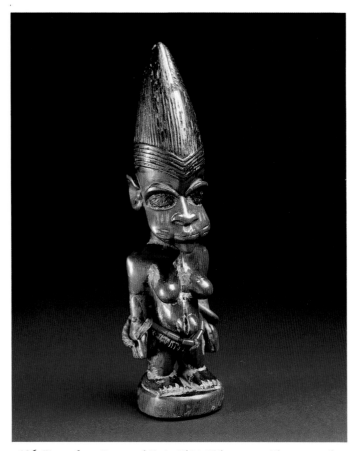

196. Figure for a Deceased Twin, Ekiti, 20th century. The carver of this *ere ibeji* emphasizes the puffy cheeks of an infant though the figure, as in all carvings for deceased twins, depicts maturity. The mother of the *ibeji* has placed black beads around the waist as protection against *abiku*, spirit children who are born to die, and added the red beads of Sango, protector of twins, and the brass bracelet of Osun. Wood, beads, brass. H. 10 in. Deborah and Jeffrey Hammer, Los Angeles.

197. Figures for Deceased Twins, Saki, 19th–20th century. This pair of *ere ibeji* are among the finest examples of the Saki style, named for a small town to the northwest of Oyo. The tall, slender figures have had earrings, necklaces, bracelets and waist beads added by the mother in her appeal to the *orisa* for protection of the deceased and in supplication for their return to the world of the living. Wood, beads, brass. H. 13⅜ and 14 in. Lawrence Gussman.

198. Figures for Deceased Twins, Yagba, 20th century. Remarkable for his highly stylized treatment of the human figure, the carver depicts the head as a cone on which the facial features are superficially sketched. The body and legs form another cone or inverted Y with the arms conceived as two curves extending from the neck to the lower portion of the leg. The patterns employed to delineate the face are similar to those found on the finials of late nineteenth century chiefs' staffs in Kwara villages. Wood, beads, iron. H. 7⅞ and 8¼ in. Private collection.

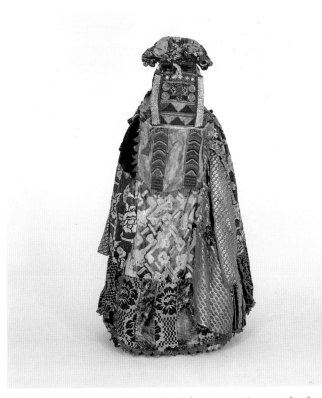

199. Egungun costume, Oyo, early 20th century. Masquerades for the ancestors are known as *egungun*, "powers concealed." The body of the dancer is completely covered by layer upon layer of cloth. On occasion one can tell the age of a masquerade by an examination of the cloths that have been used, since it is not unusual for new cloths to be added each year. The under layers of this costume reveal very old indigo-dyed cloth made of home-spun cotton. The outer layers are of machine-made cloth, including velvet. Cowrie shells, symbols of wealth, frame the sides of the netting that hides the dancer's face. Beads "crown" the masker's head, are used in horizontal rows below the face, and descend in parallel columns on the front of the costume. The wealth and status of the family, as well as the power of the ancestor, are celebrated in this assemblage of materials. Cloth, beads, cowries. H. 59 in. Eric D. Robertson.

200. Egungun costume, Oyo. Back view of Figure 199. Cloth, beads, cowries. H. 59 in. Eric D. Robertson.

201. An *egungun* masquerade of a type called Onidan, "owner of miracles." Ilogbo, Awori, Nigeria, 1982. Photograph by J. Pemberton 3rd.

202. An Onidan *egungun* whirling and transforming from one appearance to another through the inversion of its cloth. Ilogbo, Awori, Nigeria, 1982. Photograph by M. T. Drewal.

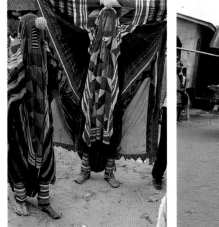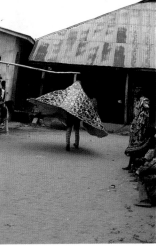

lowers of Sango in order to enhance the status of the Alafin and the *orisa* in the political and cult life of Oyo-Ile.

It appears from the oral histories that there were two groups in Oyo-Ile associated with Egungun. One was led by Chief Alapinni, a member of the Oyo Mesi, whose lineage was one of the "northern houses" in the capital city. The cult life of Alapinni's group focused upon celebrating the importance of the older nonroyal houses in the political life of Oyo-Ile. The costumes of this group were reputed to be very expensive and were probably composed of many layers of cloth. The other group was led by Chief Alagbaa, who was associated with the Oloba and Ologbin lineage groups, which traced their ancestry to other towns than those from the north. Their cult life was focused upon funerary rites, commemorative rites for the deceased and masked performances designed for public entertainment. Their costumes were of a type that entailed visual transformations.

In the early stages of the empire, towns with strong connections to the royal court, such as Ede, Ofa, and Oyan, also had well-developed Egungun cults. There was only one Alapinni, and he resided in the capital city; but the title of Alagbaa appeared in all Oyo Yoruba towns, as well as in the capital.[66] By the time of Alafin Abiodun (reigned 1774–1789), the Alapinni group was closely identified with the Oyo Mesi. The followers of the Alagbaa were clearly associated with the royal court and provided a network of communication with other towns throughout the empire in a manner similar to the organization of the Sango cult. With the expansion of the empire, the Egungun cult spread to Egba, Egbado, Awori, and Dahomey lands. It was in these areas that the organizational pattern of the Alagbaa, the leader of the local Egungun cult, and the *oje* (the members of the cult), closely paralleled that of the Mogba and *elegun* (those who were possessed) of the Sango cult locally and in its relationship to Oyo-Ile. With the fall of the Oyo Empire and the chaos that ensued during the civil wars, the movements of peoples carried the rituals and pageantry of the Egungun cult into other parts of Yorubaland where they were adapted to local traditions.

Clapperton's journal entry of February 26, 1826 regarding a performance of masked actors is the earliest account that we have of what may have been the *egungun* of the Alagbaa group in Oyo-Ile. His lengthy description suggests his fascination with what he saw, and sketches a performance and a number of masquerades that are remarkably similar to those seen today in Oyo Yoruba towns. The performance took place in the "king's park" at the front of the palace:

. . . the actors [were] dressed in large sacks, covering every part of the body; the head most fantastically decorated with strips of rags, damask silk, and cotton, of as many glaring colours as it was possible. The king's servants attended to keep the peace, and to prevent the crowd from breaking into the square in which the actors were assembled. Musicians also attended with drums, horns, and whistles, which were beaten and blown without intermission.

The first act consisted in dancing and tumbling in sacks, which they performed to admiration, considering that they could not see, and had not the free use of their feet and hands. The second act consisted in catching the boa constrictor: first, one of the sack-men came in front and knelt down on his hands and feet; then came out a tall majestic figure, having on a headdress and mask which baffle all description: it was of a glossy black colour, sometimes like a lion couchant over the crest of a helmet; at another like a black head with a large wig: at every turn he made it changed its appearance. This figure held in its right hand a sword, and by its superior dress and motions appeared to be the director of the scene, for not a word was spoken by the actors. The manager, as I shall call the tall figure, then came up to the man who was lying in the sack; another sack-dancer was brought in his sack, who by a wave of the sword was laid down at the other's head or feet; he having unsown the end of both sacks, the two crawled into one. There was now great waving of the manager's sword; indeed I thought that heads were going to be taken off, as all the actors assembled round the party lying down; but in a few minutes they all cleared away except the manager, who gave two or three flourishes with his sword, when the representation of the boa constrictor began. The animal put its head out of the bag in which it was contained, attempting to bite the manager; but at a wave of the sword it threw its head in another direction to avert the blow; it then began gradually to creep out of the bag, and went through the motions of a snake in a very natural manner, though it appeared to be rather full in the belly; opening and shutting its mouth, which I suspect was the performer's two hands, in the most natural manner imaginable. The length of the creature was spun out to about fourteen feet; and the colour and action were well represented by a covering of painted cloth, imitating that of the boa. After following the manager round the park for some time, and attempting to bite him, which he averted by a wave of the sword, a sign was made for the body of actors to come up; when the manager approaching the tail, made flourishes with his sword as if hacking at that part of the body. The snake gasped, twisted up, and seemed as if in great torture; and when nearly dead it was shouldered by the masqued actors, still gasping and making attempts to bite, but was carried off in triumph to the fetish house.

The third act consisted of the white devil. The actors having retired to some distance in the back ground, one of them was left in the centre, whose sack falling gradually down, exposed a white head, at which all the crowd gave a shout, that rent the air; they appeared indeed to enjoy this sight, as the perfection of the actor's art. The whole body was at last cleared of the incumbrance of the

The Egungun performance witnessed by Clapperton appears to have involved masquerades of a type usually referred to as Onidan ("performer of miracles"). Visually, the most spectacular are those composed of a large square of cloth overlaid with panels and bits of other cloths all of bright and contrasting colors. When the dancer extends his arms upwards and to the sides, the colors and patterns present a dazzling sight (Figure 201). The dancer is completely encased within the cloth. When he moves about, he draws the cloth up tightly between his legs in order to perform the intricate dance steps appropriate to the Onidan. The dancer sees through a netting covering his face, and on the top of his head there is a bundle of wool strips bound together enclosing powerful medicines for protection and to enable him to perform with power.

The "miracles" performed by the Onidan are numerous. Clapperton witnessed the transformation of two sacks into a boa constrictor and the wounding of the serpent by the sword-wielding masquer. The same visual trick

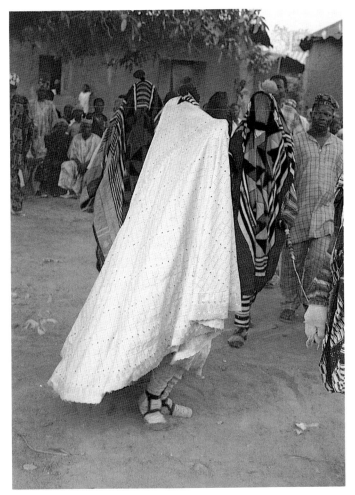

203. An Onidan *egungun* completing the miracle, that is, the transformation of its appearance with his cloth reversed or inside out. Ilogbo, Awori, Nigeria, 1982. Photograph by H. J. Drewal.

sack, when it exhibited the appearance of a human figure cast in white wax, of the middle size, miserably thin, and starved with cold. It frequently went through the motion of taking snuff, and rubbing its hands; when it walked, it was with the most awkward gait, treading as the most tender-footed white man would do in walking bare-footed, for the first time over new frozen ground. The spectators often appealed to us, as to the excellence of the performance, and entreated I would look and be attentive to what was going on. I pretended to be fully as much pleased with this caricature of a white man as they could be, and certainly the actor burlesqued the part to admiration. This being concluded, the performers all retired to the fetish house. Between each act, we had choral songs by the king's women, in which the assembled crowd joined their voices.[67]

The visual and verbal artistry for Egungun is so rich and varied that attempts at typological analyses prove to be difficult in the extreme. Over the years local histories, the movement of peoples, and the imagination of creators (artist and patron) of masquerades, as well as of dancers and singers, have resulted in variations on earlier types and the creation of distinctive regional types of costumes and performances (Figure 204).[68]

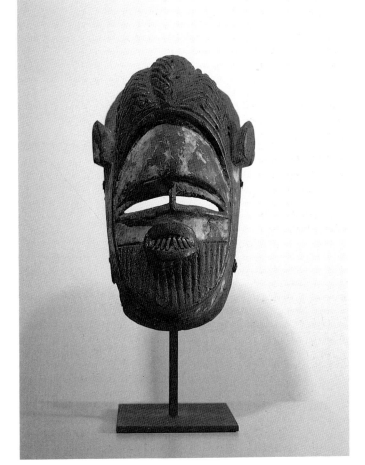

204. Egungun Face Mask, Owo, 20th century. The Agbodogin mask poses an interesting problem for the historian of Yoruba art and ritual. The form of the masquerade, in particular the carved face mask, appears to have been introduced from Ishan. It has no parallel among carvings created for western Yoruba ancestral masquerades. While the Agbodogin performs acrobatic stunts and dances as in Ishan, it has also been incorporated into Owo's ancestor festivals from western Yoruba sources. Wood, metal, pigment. H. 11 in. Collection of Toby and Barry Hecht.

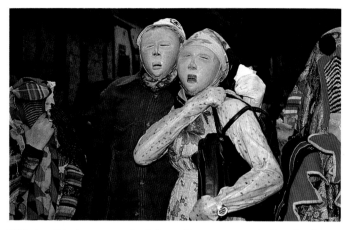

205. A satirical *egungun* depicting a European couple. She clutches her purse while he holds a Bic ballpoint pen in order to write messages to his lover, for writing, rather than dancing, is the mode of communication of the *oyinbo*, the white man. Ilogbo, Awori, Nigeria, 1982. Photographed by M. T. Drewal.

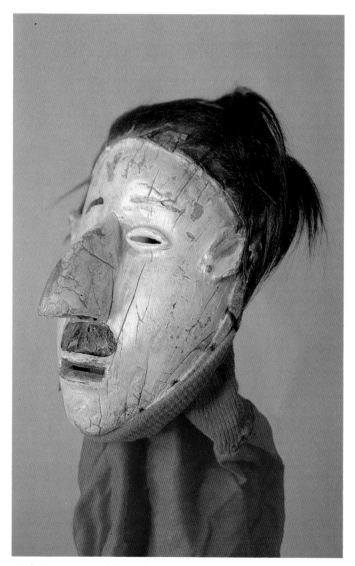

206. Egungun Headdress, Ibadan area, 20th century. Headdress for a satirical *egungun* imaging an *oyinbo*, or white man. Wood, animal fur, cloth, pigment. H. 9½ in. Private Collection.

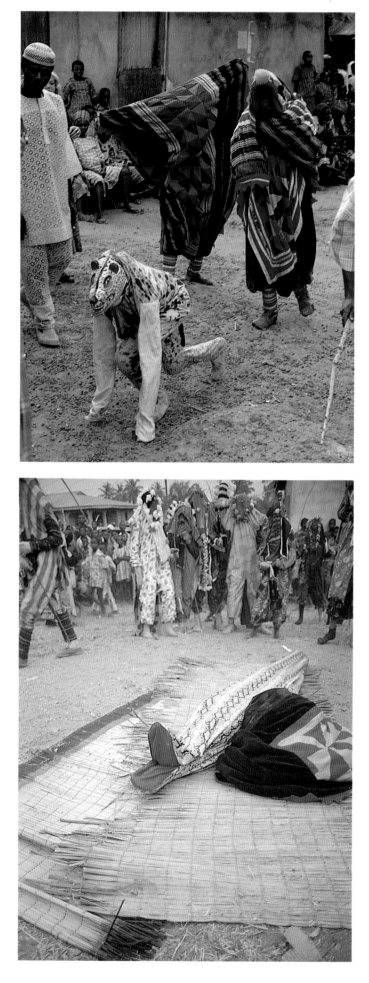

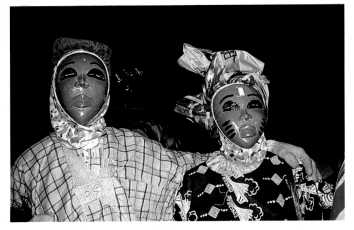

207. After nightfall and at the conclusion of the commemorative rite, the deceased mother appeared. Dressed in expensive cloth, the red and white marks of her devotion to *orisa* Oko upon her forehead, she danced briefly among her family and friends, acknowledging the honor that they had paid her. Ilogbo, Awori, Nigeria, 1982. Photograph by H. J. Drewal.

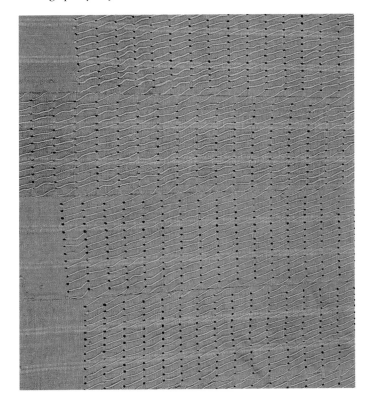

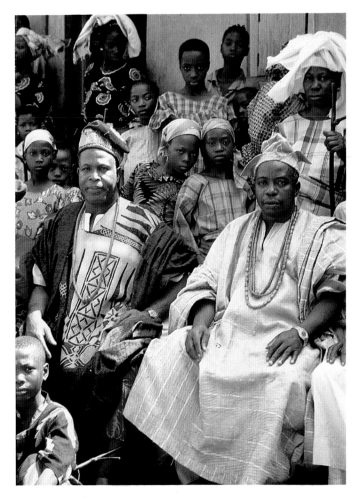

210. At the concluding rite in the Festival for the Oba in Ila-Orangun, every chief wears his finest *agbada*, a voluminous robe made of four-inch strips sewn together selvedge to selvedge and hand embroidered with silk in various designs. Chief Obaro, who sits on the left, wears a cloth called *etu* made from indigo-dyed yarn woven into four-inch strips. Chief Obale on the right wears a cloth of the type described in Figure 211. Both cloths have been hand embroidered with a design locally known as "Three Knives." Ila-Orangun, Nigeria, 1984. Photograph by J. Pemberton.

211. Strip-woven cloth, Iseyin, 20th century. Yoruba stripweaving is done by men on a double-heddle loom. Iseyin, along with Ilorin, was one of the foremost centers of weaving in the southwest of the Oyo kingdom. The yarn used to weave the four-inch strips was machine-spun, creating a lighter weight textile compared to the coarser and heavier hand-spun yarn. The openwork pattern is created by binding small groups of warp elements together by using supplementary weft floats, usually imported silk or rayon. The extra weft is laid within the ground weft and floated across one face of the cloth. Cotton. L. 81 in. Eric D. Robertson.

208. An animal *egungun* depicting a leopard. It was one of several animal types that appeared in the sequence of masquerades in a ritual performance to honor a senior woman who had died the year before. Ilogbo, Awori, Nigeria, 1982. Photograph by J. Pemberton 3rd.

209. At the conclusion of the ritual in honor of the deceased woman an Onidan masquerade appeared in the form of a serpent, whose jaws clacked open and shut as persons gave gifts of money to the family of the deceased. Ilogbo, Awori, Nigeria, 1982. Photograph by H. J. Drewal.

is part of the repertoire of Egungun groups today. The most common, and in some respects the most spectacular, transformation is that of a dancer moving about the dance area with measured steps, his multicolored cloths pulled up between his legs and loosely around his body. As the drum rhythms accelerate, the dancer turns, twists, and then whirls (Figure 202). The cloth flares out, usually revealing a lining often of a solid color. On occasion the cloth lifts off his whirling body, spinning to the ground behind him, or is reversed in such a fashion that, when he finally comes to a halt, he appears in an entirely different garb (Figure 203).

In a performance in Ota in 1982, which commemorated the life of a woman who had died the year before, the Onidan appeared first.[69] Their performance gave the clear impression that things are not always as they seem. Other Onidan of the satirical type followed, several of which depicted human stereotypes: the drunken Dahomean, the bedraggled Hausa trader, or, as Clapperton witnessed, the sad European visitor (Figures 205, 206). Then came a series of animal masquerades: happy wart hogs, copulating leopards and rambunctious rams (Figure 208). As the satirical figures staggered, shuffled, or pranced about, the viewer had the amused, uncomfortable impression that caricature and reality were not easily differentiated. The commemorative performance ended with a gathering of the Onidan, who, when they dispersed, revealed the masquerade of a large snake lying upon a mat (Figure 209). Its jaws clacked open and shut as it received gifts of money from those present. Finally, in the darkness that had descended, there appeared the masques of the beautiful mother and her husband (Figure 207). The face masks glistened with a dark olive green enamel paint. The red and white marks of *orisa* Oko were on her forehead, and she was dressed in very expensive cloth, with an elaborate headtie. She responded to the cheers of the crowd with gracious gestures of head and hand, danced a few steps, and soon disappeared into the darkness. She had been honored by the living, her children, and she in turn had honored them with her presence. The living dead are and are not as they seem to be in the world of the living. The commemorative performance is not merely a remembrance of relationships past, but an expression of relationships that now exist, albeit vastly transformed.[70] The same observation holds true for the ancestral ensembles that are identified with lineages and appear on the occasion of the annual and/or biennial town festivals or on special occasions within the life of a family, as, for example, when a death has occurred or some other misfortune has befallen the household.[71]

Although masks are used for the purpose of concealing the identity of the one who wears it, the intent of a masquerade is to reveal a reality not otherwise observable. For the Yoruba the ancestral ensembles are designed to disclose the presence and power of the living dead and also the status and filial piety of the "owner" of an *egungun*. It is through the use of cloth that the creators of a masquerade achieve both concealment and revelation. Layers upon layers of cloth cover the body of the dancer, cascading to the ground from a headpiece which, as among *egungun paaka* in the Oyo area, may consist of a narrow, cloth-covered piece of wood about three feet in length from which colorful pieces of applique are suspended (Figure 214). The cloth is usually cut in long strips so that when the dancer moves, the cloth moves in undulating patterns, giving no evidence of a person within, concealing him even when he whirls, causing the cloth to splay out in all directions (Figure 217). The number of layers of cloth often reflect the age of a masquerade; each year new cloth is added by the owner of the *egungun* and by family members to honor and petition the blessings of the ancestor. Hence, on older *egungun*, hand-woven and locally dyed strips of dark blue and red are overlaid with the bright colors and pliant textures of machine-manufactured cloth. Whether the costume is old or new, many of the panels will have a white, serrated edge, the significance of which is given various local interpretations.

The headpiece of an *egungun* usually consists of cloth sewn to a leather cap with a close mesh netting covering the dancer's face. In Figure 199 an *egungun* costume expresses the wealth and status of the family by framing the "face" with strands of cowrie shells (once a mode of currency) and weaving elaborate beaded patterns into the face netting. Beaded panels are attached below the netting and suspended from the shoulders and back of the head. On the head of other *egungun* a wooden tray will contain earth encrusted with the blood of sacrifices, the skulls of monkeys, the horns of antelopes, the beaks of birds, packets of powerful medicines marked with cowrie shells and other materials. Some *egungun* carry a carved headdress the subject of which will vary depending in part on the circumstances that occasioned the creation of the masquerade and on local perceptions of what is appropriate. Among the Igbomina Yoruba in Ila-Orangun, for example, many of the carvings juxtapose animal and human figures (Figure 212) or meld their features (Figure 213), creating an image both amusing and bordering on the grotesque, although that would not be a term acceptable to the owners. They would perceive it as strange, perhaps

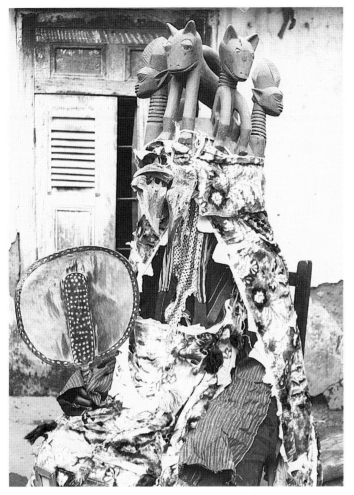

212. The *egungun paaka* called "Olobaloro" from Obale's compound in Ila-Orangun. The juxtaposition of animal and human figures in the carving and the presence of animal skulls and other natural materials juxtaposed with the human cloth is designed to convey the strange and marginal presence of the ancestor who dwells in heaven (*Ara Orun*), but appears in the midst of the world of the living. Ila-Orangun, Nigeria, 1977. Photograph by J. Pemberton 3rd.

weird, but how is one to depict the peculiar nature and extraordinary presence of the living dead?

What is being conveyed in these varied and richly imaginative creations is the presence and power of the ancestor in the life of the living. The ancestor is and is not a part of the on-going life of a lineage—is distant, yet part of the household. When they appear, they are richly clothed but do not wear their cloth in the fashion of the living. Some myths of origin concerning the Egungun cult refer to the pataguenon monkey, the creature that moves between and lives in both the forest and the cultivated fields of the farmer, who walks upright and steals the farmer's produce. The dwellers in heaven have the power to cross the boundary separating the realm of the dead from the world of the living, and they can affect the life of the household for good or for ill.

Egungun are the creations and reflections of social relationships. They reflect the continuing relationships of the living to the deceased, as well as the relationship of the living members of a family to one

another. A household may have several *egungun* identified with it, although a particular *egungun* may be considered by reason of age or power the principal representative of the lineage group. The existence of more than one *egungun* in a compound reflects the Yoruba concern to recognize the histories of subgroups and the experiences of individuals within a lineage group, and the capacity to incorporate them within the bond of reference to "the ancestor," which is an inclusive concept even when the term is used in the singular. An individual may discover through divination that he is required by a deceased parent to have an *egungun* created. He will go to a maker of masquerades and together they will decide on the general type and form of the masquerade, which may have been in part stipulated by divination and/or the need to reflect the situation that occasioned the decision. The type of headdress and cloths to be used will be decided upon. A carver may be commissioned to create a headdress of a certain general type, the details of which may be stipulated by the owner. An herbalist may be commissioned to prepare packets of protective

213. The marginal status, the strangeness, of the ancestor is conveyed by melding animal and human forms. A detail of the headdress of an *egungun* costume in the collection of The Institute of African Studies, University of Ibadan, Nigeria, 1972. Photograph by J. Pemberton 3rd.

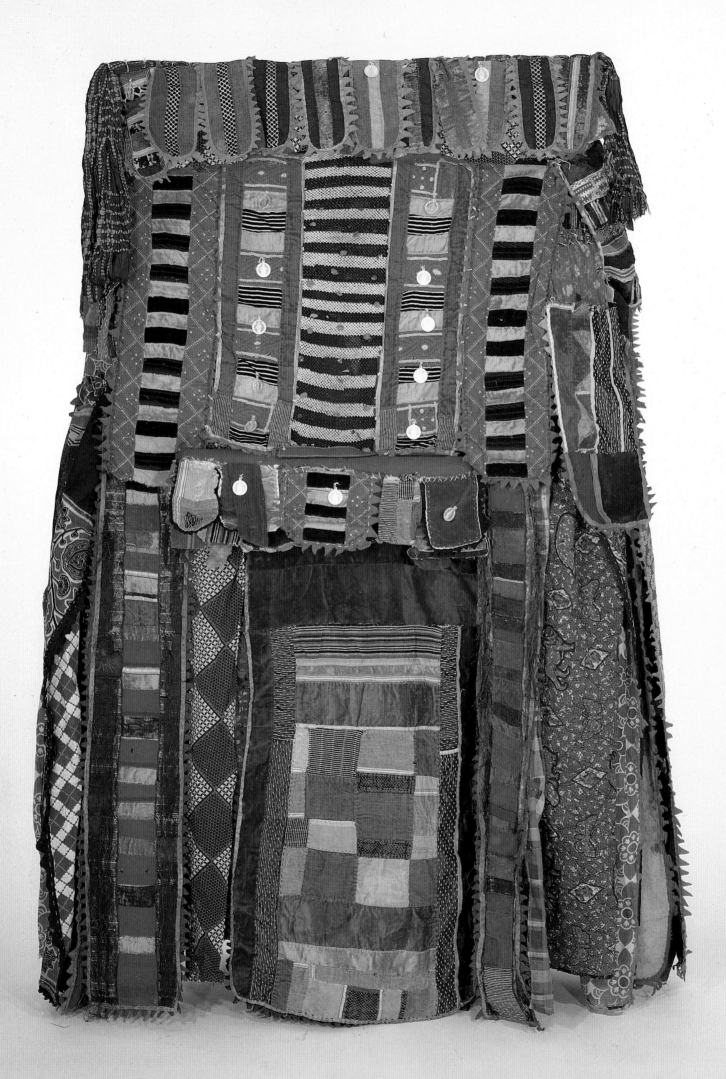

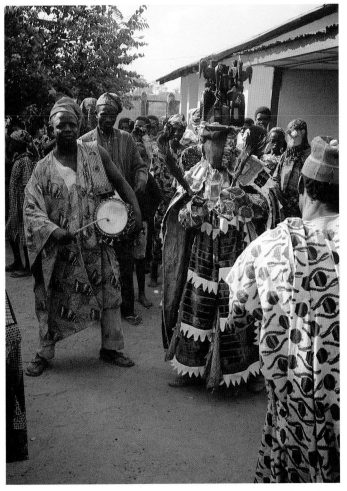

215. *Egungun* Owolewa of Obaro's compound dancing at the palace of the Orangun-Ila, where one of the daughters of Obaro's house lives as a junior wife of the king. Ila-Orangun, Nigeria, 1981. Photograph by J. Pemberton 3rd.

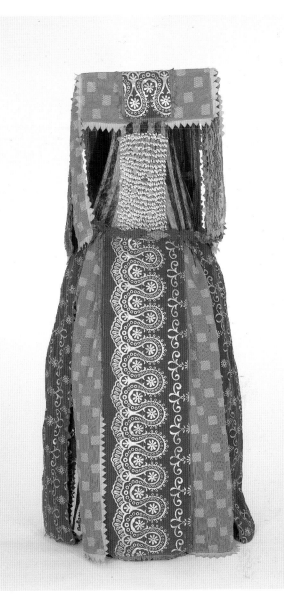

216. *Egungun* Costume, Ouidah, Popular Republic of Benin, 20th century. The box-shaped headdress with panels of brocaded fabric covers the dancer's head on three sides. At the front, a shorter panel consisting of two matching pieces at each end and a variation in the cloth at the center introduces three vertical motifs. They descend the entire length of the costume, increasing the sense of height. Pieces of older, indigo-dyed materials are used on either side of the netting which hides the dancer's face. The panels below are of recent machine manufacture, the central one consisting of a beautiful gold brocade. All of the panels are edged with a red saw-tooth pattern which is found on the earliest of *egungun* costumes. The innovative use of various types of cloth and the imaginative construction of the costume demonstrate the artistic skill of the tailors who make such costumes. Cloth, wood. H. 64 in. Eric D. Robertson.

214. *Egungun* Costume, Ogbomoso, 20th century. This type of *egungun* costume is found throughout the Oyo/Ogbomoso area. It consists of a length of wood balanced on the dancer's head from which panels of cloth are suspended. The great rectangular image completely denies and conceals the human form. The appearance of the ancestor is other than that of humans who also conceal (and reveal) themselves through the use of cloth. The owners of this costume added thirteen Roman Catholic Madonna medals which bear the inscriptions: *"Regina Sacri/Scapularis"* and *"O Mi Jesu/Misericordia."* The Yoruba have the imaginative ability to incorporate beneficent powers from whatever sources into their traditional modes of religious and artistic expression. Cloth, wood, metal. H. 59 in. Eric D. Robertson.

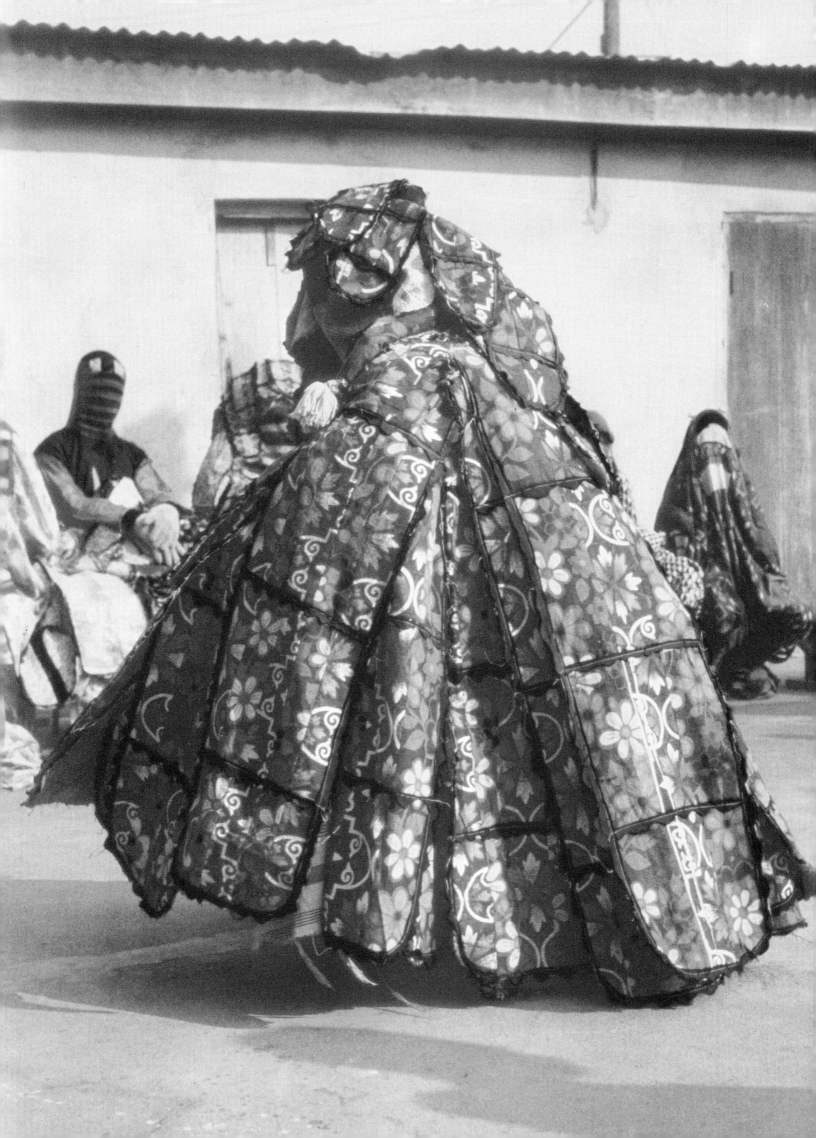

medicines. Each person involved will have his particular perception and, through role and skill, contribute to the total ensemble. When complete, the masquerade will be taken to the leader of the Egungun cult, who will perform appropriate rites and designate the person who will dance the *egungun*. The owner will name the *egungun*, for example, Obadimeji, ("The-king-has-become-two") Adinimodo, ("The-one-who-blocks-the-way-to-the-stream-of-water") or Alobaloro, ("The-one-who-comes-from-a-rich-family-and-has-a-position-of-honor").[72] Songs will be sung by the women of the house as they escort the *egungun* from the forest of the ancestors to their compounds and accompany the ancestral masquerade through the streets of the town on its visits to the compounds in which married daughters of the house now live (Figure 215).

In a measure all Yoruba art is a collective endeavor, involving artist, patron, performer, and/or devotee, but the artistry of *egungun* entails the most extensive communal creativity. There is the owner or patron, the priest of divination, the carver and tailor, the herbalist who prepares the packets of medicines, the leader of the Egungun cult, the dancer, the drummers, and the women of the house who sing the praises of the *egungun* and the lineage. There are also the lineage members who make offerings and others who proclaim the benefits received or seek through prayerful petitions the blessings of the *egungun*. The ensemble of materials and actions that constitute the masquerade reflects the ensemble of persons who compose a household. The ancestral masque gives tangible expression to life lived in relationship to the living dead, to those who founded and continue to sustain the household (Figures 216, 217).

217. An *egungun* dancing at the palace in Oru, Ijebu area. Note the multiple layers of cloth which conceal the dancer even when the panels of cloth fly out in all directions as he whirls. The performance discloses the presence of the living dead, for masquerades are intended to reveal a reality not otherwise observable. Oru, Ijebu, Nigeria, 1986. Photograph by J. Pemberton 3rd.

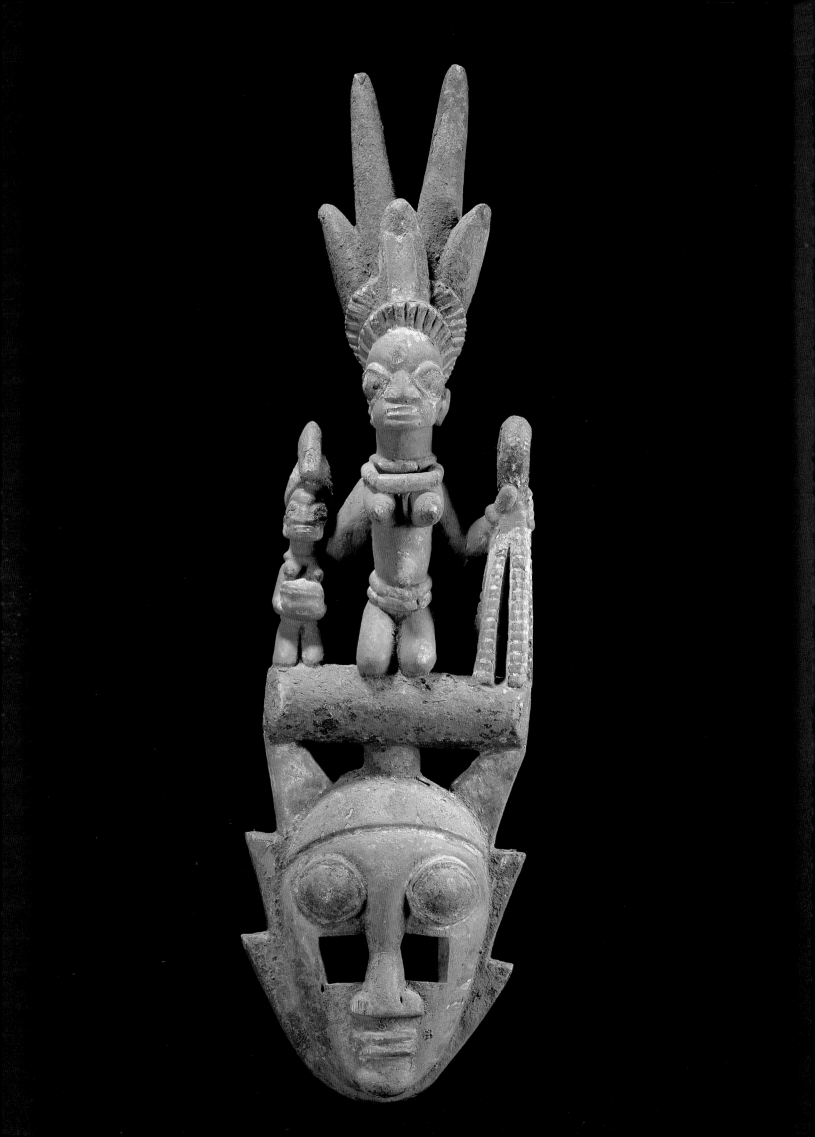

7 The Carvers of the Northeast

John Pemberton III

The intra-Yoruba warfare that was unleashed with the collapse of Oyo-Ile and the pressure from the southern extension of the Fulani Muslim *jihad* in the third decade of the nineteenth century laid waste towns and villages throughout the center of the old kingdom (Figure 219). Families and whole communities were forced to migrate, many into the southern areas of the Egba and Ijebu. Ibadan, once a center of trade, became an encampment of warrior chiefs, who, amidst shifting military alliances, controlled much of the southern Oyo, Ife, Ijesa, Ekiti, and part of Akoko. The Ijesa and Ekiti warriors (the Ekitiparapo) controlled the "route in Eastern Yorubaland to the lagoon and Lagos for the supply of breech-loading rifles," enabling the southern Oyo/Ibadan armies "to compete with Benin, Nupe and Ilorin for hegemony."[1]

The competition was bloody, and the southern Igbomina and Ekiti towns that were located in the path of the Ibadan and Ilorin armies suffered greatly. In 1867 Oba Ariyowonye, the Orangun of Ila, was forced by the invading Ibadan armies to flee with many of his townspeople

218. Olojufoforo Headdress, Osi Ilorin, Ekiti, 20th century. This superb face mask by Bamgbose of Osi Ilorin is a type unique to northern Ekiti Yoruba, although frontal masks are found among the neighboring Nupe people. In Osi Ilorin the Olojufoforo mask appears during the festival called Ijeshu in honor of the *orisa* of Osi, who is known as Baba Osi, ("Father of Osi"). In other villages within the cluster of Opin towns, which includes Osi Ilorin, these masks occasionally appear as part of Epa festivals. Wood, pigment. H. 39½ in. Deborah and Jeffrey Hammer, Los Angeles.

and take refuge in the little town of Omu-Aran some thirty miles to the northeast, where he died in 1876. His successor, Orangun Amesomoye, did not return to Ila-Orangun until 1885, when it was clear that Ibadan's strength had been sapped by the Kiriji/Ekitiparapo War of 1879–86. When he arrived in Ila, he found the town virtually deserted.[2] The Kiriji/Ekitiparapo War also reduced many Ekiti settlements to ruins. Some among the "Sixteen Traditional Ekiti Kingdoms" were so devastated that their *obas* were said to be "rulers of grass and wood."[3]

The long, drawn-out war finally "reached a stalemate [in the 1880s] and led to the invitation to the British to intervene and impose a Peace Treaty to resolve the several issues that had emerged throughout Yorubaland in the course of the many years of warfare."[4] Peace proposals were drawn up in 1882. But it was not until 1893, by which time "the British came, no longer as peace-makers, but as rulers"[5] that the prolonged state of war was brought to an end.

In the years that followed, families sought to return to their towns and rebuild their compounds, chiefs and *obas* sought to reestablish their roles and regain their authority. It was in this context that the carvers of Ekiti created images that reflected their times and shaped anew a vision of Yoruba culture.

Carvings for Epa in Northern Ekiti

Epa and Elefọn festivals are held throughout northern and southern Ekiti towns, and they are also found in southern Igbomina and in Ijesa communities. The terms Epa and Elefọn vary regionally (the former more often

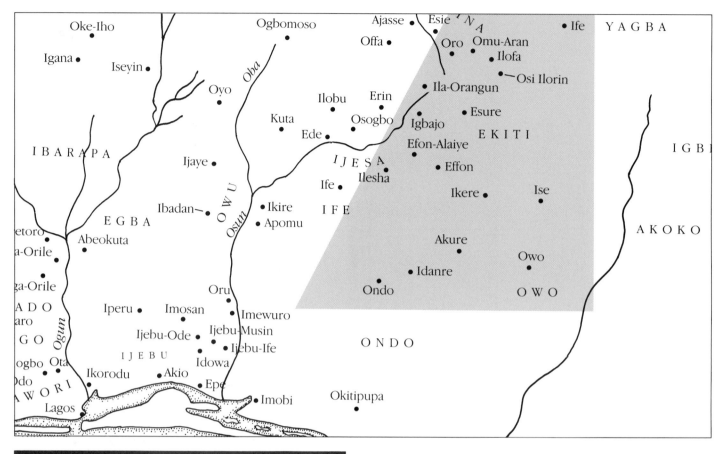

219. Map of the Northeast Region.

220. Epa Headdress, Oye, Ekiti, second half of the 19th century. Such masks depicting warriors often bear the name Jagunjagun. The style in which the helmet is carved clearly indicates its Oye, Ekiti, origin, possibly in the little town of Arigidi. Wood, iron, pigment. H. 44 in. Valerie Franklin.

221. Slit Drum, Northern Ekiti, 19th–20th century. Slit drums of this type, known as *agere*, are found almost exclusively in the Ekiti area. They are made for hunters and are played by women at various rites of passage, such as weddings and chieftaincy ceremonies. They are also played at a hunter's funeral by his wife, while she and her co-wives sing their husband's *oriki*. The decorative carving at one end of the drum may be either a male or female head. Wood. H. 34 in. Mr. and Mrs. William W. Brill.

222. Epa Headdress, Southern Ekiti, 20th century. An Epa headdress from the town of Efon-Alaiye. The figure images the authority (*ase*) of woman. She wears and holds the emblems of her status as a chief. Her power as a woman, however, is manifest in the fullness of her breasts and womb and in the conical hairstyle, which crowns her head (*ori*) and bears testimony to her personal destiny (*ori inu*). Wood, pigment. H. 44½ in. New Orleans Museum of Art, Carrie Heidrich Fund.

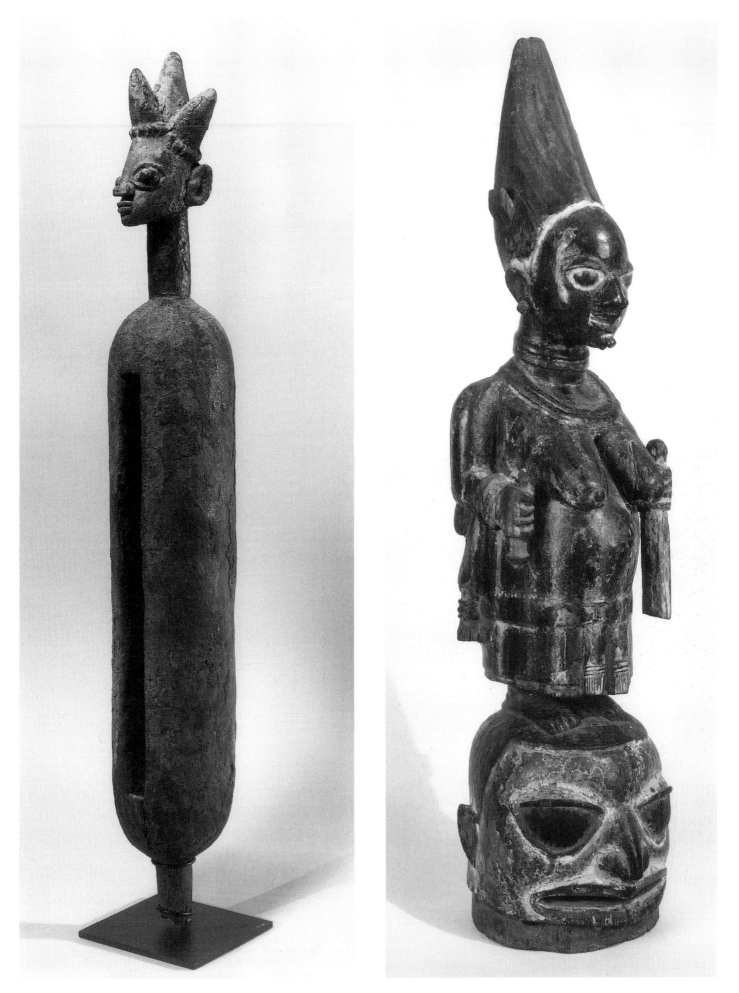

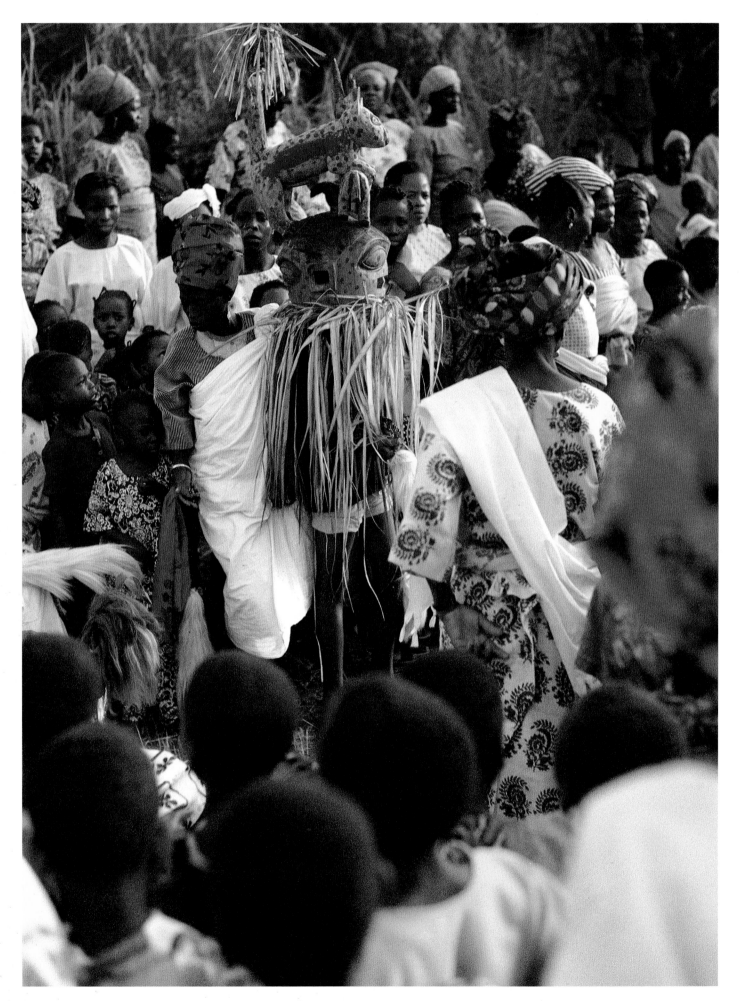

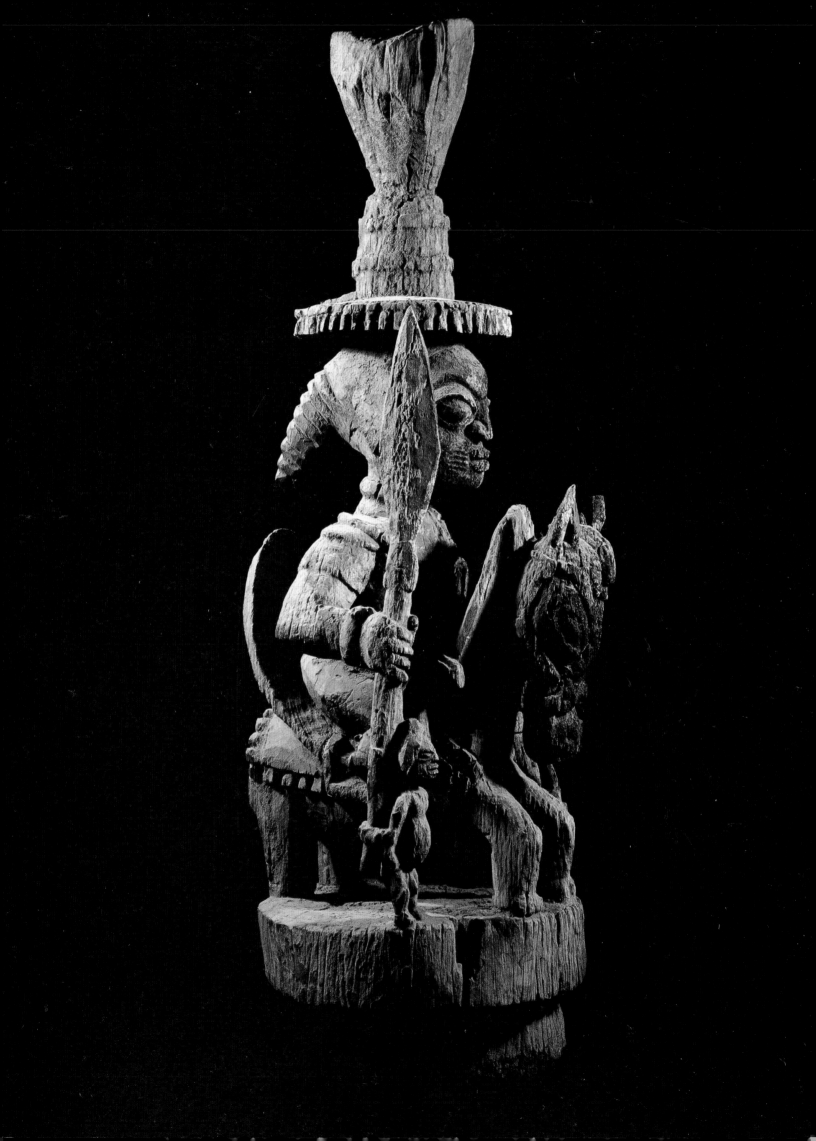

used by northern and the latter by southern peoples), but they always refer to the same festival phenomenon—the celebration of social roles upon which the life of a Yoruba town depends.

At the heart of the festival is the appearance of one or more masquerades. An Epa mask consists essentially of a carved headdress which is divided into two parts. The lower portion fits over the dancer's head. It is carved so that the dancer is able to see through the mouth of the abstract face which appears on the front (and sometimes the back) of the potlike base. The subject of the superstructure is depicted in far more realistic terms (Figure 222). The body of the dancer is barely covered by palm fronds or cloth suspended from the base of the carving, and in this respect contrasts rather markedly with the hiddenness of the dancers of *egungun*.

As with all Yoruba sculptural art, an Epa mask must be seen in use to be understood in the fullness of its meaning for the Yoruba. While an Epa carving may be placed on a shrine throughout most of the year, or for a number of years, receiving annual offerings and prayers from the elders of the house in which it resides, only when it "comes out" does it, from a Yoruba point of view, become "complete" as a work of art, achieving that for which it was created.[6] It appears among the townspeople, moving with the appropriate dance steps to the rhythms of the *bembe* drums, surrounded by its followers and receiving salutations, praise names, and songs.

On the occasion of a festival when more than one Epa mask is to be celebrated, usually a mask called Oloko is first to appear.[7] Oloko ("Lord-[or Owner]-of-the-Farm") depicts a leopard leaping upon an antelope (Figure 223). At the 1977 festival in the town of Otun, as the masquerade left the forest and ran to the dance area that had been cleared, persons from the compound or quarter with which the mask is associated shouted the mask's name and greeted it with a variety of salutations. Oloko paused for a moment before the seated chiefs and elders, then whirled and ran to the opposite end of the clearing, leaping upon a mound of earth, which is called "a tiny bit of the world" or "the land of the father." Returning to the chiefs, Oloko danced before them. In response, the chief whose house "owns" and "serves" Oloko rose and danced with Oloko, while members of the house sang, danced, and shouted Oloko's praise names. Three times

Oloko leapt upon the mound of earth and returned to dance before the chiefs. Following a final great leap, Oloko ran to the forest amidst the cheers of the crowd and in the company of several small masks, called Egburu, which were worn by young boys.

The dancer has great athletic prowess; "the leap of the leopard, in sculpture rendering, directly predicts the leap of the dancer, before the elders and upon the mound."[8] Reflecting a refrain in a praise name ("Terror-To-All-Animals-Within-The-Bush"), the "leopard's leap suggests the warrior's attack."[9] Other factors associate the leopard motif with the warrior; in some Ekiti communities, for example, the Oloko mask and the Ologun, which is specifically a warrior mask, are interchangeable. It is the "ferocious attributes of the leopard" to which reference is made, the teeth, claws and skin of the leopard being part of the warrior's dress.[10] Persons in the Ekiti towns of Otun and Erinmope, however, understood Oloko to be the "Owner or Lord of the Farm" and distinguished the Oloko mask from the warrior masks, which were called Alaase, Ologun, and Jagunjagun. In the Otun and Erinmope festivals, these followed the appearance of Oloko.

In Otun, Alaase, "The-One-With-Authority," ran from the forest, paused before the seated chiefs and raised his flywhisk to Chief Odo Ore. Then turning, he charged toward the mound of earth. As he did so, he reeled into the crowd, injuring bystanders, and had to be restrained by members of the warrior age group accompanying him. At first he had been hailed by his followers with the words, *Ologun ba an ja* ("Warrior fight for them!") but the chant quickly changed to *Ologun ma ja!* ("Warrior do not fight with me!") as Alaase fled into the forest.

Figure 220 shows a nineteenth century Epa by a carver from the Oye Ekiti area.[11] The headdress is encrusted with layers of red camwood powder and the blood of sacrificial animals, which were not the warrior's first victims, as is indicated by the row of heads that appear across the top of his shield. As significant as these iconographic and ritual elements are in conveying the power of the warrior, it is the carver's skillful treatment of the warrior's head and the head of the lower portion of the mask that conveys the image of the warrior's essential character, (*iwa*).

Oye carvers cut deeply into the wood, exaggerating the facial features on the helmet portion of the mask. The bulbous forehead, deeply recessed eyes, massive nose, and protruding lips of the mouth describe the specter of death. In contrast, the warrior's face is almost passive and yet conveys a strength in the power of the eyes and thrust of the bearded chin. The diagonal line of the hunter's cap is parallel to the curve at the top of

223. The masquerade called Oloko, "Lord-of-the-Farm," is the first to enter the dance area during the Epa festival at Otun, Ekiti, Nigeria, 1977. Photograph by J. Pemberton 3rd.

224. Veranda Post, Oye area, Ekiti, last quarter of the 19th century. Since the so-called "Sixteen Kingdoms" of the Ekiti were established by hunter/warriors without claim to descent from Oduduwa and Ile-Ife, the warrior is one of the principal subjects celebrated in sculptures by Ekiti carvers. Wood. H. 67 in. Rene Garcia collection.

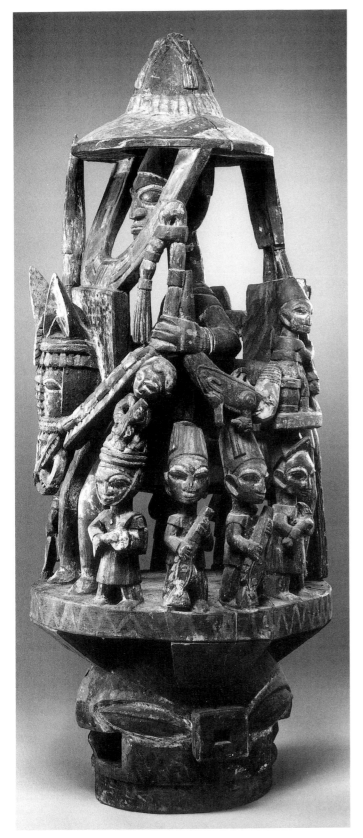

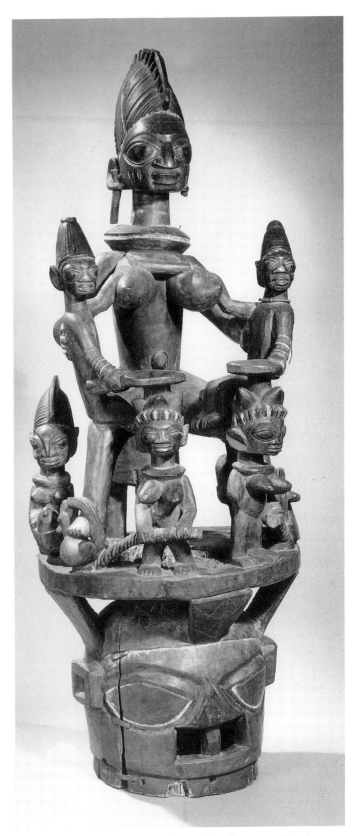

225. Epa Headdress, Odo Owa, Ekiti, 20th century. Epa headdresses are carved from a single block of *aberinberin* wood (*Riconidendron africanum*) and weigh as much as fifty or sixty pounds. This splendid one is by Bamgboye of Odo Owa, who continued to carve until his death in 1978 at the age of about 85 years. The size of his sculptures and the organization of so many figures in relationship to one another and to the great central figure give his sculptures an architectural quality rivalled only by Areogun of Osi Ilorin. Wood, pigment. H. 50 in. The Detroit Institute of Arts, Founders Society Purchase, Director's Discretionary Fund.

226. Epa Headdress, Osi Ilorin, Ekiti, 19th–20th century. Bamgbose of Osi Ilorin was one of the great Ekiti carvers at the turn of the century. In his celebration of *iyabeji*, ("Mother of Twins"), Bamgbose's use of space as part of the total sculptural form is clearly revealed. Wood, pigment. H. 49½ in. Toledo Art Museum, Gift of Edward Drummond Libbey.

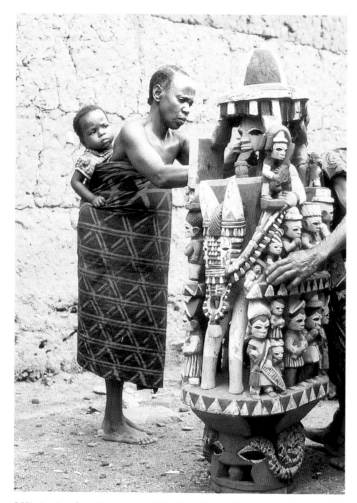

227. An Epa headdress carved by Bamgboye of Odo-Owa for the people of the small town of Erinmope, near Otun. It is called "Orangun," which is the title of the Oba of the neighboring Igbomina town of Ila-Orangun. The headdress celebrates the warrior chiefs who established the "Sixteen Ekiti Kingdoms." Erinmope, Ekiti, Nigeria, 1974. Photograph by J. Pemberton 3rd. 1974

229. Agere Ifa, Southern Ekiti area, 19th century. This masterful carving once held *ikin Ifa*, the sixteen sacred palm nuts used during Ifa divination rites. The sculptural subject is a marvelous merging of religious and domestic actions. The devotee kneels before the gods in supplication, her face composed and purposeful in its concentration, while, at one and the same moment, she holds and adjusts the child on her back. One observes such gestures by women in the market, as well as before the shrines of the *orisa*. The artistry of the work is evident in the way in which the carver has conveyed the relationship of child and mother, not only in the child's arms extending beneath those of her mother, whose arms reach back in support of her child, but also in such formal elements as the parallel lines of the mother's head, breasts, and thighs with those of the child's arms and legs, which have their counterpoint in the line extending from the mother's neck and along her arms and back. The delightful touch is the contrast between the mother's concentration upon the "face of the *orisa*," and the child's distraction as he looks off to the side, fascinated by a buzzing fly or a dog scratching its ear. Wood. H. 12½ in. Mr. and Mrs. Charles Davis.

228. Bamgboye, master carver of Odo-Owa (died 1978), at the door of his home in Odo-Owa, Ekiti, Nigeria, 1971. Photograph by J. Pemberton 3rd.

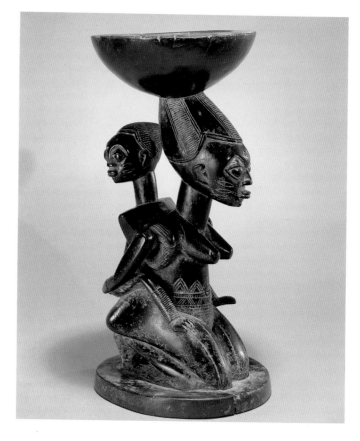

the helmet mask, visually linking the destinies (*ori*) of the two heads.

A massive veranda post of the same age and perhaps the same area also depicts a warrior figure (Figure 224). His success as a warrior is reflected in the captive bound to the shaft of his spear. What is impressive about this work is the way in which the artist distinguishes yet intimately relates horse and rider. As in most carvings of equestrian figures, the horse is disproportionately small. But the carver of this veranda post has used a very large block of wood, enabling him to give a greater presence to the animal, and he does so by thrusting the horse's front legs forward and tilting the long head of the animal, giving the impression that the horse is about to leap forward, restrained only by the hand of the rider. With extraordinary imagination, the artist extends the front and rear portions of the saddle in long upward sweeping curves that frame the body of the rider. The saddle ends at the rider's shoulders, opening the space around the rider's head and giving prominence to the face. The line of the saddle is picked up by the curve of the warrior's hairstyle at the back of the head and the fringe on the edge of his hat, the peak of which extends into the upper portion of the veranda post.

In the Epa festival the warrior masks are often followed by masks depicting herbalist priests. These masks, conveying a sense of ritual order, move more slowly than those that precede them. The herbalist Epa mask is called Ao in Igogo-Ekiti. Its "pattern of dancing further suggests knowledge and control of evil in which his healing spirit gains its perfect power."[12] Ao's appearance marks the mid-point of the festival.

In the mask of Oloko there is the dual reference to farming and hunting, and in some communities to the hunter/warriors who founded and led most Ekiti towns. Oloko refers to those activities through which man asserts control over nature for his own ends. With the appearance of the warrior and herbalist masks, a new stage of cultural activity is expressed. The warrior is essential to the establishment, defense, and expansion of political power. The prominence of the warrior masks among Epa carvings attests to the fact that nineteenth century Ekiti kingdoms were largely the creation of immigrant groups led by warrior chiefs (Figure 225). The priest of herbal medicines and of divination is the source of the knowledge that one needs in order to understand, employ, or cope with powers that give and those that destroy life. It is the cerebral and ritual power possessed by *onisegun* (herbalist priests) and *babalawo* (priests of Ifa divination). Such power is as essential to the establishment and maintenance of personal and social well-being as is the physical power and military craft of the warrior.

With the arrival of the last mask or masks, the climax of the celebration of Odun Epa is reached. In Otun the mask called *Eyerangun* ("Mother-(or Senior Wife)-of-Orangun") or another called *Eyelase* ("Mother-Who-Possesses-Power") concludes the festival. In Erinmope, it is Orangun, a splendid Epa carved by Bamgboye of Odo-Owa, and a mask of the same name in Igogo-Ekiti, carved by Areogun of Osi-Ilorin, that conclude their festivals.

Within the context of the festival the Epa masks representing female figures follow those of herbalist, warrior, and hunter/farmer. For woman's power is ultimately that upon which society depends. It is she who holds within her womb "powers concealed" (*egungun*) and the future promise of the community.[13] In some Ekiti towns and villages she appears alone at the conclusion of the festival. In other communities she will precede or accompany an Epa mask celebrating sacred kingship, such as Bamgboye's Orangun. According to the elders at Erinmope, their Epa masks remember "the great one,

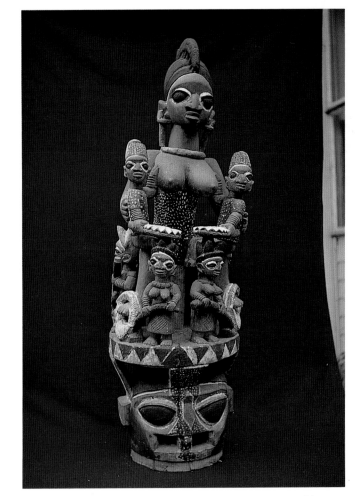

230. Epa Headdress, Osi Ilorin, Ekiti, 20th century. Areogun (about 1880–1954) of Osi Ilorin, who had been apprenticed to Bamgbose for sixteen years, in 1952 carved his own version of "Iyabeji." It is remarkably similar to Bamgbose's Epa (see Figure 226). Areogun's sculpture, however, is much more compact, lacking the use of space as part of the sculptural form. Wood and pigment. H. 51 in. National Museum, Lagos, Nigeria. Photograph by L. O. Fakeye.

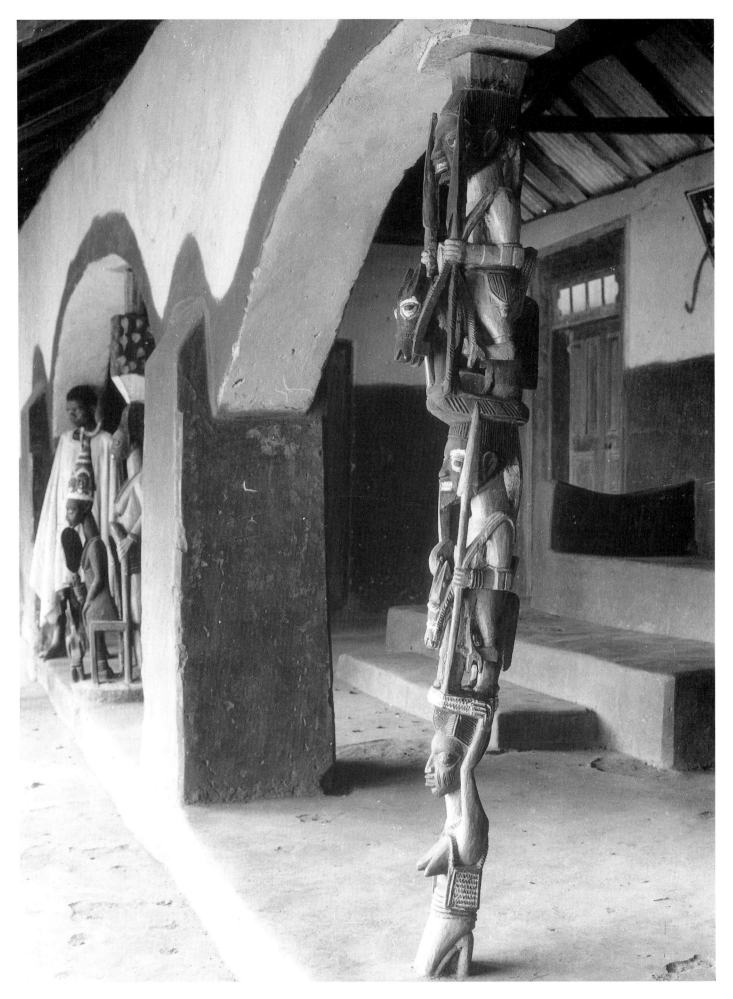

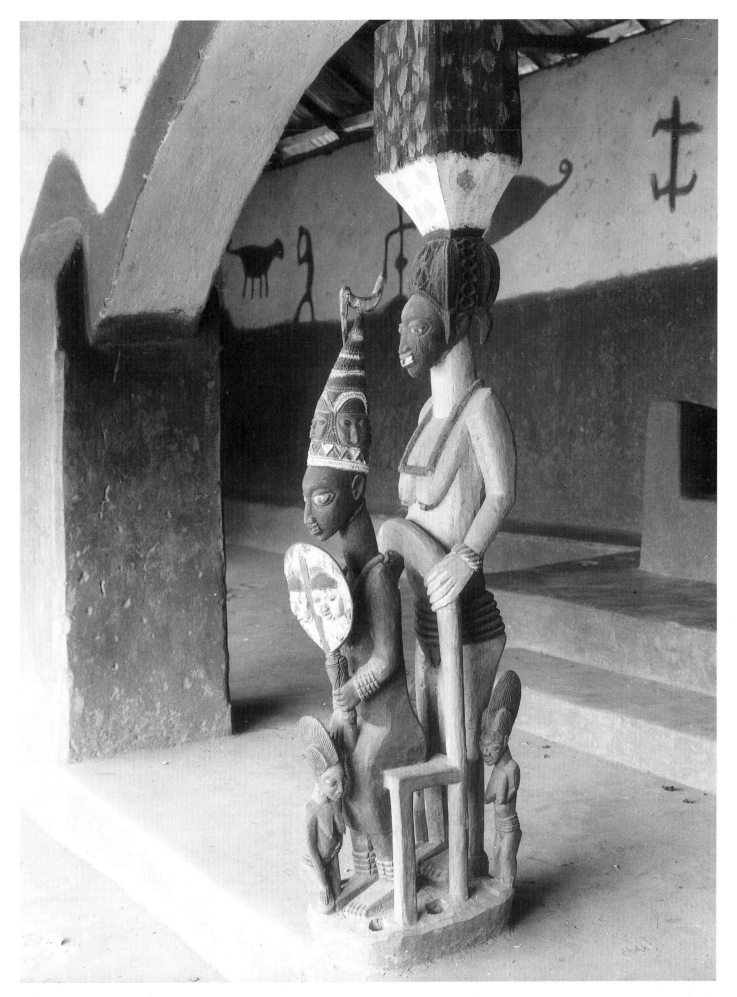

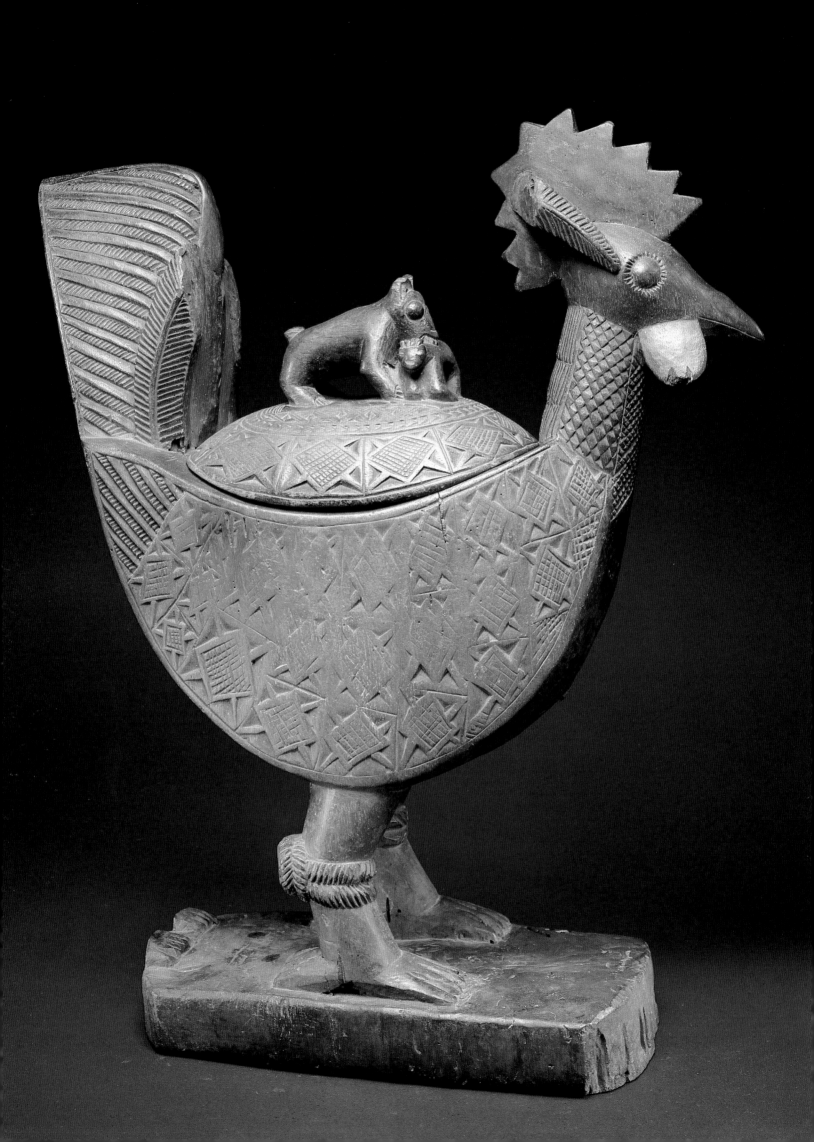

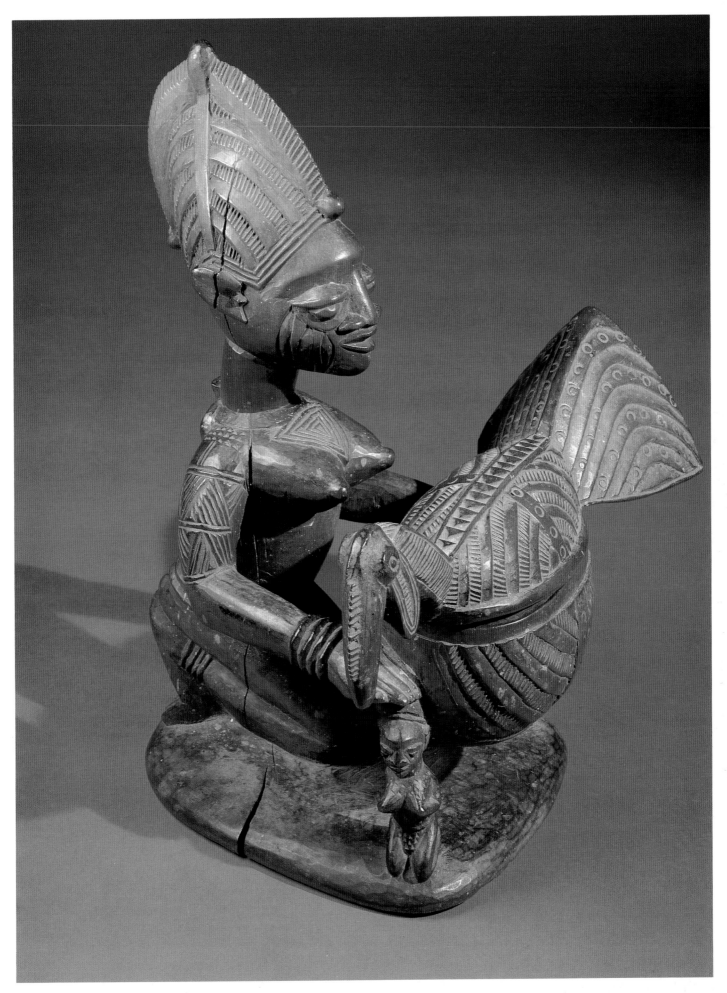

231. Courtyard of the palace at Ise, Ekiti with two of the more than thirty veranda posts carved by Olowe of Ise. Ise, Ekiti, Nigeria, 1958. Photograph William Fagg Collection. Royal Anthropological Institute of Great Britain.

232. Veranda post by Olowe of Ise in the palace at Ise, Ekiti. The carving, which depicts the seated Arinjale, king of Ise, with his senior queen standing behind him, is situated directly in front of the Arinjale's throne where he sits on ritual occasions. Ise, Ekiti, Nigeria. Photograph William Fagg Collection, 1958. Royal Anthropological Institute of Great Britain.

233. Kola Nut Container, Southern Ekiti, 19th–20th century. Simplicity of line and balance in composition permit the carver to indulge in extensive surface ornamentation without detracting from the total sculptural form. The bowl was used to hold kola nuts, which are given as a hospitable gesture to visitors to one's house. The handle of the lid depicts the ominous scene of a forest cat grasping in its jaws a smaller animal. For all the brash bearing of the cock, his freedom is limited by a rope tied to his legs. Wood. H. 21½ in. Photograph by J. S. Hammer. Deborah and Jeffrey Hammer, Los Angeles.

234. Figure With Bowl, Efon-Alaiye, Ekiti, 20th century. This exquisite work is by a member of the Adesina family, probably by the master carver Agbonbiofe, who died in 1945. In the first quarter of the century, Efon-Alaiye was the center of carving in southern Ekiti. Its most famous workshop was in the compound of the Adesina family, which was widely known not only for its carvers but also its beadworkers (see Figure 186). The kneeling female figure with cock is often referred to by Ekiti peoples as Olumeye, "One-Who-Knows-Honor," and is said to depict a woman who is a messenger of spirits. Such sculptures were used for the kola nuts offered to visitors, as shrine containers for offerings to an *orisa*, and to hold the palm nuts used in Ifa divination. Wood. H. 15½ in. Ian Auld.

the great ones of the family who are now dead."[14] The masks are not representational of a particular person; "the human reference in a mask, in a statue, or in a tale is not to an individual, or not to an individual as such, but to a corporate entity; individual traces exist in these various works only under the aspect of mythology or legend or ritual history."[15] Yet it is also true that in the Epa mask the elaborate hairstyles, the facial marks, or the adornments on costume or body may signify the social status and lineage of the person memorialized; indeed, it has been argued that some of the warrior masks may have been created to memorialize particular historical occasions and persons.[16] But hairstyles and facial marks, as social roles, are also the marks of culture, of organized productivity, to which the deceased have contributed.

It is cultural achievement that is celebrated in Odun Epa. In the acts of farming and hunting man masters nature for his own purposes. More importantly, there is the establishment and securing of communal life through bloodshed, in war and in the sacrifices divined by the *babalawo* for the powers having to do with life and death. It is the secret power of woman that is the originating and sustaining force, the fulfillment of which is the achievement of order and stability in the body politic.

Bamgbose (died c. 1920) was a master carver in the village of Osi Ilorin. Areogun (c. 1880–1954) was "ap-

prenticed to Bamgbose for sixteen years and was his most famous student."[17] The Epa mask in Figure 226, in the Toledo Museum, is a superb example of Bamgbose's work. It is remarkably similar to a later mask that Areogun carved in 1952 (Figure 230), which is now in the Nigerian National Museum in Lagos. Both Epa masks celebrate the *iyabeji* ("Mother-of-Twins"). The *ibeji* are seated on their mother's knees. With one hand they hold their mother's breasts and with the other hand hold out small wooden trays for the gifts that are to be given to an *iyabeji*. In Bamgbose's carvings the mother wears the large brass collar of a devotee of *orisa* Osun. At her feet are several female figures, standing and kneeling, with their offerings to the *orisa* who has bestowed her blessings upon *iyabeji*. There is an expansiveness about Bamgbose's work which contrasts with the compactness of the carving by Areogun. There is a remarkable use of space in Bamgbose's conception of the total sculptural form. As a result, the individual figures are clearly discernible. Nevertheless, the two carvings are intimately related not only by shared maternal and ritual gestures, but by a sculptural composition that moves upward in three equal sections from multiple figures to the twin figures to the prominent head and face of the mother. The spacious conical form is beautifully balanced by the strong vertical line of the seated mother. The sculpture is a celebration of the *ase* and the beauty (*ewa*) of the woman upon whom the *orisa* has bestowed her *ase*.

In the earlier 1960s Bamgboye of Odo-Owa (Figure 228) carved a mask called Orangun for the festival at Erinmope (Figure 227). It is an amazing assemblage of little figures surrounding and almost hiding a central figure on horseback, whose great umbrella-like hat dominates the whole. In this extraordinary carving Bamgboye depicted hunters, warriors, musicians, women, and children, all related to one another as they are related to the *oba*, the focal point of stability. In the figures of the king and his retinue, the hierarchic pattern of cultural order is expressed. For the *oba* (descendent of Oduduwa, the agent of creation and, as the first Yoruba king, the founder of the Yoruba people) carries in his person the mysterious and encompassing authority of political power. Orangun is the very embodiment of cultural achievement.

Thus, the masks of the Epa festival express and validate the social hierarchy and chain of privileges of farmer and hunter, soldier and priest, and above all, that of the king. In the appearance of Iyabeji with Orangun, not only are sexual roles established but, more importantly, in the pairing of the king and the mother at the climax of the festival in Erinmope, the vital relationship of male and female powers is affirmed.[18]

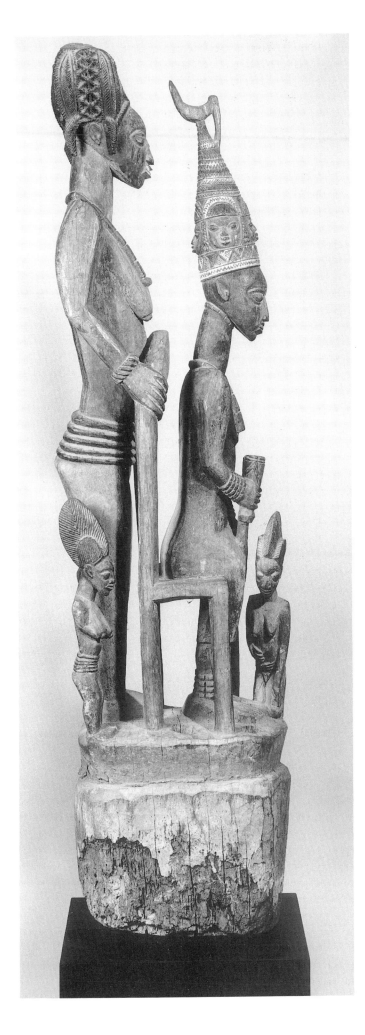

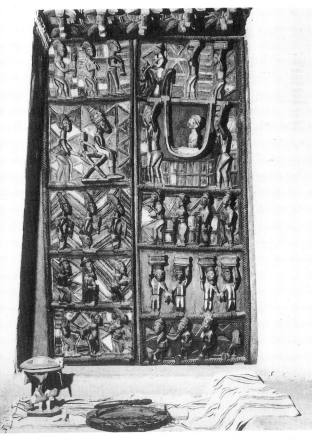

234a. Veranda Post by Olowe of Ise, Ekiti, 20th century. This was the central veranda post in the courtyard of the palace of the Arinjale, the king of Ise, Ekiti shown in Figure 232. Wood, pigment. H. 65 in. Private collection.

235. The first door by Olowe of Ise for the palace of the Ogoga of Ikere with carved lintel on display at the Museum of Mankind, London. Carved during his residence in Ikere, 1910–1914, the door was removed with the permission of the king and the consent of Olowe for exhibition at Wembley in 1924. It was obtained by the British Museum in exchange for a British throne. Trustees of the British Museum.

203

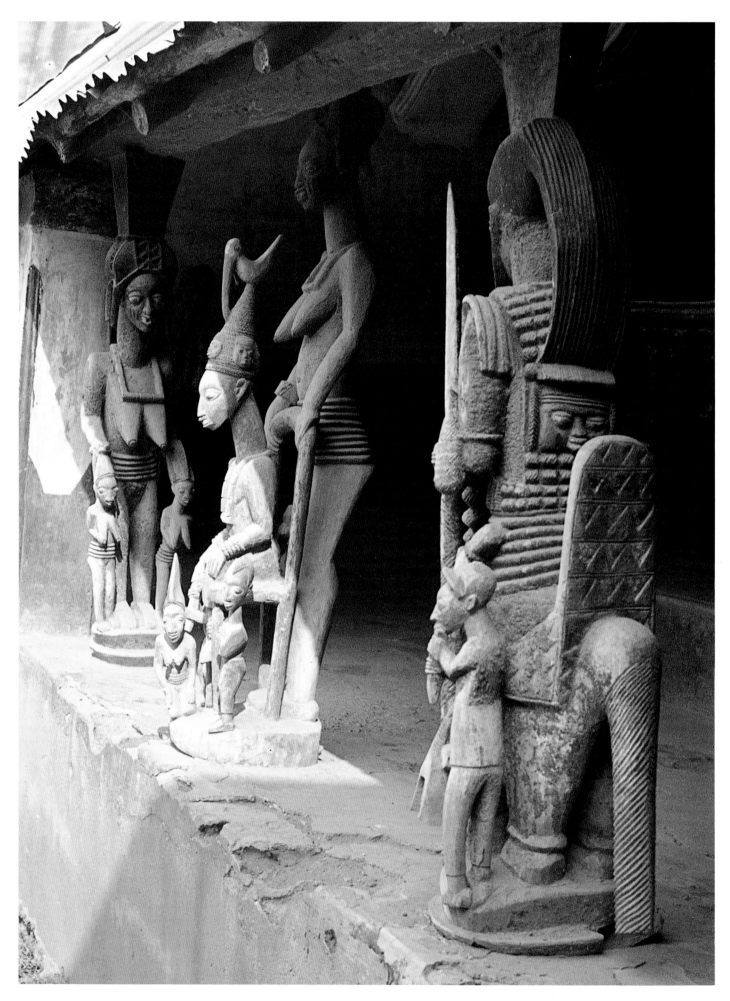

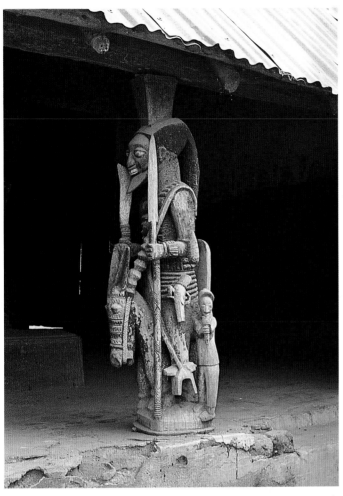

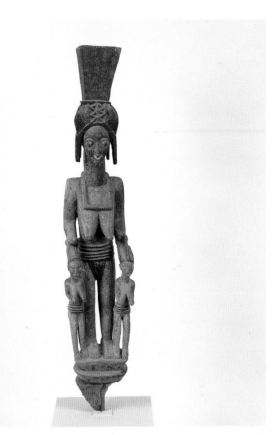

236. Veranda post depicting an equestrian figure carved by Olowe of Ise in the palace of the Ogoga of Ikere, carved there between 1910 and 1914. Ikere, Ekiti, Nigeria, 1964. Photograph by J. Picton.

237. Veranda Post, Ikere, Ekiti, 20th century. A veranda post by Olowe of Ise for the palace of the Ogoga of Ikere made during Olowe's residence in Ikere from 1910 to 1914. It depicts a queen with her twins and originally faced the central figure of the seated Ogoga, King of Ikere, shown with his senior queen standing behind the throne. (See Figure 238). Wood, pigment. H. 56 in. Memorial Art Gallery of the University of Rochester, Marion Stratton Gould Fund.

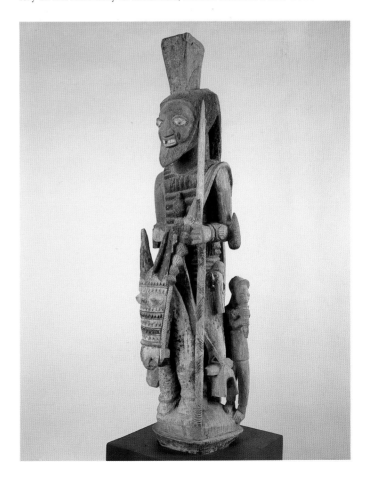

238. The palace of the Ogoga of Ikere, Ekiti, with veranda posts carved by Olowe of Ise. Olowe worked on the commission, which may have also included the massive palace door (see Figure 235), from 1910 to 1914. Ikere, Ekiti, Nigeria, 1964. Photograph by J. Picton.

239. Veranda Post, Ikere, Ekiti, 20th century. By Olowe of Ise for the palace of the Ogoga of Ikere, 1910 to 1914. It depicts an equestrian figure and originally faced the central figure of the seated King with his senior wife behind the throne. (See Figures 238, 241). Wood, pigment. H. 55½ in. New Orleans Museum of Art, Ellen West Freeman Matching Fund.

It may be true that "the people [of Ekiti] conceive the mask and superstructure as a unit of which the actual mask (*koko*) is the focus,"[19] but this observation is also misleading. The ancestral power of the mask is ritually associated with the helmet portion, which is always carved in an abstract depiction of a human face (or faces, since most Epa masks are Janus-faced). At the time of the public festival, however, it is the elaborately carved superstructures with their realistic, albeit idealized, depiction of persons and events in the history of a particular community that evoke the appropriate praise songs, drum rhythms, and dance movements, thereby shaping the participants' perceptions of what is real, of value, and to be affirmed. The clearly distinguishable parts of an Epa mask cannot be separated in the experience of the participants. The carved headpiece is seen in its totality. In this light, it is obvious that the carver's artistic imagination and his technical skill contribute in a singular way to making the masks an appropriate focus of a festival that celebrates cultural achievement.

One must bear in mind that a masquerade is not intended to hide or cloak, but to disclose concealed power, to reveal another order of reality not otherwise observable. As a myth or ritual, a masquerade distorts the manifest or apparent significance of a thing. (Bamgboye carves coiled snakes in place of ears on the helmet portion of Orangun.) In an Epa masquerade, little is hidden, not even the dancer. Rather, a vision is created with carved images, movement, and sound so that manifest meaning is refashioned. The masquerade enables a transposition of significance to other worlds of experience. So prominent is the carved headpiece of an Epa masquerade that, when created with the imagination and skill of an Areogun or a Bamgboye, the carving contains within itself and conveys to the sensitive viewer the power of the whole. It is a visual myth that allows us to understand the ancestral presence. In that presence we know that we live only as we honor the living dead, as we acknowledge their past as our memory and their presence as our future. This was the vision that the carvers of Ekiti provided their people following a century of war.

Carvings for Palaces in Southern Ekiti

Perhaps the greatest Yoruba carver of the twentieth century was Olowe of Ise (d. 1938). He was born in Efon-Alaiye, one of the foremost centers of Yoruba carving at the turn of the twentieth century, but he moved at an early age to Ise, a village to the southeast. The daughter of Obadeyi I, the late Arinjale, king of Ise (1932–1976), recalled that "Olowe made the whole palace beautiful."[20] It seemed to her that Olowe spent more time at the palace that he did in his own house. He was so busy that on occasion he had as many as fifteen assistants carving veranda posts (Figures 231, 232), doors, chairs, tables, drums, bowls, Epa masks, and ritual objects at the request of the *oba* and for others who gave him commissions.[21] So important had he become in the life of the palace that he had been named an Emese, a messenger of the Arinjale, before her father ascended the throne.

Olowe's *oriki*, sung by his wives, reveals the status that he achieved during his lifetime in the eyes of his contemporaries and how widespread was his fame as a carver:

I am . . . Oloju-ifun Olowe.
Olowe, my excellent husband.
Outstanding leader in war.
Elemoso.
One with a mighty sword.
Handsome among his friends.
Outstanding among his peers.
One who carves the hard wood of the iroko tree as though
* it were as soft as a calabash.*
One who achieves fame with the proceeds of his carving.
The frightening Esu forbids being burnt.
The frightening Esu forbids being hurt.
Whoever burns him [Olowe] invites trouble.
Whoever hurts him incurs the wrath of Esu,
Who forbids that [Olowe] be hurt in public.
Olowe, you are great!
The awesome one who moves like a stream
That flows at its own pace and wherever it wills,
That flows under the rock,
Forming its own tributaries,
Killing the fish as it flows.
A river has no slaves,
But his father's river had slaves.
The unworthy dead are its slaves
Beyond the Oro tree.
Olowe, you are indeed great!
The son of one who dines with egungun.
The son of the great leopard killer.
At home he slaughters a dog [the sacrifice to Ogun],
Yonder he kills a slave.
I only joined you in eating the dog.
I had no hand in eating Elekole's slave.
Elekole, who has a good name,
Although his oriki exaggerates it.
The son of Elekole, who counts his riches in cloth...
My lord, I bow down to you,
Leader of all carvers.
He is a great dancer,
Who dances with joy and laughter.
I adore you!
You have done well! . . .
I shall praise you always, my lord!
One who spends iroko money to achieve great things,
Who carves the iroko tree with the ease of carving a
* calabash.*
Whoever meets you at the wrong time
Becomes a sacrificial victim.
Whoever wrongs you
Sees trouble.

I shall always praise you, Olowe!
Olowe, who carves the iroko tree.
The master carver.
He went to the palace of Ogoga
And spent four years there.
He was carving there.
If you visit Ogoga's palace
And the one at Owo,
The work of my husband is there.
If you go to Ikare,
The work of my husband is there.
Pay a visit to Igede,
You will find my husband's work there.
The same thing at Ukiti.
His work is there.
At Ogbagi,
In Use too,
His carvings can be found.
In Deji's palace,
My husband's work is there at Akure.
Olowe also worked at Ogotun.
There was a carved lion
That was taken to England.
My husband made it.[22]

In Olowe's *oriki* reference is made to his having spent "four years" at the *oba* Ogoga's palace in Ikere, probably from 1910 to 1914. It was a major commission. The *oba* of Ikere had no doubt seen the palace courtyard at Ise and wished to enhance his surroundings at Ikere with architectural sculptures by the master. On the edge of the veranda at the far end of the outer courtyard, known as Owa Aje, leading to the palace, Olowe installed three sculptures (Figure 238).[23] A seated king with his queen standing behind him is positioned at the center. On the right, as one faces the veranda, an equestrian figure approaches the king; and to the left another queen presents her twins to the king. At the rear of the veranda there are two doors. The large one on the right was the entrance to an area called Imorun, which contained the shrine for the king's head, *ori*. The door which Olowe carved for this entry is one of the most remarkable carvings in the history of Yoruba sculptural art (Figure 235). We do not know whether Olowe carved a door for the smaller entry to the left, which leads to the inner courtyard.[24] The area in front of the doors is called Ojopo, and it is here that the Ogoga sits on ritual and ceremonial occasions.

The veranda posts give the impression of height and power.[25] In the carving of the queen with her twins (Figure 237), her erect posture as she balances the veranda support on her head, the descending braids of hair framing her face, the elongation of the neck, the strength of her shoulders, and the length of her pendulous breasts, all accentuate the vertical line of the sculpture, creating an impression of height far in excess of its 55 inches. The visual illusion is enhanced by the slight size and slender bodies of her children, who raise their breasts in a gesture of greeting to their father. But Olowe modifies the prominence of the vertical line by a series of parallel diagonal lines descending from the jaw, to the beads and breasts, to the arms, and to the lower portion of the buttocks. The contrast between the vertical and the diagonal is echoed in the figures of the twins. These compositional features exist within the overall diamond shape of the total sculptural form. The form moves from a relatively narrow base and swells at the center with the mother's breasts and children's heads and again tapers to the face and head of the queen. The scale and boldness of Olowe's figures permitted him to carve elaborate coiffures, incise intricate patterning on the bodies, and depict multiple strands of waist beads on his female subjects without drawing attention away from the sculptural subject.

As one approaches the veranda, the side view of the equestrian figure is first seen (Figure 236). Through the genius of a master artist, the face of the warrior catches the viewer's attention, despite the detailed ornamentation that Olowe bestows on both horse and rider. In some measure, this stems from the boldness of the facial features—the large, bulging eyes and exposed teeth, which are also in the face of the queen with her twins. But the short, sharp line of the beard, which moves up to the ear, has its counterpart in the long, sweeping line of the hunter's hairstyle, enlarging the head and framing the face. In sculpting the equestrian figure, Olowe also indulged his delight in surface ornamentation, seen in the detailed and careful carving of the horse's bridle and the warrior's garment. He never permitted surface ornamentation, however, or his concern with detail to overwhelm the work as a whole. Its basic rectangular shape is achieved by the vertical lines of the spear and the cutlass held by the warrior, and by the suggestion of the vertical line of the saddle behind the rider (Figure 239). In both the equestrian sculpture and that of the queen, the basic geometry of the composition is not forced. Indeed, it only becomes apparent when one views them in context and in relationship to the central sculpture of the king and queen (Figure 238).

The central sculpture is the most important and astonishing of the three. It is, of course, the focal point of attention, as is clearly indicated by the queen with twins and the equestrian figure facing the seated king and his senior wife. This sculpture was a free-standing work; unlike the other two sculptures, it did not support the veranda beam (see Figure 238).

Again we see Olowe as a master of composition. Unlike the dense, compact composition of the equestrian figure, the clear separation of the figures impresses the

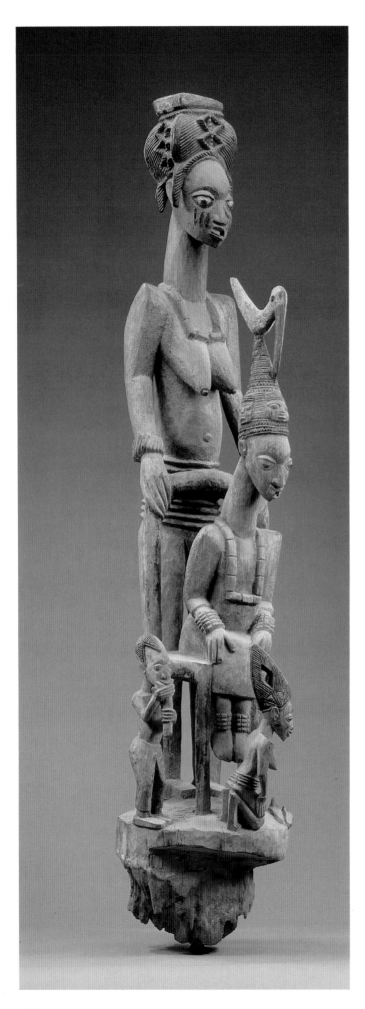

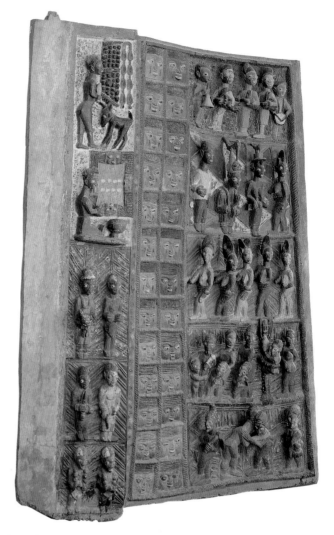

240. Palace Door, Ikere, Ekiti, c. 1925. The second door carved by Olowe of Ise for the palace of the Ogoga of Ikere, about 1925. Wood, pigment. H. 72 in. Irwin Green collection.

241. The central veranda post carved by Olowe of Ise for the palace of the Ogoga of Ikere, 1910–1914. It provides an interesting contrast to a similar one that he carved for the palace of the Arinjale of Ise several years earlier (see Figures 231, 232). Olowe enhances the diminutive size of the king by having his feet not touch the ground, thereby emphasizing the real power or authority (*ase*) of the king, which resides in the crown. The towering figure of the senior queen, whose breasts frame the king's crown, clearly indicates the relationship between male and female powers and the dependence of the king upon his queen. Wood, pigment. H. 61 in. The Art Institute of Chicago Major Acquisitions Centennial Fund.

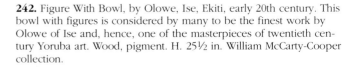

242. Figure With Bowl, by Olowe, Ise, Ekiti, early 20th century. This bowl with figures is considered by many to be the finest work by Olowe of Ise and, hence, one of the masterpieces of twentieth century Yoruba art. Wood, pigment. H. 25½ in. William McCarty-Cooper collection.

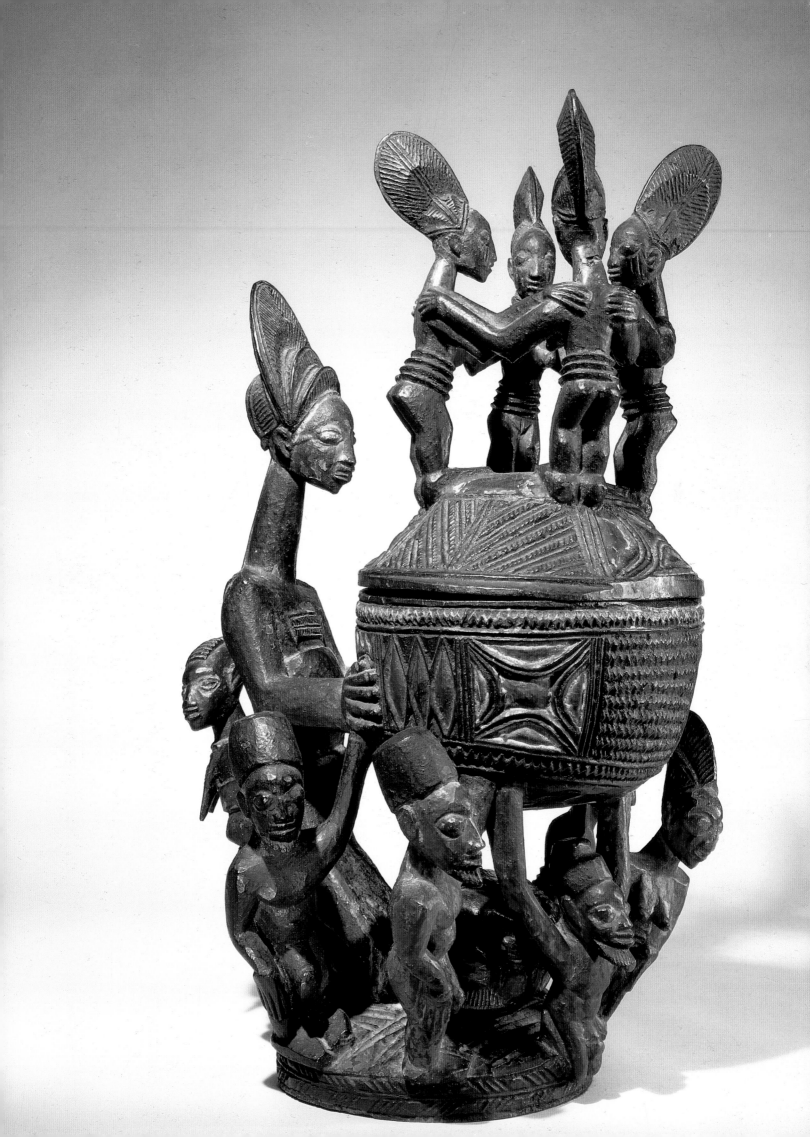

viewer (Figure 241). They are arranged in relationship to one another in a hierarchic composition, the overall form of which is that of a cone. At the base, a woman kneels before the king, her hands resting on her thighs. To the king's right a palace servant, whose head is shaved on the left, blows a flute, announcing the king's presence. On the king's left another palace servant carries the royal fan (a figure which is now unfortunately missing). The king sits on a chair, the back of which frames his body. His manner is composed, somewhat distant from the activity that surrounds him. His feet do not touch the ground. On his head is the great conical, beaded crown of a Yoruba *oba*, with a bird whose beak reaches halfway down the crown perched on the top. Behind the king is the tall, slender figure of a queen, whose breasts, again pendulous and conical, frame the king's crown, and whose neck and head tower above the crown. As in the sculpture of the queen with her twins, Olowe again uses the diagonal line intersecting the vertical as a device for relating the figures of the king and queen. The line of the queen's jaw is picked up in the tail of the bird, forming a graceful curve with its counterpoint in the bird's beak as it touches the crown. The diagonal line of the queen's breasts continues in the jaw line of the king and is repeated in the lower arms of queen and king. The pattern of the layers of beads around the queen's waist is repeated in the beaded pattern of the crown. Olowe's skillful composition expresses the intimate relationship of queen and king. What may seem extraordinary is the monumental size of the queen and the diminutive size of the seated king, but this and other aspects of the iconographic significance of the sculpture cannot be discerned without understanding that it is not the man but the crown that is the focus of attention and the locus of power.

When the crown of the Ogoga of Ikere is placed upon his head by the senior queen, his destiny (*ori*) is linked to all who have worn the crown before him.[26] The great bird on the crown refers to "the mothers," a collective term for female ancestors, female deities and for older living women, whose power over the reproductive capacities of all women is held in awe by Yoruba men. Referring to the cluster of birds on his great crown, the Orangun-Ila said: "Without 'the mothers,' I could not rule."[27] Thus, the bird on the Ogoga's crown and the senior queen, whose breasts frame the crown represent one and the same power—the hidden, covert, reproductive power of women, upon which the overt power of Yoruba kings ultimately depends. But as the positioning of the bird indicates, the power of kings is the crown, for the crown is an *orisa*.

Olowe, the master carver, understood the symbols of power in Yoruba society. In the sculpture of the king and queen, hierarchic sculptural form accords with the relationship of male and female powers. It is a work in which aesthetic considerations and iconographic concerns successfully combine to convey the meaning of an image.

The large double door at the right rear of the veranda, which led to the small courtyard with the shrine for the *oba*'s head, is a memorial not only to Yoruba royalty but to Olowe's brilliance as a sculptor and colorist (Figure 235).[28] The door panels illustrate a moment in the history of the people of Ikere when Captain Ambrose, who was Travelling Commissioner for the Ondo Province in 1897, was received by the Ogoga. Captain Ambrose is seated in a litter, looking a bit haughty, very uncomfortable, and rather small in comparison with the king in the opposite panel, as if "Olowe has carved Captain Ambrose himself as almost a suppliant of the king."[29] Ambrose's retinue is depicted above and below him, including bound and shackled prisoners carrying Ambrose's luggage. The Ogoga, wearing his great crown, waits with quiet dignity for his visitor. His senior wife stands behind him. other wives with children on their backs, palace attendants, and slaves are portrayed above and below the Ogoga. Although the panel on the right is slightly larger, the figures on the left are much more striking and certainly livelier. The carving may be unique in Yoruba art in its reference to a specific historical moment.

The doors were borrowed from the Ogoga in 1924 for the British Empire exhibition held in London. Apparently the Ogoga consulted Olowe, who gave his consent but declined to go to England himself, explaining that he was a family man with many wives and children and thus did not wish to leave home.[30] At the close of the exhibition the British Museum arranged an exchange with the Ogoga, whereby the latter would receive a British throne carved to the Ogoga's specifications and the British Museum would keep the Olowe doors, which as William Fagg observed, "does not seem to me to have been a very good bargain for him, for the wooden throne is not a very distinguished piece of British craftsmanship, but I am happy to say that Olowe, being still alive, carved a fine new door to fill the gap left by ours."[31]

Olowe's second door is also carved from two pieces of *iroko* wood and is composed of three vertical panels (Figure 240). Most fascinating, in terms of its iconography and composition, is the series of thirteen faces, which appear to the left of center. These highly stylized faces are markedly similar to those that Olowe depicts on the crown worn by the king in the scene in the upper right panel. But he used the image on other carv-

ings as well, as, for example, on a drum for Ogun that is still in use in an Ekiti town (Figure 243). Apart from variation in coloring, the faces appear identical, except that the design of the headpiece changes with the seventh pair from the top. The original design is repeated again with the eighth pair, and then the design for the seventh pair is continued on the faces of the ninth through thirteenth pairs. The change is probably of no other significance than to provide a subtle and delightful variation in the repetition of faces. It is a marvelous example of *oju-ona* ("design-consciousness").[32]

The larger panel on the right consists of five scenes depicting persons engaged in various activities. The king's drummers and trumpeter at the top announce his royal presence. The seated monarch, wearing his great crown and holding a flywhisk, receives two important visitors. The king's wife stands to the side; and other wives stand below. In the lower panels, slaves are supervised by palace officials, a palmwine tapper is at work, a hunter moves along the way, and two youths engage in a wrestling match which is always a part of the New Yam Festival. The narrow panel on the left provides scenes of Ifa divination and animal sacrifice. Below, the devotees of the various gods of the Yoruba pantheon make their offerings.

There is no narrative to be read in the panels. Rather, they provide a series of vignettes, hierarchically arranged, of the religious and domestic life of the palace. In this respect, the door is like many other palace doors. What distinguishes it is that Olowe does not carve the figures in low and even relief: "Olowe, entirely on his own, seems to have introduced the practice of carving the figures to stand out at an angle from the door, so that the heads may project as much as six inches, whereas the feet are firmly attached to the wood of the single block from which the whole is carved."[33] Thicker and heavier planks of wood were required and, hence, a commitment on the part of the carver to spend the time and energy to complete the project. Such a commitment is solely the product of artistic imagination and the need to realize what one has envisioned. Equally audacious is Olowe's patterning of the background, which adds to the sense of the three-dimensional depth of the figures and also helps distinguish one panel from another. The largest and boldest patterns are used in the panel depicting the *oba*. In addition, Olowe painted his carvings, using a restrained palette and revealing himself to be a fine colorist.

Olowe's masterpiece is the depiction of a kneeling female figure with bowl (Figure 242). One other sculpture of a similar type has survived.[34] Both are splendid carvings, but the present carving is superior for the way in which it extends into the surrounding space. It is a

work that is vibrant, filled with energy. Here is the great difference between the aesthetic of Olowe and that of Areogun, whose sculptures tend to be static by comparison. Rather than placing the male and female figures beneath the bowl in order to bear its weight, Olowe has them leaning out over the edge of the platform base as they hold the bowl aloft, creating a tension between the action of the figures and the weight of the bowl. On the bowl's lid four female figures are joined together in a dance. The slender and beautifully coiffured woman and child kneeling at the side link the figures below with those above. Olowe extends the tapered neck to a point which risks the grotesque in order to express elegance of line and the beauty of the head. The surface of the offering bowl is elaborately decorated with a variety of carved and painted designs that in their juxtaposition make the bowl the center of the energy that pervades the entire work.

Artistic genius requires a confidence in one's technical skills, an understanding of the possibilities and limitations of the materials with which one is working, and an imagination that forces the artist to press the limits of received ideas and envision anew accepted forms. Olowe possessed such a genius.

> *I shall always praise you, Olowe.*
> *Olowe, who carves the iroko tree.*
> *The master carver.*

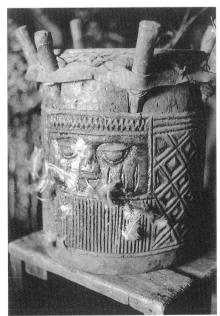

243. Drum carved by Olowe for use in the festival for Ogun, the god of iron. All Yoruba carvers and blacksmiths worship Ogun. According to Olowe's family, the festival for Ogun was of great importance to him and they continue to celebrate it every September in his honor. The face on the drum appears on so many of Olowe's carvings that it might well be considered his trademark. Southern Ekiti, Nigeria, 1988. Photograph by J. Pemberton 3rd.

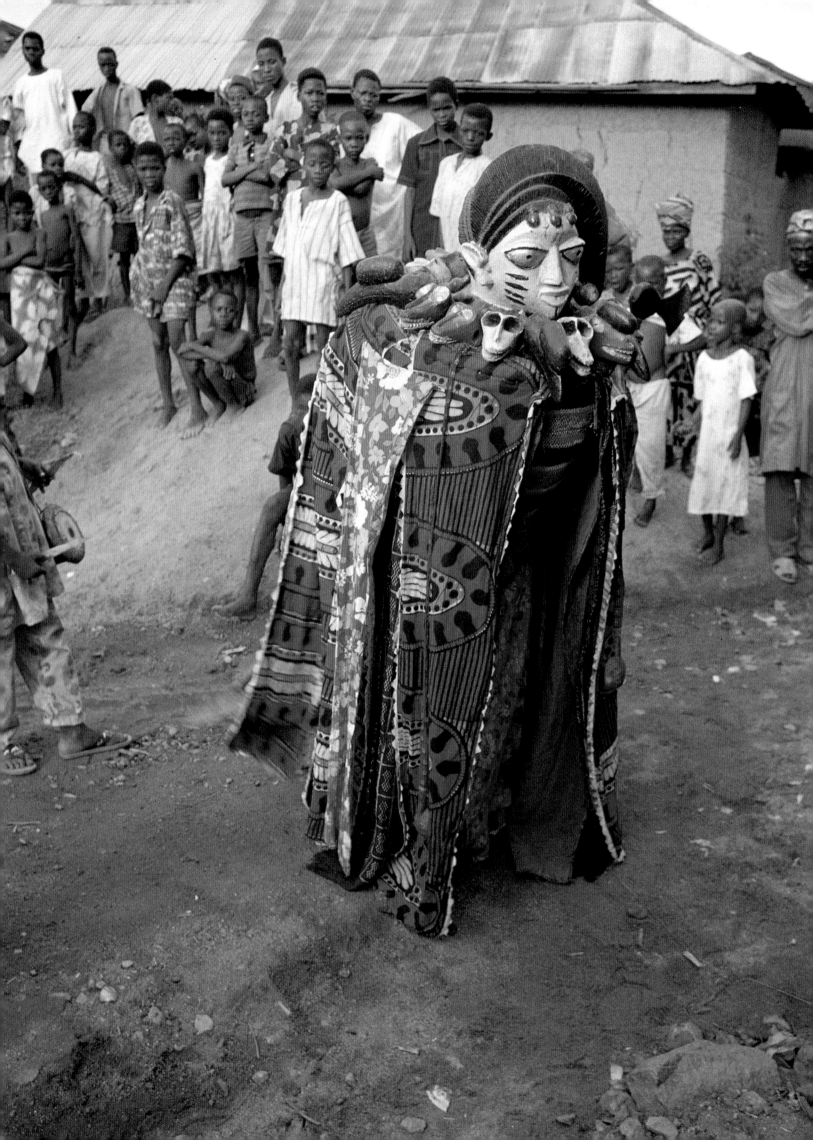

Henry John Drewal

The histories of various western Yoruba kingdoms are tied primarily to two states in the region—the ancient Ketu realm and, later, the Oyo Empire.[1] Located between the Weme River in the Popular Republic of Benin and the Ogun River, the region is relatively flat with fertile land, open forests, a network of streams, and a major river, the Yewa. The forested and well-watered area known as Egbado ("Egba-of-the-Water") seems to have been an early source of game for Ketu and Oyo hunters and was not very densely populated. Oral histories in many Egbado towns indicate that the earliest settlers were from Ketu, the later ones from Oyo. In fact, it seems quite clear that the expansion of the Oyo Empire in the seventeenth and eighteenth centuries was responsible for the rapid spread of Sango worship, Egungun masking and other religious practices, and Oyo arts throughout much of western and southern Yorubaland (see Chapter 6).[2] Before this intrusion of Oyo culture in the region, however, it was Ketu that exerted the dominant influence (Figure 244).

Ketu Art and History

Ketu is one of the oldest Yoruba kingdoms. According to legend, it was founded by a grandson of Oduduwa at Ife, who fathered the mother of the first ruler, the Alaketu.[3] Some Egba accounts acknowledge the seniority of the Alaketu, and migration myths of the Aja and Ewe peoples in Benin and Togo mention Ketu as

an important stopping place.[4] Several waves of immigrants seem to have populated the region and a well-documented king list at Ketu itself suggests origins in the fourteenth century. While unlike Oyo it never expanded its territories greatly, it seems to have maintained its autonomy until the nineteenth century.[5] Ketu was built on a plateau and was noted for its fortifications, especially the formidable Idena gate (see Figure 53).

The expansion of Oyo in the seventeenth and eighteenth centuries brought dramatic changes. With the aid of their cavalry, the Oyo set up a trading corridor to the sea that skirted the western edge of the Ketu kingdom and moved southward through Fon and Aja to Whydah and Allada. Then, in about the late eighteenth century, Oyo shifted this corridor eastward to the Egbado area, ending at Ajase (Porto Novo) and Badagri. According to traditions, sons of Alafin Abiodun (about 1774–89) founded towns along the route. During this period Ketu and especially Egbado experienced rapid growth in its towns and cities and enjoyed a period of peace and prosperity. This led to an influx of people from Oyo, other northern Yoruba areas, and elsewhere. They brought with them their beliefs and sacred images, such as dancewands for Sango (Figure 246), Egungun masks (Figure 245), and Orisa Oko staffs (Figure 247). Western Yorubaland flowered in this era of trade and stability, but it was not to last long.[6]

The collapse of Oyo at the beginning of the nineteenth century ushered in a long and painful period of war, disruption, and dislocation. Ketu, Egbado, and other western Yoruba areas within Oyo's sphere became the

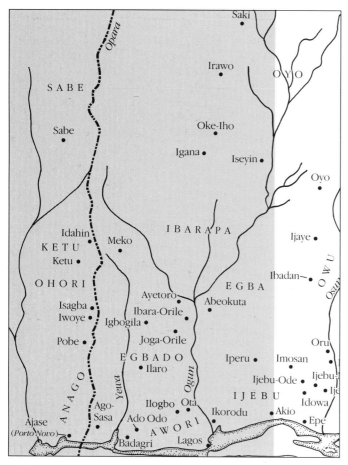

244. Map of western kingdoms.

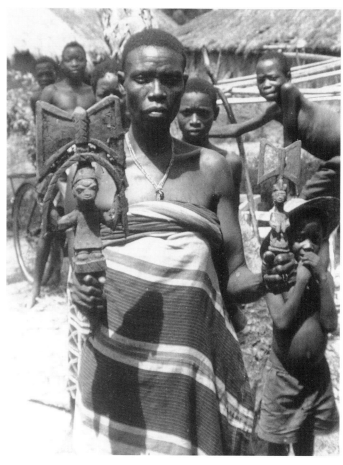

245. An ancestral Egungun masker called Aripon dances during the annual festival in Itesi Quarter of Abeokuta. The headdress that includes images of a human head with hunter's coiffure surrounded by carved monkey and hornbill skulls was made by a master sculptor in the Esubiyi Workshop. Abeokuta, Nigeria, 1978. Photograph by M. T. Drewal. See Page 212.

246. A Sango worshipper proudly displays two of her ritual objects. When not adorning altars to the god, they serve as dancewands during festivals and possession performances. The double-bladed celts shown on the heads of the devotees in the dancewands evoke the spiritual unity of deity and devotee. Both were carved in Ohori. Obelle, Ohori, Nigeria, 1975. Photograph by H. J. Drewal.

247. The worship of Orisa Oko was introduced into Egbado with the expansion of the Oyo Empire. Here two Egbado women stand beside the god's primary symbol—a large iron staff clothed in its beaded garment. Ilaro, Egbado, Nigeria, 1977. Photograph by H. J. Drewal.

248. Ifa divination cup by an unknown nineteenth century Ketu artist. It depicts a marvelously diverse scene of soldiers and their prisoners, mothers nursing, an Egungun masker, his attendants and drummer, and a chief on horseback. Photograph by H. J. Drewal, 1978.

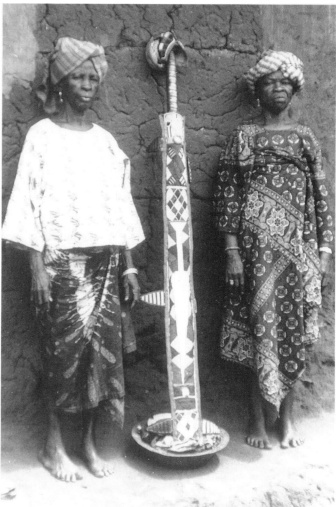

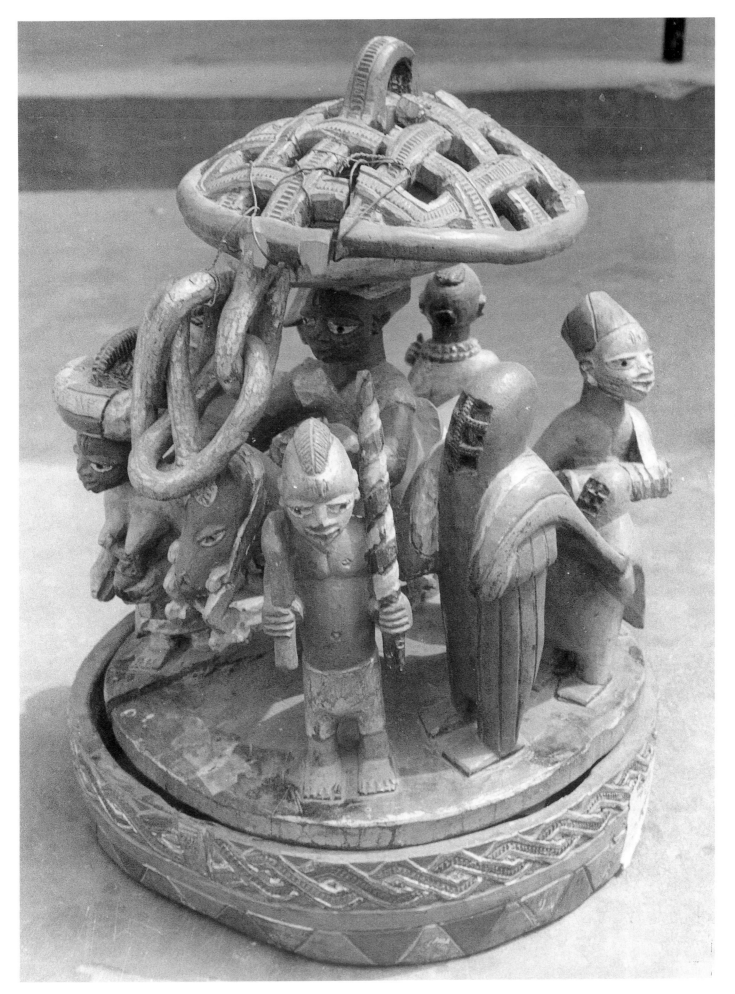

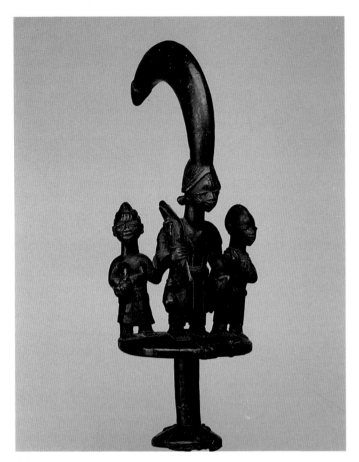

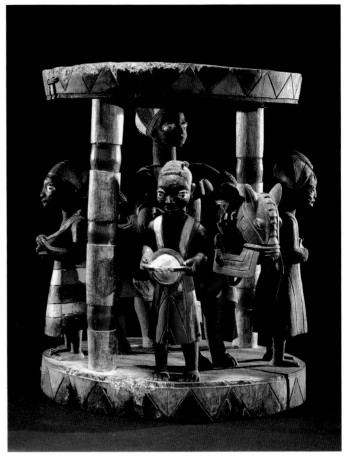

249. Esu Dance Staff, Ketu, 19th century. Esu staffs decorate the shrines for Esu/Elegba. On ritual occasions, such as processions and annual festivals, they are carried out and manipulated during dances in honor of the deity. They are held in the hand or draped over the shoulder, their form reminiscent of the *ogo* (club), one of Esu's implements. This one depicts a warrior with a captive on his right and a nursing mother on his left. Wood. H. 19½ in. Whipple collection.

250. Stool, Ketu, 19th–20th century. A stool is a mark of rank. This one, the work of an unknown Ketu master, depicts an equestrian warrior chief surrounded by an entourage of drummers and titled women. The horse, horse trappings, and garment fashions seem to suggest Oyo cultural elements and their impact on Ketu life. Wood. H. 16¼ in. Ida and Hugh Kohlmeyer.

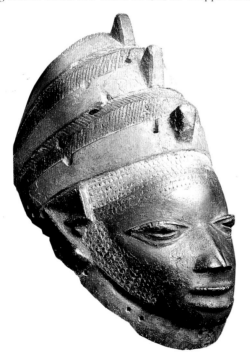

252. Gelede Headdress, Ketu, 20th century. A Gelede mask displays two young hunters holding the hind legs of a pangolin as it makes a valiant attempt to escape down the forehead of the mask. While ostensibly honoring the social contributions of hunters, this mask also presents ideas and lessons about Ogun. He is the divine patron of hunters, myths, and those metaphors concerning aggression, protection, and cooperation that enlighten society, the "children of our mothers." The mask was carved by the master Fagbite or his son Falola Edun from the Ketu Yoruba town of Idahin, Republic of Benin. Wood, pigment. H. 12 in. Neal Ball.

251. Gelede Headdress, Anago, Popular Republic of Benin, 19th–20th century. The delicate lines of the face, the distinctive angular design of the ear, and the rows of tiny triangles incised across the forehead and from ear to cheek indicate the familiar hand of an unnamed master carver from the Anago area. Wood, pigment. H. 10½ in. Private collection.

253. An elderly priestess of the goddess Odua is among the loved, respected, and feared elderly women known as *awon iya wa*, "our mothers," for whom Gelede is performed. She wears white garments symbolic of her deity and holds in her hand the ritual bell (*agogo*) used to call the god. Ilaro, Nigeria, 1975. Photograph by H. J. Drewal.

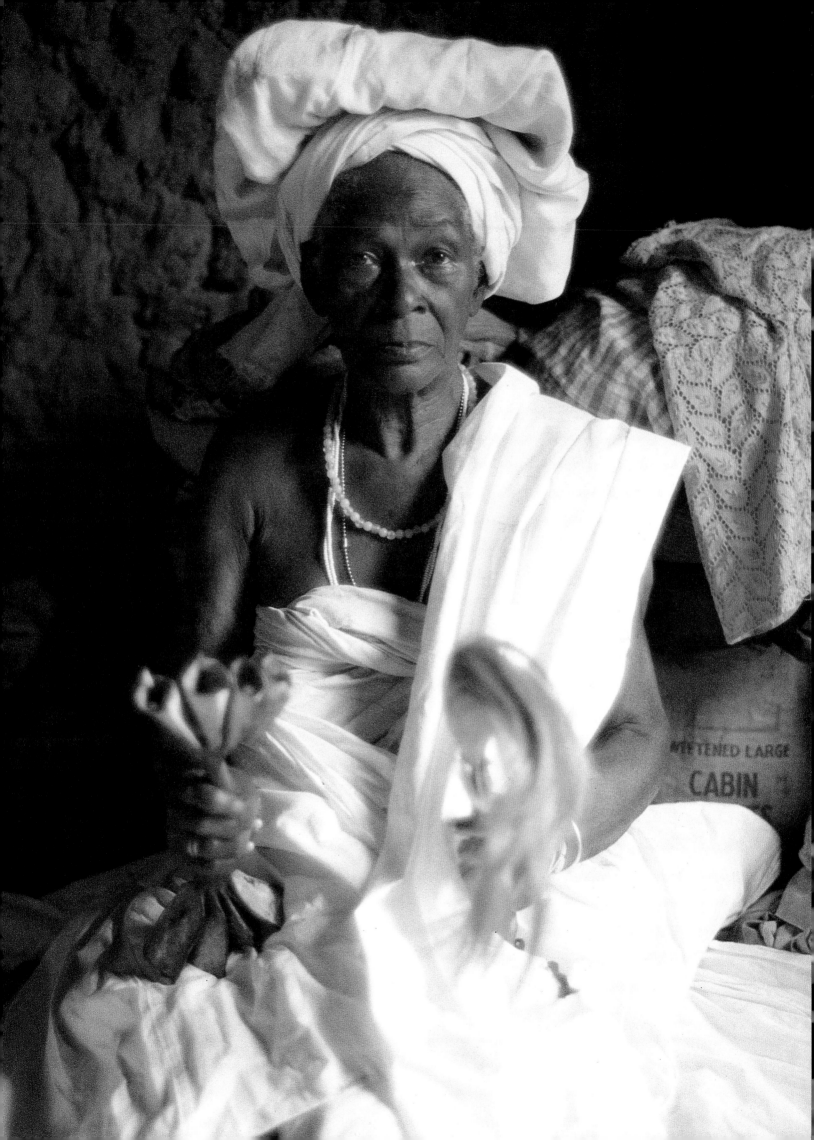

battlegrounds for the armies of the Fon from Abomey, the Ibadan, Egba, and Ijaye from the east, and the Egun from the south.[7] These armies rose to challenge the former might of Oyo.

The political, social, and economic changes that resulted meant a state of enormous flux in western Yorubaland for most of the nineteenth century. Such a situation is reflected in the diversity of styles that one may find in the same town or carving center. The personal histories of many artists in this region describe the long-distance migrations of their families. A father may carve in the style of his origins, and his son might develop another style, one influenced by the family's new home and the artists around him. In many instances, the styles and motifs characteristic of Oyo were synthesized with those of Ketu to produce new, hybrid visions.

Although a significant number of Ketu artists created a large corpus of work, unfortunately we know the names of only a few, such as Otooro[8] and Alaye Adeisa Etuobe. Etuobe's relatives in the Fagbite family are also well-known carvers; their sons emigrated to various Egbado towns, bringing their distinctive Ketu style with them.[9] They include Olatunji Fagbite at Save, Ogundeji Oguniyi at Idofa, and Adegbola Etuobe at Igbogila. Atoba, another popular Ketu carver, did many works at Ajilete. This dispersion of Ketu artists may be a fairly old phenomenon to judge from the fine works scattered in Ibarapa, Abeokuta, and elsewhere in western Yorubaland.

One unknown Ketu master did a series of Ifa divination cups for such powerful patrons as Balogun Ibikunle, head of the Ibadan forces during the Ijaye wars of 1850–60.[10] A king at Abeokuta also commissioned a divination cup from this Ketu master. It depicts a marvelously diverse scene of soldiers and their prisoners, mothers nursing, an Egungun masker, his attendants and drummer, and a chief on horseback (Figure 248). Some of the same lively figures are shown in a very fine figurated sculpture for Esu/Elegba by the same master (Figure 249). The central figure, the priest of the divinity whose sanctified head is marked by an enormous, curving phallic projection, is flanked by two others—a bound captive on his left and a female attendant on the right. In the priest's left hand is his own miniature ritual implement. Such works decorate the shrines for Esu/Elegba, and on ritual occasions, such as processions and annual festivals, are carried out and are manipulated during dances in honor of the deity. They are held in the hand or draped over the shoulder, their form reminiscent of the *ogo* (club) of Esu's implements.

A stool is a mark of rank, a sign of the *ase* of its owner. Usually circular, stools often have a cluster of figures depicting scenes from Ketu society that relate to

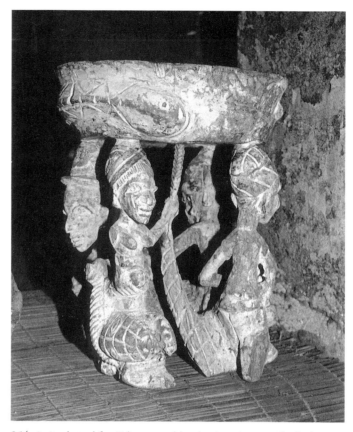

254. A ritual stool for Odua carved by the Awori master Dadaolomo in the late 19th century. Around its perimeter the artist has woven a complex network of animated human, snake and crocodile images. Ota, Awori, Nigeria, 1981. Photograph by H. J. Drewal.

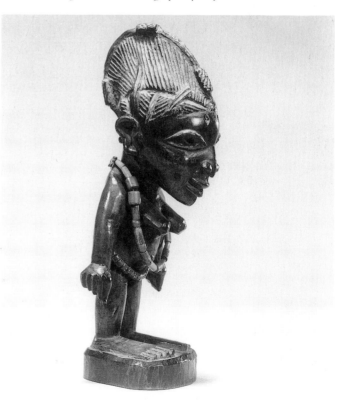

255. Single Ibeji Figure, Ota, 19th century. The distinctive style of the master sculptor Dadaolomo can be seen in the strong, angular volumes, smooth surfaces, and forward leaning stance of this *ere ibeji* figure. His refined technique is particularly evident in fine Gelede masks that were praised for the thinness of their carving. Wood. H. 9½ in. Mr. and Mrs. Charles Davis.

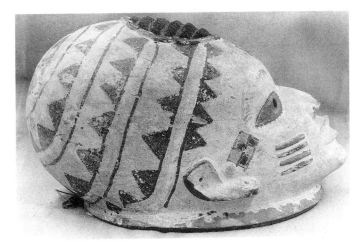

256. Gelede Headdress, Ota, 19th century. Gelede mask carved by an unknown 19th century master at Ota who seems to have flourished in the 1870s and 1880s. One of his favorite subjects seems to have been *orisa* initiates whose heads have been shaved, washed, painted, and prepared to receive the spirit of the deity during possession trances. Here a tuft of hair marks the sanctified head, its border set off by a circle of beads. Wood, pigment. H. 12 in. The Port of History Museum and The Civic Center Museum, Philadelphia.

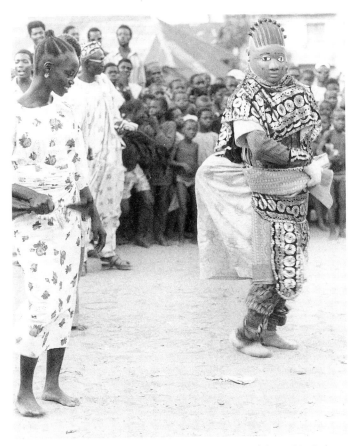

257. A Gelede masker in performance at the annual festival in Isale-Eko, Lagos, accompanied by one of the female officials of the society. The mask, depicting a woman with a carefully braided coiffure, was carved by Kilani, the grandson of Olaniyan. They and other Ota carvers have been supplying Gelede masks for Lagos patrons for at least three or four generations. Isale-Eko, Lagos, Nigeria, 1978. Photograph by M. T. Drewal.

those who commissioned them (Figure 250). At the center, a caryatid equestrian rides in glory, flanked by his entourage. In front, his drummers play his praise names. On the left, the *gudu* drummer, playing with two sticks, sounds the fast, background rhythm while the senior drummer on the left manipulates his pressure-talking drum to approximate Yoruba tonal structure and thus "speak" percussively. Titled women with multi-stranded necklaces lift their breasts in a gesture of greeting and generosity. At the center of all this activity is the warrior chief, his long sword sheathed at his side, a flywhisk draped over his shoulder. Great attention has been paid to the details of the clothing on all the figures, as well as the horse trappings which probably represent Oyo leatherwork. In fact, the regalia, dress style, and equestrian warrior may be references to the impact of Oyo on Ketu society. The zig-zag, serrated pattern around the perimeter recalls the edges of Egungun ancestral masking costumes as well as the typical form of warriors' protective amulets known as *tira*. All of these finely rendered details are enlivened by the rich and distinctive pastel polychromy typical of much Ketu work.

This wonderful stool is the work of an unknown nineteenth-century Ketu master. Its composition and themes relate closely to the Ketu master of the Ifa divination cups and Esu/Elegba *ogo*. While the stool was certainly made by a different hand, the concept and sense of detail suggest connections and interactions between the two artists or their workshops in the mid- to second half of the nineteenth century.

Perhaps Ketu's greatest artistic contribution is the masking tradition known as Gelede. The Ketu Yoruba people are credited with the invention of Gelede. While the Ketu town of Ilobi is given specific credit, the city-state of Ketu earned the widespread reputation of being the major and distinctive carving center for Gelede masks and many other types of objects as well.

According to traditions throughout Egbado and Ketu, Gelede seems to have originated sometime during the period of prosperity in the latter part of the eighteenth century.[11] Found primarily among western Yoruba peoples, Gelede pays homage to the spiritual powers of elderly women known affectionately as *awon iya wa* ("our mothers"; Figure 253). The powers possessed by such women, comparable to those of the gods, spirits, or ancestors, may be used for the benefit or the destruction of society. When manifesting their negative dimension, such elderly women are termed *aje* (witches). If angered, they can bring down individuals and entire communities. Gelede masquerades entertain and enlighten the community and "our mothers," pleasing,

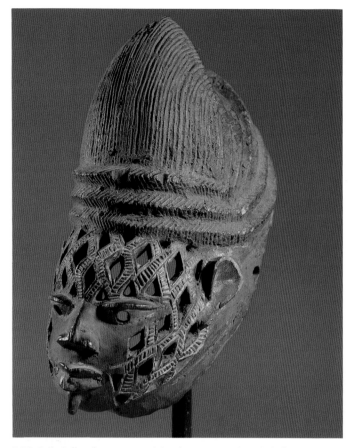

258. Gelede Mask, Anago, 19th–20th century. This mask from Ketu's southern neighbor in the Anago town of Pobe is probably the work of Arobatan or one of the artists in his workshop. The intricate interplay of mass and space expresses the artist's ingenuity and dexterity. He plays with the theme of masking by including openwork that obscures yet also reveals the dancer's features. Wood, pigment. H. 14 in. Private collection.

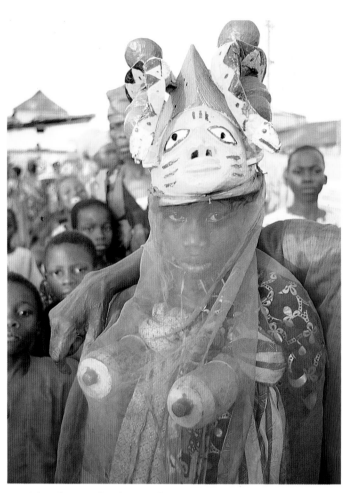

259. The identity of Gelede performers is often easily known, as shown by this masker who wears a thin cloth veil that reveals his facial features. In contrast to ancestral Egungun masks that completely conceal the wearer, Gelede performers' identities are known and celebrated just as the masks themselves comment on individuals and groups in the society. Ilaro, Egbado, Nigeria, 1978. Photograph by M. T. Drewal.

placating, and thus encouraging them to use their extraordinary powers for the well-being of society.

Female and male titled elders direct the Gelede society. Others specialize in different artistic activities for the performances—mask and costume preparations, song-writing, drumming, and choreography. All the masqueraders are males, yet the cloths for their costumes are borrowed from the women of the community. The choruses are made of both females and males, while the honored guests are the elders, especially the women, of the community.

In contrast to Egungun, Agbo, Oro, and other masking traditions whose main concerns are the spiritual forces in *orun*, Gelede concentrates on forces in the world, primarily the elderly mothers. The workings of otherworldly entities are not ignored, but humanity and the issues of *aye* take center stage. The performances are thus an *ebo* (sacrifice), or appeal to forces in the world using the aesthetic power of sculpture, costume, song, and dance. They offer explicit commentary on social and spiritual matters, helping to shape society and those within it in constructive ways.

Gelede imagery evokes all aspects of Yoruba society.

The masks refer to a wide variety of female and male roles and activities either in objects associated with such roles or in genre scenes depicting them. They also depict animals that serve as metaphors for human actions or as illustrations of popular proverbs and songs that often accompany the mask's appearance. Such images are intended to provoke explicit reactions from the audience. They frequently comment on specific situations or persons in the community, either praising positive, productive contributions or damning destructive, antisocial ones. The images in the masks are diverse and encompassing because the mothers are "the owners of the world," and society constitutes "the children of our mothers." All the masks express some sort of social or spiritual commentary, or both simultaneously. They often convey a particular point of view, whether of praise, humor, or condemnation, though this is often difficult to determine with certainty unless specific contextual and performance data have been recorded for a mask.

The themes that occur in Gelede may be grouped broadly into three categories—role recognition, satire,

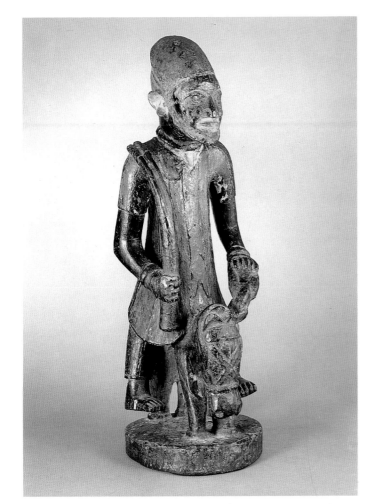

260. Equestrian Figure, Ota, 19th century. An equestrian image that probably adorned an *orisa* altar. The horse, a rare presence in southern Awori country, was used primarily as a status symbol on public occasions. Here it has received very summary treatment by the sculptor. The almost-standing male commands attention, his garment and regalia signifying his importance. Wood. H. 22 in. Barbara and Richard Faletti collection

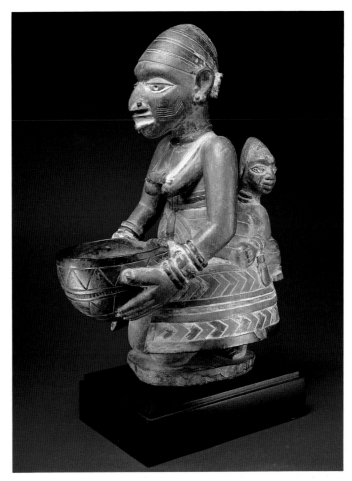

261. Kola Nut Bowl, Ekiti, 19th century. Finely figurated bowls hold kola nuts that are presented as a sign of peace and welcome to guests and also used to communicate with otherworldly forces. Here, a priestess (indicated by her necklace and bracelets) kneels to offer kola nuts as her child watches from behind. Wood. H. 21½ in. Deborah and Jeffrey Hammer, Los Angeles.

and concerns about the workings of various cosmic forces. These thematic categories are not mutually exclusive. In the first, individuals and/or groups are praised and honored for their contributions to society. The second does just the opposite—it ridicules and damns antisocial persons or groups. The third, by both explicit depictions or metaphoric allusions, treats the forces in the world and beyond that affect the life of the community.

Some of the most popular and active images on the superstructures of Gelede masks are scenes of hunters (both human and animal) trying to capture their prey. It is not always clear, however, who is the captor and who the captive! In one work, a hunter points his gun at his diminutive elephant, while on the other side of the headdress, another animal has treed the hunter's companion.[12] Hunting has traditionally been an important profession in the extensive forests of western Yorubaland. Many myths of the founding of towns describe how hunters tracked their prey and discovered

suitable locations for a town near water, fertile land, or plentiful game.

Hunting has important sacred dimensions. Forests are not only the abode of animals, but also of spirits. Hunters therefore have to arm themselves with guns, arrows, traps, and knives as well as with spiritual armament—amulets and incantations to protect themselves and charm their prey into agreeing to be caught. Ogun, the god of iron, is their patron, the one whose metal makes their work possible. Some of the hunters' magical medicines allow them to transform themselves, to make themselves invisible at moments of danger, or to stop a charging animal in its tracks. Other stories tell of a mythic time when animals and humans spoke the same language and changed their outer appearance— humans into animals, animals into humans. Ifa divination literature talks about birds that were once famous diviners, singing endlessly the poetic verses from the divination literature. In addition, hunters' lore records an ancient agreement with animals. Humans could kill

them, but only as many as they required to feed their families. Wanton destruction brought a curse on a hunter's head.[13] Thus images of hunters and animals are much more than recognition of the hunters' profession. They are treatises on Ogun, the *ase* of different creatures, myths about humans in relation to their environment, and magical medicines.

In a wonderfully animated scene on a mask from the Ketu town of Idahin, carved by the master Fagbite or his son Falola Edun, we witness two young hunters grasping the hind legs of an *arika* (pangolin), as it makes a valiant effort to escape down the front of the mask (Figure 252). The hunters link arms and legs in their effort, probably a gesture of cooperation somewhat reminiscent of the brass couple at Ita Yemoo, Ife (see Figure 74). They wear cutlasses at their hips and have distinctly different hairstyles. The hair tufts, known as *osu*, usually signify a head prepared for certain spiritual purposes such as devotion to a divinity, in this case probably Ogun, their patron. In other cases such hair tufts may mark a particular situation that called for medical and spiritual remedies.

Animals are a rich source of metaphors for the Yoruba. The *arika* provokes ideas and provides lessons useful to humans. *Arika* epitomizes one who possesses a defense usually impervious to the attack of its more powerful enemies. When threatened, it rolls itself into a tight ball, its hard scaly skin protecting its soft underbelly from attack. Because of this, the *arika* is highly prized as an ingredient in protective medicines. Its skin has become the symbol for self-preservation in the face of deadly challenges.[14] No wonder it appears as the caryatid of an Ifa divination bowl, supporting the key symbols of Ifa, the sixteen palm nuts of the diviner, to reveal the forces operating in a situation (Figure 262). The sculptor has captured the encircling action of an *arika* as it prepares to defend itself.

In the Gelede mask (see Figure 252), the hunters work together to prevent an *arika* from becoming a scaly ball. His legs are stretched apart and his tail curled upward. For the moment, the hunters seem to have the upper hand in the struggle. At other levels of meaning, this scene may be an allegory on communal effort in the eternal struggles that characterize the Yoruba cosmos of competing forces, each with its own distinctive *ase*. A poem from Ifa (paraphrased here) tells of such a world and offers a solution for dealing with it:

> Kankan, meaning "by force," invited pairs of creatures and things to help him with a communal labor project, *owe*. Each agreed but told Kankan that he must not invite its natural nemesis. Kankan agreed but then promptly ignored his word. Without telling them, he invited grass-

hopper and hen, wolf and dog, hyena and hunter, fire and rain, drought and dew-drops. After they were all assembled, he left them without food or water until chaos broke out and they started to devour each other. Only dew prevented the situation from turning into total destruction. It began to fall gently on their heads, cooling and refreshing them. Soon they stopped fighting and instead rejoiced together, praising the dew for its life-giving properties.[15]

Dew symbolizes a soothing, pacifying, and regenerating force, one that accomplishes its task, not by aggression, but through persuasion and life-affirming qualities. Thus "devouring" motifs that may seem to stress competition and aggression, may in fact be counseling other strategies to achieve the desired results. In the context of Gelede, such imagery may allude to the essence of the tradition, the soothing or "petting" (*ge*) placation and praising of the "mothers" and their life-giving powers, rather than attacking them for their negative actions as "witches." In the verbal arts, proverbs or allegories are useful precisely because their messages are indirect and subtle. Their lessons are revealed after reflection. They are not confrontational. The visual allusions in Gelede work in similar ways.

A mask from Ketu's southern neighbor in the Anago town of Pobe is probably the work of Arobatan or one of the artists in his workshop (Figure 258). The intricate interplay of mass and space expresses the artist's ingenuity and dexterity. He celebrates himself as an *onisona* (artist) of fanciful form meant to delight and surprise. His work admirably fulfills its purpose of entertaining the mothers and is therefore the most appropriate sacrificial offering that could be made. Crowning the head is an elegantly plaited conical coiffure with tightly bound rows of braids over the brow. A stone labret accentuates the lower lip to balance the rising hair. The artist plays with the theme of masking by including openwork that obscures yet also reveals the dancer's features. It is a mask that unmasks. This could never be done in Egungun where the performer's identity must be shrouded by the enveloping cloth (see Figure 245). Gelede is different. Since it is paying tribute to living members of society, the mothers, and invoking persons and roles in songs, dances, and masks, the performer can likewise be known and celebrated for his performance, or criticized if it does not live up to expectations. Drummers will often incorporate the name of the dancer in their drummed phrases, invoking his family's *oriki*, to spur him on to excel during his display. The cloth that covers the performer's face is often a thin gauze that reveals his features (Figure 259). At the end of performances, maskers will part or lift the cloth veil attached to the rim of the mask, circulate in the milling crowd, hopeful of compliments in praise of their efforts.

Ota and the Awori Yoruba

Another major carving center for Gelede and many other types of objects was Ota, the capital of the Awori Yoruba. Ota seems to have been the source for works over a wide area along the coast, especially Lagos. Ota was a gathering center for various peoples including the Oyo and Egba who extended their realm as far south as Ota and had farms in the area. From the west came Egbado peoples; from along the coast came the Egun and Anago from the towns of Ajase and Badagri, and the kingdom of Ifonyin; from the east came the Ijebu and possibly the Edo from the Benin kingdom during its sixteenth and seventeenth century expansion.

Quite a number of carvers are remembered at Ota. The most famous ones are: Dadaolomo of the Emopa Quarter (d. about 1908), Ijikeku Akinlase of Iyanru Quarter (d. about 1932), Asaoku Odu Afija of Ago Egusi Quarter (d. about 1920), Olabimtan Odunlami of Ijana Quarter (d. about 1930), and Olaniyan Odunburu of Oruba Quarter (d. April 1948) whose grandson Kilani Olaniyan is one of the few remaining artists active at Ota.

Dadaolomo earned a widespread reputation for his finely carved and smooth-surfaced works and strong, somewhat angular volumes. His twin memorial figures are distinctive (Figure 255). The massive head and elaborate coiffure with ornaments dominate the work. The size of this upper portion seems to pull the figure forward into a leaning stance. Only the long, broad feet and high, tight buttocks counter the strongly oblique angle of the legs and back. Firm breasts jut out as arms and clenched hands with downward-projecting thumbs flank the figure, detached from the torso in a treatment typical of this region.

The head is most remarkable, especially the large, wrapped eyes, strong nose bridge, flared nostrils, firm jawline, and pointed chin. A distinctive thrust and strength dominated the Ota style at the turn of this century and may have derived from Dadaolomo's work which clearly dates to the last three decades of the nineteenth century. Dadaolomo's wonderful ritual stool for Odua (Figure 254) shows the flow and elaboration of his compositions. Around the perimeter several humans interact with sinuous snakes, crocodiles, and other creatures. White, Odua's color, covers the form. The faces of the figures look out at the passing scene in animated fashion. Gelede masks attributed to him have a notable feature—extremely smooth surfaces and very thin walls, praised with the adjective *fele*.[16]

A number of carvers, some of them contemporaries of Dadaolomo, made Ota a rich source of images for Gelede societies in many towns in the region. Their major commissions were for patrons in the thriving

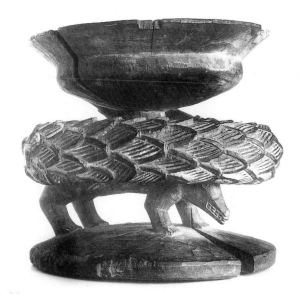

262. Bowl With Pangolin, Oyo, 19th–20th century. The pangolin appears as the caryatid of an Ifa divination cup. Notice the method by which the sculptor captured the encircling action of a pangolin as it prepares to defend itself. Wood. H. 6¾ in. Barry D. Maurer.

metropolis of Lagos. The names of two Ota carvers were recorded in 1949, Aye Onaneye (d. about 1909) and Idowu Olalaye.[17] Then came Olabimtan and Olaniyan who also worked for patrons at Lagos. Along with their apprentice sons and grandsons, they created the large number of masks associated with the Lagos Gelede societies (Figure 257). According to their grandsons, they were related through the mother's family.[18] Their works exhibit Dadaolomo's influence, especially the very thin, *fele* walls, the trademark of Ota and other Awori carvers.

A Gelede mask may have been made by a predecessor of Olabimtan, but not Dadaolomo (Figure 256). Several works closely related to this mask entered European collections between 1878 and 1881. Their strength and assuredness suggest that the 1870s–80s were a high point in the career of an unknown master, comparable in technical ability to Dadaolomo. One of this unknown master's favorite subjects in the 1880s, to judge from other masks by him depicting the same subject collected in 1891, is of an *orisa* initiate.[19] The person's head was shaved, washed, and prepared with substances to allow him to receive the spirit of his divinity during the possession trances that are an essential part of rites in honor of the gods.[20] Remnants of the painted patterns can be seen on the head of the mask. The spot of the power materials is where *osu* is grown. Here, the tuft of hair is set off with a ring of beads whose colors again signify the *orisa* to whom this person is devoted. The mask thus proclaims the presence

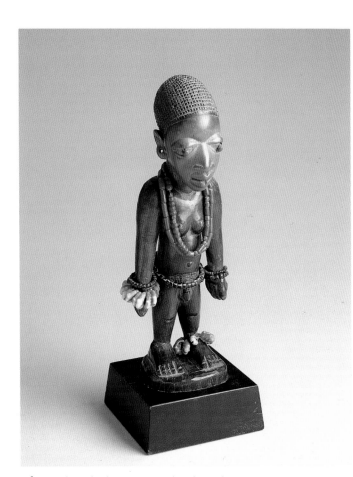

263. Single Male Ibeji Figure, AdoOdo, 19th century. A twin memorial figure, *ere ibeji*, by the same master's hand as one collected before 1877 and now in the Linden Museum, Stuttgart. Its full, fleshy and generally more realistic treatment, especially in the definition of arm and leg muscles, characterizes southern and southwestern sculptural style especially in Awori and westward in the vicinity of Ado Odo. Wood. H. 10¼ in. Deborah and Jeffrey Hammer, Los Angeles.

264. Doll, Ado Odo, 19th century. Dolls known as *omolangidi* are washed, dressed and carried by Yoruba girls in imitation of mothers' care of their children. While usually simple work by carving apprentices, this is the carving of a master, possibly the same hand or workshop as the twin memorial in Figure 263. Wood. H. 12¹⁄₁₆ in. Musée Royal de L'Afrique Centrale, Tervuren.

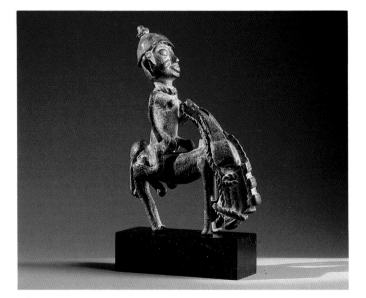

265. Equestrian Figure, Abeokuta, 19th century. A brass equestrian figure that seems related to the work of the "Master of the Courtly Entourage," an artist working in Abeokuta in the 19th century. It may have been part of a larger tableau, perhaps an Ifa divination cup or an Osugbo piece. Brass. H. 3⅛ in. Gaston T. deHavenon Collection.

266. Title Staff, Abeokuta, 19th century. A blacksmith's staff depicting the figure of a titled follower of Ogun, god of iron and divine patron of all who work with his metal. These staffs are carried to meetings and serve as insignia of office. Bronze. H. 20½ in. Gift of Fred M. Richman, Collection of the High Museum, Atlanta.

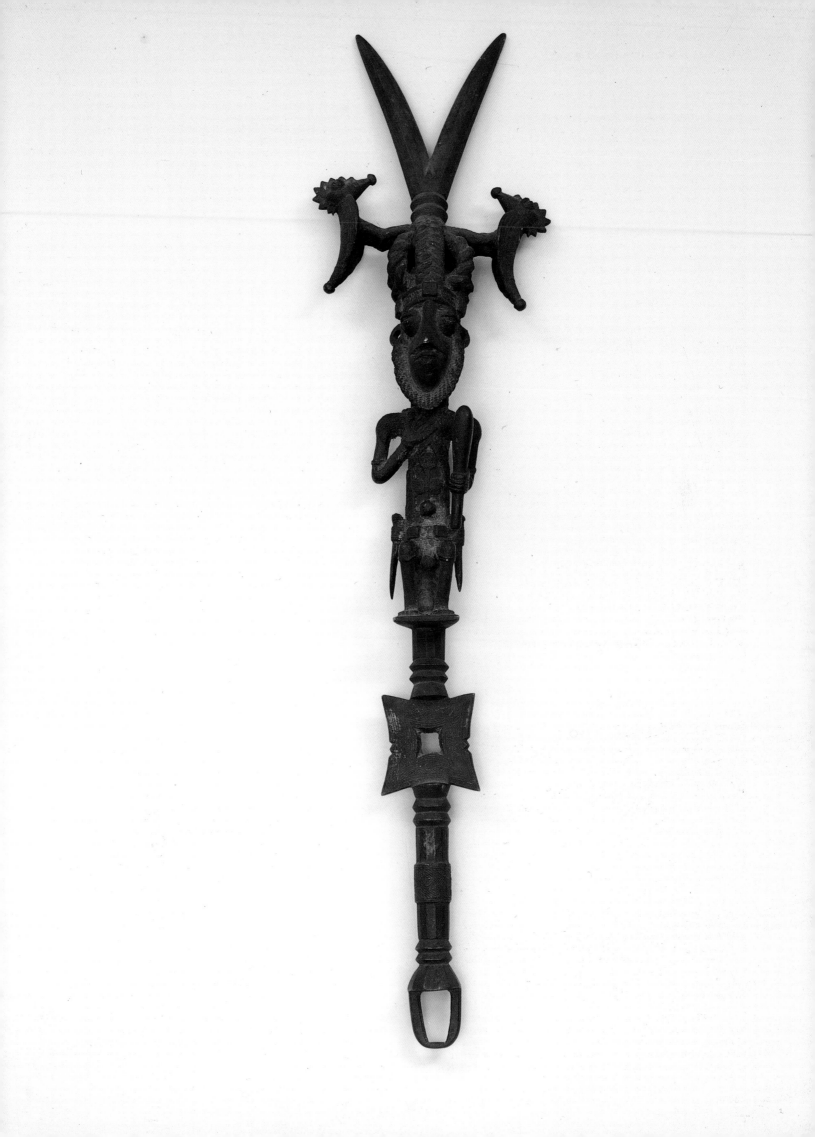

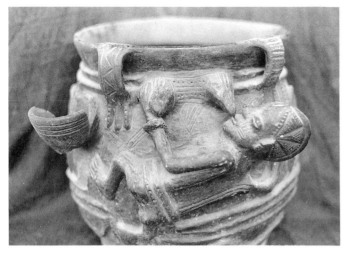

267. A ritual vessel possibly for Yemoja, goddess of the river Ogun. The vessel is transformed into a woman's body whose breasts sustain life in feeding a child. 19th–20th century, Abeokuta. Institute of African Studies, Ibadan University. Photograph by H. J. Drewal.

268. A figurated Eyinle vessel by Abatan showing her treatment of the figure grasping the small kola nut bowl in her hands. Ajilete, Egbado, Nigeria, 1978. Photograph by M. T. Drewal.

269. An Eyinle altar at Ilaro. It shows sculpted figures around the perimeter of the darkened earthen platform and vessels for the stones of Eyinle sitting on white sand. Osanyin's iron staff, covered in white cloth, appears at the back. Ilaro, Nigeria, 1978. Photograph by H. J. Drewal.

of the gods in the world as they temporarily occupy the spiritual *ori inu* of their followers during rituals.

A fine Ota work demonstrates the firm, upright posture and vertical thrust of much Awori figural work (Figure 260). Its style is very close to the unknown nineteenth-century master of the Gelede mask.[21] This would have been an altarpiece honoring an *orisa*. The long-sleeved, V-neck garment is striped, indicating one made of traditional men's woven strip cloth, *aso oke*, given a cut that has a northern Yoruba feel. He holds a whisk in his right hand and wears bracelets and a necklace indicative of rank. His diminutive mount also suggests his importance. Horses were rare in the forested southern regions of Awori. They were used primarily for public processions, not warfare, and were status symbols. In fact, because of his fame and wealth as a carver and trader, the master Olabimtan Odunlami owned two horses.[22] The abbreviated treatment of the horse here seems to reveal the sculptor's unfamiliarity with the subject.

Another Ota masterpiece is a kola nut bowl of a kneeling mother with her child on her back (Figure 261). Her lower lip, left nostril, and earlobes are embellished with plugs, a fashion popular in the nineteenth century. Multiple bracelets encircle her wrists. She wears a necklace of rank, a large stone bead that rests on her firm breasts and is suspended from multiple strands of white beads. Her finely woven wrapper is tied with an elaborate knot at the front. Her self-presentation and gesture epitomize the requisite propriety for the gift-giving act, when a guest is offered kola as a sign of peace and welcome. The style of this work, especially the hooked nose bridge, long, lidded eyes, and wide, flattened nostrils recall two Gelede masks that entered the British Museum in 1887.[23] Perhaps it is the work of Olabimtan's father.

Abeokuta—Refuge for Sculptors in Metal and Wood
With the demise of the Oyo Empire in the early nineteenth century, various peoples gathered together in urban centers for protection, such as the one established about 1830 at Abeokuta, "the town under the rock." It served as a refuge for Egba, Egbado, Owu and other Yoruba peoples, including artists from various locations, notably Ketu and Egbado.[24] The most famous workshops at Abeokuta were founded by members of two Egbado families: Esubiyi and Ojerinde. Esubiyi, who established his workshop in Itoko Quarter, came from Ibara Orile sometime in the 1860s. His son Akiode earned the title of Olori Ona ("Head of the Sculptors") conferred on him by the king, or Alake, of Abeokuta. Ojerinde, nicknamed Adugbologe, arrived in the 1850s and set up shop in the same quarter as Esubiyi.

Ojerinde's family was originally from Aibo in northern Egbadoland. These two workshops have been the principle creators of what might loosely be termed an "Abeokuta style." The style is a synthesis of Egbado and Egba elements, both of which have been strongly affected by the full, rounded naturalism of Ketu (see Figure 245).

Abeokuta was not only a carving center, but a major metal-working center as well. Brass casting seems to have been influenced by Ijebu work, and soon artists were producing works for the Osugbo/Ogboni society. Blacksmiths began to create title staffs for themselves—images to celebrate their divine patron, Ogun. These take a variety of forms, but most are swords with elaborately chased blades and figurated handles, pokers (*iwana Ogun*) and staffs. Title staffs serve as insignia of office or confirmations of messages from blacksmiths and war chiefs.[25]

An unknown nineteenth-century master fashioned a series of title staffs in a distinctive style that may be related to work at Abeokuta, although it contains some traits found in the Obo Ayegunle school as well (Figure 266).[26] A titled follower of Ogun stands majestically. Two daggers at his hips, a whisk over his right shoulder and an openwork headdress complete his attire. An open square on the shaft leads to a phallus at the end—one of Ogun's favorite symbols. It is often included in his *oriki*, such as this one from the town of Ayetoro near Abeokuta:

Ogun Onire...
>*Honor to the one whose penis stood up to father a child in the room
>*He made his penis lengthen to father a child in the house of Ijana
>*We heard how the penis struck those in the market
>*Ogun, the one who saw the king's mother and did not cover his penis[27]

The strength and vigor of forms in this title staff capture the essential *ase* of Ogun and his followers.

A small and refined equestrian (Figure 265) provides quite different visual qualities from those of the sturdy title staff. Its context is uncertain, but it may have been part of an ensemble of figures, perhaps an *agere* Ifa tableau, or related to Osugbo equestrian brasses.[28] However, this one lacks specific Osugbo icons such as the greeting sign or the crescent marks on the forehead. This figure seems related to work by The Master of the Courtly Entourage, a nineteenth-century artist probably from Abeokuta.[29]

Other Western Yoruba Centers and Images
Other carving centers sprang up along the trading routes established by the Oyo Yoruba and others. As more and more people and wealth came into the

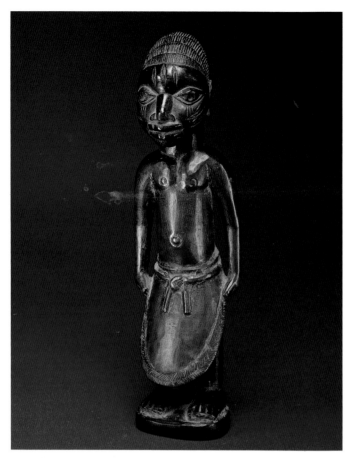

270. Single Male Ibeji Figure, Oke Odan, 20th century. The work of an unknown artist from the Oke Odan area which is distinguished by the long, projecting loin cloth or *bante*. Wood. H. 11 in. Deborah and Jeffrey Hammer, Los Angeles.

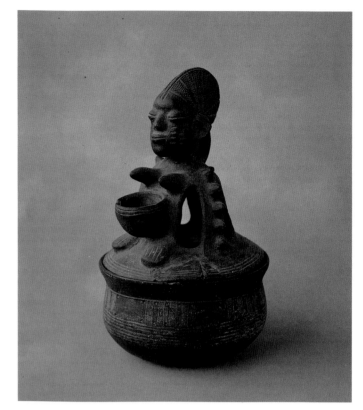

271. Figurated Eyinle Pot, Oke Odan, 19th century. Known as a *woota* Eyinle, "vessel for the stones of Eyinle." The god Eyinle is linked with hunting, rivers and healing leaves. River stones kept in fresh water within the lidded vessel constitute the *ase* and witnessing objects of the divinity. The female figure on the lid refers to the devotee. She cradles a small bowl used to hold a kola nut and two cowrie shells to communicate with Eyinle. This is a 19th century work of "the rival of Abatan" which distinguishes her from another Egbado master potter. Terracotta. H. 18½ in. Arnold and Phyllis Weinstein.

region, sculptors found ample work, especially commissions for twin memorial figures. The full and fleshy forms of figures that characterize much southern Egbado and Awori work are dramatically shown in twin memorial figures (Figures 263, 270). The sculpture in Figure 263, which is by the same hand as one carved before 1877 and now in the Linden Museum, Stuttgart, is said to come from near Ilaro.[30] The reasons for the attribution of Ilaro are unclear, particularly since work documented there and dating to the mid-nineteenth century is quite different.[31] On the basis of style, it may have been carved farther south, perhaps in the vicinity of Ado Odo. Rounded muscles distinguish the upper arms, torso, and legs, and it has detached, clenched hands.

In a very similar style is an old and wonderful doll known as an *omolandgidi* (Figure 264). Such dolls are usually among the first works that a carver's apprentice creates during his training. They provide practice for head and facial features without the challenge of a fully

272. Knife Handle, Oke Odan, 20th century. The small, delicately rendered human figure on the handle of a carving knife by the artist of the *ibeji* shown in Figure 270 proclaims his inventiveness on the very instrument of his creativity. The artist of these two pieces was first identified by Deborah and Jeffrey Hammer. Wood. H. 10 in. Deborah and Jeffrey Hammer, Los Angeles.

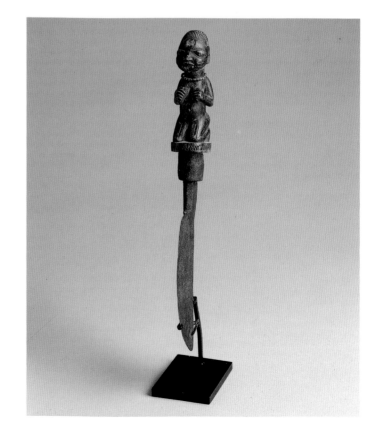

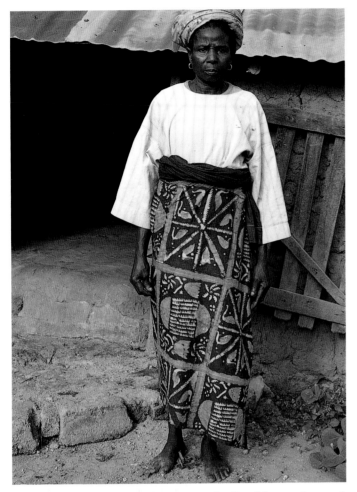

273. The time consumed in the creation of *adire eleko* was shortened by the use of stencils made from the lids of tin boxes in which the British shipped their tea to Nigeria. Traditional patterns were cut out from the tin. Cassava starch was applied with a large paintbrush over the stencil, thereby rapidly applying the pattern to cloth. With two stencils for the alternating patterns (on this cloth: "Ostriches" and "Ducks and Chief's leaves") and a narrow board along which to trace lines separating the patterns, a cloth could be completed in a tenth of the time that a hand-drawn cloth would take. The result, however, conveys a static repetition of images and often lacks the finished quality that is the hallmark of the finest *adire eleko*. Ila-Orangun, Nigeria, 1982. Photograph by J. Pemberton 3rd.

274. Adire Eleko, Abeokuta, 20th century. Yoruba women make two types of *aso adire* ("dyed cloth"): *adire oniko* and *adire eleko*. The former is the well-known tie-dyed cloth. The latter is created by the application of cassava starch with a chicken's feather on a white cotton cloth which, when dry, is dipped in vats of indigo dye. The starch "resists" the dye, creating the beautiful shades of light blue against the dark blue background. Names are given to cloths, as well as to individual patterns on a cloth. The name of this cloth is "Many Beads." Beads are a sign of wealth and status among the Yoruba. The number of intricate patterns make this cloth one of the most time-consuming to create. Cloth. H. 71 in. Jane and John Pemberton Collection.

rendered figure. This one, however, is clearly the work of a master, not a student. A delicately rendered coiffure crowns the head, and a plug, the lower lip. The full and fleshy lips and broad rounded head resemble those of the twin memorial figure from Ado Odo and the two works may in fact be by the same artist.

Omolangidi are used by young girls who decorate, dress, wash, feed, and carry them in imitation of their mothers. They also provide a kind of visual aid in lessons about proper behavior. The saying, "a doll does not cry when it is not breast-fed" is used to criticize someone for showing ingratitude.[32] In other instances, they may replace twin memorial figures or serve other ritual purposes in matters of childbirth.

The artist of another twin memorial comes from the vicinity of Oke Odan (Figure 270).[33] The feature that distinguishes his work is the long *bante* (loincloth) that juts out in front. The broad shape of the head is reminiscent of Gelede masks from this same general area. His sensitive treatment of the human form can also be seen in miniature on the figurated handle of one of his knives (Figure 272). The artist has proclaimed his uniqueness by individualizing and humanizing the tool of his creativity.

Dancewands for the thundergod Sango celebrate the power and presence of the divinity. His followers became an instrument of government and spread their faith along with the Oyo Empire in the seventeenth and eighteenth centuries. Figurated wands depict the followers of Sango, such as the mother holding twins in her arms and balancing Sango's thundercelt on her head (see Figure 166). Twins are often associated with Sango since he himself was a twin. The position of Sango's celt on the worshipper's head alludes to possession trance when the god's spirit enters the person's *ori inu* and the devotee and deity become one. The scarification patterns on the double-bladed celt suggest both the humanity of the god and the sacred bond between persons and their deities.

Ceramics by women are another artistic marvel of the western Yoruba. This is especially evident in figurative

vessels for the *orisa* Eyinle known as *awo ota Eyinle* ("vessel for the stones of Eyinle"; Figure 271).[34] Eyinle is linked with a number of sacred Oyo traditions—Ogun, god of iron; Osanyin, deity of herbal medicines; river divinities such as Osun and Yemoja; and the patron of hunting, Osoosi. At the time of initiation, the new devotee is given two river stones, sand, and water from the river. They are the witnessing objects of Eyinle, possessing the *ase* of the deity and kept within the vessel. Other stones may be added as they are collected during bathing in the river sacred to the deity. The vessel is thus a womb that protects and nurtures the *ase* of the god as it in turn invigorates the worshipper. In a related tradition, a ritual vessel possibly for Yemoja, goddess of the River Ogun, is itself transformed into a woman's body whose breasts sustain life in feeding a child (Figure 267).

The lid hints at the presence of the river stones within. The bosses running up the arching sides of the female figure are references to them. This entire four-sided openwork summit is called an *ade* (crown). The *ade* and deep indigo color of the vessel convey Eyinle's mythic royalty.[35] The conical form of the *ile ori* ("House of the Head") and its allusion to the crowning glory of one's spiritual essence is also at work here. It marks the union of the devotee's head and destiny with that of the divinity.

Such vessels are placed on raised earthen platforms that are elaborately sculpted and embellished with a variety of forms and media (Figure 269). In this altar at Ilaro, a series of kneeling figures form a line of human buttresses at the perimeter of the platform, their heads and torsos shining with rows of embedded cowrie shells. The deep blue-black indigo color of the room, its altar, and earthenware vessels proclaim the riches and royalty of Eyinle. They also allude to his realm at the bottom of the river's dark depths, just as the white sand on the altar's surface evokes the river's banks. At the back and covered in its white cloth garment is the iron staff of the divine herbalist, Osanyin, companion to Eyinle. The entire ensemble constitutes *ojubu* ("face of worship"), the site where devotees and deities encounter each other across the threshold joining *aye* and *orun*.

This vessel in Figure 271 is the work of an unknown nineteenth century master who has been dubbed the "rival of Abatan."[36] Abatan was perhaps this century's master potter among the Egbado. In Abatan's work, the central female figure holds the small bowl with her hands, as can be seen in a vessel by her photographed in Egbado in 1978 (Figure 268).[37] The woman in Figure 268 cradles the bowl between her arms and under her firm and ample breasts. This miniature vessel is meant

to hold a kola nut and two cowrie shells used as offerings or a means of communication with the deity.[38] The marks on the face are those of the owner and devotee, as in other Yoruba sacred arts. Her coiffure is in the *agogo* style, specially braided for festivals, weddings, and other ritual occasions. The braid at the back descends to the nape of the neck and may be a discreet reference to the preparation of the person's spiritual head at the time of initiation. Together the pride of presentation and the elegant enclosure of the emblems of immortality represented by the hard and shiny stones under the cooling water within the womb of the vessel proclaim the hope of a productive life and an eternal afterlife.

Art and Belief

Like the iron of Ogun, the thunder celts of Sango, or the river stones, sand, and water of Eyinle, all otherworldly entities have material manifestations in the world. Such presences are given imaginative form in every one of the Yoruba arts. The sacred arts serve to focus and intensify worship by attracting spiritual forces with their aesthetic power. They are not "idols," that is, the objects of worship. Rather they help to intensify and focus devotions. As the "face" of the divinity, or the *ojubu*, Yoruba sacred art is the point of contact with invisible otherworldly forces. It does not depict the gods, since no one knows what they look like, but rather depicts the worshippers of the gods, usually in acts of devotion. Sometimes there may be an explicit portrayal of devotees in possession trance. In such cases, the image must be understood as showing both humanity and divinity simultaneously (see Figure 166).

As one diviner explained: "If you see the image there, you will know exactly where I face, and you will know to face me and how to contact me directly. That is what the article [object] is for. The spirit is within the article. But to know directly how to face the spirit and where the spirit will stay is the reason for the article . . . and [for] blessing the article with the spirit, [for] calling the spirit together with the article."[39]

The worshipper directs invocations and ritual actions toward this "face" to "alert" the deity. If a person neglects his/her shrine by not beautifying it or providing offerings or prayers, the spiritual entity will leave. As the diviner Ositola remarked, "Deities do *not* come because of the images; images come because of the deities."[40] It is the *idea* of the sacred that is important, not the material object used to attract it.

Whereas the sacred is foremost in the consciousness of the Yoruba, art is tangible proof of a worshipper's devotion. It constitutes a form of *ebo* like any offering, prayer, or rite. Art's presence and visual power, there-

fore, help to make an altar or ritual efficacious. It literal-
ly and figuratively shapes religious thought and practice.

The various images for mothers, hunters, warriors,
fathers, and their gods express historical and cultural
themes central to the development of Yoruba civiliza-
tion. The equestrian figures evoke the impact of war-
fare in the formation of Yoruba kingdoms and empires
from the sixteenth to the nineteenth centuries, while
the maternity image signals one of the many roles of
women. The Yoruba say, "mother is gold, father is
glass," to distinguish the close, extended nurturance by
mothers of their children involving breast-feeding for
two to three years, in contrast to the more distant
relationship children have with fathers who may have
several wives, and therefore many children. The theme
of gender differences runs like a leitmotif through all
Yoruba art and thought. Art portrays the socially con-
structed definitions of men and women in activities and
expressions seen as appropriate within the culture. It
thus distinguishes one from the other, honoring men
as warriors, kings, hunters, blacksmiths, and so on,
and women as mothers, priestesses, traders, queens,
and "witches." Women and men are the pillars, *opo*,
of society, both literally and figuratively as seen in
veranda posts (see Figure 231). They sustain society
and, at the same time, shape and re-create it through
the efficacy of their actions and the power of their
aesthetic visions.

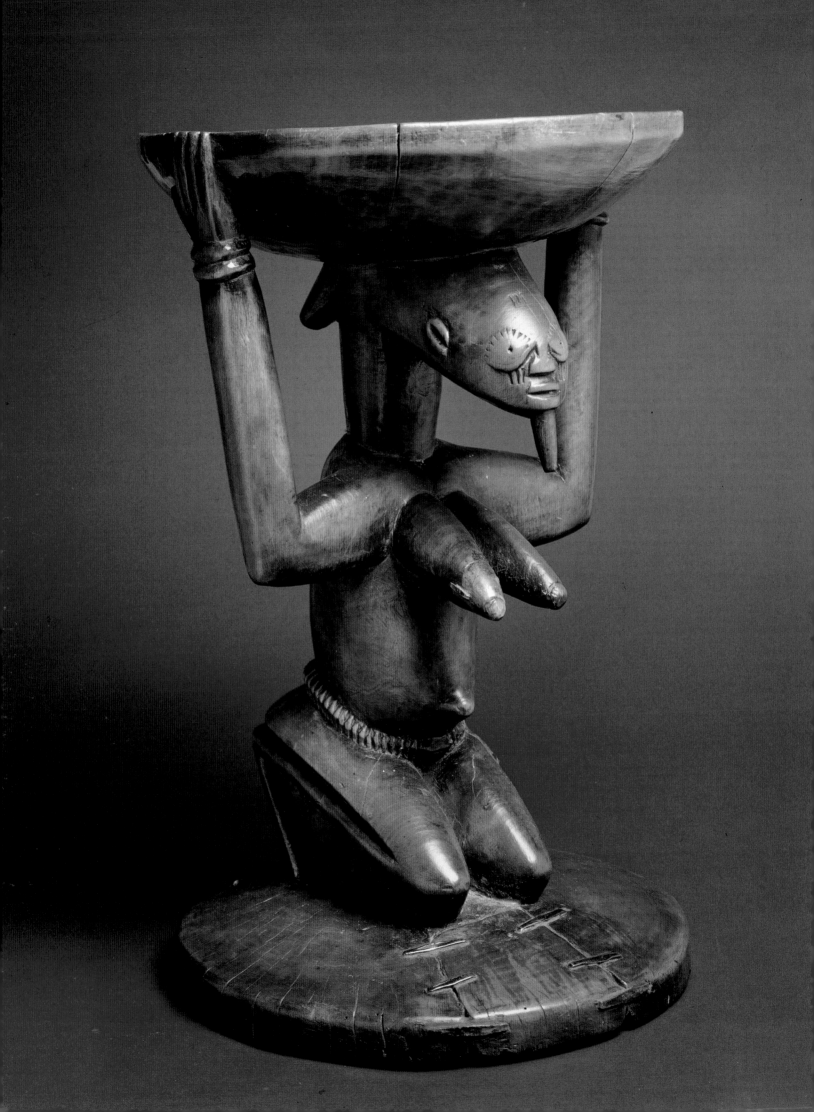

Conclusion: The River that Never Rests

Henry John Drewal
John Pemberton III
Rowland Abiodun

Our study of nine centuries of Yoruba art and thought has been shaped by four considerations. We have sought to trace the history of Yoruba art, revealing its antiquity, its rich diversity in media and style, and its continuity over time, thereby challenging the popular misconception of African art as ahistorical. We have attempted to illustrate the plurality of "centers" that at various times and in diverse ways significantly shaped the course of Yoruba cultural development, thereby calling into question the notion that Yoruba culture is a single, monolithic whole, or one that is understood primarily in terms of a particular center, such as Ife or Oyo. We have been concerned to understand Yoruba aesthetic perceptions and artistic creativity in terms of the linguistic and conceptual categories of the Yoruba, thereby avoiding the uncritical use of Western aesthetic and art historical concepts in our attempt to understand Yoruba art. Finally, we have been concerned to see the artist in Yoruba culture as one who possesses (and is

275. Stool or Shrine Base for a Sango Shrine, Owu, Igbomina, 19th–20th century. The imagination and artistry with which this stool has been conceived and carved mark its creator as one of the few who may be called master carver. John Picton's photographs in the National Museum in Lagos have identified this carver with the little Igbomina town of Owu, not far from Ila-Orangun. The subject of the *arugba* ("bowl carrier") is common among northeast Yoruba carvers (see Figure 169). What marks this as the work of a gifted artist is the superb balance of its composition and the unique treatment of its head and face. Wood, metal. H. 18⅜ in. Gaston T. deHavenon Collection.

granted) an authority and freedom to respond to his or her society with innovative creativity, thereby calling into question the notion that cultural tradition places constraints on the African artist.

The study of historical antiquity and cultural diversity are inseparable. Early in our research we determined that later, in fact, very recent, political history must not be allowed to determine one's understanding of Yoruba cultural history. As Ade Obayemi and other Yoruba scholars have noted, the widespread concern by communities throughout Yorubaland to establish a political heritage linking them to Oduduwa and Ile-Ife is a twentieth century phenomenon.[1] While the Oyo Empire and the Ibadan military/commercial system integrated some Yoruba groups, they never included peoples from the northeast, east, south, or southeast. The British colonial system, especially its policy of indirect rule which enhanced the importance of *obas*, was responsible for bringing more Yoruba-speaking groups together under one state structure than ever before in their history.

Nevertheless, as we have tried to show, Ife has long held a special place in the history of Yoruba art and culture. In the eleventh century it was a cluster of villages in a fertile agricultural bowl whose men laid out patterned potsherd pavements in their compounds and whose women created terracotta ritual objects of extraordinary artistic quality. Chieftaincy titles along with their ritual roles from this early period remain among Ife's people today.[2] With the coming of Oduduwa there was the beginning of the dynastic period from the twelfth to the fifteenth centuries, when terracotta and

bronze sculptures of such exquisite beauty were created that Ife's place in the history of African and world art was assured.

We are now aware that coincident with the political and artistic developments in Ife, the Oba culture in what is now called the Igbomina area was flourishing. A direct tie between the Oba culture and the extraordinary stone carvings found at Esie has yet to be established, although there is increasing archaeological and oral historical evidence to support such a link. The Oba culture may be dated to the eleventh century. There are, however, other possibilities as well. The carvings may be the work of the descendants of Oba following the latter's destruction by the armies of Olowu. There is also evidence suggesting possible contact between Oba/Igbomina towns and the people of Ife to the south and the Nupe to the north.

Other "centers" of culture developed over the next few centuries—Owo in the southeast and Ijebu-Ode in the south. The antiquity and cultural independence of Owo are in no measure diminished by the increasing evidence of the influence of Ife, and to a lesser extent, as we now know, Benin, in its political and artistic life. The Owo terracottas of the fifteenth century provide ample testimony to the artistic genius of women potters which is equal to that of Ife's artists. The sixteenth century Owo carvers of ivory, however, are without peer in other Yoruba communities.

During the same centuries, the Ijebu people were importing considerable quantities of brass and fashioning for the Osugbo elders bronze ritual artifacts that were extraordinary in their craftsmanship and artistry. The political and artistic links of the Ijebu with Benin are well documented. Yet, as with Owo, the cultural and artistic independence of the Ijebu people is now equally apparent, and the influence of Ife political thought and iconography upon Benin and Ijebu artistry is only now beginning to be understood.

In the history of Yoruba art, Oyo as a "center" is relatively late. The Oyo-Ile Empire (c. 1680–1836) established a political hegemony over northern and western Yoruba peoples, but failed to diminish the position of Ile-Ife in the cultural memory of central Yoruba peoples or the political and cultural independence of the Owo and Ijebu peoples. Through the cult of *orisa* Sango and the rituals for the ancestors (*egungun*) Oyo-Ile made an impact upon the religious and artistic life of those who came within her political orbit. With the destruction of Oyo-Ile by the Fulani and the removal of the capital to the south, imperial hegemony was replaced by a century of civil war and the movement of Oyo Yoruba peoples to the east and south. They took with them their rituals and artifacts, in particular the masked fes-

tivals for the ancestors, which were adapted to the lineage and political systems of the peoples with whom they lived.

Over the centuries Yoruba history has been shaped by a number of such cultural and political "centers." Each has had its own distinctive history and possessed (or possesses) its own defining cultural characteristics. In various ways and to varying degrees they have influenced one another through political and commercial ties, military engagement, or the migrations of people. A few "centers," such as the Oba culture, remain only in the material artifacts, artistry, and cultural memory of the Yoruba. The other "centers" which we have studied have struggled to remain vigorously independent in their cultural identity, yet have found themselves increasingly interdependent, as forces of history beyond their control have bound them together. Hence, there has been the continuing search for a unifying center, out of which has emerged the Oduduwa myth as the embodiment of Yoruba cultural identity.

The Yoruba describe their culture as "a river that is never at rest." The metaphor is apt, for it conveys the Yoruba sense of continuous change, of life as caught up within swift-moving currents that can run deep and quietly, or are turbulent and overpowering. It is not an image that implies a sense of fate and helplessness. On the contrary, as we have seen, the Yoruba have a lively sense of the individual's obligation to make life meaningful by drawing upon one's own creative capacities (*ori inu*) and acknowledging, that is, sacrificing (*ebo*) to those powers that pervade the universe of one's experience. Sacrifice is not only identified with the offering of a kola nut or the blood of an animal on the altar of an *orisa*. It is also present in the song sung in praise of a god or an ancestor, in the rhythms sounded on the membranes of a drum, the steps of a dance, the shaping of a sculptural form.

It is the artist who is sensitive to the currents of life and who depicts the essential nature (*iwa*) of the variety of lives lived and the authority (*ase*) by which they are lived. It is through the imaginative creations of the artist that persons see themselves and their world anew and are empowered to respond creatively to the world in which they live.

1/The Yoruba World

1. Throughout this book we use the term *Yoruba* as shorthand for Yoruba-speaking peoples who historically identified themselves by their independent but interactive city-states, such as Ife, Ijebu, Owo, Ekiti, Oyo, and others. Despite significant cultural diversity, Yoruba-speaking peoples assert their common origins at Ile-Ife and share certain fundamental social, political, religious, philosophical, and artistic concepts that justify the now widely used and accepted designation of Yoruba. For discussions of this topic, see Crowther 1852; Johnson 1897/1921; Bascom 1969a; Smith 1969; Eades 1980; Awoniyi 1981.

2 Willett 1971; Calvorcoressi and David 1979; Eluyemi 1980.

3. The African-American religious communities include Lucumi, Candomble, Shango, Santeria, Vodun,Umbanda, and Macumba.

4. See Lapin 1980; Abiodun 1983:21–22.

5. For fuller discussions of the relationships between verbal and visual arts among the Yoruba and the concept of *oju inu*, see Lapin 1980; Abiodun 1983, 1987a; and Drewal and Drewal 1987.

6. M. T. Drewal 1977.

7. For a related discussion of Yoruba oral history, see Peel 1984.

8. The importance of creativity in Yoruba ritual practice has been documented in M. T. Drewal 1989a; see also Pemberton 1989.

9. For critiques of hierarchical structuring in writing about the pantheon of Yoruba gods, see Pemberton 1975; J. R. O. Ojo 1978; Barber 1981.

10. For writing on the terms *Ifa* and *Orunmila* and the divination system in general, see Abimbola 1975a and b, 1976, 1977; Bascom 1969a and b.

11. Mason 1988:16.

12. For the importance of the metaphor of the "journey" in Yoruba thought and in ritual practice, see M. T. Drewal 1989a.

13. Drewal and Drewal 1987.

14. The literature on the concept of *ase* is extensive. See Bascom 1960:408; Prince 1960:66; Verger 1964:15–19; Ayoade 1979:51; Fagg and Pemberton 1982:52ff; Drewal and Drewal 1983a:5-6, 73ff.

15. For a full discussion and other examples of distributed power and the essentially open nature of Yoruba society, which differs from much of the standard literature on Yoruba social organization, see Drewal and Drewal 1978; *idem* 1987.

16. Drewal and Drewal 1987:225–251.

17. For more on segmented/seriate composition in Yoruba art see Drewal and Drewal 1987; H. J. Drewal 1988b; M. T. Drewal 1988b.

18. For a discussion of Ifa art and oral tradition, see Abimbola 1975b; for an analysis of segmented composition and mythic allusions in Ifa arts, see H. J. Drewal 1987.

19. Abiodun 1975a:436.

20. Weickmann Collection, inventory no. 46. While Yoruba were certainly present in Allada in the 17th century, the style and iconography of this divination tray suggest Aja or Fon work rather than Yoruba. Regardless of the exact provenance, it is certain that Ifa was widely practiced in this area as a result of Yoruba cultural influence. The composition and iconography, therefore, can be said to reflect Yoruba cosmological ideas.

21. See Drewal 1987; Vogel has also noted changes in scale and shifting perspective in both Ife ritual pots and Yoruba bronze rings (1983:349).

22. Frobenius (1973:188–189). The importance of cardinal points and Yoruba astronomical concepts requires serious study; they are rooted in Ifa and other Yoruba beliefs and practices. E.g., Ifa shrines and rituals are oriented on an east/west axis; entrances to shrines and groves must face east, the direction from which Orunmila (Ifa) is said to have come; from which light, i.e., knowledge, comes (see Drewal 1987). Beier notes an old crown at Okuku that has two faces, one white, one black (1982:50). When appearing in the morning, the king wears the white face forward and when returning from a rite, the black one.

23. *Oju-opon* would normally refer to the circular central portion covered with camwood powder, on which divination marks are pressed. E.g., *oju-owo* in Yoruba would refer to the depressed central part of a plate that holds stew, while the surrounding border is called *eti* (ears). Thus, the face usually depicted on the surrounding border of *opon ifa* cannot be said to belong strictly to its *oju* but to its *eti* which leaves us with another possible interpretation of the face on the border, namely, that it may be that of Esu (see Abimbola 1975b:437–438).

24. H. J. Drewal 1987:148–149

25. Drewal and Drewal 1983b:4

26 M. T. Drewal 1977.

27. For more on Esu/Elegba, see Verger 1957; Wescott and Morton-Williams 1962; dos Santos and dos Santos 1973; Pemberton 1975; M. T. Drewal 1977.

28. Kolawole Ositola, personal communication, July 1982; J. Mason, personal communication, March 1989.

29. Ositola, personal communication, June 1982.

30. Akinnaso 1983:145. For detailed discussions on Yoruba naming traditions, praise poetry, and related matter, see Bascom 1960:404; Babalola 1966; Ekundayo 1977; Awolalu (1979:chap. 3); Eades 1980; Akinnaso 1981, 1983; Barber 1981.

31. See Akinnaso 1981:51.

32. See M. T. Drewal 1977. For the role and importance of the head in Yoruba art and thought, see Abimbola 1975b and Abiodun 1987a. Elaborately carved tusks emanating from the bronze ancestral heads on Benin royal altars are another manifestation of the same concept—the outward, visible expression of

the inner, spiritual head. For discussions of this, see Ben-Amos and Rubin 1983.

33. Details on the composition of the *iponri* come from dos Santos and dos Santos 1973:51–53.

34. As Abiodun and Drewal have shown, the spinning of the umbrella (*akata ghirigbiri*) like the whirling of Egungun maskers, whose breeze is viewed as one of benediction, and like the spinning disk on the top of the night masker's headdress of the Efe/Gelede complex in Egbado and Lagos, may all be linked with the energy and action of Esu/Elegba, whose dance is likened to the spinning of a shell used as a top by Yoruba children; hence, the phrase "dancing like the *okoto* shell" (*jijo bi okoto*).

35. Other cones and triangles may also be mentioned. In the rituals of the Epa festival, maskers leap on mounds of earth called "a little bit of the world" or "the land of the fathers." It represents the act of stepping-upon-the-earth which one finds in other ritual contexts. In Owo, where this kind of conical mound of earth is known as *esi*, it usually marks the spot where a community, settlement, or market was founded. It is believed that beneath such mounds human and animal sacrifices were buried. According to John Picton, a terracotta crown at Eruku village, Ekiti (Thompson 1971:chap. 9/4) was used in title-taking. For a discussion of mound/anthill images and ideas among the Igbo and Edo, which may be related to those of the Yoruba, see also Henderson and Umunna 1988. Mound/cone concepts, which may ultimately derive from ancient yam-growing traditions in this region, suggest the breadth and importance of this image.

36. See Dobblemann 1976a:47.

37. For a detailed description and analysis of the Ifa rites of in-dividuation, see M. T. Drewal 1989a.

38. For a full discussion of the relationship between Yoruba verbal and visual metaphors, concepts of the head, and proverbs as art, see Abiodun 1987a.

39. *Oba* William Adetona Ayeni, personal communication, July 1974.

40. Fagg 1980:10.

41. Ibid.:10, 12, 15.

42. Ogunba 1964:249–261.

43. Beier 1982:24.

44. *Oba* William Adetona Ayeni, personal communication, July 1977.

45. Beier 1982:24. Some of Beier's informants have said that the face represented Oduduwa.

46. The daughter of the late Arinjale of Ise said that when a crown maker from Efon Alaiye came to the palace to work, he would stay in a room which no one should enter, in which he lived night and day. He would see no one, except when brought food passed through the slightly opened door (personal communication, June 1988).

47. Kolawole Ositola, personal communication, July1982.

48. Beier 1982:24.

49. The *Iya kere* is the second highest ranking woman among the palace officials, *ilari*. She is in charge of the royal regalia and can withhold the crown or other symbols of power if displeased with the king. Johnson 1897/1921:45, 63–64.

40. Thompson 1970; 1971.

51. H. J. Drewal 1977:12.

52. *Oba* William Adetona Ayeni, personal communication, July 1977.

53. For literature on Ogboni/Osugbo, see Morton-Williams 1960; Idowu 1962; Williams 1964; Fadipe 1970; Roache 1971; J. R. O.Ojo 1973; Witte 1988; H. J. Drewal In press.

54. The earliest documented depiction of *edan* may be of an un-figured, linked pair of staffs on Ife terracotta vessels dated c. A.D. 1000–1200.

55. Ositola, personal communication, 1982.

56. See Dobblemann 1976a.

57. Thompson 1968, 1973; Bascom 1969a, 1973; Armstrong 1971; Lawal 1974.

58. Abiodun 1983.

59. Abimbola 1976:393

60. Abiodun 1983:15.

61. Ibid.:21–25.

62. H. J. Drewal 1980:9–10.

2/Ife: Origins of Art and Civilization

1. *Ife ondaiye, ibi oju ti imo wa* (Akinjogbin 1967:41).

2. Variants of the creation myth can be found in Crowther 1852; Johnson 1897/1921; Beier 1956; Verger 1957; Crowder 1962:51; Aderigbigbe 1965:186; Fabunmi 1969; Smith 1969:97; Willett 1970:303–306; Biobaku 1973; Eyo 1974b.

3. The issue of the relationship between Ife and Nok (c. 500 B.C.–A.D.200) cannot be explored here. The perceived similarities in technique, style, and iconography, however, remain unconvincing as evidence for direct historical and artistic links. Only such arbitrary configuration as a "snake-winged bat" or "self-dompting fish-legged figure" will demonstrate direct connections. Despite further evidence presented in a recent article (Willett 1984), there remains the question of what constitutes "Nok," as well as what happened in the time, space, and style gaps between Nok and Ife. It is more useful at present to consider them as separate traditions (see also Bitiyong 1981).

4. Many of these myths mention movement from the "east," westward to the Ife area. Such suggestions may have been shaped by relatively recent cultural, political, and religious factors and not by any consideration of date, however meager. E.g., many writers have mistakenly linked Yoruba history with that of Islam in the Lamurudu myth and migrations from Mecca. Others have sought without evidence to associate the Yoruba with Egyptian or Meroitic civilizations. A more recent hypothesis may warrant serious investigation. Bascom (1969a) has suggested that the Yoruba may have originally come from the west and moved eastward, perhaps along or south of the Niger River valley and then into the forested savanna and rain forest areas where they

have lived since at least the first millennium B.C. Linguistic data may support such a theory. The Kwa branch of West African languages which evolved over a long period of time (Armstrong 1971), includes Akan, Aja, Ga, Ewe, Fon, Gun, and Yoruba. All are to the west of present-day Yorubaland. Edo, Ijo, Nupe, and Igbirra are north and south. Idoma, Igala, and Igbo are to the east. There appear to be more Kwa languages west of Yorubaland than east of it. In addition, several ancient groups of Yoruba-speakers, such as the Ana in central Togo, and others in Ghana and Benin (RPB), are far west of Ife. This issue demands serious study to help clarify many other issues.

5. The divisions between original divinities and usurpers is very widespread in Yoruba traditions. For information on Okuku and Edi at Ife, see Beier 1982:106–107; on the Obatala/Oduduwa conflict, see Beier 1956; Idowu 1962:23; Fabunmi 1969; Awolalu 1979:27.

6. Beier 1956; H. J. Drewal inpress. For a thorough analysis of gender issues in Yoruba ritual practice and art, see M. T. Drewal 1989a.

7. Shaw and Daniels 1984.

8. Shaw 1978:49.

9. This is according to evidence at Woye Asiri, Ife (Garlake 1977).

10. Ozanne 1969.

11. Willett 1971a. The pre-florescence period of Ife is still little known. For some time, archaeologists doubted that Stone Age humans could have penetrated and survived in the rain forest areas before the advent of iron or other metal tools (see Livingston 1958:551; Gray 1962). Widespread occurrence of ground stone axes in southern Nigeria and extensive excavations at Iwo Eleru near Akure, southeast of Ile-Ife (Shaw and Daniels 1984), suggest otherwise. We believe that yam cultivation in southern Nigeria goes back 4,000–5,000 years, and many yam rituals today have prohibitions against the use of iron tools which suggests pre-Iron Age origins (Shaw 1978:65). The yam economy may be another factor contributing to the cone icon— the yam heap as cosmic cone. The development of agriculture, availability of water, and abundance of game/protein including the large snails that have long been prolific in southern Nigerian forests may have been responsible for high population densities, the emergence of larger social and political systems and elaborated trading networks that fostered the elaborate artistic tradition considered here.

12. Abraham 1958:378.

13. The first millennium A.D. is still largely unknown to archaeologists, who are just beginning to explore this crucial era. Only systematic archaeological research can answer our questions. The difficulties attending the reconstruction of Ife art history are compounded by the fact that the city was abandoned repeatedly in the 18th and at least twice in the 19th century due to wars. There seem to have been earlier disruptions as well, for there is a definite gap in art production from about the 16th to the 17th or 18th centuries. We are also hampered by the longstanding tradition of burying, then unearthing and reburying venerated objects over the centuries, making historical reconstruction very problematic because few primary sites have been found.

14. Bernard Fagg cited in Allison 1968:14.

15. Willett 1967:80. Recently another large lump of fused iron was discovered about 27½ miles north of Ife at a forest grove between Igbetti and Old Oyo (Shaw 1978:141).

16. These include a snake or fish with iron eyes and nostrils at the Ore Grove; relief stone carvings at Agidi about 9 miles south of Ife, showing swords, arrows or swords, hands with swords, a decapitated and bound human figure, and a rectangular stone box like the one in the Ore Grove—all evocative of propitiatory rituals and the involvement of iron.

17. Allison 1968:17.

18. This alignment is identical to a series of shrines to the gods along an ancient road in western Yorubaland between Ilaro and Ijado. These shrines were filled with sacred objects and ritual pots and appear to indicate a traditional placement pattern that can reveal important archaeological sites in the future. Other early works include a conical head at Efon to the northeast and stones northwest at Erumu. Willett 1967:79–82; Allison 1968:pl. 1, 2, 4, 10, 11.

19. Willett interprets this figure as female, but the five-tiered headdress seems to appear on both women and men.

20. Recently, Willett (1984:fig. 70) illustrated a crowned figure seated on the stool, holding a head in his hands. It appears to be a late stone work, perhaps the 18th or 19th century.

21. This is based on field discussions with an herbalist/diviner who showed me a sanctified stool used by his barren wife to help her conceive.

22. Fagg 1960. At Benin during the coronation and rites of kingship, a messenger comes with certain gifts from Ife that confirm the new ruler. Those items are carried in a cylindrical container (*ekpokin*) from which the throne of the Benin monarch may be adapted along with supports for the king's arms—tall, thinner cylinders sometimes covered in brass (see Ben-Amos 1980:84–51; Nevadomsky 1983:fig. 4).

23. See Bascom 1969b:82–83, pl. 21a.

24. R. Abiodun, personal communication, 1986.

25. Eyo and Willett 1980:pl. 55. The stool companion is a four-legged rectangular granite-gneiss stool with a slightly concave top. As with the looped elephant trunk handle of the larger stool, this one's overall organic shape suggests the body of an animal. Another stool has double loops that appear to be human legs or hands (Willett 1967:fig. 15). Other renderings of these objects show them to have been made of other materials as well. The terracotta version represents a stool probably made of wood and decorated with bronze bands into which were set glass bosses, remnants of which were found in the Iwinrin Grove (Willett 1967:82).

26. Ritual procedures of elevation are widespread. At particular moments, participants' feet must be off the ground either by wearing special footwear, like the beaded boots/sandals of kings, or by standing on specially prepared mats. Altars, "seats" of the

gods, are also elevated. The elevation of feet may explain the ring on the second toe of the left foot shown in some Ife terracotta fragments (Willett 1967:figs. 52, 54), and oral traditions that speak of the big toe as an *orisa*.

27. Willett mentions them being found to the west in Ketu and the Kabrai area of Togo, south at Ikeja near Lagos and Benin (1967:104). A systematic survey and analysis of these pavements could trace the extent and quality of Ife/Yoruba influence.

28. A fragmented Ife vessel actually depicts a "face of worship." Arrayed around its rim are eyes, ears, and mouth. It was collected by Frobenius and is presently in Berlin.

29. Garlake 1974, 1977. For the importance of the cardinal directions in Ifa art and ritual, see H. J. Drewal 1987.

30. Ozanne 1969:29.

31. Ozanne 1969:36–37; Willett 1970:320–321.

32. In the early 16th century, Pacheco (quoted in Hodgkin 1960:92) described the Ijebu capital as "a large town called Geebuu, surrounded by a very large ditch." See below, chapter 5.

33. See Ozanne 1969:35.

34. Ibid.

35. At Oyo-Ile, extensive walls and gates seem to date to the same period as those at Ife, or earlier. Agbaje-Williams and Onyango-Abuje (1981) obtained four dates, two c. A.D. 800, and two c. 11th–12th centuries. The inner wall without ditch probably enclosed the palace. The city wall with ditch enclosed an oval space approximately 1 mile from north to south, and less than 1 mile from east to west.

36. For discussions of the nature of Yoruba armament and warfare, see Smith 1967.

37. Personal communications from various kings, priests, and elders in Yorubaland, 1975, 1977–78, 1982.

38. Excavations at Woye Asiri found glass pottery crucibles in association with pavements dated to the 13th century which confirms an Ife glassworking industry during the era. See also Garlake 1977.

39. For discussions of Segi and *akori* beads, see Fage 1962; Davison *et al.* 1971.

40. See Thompson 1973; Eyo and Willett 1980:120–126; Bassani and Fagg 1988.

41. Willett 1967:fig. 16.

42. Eyo 1974b. The Lafogido site, dated to the 12th century A.D., has been interpreted as either a shrine or grave. All the site features at Lafogido are ancient sacred space concepts of the Yoruba in which the ram became an important emblem of power, prestige, and alertness (see below, chapter 4).

43. For an excellent report of excavations at Obalara, see Garlake 1974.

44. Garlake 1977. However, one cluster of realistic terracotta fragments was arranged after they had broken—an indication that they may have been modeled before the 13th century.

45. Garlake 1974:fig. 6. Another vessel with many of the same relief images was found at Koiwo Layout (see Vogel 1983:fig. 36). On this one, skulls are shown at the base of the posts of a

covered altar and the base of a ritual staff. Several elders in 1977–78 indicated that human sacrifices were performed and the heads placed at the foundations of certain sacred structures such as town gates, shrines, and palaces.

46. Willett 1967:40.

47. Garlake 1974:fig. 6.

48. Garlake 1974:pl. 51.

49. Willett 1967:pls. 13, 14.

50. Eluyemi 1976. The rosettes are similar to those on some of the Ife metal and terracotta heads, like one found at Akarabata, Ife (Willett 1967:fig. 15).

51. In a detailed analysis of pottery at Woye Asiri and dated to somewhat earlier than Obalara, Garlake concluded that there was a clear continuity between 13th and 19th–20th century Yoruba pottery in shape, rim/lip forms, decorations, and functions (1977:89).

52. Frank Willett states, "I have two new thermoluminescent dates that I have not published which suggest that the [metal] heads from the Wunmonije Compound are contemporary with the radiocarbon dates from Ita Yemoo" (personal communication, Feb. 4, 1988).

53. Willett 1966; 1967; Eyo and Willett 1980. For a discussion of *ako* figures in the context of other funeral effigies in southwestern Nigeria, see Poynor 1987. According to Nevadomsky, *ako* figures do appear at second burials for kings, the war captain, and his chief priest, while smaller chalk ones may be made for the parents of the king's wives (1984a:46).

54. Abiodun 1976.

55. the Ijebu data come from my own work there in 1982–86, and R. Abiodun provided confirmation for Ife and Owo (personal communication, April 8, 1989).

56. This information comes from elders in Egbado collected in 1977–78, and Ijebu in 1982 and 1986. Willett was told the same at Ilesa (1967:131).

57. For a discussion of this mask, see Blier 1985.

58. Beier 1982:91–112.

59. Goats and other large offerings such as cows are contemporary substitutions for the human sacrifices of the past.

60. Further support for this theory comes from the installation rites of kings at Benin. Nevadomsky states that in the early morning, the prince or Edaiken kneels on a pile of cowries to receive his crown: "In front of the Edaiken a terracotta head, from which a bronze one would later be cast, held his crown of coral beads" (1984b:52). After one of the king-makers called his new name for a fourth time the Edaikin responded, and the Oliha, head of the king-makers, put the crown on his head and proclaimed him king.

61. Fagg and Willett 1962.

62. Eluyemi 1977.

63. Brincard 1980:123.

64. Johnson 1897/1921; Willett 1984.

65. Scarification on Ife heads may represent a permanent transformation of a person into an *oba*. It is a kind of masking that uses

flesh as its medium. Later, this may have become a temporary transformation using the extract from the blister beetle (*Cantharidae*) to raise welts or keloids on face, like those on the Berlin head. For a description of this process as told by the Oni of Ife, see Willett 1967:fig. 23. Finally, these marks were replaced entirely by beaded veils. Alternatively, the striations may represent facial paint, as is done in initiation ceremonies of the gods and Ifa rites of individuation (see M. T. Drewal 1989a), which have remarkable parallels with those for kings.

66. Willett 1967.

67. See Vogel 1983.

68. Paula Ben-Amos has suggested that some of the bronze heads at Benin probably depict sacrificial victims, not royals (1980). The same is probably true for Ife, and quite certain in the terracotta corpus.

69. Willett 1967:pl. 45.

70. See Ben-Amos and Rubin 1983:73–74.

71. See Willett 1967:fig. 89.

72. Egharevba 1968; Ben-Amos 1980; Nevadomsky 1984a, 1984b.

73. Shaw mentions that Tunde Lawal suggested the Nupe confiscated the bronzes from the Yoruba (1973). I believe this is likely.

74. It is probably the work of the sculptor who created an image in honor of Esu/Elegba (Allison 1968:pl. 12).

75. Smith 1969:42.

76. A group of stone stools at Kuta, near Iwo, serve as a "ritually sanctioned boundary marker" (Fagg 1960:114). Philip Ravenhill informed me of A. Adande's report on stone sculpture found in the area north of the ancient Yoruba city-state of Save in central Benin (RPB) and of a report published in *Bulletin de l'Equipe de Recherche Archeologique Beninoise,* No. 1, Departement d'- Histoire et Archeologie, Benin. An important sculpting tradition needing systematic investigation is suggested (Ravenhill, personal communication, April 1, 1989).

77. The fortifications and dates at Oyo (11th–12th centuries and possibly earlier) lend strong support to this theory (see also Obayemi 1976:260 and G. J. A. Ojo 1966a:121–22). As Phillipson remarks, while 11th century Ife may be heir to an ancient terracotta tradition, the flowering of its casting tradition must have depended on long-distance trading ties (1985:193). The growing evidence of major trading, state-formation, and art at the inland delta of the Niger at Jene-Jeno by A.D. 1000 (McIntosh 1989:79), and of a major urban center at Old Oyo about the same time, suggest one possible trade route. Andah points to the need to develop Afrocentric rather than Eurocentric concepts of urbanization and state formation if we are to comprehend the meaning of archeological evidence (1982:68). This is particularly true of debates about the antiquity of urbanism among the Yoruba. For the literature on this topic, see M. T. Drewal 1989a.

78. See this discussion in Shaw 1978:160.

79. Garlake 1977.

80. Sacrifice is an essential part of *orisa* religious belief and practice. Humans were the ultimate sacrifice and they came from special categories of persons—war captives, criminals already sentenced to death, strangers/foreigners, and "extra-ordinaries" (hunchbacks, cripples, albinos, dwarfs or those with visibly dramatic ailments such as goiter or elephantiasis). Such distinctive physical traits were interpreted as the handiwork of the gods and in accordance with Yoruba practice, they were persons chosen in *orun* to serve the gods in *aye*.

81. Willett 1967:77.

82. Garlake 1974:131.

3/The Stone Images of Esie

1. Frobenius 1968:I, 318; for photographs of the three Esie heads, see ibid.:pl. 9, facing p. 322.

2. Milburn 1936; Daniel 1937; Clarke 1938a.

3. Opeoluwa Onabajo recently reported that at an archaeological site at Owoto Grove in Esie a trench dug for stratigraphic study disclosed "two metal objects, one [of]...triangular shape which probably could [have] been used in carving stone sculptures" (1989:5).

4. Clarke 1938b:106.

5. Stevens 1978:62.

6. R. J. Barber 1985:90.

7. O. Onabajo, personal communication, June 1988. H. M. Hambolu (1989) notes that the Oyo inhabitants of Esie left Oyo-Ile c. A.D. 1600 and settled at Oko-Odo, about 3 miles from the present Esie. In 1775 they left Oko-Odo and resettled at Esie. A stone sculpture of the type found in Esie has also been recovered at Oko-Odo. Whether it was carved in Oko-Odo or removed from Esie to Oko-Odo at some time has not yet been determined.

8. S. J. Fleming commenting on the report of Thurson Shaw, in Stevens 1978:83.

9. With reference to the block of soapstone, Onabajo reports that a sample from the block was examined geologically, compared with the stone used in the sculptures, and "found to be of the same mineralogical content of Talc, Migmatite, Chromite, Tremolite and Anthrophylite" (1989:7). Reports by S. O. Olabanji, V. O. Olarewaju, and O. Onabajo based on a Pixe Analysis (Particle Induced X-ray Emission) of the soapstone sculptures and stones from local quarries within a five-kilometer radius of Esie indicate a clear correspondence between the steatite used in the carvings and that found in the area (Onabajo, personal communication, April 1989). H. M. Hambolu (1989) reports that at the Oka-Odo site near Esie there is "evidence of hewing of soapstone boulders" and suggests that it may have been a source of raw materials for the carvers.

10. Stevens 1978:82.

11. See ibid.:3–7.

12. Ibid.:22–29.

13. Ibid.:24. The term *egungun* means masquerade or "powers concealed" and is used most often to refer to the masquerade created for the festival for the ancestors, known as *egungun paaka* in Igbomina towns.

14. In 1988, when I visited Esie and the shrine, which is now part

of a National Museum complex of buildings, the cult of Oba Ere had been without a priest for three years and no one had been found willing to take on the responsibilities. Nonetheless, the annual rites had been performed in a token fashion by a few elderly women. Although few persons participate in the rituals at the shrine during the Festival of the Images, the festival has become a civic occasion, providing the context for an annual "homecoming" celebration.

15. E.g., in Ikere Ekiti the Ogoga is the king of the town, while the Olukere, Owner of Ikere, is responsible for performing sacrificial rituals at the Olosunta Rock during the annual Olosunta Festival. Since the Ogoga may not attend the rite, the Olukere goes to the palace to inform the Ogoga that the rite has been performed. It is the only occasion during the year when the Ogoga and the Olukere meet. According to local historians, the Ogoga came from Benin and the Olukere came from Ile-Ife (Chief Sao of Ikere; personal communication, June 1988). According to John Picton, who visited Ikere in the 1960s, the Olukere, a descendant of the original settler who was well known for his knowledge of herbal medicines, has powers that are "priestly," while the power of the Ogoga is that of an Oba (personal communication, June 1988).

16. Stevens 1978:82.

17. Ibid.:79–84.

18. Adepegba 1988:72–72.

19. L. O. Fakeye, personal communication, March 1988. As a youth in the 1930s, Fakeye lived in a small village three miles from Esie and recalls joining other boys in tossing the stone heads to one another. He remembers being told that the figures were humans who had been turned into stone "during the war," but the time or nature of the war was not specified.

20. Obayemi 1974:14.

21. Obayemi n.d.

22. Ibid.:3.

23. Obayemi 1974; Afolayan 1989:3–4.

24. Afolayan 1989:8.

25. Ibid.

4/The Kingdom of Owo

1. I am grateful to Oladipo Olugbadehan, a scholar of Owo history, for sharing his profound knowledge of Owo precolonial history and culture.

2. Awe 1977.

3. Poynor 1976, 1978.

4. Fagg 1951; Eyo 1972, 1974a, 1976.

5. Olugbadehan 1986.

6. G. J. A. Ojo 1966b:23.

7. Ashara 1973.

8. Abimbola 1975a:51–72.

9. Ibid.:56–57.

10. Ibid.:56–57.

11. *Obi Iaba ti mo bimo tan ni won nfowo omoo mi womi/Oun ni won fyoye Olowo lutu Ife.* Akinnaso comments extensively on the cultural and linguistic bases of names. He states: "Besides its more obvious function which is the differentiation of individuals, personal naming in Yoruba is another way of talking about what one experiences, values, thinks, knows in the real world. Consequently, the construction of Yoruba personal names is based on systematic cultural principles and the coding of information into them [which] is based on lexical, syntactic, semantic and pragmatic rules of language" (1983:140).

12. Fagunmi 1972:65. *Mo deni owe loni, e j'olowo o lo o/Iku ni mbe lona, ko ya fun mi/Arun ni mbe lona, ko ya fun mi/Ohun buburu gbogbo timbe lona, eya fun mi/Opa kan soso mi tu igba eiye/Eya fun mi.* This account is perhaps more accurate than those of certain other field informants because it was collected in Oyo State which in this context may be considered neutral ground.

13. Willett 1967:pl. 3.

14. Egharevba 1968. The author, Chief Jacob Eghareva, is the Benin court historian; the claim has been repeated by his Owo counterpart, Chief M. B. Ashara.

15. Poynor 1976:40.

16. Ibid.:40.

17. This practice is not peculiar to the Olowo alone. It is believed that most Yoruba kings live long because other people are made to bear any illness, disease, or catastrophe that might befall the king. In a way, this is not too different from what palace chiefs do when the king sneezes or coughs. They beat their chests and act as if they are the ones affected and not the king.

18. Buckley 1985:246.

19. Ojomo of Ijebu-Owo, personal communication, 1975.

20. Paula Ben-Amos in Poynor 1976:12.

21. A slightly different version of this account in Ashara's unpublished manuscript, "History of Owo," states that Oronsen stopped to dine at Ugbo' Laja where she forgot her headgear and hunters found it.

22. Eyo and Willett 1980:14.

23. A historical study of artists' families and compounds in Owo would reveal where they come from and how they acquired their craft. As pottery is traditionally a female occupation, there is reason to believe that Owo terracotta sculptures were made by women.

24. See Eyo and Willett 1980:14, pl. 60, 65.

25. The study of second-burial effigies was pioneered by William Fagg (1951). We are indebted to him for first drawing scholarly attention to this important artistic phenomenon in Owo. Justine Cordwell (1953), and Frank Willett (1966) have also called attention to the *ako* in Owo and its importance in the stylistic interpretation of the life-size bronze heads from Ife. I published a reconsideration of the Willett's study (1976) which strongly questions many of his conclusions. Further information has since been given by Robin Poynor (1976, 1978, 1987, 1988).

26. *Ekiti-iwa ti i segbon ori* (Idowu 1962:189).

27. Abimbola 1968:76. A translation with author's assistance.

28. Abiodun 1976:9.

29. See Bassani and Fagg 1988.

30. Fagg and Pemberton 1982:46, 47.

31. *Ajanaku kuro ninu, mo ri nkan firi, bi a ba ri erin ki a ri erin* (Ajibola 1971:4, 45).

32. *Oniruro obe laari nijo ku erin, awon omo agbe, Won a yo obe silo* (Lamidi Fakeye, personal communication, 1989).

33. *Gbolajokoo, omo okinkin tii merin nfon* (Abimbola 1975a:64).

34. At the turn of the century Ore ceased to be celebrated and Igogo became the primary festival in Owo. The worship of Oronsen and her role in helping Owo to meet threats of Benin invasion may have brought about the emphasis of Igogo. Its predominance could have been caused by the lack of threats of war from Ife or Western Yorubaland which allowed for the emphasis of Ore. There is not enough information to reconstruct the Ore festival, but my informants, Olalumade Agbe and Oladipo Olugbade, recall that it was long and elaborate and the Olowo appeared in his most impressive regalia and with emblems of authority, especially those derived from Ife.

35. Douglas Fraser in Vogel 1981:128.

36. *Oni owo odo*. For a similar significance of the crocodile in ritual context, see Buckley 1985:245, 246.

37. *A kii de' le iku ki a fe ori ku, bi a ko ba ri tutu a o ri gbibe* (Ajibola 1971:5, 47).

38. Bassani and Fagg 1988:176.

39. This was probably how Maurice Cockin received a ceremonial ivory sword *udamalore* from the Olowo of Owo, most likely from *oba* Ogunoye I who reigned from 1902 to 1913 (Fagg and Pemberton 1982:49).

40. For a picture of the complete *orufanran* costume with the hat and the ceremonial dance sword (*ape*), see Vogel 1981:fig. 25.

41. Poynor 1984:18.

42. The following proverb supports such an idea: *"A kii gba akaki lowo akiti, a kii gba ile baba eni lowo eni,"* ("You cannot cure a monkey of squatting, so you cannot take a man's ancestral house from him"; Ajibola 1971:5, 48).

43. Buckley 1985:245, 246.

44. An *udamalore* in the British Museum, which was acquired in 1878 by Sir Augustus Wollaston Franks (Fagg and Pemberton 1982:49) may have served as a model for others. It is difficult to share Poyner's belief that the *udamalore* is part of the *orufanran* costume (Poyner in Vogel 1981:133, 134). There is no visual or oral evidence to support this contention. As a native of Owo as well as a researcher in the field, I have not yet encountered anyone wearing the *udamalore* on the *orufanran* dress.

45. Ojono of Ijebu-Owo, personal communication, 1974.

46. In Vogel 1981:133, Poynor gives the correct name for the ivory sword called *udamalore*, which is a shortened form of *uda-omalore* (literally, "sword of the wellborn"). We may therefore assume that the chiefly figure represented in the ivory piece (pl. 76) is holding an *uda* and not an *ada*, a ceremonial sword held by a page called *omada* (the child who carries *ada*). This *ada* carrier accompanies the Olowo or a very high-ranking chief like Ojomo in Owo. For an example of *ada*, see Eyo and Willett 1980:fig. 10. *Uda* in the Owo dialect is the same as *ida* in Oyo Yoruba.

47. Abimbola 1975a:64.

48. For a more detailed discussion on *ori*, see Abiodun 1975a, 1981, 1987a; Lawal 1985.

49. For more on women's traditional roles in art and religion, see Abiodun 1982.

50. David Adeniji, Research Associate, Institute of African Studies, University of Ibadan, personal communication, 1974.

51. Fagg and Pemberton 1982:pls. 6, 15, 24, 51.

52. Abimbola 1968:26.

53. Ibid.:72.

54. Willett and Picton 1967.

55. Agbe, Olalumade of Ogwa Agbe, Owe, personal communication, 1972.

56. Poynor 1984:17.

57. Olugbadenhan 1986.

5/Art and Ethos of the Ijebu

1. *Esmeraldo de Situ Orbis*, quoted in Hodgkin 1960:92.

2. See Lloyd 1959.

3. For some of these accounts, see Smith 1969:77 and Oduta 1978.

4. Ogunkoya 1956:49.

5. Johnson 1897/1921:20.

6. Lloyd 1961.

7. Egharevba 1960:24; Dapper 1686:311; Smith 1969:79–80.

8. Bovell-Jones 1943:74.

9. Only 20 percent are farmers while the remainder are craftspersons, traders, administrators and professionals, laborers, and retired persons (Lloyd 1962:36–38, 59).

10. Bradbury 1973:149.

11. Lloyd 1962:53–54.

12. Rowland Abiodun, personal communication, 1989.

13. Lloyd 1962:141; Smith 1969:79–80.

14. Interview with the Olisa at Ijebu-Ode, 1986, and also the "M-Inutes, Ijebu Traditional Council, 10/24/77." For Benin, see Nevadomsky 1984b. The many titles associated with kings in Ijebu resemble the system at Benin to a certain extent (Lloyd 1962:148; Bradbury 1973:10). Senior palace servants (*odi*) lead about twenty different groups distinguished by their roles, e.g., drummers and trumpeters. They also participate in such rites as the selection, installation, and funeral of rulers. The *ifore* society, open to all free-born Ijebu, consists of those who request membership from the king through his palace attendants and pay the necessary fees. The Ogbeni Oja, a senior and powerful title at Ijebu-Ode, is selected alternatively from the *odi* and the *ifore*. He acts as regent during interregna with advice from the town chiefs. Two other hereditary chieftaincies reinforce the system of distributed authority at Ijebu-Ode: the Olisa and the Egbo. The Olisa is regarded as the *oba* of Ijebu-Ode, while the Awujale is

regarded as ruler of the kingdom. This parallels the Ile-Ife tradition of the Orunta who is regarded as the "king of the town" (*oni ode*) and the Oni who is seen as the "king of the house" (*oni ile*) (Bascom 1969a:33). The Egbo is a chief said to have come from the vicinity of Benin with the tenth Awujale (Lloyd 1962:148). Together these chiefs—the senior *ipampa*, *ifore*, and the Ogbeni Oja—formed the group called *ilamuren*, all of whom were members of Osugbo.

15. Nevadomsky 1984b.

16. Ben-Amos 1980:18–29.

17. Williams 1974:253.

18. William Fagg suggested Owo (Fagg cited in Fraser 1975), and J. R. O. Ojo suggested Benin (1975).

19. See Tunis 1981.

20. Williams 1974:255, fig. 195; J. R. O. Ojo 1975.

21. For one from the Kunsthistoriches Museum, Vienna, see Bassani and Fagg 1988:261/2.

22. There are several legends suggesting that Portuguese lived in a particular quarter at Ijebu-Ode.

23. LaPin 1980.

24. My thanks to Roslyn Hackett for this reference.

25. See H. J. Drewal 1986.

26. See Drewal and Drewal 1983b:204–209.

27. Williams 1974:253.

28. See Abraham 1958:154 and 721, ill. 11c.

29. Losi 1914:25.

30. Dark 1973:102.

31. Willett traces the evolution of this motif from Ife to other areas of Southern Nigeria (1988:122).

32. *Adan dorikodo, o nwo ise eye* (Abraham 1958:15, 345).

33. Foluso Longe, personal communication, 1986.

34. Rowland Abiodun, personal communication, 1986.

35. Bats are also related to owls (*owiwi*). Silent and fast, dropping on its prey without being seen or heard, whose call is a harsh shriek, the owl is considered a witch-bird (Abraham 1958:495). It is significant that in the Berlin fragment of a janus man and owl (see fig. 68), the owl has in its beak the same looped ribbon as the bat on the stool.

36. Nevadomsky 1984a:47.

37. See Dark 1973:pls. 20, 51, 53.

38. Douglas Fraser (1975) in a well-argued piece credits Owo as the source of the Gara group of Tsoede bronzes, some of them with motifs that occur on this stool. When Fraser raised the central question of finding "an art that has Benin-like iconography without being specifically Benin in style," his answer was Owo, yet it could have also been Ijebu. The "bird"/bat motif is crucial, occurring on at least two bronze bracelets that are almost certainly Ijebu in origin. It is self-dompting which as Fraser points out is found in Yoruba, not Benin art (see Willett 1988:fig. 7). He also noted that the bat ("snake-winged bird") juxtaposed with the fish-legged figure in many instances indicated "some sort of cosmic counterpart symbolism" (Fraser 1975:35)—a land/water, sky/earth duality. In light of the bat identification by

Willett, I would suggest the themes are land/water and night/day, and Ijebu seems probable as the source of the stool. Peter Garlake's work has demonstrated close and early Ife-Benin artistic links and/or closer Ife-Owo artistic ties than those between Owo and Benin which come later. Ijebu also has many of these same motifs, and more importantly, an early and extensive bronze-working tradition, unlike Owo. It is therefore very plausible that, just as Benin got much of its ivory from Owo, it also got bronze work from Ijebu. Ijebu may be the likely source of many of the works termed "Lower Niger." These same waterways were the key factor in Ijebu's trading prosperity and the link to its eastern neighbors—Ikale, Ilaje, Ijo, Itsekiri, and Benin.

39. This discussion is based on an interview with the Odi at the Olisa's palace, Ijebu-Ode, 1986.

40. A face bell by the same hand or workshop was photographed at Ijebu-Ode before 1926 (see Talbot 1926 vol. 3:fig. 225).

41. See Thompson 1970; Fagg and Pemberton 1982:38–39. Significantly, many such bells are shown worn on the left hip of Benin persons, on countless plaques dated to the 16th or 17th century (see Dark 1973:pls. 11, 30, 48; Read and Dalton 1899:pls. 17, 19, 20, 24, 25).

42. Information from several Ijebu elders, priests, and the Olisa at Ijebu-Ode, 1986.

43. Very similar ones in a distinctly Benin style were found on royal altars in Benin. For a detailed discussion of these rings, see Vogel 1983. Recent fieldwork in Ijebu lends further support to her suggestion that Ijebu may have been the source of many of the problematic "Lower Niger," "Provincial Benin," and "Tsoede" bronzes (see n. 38).

44. Dark illustrates a Benin ring showing what appear to be two of these rings. (1982:ill. 51). Next to one of them stands a person holding a head upside down in his hands—perhaps suggesting that the head is about to be placed on the ring.

45. Calvocoressi 1978.

46. The diviner's staff of power is the *opa orere* or *opa osun*. See Abiodun 1975:450–454; Drewal and Drewal 1983b.

47. It is impossible to treat here the fascinating diffusion and meanings of this ancient southern Nigerian motif pursued so admirably by Douglas Fraser (1972). It is very widespread and important in Ijebu, more evidence of long-term and intimate Benin-Ijebu interactions.

48. Ben-Amos and Rubin 1983. William Fagg (1980:fig. 14) photographed a drum set by the same hand being used by drummers at Ijebu-Igbo.

49. The Ijebu, some Egba, and other southern Yoruba call it Osugbo; Ibadan, Oyo, and other northern kingdoms refer to it as Ogboni. Despite the differences in name, it is essentially the same institution.

50. Age grades, three-year sets known as *ipampa*, and the Osugbo decide most matters at the village level. At the capital, the Osugbo shares authority more widely but still dominates. The heads of the most important Ijebu societies and certain

hereditary chiefs known as the *ilamuren*, in consultation with the Osugbo, make all decisions which are then announced by the king, the Awujale. The age grades and a complex system of titles and association share power in the political realm. At Ile-Ife the *ipampa* controlled all trade in foreign goods and was closely associated with Ijebu and its monopoly on trade from the coast to the interior (Bascom 1969a:26–27). As Atanda (1973b:369) points out, "the Ilamuren chiefs, like other important dignitaries in Ijebu, had to belong to the Osugbo."

51. For a critique of this literature, see H. J. Drewal in press.

52. Ositola, personal communication, 1982.

53. See Awolalu 1979.

54. Ositola, personal communication, 1982. Pairing occurs in the central doctrine of Osugbo, embedded in the saying *"Ogboni meji li o mo idi Eta"* ("Two Ogbonis know the meaning and matter of the three"), a reference to three cowries strung and sent as a message to indicate unanimity (Gollmer 1884:170), or tied tightly on the left wrist of Osugbo initiates and said to leave a permanent mark. (Yoruba body artists have this design as part of their repertoire of pigmented scarifications which they call "the Ogboni three" (see H. J. Drewal 1988b). Another interpretation of the saying could be a play on the word *odi* (inner sanctum). It is there that the unseen third, the *onile*, is kept to witness all agreements between Osugbo members. See Thompson (1971:chap. 6/1) for other interpretations of threeness in Ogboni. An extensive survey of both published and unpublished *onile* reveals the existence of 21 female figures; 22 male ones; and 16 pairs (male and female). This random sample gathered over many years clearly indicates an almost even distribution of female and male figures, which strongly suggests that *onile* have been traditionally cast as a couple as Ijebu claim.

55. At Ijebu-Imusin, legend relates how the ancestors brought their deity Orisalale ("The-God-of-Founding-a-New-Land") who was represented by a male and female pair of images. The male figure was deposited at a site near Itele, while the female was brought to Ijebu-Imusin and placed in a shrine that plays a central role in rites of royal installation. A similar story is told at Ijebu-Ife. There the shrine of the patron deity, Odudua, contains one figure of what was originally a male/female pair of images. The other of the pair was deposited at a site along the migration path.

56. The earliest depictions of paired metal objects associated with Osugbo/Ogboni may be the linked unfigured spikes on the two terracotta vessels from Obalara (see chapter 2) and another from Koiwo Layout, Ile-Ife, dated c. 1100–1400. Similar metal spikes are part of the regalia of the Alaja, the priest of the sacred Igbo' Laja grove at Owo where ancient terracotta heads are kept (Eyo and Willett 1980:fig. 11, pl. 58.) A paired male and female figure cast in brass and dating to c. 1000–1300 was excavated in Ife at Ita Yemoo (Willett 1967:pl. 10, color pl. 3); other earthen ones (undated) are in the Odudua shrine.

57. In a related interpretation of the term *iledi*, Biobaku (1956:257) suggests that it refers to *ile ti a di nkan si* ("house in which something is wrapped [and kept]"). This lodge is also known as *ile awo* ("house of secret [discussions]"). In all cases, the emphasis is on restricted, privileged knowledge. For a general diagram of an Osugbo *iledi*, see H. J. Drewal In press.

58. Lloyd 1962:72.

59. Bovell-Jones 1943:74.

60. See also Thompson (1971:chap. 6/2–3) who reports on large wooden spoons and their uses in the Osugbo lodge at Iperu. These spoons are occasionally depicted in *edan* (Dobbelmann 1976a:29).

61. A related oath-taking ritual is known as *imule*, literally "to-drink-from-the-earth." In this rite, participants, prostrate on the ground, must touch their tongues to the *edan* pair. It may be because of this that the *edan* pair is sometimes called "mother" (*iya*) and Osugbo members "children of one mother" (*omo iya*). When Osugbo members greet each other one will say "mother's breast is sweet," (*omun iya dun*) and the other will reply "we all suck it" (*gbogbo wa la jo nmu*) which, as J. R. O. Ojo explains "indicates the bond existing between cult members" (1973:51). The *imule* rite was described by Frobenius although he knew neither its name nor its significance. Thompson cites a related rite: "According to tradition, two men who swear to each other to embark jointly upon a serious matter touch the earth to make their contract binding. Earth was the third, the witness to their words" (1971:chap. 6/1).

62. Ositola, personal communication, 1982.

63. The limited visibility of the *onile*, because of its spiritual powers, extends to Osugbo members themselves. Bascom describes an unresolved dispute among the chiefs at Ife that "was referred to the Ogboni house where it was heard by the members who were concealed behind palm fronds" (1969a:37). This is how the *onile* is kept in the *ile odi*.

64. Willett 1967:pl. 101.

65. Biobaku stated that the receipt of the male figured *edan* signifies "wrath" while the female conveys "friendly greetings," although he does not explain whether the chain is removed or separated male and female *edan* are used (1956:259–260). These data may be related to information collected by Williams (1964:141) about Ajagbo, a brass casting of an ithyphallic male figure said to be associated with execution.

66. Lloyd 1962:20.

67. Ositola, personal communication, 1982. The manipulation of the *edan* in relation to the life or death of an individual has parallels in other Yoruba forms and contexts. E.g., the diviner's *osun* staff must always stand upright to indicate the life, vigor, and well-being of its owner as expressed in the prayer, "*osun* stand up, don't fall down" (*osun duro, maa subule*). When a diviner dies, his staff is placed down on the ground and reinstalled when his successor resumes divination activities (cf. Drewal and Drewal 1983b:66). Similar concepts also pertain to the staff of the herbalist.

68. See Abiodun 1982. A comparable act may also be referred to in ithyphallic male figures, although no Yoruba have stated this

to me explicitly.

69. Some have mistakenly interpreted the gesture of a copper figure found at Tada as this Osugbo greeting. It is not, however, because one hand does not grasp "the thumb of the other" (Eyo and Willett 1980:152).

70. See Thompson (1971:chap. 6/1–2) for other interpretations of the left in Ogboni/Osugbo symbolism.

71. Large-scale male and female Ogboni wood sculptures exist. E.g., the Photograph Study Collection, The Robert Goldwater Library, The Metropolitan Museum of Art: Photograph by W. Fagg, #49-50/44/12.

72. I have seen examples of large earthen sculpture incorporated into the architecture of Osugbo lodges. They have been roughly covered in a layer of cement to preserve them.

73. Ogunba 1964:256.

74. Adenaike, Chief Posa of Imosan, personal communication, 1986. Magbo has sometimes been confused with Agbo, Ijebu headdresses in honor of water spirits. Before conducting field research on Oro and its masks in 1986, I had not fully understood this distinction and had tentatively identified the Eiteljorg mask as Agbo.

75. See Fagg 1952.

76. For a discussion of Oro maskers and photographs of them in performance during annual Oro festivals, see Ogunba 1964.

77. *Omolokun ogbolu/Oba leni, oba lola, ola nigba kugba/Ina ori omi kuku gbona ku.*

78. See H. J. Drewal 1986.

79. Horton 1960, 1963.

80. The house may also refer to the close interactions between humans and the "water people" where Ijo fish-buying families would live on their boats for 9 months out of the year (Horton 1960:10).

81. Fagg says of these *igbile* masks, "Although they were carved by Bini, the style is that of the western Ijo of the Delta, from whom the Ilaje Yoruba adopted it; from them it was imported, together with Ilaje songs, by the Bini" (1963:pl. 106).

82. This attribution was suggested by William Fagg.

83. William Fagg photographed an almost identical headdress in Ijebu. Another Agbo headdress photographed in the same place had metal strips covering portions of the face, one down the center of the forehead and nosebridge, others that are bands under the eyes and down the cheeks representing Ijebu facial scarifications (Photograph Study Collection, #s 1959/6–11, 12, 7–2, 3, Robert Goldwater Library, Metropolitan Museum of Art).

84. See H. J. Drewal 1988a.

85. Anderson 1983:182, and personal communication, 1986.

86. See Brincard 1980:H39.

87. Alagoa 1969:151–6.

6/The Oyo Empire

1. Law 1977:43–44.

2. Johnson 1897/1921:4–74; Law 1977:61–82.

3. Johnson 1897/1921:57ff; Law 1977:676ff; Morton-Williams 1967:32–69.

4. Law 1977:43–44.

5. Johnson 1897/1921:10, 25.

6. Ibid.:206.

7. Law 1977:135–137.

8. Johnson 1921:17.

9. Ajisafe 1964:13; cited in Law 1977:138.

10. Law 1977:90.

11. Clapperton 1829:79.

12. Ibid.:74, 83.

13. Ibid.:76.

14. Ibid.:90.

15. Clapperton's rather unreliable source of information on rituals of sacrifice and shrines for the *orisa* was "a native of Bornou, a Mahometan and a slave to the caboceer of Janna" (ibid.:82).

16. Law 1977:43.

17. Johnson 1897/1921:217.

18. Ibid.:268.

19. Clarke 1938b:248; see also idem 1938c:141–142.

20. Willett 1960:74. Willett pioneered the Oyo-Ile excavations in 1956–57.

21. It is also claimed that Oranyan fathered the first king of Benin, a tradition preserved in Benin court histories.

22. Johnson 1897/1921:150.

23. Law 1977:31.

24. Ibid.:125.

25. Johnson 1897/1921:34.

26. Morton-Williams 1964:255.

27. Wescott and Morton-Williams 1962:27.

28. J. A. Atanda has argued convincingly that the Ogboni cult did not exist in Old-Oyo (1973b:365–372). Although the Ogboni cult may have had its origins in Ife, it played a significant role in the political life of the Ijebu Yoruba, where it was known as Osugbo, and also among the Egba Yoruba. (See chapter 5.)

29. Atanda 1973a:40–42.

30. See Isola 1975:777–806; idem 1976:80–103.

31. Selections from a Sango-*pipe* sung by Ade Aniku, Olorionisango's compound, Ila-Orangun, June 1977.

32. Beier and Gbadamosi 1959:16.

33. Isola 1976:94.

34. Identification confirmed by John Picton who photographed a similar *arugba Sango* in Omu in 1963 (personal communication, July 1988).

35. R. Abiodun, personal communication, March 1989.

36. A line from an *oriki* for Sango sung by Owoade, Edigbon's compound, Ila-Orangun, March 1981.

37. R. Abiodun, personal communication, March 1989. For a discussion of the significance of the blackness of the *ikin Ifa*, the sacred palm nuts used by Ifa priests in divination rites, see Abiodun 1975a:433.

38. Leuzinger 1978:132.

39. Pemberton 1987:117–147.

40. Frobenius 1968:I, 47.

41. According to Taiwo's son Bello of Ore's compound in Ila-Orangun, his father would be gone for as long as three months to work on commissions in Osogbo to the south, Erin to the northwest (where Taiwo's grandfather had lived before moving his family to Ila), and various towns in Kwara State to the northeast of Ila (personal communication, April 1981).

42. For a discussion of the work of Maku and other carvers from Erin, see Beier 1957. Lamidi O. Fakeye, the well-known carver from Ila-Orangun, is also of the opinion that the equestrian veranda posts in the Frobenius' photograph were probably by two different carvers from Erin (personal communication, February 1989).

43. For a discussion of the Ogun festival in Ila-Orangun, see Pemberton 1986, 1989.

44. Beier 1957:3.

45. For somewhat contrasting analyses of the pantheon of the orisa, see Pemberton 1977; K. Barber 1981.

46. R. F. Thompson entitles his excellent essay on twin images among the Oyo and other Yoruba groups, "Sons of Thunder" (1971). Since twin imagery includes both males and females, it seems more appropriate to refer to "children of thunder."

47. Nylander 1969:33, 41–44.

48. Jeffery Hammer, personal communication, April 1988.

49. Sung by Dorcas Oyaleye, Odoode's compound, Ila-Orangun, March 1981.

50. Chappel 1974:253.

51. Johnson 1897/1921:25.

52. Ibid.

53. Chappel 1974:250–265.

54. Abimbola 1982.

55. See Chappel's summary of the literature, 1974:250.

56. Chief Ajanaku, Araba of Lagos (ibid.).

57. Hallett 1965:70.

58. Ibid.:72.

59. Houlberg 1973:20–27, 91–92.

60. The following discussion is based upon conversations with Lamidi O. Fakeye, a fourth-generation carver of Inurin's compound in Ila-Orangun (see also Fakeye 1982).

61. Pemberton 1977:117–147. Fakeye assisted with the studies at Inurin's compound.

62. H. J. Drewal 1976:52–53.

63. Festivals for the ancestors are not unique to the Oyo Yoruba. They are found throughout West African societies and among many other African peoples as well. Indeed, the use of masquerades in association with rituals for the ancestors is not unique to the Oyo Yoruba. Other Yoruba groups and their non-Yoruba neighbors have well-established masking traditions. However, the term egungun, although it means "masquerade" and may be applied to any masking tradition, has come to have a distinctive association with the festivals for the ancestors among the Oyo Yoruba.

64. Rowland Abiodun, quoted in H. J. Drewal 1978:18.

65. This discussion of the Egungun cult is based on studies made by S. O. Babayemi. Babayemi has analyzed numerous passages in Odu Ifa, the vast corpus of Ifa divination poetry, and collected the oriki of many of Oyo's lineages and those in neighboring towns which make reference to Egungun and has argued cogently for an Oyo origin (1980:1–29).

66. According to Babayemi, several oral histories suggest that the Egungun cult was introduced to the Igbomina area through the town of Omu Aran (1980:26–27). It is noteworthy that in Ila-Orangun, which is a crowned town (adile), the Alapinni title is an important chieftaincy. As in Old-Oyo, Chief Alapinni is in charge of the Egungun cult, although it is the Alagbaa who oversees the activities of the cult.

67. Clapperton 1829:84–87.

68. See H. J. Drewal 1978:18–19, 97. In this special issue of African Arts, edited by Drewal, there are also essays by various scholars on Egungun in the areas of Remo, Egbado, Igbomina, Iganna, Owo, and Oyo.

69. This performance was attended by Henry Drewal and John Pemberton.

70. see Lawal 1977:50–61.

71. In the northern Oyo Yoruba areas the lineage masquerades are called egungun paaka. The term is known in other areas, but not commonly used.

72. These are the names of egungun in Ila-Orangun associated with the houses of Chief Alapinni, Chief Oloyin, and Chief Obale.

7/Carvers of the Northeast

1. Ajayi 1986:9.

2. Adetoyi 1974:15.

3. Adediran 1986:732, quoting a statement by Owa Agunloye, Jan. 12, 1882, cited in C.O.147/48/Stat.C.

4. Ajayi 1986:9.

5. Ibid.:14.

6. For a discussion of the Yoruba term pipe, which may be translated as "correctness" or "finishing completeness," and je or dahun, which may be used to refer to the "efficacious" quality of a work of art, see Abiodun 1983:23–24.

7. The following discussion and analysis is based on my field research in the Northern Ekiti towns of Otun and Erinmope in 1977 and on Robert F. Thompson's description of an Epa festival in Igogo-Ekiti which he witnessed in 1965 (Thompson 1974:191–198).

8. Thompson 1974:194–195.

9. Ibid.:192, 195.

10. J. R. O. Ojo 1986:936.

11. Lamidi Fakeye identifies the carving as having come from Arigidi, a small town about two miles from Oye (Fakeye, personal communication, March 1989; see also Carroll 1966:32, fig. 3).

12. Thompson 1974:196.

13. Rowland Abiodun called my attention to the fact that the term

egungun is used to refer to a woman's clitoris (personal communication, March 1989).

14. M. Adeyeni, personal communication, June 1977.

15. Olney 1973:76–77.

16. J. R. O. Ojo 1978b:455–470.

17. Carroll 1966:79. As Carroll notes, "Areogun" is an abbreviation of the name "A-ri-eo-ogun-yan-na." In the analysis of the two Iyabeji Epa masks that follows, it is John Picton's opinion that the Toledo Epa is an early work by Areogun (personal communication, 1988). Lamedi Fakeye is of the opinion that the earring is by Bamgbose (personal communication, March 1989).

18. Gender and social roles in Yoruba society do not limit the role of women to that of the mother. Epa masks also include images of female chiefs. The significance of "mother" or "the mothers" in referring to female *ase* has been analyzed by Henry and Margaret Drewal in their study of Gelede festivals among the southwestern Yoruba (see Drewal and Drewal 1983b).

19. Carroll 1956:9.

20. Interview in Ise, June 1988.

21. The relationship between the master carver and his apprentices and assistants requires that the master "rough out" the basic structure of the sculpture with adz and chisel, defining the form until he can turn the carving over to others to finish under his supervision (Lamidi Fakeye, personal communication, March 1971).

22. Oloju-ifun of Ise, personal communication, June 1988. Oloju-ifun is the fourth of Olowe's five wives. I am grateful to Sanmi Adu-Fatoba, J. F. Ade Ajayi, and R. Abiodun for assistance with the transcription and translation of the tape recording of Olowe's *oriki*.

23. William Fagg photographed Olowe's palace sculptures at Ikere in 1958. John Picton also photographed them and other areas of the palace in 1964. Picton has kindly shared with me his detailed notes on the palace, its layout and the use made of the various areas in the past and at the time of his visit.

24. When William Fagg visited the palace in 1958, and John Picton in 1964, a panel of wood, covered by a sheet of brass with hammered designs, functioned as a door to the smaller entry. The Ogoga told Picton that it had been made locally.

25. The following analysis of the Ikere palace sculptures was first presented as a portion of my lecture, "Art and Rituals for Sacred Kings," as *The Fry Lecture on African Art* sponsored by the Art Institute of Chicago, May 13, 1986.

26. The Ogoga traces his descent to the kings of Benin, not to ife. Hence, the faces on the crown do not constitute a reference to Oduduwa but to the line of the *obas* of Ikere (Chief Sao of Ikere, personal communication, June 1988; Beier 1954:304, 307, 310). Many Yoruba and Benin oral histories, however, refer to Oranmiyan, son of the *Ooni* of Ife, as the father of the present Benin dynasty (see Bradbury 1973:6, 7, 19n, 20, 22).

27. *Oba* William Adetona Ayeni, personal communication, July 1977.

28. W. B. Fagg dates the doors to "about 1916" and notes that it was Philip Allison who had met Olowe at Ise the year before

Olowe died in 1938 and subsequently identified the doors as the work of Olowe (Fagg in Vogel 1981:104).

29. Fagg 1969:56.

30. Oloju-ifun Olowe, personal communication, June 1988.

31. Fagg 1969:55.

32. Abiodun 1983:22.

33. Fagg 1969:56.

34. The second bowl is illustrated in Vogel 1981:105.

8/The Artists of the Western Kingdoms

1. The western kingdoms include Ketu, Save, Dassa-Zoume, Ifonyin/Anago, Ana, Ohori, Awori, Egba, and Egbado (see Parrinder 1967; Palau-Marti 1979; Smith 1969; Law 1977).

2. See Law 1977; Lawal 1970.

3. Johnson 1897/1921:7–8.

4. Ajisafe 1964; Bertho 1949.

5. Atanda 1973a.

6. Asiwaju 1976; Law 1977:211–228.

7. Asiwaju 1976.

8. Carroll 1966.

9. Based upon fieldwork in 1970.

10. See the Ibikunle piece illustrated in Ajayi and Smith 1964:opposite p. 2. About seven works by this master are known, one in the Seattle Museum of Art.

11. See Drewal and Drewal 1983a:chap. 7.

12. Ibid.:pls. 108–9.

13. Discussions with the head of the hunters at Ilaro, Egbado, 1978.

14. This same symbolic meaning is behind the ritual garments of certain prominent chiefs of Benin, made of layered lapets to approximate the scales of a pangolin's hide. See Ben-Amos 1980:pl. 76–78.

15. Abimbola 1975a:411–448.

16. Olaniyan, personal communication, 1982.

17. Kenneth Murray fieldnotes, Nigerian Museum, 1950. However, they were not remembered in Ota in 1981. As the Olota of Ota suggested to me, this may be because their names indicate they may have been Ijebu, a sizable number of whom settled in the Ota vicinity in the 19th century.

18. Kilani Olaniyan and Assan Taiwo, personal communication, 1982.

19. This mask is in the Musee de l'Homme, Paris (#91.22.99) and is illustrated in Drewal and Drewal 1983a:170.

20. See M. T. Drewal 1977, 1986.

21. A headdress that entered the Reiss Museum, Manheim in 1881 (IVAf 1562) seems related.

22. Olaniyan, personal communication, 1982.

23. British museum (1887.2–3.1 & 2) illustrated in Drewal and Drewal 1983a:190.

24. Ajisafe 1964; Ajayi and Smith 1964.

25. See Thompson 1971:chap. 7/2.

26. Two works by the same hand were collected by Oldman

before 1909 and illustrated in Krieger 1969:fig. 166, 167. Another is in the UCLA Museum of Cultural History (x70-690). For a discussion of the Obo Ayegunle school, see Williams 1974:211–217.

27. Recorded at Ayetoro, 1971.

28. Witte 1988:94–97.

29. For a discussion of his work, see Thompson 1971:chap. 7/2, fig. 6.

30. Willett 1971b:90.

31. See H. J. Drewal 1984.

32. Abraham 1958:402.

33. A figure by the same hand is in the Nigerian Museum (#65.2.35).

34. For an excellent study of the master Egbado potter Abatan and her vessels in honor of Eyinle, see Thompson 1969. Much of the information here is summarized from that article.

35. Ibid.:142–145.

36. Thompson 1971:chap. 9/2–3.

37. See Thompson 1969:fig. 83–93, especially 92.

38. Ibid.:150.

39. Ositola, personal communication, 1982.

9/The River That Never Rests

1. Obayemi n.d.:120.

2. Ibid.:126–127; Eluyemi 1980.

3. Beier 1970:39.

Glossary

abetiaja. A type of man's cap with "dog-eared" flaps at the side.

abiku. A child "born to die," that is, one who is thought to be allied with spirits who attract it from the world of the living.

ada. Sword.

ade. King's crown.

alaase. One who possesses power, authority, and life force (*ase*).

agba. A barrel-shaped single membrane, wooden drum.

agemo or *alagemo*. Chameleon; *Alagemo* also refers to a member of an Ijebu masking society.

agere Ifa. A carved container used to store the sacred palm nuts during Ifa divination rites.

aito. A ritual act which acknowledges a spiritual presence.

aje. Female power which may be used for good or ill.

akara. Fried bean cake.

ako. A naturalistic life-size, wooden effigy; also refers to the second burial rites in which effigies are used.

akori. A type of glass bead, coral in color, used by chiefs and priests as a sign of their office.

akunlebo. An act of worship which requires that one kneel down.

ape. A flat, metal, ceremonial dance sword in the shape of a fish.

apere. Ife dialect for a cylindrical stool, which usually contains ritually efficacious materials.

apo akurodun. A special bag made of woven raffia used to hold ritual artifacts of the Osugbo society.

ara. Creativity, innovation, novelty.

ara orun. Literally, "dwellers in the other world," a term referring to ancestors and other spiritual entities.

araye. Literally, "people of the world," a term referring to persons who harbor ill-will towards others.

arugba Sango. A carving for Sango shrines depicting a female figure carrying a bowl.

ase. Authority, power, and life force within all creatures.

ato. A female child born in a caul, who is initiated into the cult of the ancestors.

awure. A charm or incantation that brings good luck and riches.

ayanmo. Literally, "that which is affixed to one," that is, associated with one's prenatal destiny.

babalawo. Literally, "father of ancient wisdom," used to refer to Ifa divination priests.

baale. Literally, "the father who heads the house," used to refer to either the senior male members of a compound. With different tones and spelling, used to refer to the title of a senior chief of a settlement, literally, "the father who owns/rules the land."

balogun. Warrior chief.

bata. A double membrane drum used for rituals for *orisa* Sango.

bembe. A single membrane drum made from the wood of the *omon* tree.

Dada. A name given to a child born with curly hair.

dudu. Literally, "black," used also to refer to esoteric knowledge.

edan. Pair of linked brass male and female figures, symbols of the Osugbo/Ogboni Society.

edun ara. "Thunder celts" associated with *orisa* Sango.

efun. Lime, chalk used to decorate shrines and artifacts for the *orisa funfun*, deities associated with cool and white materials.

egbe abiku. Literally, the "society of children born to die."

egun iponri. The ancestral portions of a person's inner, spiritual essence.

egungun. Masked dancers/performers associated with ancestral rites.

ehin-iwa. Afterlife.

ekine. Water spirit, or children born through the intercession of water spirits.

eredo. Ramparts.

ekeji orisa. Next to or deputy of the gods.

elegun. One who is "mounted" or possessed by an *orisa*.

eleye. Literally, "women who own birds," that is, spiritually powerful women.

emi. Breath, spirit.

ere ibeji. Wooden images for deceased twins.

erhe. Benin dialect, cylindrical stool (see *apere*.).

ese Ifa. Verse of Ifa divination poetry.

eso. Caution.

ewa. Beauty.

ewo. Taboo, that which is prohibited.

gbedu. A large single membrane, wooden drum used on ritual occasions for a king or for diviners.

ibeji. Twin.

ibolukun. Ceremonial skirt.

ibori. Cone-shaped icon symbolizing a person's individuality and destiny, *ori*.

irobun. Woman's shoulder cloth.

idile. Family lineage group.

ifarabale. Composure, calmness.

igbale egungun. Forest grove where rituals for the ancestors are performed.

igbo. Forest grove.

ijoko. Seat, stool.

ijoko orisa. Literally, "god's seat," that is, a raised platform on an *orisa* shrine where the symbols of the god reside.

ikin Ifa. The sixteen sacred palm nuts given by Orunmila to his children for communication with him and the other *orisa*.

ikunle abiyamo. Literally, "the kneeling posture of a woman experiencing the pains of childbirth."

ilari. A king's messenger whose head is shaved on one side.

ilè. Earth.

ilé. House.

ile ori. Literally, "the house of the head," that is, a shrine to one's personal destiny.

iledi. The lodge of the Osugbo/Ogboni Society, literally, "house-with-inner-sanctum."

ilu-alade. Literally, "crowned town."

iluti. Teachability.

imo. Knowledge.

imoju-mora. Good perception, insight.

imori. Literally, "knowing the head"; a divination rite performed to determine a person's prenatal destiny.

ipade. Meeting or gathering.

ipade. A hunter's funeral effigy.

ipawo ase. Literally, "a hand-held staff of authority."

iran. Mental images.

iro. A woman's cloth wrapper.

iroke-Ifa. An Ifa divination tapper.

iroko. African teak; *Chlorophora Excelsa.*

irubo. A place of sacrifice.

ita. Crossroads.

itagbe. An elaborately woven shoulder cloth used by Osugbo elders in the Ijebu area as a sign of office.

iwa. The essential nature of a person or thing.

iya ade. Literally, "mother crown," that is, the oldest and most honored crown of a king.

iya ilu. Literally, "mother drum," that is, the lead drum.

iyeye. Leaves from the *ekika* tree.

iyi. Dignity, honor.

jijo. Resemblance.

kobi. Veranda.

koko. Pot; a term used to refer to the helmet portion of an Epa headdress.

laba Sango. A large, decorated leather bag worn by Sango priests.

mariwo. Palm fronds.

oba. King.

oba ilu. Ruler of a town.

obi. Kola nut.

odo Sango. A carved, inverted mortar used on Sango shrines.

ode. Outer or exterior.

odi. The inner sanctum of the Osugbo/Ogboni lodge.

Odu Ifa. A major section or chapter of Ifa divination poetry.

ogbon. Wisdom.

oja. A length of cloth usually wrapped around one's head.

Ojomu. The Chief of Ijebu-Owo, who is next in rank to the Olowo.

oju. Face.

ojubo. Literally, "face of worship," that is, the place one faces when worshipping.

oju-ona. Literally, "an eye for design," originality.

ojupo. A shrine for the ancestors.

oke iponri. The summit of the symbol of a person's individuality and destiny, the *ibori.*

okin. A bird known as the "king of birds," whose long, white tail feather is often worn at the top of an *oba*'s crown.

okiti. Literally, "mound of earth," refers to a place where oaths are taken and powerful substances are buried.

okute. A royal ancestral staff.

olori. Women of a palace, kings' wives, queens, widows.

olori-ebi. Head of a family.

oloye. Chief.

oluserepe. Refers both to the drum and the music played for one who wears an *orunfanran,* an Owo ceremonial war-dress.

omo. A brass face bell worn by chiefs and elders in the Ijebu area.

omo iya. Literally, "children of the same mother," used in reference to members of the Osugbo/Ogboni Society.

omolokun. Literally, "children of the sea," used in reference to children born through the intercession of water spirits.

onile. A pair of large freestanding metal-cast figures, symbols of the Osugbo/Ogboni Society, literally, "owners of the house.".

onisegun. A herbalist priest.

onisona. Artist.

oogun. Traditional medicinal/magical preparations.

oogun ase. Very powerful medicinal/magical preparations.

opa. Staff.

opon-Ifa. Divination tray.

ori. Head; a person's prenatal destiny.

ori inu. The inner head or spiritual self.

oriki. Praise song or poem.

orin. Song.

ori ode. The outer or physical head.

orisa. Gods.

orisa funfun. The "cool" or calm gods.

orisa gbigbona. The "hot" or aggressive gods.

orita or *orita meta.* Crossroads.

oro. Spiritual presence.

oruko amutorunwa. A name dictated by the nature of one's birth.

oruko abiso. A name given independently of the circumstances of birth.

orun. Otherworld.

orun oba. Figurated mortar symbolic of rulers in Ekiti.

orufanran. A ceremonial war-dress worn in Owo.

osanmasinmi. A wooden ram's head used on ancestral altars in Owo.

ose Sango. A double axe dancewand carried by devotees of Sango.

osi. Ijebu dialect, collective term for ancestors.

oso. Male power that may be used for good or evil.

osu. Projection, tuft on head marking site of empowering medicines.

Owanrin meji. One of the *Odu* of Ifa.

owo. Respect.

oye. Understanding.

pakato. Beaded band.

pere. Ijo dialect, stool.

sere Sango. A prayer rattle used by devotees of Sango.

sigidi. A mud sculpture used to invoke malevolent powers.

sonso ori. A pointed projection from the head.

suuru. Patience.

tito. Endurance, genuineness..

udamolore. A ceremonial sword of a type used in Owo.

uku/iku. Death.

woro. A water plant.

yata. A beaded dance panel.

Bibliography

ABIMBOLA, W. 1968. *Ijinle Ohun Enu Ifa, Apa Kiini.* Glasgow: Collins.

——. 1969. *Ijinle Ohun Ifa, Apa Keji.* Glasgow: Collins.

——. 1975a. *Sixteen Great Poems of Ifa.* Paris: Unesco.

——, ed. 1975b. *Yoruba Oral Tradition.* Ile-Ife: Department of African Languages and Literature, University of Ife.

——. 1976. *Ifa: An Exposition of Ifa Literary Corpus.* Ibadan: Oxford University Press.

——. 1977. *Ifa Divination Poetry.* New York: Nok Publishers, Ltd.

——. 1982. "From Monster to King and Divinity: Stories of Ibeji in the Ifa Literary Corpus." Paper presented at the *Conference on Ere Ibeji*, National Museum, Lagos.

——. 1983. "Ifa as a Body of Knowledge and as an Academic Discipline." *Journal of Cultures and Ideas* 1 (1):1–11.

ABIODUN, R. 1975a. "Ifa Art Objects: An Interpretation Based on Oral Tradition." In *Yoruba Oral Tradition.* Edited by W. Abimbola. Ife: Department of African Languages and Literatures, University of Ife, pp. 421–468.

——. 1975b. "Naturalism in 'Primitive' Art: A Survey of Attitudes." *Odu, Journal of West African Studies* 10:129–136.

——. 1976. "A Reconsideration of the Function of Ako, Second Burial Effigy in Owo." *AFRICA, Journal of International African Institute* 46 (1):4–20.

——. 1981. "Ori Divinity: Its Worship, Symbolism and Artistic Manifestation." In *Proceedings of the World Conference on Orisa Tradition.* Ife: Department of African Languages and Literatures, University of Ife, pp. 484–515.

——. 1982. "Concept of Women in Traditional Yoruba Art and Religion." In *Nigerian Women and Development*, Edited by A. Ogunseye, et al. Ibadan: University of Ibadan Press, pp. 950–968.

——. 1983. "Identity and the Artistic Process in the Yoruba Aesthetic Concept of Iwa." *Journal of Cultures and Ideas* 1 (1):13–30.

——. 1987a. "Verbal and Visual Metaphors: Mythic Allusions in Yoruba Ritualistic Art of Ori." *Word and Image* 3 (3):252–270.

——. 1987b. "The Future of African Art Studies: An African Perspective." Paper presented at the National Museum of African Art, Smithsonian Institution, Washington, D.C.

——. In press. "Woman in Yoruba Religious Images: An Aesthetic Approach." In *Visual Art as Social Commentary.* Edited by J. Picton. London: School of Oriental and African Studies, University of London.

ABRAHAM, R. C. 1958. *Dictionary of Modern Yoruba.* London: University of London.

ADEDIRAN, B. 1986. "The Nineteenth Century Wars and Yoruba Royalty." In *War and Peace in Yorubaland, 1793–1893.* Edited by I. A. Akinjogbin. Conference on the Centenary of the 1886 Kiriji/Ekitiparapo Peace Treaty, Obafemi Awolowo University, Ile-Ife.

ADEGBITE, A. M. 1978. "Oriki: A Study in Yoruba Musical and Social Perception." Ph.D. thesis, University of Pittsburgh.

ADEPEGBA, C. O. 1983. "Ara; The Factor of Creativity in Yoruba Art," *Nigerian Field* 48:53–66.

——. 1988. "The Historical Significance of the Esie Stone Images." In *Yoruba Images: essays in honour of Lamidi Fakeye.* Edited by M. Okediji. Ife: Ife Humanities Society.

ADERIGBIGBE, A. A. B. 1965. "Peoples of Southern Nigeria." In *Thousand Years of West African History.* Edited by J. F. A. Ajayi and E. Espie. Ibadan: University of Ibadan Press pp. 191–205.

ADETOYI, A. 1974. *A Short History of Ila-Orangun.* Ila-Orangun, Nigeria: Iwaniyi Press.

AFOLAYAN, F. 1989. "The Esie Lithic Culture: Perspectives from the Igbomina Tradition." Paper presented at the *Seminar on Material Culture, Monuments and Festivals in Kwara State*, National Museum, Esie, April.

AGBAJE-WILLIAMS, B. and J. C. ONYANGO-ABUJE. 1981. "Recent Archaeological Work at Old Oyo: 1978–81." *Nyame Akuma* 19:1–11.

AJAYI, J. F. A. 1986. "Nineteenth Century Wars and Yoruba Ethnicity." In *War and Peace in Yorubaland, 1793–1893.* Edited by I. A. Akinjogbin. Conference on the Centenary of the 1886 Kiriji/Ekitiparapo Peace Treaty, Obafemi Awolowo University, Ile-Ife.

AJAYI, J. F. A., and R. SMITH. 1964. *Yoruba Warfare in the Nineteenth Century.* Cambridge: Cambridge University Press, 1964.

AJIBOLA, J. O. 1971. *Owe Yoruba.* Ibadan: Oxford University Press.

AJISAFE, A. K. 1964. *History of Abeokuta.* Abeokuta: M A. Ola.

AKINJOGBIN, I. A. 1967. "Ife: The Home of a New University." *Nigeria Magazine* 92:40–46.

AKINNASO, F. N. 1981. "Names and Naming Principles in Cross-Cultural Perspective." *Names: The Journal of the American Name Society* 29 (1):37–63.

——. 1983. "Yoruba Traditional Names and the Transmission of Cultural Knowledge." *Names: The Journal of the American Name Society* 31 (3):139–158.

ALAGOA, E. J. 1968. "Oproza and Early Trade on the Escravos: A Note on the Interpretation of Oral Tradition of a Small Group." *Journal of the Historical Society of Nigeria* 5 (1).

ALLISON, P. A. 1968. *African Stone Sculpture.* London: Lund Humphries.

ANDAH, B. W. 1982. "Urban 'Origins' in the Guinea Forest with Special Reference to Benin." *West African Journal of Archaeology* 12:63–71.

ANDERSON, M. 1983a. "Central Ijo Art: Shrines and Spririt Images." PhD dissertation, Indiana University, Bloomington.

——. 1983b. "The Funeral of an Ijo Shrine Priest." *African Arts* 21 (1):52–57, 88.

ARMSTRONG, R. P. 1971. *The Affecting Presence: An Essay in Humanistic Anthropology.* Urbana: University of Illinois Press.

ASHARA, M. B. 1973. "The History of Owo." Manuscript, revised version.

ASIWAJU, A. I. 1976. *Western Yorubaland under European Rule, 1889–1945.* Atlantic Highlands: Humanities Press.

ATANDA, J. A. 1973a. *The New Oyo Empire: Indirect Rule and Change in Western Nigeria 1894–1934.* London: Humanities Press.

——. 1973b. "The Yoruba Ogboni Cult: Did it Exist in Old Oyo?" *Journal of the Historical Society of Nigeria* 6 (4):365–372.

AWE, S. H. A. 1977. "An Examination of the Traditional Socio-Political Organization of Owo: A Study in Cultural Diffusion." Paper presented at the *Seminar on Culture in West Africa During the Second Millennium*, A.D. 1000–A.D. 1976, Ahmadu Bello University, Zaria.

AWOLALU, J. O. 1979. *Yoruba Beliefs and Sacrificial Rites.* London: Longmans.

AWONIYI, T. A. 1981. "The Word Yoruba." *Nigeria* 134–35:104–107.

AYANDELE, E. A. 1966. *The Missionary Impact on Modern Nigeria, 1842–1914: A Political and Social Analysis.* London: Longman.

——. 1969. "The Ideological Ferment in Ijebuland, 1842–1943." *African Notes* 5 (3):17–40.

——. 1970. "The Changing Position of the Awujales of Ijebuland under Colonial Rule." In *West African Chiefs: Their Chang-*

ing Status under Colonial Rule and Independence. Edited by Michael Crowder and Obaro Ikime. New York and Ile-Ife: Africana Publishing Corp./University of Ife Press, pp. 231–254.

———. 1979. *Nigerian Historical Studies*. London: Frank Case and Company, Ltd.

———. 1983. "Ijebuland 1800–1891: Era of Splendid Isolation." In *Studies in Yoruba History and Culture*. Edited by G. O. Olusanya. Ibadan: Ibadan University Press, pp. 88–107.

AYOADE, J. A. A. 1979. "The Concept of Inner Essence in Yoruba Traditional Medicine." In *African Therapeutic Systems*. Edited by Z. A. Ademuwagun, et al. Waltham, Mass.: Crossroads Press.

BABALOLA, S. A. 1966. *The Content and Form of the Yoruba Ijala*. Oxford: Clarendon Press.

BABAYEMI, S. O. 1980. *Egungun Among the Oyo Yoruba*. Ibadan: Board Publications Ltd.

BARBER, K. 1981. "How Man Makes God in West Africa: Yoruba Attitudes Toward the Orisa." *Africa* 51 (3):724–745.

BARBER, R. J. 1985. "Land Snails and Past Environment at the Igbo-Iwoto Site, Southwestern Nigeria." *West African Journal of Archaeology* 15:89–102.

BASCOM, W. R. 1944. "The Sociological Role of the Yoruba Cult Group." *Memoirs of the American Anthropological Association* 46(1) pt. 2.

———. 1959. "Urbanism as a Traditional African Pattern." *Sociological Review* 7 (1):29–43.

———. 1960. "Yoruba Concepts of the Soul." In *Men and Cultures*. Edited by A. F. C. Wallace. Berkeley: University of California Press.

———. 1969a. *The Yoruba of Southwestern Nigeria*. New York: Holt, Rinehart, and Winston.

———. 1969b. *Ifa Divination: Communication Between the Gods and Men in West Africa*. Bloomington: Indiana University Press.

———. 1973. "A Yoruba Master Carver: Duga of Melco." In *The Traditional Artist in African Societies*. Edited by W. d'Azevedo. Bloomington: Indiana University Press, pp. 62–78.

BASSANI, E., and W. B. FAGG. 1988. *Africa and the Renaissance*. New York: The Center for African Art.

BEIER, H. U. 1954. "Palace of the Ogogas in Ikere." *Nigeria* 44:303–314.

———. 1956. "Before Oduduwa." *Odu* 3:25–32.

———. 1957. *The Story of Sacred Wood Carvings from One Small Yoruba Town*. Lagos: Nigeria Magazine.

———. 1959. *A Year of Sacred Festivals in One Yoruba Town*. Lagos: Nigeria Magazine.

———. 1970 *Yoruba Poetry: An Anthology of Traditional Poems*. Cambridge, Eng.: Cambridge University Press.

———. 1982. *Yoruba Beaded Crowns: Sacred Regalia of the Olokuku*. London: Ethnographica.

BEIER, H., and B. GBADAMOSI. 1959. *Yoruba Poetry*. Special Edition of "Black Orpheus." Ibadan: Ministry of Education.

BEN-AMOS, P. 1980. *The Art of Benin*. New York: Thames and Hudson.

BEN-AMOS, P., and A. RUBIN. 1983. *The Art of Power, The Power of Art*. Monograph Series 19. UCLA: Museum of Cultural History.

BERTHO, J. 1949. "La Parente des Youruba aux Peuplades de Dahomey et Togo." *Africa* 19:121–132.

BEYIOKU, O. A. 1971. *Ifa, Its Worship and Prayers*. Ebute Metta, Nigeria: Salako Press.

BIOBAKU, S. O. 1956. "Ogboni, the Egba Senate." In *Proceedings of the Third International West African Conference, Ibadan, December 12–21, 1949*. Lagos: Nigerian Museum.

BIOBAKU, S. O., ed. 1973. *Sources of Yoruba History*. Oxford: Clarendon Press.

BITIYONG, V. I. 1981. "Central Nigerian Terracotta Figurines: A Stylistic Study." M.A. thesis, University of Birmingham (England).

BLIER, S. 1985. "Kings, Crowns, and Rights of Succession; Obalufon Arts at Ife and Other Yoruba Centers." *Art Bulletin* 67 (3):383–401.

BOVELL-JONES, T. B. 1943. "Intelligence Report on Ijebu Ode Town and Villages, May 7" (IJE Prof. 2/122, Confidential File C55/1), National Archives, Ibadan University.

BRADBURY, R. E. 1973. *Benin Studies*. London: Oxford University Press.

BRINCARD, M. T. 1980. "Les Bracelets Ogboni: Analyse Iconographique et Stylistique." Maitrise d'Art et d'Archeologie, Universite de Paris I, Sorbonne.

BUCKLEY, A. 1985. *Yoruba Medicine*. Oxford: Clarendon Press.

CALVORCORESSI, D. 1978. *Rescue Excavation of the First Otunba Suna*. Ibadan: Biyi Printing Works.

CALVORCORESSI, D., and M. DAVID. 1979. " New Survey of Radiocarbon and Thermoluminescence Dates for West Africa." *Journal of African History* 20:1–20.

CARROLL, K. C. 1956. "Yoruba Masks." *Odu* 3:3–11.

———. 1966. *Yoruba Religious Carving*. London: Geoffrey Chapman.

CHAPPELL, T. J. H. 1974. "Yoruba Cult of Twins in Historical Perspective." *Africa* 44 (3):250–265.

CLAPPERTON, H. 1829. *Journal of the Second Expedition into the Interior of Africa*. Philadelphia: Carey, Lea and Carey.

CLARKE, J. D. 1938a. "The Stone Figures of Esie." *Nigeria Magazine* 14:106–108.

———. 1938b. "Carved Posts at Old Oyo." *Nigeria Magazine* 15:248–249.

———. 1938c. "A Visit to Old Oyo." *The Nigerian Field* 7 (3):129–142.

CORDWELL, J. 1953. "Naturalism and Stylization in Yoruba Art." *Magazine of Art* 46:220–225.

CROWDER, M. 1962. *The Story of Nigeria*. London: Faber and Faber.

CROWTHER, S. G. 1852. *A Vocabulary of the Yoruba Language*. London: Seeleys.

CURNOW, K. 1983. "The Afro-Portugese Ivories: Classification and Stylistic Analysis of a Hybrid Art Form." PhD dissertation, Indiana University, Bloomington.

DANIEL, F. de F. 1937. "The Stone Figures of Esie, Ilorin Province, Nigeria." *Journal of the Royal Anthropological Institute* 67:43–49.

DAPPER, O. 1686. *Description de L'Afrique*. Amsterdam: Wolfgang, Waesberge, Boom and van Someren.

DARK, P. J. 1973. *An Introduction to Benin Art and Technology*. London: Oxford University Press.

———. 1982. *An Illustrated Catalog of Benin Art*. Boston: G. K. Hall.

DAVISON, C., et al. 1971. "Two Chemical Groups of Dichroic Glass Beads from West Africa." *Man* 71 (6):645–659.

DOBBELMANN, A. H. M. 1976a. *Der Ogboni-Geheimbund: Bronzen aus Sudwest-Nigeria*. Berg En Dal: Afrika Museum.

———. 1976b. *Het Geheime Ogboni-genootschap*. Berg En Dal: Afrika Museum.

DOS SANTOS, J. E., and D. M. DOS SANTOS. 1973. "Esu Bara, Principle of Individual Life in The Nago System." In *Colloques Internationaux du CNRS*. Paris: Centre National de la Recherche Scientifique, pp. 45–60.

DREWAL, H. J. 1976. *African Artistry: Technique and Aesthetics in Yoruba Sculpture*. Atlanta: High Museum, 1976.

———. 1977. *Traditional Art of the Nigerian Peoples*. Washington, D.C.: Museum of African Art.

———. 1978. "The Arts of Egungun among the Yoruba Peoples." *African Arts* 11 (3):18–19, 97–98.

———. 1984. "Art, History, and the Individual: A New Perspective

for The Study of African Visual Traditions." *Iowa Studies in African Art* 1:87–114.

——. 1986. "Flaming Crowns, Cooling Waters: Masquerades of the Ijebu Yoruba." *African Arts* 20 (1):32–41, 99–100.

——. 1987. "Art and Divination among the Yoruba: Design and Myth." *Africana Journal* 14 (2–3) (1987):139–156.

——. 1988a. "Performing the Other: Mami Wata Worship in West Africa." *TDR: Performance Studies* 32 (2), T118:160–185.

——. 1988b. "Beauty and Being: Aesthetics and Ontology in Yoruba Body Art." In *Marks of Civilization.* Edited by A. Rubin. Los Angeles: UCLA Museum of Cultural History, pp. 83–96.

——. In press. "Meaning in Osugbo Art among the Ijebu Yoruba." In *Man Does Not Go Naked: Textilien und Handwerk aus Afrikanischen und Anderen Landern,* Vol. 29. Edited by B. Englebrecht and B. Gardi. Basel: Basler Beitrage zur Ethnologie.

DREWAL, M. T. 1977. "Projections from the Top in Yoruba Art." *African Arts* 11 (1):43–49, 91–92.

——. 1986. "Art and Trance among Yoruba Shango Devotees." *African Arts* 20 (1):60–67, 98–99.

——. 1988a. "Ritual Performance in Africa Today." *TDR: Performance Studies* 32 (2), T118:25–30.

——. 1988b. *Yoruba: Art in Life and Thought.* Victoria, Australia: African Research Institute, Latrobe University.

——. 1989a. "Performer, Play, and Agency: Yoruba Ritual Process." Ph.D. thesis, New York University.

——. 1989b. "Dancing for Ogun in Yorubaland and in Brazil." In *Africa's Ogun: Old World and New.* Edited by S. Barnes. Bloomington: Indiana University Press, pp. 199–234.

DREWAL, M. T., and H. J. DREWAL. 1978. "More Powerful than Each Other: An Egbado Classification of Egungun." *African Arts* 11 (3):28–29, 98–99.

——. 1983a. *Gelede: A Study of Art and Feminine Power Among the Yoruba.* Bloomington: Indiana University Press.

——. 1983b. "An Ifa Diviner's Shrine in Ijebuland." *African Arts* 11 (3):28–39, 98.

——. 1987. "Composing Time and Space in Yoruba Art." *Word and Image: A Journal of Verbal/Visual Enquiry* 3 (3):225–251.

EADES, J. S. 1980. *The Yoruba Today.* Cambridge: Cambridge University Press.

EGHAREVBA, J. 1968. *A Short History of Benin.* Ibadan: Ibadan University Press.

EKUNDAYO, S. A. 1977. "Restrictions on Personal Name Sentences in the Yoruba Noun Phrase." *Anthropological Linguistics* 19 (1):55–77.

ELUYEMI, O. 1976. "Egbejoda Excavations, Nigeria, 1970." *West African Journal of Archaeology* 6:101–108.

——. 1977. "Terracotta Sculpture from Obalara's Compound, Ile-Ife." *African Arts* 10 (3):41, 88.

——. 1980. *Oba Adesoji Aderemi: 50 Years in the History of Ife.* Ile-Ife: Unpublished manuscript.

EYO, E. 1968. "Ritual Pots from Apomu Forest, Ondo Province, Western Nigeria." *West African Archaeological Newsletter* 8:9–14.

——. 1972. "New Treasures from Nigeria." *Expedition* 14:2.

——. 1974a. "Recent Excavations at Ife and Owo and their Implications for Ife, Owo and Benin Studies." Ph.D. thesis, University of Ibadan.

——. 1974b. "Odo Ogbe Street and Lafogido: Contrasting Archeological Sites in Ile-Ife, Western Nigeria." *West African Journal of Archeology* 4:99–109.

——. 1976. "Igbo' Laja, Owo, Nigeria." *West African Journal of Archaeology* 6:37–58.

EYO, E., and F. WILLETT. 1980. *Treasures of Ancient Nigeria.* New York: Alfred A. Knopf.

FABUNMI, M. A. 1969. *Ife Shrines.* Ile-Ife: University of Ife Press.

——. 1972. *Ajayo, Ijinle Ohun Ife.* Ibadan: Anibonoje Press.

FADIPE, N. A. 1970. *The Sociology of the Yoruba.* Ibadan: Ibadan University Press.

FAGE, J. D. 1962. "Some Remarks on Beads and Trade in Lower Guinea in the Sixteenth and Seventeenth Centuries." *Journal of African History* 3 (2):343–347.

FAGG, W. B. 1951. "Tribal Sculpture and the Festival of Britain— The Art Style of Owo." *Man* 51:73–76.

——. 1952. "Notes on some West African Americana." *Man* 52:119–121.

——. 1960. "Ritual Stools of Ancient Ife." *Man* 60:113–115.

——. 1963. *Nigerian Images.* New York: Praeger.

——. 1969. "The African Artist." In *Tradition and Creativity in Tribal Art.* Edited by D. Biebuyck. Berkeley: University of California Press, pp. 42–57.

——. 1980. Descriptive catalog entries in *Tribal Art* (Auction, March 18). London: Christie, Manson & Woods.

——. 1981. Descriptive catalog entries in *For Spirits and Kings.* Edited by S. M. Vogel. New York: The Metropolitan Museum of Art.

FAGG, W. B., and J. PEMBERTON 3rd. 1982. *Yoruba Sculpture of West Africa.* New York: Alfred A. Knopf.

FAGG, W. B., and F. WILLETT. 1962. "Ancient Ife, an Ethnographical Summary." *Odu* 8:21–35.

FAKEYE, L. 1982. "How *Ere Ibeji* is Traditionally Commissioned in Yorubaland." Paper presented at a conference at the Nigerian National Museum, Lagos, March.

FOSS, P. 1973. "Festival of Ohworu at Evwreni." *African Arts* 6 (4):20–27, 94.

FRASER, D. 1972. "The Fish-legged Figure in Benin and Yoruba Art." In *African Art and Leadership.* Edited by D. Fraser and H. M. Cole. Madison: University of Wisconsin Press, pp. 261–274.

——. 1975. "The Tsoede Bronzes and Owo Yoruba Art." *African Arts* 8 (3):30–35, 91.

——. 1981. "Pair of Armlets." In *For Spirits and Kings.* Edited by S. M. Vogel. New York: Metropolitan Museum of Art.

FROBENIUS, L. 1913/1968. *The Voice of Africa,* 2 vols. Reprint. New York: Benjamin Bloom, Inc.

——. 1973. "The Religion of the Yoruba." In *Leo Frobenius, 1873–1973: An Anthology.* Edited by E. Naberland. Wiesbaden, West Germany: Franz Steiner Verlag, pp. 160–191.

GARLAKE, P. E. 1974. "Excavations at Obalara's Land, Ife, Nigeria." *West African Journal of Archaeology 4:111–148.*

——. 1977. "Excavations of the Woye Asiri Family Land in Ife, Western Nigeria." *West African Journal of Archaeology* 7:57–95.

GOLLMER, C. A. 1884. "On African Symbolic Messages." *Journal of the Anthropological Institute* 14 (2):169–182.

GRAY, R. 1962. "A Report on the Third Conference on African History and Archaeology." *Journal of African History* 3 (2):175–191.

HALLETT, R. 1965. *The Niger Journal of Richard and John Lander.* New York: Praeger.

HAMBOLU, H. M. 1989. "An Archaeological Up-date on the Mystery of the Esie Stone Figures." Paper presented at the *Seminar on Material Culture, Monuments and Festivals in Kwara State,* National Museum, Esie, April 6–7.

HENDERSON R., and I. UMUNNA. 1988. "Leadership Symbolism in Onitsha Igbo Crowns and Ijele." *African Arts 21 (2):28-37, 94-96.*

HODGKIN, T. 1960. *Nigerian Perspectives.* Oxford: Oxford University Press.

HOPE, W. H. ST. JOHN. 1907. "On the Funeral Effigies of Kings and Queens of England." *Archaeologia* 60:417–470.

HORTON, R. 1960. *The Gods as Guests.* Lagos: Nigeria Magazine.

——. 1963. "The Kalabari *Ekine* Society; A Borderland of Religion and Art." *Africa* 33 (2):94–114.

HOULBERG, M. H. 1973. "Ibeji Images of the Yoruba." *African*

Arts 7 (1):20–27, 91–92.

IDOWU, E. B. 1962. *Olodumare: God in Yoruba Belief.* London: Longmans.

"IGOGO Festival." 1963. *Nigeria Magazine:*91–104.

ISOLA, A. 1975. "The Rhythm of Sango-pipe." In *Yoruba Oral Tradition.* Edited by W. Abimbola. Ile-Ife, Nigeria: Department of African Languages and Literatures, University of Ife, pp. 777–806.

——. 1976. "The Artistic Aspects of Sango-pipe." *Odu* 13:80–103.

JOHNSON, S. 1897/1921. *The History of the Yorubas.* Reprint. London: Routledge & Kegan Paul Ltd.

KANTROROWICZ, E. H. 1957. *The King's Two Bodies: A Study in Medieval Political Theology.* Princeton: Princeton University Press.

KRIEGER, K. 1969. *Westafrikanische Plastik.* Berlin: Museum fur Volkerkunde.

LANDER, R., and J. LANDER. 1832/1837. *Journal of an Expedition to Explore the Course and Termination of the Niger.* New York: Harper + Brothers.

LAPIN, D. 1980. "Picture and Design in Yoruba Narrative Art." Paper read at the *Conference on the Relations between Verbal and Visual Arts in Africa,* Philadelphia, Pennsylvania, October 10–14.

LAW, R. 1977. *The Oyo Empire c.1600–c.1836.* Oxford: Oxford University Press.

——. 1988. "Early European Sources Relating to the Kingdom of Ijebu (1500–1700): A Critical Survey." *History in Africa* 13:245–260.

LAWAL, B. 1970. "Yoruba Sango Sculpture in Historical Perspective." Ph.D. dissertation, Indiana University, Bloomington.

——. 1974. "Some Aspects of Yoruba Aesthetics." *The British Journal of Aesthetics* 14 (3):239–249.

——. 1977. "The Living Dead: Art and Immortality Among the Yoruba of Nigeria." *Africa* 47 (1):50–61.

——. 1985. "Ori: The Significance of the Head in Yoruba Sculpture." *Journal of Anthropological Research* 41 (1):91–103.

LEUZINGER, E. 1978. *African Sculpture.* Zurich: Museum Rietberg Zurich.

LIVINGSTON, F. B. 1958. "Anthropological Implications for Sickle-cell gene distribution in West Africa." *American Anthropologist* 60 (3):533–561.

LLOYD, P. C. 1959. "Sungbo's Eredo." *Odu* 7:15–22.

——. 1961. "Installing the Awujale." *Ibadan* 12 (1961):7–10.

——. 1962. *Yoruba Land Law.* London: Oxford University Press.

——. 1963. "The Status of the Yoruba Wife." *Sudan Society* 2:35–42.

——. 1965. "The Political Structure of African Kingdoms: An Exploratory Model." In *Political Systems and the Distribution of Power.* Edited by M. Gluckman and F. Eggan. London: Tavistock Publications, pp. 63–112.

——. 1967. "Osifekunde of Ijebu." In *Africa Remembered: Narratives from the Era of the Slave Trade.* Edited by P. D. Curtin. Madison: University of Wisconsin Press, pp. 217–288.

——. 1971. *The Political Development of the Yoruba Kingdoms in the Eighteenth and Nineteenth Centuries.* Royal Anthropological Institute Occasional Paper No. 31. London: Royal Anthropological Institute.

——. 1973. "The Yoruba: An Urban People?" In *Urban Anthropology.* Edited by A. Southall, New York: Oxford University Press, pp. 107–123.

——. 1974. *Power and Independence.* London: Routledge & Keegan Paul.

——. 1977. "Ijebu." In *African Kingdoms in Perspective: Political Change and Modernization in Monarchial Settings.* Edited by Rene Lemarchand. London: Frank Cass and Company.

LOSI, J. B. 1914. *History of Lagos.* Lagos.

MASON, J. 1985. *Four New World Yoruba Rituals.* Brooklyn: Yoruba Theological Archministry.

——. 1988. "Old Africa, Anew." In*Another Face of the Diamond.*

New York: INTAR Latin American Gallery.

McCLELLAND, E. 1982. *The Cult of Ifa Among the Yoruba (Folk Practice and the Art,* vol. 1). London: Ethnographica.

McINTOSH, R. 1989. "Middle Niger Terracottas Before the Symplegades Gateway." *African Arts* 22 (2):74–83.

MILBURN, S. 1936. "Stone Sculptures at Esie (Ilorin Province)." *The Nigerian Teacher* 8:2–7.

MORAKINYO, O., and A. AKINSOLA. 1981. "The Yoruba Ontology of Personality and Motivation: A Multidisciplinary Approach." *Journal of Social Biological Structures* 4:19–38.

MORTON-WILLIAMS, P. 1960. "The Yoruba Ogboni Cult in Oyo." *Africa* 30 (4):362–374.

——. 1964. "An Outline of the Cosmology and Cult Organization of the Oyo Yoruba." *Africa* 34 (3):243–260.

——. 1967. "The Yoruba Kingdom of Oyo." In *West African Kingdoms in the Nineteenth Century.* Edited by D. Forde and P. Kaberry. London: Oxford University Press.

MURRAY, K. C. 1951. "The Stone Images of Esie and Their Yearly Festival." *Nigeria Magazine* 37:45–64.

NEVADOMSKY, P. 1983. "Kingship Succession Rituals In Benin—1: Becoming a Crown Prince." *African Arts* 17 (1):47–54, 87.

——. 1984a. "Kingship Succession Rituals in Benin—2: The Big Things." *African Arts* 17 (2):41–47, 90–91.

——. 1984b. "Kingship Succession Rituals in Benin—3: The Coronation of the Oba." *African Arts* 17 (3):48–57, 91–92.

NYLANDER, P. P. S. 1969. "The Frequency of Twinning in a Rural Community in Western Nigeria." *Annual on Human Genetics* 33:41–44.

OBAYEMI, A. M. U. 1974. "Soundings in Culture History: The Evolution of the Culture and Institutions of the 'Northern Yoruba, the Nupe and the Igala' Before A.D. 1800." Paper read at the *Niger-Benue Seminar,* Ahmadu Bello University.

——. 1976. "The Yoruba and Edo-Speaking Peoples and their Neighbors before 1600." In *The History of West Africa,* vol. 1, 2nd rev. ed. Edited by J. F. A. Ajayi and M. Crowder. Cambridge, England: Cambridge University Press.

——. [n.d.] "The Phenomenon of Oduduwa in Ife History." In "A History of Ife: from the earliest times to 1980." Edited by I. A. Akinjogbin. Ile-Ife: Unpublished manuscript.

ODUTA, A. 1978. *An Introspection into the History of Ijebu-Musin.* Published privately.

OGUNBA, O. 1964. "Crowns and 'Okute' at Idowa." *Nigeria* 83:249–261.

——. 1967. "Ritual Drama of the Ijebu People: A Study of Indigenous Festivals." Ph.D. dissertation, Ibadan University.

OGUNKOYA, T. O. 1956. "The Early History of Ijebu." *Journal of the Historical Society of Nigeria* 1 (1):48–58.

OJO, G. J. A. 1966a. *Yoruba Culture: A Geographical Analysis.* London: University of London Press.

——. 1966b. *Yoruba Palaces.* London: University of London Press.

OJO, J. R. O. 1973. "Ogboni Drums." *African Arts* 6 (3):50–52, 84.

——. 1975. "A Bronze Stool Collected at Ijebu Ode." *African Arts* 9 (1):48–51, 92.

——. 1978a. "The Hierarchy of Yoruba Gods; An Aspect of Yoruba Cosmology." Paper presented at *Department of African Language and Literature Seminar,* University of Ife, Nigeria.

——. 1978b. "The Symbolism and Significance of Epa-Type Masquerade Headpieces." *Man* 12 (3):455–470.

——. 1986. "Reflections of War in an Ekiti Festival." In *War and Peace in Yorubaland, 1793–1893.* Edited by I. A. Akinjogbin. *Conference on the Centenary of the 1886 Kiriji/Ekitiparapo Peace Treaty,* Obafemi Awolowo University, Ile-Ife.

OLNEY, J. 1973. *Metaphors of Self.* Princeton: Princeton University Press.

OLUGBADEHAN, O. 1986. "The Constitutional Troubles of Owo in the 19th Century." Paper presented at the *Conference on the Centenary of the 1886 Kiriji/Ekitiparapo Peace Treaty,* Obafemi Awolowo University, Ile-Ife.

ONABAJO, O. 1989. "Esie Stone Sculpture: the state of the research and future direction." Paper presented at the *Seminar on Material Culture, Monuments and Festivals in Kwara State,* National Museum, Esie, April 6–7.

OWOMOYELA, O. 1979. "A Fractioned Word in a Muted Mouth: The Pointed Subtlety of Yoruba Proverbs." Paper presented at the *Annual Meeting of the African Studies Association,* Los Angeles, October 31-November 3.

——. 1987. "Africa and the Imperative of Philosophy: A Skeptical Consideration." *African Studies Review* 30 (1):79–100.

OZANNE, P. 1969. "A new archaeological survey of Ife." *Odu* (n.s.) 1:28–45.

PALAU-MARTI, M. 1979. "Les Sabe—Opara (Hinterland de la cote du Benin): Apport de Materiaux et Essai d'Interpretation." 3 parts. Doctorat d'Etat, Universite de Paris, Sciences Humaines, Sorbonne.

PARRINDER, G. 1967. *The Story of Ketu.* Ibadan: Ibadan University Press.

PEEL, J. D. Y. 1984. "Making History: The Past in the Ijesha Present" *Man* (n.s.) 19 (1):111–132.

PEMBERTON, J. 1975. "Eshu-Elegba: The Yoruba Trickster God." *African Arts* 9(4):20–27, 66–70.

——. 1977. "A Cluster of Sacred Symbols: Orisha Worship among the Igbomina Yoruba of Ila-Orangun." *History of Religions* 7 (3):1–29.

——. 1978. "Egungun Masquerades of the Igbomina Yoruba." *African Arts* 11 (3):40–47.

——. 1986. "Festivals and Sacred Kingship among the Igbomina Yoruba." *National Geographic Research* 2:216–233.

——. 1987. "The Carvers of Ila-Orangun." *Iowa Studies in African Art* 2:117–147.

——. 1988. "The King and the Chameleon: Odun Agemo. *Ife: Annals of the Institute of Cultural Studies* No. 2:47–64.

——. 1989. "The Dreadful God and the Divine King." In *Africa's Ogun: Old World and New.* Edited by S. T. Barnes. Bloomington: Indiana University Press.

PHILLIPSON, D. W. 1985. *African Archeology.* New York: Cambridge University Press.

PICTON, J., and J. MACK. 1979. *African Textiles: Looms, Weaving and Design.* London: The Trustees of the British Museum, 1979.

POYNER, R. 1976. "Edo Influences on the Arts of Owo." *African Arts* 9 (4):40–45.

——. 1978. "The Egungun of Owo" *African Arts* 11 (3):65–76, 100.

——. 1980. ""Traditional Textiles in Owo, Nigeria." *African Arts* 14 (1):47–51, 88.

——. 1981. "Fragment of an Ivory Sword, *Udamalore*."" In *Spirits and Kings.* Edited by S. M. Vogel. New York: Metropolitan Museum of Art, pp. 133–134.

——. 1984. *Nigerian Sculpture: Bridges to Power.* Exhibition catalogue. Birmingham, Alabama: Birmingham Museum of Art.

——. 1987. "Naturalism and Abstraction in Owo Masks." *African Arts* 20 (4):56–61.

——. 1988. "Ako Figures of Owo and Second Burials in Southern Nigeria." *African Arts* 21 (1):62–63, 81–83, 86–87.

PRINCE, R. 1960. "Curse, Invocation and Mental Health among the Yoruba." *Canadian Psychiatric Journal* 5 (2):65–79.

READ, C. H. and O. M. DALTON. 1899. *Antique Works of Art from Benin.* London: William Clowes and Sons, Ltd.

ROACHE, L. E. 1971. "Psychophysical Attributes of the Ogboni Edan." *African Arts* 4 (2):48–53.

SHAW, T. 1973. "A Note on Trade and the Tsoede Bronzes." *West African Journal of Archaeology* 3:233–238.

——. 1978. *Nigeria: Its Archaeology and Early History.* London: Thames and Hudson.

SHAW, T., and S. G. H. DANIELS. 1984. "Excavations at Iwo Eleru." *West African Journal of Archaeology* 14.

SMITH, R. S. 1967. "Yoruba Armament." *Journal of African History* 8:87–106.

——. 1969. *Kingdoms of the Yoruba.* London: Methuen.

——. 1971. "Nigeria-Ijebu." In *West African Resistance: The Military Response to Colonial Occupation.* Edited by M. Crowder. New York: Africana Publishing Corporation, pp. 170–204.

SPRAGUE, S. F. 1978. "Yoruba Photography: How the Yoruba See Themselves." *African Arts* 12 (1):52–59,107.

STEVENS, P., Jr. 1978. *The Stone Images of Esie, Nigeria.* New York: Africana Publishing Company.

TALBOT, P. A. 1926. *The Peoples of Southern Nigeria,* vol. 1. London: Oxford University Press.

THOMPSON, R. F. 1966. "The Aesthetic of the Cool: West African Dance." *African Forum* 2 (2):85–102.

——. 1968. "Aesthetics in Traditional Africa." *Art News* 66 (9):63–66.

——. 1969. "Abatan: A Master Potter of the Egbado Yoruba." In *Tradition and Creativity in Tribal Art.* Edited by D. Biebuyck, Berkeley: University of California Press, pp. 120–182.

——. 1970. "The Sign of the Divine King: An Essay on Yoruba Bead-Embroidered Crowns with Veil and Bird Decorations." *African Arts* 3 (3):8-17, 74-80.

——. 1971. *Black Gods and Kings: Yoruba Art at UCLA.* Los Angeles: University of California Press.

——. 1973. "Yoruba Artistic Criticism." In *The Traditional Artist in African Societies.* Edited by W. d'Azevedo. Bloomington: Indiana University Press, pp. 19–61.

——. 1974. *African Art in Motion.* Berkeley: University of California Press.

TUNIS, I. 1981. "A Study of Two Cire-Perdue Cast Copper-Alloy Stools Found in Benin City, Nigeria." *Baessler-Archiv* 29:1–66.

VERGER, P. 1954. "Role Joue par l'Etat d'Hebetude au cours de l'Initiation des Novices aux Cultes des Orisha et Vodun." *Bulletin de l'I.F.A.N.* serie B, 16 (3–4):322–340.

——. 1957. "Notes sur le Culte des Orisa et Vodun a Bahia, la Baie de tous les Saints au Bresil et a l'Ancienne Cote des Esclaves en Afrique." *Memoires de l'Institute de L'Afrique Noire* 51.

——. 1964. "The Yoruba High God—A Review of the Sources." Paper presented at the *Conference on the High God in Africa,* University of Ife.

——. 1969. "Trance and Convention in Nago-Yoruba Spirit Mediumship." In *Spirit Mediumship and Society in Africa.* Edited by J. Beattie and J. Middleton, New York: Africana Publishing Company.

——. 1976/1977. "The Use of Plants in Yoruba Traditional Medicine and its Linguistic Approach." In *Seminar Series,* no. 1, pt. 1. Edited by O. O. Oyelaran. Ife: Department of African Languages and Literatures, University of Ife.

VOGEL, S. M., ed. 1981. *For Spirits and Kings.* New York: The Metropolitan Museum of Art.

——. 1983. "Rapacious Birds and Severed Heads: Early Bronze Rings from Nigeria." *The Art Institute of Chicago Centennial Lectures: Museum Studies,* 10:331–357.

WESCOTT J., and P. MORTON-WILLIAMS. 1962. "The Symbolism and Ritual Context of the Yoruba Laba Shango." *Journal of the Royal Anthropological Institute* 92:23–37.

WILLETT, F. 1959. "A Terra-Cotta Head from Old Oyo, Western Nigeria." *Man* 59:180–181.

——. 1960. "Investigations at Old Oyo, 1956–57: An Interim Report." *Journal of the Historical Society of Nigeria* 2

(1):59–77.

———. 1966. "On the Funeral Effigies of Owo, Benin and the Interpretation of Life-Size Bronze Heads from Ife, Nigeria." *Man* (n.s.) 1:34–35.

———. 1967. *Ife in the History of West African Sculpture*. New York: McGraw-Hill.

———. 1970. ""Ife and Its Archeology." In *Papers in African Prehistory*. Edited by J. D. Fage and R. A. Oliver. Cambridge: Cambridge University Press, pp. 303–326.

———. 1971a. "A Survey of Recent Results in the Radiocarbon Chronology of Western and Northern Africa." *Journal of African History* 12:339–370.

———. 1971b. *African Art: An Introduction*. Thames and Hudson.

———. 1984. "A Missing Millennium? From Nok to Ife and Beyond." *Arte in Africa*:87–100.

———. 1988. "The Source and Significance of the Snake-Winged Bird in Southwestern Nigeria." *Art Journal* 47 (2):121–127.

WILLETT, F., and J. PICTON. 1967. "On the Identification of Individual Carvers: A Study of Ancestor Shrine Carvings from Owo, Nigeria." *Man* (n.s.) 1 (1):62–70.

WILLIAMS, D. 1964. "The Iconology of the Yoruba Edan Ogboni." *Africa* 34 (2):139–165.

———. 1974. *Icon and Image: A Study of Sacred and Secular Forms in African Classical Art*. New York: New York University Press.

WITTE, H. 1988. *Earth and the Ancestors: Ogboni Iconography*. Amsterdam: Gallery Balolu.

Photograph Credits

Afrika Museum, Berg en Dal, 124, 148; America West Primitive Art, Tucson, 118; The Art Institute of Chicago, 31, 168, 241; Dirk Bakker, 73; Neal Ball, 252; Richard Beaulieux, 24, 42; Robert Braunmüller, 3; Courtesy William W. Brill, 221; The Brooklyn Museum, 55; Christie's, London, 143, 242; Rick Chou, 260, 270, 272; Civic Center Museum, Philadelphia, 256; Prudence Cuming Associates Ltd., 234; Charles Davis, 229, 255; Balint B. Denes, 32, 130, 131, 139; The Detroit Institute of Arts, 109, 225; Nate Eatman, 206; Courtesy Dufour collection; The Fine Arts Museums of San Francisco, 78, 146; Valerie Franklin, 185, 220; Rene Garcia collection, 224; P. J. Gates Ltd., 178; Robert Graetz, 270; Irwin Green Collection, 240; Jeffrey Hammer, 166, 196, 218, 233, 263, 265, 269, 275; B. Hanson, 8; Barry Hecht, 204; B. Heller, 154; High Museum of Art, Atlanta, 266; Hood Museum of Art, Dartmouth College, 187; Indianapolis Museum of Art, 151; Kohlmeyer Collection, 250; Malcolm Mclean, 112; Daniel and Marian Malcolm, 36; Michael Mauer, 9; Barry D. Maurer, 13, 262; Memorial Art Gallery, University of Rochester, 237; The Metropolitan Museum of Art, 81, 152; Joan and Thomas Mohr collection, 193; Museum für Volkerkünde, West Berlin, 67, 68; Musee Royal de L'Afrique Centrale, Tervuren, 164, 264; Michael Myers, New Orleans, 125; National Museum of African Art, Eliot Elisofon Archives, 162; New Orleans Museum of Art, 113, 222, 239; George Ortiz, 117, 128; Peabody Museum, Salem, 150; John Pemberton III, 35, 77, 184; John Pinderhughes, 199, 200, 214, 216; Fred and Rita Richman, 107; Rietberg Museum, Zurich, 165; Peter Schnell, 14; The Seattle Art Museum, 30; Richard L. Smith, 249; Courtesy of Sotheby's, 33; Philip Stevens Jr., 82, 83, 84, 85, 86, 87, 88, 89, 90; Jerry L. Thompson, 10, 15, 25, 38, 39, 43, 44, 54, 59, 60, 65, 66, 69, 70, 72, 75, 79, 96, 106, 110, 116, 120, 126, 133, 137, 141, 147, 153, 173, 179, 181, 197, 206, 211, 264, 273, 274; Richard Todd, 23, 142, 149, 198; Toledo Museum of Art, 226; Ulmer Museum, Ulm, 11, 108; Frank Willett, 74, 76; James Willis Gallery, San Francisco, 177; Zehr Photography, 101, 159, 259.

Drawings, 45, 46, 84, by Elizabeth Simpson

Maps by Irmgard Lochner

Index

A

Abeokuta 175, 214, 218, 224, 226 – 227, 229
Ado Odo 224, 228 – 229
Ajase 13, 213, 223
Akio 27
Akoko 189
Akure 62, 88, 207
Anago 55, 148, 216, 220, 222 – 223
Apomu 138
Awori 177 – 181, 218, 221, 223 – 224, 227 – 228
Ayetoro 67, 227

B

Badagri 213, 223
Benin 13, 38, 49, 60 – 63, 65 – 67, 69, 71, 77, 91, 96 – 99, 101, 103 – 104, 106, 108 – 109, 113, 117, 120 – 127, 132, 136, 144, 148, 156, 185, 189, 213, 216, 223, 234

E

Ede 138, 150, 153, 156, 162, 178
Efon-Alaiye 168, 190, 202, 206
Egba 148, 178, 189, 213 – 218, 223, 227
Egbado 18, 25, 27, 55, 59, 129, 148, 150 – 152, 175, 178, 213 – 214, 218 – 220, 223, 226 – 228, 230
Ekiti 19, 23, 29, 32 – 33, 88, 91, 130, 148, 153, 155, 162, 164, 175 – 176, 189 – 190, 194 – 197, 202 – 203, 205 – 206, 208, 211
Epe 132 – 133, 145
Erin 156, 161, 166 – 167
Esie 13, 77 – 78, 80 – 83, 85 – 86, 88 – 89, 234
Esure 58

I

Ibadan 19 – 23, 30, 69, 156, 159, 161, 163, 166, 180, 183, 189, 214 – 218, 226, 233
Ibarapa 218
Idahin 216, 222
Idanre 38, 148
Idowa 143
Ife 13, 19 – 23, 26 – 27, 38, 45 – 47, 49 – 51, 55, 58 – 59, 61 – 67, 69 – 74, 77, 82, 88, 93, 96, 99, 101, 103, 106, 113, 117, 120, 125, 127, 129, 132, 143, 147, 155 – 156, 158, 170, 189, 213, 222, 233 – 234
Igbajo 69, 74
Igbogila 25, 218
Igbomina 29, 33, 77, 88, 148, 153, 162 – 163, 166, 182, 189, 196, 234
Ijara 88
Ijaye 159, 214 – 218
Ijebu 13, 16 – 17, 21 – 24, 27, 32 – 33, 38, 41 – 42, 46, 55, 63 – 64, 66 – 67, 94 – 96, 103, 117, 119 – 121, 123 – 128, 130 – 133, 136 – 138, 140, 143 – 145, 148, 161, 167, 174 – 175, 187, 189, 223, 227, 234
Ijebu-Ife 127, 137
Ijebu-Ode 17, 117, 119 – 120, 124 – 125, 127 – 129, 132, 143, 148, 234
Ijesa 69, 148, 189
Ijo 120, 124, 137, 143 – 145
Ikere 203, 205, 207 – 208, 210
Ikorodu 138, 144
Ila-Orangun 25, 29, 33, 37, 41, 88, 152, 163, 165 – 166, 168 – 169, 172, 174 – 175, 181 – 183, 185, 189, 196, 229
Ilaro 24, 214, 216, 220, 226, 228, 230
Ilobu 153, 156, 167 – 168

Ilorin 38, 152 – 155, 162, 181, 189, 195, 197, 202
Imosan 24, 130, 174
Iperu 131, 138
Irawo 167, 169
Ise 23, 202 – 203, 205 – 208
Iseyin 181

K

Ketu 55, 59, 62, 148, 151, 163, 213 – 214, 216, 218 – 220, 222, 227

L

Lagos 55, 117, 125, 138, 144, 153, 189, 197, 202, 219, 223

M

Meko 138, 144

N

Niger 13, 17, 62, 67 – 69, 71, 117, 120, 144
Nigeria 13, 17 – 18, 21, 23 – 25, 27, 29 – 30, 37 – 38, 41, 45, 49, 55, 58 – 59, 61, 74, 77 – 78, 86, 89, 91, 94, 97, 99 – 100, 103 – 104, 113, 119, 121, 127, 129 – 133, 147, 149 – 150, 153, 161, 164 – 165, 168 – 169, 172, 174, 177, 179 – 181, 183, 185, 187, 194, 196 – 197, 202, 205, 211, 214, 216, 218 – 220, 226, 229
Nupe 67 – 69, 85, 88, 147 – 148, 156, 175, 189, 234

O

Oba 15, 17, 30, 33, 39, 47, 58 – 59, 62 – 67, 71, 74, 86, 88, 96, 117, 125, 129, 132, 159, 168, 181, 183, 189, 196, 234
Offa 77 – 78
Ogbomoso 151, 185
Ogun 15, 28 – 32, 38 – 39, 41, 46, 49, 55, 69, 101, 103, 159, 161, 164, 166 – 167, 173, 211, 213, 216, 221 – 222, 224, 226 – 227, 230
Ohori 25, 147, 214
Okitipupa 137, 145
Old Oyo 155
Omu-Aran 189
Ondo 33, 46, 117, 120, 124, 137, 148, 171, 210
Oro 64 – 65, 123, 129, 136, 138, 143 – 144, 166, 206, 220
Oru 187
Osi-Ilorin 19, 197
Osun 15, 30, 39, 143, 161, 165 – 168, 170, 176, 202, 230
Ota 182, 218 – 219, 221, 223, 227, 230
Owo 13, 17, 22, 46, 62 – 63, 65 – 66, 71, 91, 93 – 97, 99 – 101, 103 – 106, 108 – 109, 111 – 113, 120, 124, 171, 179, 185, 207, 234
Owu 131, 138, 148, 227
Oyo 13, 15 – 16, 24, 30, 32, 34 – 38, 46, 49, 66 – 69, 71, 86, 88, 117, 120, 147 – 150, 152 – 159, 161, 163, 166 – 168, 170 – 172, 175 – 178, 181 – 182, 185, 189, 213 – 219, 223, 227, 229 – 230, 233 – 234

P

Pobe 55, 220, 222

R

Republic of Benin 13, 34, 59, 213

S

Sabe 148
Saki 167, 176

T

Tada 67, 69, 71, 106

Y

Yagba 176
Yewa 15, 213